A BIBLIOGRAPHY
OF THE PUBLISHED WORKS OF
CHARLES M. RUSSELL

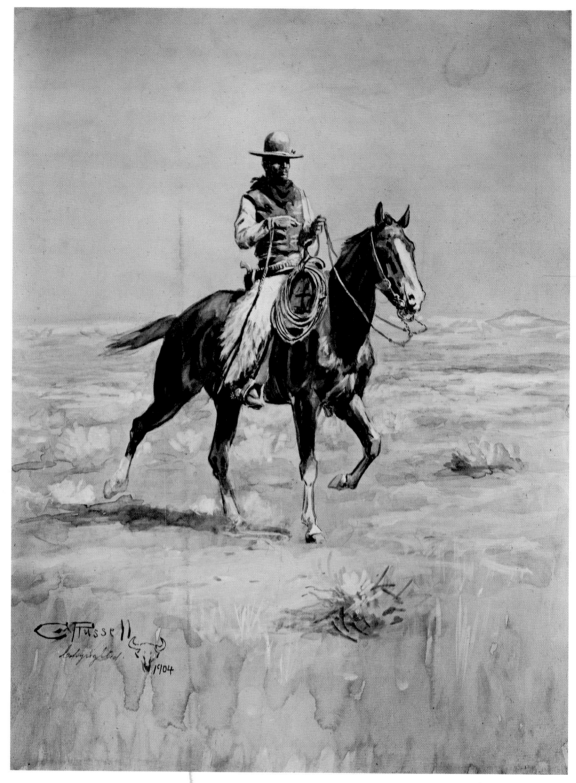

COWBOY #3
First appearance in color.

A BIBLIOGRAPHY
OF THE
PUBLISHED WORKS OF
CHARLES M. RUSSELL

Compiled by

Karl Yost and Frederic G. Renner

UNIVERSITY OF NEBRASKA PRESS · LINCOLN

Copyright © 1971 by the University of Nebraska Press

All rights reserved

International Standard Book Number 0–8032–0722–0

Library of Congress Catalog Card Number 68–11567

Manufactured in the United States of America

Foreword

The first attempt at a bibliography relating to Charles Marion Russell was a list of forty-four items, compiled by James Brownlee Rankin and published in 1938 in Theodore Bolton's *American Book Illustrators*. Ten years later *Charles M. Russell, the Cowboy Artist: A Bibliography*, compiled by Karl Yost, described 865 books, magazine articles, and other publications by or about this famous artist. In the foreword of that volume Yost indicated that it was doubtful that all the pertinent references then available had been uncovered, but expressed hope that publication of the bibliography would help bring other references to light. This has proved to be the case. The present bibliography contains approximately 3,500 citations—more than four times the number in 1948. Somewhat less than half of these have been published since then.

The tremendous growth in the amount of material which should be included in a bibliography of Charles M. Russell is a direct corollary to the increased public interest in western art in general and in the work of this artist in particular. In 1938 and even in 1948 the public had few opportunities to view important exhibits of Russell's work. Since then, beginning with the C. M. Russell Gallery at Great Falls, the Montana Historical Society Museum at Helena, the Whitney Gallery of Western Art at Cody, the R. W. Norton Art Gallery at Shreveport, and the greatest of them all, the Amon Carter Museum of Western Art at Fort Worth, have opened, augmenting the previously established Gilcrease Institute of American History and Art at Tulsa and the Woolaroc Gallery at Bartlesville. These great galleries have made Russell's work available to millions of people in recent years.

Every person who is introduced to Russell's work becomes a collector, in greater or lesser degree, and as more and more people learn about Russell, it is inevitable that more information will come to light. We do not claim that this is an impeccable job. It does represent the efforts of our combined sixty years of collecting and annotating Russell, but we will not be surprised if something turns up in the future. Our cut-off date has been arbitrarily set at December 31, 1966.

Many editors and authors, in publishing Russell's work, have exhibited an exasperating proclivity to ignore, or to fail to determine, the correct, or established, title of a painting or drawing or sculpture, and to invent new titles. One illustration, for example, LEWIS AND CLARK MEETING INDIANS AT ROSS' HOLE, has been published under twenty-two other titles. Therefore, our biggest problem has been that of assigning the correct title to each illustration, regardless of how it is captioned. We have adopted certain rules in establishing correct titles to paintings, drawings, sculpture, and stories. They are:

1. The first published title accompanying a reproduction of a painting, drawing or sculpture,

(a) unless we know that Russell assigned a title, which might be ascertained from a caption on the work itself (e.g., MEN THAT PACKED THE FLINT LOCK), or from Russell's notes or letters (e.g., COW AND CALF BRAND WRONG), or from his copyright applications, or from information supplied by his wife, Nancy (e.g., COON-CAN—A HORSE APIECE), in which event we use the Russell title. There are 95 instances of such titles. They are indicated by the symbol ® in the index;

(b) or unless someone other than Russell copyrighted a title before the first published appearance, in which event we use that title. There are thirteen instances of such titles. They are indicated by the symbol © in the index;

(c) or unless the first published title with accompanying illustration appeared since 1948, in which event we use the title assigned by Yost in his bibliography.

2. All other titles are those assigned by Yost in 1948 or by the present compilers for this bibliography. Assigned titles—those in categories 1(c) and 2—are indicated by the symbol § in the index.

We have not adhered strictly to the rule of "first published title," because in a few cases titles are inappropriate. For example, ME AN' MORMON MURPHY is the first published title for a drawing that was made to illustrate a line in the story "The Olden Days," which includes the phrase "two riders, one leading a pack horse," the title we have adopted, but has no reference whatsoever to the Mormon Murphy story. Another example is the picture PETE LANDS RUNNIN'. This actually is the second published title. The picture first appeared without a caption. It next appeared with the caption BUFFALO DISCOURAGES LINEBARGER, which is so egregiously inappropriate that we could not use it. The picture was drawn to illustrate the story "When Pete Sets a Speed Mark" and appeared in *Rawhide Rawlins Stories* in 1921 with the caption PETE LANDS RUNNIN'. Therefore, we adopted that title. There are quite a few similar instances of what might be termed title selection.

Where the same title has been used for more than one picture, e.g., THE SCOUT, we have numbered them in chronological sequence.

Throughout this bibliography we have shown the title as it actually was printed in the particular item described, and if that title does not conform to our rules, we have supplied "i.e." and the correct title.

We have used parentheses in titles of pictures to indicate that a word is superfluous, and we have used brackets to indicate that words are missing. We have attempted to follow this procedure with articles in titles. In the case of COWBOY SPORT (ROPING A WOLF) #1, COWBOY (MEXICAN), ROPING A (WHITE) BUFFALO WOLF, WAR (INDIAN TELEGRAPHING), and CHARLES M. RUSSELL (CARICATURE STATUETTE), the parentheses actually appear in the title as printed, and the parentheses do not in these instances indicate superfluous words. We have frequently disregarded errors in punctuation.

The first published appearance of an illustration is indicated by an asterisk.

Quite a few publications have carried illustrations of fake Russell paintings. Rather than explain these, we have simply omitted them.

Classification is always difficult, and in the case of CMR particularly so, because of the wide variety of forms in which his work appears, but we have made the following classifications, in nineteen sections:

Section I, Collations, is arranged chronologically, and describes books, usually in hard covers, containing the first publication of one or more Russell illustrations, as well as his writings. There are a few items, such as advertisements for certain books, which are included in Section I. In this section we have used virgules in only a few instances to emphasize the difference in title pages of different editions.

Section II is a chronological list of catalogs issued by museums, galleries and art dealers in connection with exhibits of Russell's work. We think that the chronological form gives an insight into Russell's career and development.

Section III is an alphabetical list of periodicals, including company house organs and school annuals, containing illustrations or articles by or about the artist. Dates are shown in parentheses simply because this seems to be standard bibliographic practice.

Section IV is an alphabetical list of newspapers, including all issues containing Russell illustrations that have come to our attention, plus a selection of newspapers that have carried accounts of Russell's life or art. The selection is intended to reflect the considerable publicity given to Russell during his life and since his death, locally and nationally.

Section V is a chronological list of portfolios of Russell prints. Section VI is an alphabetical list of color prints. Section VII is an alphabetical list of black and white prints.

Section VIII is an alphabetical list of postcards, according to title. Section IX is an alphabetical list of Christmas cards, according to title, which carry a reproduction of a Russell painting or drawing.

Section X comprises ephemeral items (sixteen pages or less) not otherwise classified, which carry Russell illustrations. Since many of them are not dated, they are arranged alphabetically as to title of the item.

Section XI covers advertisements, arranged alphabetically by the issuing firm, which utilized Russell illustrations as an attraction. We have included "booster" pamphlets in this section.

Section XII includes broadsides, flyers, and a variety of other transitory items with Russell illustrations or references, issued by the Montana Historical Society, arranged alphabetically according to caption of the item.

Section XIII covers price lists from dealers in prints and other Russell material, and is arranged alphabetically according to the issuing firm or organization.

Section XIV includes stationery, letterheads, envelopes, business forms, and bookplates carrying Russell illustrations, arranged alphabetically according to the individual or firm which used the illustration.

Section XV embraces what, for lack of a better term, we have called Related Objects. Here we include the considerable variety of objects, from ash trays to window posters, which carry reproductions of Russell's work. They are arranged alphabetically according to the nature of the item.

Section XVI, called Appearances, is a chronological list of books containing Russell illustrations which had been published previously.

Section XVII is a chronological list of references to Russell, but without illustrations of his art. Most of these are of minor importance, but some of them contain significant information.

Section XVIII is the Index to Paintings, Drawings and Sculpture. Section XIX is the General Index.

The terms folio, 4to, etc., refer to the fold of the sheet. The size refers to the page size in inches, the horizontal measurement being given first. A reference to wrappers indicates that there are wrappers in addition to the text pages. If an item is issued in what may be termed "self-wrappers," there is no mention of wrappers, but merely a reference to the number of pages.

We could not have compiled this bibliography without the help of Marion Whitver, amanuensis extraordinary, who not only typed and re-typed the manuscript, prepared both indices, and read proof, but also performed so much research over a period of seven years that she should properly be considered a co-author.

We wish to thank the following collectors who have divulged bibliographic secrets or have permitted us to examine their copies of Russell items or, not infrequently, have pursued inquiries at libraries on our behalf: Earl C. Adams, Donald Baird, John W. Bowman, Mark H. Brown, Henry W. Collins, William C. Decker, Steven Eckhart, Howard Foulger, Michael Harrison, Robert Kingery, Robert Kornemann, Henry E. Kuehl, K. S. Kurtenacher, R. W. Little, William R. Mackay, Mrs. Walter Marshall, Dr. Van Kirke Nelson, S. H. Rosenthal, Don Russell, Richard R. Sackett, Ralph J. Smith, Dr. and Mrs. Franz Stenzel, Thomas Teakle, Jack Tieman and Robert Warden.

We wish to thank the following librarians and others who have patiently answered our myriad inquiries: Margaret Auxier of the University of Alberta; Alfred Bush of the Princeton University Library; Hugh A. Dempsey of the Glenbow Foundation; Mary K. Dempsey and Harriett T. Meloy of the Montana Historical Society (and indeed many other staff members of the Montana Historical Society); Mildred Goosman of the Joslyn Art Museum; Gene M. Gressley of the University of Wyoming; Archibald Hanna of the Yale University Library; Pauline W. Jennings and Lavern Kohl of the Great Falls Public Library; Michael Kennedy, formerly of the Montana Historical Society; Dean Krakel of the National Cowboy Hall of Fame; Paul Rossi of the Gilcrease Institute; and Charlotte Tufts and Joan West of the Southwest Museum.

We also wish to thank the Amon Carter Museum, the Minnesota Historical Society, the Missouri Historical Society, the St. Louis Post Dispatch and the St. Louis Public Library for answering inquiries.

We also wish to thank the following antiquarian dealers who have helped us over the years: Richard S. Barnes of Chicago; Helen L. Card of Springfield, Va.; Peggy Christian of Los Angeles; Ken Crawford of Minneapolis; J. C. Dykes of College Park, Maryland; Dick Flood of Idaho Falls, Idaho; Paul W. Galleher of the Arthur H. Clark Company at Glendale; Wright Howes of Chicago; O'Neil Jones of Bigfork, Montana; Norman Kane of Pottstown, Pa.; John S. Van E. Kohn of the Seven Gables Bookshop, New York; Richard Mohr of International Book Finders; Samuel R. Morrill of Boston; J. E. Reynolds of Van Nuys, Calif.; and Charles Yale (deceased) of Pasadena.

We wish expressly to thank Helen Britzman of Colorado Springs for digging into the records of her late husband, Homer E. Britzman, and supplying us with valuable information, and William Bertsche of Great Falls for valuable assistance rendered.

Karl Yost
207 East Lincolnway
Morrison, Illinois

Frederic G. Renner
6692 32nd Place, N.W.
Washington, D.C.

Contents

List of Illustrations

SECTION I

Collations

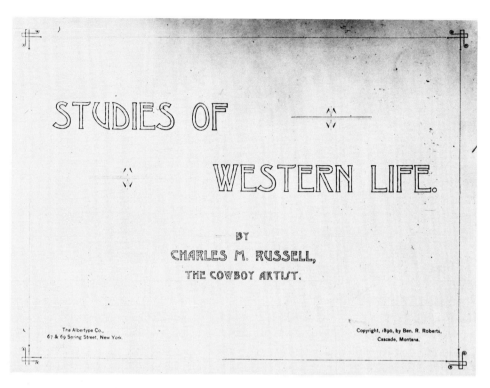

Titlepage of first edition of *Studies of Western Life*

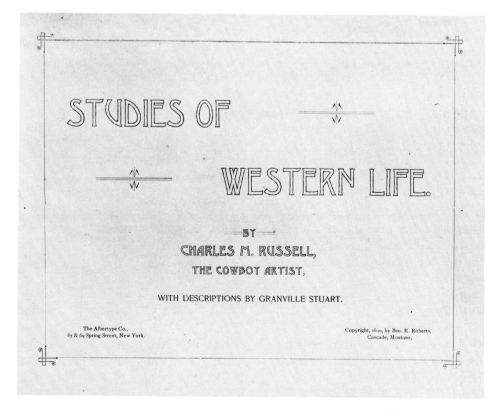

Titlepage of second edition of *Studies of Western Life*
(Note addition of line "With descriptions by Granville Stuart.")
See items 1 and 1a this section.

SECTION I

Collations

1. *Studies of Western Life*: 1890
Studies of / [rules] / [rules] Western Life. / [rules] By [rules] / Charles M. Russell, / The Cowboy Artist. / The Albertype Co., / 67 & 69 Spring Street, New York. / Copyright, 1890, by Ben R. Roberts, / Cascade, Montana.
Pp. [26]. Portfolio, size 9¼ × 6⅞, red cloth, three-punch silk tie. No letterpress. Printed obverse of leaves only.
p. [1]: Title page as above (see illustration).
p. [3]: WAR, (INDIAN TELEGRAPHING.)*
p. [5]: COWBOY SPORT, (ROPING A WOLF.) #1*
p. [7]: HANDS UP!*
p. [9]: CLOSE QUARTERS*
p. [11]: THE FORD*
p. [13]: DRIFTING*; also inset LINE RIDER*
p. [15]: ROPING A MAVERICK #1*; also inset HEARD SOMETHING DROP*
p. [17]: CROSSING THE MISSOURI #1*; also inset THE STAND*
p. [19]: THE HORSE WRANGLER #1*
p. [21]: DRIVING IN*; also inset BRONCHO BUSTING*; also inset COW PUNCHER*
p. [23]: OUT FOR MISCHIEF*; also TRAILING DEER*; also MOVING CAMP #1*; also IN CAMP*; also INDIAN GRAVE*; also INTERIOR OF TEPEE*
p. [25]: THE SENTINEL*

1a. *Studies*: Second Edition, 1890
Studies of [rules] / [rules] Western Life / [rules] By [rules] / Charles M. Russell, / The Cowboy Artist, / With descriptions by Granville Stuart. / The Albertype Co., / 67 & 69 Spring Street, New York. / Copyright, 1890, by Ben. R. Roberts, / Cascade, Montana
Pp. [48]. Portfolio, size 9¼ × 6¾. Ribbed cloth, three-punch silk tie.

The first issue of the second edition has no letterpress on the verso of the title page; the second issue has letterpress relating to the illustration entitled WAR on the verso of the title page. See Plate 2 for reproduction of title page. We have seen this item in brown, in red, in green, and in blue cloth, but the color of the cloth apparently has no bearing on priority. Each plate is on a separate sheet, printed on the recto, with verso blank; and except for the first plate, the letterpress for each plate is on a separate sheet also, printed on the recto, with verso blank.

Contains 12 Albertypes, as in first edition, with minor variations in punctuation and spelling.

1b. *Studies* (Advertisement 1891)
[illustration] / Studies of Western Life / By / Chas. M. Russell, / The Cowboy Artist. / [rule] / With Vivid Descriptions by Hon. Granville Stuart. / [six lines]
Pp. [4]. Folio, size 5½ × 8⅞.
This advertisement, not a prospectus, was published about May, 1891, judging from the dates of the reviews it contains. The illustration on p. [1] is: COWBOY SPORT —ROPING A WOLF #1.

1c. *Studies* (Robbins Reprint 1919)
Studies of / Western Life / —By— / Charles M. Russell / The Cowboy Artist / with descriptions by Granville Stuart / [vignette] / Published by J. L. Robbins Co. / Spokane, Wash. / [rule] / Copyright by Ben R. Roberts The Albertype Co., Brooklyn, N.Y.
There is no date on the title page. Published 1919.
Pp. [26]. Folio, size 9¾ × 7⅞. Wrappers, punched and tied. This edition contains the same 12 plates as the first edition, but the letterpress relating to each plate is on the verso of the preceding plate. The front wrapper

bears an early portrait of CMR on the left half, and on the right half: WAITING FOR A CHINOOK.

2. *How the Buffalo Lost His Crown* (1894)

How the Buffalo / Lost his Crown / [device] / With Illustrations by Charles M. Russell / [device] The Cowboy Artist [devices]

There is no date on the title page.

Pp. [8]+9–41+[42–44]. Folio, size 12½ × 10. Bound in dull greenish-grey cloth with silver embossing. Title on upper right, author's name on lower right, and triangular design on upper left. Deckle edges.

The name of the author, John H. Beacom, appears on the cover, but then only his surname is printed. The text is printed, and the pages numbered, on the recto only of each letterpress page. Although the illustrations are tipped in, they are included in the pagination.

The words "Copyright 1894 by John H. Beacom. Forest and Stream Publishing Co. Print" appear on verso of title page.

See Plate 3 for reproduction of title page. Contains eight illustrations:

cover: IN HIS HEAD THE MOUSE SHALL HENCEFORTH MAKE HIS HOME*
p. [11]: AN EVENING WITH OLD NIS-SU KAI-YO*
p. [15]: THE BONE GAME*
p. [19]: OLD MAN SENDING COURIER*
p. [23]: THE GREAT GAME FOR THE RULERSHIP OF THE WORLD*
p. [27]: "FROM THIS DAY FORTH"*
p. 29: same as cover, but reduced size
p. [31]: "THOU SHALT LIVE ON THE FLESH OF THE BUFFALO"*
p. 39: photograph of Charles M. Russell
p. 41: BONES FOR HAND GAME*

2a. *How the Buffalo* (R. H. Russell Imprint 1898)

Using the same plates as the first edition, R. H. Russell published a second edition in 1898. See Plate 4 for a reproduction of the title page of the first issue of this second edition. It was bound like the first edition. See Plate 4 for reproduction of the title page of the second issue of the second edition. It was bound in red boards, stamped in yellow on the front cover. Both issues of the second edition contain the same illustrations as the first edition.

3. *Cattle Queen of Montana*: 1894

The / Cattle Queen / of Montana / [rule, 11 lines and rule] / Compiled by / Charles Wallace. / [rule] / Illustrations from special photographs. / [rule] / St. James, Minn. / C. W. Foote, Publisher / 1894.

Pp. 249. 8vo, size 5⅛ × 7½. Wrappers. Contains three halftones, all tipped in, facing:

p. 146: LOST IN A SNOWSTORM—"WE ARE FRIENDS"*
p. 152: A VIEW IN THE "BAD LANDS"* (published as SHOOTING A SPY after CMR added the three mounted Indian figures. Cf. "The Artist," Sec. III, *infra*.)
p. 244: AT WORK ON A ROUND UP, i.e., BRANDING CATTLE—A REFRACTORY COW

3a. *Cattle Queen* (Revised, 1898)

The Cattle / Queen / of Montana / [13 lines] Revised and Edited by / Alvin E. Dyer / The Press of the / Dyer Printing Company, / Spokane, Wash.

There is no date on the title page; probably issued 1898.

Pp. 260, 8vo, size 5½ × 7⅞. Pictorial wrappers. Contains two halftones, facing:

p. 48: INDIANS MAKING SIGN OF PEACE TO WHITE MEN IN SNOWSTORM, i.e., LOST IN A SNOWSTORM—"WE ARE FRIENDS"
p. 152: A VIEW OF (i.e., IN) THE "BAD LANDS"

4. *Illustrated History* (1896)

Illustrated History of the Union Stockyards. Sketchbook of familiar faces and places at the yards. [7 lines]. By W. Jos. Grand. Illustrations from photographs by O. Benson, Jr. Thos. Knapp Ptg. & Bdg. Company, 341–351 Dearborn Street, Chicago.

There is no date on the title page. Copyright 1896.

Pp. 362+24 pp. ads+5 blanks. 8vo, size 5¼ × 7¾. Brown cloth with stamping in silver on front cover and spine. Also in green. Also encountered in light blue cloth, with silver stamping, but the illustrations are dark, almost obscure, indicating plate wear and, thus, a later edition. There is an edition of this book copyrighted 1896 which does not carry any illustrations. There is another edition copyrighted 1901 bound in limp red cloth which does carry the illustrations.

Contains two halftones:

p. 263: COON-CAN—A HORSE APIECE
p. 264: COON-CAN—TWO HORSES*

5. *Story of the Cowboy*: 1897

The Story of the Cowboy by E. Hough [1 line]. Illustrated by William L. Wells and C. M. Russell [vignette] New York, D. Appleton and Company, 1897.

Pp. 344+5. 8vo, size 5 × 7⅞. Bound in decorated cloth, stamped in silver. "Story of the West Series." There were editions in 1898 and 1904 similar in content. The editions of 1929 and 1933 do not contain illustrations.

Contains six halftones by CMR, tipped in, facing:

p. 172: ROPING A MAVERICK #2*
p. 194: A STAMPEDE #1*
p. 257: A CONTEST OF RACES, i.e., COON-CAN—A HORSE APIECE
p. 261: "RED WINS," i.e., COON-CAN—TWO HORSES

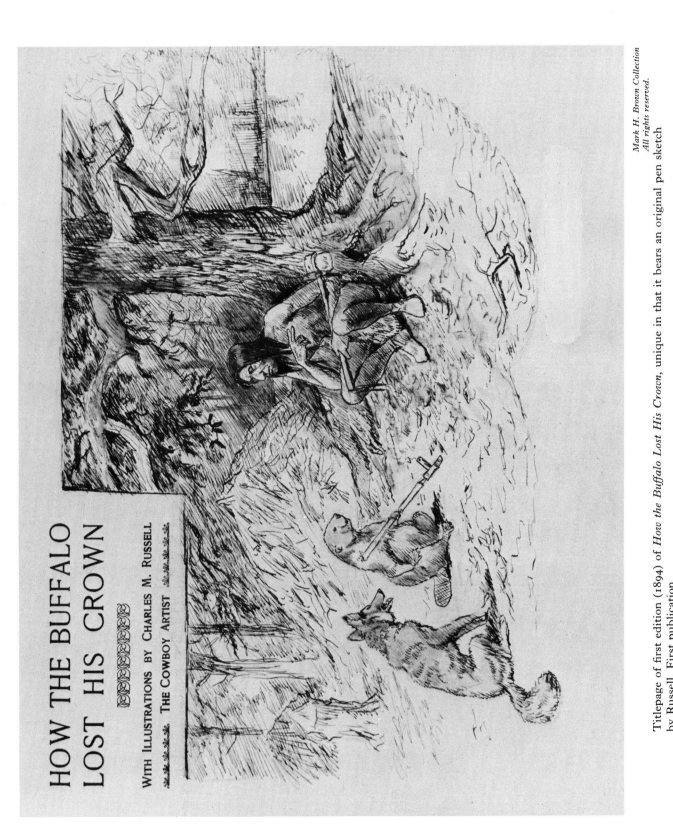

Titlepage of first edition (1894) of *How the Buffalo Lost His Crown*, unique in that it bears an original pen sketch by Russell. First publication.
See item 2, this section.

HOW THE BUFFALO
LOST HIS CROWN

With Illustrations by Charles M. Russell
The Cowboy Artist

R. H. RUSSELL
Publisher New York
1898

Titlepage of second edition, first issue (1898) of *How the Buffalo Lost His Crown.*
Note large logotype, and date in Arabic figures.

HOW THE BUFFALO
LOST HIS CROWN

With Illustrations by Charles M. Russell
The Cowboy Artist

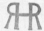

NEW YORK
R. H. RUSSELL
MDCCCXCVIII

Titlepage of second edition, second issue (1898) of *How the Buffalo Lost His Crown.*
Note small logotype, and date in Roman figures.
See item 2a, this section.

p. 278: LOOKING FOR RUSTLERS*

p. 307: A MEETING IN A BLIZZARD (TALKING IN SIGN LANGUAGE), i.e., LOST IN A SNOWSTORM—"WE ARE FRIENDS"

5a. *Story of the Cowboy* (Brampton)

National edition complete in twelve volumes. Builders of the Nation. The Cowboy I by E. Hough Author of the Singing Mouse Stories etc. [seal]. Illustrated. New York, The Brampton Society Publishers.
There is no date on the title page. Copyright 1908.
Two volumes. Vol. I: Pp. x + 181. Vol. II: Pp. 182–349.
Appleton edition plates.

Vol. I
fcg. p. 172: ROPING A MAVERICK #2

Vol. II
fcg. p. 256: A CONTEST OF RACES, i.e., COON-CAN—A HORSE APIECE
fcg. p. 260: "RED WINS," i.e., COON-CAN—TWO HORSES
fcg. p. 278: LOOKING FOR RUSTLERS
fcg. p. 306: A MEETING IN A BLIZZARD (TALKING IN SIGN LANGUAGE), i.e., LOST IN A SNOWSTORM— "WE ARE FRIENDS"

N.B. "A Stampede," p. 182, is not same as in Appleton edition, and is not by CMR.

6. *Pen Sketches* (1899)

Pen [device] / Sketches / By / Chas. M. Russell / The Cowboy Artist / [SKULL #1*] / CMR
There is no title page. The foregoing appears on the left half of the front cover. INDIAN HEAD #5* appears on the right half of the front cover. Published by W. T. Ridgley Printing Co., Great Falls, Mont., 1899.
Twelve plates, each preceded by a leaf on the recto of which is printed the title of the plate, a poetic quotation, and a brief description of the plate. Contains:
THE INDIAN OF THE PLAINS AS HE WAS*
NATURE'S CATTLE #1*
PAINTING THE TOWN*
HOLDING UP THE OVERLAND STAGE*
THE TRAIL BOSS*
THE CHRISTMAS DINNER*
THE SHELL GAME*
THE INITIATION OF THE TENDERFOOT*
INITIATED*
THE LAST OF THE BUFFALO*
THE RANGE RIDER'S CONQUEST*
THE LAST OF HIS RACE*

The first edition is bound in cloth and gilt, size 14 × 11. The plates are on heavy kid cardboard.

The second edition is bound in black morocco. There are several issues. The first issue has a vignette of a camping scene on the flyleaf above the publisher's imprint, and titles are printed on each plate. The second issue differs in that the camping scene has been replaced with SKULL #1. We have also seen this issue in suede, with letterpress pages on Strathmore paper, no watermark on plate pages.

The third edition, also in black morocco, has no titles printed on the plates; the flyleaf bears a heavy scroll design below the publisher's imprint; the plate INITIATED has been replaced by the plate BLAZING THE TRAIL, i.e., LEWIS AND CLARK AT THREE FORKS OF THE MISSOURI.

The fourth edition, also in black morocco, has the words "Published by W. T. Ridgley Printing Company, Great Falls, Mont." stamped in gold in the lower left-hand corner of the cover. An issue of this edition has the letterpress on thin paper, sometimes referred to as tissue guards.

The fifth edition was bound in boards, light blue color. Plates have printed on them: "Copyrighted by W. T. Ridgley."

There were also copies issued in portfolios. The advertisement described immediately below refers to portfolios priced at $4.00. Inasmuch as the advertisement is not dated, we cannot tell positively which edition is described. The *Great Falls Tribune* for December 8, 1901, has an advertisement for *Pen Sketches*, illustrated by THE LAST OF THE BUFFALO, which reads: "The book of pen sketches published by the W. T. Ridgley Printing Co. is now issued in an improved form and contains several new drawings by Mr. Russell. Besides being issued in book form, it is also put up in portfolio, each picture being suitable for framing. The work contains twelve drawings by this western Artist. Price of book, $5.00; Portfolio, $3.50." We have not unearthed a copy of the portfolio of either price, but it would appear that they were folders with the sketches loose. We cannot be positive, but it seems that the advertisement refers to the third edition, and the *Great Falls Tribune* advertisement refers to the fifth edition.

6a. *Pen Sketches* (Advertisement)

[INDIAN HEAD #5, embossed] / Pen Sketches / by / Chas. M. Russell / The Cowboy Artist.
The front wrapper serves as the title page. There is no date on the title page. Probably 1900.
Pp. [4], folio, size 4½ × 6¼. Dark brown wrappers.
p. [1]: Pen Sketches by Chas. M. Russell, Cowboy Artist. The most beautiful Holiday Book ever issued in the west. The work contains twelve Pen Sketches by Chas. M. Russell, the Cowboy Artist, and shows him at his best with the pen. Life of the far West is here portrayd [sic] as no

other artist has been able to do. The sketches are on fine vellum paper and handsomely bound. Price, Morocco Binding $6. Portfolios, $4. Mail Prepaid. W. T. Ridgley Printing Works. Tod Building, Great Falls, Montana.

SADDLE #1

p. [2]: [THE] INITIATION OF THE TENDERFOOT

p. [3]: INITIATED

7. *Butte and Its Copper Mines* (1899)

1899 / [double rule] / . . . Butte, Montana . . . / The Greatest Copper Mining / District in the World . . . / Issued by / The Thompson Investment Company / Butte, Montana / [5 lines]

There is no date on the title page.

Pp. 24. Folio, size $8\frac{9}{16} \times 6\frac{1}{2}$. Pictorial wrappers. It was probably issued about February of 1899—in any event, early in the year.

The front cover is reproduced in the *American Book Collector*, November, 1961, p. 14. Renner has the only known copy in his collection. Contains one halftone:

p. 3: PIONEER PROSPECTORS*

8. *Rhymes from a Round-Up Camp*: 1899

Rhymes / from the Round-Up Camp. / [rule] / By Wallace D. Coburn. / [rule] / Copyrighted 1899, / by Wallace D. Coburn.

Pp. 138, 12mo, size $5 \times 6\frac{1}{2}$. Bound in olive green cloth, with front cover stamped in blind—Rhymes from a Round-Up Camp—with relief in gold. Deckle edge. Endsheets of coated, ribbed paptrie. Some copies bound in limp morrocco leather with endsheets of the same paper as the text.

In the first issue the article "the" appears in the title, on the title page. There are no pages on stubs. There are typographical errors on pages 49, 52, 57, 66 and 100. The stanzas on page 110 are transposed. The first stanza begins "But on the fourth." The second paragraph on page 130 contains six lines, the last three lines of which read: "nowadays with a bunch of dogie* cattle, and imagine / nowadays, with a bunch of dogie cattle, and imagine / they've learned all there is 'bout punchin' cows."

In the second issue pages 109–110 are on a stub and the stanzas on page 110 have been changed but are still not in correct order. The first stanza begins "But brave was he." Pages 129–130 are on a stub, but the second paragraph on page 130 contains only five lines.

In the third issue pages 49–50, 51–52, 57–58, 65–66, 99–100 and 129–130 are on stubs. Typographical errors have been corrected. Pages 109–110 may be bound in with stanzas on page 110 as in the first issue, or on a stub with stanzas in proper sequence. The second paragraph on page 130 contains six lines. There is an aberration to this issue in which pages 99–100 and 129–130 are bound in but the sixth line of the second paragraph of page 130 contains one word, "cows," only.

In the fourth issue pages 49, 51, 57, 65, 99, 109 and 129 are on stubs with typographical errors corrected, with stanzas on page 110 in correct order, and with second paragraph on page 130 containing six lines.

The limp leather binding is not an indication of priority, because it exists on copies of both the second and third issues. The leather was a "deluxe" binding. The story that only three copies were bound in leather for Coburn, Ridgley, and CMR is purely apochryphal, because Yost has leatherbound copies of the second and third issues. See illustrations of title pages on Plate 5.

All issues of the first edition contain eight line engravings, tipped in, facing:

p. 9: DAME PROGRESS PROUDLY STANDS*

p. 17: "AND I FIND I AM RIDING IN THE MIDST OF RUNNING STEERS"*

p. 24: "NOW HERDER, BALANCE ALL"*

p. 33: O GHASTLY RELIC OF DEPARTED LIFE*

p. 41: "AND WITH A SORT O' STATELY BOW HE TURNED HIS BACK ON SIM"*

p. 65: HIS FIERCE JAWS SNAP, HIS EYEBALLS GLARE*

p. 133: "SO WITHOUT ANY ONDUE RECITATION I PULLS MY GUNS AN CUTS DOWN ON THEM THERE TIN-HORNS"*

p. 137: "SO ME RUN UP BEHIN SHOVE DE GUN IN HIS BACK AN' TELL HIM STOP HIS PONY"*

8a. *Rhymes*: Revised, 1899

Rhymes from A / Round-Up Camp / By Wallace D. Coburn. / Illustrated by Chas. M. Russell. / [vignette] Copyrighted 1899. / [5 dots] / W. T. Ridgley Press / Great Falls, Montana.

Pp. 147 (148 blank). 12mo, size $5\frac{5}{16} \times 7\frac{11}{16}$. Bound in green cloth. Front cover stamped in gold and blind. Backbone stamped in gold running lengthwise.

There are a few copies known, bound in limp red or brown leather, size $6\frac{3}{4} \times 9\frac{3}{8}$. The *Great Falls Daily Tribune* for December 24, 1900, p. 6, has an ad: "You couldn't find a better or more acceptable Christmas gift than a copy of Rhymes from a Round-Up Camp which is having such a phenomenal sale at Randall Drug Co. In fawn and wine leather, $2.00; cloth $1.50. New Xmas edition just out. Call and examine." We have never seen a copy in fawn leather, and do not know for sure whether the "wine" leather refers to the red leather which we have seen. In any event, this seems to be a variant binding, perhaps a second issue of the second edition. See Plate 5 for reproduction of

Titlepages of *Rhymes From A Round Up Camp*

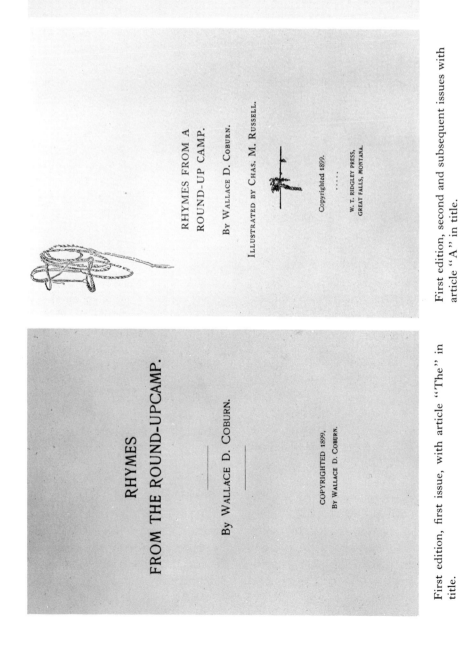

RHYMES
FROM THE ROUND-UPCAMP.

By Wallace D. Coburn.

COPYRIGHTED 1899,
By Wallace D. Coburn.

RHYMES FROM A
ROUND-UP CAMP.

By Wallace D. Coburn.

Illustrated by Chas. M. Russell.

Copyrighted 1899.

.

W. T. RIDGLEY PRESS,
GREAT FALLS, MONTANA.

RHYMES
FROM A ROUND-UP CAMP.

By Wallace D. Coburn.

COPYRIGHTED 1899,
By Wallace D. Coburn.

First edition, first issue, with article "The" in title.

First edition, second and subsequent issues with article "A" in title.

Second edition.
See item 8, this section.

Window card advertising *Rhymes From A Round Up Camp*
See item 8b, this section.

title page. Contains the same full-page plates as Coll. 8 plus the following 15 line engravings:

t.p.: HACKAMORE*
SPEAR AND WAR BONNET*
p. 8: QUIVER, TWO BOWS AND SHIELD*
p. 9: SADDLE AND SPURS*
p. 32: BELT AND KNIFE SCABBARD*
p. 51: MOCCASINS*
p. 52: RABBIT HEAD*; DEER HEAD*; BEAR HEAD*; WOLF HEAD*
p. 54: TEN GALLON HAT, CARTRIDGE BELT AND REVOLVER IN HOLSTER*
p. 68: WOLF HEAD, TONGUE OUT*
p. 74: "MEDICINE" STICKS*
p. 112: SHIELD AND WAR HATCHET*
p. 114: WAR BONNET AND STONE AX*
p. 124: SADDLE #1*
p. 126: QUIRT*
p. 130: same as p. 54
p. 147: BUFFALO HEAD*

8b. "Rhymes from a Round-Up Camp" by W. D. Coburn. Realistic Western Poems by a Western Man Price in leather, $2.50, Cloth, $2.00. Randall Drug Co., Great Falls, Montana. Window card, size $5\frac{3}{4} \times 7\frac{1}{4}$.
O GHASTLY RELIC OF DEPARTED LIFE

8c. Coburn's Immortal West. As world-famous cowboy artist, Chas. M. Russell put it in pictures, and Wallace David Coburn in poems, in the famous book, "Rhymes from a Round-Up Camp." Window card, size 11 × 14.
I PULLS MY GUNS AN CUTS DOWN ON THEM THERE TIN-HORNS, i.e., SO WITHOUT ANY ONDUE RECITATION I PULLS MY GUNS AN CUTS DOWN ON THEM THERE TIN-HORNS

8d. *Rhymes*: Revised, 1903
Rhymes from A / Round-Up Camp / By / Wallace David Coburn / Illustrated by / Charles M. Russell / New Edition, Revised and Enlarged / [device] / G. P. Putnam's Sons / New York and London / The Knickerbocker Press / 1903.
Set within rule border.
Pp. xii + 137. 8vo, size $5\frac{1}{4} \times 7\frac{1}{2}$. Decorated cloth, gilt top. Variant copies exist with (a) the words "Reprinted, October 1903" instead of "Published, October 1903" on verso of title page; (b) the word "Preface" in upper and lower case instead of caps; (c) frontispiece included in list of illustrations. No difference in contents, however.
Contains 14 line engravings, with captions:
front.: THE INDIANS' TALE OF CHRIST, i.e., HIS LAST HORSE FELL FROM UNDER HIM*

p. 2: DAME PROGRESS PROUDLY STANDS
p. 9: I SPURRED HIS REEKING FLANKS, i.e., AND I FIND I AM RIDING IN THE MIDST OF RUNNING STEERS
p. 20: "NOW, HERDER, BALANCE ALL"
p. 24: "O GHASTLY RELIC OF DEPARTED LIFE"
p. 31: HE TURNED HIS BACK ON SIM, i.e., AND WITH A SORT O' STATELY BOW HE TURNED HIS BACK ON SIM
p. 45: "HIS FIERCE JAWS SNAP, HIS EYEBALLS GLARE"
p. 59: "WE FOUND HIS LIFELESS BODY"*
p. 63: "THEN POOR BILL FELL BACK UNCONSCIOUS"*
p. 72: "HERE LIES POOR JACK; HIS RACE IS RUN"*
p. 83: "HIS LAST HORSE FELL FROM UNDER HIM"
p. 108: "THEY FOUGHT TO THE DEATH WITH THEIR BOWIES"*
p. 112: OUT ON THE PRAIRIE'S ROLLING PLAIN*
p. 129: I PULLS MY GUNS AN' CUTS DOWN ON THEM THERE TIN-HORNS, i.e., SO WITHOUT ANY ONDUE RECITATION I PULLS MY GUNS AN CUTS DOWN ON THEM THERE TIN-HORNS
p. 133: SO ME RUN UP BEHIN', SHOVE DE GUN IN HIS BACK AN' TELL HIM STOP HIS PONY
Contains 24 line engravings, without caption:
p. 3: TEN GALLON HAT, CARTRIDGE BELT AND REVOLVER IN HOLSTER
p. 4: BUCKING HORSE*
p. 12: COWBOY TWIRLING LARIAT, LONGHORNS RUNNING*
p. 15: RABBIT HEAD; DEER HEAD (same as p. 36)
p. 16: BRANDS #1*
p. 22: COWBOY STANDING, RIGHT HAND ON HIP*
p. 26: BULL AND COW*
p. 36: RABBIT HEAD; DEER HEAD; BEAR HEAD; WOLF HEAD
p. 37: BRANDS #2*
p. 42: COWBOY ON A SPREE*
p. 52: TWO MEN THROWING PACK HORSE HITCH*
p. 54: WOLF HEAD, TONGUE OUT
p. 65: BELT AND KNIFE SCABBARD
p. 75: PIPE, BELT AND STEEL*
p. 78: THREE HORSES' HEADS
p. 80: MOCCASINS
p. 94: COWBOY, SIDE VIEW, CIGARETTE IN LEFT HAND*
p. 97: FOUR COWBOYS GALLOPING*
p. 99: SQUAW SADDLE*
p. 110: SADDLE AND SPURS
p. 113: COWBOY ABOUT TO SADDLE HORSE*
p. 117: SHIELD, BOW, WAR HATCHET, PIPE AND SCALP*
p. 121: QUIRT
p. 123: BEAR HEAD (same as p. 36)
p. 125: HACKAMORE
p. 131: RIFLE, POWDER HORN AND SHOT POUCH*

8e. *Rhymes*: Gem, 1925

Rhymes from A Round-Up Camp By Wallace David Coburn Illustrated by Charles M. Russell. New Edition, Revised and Enlarged [device] Gem Publishing Company, Los Angeles, Calif., 1925

Pp. xx + 137. 8vo, size $5\frac{1}{4} \times 7\frac{1}{2}$.

This edition was published simultaneously in three styles of binding: (a) the De Luxe edition in calf, punched and tied; (b) the Art edition in boards simulating a bunkhouse door; (c) the Regular edition in brown cloth stamped in gold.

This edition contains a foreword entitled "Wallace David Coburn," which is attributed to Russell. In other respects, this is the same as 8d because those plates were used.

9. *Wonderland*: 1900

Wonderland 1900 By Olin D. Wheeler, Illustrated [14 lines] Copyright, 1900 by Chas. S. Fee, General Passenger and Ticket Agent, Northern Pacific Railway, St. Paul, Minn.

Pp. 132. 8vo, size $6\frac{3}{4} \times 9\frac{5}{8}$. Pictorial wrappers.

Contains one color plate:

front.: LEWIS AND CLARK MEETING THE MANDAN INDIANS*

10. *Great Falls Directory*: 1900

R. L. Polk & Co. and W. T. Ridgley's Great Falls City Directory 1900 [10 lines, design] Also a Complete Classified Business Directory [design] R. L. Polk & Co. and W. T. Ridgley, Publishers. [5 lines]

Pp. 366 + 2. 8vo, size $5\frac{3}{4} \times 8\frac{3}{4}$. Buckram.

Contains one sepiatone:

fcg. p. 252: ANTELOPE HUNT*

11. *Then and Now*: 1900

Then and Now: or, Thirty-Six Years in the Rockies. Personal Reminiscences of Some of the First Pioneers of the State of Montana. Indians and Indian Wars. The Past and Present of the Rocky Mountain Country, 1864–1900. By Robert Vaughn. Minneapolis: Tribune Printing Company, 1900.

Pp. 461. 8vo, size $5\frac{3}{4} \times 8\frac{1}{2}$. Bound in pictorial cloth. There was also a deluxe full leather binding, gold stamped, gilt edges, art endsheets, inscribed by author. The *Great Falls Tribune* for December 22, 1900, p. 6, has an ad: "By request, the author has had a few copies of the book, Then and Now, bound in morocco with gold gilt especially for the holidays. For sale in the two different bindings at Porter Bros., The Randall Drug Store, and at room 15 Vaughn Bldg."

The *Great Falls Tribune* for June 16, 1901, p. 6, col. 2, has this: "Robert Vaughn has just received the second edition of his book Then and Now. For sale at room 15, Vaughn Bldg., and at various book stores in the state." We surmise that this refers to a second printing, rather than a second edition. We have not seen a copy which can be identified.

Contains eight halftones:

p. 59: A PRAIRIE SCHOONER CROSSING THE PLAINS*

p. 82: LEWIS AND CLARK MEETING THE MANDAN INDIANS

p. 126: INDIANS HUNTING BUFFALO*

p. 143: THE PIEGANS LAYING THEIR PLANS TO STEAL HORSES FROM THE CROWS, i.e., INDIAN HORSE THIEVES

p. 145: GOING HOME WITH THE STOLEN HORSES, i.e., EARLY MONTANA, INDIANS RUNNING OFF HORSES

p. 403: ROPING A STEER TO EXAMINE THE BRAND, i.e., BRANDING CATTLE—A REFRACTORY COW

p. 406: THE ROUND-UP. TURNING OUT IN THE MORNING, i.e., BREAKING CAMP #1

p. 408: FIRST ATTEMPT AT ROPING

12. *Brief History of Butte*: 1900

A Brief History of Butte, Montana, The World's greatest mining camp. Illustrated. By Harry C. Freeman, Butte, Montana. Chicago, The Henry O. Shepard Company, Printers of The Inland Printer, 1900.

Pp. [ii] + 123 + 5 pp. ads. 8vo, size $8\frac{1}{4} \times 11\frac{1}{8}$. Bound in copper colored cloth. Front cover lettered in black.

Contains four halftones:

p. 8: AMBUSH OF PACK TRAIN, i.e., THE AMBUSH

p. 11: FOR SUPREMACY*

p. 12: SHOOTING UP THE TOWN*

p. 13: SURRENDER OF THE OUTLAWS, i.e., BESTED

13. *Great Falls and Cascade Directory*: 1901

R. L. Polk & Co. and W. T. Ridgley's Great Falls and Cascade County Directory, 1901–2 [17 lines].

Pp. 594. 8vo, size $5\frac{3}{4} \times 8\frac{1}{2}$, cloth.

p. A: THREE HORSES' HEADS*

14. *Progressive Men* (1902)

Progressive Men of The State of Montana. [rule] Illustrated. [rule] [2 lines] [rule] Chicago: A. W. Bowen & Co., Engravers and Publishers.

There is no date on the title page. Published in 1902; see below.

Pp. 1886. 4to, size $8\frac{3}{4} \times 11$. Bound in full leather, blind stamped, gold lettering on spine, gilt edges, decorative endsheets.

This is one, and we think the first, in a series of mug books. The picture is dated 1902, and from internal evidence it is likely that the data were compiled during 1901, up to about November 1. The picture is a Montana scene, and it is not likely that CMR would paint a picture of Colorado, and then change the title

to represent Montana. All the other mug books are dated (1903, 1904, or 1905) and are listed in the Appearances section, *infra*.

Contains, in addition to a biographical account of CMR with full-page photo portrait, pp. 1320–1321, one halftone:

p. 688: EARLY LIFE IN MONTANA*

15. *Eighth Report* (1902)

Eighth Report of the Bureau of Agriculture, Labor and Industry of the State of Montana for the year ending November 30, 1902. J. A. Ferguson, Commissioner. L. P. Benedict, Chief Clerk. Independent Publishing Company, Official State Printers and Binders, Helena, Montana.

Pp. 733. 8vo, size $6\frac{3}{4} \times 10\frac{1}{8}$. Bound in black cloth.

Contains one halftone, tipped in, facing:

p. 24: THE WAY IT USED TO BE*

p. 149: photo, Starting on the Round-Up, includes Russell on horse

p. 153: photo, Cowboys at Mess, includes Russell seated on ground

16. *Adventures with Indians*: 1903

Adventures with Indians and Game, or Twenty Years in the Rocky Mountains by Dr. William A. Allen. Illustrated. Chicago, A. W. Bowen & Co., 1903.

Pp. 302, 16mo, size $5\frac{3}{4} \times 8\frac{3}{4}$. Bound in three-quarter black calf, marbled boards. Backbone gold-stamped. Top edge gilt, fore and lower edges trimmed.

Contains three halftones:

p. 63: CUSTER'S LAST BATTLE*

p. 120: BATTLE OF THE ELKS*

p. 221: DEATH BATTLE OF BUFFALO AND GRIZZLY BEAR*

17. *Hope Hathaway*: 1904

Hope Hathaway A Story of Western Ranch Life by Frances Parker [seal] Boston, Mass. C. M. Clark Publishing Co. (Inc.) 1904.

Pp. viii + 408. 8vo, size $5 \times 7\frac{3}{8}$. Bound in light green cloth, with details following.

The first issue of the first edition is $1\frac{1}{4}$ inches thick including covers; French back; the front cover is stamped in white enamel, black and brown ink; the spine is stamped in white; all the copies of this edition we have seen have the illustration HARRIS AND HIS FRIENDS tipped in facing p. 192, although the List of Illustrations calls for it as facing p. 24.

The second issue of the first edition is $1\frac{7}{16}$ inches thick including covers; round back; other points the same as first issue.

The second edition is $1\frac{7}{16}$ inches thick including covers; the front cover is stamped in gray, black, and brown ink; the spine is stamped in white; and the illustration HARRIS AND HIS FRIENDS is tipped in facing p. 24.

The third edition, or perhaps it may be the second issue of the second edition, is $1\frac{5}{16}$ inches thick including covers; the front cover is stamped in gray, black, and brown ink; the spine is stamped in brown; and the illustration HARRIS AND HIS FRIENDS is tipped in facing p. 24.

A fourth edition appeared without illustrations. A Grosset & Dunlap edition appeared with the colored frontispiece and all the black and white illustrations except OLD JIM MCCULLEN.

N.B.: Eight of the illustrations (all except HOPE HATHAWAY and OLD JIM MCCULLEN) appeared as a set of black and white lithographs. See Section V for details. Contains frontispiece color plate and 9 halftones, all tipped in:

front.: HOPE HATHAWAY*

fcg. p. 22: AS QUICKLY THE HORSE TOOK FRIGHT*

fcg. p. 24: HARRIS AND HIS FRIENDS* (see note above)

fcg. p. 34: "IT IS GOOD, JUST AS I THOUGHT, AND AS COLD AS ICE," HE SAID*

fcg. p. 54: NEARLY UNSEATING THE OLD COWPUNCHER IN HER DEMONSTRATIONS OF WELCOME*

fcg. p. 108: OLD JIM MCCULLEN*

fcg. p. 122: ON HER FACE WAS THE SNARL OF A DOG*

fcg. p. 244: OLD PETER . . . ROLLED OVER IN A CONVULSED HEAP*

fcg. p. 266: BROUGHT HER FACE TO FACE WITH LONG BILL AND SHORTY SMITH*

fcg. p. 392: DRAGGED THE HEAVY BODY UP TOWARD THE SHELTER OF ROCKS*

17a. *Hope Hathaway* ad, broadside, size $13\frac{3}{4} \times 25\frac{3}{4}$.

C. M. Clark Publishing Co. (Inc.) Illustration HOPE HATHAWAY in color. Printed by Geo. H. Walker & Co., Boston.

18. *Trail of Lewis and Clark*: 1904

The Trail of Lewis and Clark 1804–1904 [4 lines] By Olin D. Wheeler [5 lines] Volume I. G. P. Putnam's Sons, New York and London, The Knickerbocker Press, 1904.

Pp. xxiv + 277 + 5. 8vo, size $5\frac{3}{4} \times 8\frac{1}{4}$. Bound in red cloth, gold-stamped front and backbone. Back cover blank. Top edge gilt. Volume I of two-volume set described. Words "Published June 1904" on verso of title page. A new edition in two volumes, with an introduction by Frederick S. Dellenbaugh, and containing the same text and same illustrations, was published New York, 1926.

Contains 1 color plate and 2 halftones tipped in:

front.: CAPTAIN LEWIS, WITH DREWYER AND SHIELDS, MEETING THE SHOSHONE INDIANS, AUGUST 13, 1805, ON THE HEADWATERS OF THE SNAKE (LEMHI) RIVER, IN IDAHO, i.e., CAPTAIN LEWIS MEETING THE SHOSHONES* (color)

p. 249: INDIANS HUNTING THE BISON IN THE DAYS OF LEWIS AND CLARK, i.e., MANDAN BUFFALO HUNT*

p. 333: CAPTAIN CLARK, CHABONEAU, SACAGAWEA, AND PAPOOSE IN THE CLOUD-BURST NEAR THE GREAT FALLS, ON JUNE 29, 1805*

19. *Bucking the Sagebrush*: 1904

Bucking the Sagebrush or The Oregon Trail in the Seventies by Charles J. Steedman. Illustrated by Charles M. Russell. G. P. Putnam's Sons, New York and London, The Knickerbocker Press, 1904.

Pp. x + 270. 8vo, size $5\frac{1}{2} \times 8\frac{1}{8}$. Cloth. Words "Published November, 1904" on verso of title page. Contains frontispiece color plate, 8 halftones, and 15 marginal line engravings:

front.: POINTING OUT THE TRAIL*

Halftones, tipped in, facing:

p. 56: TESTING THE HORSE MARKET*

p. 58: A STRENUOUS MATINEE*

p. 62: HOLDING 'EM UP*

p. 134: SIGNS OF INDIANS*

p. 216: BLANCO*

p. 218: "STA-Y WITH HIM, BLANCO"*

p. 234: BROKE LOOSE AND COMING YOUR WAY*

p. 264: THE DISAPPOINTMENT OF A LIFETIME*

Marginal pen and inks, not captioned:

p. v: BUCKING HORSE

p. 9: WOLF HEAD

p. 27: BEAR HEAD

p. 38: DIAMOND HITCH, SIDE AND TOP VIEWS*

p. 50: TWENTY MULE TEAM*

p. 63: MOUNTED COWBOY*

p. 82: same as p. 50

p. 99: HORSE AND COWBOY TUMBLING DOWNHILL*

p. 114: same as p. 63

p. 128: COWBOY INITIATING TENDERFOOT*

p. 152: TRAIL DRIVERS WATCHING HERD*

p. 164: same as p. 38

p. 176: THREE INDIAN TIPIS*

p. 190: same as p. 152

p. 220: BULL AND COW

p. 230: TWO MEN THROWING PACK HORSE HITCH

p. 247: TEN GALLON HAT, CARTRIDGE BELT, AND REVOLVER IN HOLSTER

p. 259: COWBOY TWIRLING LARIAT, LONGHORNS RUNNING

p. 270: COWBOY ON A SPREE

20. *My Sixty Years*: 1905

My Sixty Years on the Plains Trapping, Trading, and Indian Fighting. By W. T. Hamilton ("Bill Hamilton") Edited by E. T. Sieber. With Eight Full-Page Illustrations by Charles M. Russell [vignette] New York, Forest and Stream Publishing Co., 1905.

Pp. 244. Size $5\frac{5}{8} \times 8\frac{1}{8}$, red cloth.

Second edition, so marked, same date. Third edition dated 1909. Although the title page states that there are 8 full-page illustrations by Russell, actually there are only 6. A photograph of the author, used as frontispiece, and a photograph of Washakie, facing page 64, make up the eight illustrations.

Contains six halftones, tipped in, and not included in pagination, facing:

p. 30: "I BROKE THE COW'S BACK"*

p. 38: "HIS ARROW LODGED IN THE FLESHY PART OF MY HORSE'S SHOULDER"*

p. 96: "NEXT MORNING SOME UTAH INDIANS CALLED ON US"*

p. 178: FREE TRADERS*

p. 190: PAWNEE HORSE THIEVES*

p. 228: "THE TRAPPERS PASSED THROUGH THEM WITH THEIR COLT'S REVOLVERS"*

20a. *My Sixty Years* (Long)

Reprinted by Long's College Book Co., Columbus, Ohio, 1951, with a special preface by J. Cecil Alter. Limited to 1,000 copies reproduced in photographic facsimile, hence same pagination as original, plus dustwrapper bearing PAWNEE HORSE THIEVES.

20b. *My Sixty Years* (Oklahoma)

Reprinted by University of Oklahoma Press, Norman, Oklahoma (1960). In the Western Frontier Library with an Introduction by Donald J. Berthrong. Reproduces the six CMR illustrations only.

21. *Chip of the Flying U* (1906)

Chip, / Of the Flying U / [ornamental rule] / By / B. M. Bower / (B. M. Sinclair) / Author of / "The Lure of the Dim Trails", "Her Prairie Knight", / "The Lonesome Trail", etc. / [ornamental rule] / Illustrated in Colors / By / Charles M. Russell / [ornamental rule] / Street & Smith / New York and London.

Title page set within ornamental rule. There is no date on the title page.

Pp. 264. 8vo, size $4\frac{7}{8} \times 7\frac{1}{4}$. Bound in red cloth. The verso of the title page bears the words "Copyright, 1904 / Street & Smith / [two rules] / Chip, of the Flying U / [ornament]."

Contains three color plates:

front.: "CAME DOWN WITH NOT A JOINT IN HIS LEGS AND TURNED A SOMERSAULT"*

Advertisement for first edition of *Chip of the Flying U*, substantiating precedence of Street & Smith edition.

See item 21, this section.

Titlepage of first edition of *Chip of the Flying U* (1906, Street & Smith), preceding Dillingham.

fcg. p. 176: "THE LAST STAND"*
fcg. p. 252: "THROWING HERSELF FROM THE SADDLE SHE
SLID PRECIPITATELY INTO THE WASHOUT,
JUST AS DENVER THUNDERED UP"*

This book has been a bibliographical puzzle for some time. We can now say unequivocally that the Street & Smith edition is the first edition, despite some apparent anachronisms. *Chip of the Flying U* first appeared in the October, 1904, issue of *Popular Magazine*, without illustrations, and was copyrighted that year by the publisher, Street & Smith. Its first appearance in book form is described above and was advertised in the May, 1906, issue of *Popular Magazine* (see Sec. III, *infra*). At the time the advertisement appeared, publication rights had been sublet to G. W. Dillingham Company, which published numerous subsequent editions. Most likely the advertisement was set up before the transfer to Dillingham was consummated. Undoubtedly what Dillingham did was print up a new title page for the stock of sheets Street & Smith had on hand, encase them, and perhaps send a copy to the Library of Congress. We have heard of, but have not seen, a copy in wrappers. This may be apocryphal; on the other hand, it may not.

21a. *Chip* (Dillingham Edition 1906)

Chip / Of the Flying U / By / B. M. Bower / (B. M. Sinclair) / Author of / "The Lure of the Dim Trails", "Her Prairie Knight", / "The Lonesome Trail", etc. / [publisher's seal] / Illustrations by / Charles M. Russell / G. W. Dillingham Company / Publishers New York.

There is no date on the title page. Text of title page enclosed in a border of printer's ornament.

Pp. 264, 8vo, size $4\frac{7}{8} \times 7\frac{1}{4}$. Bound in red cloth, white enamel lettering on front cover and spine. The verso of the title page bears the words "Copyright, 1904, by Street & Smith. Copyright, 1906, by G. W. Dillingham Company. Chip of the Flying U. Issued April, 1906." The first issue of the Dillingham edition contains the same illustrations as the Street & Smith edition, in color. The second issue contains the same illustrations, all in sepia. The lettering on the front cover is in black ink. Later, there was a "Popular Edition," indistinguishable from the second issue of the Dillingham edition unless it carries the dustwrapper.

21b. *Chip* (Grosset & Dunlap Edition)

Grosset & Dunlap of New York, using the plates of the Dillingham and Street & Smith editions, brought out several editions, with plates in black and white. We believe that the first of these was in 1913, but we have no proof.

22. *The Range Dwellers* (1907)

The Range Dwellers / By / B. M. Bower / (B. M. Sinclair) / Author of / "Chip, of the Flying U", "The Lure of the / Dim Trails", "Her Prairie Knight", / "The Lonesome Trail", etc. / Illustrated in Colors / by / Charles M. Russell / Street & Smith / New York and London

Pp. 256. 8vo, size $4\frac{7}{8} \times 7\frac{1}{4}$. Cloth, with front cover stamped in black, of principal horse in illustration found opposite p. 90. The story "The Range Dwellers" first appeared in *Ainslie's Magazine*, a Street & Smith publication, for July, 1906, without illustrations. In magazine form it was copyrighted by Street & Smith. Thereafter Street & Smith printed it in book form, and sold some copies with their imprint, before the publication rights were assigned to G. W. Dillingham Co., who filed application for copyright January 9, 1907, and deposited copies February 4, 1907. Apparently the book form was never copyrighted by Street & Smith, but Dillingham did so in order to protect the illustrations.

Contains three color plates:

front.: "SHE TURNED HER BACK ON ME AND WENT
IMPERTURBABLY ON WITH HER
SKETCHING"*

op. p. 90: "HIS HIND FEET CAUGHT THE TOP WIRE AND
SNAPPED IT LIKE THREAD"*

op. p. 142: "FROSTY STILL STOOD WHERE I HAD LEFT
HIM LOOKING DOWN AT THE GRAY
HORSE"*

22a. *The Range Dwellers* (Dillingham)

The Range / Dwellers / By / B. M. Bower / (B. M. Sinclair) / Author of / "Chip, of the Flying U", etc. / [seal] / Illustrations by / Charles M. Russell / G. W. Dillingham Company / Publishers, New York. There is no date on the title page. Same collation as Street & Smith edition. The words "Copyright, 1906, By Street & Smith Copyright, 1907, By G. W. Dillingham Company Issued Feb. 1907" appear on the verso of the title page. Contains same color illustrations as the Street & Smith edition. Another edition carries 2 plates in sepia: SHE TURNED HER BACK and HIS HIND FEET CAUGHT THE WIRE. There was also an edition with all plates in black and white. We have seen a copy with the plate FROSTY STILL STOOD in color as a frontispiece, but without the other illustrations. Inasmuch as the plates were tipped in, it is a reasonable surmise that when the publisher ran out of all the plates, he simply threw in what was on hand, and then later ran some more in sepia and still later in black and white. For that reason probably any copy with a color plate should be considered as earlier than a copy with sepia plates or black and white plates.

22b. *The Range Dwellers* (Grosset)
Grosset & Dunlap brought out an edition using the same plates as the Street & Smith and Dillingham editions, with the illustrations in halftone, and SHE TURNED HER BACK on the dustjacket in color.

23. *The Lure of the Dim Trails* (1907)
The / Lure of the Dim Trails / By / B. M. Bower / [2 lines] / Illustrations by C. M. Russell / [seal] / G. W. Dillingham Company / Publishers, New York. There is no date on the title page.
Pp. x + 210 + 4. 8vo, size 5⅜ × 7½. Tan cloth. "The Lure of the Dim Trails" appeared in *Popular Magazine*, August, 1905. The verso of the title page bears the words "Issued October, 1907." First edition in tan cloth with white enamel lettering and yellow, white, and black stamping on front cover. Second edition in red with black lettering.
Contains three color plates, tipped in:
front.: OUT WHERE THE TRAILS OF MEN ARE DIM AND FAR APART*
fcg. p. 94: A RIFLE CRACKED AND BOB TOPPLED LIMPLY TO THE GRASS*
fcg. p. 204: THURSTON HELD MONA SOMEWHAT TIGHTER THAN HE NEED TO HAVE DONE*
Contains 29 marginal pen and ink sketches:
p. 5: COWBOY, MOUNTED, AND PACK HORSES*
p. 16: WOMAN PETTING AN UNSADDLED HORSE*
p. 19: TRAIN ROBBERY, HORSES STANDING*
p. 25: HEAD OF A COWBOY*
p. 39: COWHORSE, SADDLED*
p. 49: COWBOY SADDLING A HORSE*
p. 56: BRANDING IRONS*
p. 60: COWBOY, MOUNTED, TWIRLING A ROPE*
p. 65: COWBOY, MOUNTED, HORSE STANDING*
p. 67: STEER #1*
p. 74: COWBOY ON FOOT LASSOING HORSE*
p. 88: MARE AND FOAL*
p. 102: STRING OF FIVE MOUNTED COWBOYS*
p. 119: COWBOY ON A BUCKING HORSE*
p. 127: ANTELOPE STAMPING ON A RATTLESNAKE*
p. 137: COWBOY TIGHTENING CINCH ON A FRACTIOUS HORSE*
p. 139: STEER #2*
p. 143: COWBOY, MOUNTED, DRIVING A STEER*
p. 146: COWBOY SEATED ON GROUND, HORSE STANDING*
p. 149: TWO WOLVES*
p. 150: PACK HORSE #1*
p. 154: STEER SKULL*
p. 160: COWBOYS RESTING ON GROUND, HORSES STANDING*
p. 164: BIT AND BRIDLE*
p. 169: JACKRABBIT*
p. 173: COWBOY SITTING CROSSLEGGED ON HORSE*
p. 178: BRANDS #3*
p. 179: VULTURE ON BUFFALO CARCASS*
p. 182: CALF LYING DOWN, COW IN BACKGROUND*

23a. *The Lure of the Dim Trails* (Grosset & Dunlap)
There were two editions by Grosset & Dunlap, bound in red cloth with black lettering. One has a French back with the words "The Lure of the / Dim Trails / By / the Author of / 'Chip of the Flying U'" and figures stamped in yellow on cover. This has frontispiece OUT WHERE THE TRAILS OF MEN ARE DIM AND FAR APART, and p. 204, THURSTON HELD MONA. The other has a rounded back with the words "The Lure of the / Dim Trails / B. M. Bower" and figures stamped in brown on cover. The dustwrapper bears colored illustration of OUT WHERE THE TRAILS OF MEN ARE DIM AND FAR APART and frontispiece of the same illustration in black and white. No priority established.

24. *Chaperoning Adrienne* (1907)
Chaperoning Adrienne A Tale of the Yellowstone National Park by Alice Harriman-Browne Author of Stories of Montana, Songs o' the Sound, etc. With illustrations by Charles M. Russell (The Cowboy Artist) and photographs.
There is no date on the title page. Copyrighted 1907.
Pp. 92 + 4. 8vo, size 6 × 9. This appears in four bindings. Based on dates of presentation copies, priority is as follows: The first binding is in green cloth with short title and author's name in dark green lettering on front cover, and a photograph of a woman pasted in a stamped oval; the second is green cloth with an illustration of a six-horse stage (not by CMR) and the title of the book in fancy lettering pasted on the front cover; the third is in boards with the six-horse stage illustration and wallet edges; the fourth is in yellow cloth with the six-horse stage illustration pasted on front cover.
Contains six line engravings, without captions:
front.: STAGECOACH IN SILHOUETTE*
p. 37: CUPID IN THE WEST IS A COWBOY*
p. 44: FIFTY FEET UP A TREE IT WAS*
p. 51: ELK HORN*
p. 81: FOOTSTEPS OF THE FURTIVE FOLK*
p. 83: FAWNS NUZZLING FOR DINNER*

25. *Fifteen Thousand Miles by Stage*: 1911
Fifteen Thousand Miles by Stage By Carrie Adell Strahorn With 350 Illustrations from Drawings by Charles M. Russell and others, and from Photographs. New York—G. P. Putnam's Sons—London, The Knickerbocker Press, 1911.
Pp. xxviii + 673. 8vo, size 6 × 8⅞. Bound in green cloth. Front cover gold-stamped, with pasted label of illustra-

tion on p. 205, QUICK AS A THOUGHT. Backbone gold-stamped. Back cover blank. Top edge gilt, fore and lower edges trimmed. There were 12 copies especially bound for presentation in full green morocco extra. The endpapers are enlarged negative-plate reproductions of the illustration on p. 222, A SHARP TURN. Dust-wrapper also bears line illustration, without caption, of SIX HORSE STAGE*. Contains 85 Russells in all. Four color plates, tipped in, and not included in the pagination, with descriptive letterpress on tissue guards:

fcg. p. 6: AS COCHRANE AND PARD LEAPED INTO THEIR SADDLES*

fcg. p. 80: THE STAGE AHEAD OF US HAD BEEN AT-TACKED*

fcg. p. 148: THAT NIGHT IN BLACKFOOT WAS A TERROR*

fcg. p. 270: WHEN THE ELK WAS BELIEVED TO BE DEAD*

13 halftones:

p. 33: IN THE SHADOW OF THE CHIEF, THE SQUAW, AND PAPOOSE MOUNTAINS*

p. 105: LAUGHED AT FOR HIS FOOLISHNESS AND SHOT DEAD BY SLADE*

p. 123: THAT DAMN THING AHEAD OF US IS A BEAR*

p. 157: HE TRIPPED AND FELL INTO A DEN OF A MOTHER BEAR AND HER CUBS*

p. 161: TEN OR TWELVE HORSES TO A WAGON STRETCHING THEMSELVES OUT IN LONG MUSCULAR TENSION*

p. 205: QUICK AS A THOUGHT HE WAS PULLING HIS GREAT STALWART FIGURE FROM OUT THE COACH*

p. 219: WE WENT OVER WITH BAGGAGE, MAIL, TREASURE BOX, AND TOOLS*

p. 323: IF EVER I SENT UP AN EARNEST PRAYER FOR HELP I DID IT THEN*

p. 399: HIGHWAYMEN RUN DOWN A PEDESTRIAN ONLY HALF A BLOCK FROM US*

p. 403: IN THE COURT OF A WOOD MERCHANT*

p. 499: THE HOLDUP AT AMERICAN FALLS*

p. 539: IT WAS A PERILOUS MOMENT AND AN UNFORTU-NATE HOUR*

p. 560: A POTLATCH AT JUNEAU*

38 line illustrations, bearing captions:

p. 3: BOB'S STAMPEDED MOUNT FELL OVER A PRECIPICE AND BROKE ITS NECK*

p. 6: A BUFFALO HERD HOLDING UP A TRAIN*

p. 22: THE BANDITS HOPED FOR A RICH HAUL*

p. 34: HE LURED THE IRATE LANDOWNER INTO A DEEP HOLE*

p. 81: INDIANS WERE SEEN ON THE ROAD*

p. 85: MRS. CORBET LIFTED HIM BY THE EARS AND PUT HIM OUT*

p. 88: TYPICAL HOME STAGE STATION*

p. 99: FINDING THE GOLD THAT MADE VIRGINIA CITY FAMOUS*

p. 104: HIGHWAYMAN WAITING FOR HIS PREY*

p. 147: COLONEL LINSLEY'S BAPTISM*

p. 149: DANIELSON'S DOUBLE-END STORE*

p. 162: INDIANS SCRAPE THE JUICY NUTRIMENT FROM UNDERNEATH THE BARK*

p. 175: THE FIGHT BETWEEN THE TWO HAD BEEN A LIVELY ONE*

p. 212: THE BRANCHES RUBBED ME OUT OF MY SADDLE*

p. 222: A SHARP TURN*

p. 234: HUNTING ON SKEES*

p. 239: A HERD OF ANTELOPE SCENTING DANGER*

p. 259: LORDS OF THE YELLOWSTONE*

p. 279: IN CAMP NEAR THE GREAT FALLS* (this is on p. 254 also, without caption)

p. 298: IDAHO OX TEAMS WERE BRINGING IN SOME 6,000,000 POUNDS OF FREIGHT ANNUALLY* (this is on p. 120 also, without caption)

p. 321: SPOKANE FALLS WAS THE CROSSROADS FOR ALL THE INDIAN TRIBES IN THE COUNTRY*

p. 328: THE COWHIDE ON THE RAILS SMELLED GOOD TO THE FAMISHED WOLVES*

p. 389: IN THE LAND OF THE NAVAJOS*

p. 397: IT WAS THE FIRST TIME OUR FELLOW PASSENGERS HAD BEEN HELD UP BY A MULE*

p. 430: HE HELD HIS REVOLVER PRESSED INTO PARD'S SIDE*

p. 434: THERE WAS NO OTHER JAIL BUT A HOLE IN THE GROUND WITH GUARDS OVER IT*

p. 458: PREPARING FOR A QUICK CHANGE OF HORSES*

p. 476: MANY TIMES THE MEN HAD TO GET OUT AND PICK THEIR WAY AROUND THE MUD-HOLES*

p. 503: TEAMS AND SADDLE HORSES LEFT THEIR OWNERS TO GET HOME AS BEST THEY COULD*

p. 518: THE COYOTES SCENTED THE PREY*

p. 526: THEN THE CALDWELLITES CHARTERED THE STAGE AND WENT HOME* (this is on p. 91 also, without caption)

p. 529: THEY HOISTED THEIR BURROS A HUNDRED AND SIXTEEN FEET*

p. 532: HE RAN ALL OVER THE PASTURE WITH THE PIG SQUEALING AT EVERY JUMP*

p. 590: IT REQUIRED NEARLY THREE HOURS TO GET AROUND OUR OWN LITTLE PARK*

p. 621: AN INDIAN FISHING CAMP*

p. 630: INDIAN HARRY IN BORROWED FINERY*

p. 642: PARD IN SLIPPERS AND PAJAMAS HASTENED TO INVESTIGATE*

p. 671: THERE IS A MEASURE OF SADNESS IN THE PASSING OF THE LUMBERING STAGE-COACH, i.e., DAME PROGRESS PROUDLY STANDS

30 vignettes in line, without caption:

p. v: TWO MEN, MOUNTED, WITH THREE PACK PONIES*

p. 1: GUNMAN ROPED BY CUPID ON HORSEBACK*

p. 11: COWBOY, MOUNTED #1*
p. 27: KICKED HALFWAY ACROSS THE STREET*
p. 44: COWBOY, HAND IN WAISTBAND*
p. 65: MOUNTAIN SHEEP*
p. 75: INDIAN, MOUNTED #2*
p. 91: same as p. 526.
p. 101: MASKED MAN, A VIGILANTE*
p. 112: MAN ON ROCKY LEDGE*
p. 120: same as p. 298
p. 127: INDIAN SQUATTING, BACK TURNED, HORSE NEAR-BY*
p. 134: INDIANS WITH TRAVOIS*
p. 160: BEAR, FOREFEET ON LOG, LOOKING AT RANCH HOUSE*
p. 176: PRAIRIE CHICKENS*
p. 186: TWO MEN LOADING PACK HORSE, SADDLE HORSES NEARBY*
p. 203: BULL ELK*
p. 223: DEER RUBBING ANTLERS AGAINST TREE*
p. 245: same as p. v
p. 254: same as p. 279
p. 310: WE MUST RIDE LIKE THE DEVIL*
p. 341: INDIAN SPEARING FISH*
p. 364: SNAKES CRAWLING AROUND TWO BOXES*
p. 391: INDIAN WEARING SERAPE AND WIDE-BRIMMED STRAW HAT*
p. 432: INDIAN TOMAHAWK, PIPE, AND "MEDICINE"*
p. 448: OWL ON BUFFALO SKULL*
p. 492: THREE MEN ON HORSES*
p. 535: CAMPER FLIPPING FLAPJACKS*
p. 545: THREE COYOTES OR WOLVES HOWLING, RANCH IN BACKGROUND*
p. 552: SAILING VESSEL NEAR ROCKS IN OCEAN*
p. 575: INDIAN, MOUNTED, CONFRONTING WHITE MAN, MOUNTED*
p. 605: GRIZZLY WITH SACK OF FLOUR*
p. 618: INDIANS IN PIROGUE*
p. 648: INDIAN HOLDING SCALP OF SLAIN WHITE MAN ALOFT*

25a. *Fifteen Thousand Miles*: Second edition, 1915
A second edition of *Fifteen Thousand Miles by Stage* was published in 1915. The words "Second Edition" are on the title page just above the publisher's imprint. The date, 1915, is on the title page. Bound in orange-red cloth with pasted label, also in barn-red cloth without label. Priority undetermined. This second edition does not have the pictorial endsheets that graced the first edition, but it does contain one additional illustration, which is not listed in the table of contents, tipped in, facing:
p. 426: RIVALS HAVING APPROPRIATED THE CARRIAGE, THESE YOUNG MEN DECAMPED FOR THE CHRISTMAS BALL AT BELLEVUE*

26. *The Virginian*: 1911
The Virginian A Horseman of the Plains by Owen Wister [two lines] New Edition with illustrations by Charles M. Russell and drawings from western scenes by Frederic Remington. New York, The Macmillan Company, 1911. All rights reserved.
Pp. xvi + 506 + 6. Frontispiece tipped in. 8vo, size $5\frac{1}{8} \times 7\frac{1}{2}$. Bound in embossed red cloth. Front cover gold-stamped with pictorial paper label in colors, which is the same Russell illustration as the frontispiece, although reduced. Top edge gilt.

The verso of the title page, that is, p. [iv], bears these words: "New illustrated edition, October, 1911. Special Limited Edition, October, 1911. Set up and electrotyped. Published October, 1911."
Contains frontispiece color plate and 42 line engravings, for which captions have been supplied (those titles followed by the initials "CMR" are taken from Russell's own work copy of *The Virginian*, in which he made notes of suitable incidents for illustration):
front.: THEY SAT LONG TOGETHER AT BREAKFAST*
p. 2: THE ROPE WOULD SAIL OUT AT HIM*
p. 15: SIDE SADDLE*
p. 29: FARO LAYOUT* (CMR)
p. 45: WASH TROUGH* (CMR)
p. 64: WOLF #2*
p. 78: HEN AND PUPPIES* (CMR)
p. 88: COW AND CALF BRAND WRONG* (CMR)
p. 101: COWPUNCHERS PULLING STAGE OUT OF RIVER* (CMR)
p. 117: VIRGINIAN ON A HORSE*
p. 129: WHERE THE LASSO TRAVELS FREE*
p. 140: SCOOL MARM* (CMR)
p. 146: MOLLY AND HER VIRGINIAN SAT AT A CERTAIN SPRING*
p. 164: MAN KICKED OFF TRAIN* (CMR)
p. 176: CRACKING SNAKE FROM HORSE* (CMR)
p. 190: BUNCH OF RIDERS* (CMR)
p. 202: FROGGS* (CMR)
p. 211: COWBOY SEATED, HORSE NUZZLING HIS LEFT HAND*
p. 219: PICKING UP ROPE* (CMR)
p. 230: COWBOYS*
p. 246: COWBOY MOUNTED #2*
p. 254: COWBOY MOPPING BROW TENDING BRANDING IRON FIRE*
p. 269: STRING OF CATTLE DESCENDING PATH*
p. 282: SKELETON OF A STEER #2*
p. 298: SHORTY PETTING HORSE* (CMR)
p. 311: VENGEANCE LIKE A BLAST STRUCK BALAAM*
p. 322: VULTURE FLYING*
p. 335: VIRGINIAN WOUNDED* (CMR)
p. 349: INDIAN MAN MOUNTED, SQUAW AND THREE PACK-HORSES*

Cover of new illustrated edition of *The Virginian*, 1911

"THEY SAT LONG TOGETHER AT BREAKFAST, BREATHING THE MORNING BREATH OF THE EARTH THAT WAS FRAGRANT WITH WOODLAND MOISTURE AND WITH THE PINES."

Frontispiece to *The Virginian*
See item 26, this section.

p. 365: INDIAN WITH HORNS* (CMR)

p. 380: HORSEMEN WITH PRISNERS* (CMR)

p. 394: DIMOND HICH IN RANE* (CMR)

p. 403: INDIAN WITH RIFLE, CROUCHED IN A DEADFALL*

p. 421: SADDLE, DOUBLE-RIG*

p. 434: THE VIRGINIAN* (CMR)

p. 446: RANCH HOUSE, THREE HORSES TIED TO RAIL*

p. 451: VIRGINIAN SHOOTING SNAKE FROM HORSE* (CMR)

p. 460: RIDING HERD*

p. 473: COWBOY SLEEPING ON GROUND, HORSE STANDING*

p. 484: THE VIRGINIAN STOOD LOOKING DOWN AT TRAMPAS*

p. 494: CHUCKWAGON, COWBOYS EATING ON GROUND*

p. 499: ANTILOPE* (CMR)

p. 506: THEY CAME OUT INTO THE PLAINS ONCE MORE*

26a. *The Virginian* (Limited Edition). A special limited edition of 100 copies printed on Japan vellum, bound in brown boards, vellum parchment back, gilt top, uncut, signed by the author, was issued in the same month that the foregoing edition was issued. Size $5\frac{1}{2} \times 8\frac{3}{4}$.

26b. *The Virginian* (Grosset & Dunlap). The plates of the illustrated edition were taken over by Grosset & Dunlap about 1916, and that firm issued numerous editions, in which all the line engravings are present, but the frontispiece and the pictorial label on the cover are absent.

The Virginian (other editions)
26c. The 1911 edition was reprinted March, 1925, bound in purplish-brown cloth.

26d. The MacMillan Company issued an edition in 1935. It is identical with the 1911 edition except it is in brown cloth and does not contain the frontispiece. Has pasted illustration of THEY SAT LONG TOGETHER AT BREAKFAST on cover. Also has dustwrapper with same illustration in color and THE VIRGINIAN on the spine.

26e. Pocket Books Edition, published January, 1956, bears COWBOY MOUNTED #2 on title page.

26f. Cardinal Edition by Pocket Books, Inc., March, 1956, bears COWBOY MOUNTED #2 on title page.

27. *Illustrated Souvenir*: 1912
Illustrated Souvenir of Great Falls Fire Department [design] Published by the Great Falls Fire Department, August, Nineteen Twelve.
Pp. 130. 8vo, size $6 \times 8\frac{3}{4}$, illustrated blue cloth.
Contains four halftones:
p. 91: I BEAT YOU TO IT
p. 99: THE BIG STACK IS OUR LANDMARK*

p. 111: Charles M. Russell The Cowboy Artist (photo)
p. 123: THE TENDERFOOT #1

28. *The Uphill Climb*: 1913
The Uphill Climb by B. M. Bower. Author of "Lonesome Land", "Good Indian", "Chip of the Flying U", etc. With illustrations by Charles M. Russell. Boston, Little, Brown and Company, 1913.
Pp. [xii] + 282 + 8. 8vo, size $5 \times 7\frac{3}{8}$. Cloth. The words "Published April 1913" are on verso of title page. Also a Grosset & Dunlap edition.
Contains four halftones, tipped in:
front.: "HELLO, FORD, WHERE THE BLAZES DID YOU DROP DOWN FROM?" A WELCOMING VOICE YELLED*
fcg. p. 74: SHE LIFTED HER HEAD AND LOOKED AT HIM, AND DREW AWAY*
fcg. p. 208: DICK TOTTERED UPON THE STEP AND WENT OFF BACKWARD*
fcg. p. 254: "FORD, I'M NO COQUETTE", SHE SAID STRAIGHTFORWARDLY*

29. *Trent's Trust* (1914)
Trent's Trust and Other Tales by Bret Harte. Boston and New York, Houghton, Mifflin and Company, The Riverside Press, Cambridge.
There is no date on the title page. The words "Copyright 1903" appear on the verso of the title page, but that was the date of the first edition of the book, which was not illustrated.
Pp. 433, 8vo, size $5\frac{5}{8} \times 8\frac{5}{8}$. This is Volume XIX of the Autograph edition of Bret Harte's writings, issued 1914, limited to 350 copies, some of which were bound in cloth and a few of which were bound in three-quarter red morocco with gold stamping and marbled endsheets, uncut. Some of the artists who executed illustrations for this Autograph edition signed the plates in pencil, but we have not heard of a copy signed by Russell. After the Autograph edition there were the Riverside and the Overland editions, and a special edition printed for the *Review of Reviews*. In these editions the title is *Trent's Trust and Other Stories*; they contain only one CMR illustration, that shown on p. 240 below.
Contains two photogravures, tipped in, with titles on tissue guards, facing:
p. 240: TWO RIFLE SHOTS CRACKED FROM THE THICKET*
p. 254: THE SHOCK HAD BROKEN THE INDIAN'S NECK*

30. *Indian Why Stories*: 1915
Indian Why Stories Sparks from War Eagle's Lodge-Fire By Frank B. Linderman (Co-skee-see-co-cot) Illustrated by Charles M. Russell (Cah-ne-ta-wah-see-na-e-ket) The Cowboy Artist. Charles Scribner's Sons, New York, 1915.

Pp. xvi + 236. 8vo, size 6 × 7⅞. Bound in red cloth. Front cover bears paper label with lettering in red, and colored illustration. Backbone stamped in gold. Top edge stained light orange. Words "Published September 1915" appear on the verso of the title page. However, there were several editions carrying the date 1915 on the title page, and the first edition may be identified by the blank verso of the bastard title. Dustwrapper carries THE STORY TELLER #2 in color.

Contains 10 color plates:

cover.: THE STORY TELLER #2*
front.: "YES—THE MICE-PEOPLE ALWAYS MAKE THEIR NESTS IN THE HEADS OF THE DEAD BUFFALO-PEOPLE, EVER SINCE THAT NIGHT"*
title page: ALL ABOUT OLD-MAN'S FIRE THEY SAT*
fcg. p. 8: "THE PERSON WAS FULL OF ARROWS, AND HE WAS PULLING THEM FROM HIS UGLY BODY"*
fcg. p. 76: "THEN SHE SANG A QUEER SONG OVER AND OVER AGAIN UNTIL THE YOUNG-MAN HAD LEARNED IT WELL"*
fcg. p. 80: "'I AM SORRY FOR YOU', SAID THE WHITE BEAVER—CHIEF OF ALL THE BEAVERS IN THE WORLD"*
fcg. p. 84: "'SMOKE', SAID OLD-MAN, AND PASSED THE PIPE TO HIS VISITOR"*
fcg. p. 86: "HO!—WHEN THE GHOST-PEOPLE SAW THE UNLUCKY-ONE THEY RUSHED AT HIM WITH MANY LANCES"*
fcg. p. 160: "THIS BIG SNAKE USED TO CRAWL UP A HIGH HILL AND WATCH THE MOON IN THE SKY"*
fcg. p. 216: "HE WENT UP ON THE STEEP HILLSIDE AND COMMENCED TO ROLL BIG ROCKS DOWN UPON HER LODGE"*

Contains 12 black and white line engravings:

p. [i]: INDIAN THROWING TOMAHAWK AT KINGFISHER*
p. [1]: THREE ANTELOPE*
p. [15]: INDIAN PAINTING DUCKS*
p. [25]: same as p. [i]
p. [35]: TWO WOLVES, TROTTING, SIDE VIEW*
p. [45]: BADGER, SKUNK, BEAVER, PORCUPINE, AND WOODCHUCK*
p. [63]: TWO WOLVES, WALKING, FRONT QUARTER VIEW*
p. [73]: INDIANS IN MEDICINE DANCE, WEARING MASKS*
p. [89]: OWL ON A DEAD TREE-LIMB*
p. [103]: MAGPIE SURVEYING INDIAN TIPI VILLAGE*
p. [115]: BUFFALO, ONE BULL FOREGROUND, HERD BACKGROUND*
p. [125]: same as p. [35]
p. [135]: BEAR AND INDIAN SMOKING PEACE PIPE*
p. [149]: same as p. [63]

p. [157]: same as p. [89]
p. [165]: same as p. [1]
p. [173]: same as p. [45]
p. [183]: INDIAN WITH "MEDICINE", HEAD LEANING ON LANCE*
p. [197]: same as p. [103]
p. [205]: same as p. [115]
p. [211]: same as p. [135]
p. [219]: same as p. [73]
p. [231]: same as p. [183]

30a. *Indian Why Stories* (Other editions). There was an edition published without a date on title page, and an edition with the date 1926 on title page, which contain all foregoing illustrations except the color plates on pp. 80 and 84.

30b. *Indian Lodge-Fire Stories* (1918)
Indian Lodge-Fire Stories By Frank B. Linderman (Co-Skee-See-Co-Cot) Illustrated by Charles M. Russell The Cowboy Artist. Charles Scribner's Sons, New York, Chicago, Boston.
Pp. 124 + The Scribner Series of School Reading, 2 pp. Size 4⅝ × 7⅞. Words "Copyright 1915, 1918 by Charles Scribner's Sons" appear on verso of title page.
Contains three halftones:

front.: WAR EAGLE IN HIS LODGE, i.e., THE STORY TELLER #2
fcg. p. 22: THE PERSON WAS FULL OF ARROWS, AND HE WAS PULLING THEM FROM HIS UGLY BODY
fcg. p. 66: YES—THE MICE PEOPLE ALWAYS MAKE THEIR NESTS IN THE HEADS OF THE DEAD BUFFALO PEOPLE EVER SINCE THAT NIGHT

Contains eight black and white line engravings:

p. [1]: INDIAN THROWING TOMAHAWK AT KINGFISHER
p. [15]: THREE ANTELOPE
p. [29]: INDIAN PAINTING DUCKS
p. [39]: same as p. [1]
p. [49]: TWO WOLVES, TROTTING, SIDE VIEW
p. [59]: TWO WOLVES, WALKING, FRONT QUARTER VIEW
p. [69]: OWL ON A DEAD TREE LIMB
p. [83]: same as p. [49]
p. [94]: same as p. [59]
p. [101]: BADGER, SKUNK, BEAVER, PORCUPINE AND WOODCHUCK (part)
p. [111]: BEAR AND INDIAN SMOKING PEACE PIPE

31. *I Conquered* (1916)
"—I Conquered" By Harold Titus With a frontispiece in color by Charles M. Russell. Rand McNally & Company, Chicago.
There is no date on the title page. Pp. 302 + 2. 8vo, size 5¼ × 7⅝. Bound in russet cloth, front cover stamped in blind and gold. Words "Copyright, 1916, by Rand

McNally & Company" appear on the verso of title page.
Contains one color plate, tipped in:
front: THE CAPTAIN TORE AT THE SHOULDERS AND NECK OF THE GREY HORSE WITH HIS GLEAMING TEETH*
The same illustration appears on the dust wrapper in color.

31a. There is an A. L. Burt reprint without date which has the same collation and the same illustration as the first edition, but it is bound in green cloth with red and orange stamping.

32. *In the Land of Chinook* (1917)
In the Land of Chinook or The Story of Blaine County by Al J. Noyes (Ajax). State Publishing Co., Helena, Mont.
There is no date on the title page. Copyright, 1917. Pp. 152. 8vo, size $6\frac{3}{8} \times 9\frac{3}{8}$. Bound in dark green cloth. ·Front cover gold-stamped. Russell mentioned on pp. 22 and 52, and Chap. XI, pp. 119–126 on Russell.
Op. p. 119: photo of Russell
Plates facing p. 126 contain on three separate plates a "facsimile of a hand written illustrated letter from Chas. M. Russell, the cowboy artist, to his old friend 'Kid' Price" dated June 1st, 1917.
IN THE SHADE OF A WAGON*
I'D RATHER RIDE THE BULL*

33. *Brother Van* (1919)
Brother Van by Stella W. Brummitt. New York, Missionary Education Movement of the United States and Canada.
There is no date on the title page.
Pp. x + 171 + 3. 8vo, size $5\frac{1}{8} \times 7\frac{1}{2}$. Issued in pictorial wrappers and tan cloth, apparently simultaneously, as both bear the same copyright date—1919—on the verso of the title page. There was an edition in wrappers, same collation and illustrations, issued under the imprint of the Methodist Book Concern. No doubt these were sheets of the Missionary Education Movement printing with merely a change in the publisher's imprint.
Contains two halftones, facing:
p. 78: INDIANS WERE EVERYWHERE STEALING HORSES AND TERRIFYING SETTLERS, i.e., THE ATTACK #1
p. 142: RIDING TOWARD THE FRONT OF THE STAMPEDING BEASTS, BROTHER VAN SHOT THE HERD LEADER IN THE HEAD*

34. *Applied Cartooning*: 1920
Applied Cartooning Division 12. Contents [19 lines]. Compiled and Edited by Chas. L. Bartholomew and Joseph Almars. Advisors and Contributors [28 lines].

Copyrighted 1920 by Federal School of Applied Cartooning, Minneapolis, Minn.
Pp. [96]. 8vo, size $8\frac{3}{8} \times 10\frac{7}{8}$, wrappers, together with chart.
Contains: "Preliminary sketches for painting by Charles M. Russell", pp. 55–58, text, and 4 line engravings:
p. 55: STUDY BY CHARLES M. RUSSELL*
p. 56: PRELIMINARY PENCIL SKETCH*
p. 57: THE LAST OF THE BUFFALO
p. 58: PRELIMINARY PENCIL SKETCH FOR "WILD HORSE HUNTERS"*
Chart insert: WILD HORSE HUNTERS #2
N.B. This was reprinted many times by the Federal School, usually under title of *Modern Illustrating*. See Section XVI for other entries.

35. *Indian Old-Man Stories*: 1920
Indian Old-Man Stories More Sparks from War Eagle's Lodge-Fire By Frank B. Linderman (Co-See-Co-Cot) [illustration] Illustrated by Charles M. Russell (Cah-Ne-Ta-Wah-See-Na-E-Ket) The Cowboy Artist. Charles Scribner's Sons, New York—1920.
Pp. xxii + 169. 8vo, size 6×8. Bound in red cloth with portion of frontispiece in color pasted on front cover. Top edge tinted red; endsheets tinted buff. Words "Published September, 1920" follow copyright notice on verso of title page, identifying first edition. Contains nine color plates:
label: Same as frontispiece
front.: "'BROTHER', SAID QUO-TOO-QUAT TO THE WOLF'"*
t.p.: STRIKES-AND-KILLS ROLLED THE HOOPS FOR HIM*
fcg. p. 42: "'I DIDN'T HEAR YOU, OLD-MAN', SAID THE CRANE'"*
fcg. p. 54: THEN, UPON TURNING A PATCH OF WILLOWS HE SAW THE SKUNK SUCKING THE EGGS IN THE NEST OF A BLUE GROUSE*
fcg. p. 66: "LOOK OVER THERE BY THAT FIRE. THAT IS WIN-TO-COO, THE MAN-EATER"*
fcg. p. 76: OLD-MAN STOOD UP SO THE BEAR COULD SEE HIM*
fcg. p. 88: HO, A MIGHTY PERSON, A TERRIBLE PERSON, STOOD BEFORE HIM*
fcg. p. 102: WHEN HE WAS YET FAR FROM THE PERSON HE STOPPED*
fcg. p. 120: HE DROVE HIS KNIFE INTO THE HEART ONCE, TWICE, THREE TIMES*
Contains 10 line engravings:
p. [i]: Same as p. [69]
p. [xv]: SETTING OF A LODGE FOR "MEDICINE SMOKE"*
p. [1]: OLD-MAN FOUND A BIG ROCK AND SAT UPON IT*
p. [25]: WHY OUR SIGHT FAILS WITH AGE*

p. [35]: OLD-MAN SAW A CRANE FLYING OVER THE LAND*
p. [49]: part of illustration on p. [1]
p. [57]: WHY THE WEASEL IS WHITE*
p. [69]: OLD-MAN AND HIS NEW WEAPONS*
p. [81]: LOOKS AT THE STARS*
p. [97]: THE FOX BROUGHT A FEATHER TO THE LODGE*
p. [105]: STRIKES-AND-KILLS ROLLED THE HOOPS FOR HIM
p. [123]: part of illustration on p. [1]
p. [133]: part of illustration on p. [105]
p. [145]: OLD-MAN WAS TRAVELING IN THE FOREST*
p. [155]: part of illustration on p. [97]

35a. There were several other editions with date 1920 on title page. Also, a later edition bound in blue cloth with frontispiece in color, HO, A MIGHTY PERSON, A TERRIBLE PERSON STOOD BEFORE HIM, but no other color plates; part of illustration BROTHER, SAID QUO-TOO-QUAT TO THE WOLF stamped on front cover and printed on dustwrapper; title page illustration in line engraving.

A salesman's dummy was prepared in the binding of the first edition of the book, containing the pasted cover illustration, all the color illustrations of the first edition, and the line engraving from p. [i] of the first edition.

36. *Rawhide Rawlins Stories*: 1921
Rawhide Rawlins Stories By C. M. Russell With Illustrations by the Author. Printed by Montana Newspaper Association, Great Falls, Montana, 1921.
Pp. iv + 60, 8vo. The first printing appeared in cream-colored cloth and in cream-colored wrappers, both with printing in dark brown on the front and back. We have not been able to establish any priority, and we surmise that both were issued at the same time, merely to give the customer a choice of binding, although the cloth binding seems to be much the scarcer. The cloth binding page size is $7\frac{1}{2} \times 10\frac{7}{8}$. The picture of RAWHIDE RAWLINS is on the front cover, and SKULL #1 in relief is on the back cover, but there is no illustration on the recto of the back cover. The wrappers binding page size is $7\frac{3}{8} \times 10\frac{11}{16}$. The picture of RAWHIDE RAWLINS is on the front wrapper, SKULL #1 is on the back wrapper, and the recto of the back wrapper bears a picture which we have entitled THROWING THE DIAMOND.

Dawson's catalog 371 lists a copy in full limp leather binding, unquestionably a special presentation binding, and not a stock item.

The second printing is so marked at the bottom of the title page, following the publisher's imprint and date. This appeared in cream and also in buff wrappers, page size $7\frac{3}{8} \times 10\frac{11}{16}$. The wrappers illustrations and printing are the same as the wrappers of the first

printing. We have not seen any copies of the second printing bound in cloth.

The third printing is so marked at the bottom of the title page, and is otherwise the same as the second printing. We have not seen any copies of the third printing in cloth.

The fourth printing is so marked at the bottom of the title page. There are copies in cream wrappers, page size $7\frac{3}{8} \times 10\frac{5}{8}$, with printing and illustrations on the wrappers the same as the first printing; and there are copies in cream wrappers and in dark brown wrappers, but with the picture of DUM DUM BILL and printing on the front wrapper in green, and nothing on the back wrapper, either recto or verso. The page size of the copies in the dark brown wrappers varies between $7\frac{3}{8} \times 10\frac{9}{16}$ and $7\frac{1}{4} \times 10\frac{3}{8}$. It will be noted that the page size of this book has grown progressively smaller over the time of the various printings. The dark brown wrappers may have been printed as late as 1945, and the pages were trimmed to freshen them. We have not seen any copies of the fourth printing in cloth.
Contains the following written material by Russell:
p. [iv]: Foreword
p. [1]: A Ride in a Moving Cemetery
p. [5]: There's More Than One David
p. [8]: Highwood Hank Quits
p. [11]: Tommy Simpson's Cow
p. [13]: How Pat Discovered the Geyser
p. [16]: How Louse Creek Was Named
p. [18]: Some Liars of the Old West
p. [22]: Mormon Zack, Fighter
p. [25]: Johnny Sees the Big Show
p. [29]: When Mix Went to School
p. [33]: When Pete Sets a Speed Mark
p. [34]: Bill's Shelby Hotel
p. [37]: A Reformed Cowpuncher at Miles City
p. [41]: The Story of the Cowpuncher
p. [46]: Bronc Twisters
p. [54]: Johnny Reforms Landusky
p. [57]: The Horse
Contains the following illustrations all in black and white:
cover: RAWHIDE RAWLINS
p. 2: EYES OPENED ON A TOMBSTONE*
p. 3: HE TRIED TO CUT A FREIGHT IN TWO*
p. 6: THE SHEPHERD HURLS A BOULDER AT "GOLIAR"
p. 9: "YES, YOU DID!"
p. 11: TOMMY SIMPSON'S COW*
p. 12: MILKING TIME*
p. 14: THE GEYSER BUSTS LOOSE
p. 15: MOVES HIS HOTEL
p. 16: PETE HAD A WINNING WAY WITH CATTLE*
p. 17: I'LL GET THE BIG ONES ANYWAY!*
p. 20: THEY KILLED ME*

p. 24: ZACK PICKS OUT THE BIGGEST, HARDEST-LOOKIN'
CITIZEN HE CAN SEE
p. 25: TOOK FOUR STEWARDS TO UNLOAD JOHNNY
p. 28: JOHNNY LUNCHES WITH THE KING
p. 30: WHISKERS DIDN'T HELP HIM
p. 31: WE LOVE OUR LOVIN' TEACHER
p. 32: PETE LANDS RUNNIN'
p. 35: BILL'S CHEF*
p. 36: SHELBY HUMORISTS ENTERTAIN PASSENGERS, i.e.,
SHELBY IN THE EARLY DAYS
p. 38: RUNS DOWN A JACKRABBIT, i.e., HE'S JUST TOPPIN'
THE HILL OUT OF MILES CITY WHEN HE RUNS
DOWN A JACKRABBIT THAT GETS IN HIS WAY
p. 40: STRADDLES IT INSTEAD OF SITTIN' LIKE A HUMAN,
i.e., HIS LEGS IS WARPED
p. 42: A CENTER-FIRE FASHION LEADER*
p. 44: RIM-FIRE, OR DOUBLE CINCH, RIG*
p. 46: A CONTEST RIDER*
p. 47: OLD MACHEER SADDLE WITH TEXAS TREE*
p. 48: AN OLD-TIME BRONC*
p. 50: THE BRONC'S LODGED IN THE TOP OF A COTTON-
WOOD*
p. 52: ABOUT THE THIRD JUMP CON LOOSENS*
p. 53: SORROWFUL JOURNEY*
p. 55: REMINDS HIM OF A CHROMO OF GETTYSBURG, i.e.,
LANDUSKY IN ITS HEYDAY
p. 56: DUM DUM BILL
p. 58: THE FAMILY STARTS OUT MOUNTED*
p. 60: MIGHTY HANDY WITH ALL FOUR FEET*
recto b. cover: THROWING THE DIAMOND*
b. cover: SKULL #1

36a. *Rawhide Rawlins* (Revised, 1946)
Trail's End Publishing Co., in September, 1946, issued
what is described on the title page as the "First Re-
vised Edition." Actually, it was not a revision, because
the original book was reproduced by photo-lithography
without change. There were additions, however; the
illustrations on p. 9 and p. 32 of the first edition are
used as endpapers, and there is a short Biographical
Note with a photo of Russell.

36b. *Rawhide Rawlins* (Window Card)
Rawhide Rawlins Stories / By Charles M. Russell /
The famous western artist / With 35 Drawings by the
Author / [illustration] / From the Story of the Horse /
A book of humor of the Old West / Price $1.00.
Broadside, size $9\frac{7}{8} \times 14$. A showcard, for window
display purposes, printed in colors. The illustration is
from p. 58 of *Rawhide Rawlins Stories*, THE FAMILY
STARTS OUT MOUNTED.

37. *Back Trailing on the Old Frontiers*: 1922
Back Trailing on the Old Frontiers Illustrated by
Charles M. Russell. Published by Cheely-Raban
Syndicate, Great Falls, Montana, 1922.
Pp. iv + 56. 4to, size $7\frac{1}{2} \times 10\frac{7}{8}$.
The first issue is bound in green wrappers with
printing and illustrations on wrappers in red. The
second issue is bound in dark brown wrappers with
printing and illustration on front in yellow, and lacks
SKULL #1 on back wrapper. Textually the two issues
are similar.
Contains 15 line engravings:
cover: BACK TRAILING*
p. [2]: LA VERENDRYES DISCOVER THE ROCKY MOUN-
TAINS
p. [6]: BLACKFEET TRADING PARTY IN SIGHT OF FORT
BENTON
p. [10]: ATTACKED BY GRIZZLY BEAR
p. [14]: FINK KILLS HIS FRIEND
p. [18]: ATTEMPTED MASSACRE OF BLACKFEET INDIANS
AT FORT MCKENZIE
p. [22]: CARSON DEFEATS FRENCH BULLY IN HORSEBACK
DUEL
p. [26]: KELLY'S DUEL WITH SIOUX INDIANS
p. [30]: A PONY EXPRESS RIDER ATTACKED BY INDIANS
p. [34]: ANNIHILATION OF FETTERMAN'S COMMAND
p. [38]: (THE) WAGON-BOX FIGHT
p. [42]: THE BATTLE OF BEAR PAWS
p. [46]: PLACER MINERS PROSPECTING NEW STRIKE
p. [50]: A TEXAS TRAIL HERD
p. [54]: BATTLE BETWEEN CROWS AND BLACKFEET
b. cover: SKULL #1 in relief

38. *Cow Range and Hunting Trail*: 1925
Cow Range and Hunting Trail by Malcolm S. MacKay
with 38 illustrations. G. P. Putnam's Sons, New York
& London, The Knickerbocker Press, 1925.
Pp. xvi + 243. 8vo, size $5\frac{3}{4} \times 8\frac{1}{2}$. Bound in green cloth,
gold-stamped on front cover and backbone. Back cover
blank. Top and lower edge trimmed, fore edge
untrimmed.
Contains reference to CMR p. 199 and 3 illustrations
(1 halftone and 2 line engravings, in that order), all
tipped in:
front.: QUICK SHOOTING SAVES OUR LIVES*
fcg. p. 28: THE ODDS LOOKED ABOUT EVEN*
fcg. p. 34: LIKE A FLASH THEY TURNED*

39. *More Rawhides*: 1925
More Rawhides by C. M. Russell. Author of "Rawhide
Rawlins Stories" with illustrations by the author.
Printed by Montana Newspaper Association, Great
Falls, Montana, 1925.
Pp. iv + 60. 8vo, size $7\frac{3}{8} \times 10\frac{1}{2}$. Green wrappers, printed
in light green on front. There was only one edition,
published December 10, 1925.

Contains 18 stories and preface:

Contains 38 line engravings:

39a. *More Rawhides* (Revised, 1946)

Trail's End Publishing Co., in September, 1946, issued what is described on the title page as the "First Revised Edition." Actually it was not a revision, because the original book was reproduced by photo-lithography, without change. There were additions, however; the illustrations on p. [30] and p. [4] of the first edition are used as endpapers, and a page of the manuscript of "A Few Words About Myself" is reproduced on p. [iv].

40. *Blazed Trail of the Old Frontier*: 1926

The Blazed Trail of the Old Frontier by Agnes C. Laut with many illustrations from drawings by Charles M. Russell. Published by Robert M. McBride and Company, New York, MCMXXVI.

Pp. xii + 266. 8vo, size $6\frac{1}{8} \times 9\frac{1}{2}$. Bound in red, also green cloth, with pictorial stamping in black and gold on front cover and backbone. An edition of 200 copies published simultaneously with the first edition contains exactly the same material, and differs only by the inclusion of a tipped-in leaf containing a limitation note which is signed by the author.

Contains 34 line engravings:

p. 27: LA VERENDRYE DISCOVERS THE SHINING MOUNTAINS, i.e., LA VERENDRYES DISCOVER THE ROCKY MOUNTAINS

p. 41: THE FREE TRAPPER*

p. 53: THE BUFFALO HUNT, i.e., EARLY DAY WHITE BUFFALO HUNTERS

p. 59: A RAID OF THE BLACKFEET, i.e., ANNIHILATION OF FETTERMAN'S COMMAND

p. 67: RADISSON ON THE MISSISSIPPI, i.e., RADISSON RETURNS TO QUEBEC WITH 350 CANOES LOADED WITH FURS

p. 73: THE "BIRD WOMAN" RECOGNIZES HER BROTHER, i.e., MEETING OF SACAJAWEA AND HER RELATIVES OF THE SHOSHONE TRIBE

p. 81: TO FORT UNION TO TRADE, i.e., BLACKFEET TRADING PARTY IN SIGHT OF FORT BENTON

p. 89: THE BUILDING OF FORT MCKENZIE, i.e., BUILDING FORT MANUEL IN 1807

p. 93: FORT PIEGAN, i.e., THE FORT AT THREE FORKS

p. 99: HUGH GLASS'S DEADLY ENCOUNTER WITH THE GRIZZLY, i.e., ATTACKED BY GRIZZLY BEAR

p. 105: SCOUT PURSUED BY WARRIORS, i.e., A PONY EXPRESS RIDER ATTACKED BY INDIANS

p. 109: THE FIRST FIRE CANOE NEARS FORT UNION, i.e., PAWNEES SEE "WATER MONSTER"

p. 113: A FIGHT AT FORT MCKENZIE, i.e., ATTEMPTED MASSACRE OF BLACKFEET INDIANS AT FORT MCKENZIE

p. 121: THE CROWS AND THE BLACKFEET MEET AT SUN RIVER, i.e., BATTLE BETWEEN CROWS AND BLACKFEET

p. 129: THE COMING OF THE SETTLERS, ARE THEY FRIENDS OR ENEMIES? i.e., INDIANS MEET FIRST WAGON TRAIN WEST OF MISSISSIPPI

p. 139: JOSEPH TAKES THE WAR-TRAIL AGAINST THE WHITE INVADER, i.e., WAGON BOX FIGHT

p. 153: SNAKE CREEK, THE LAST STAND OF THE RED MAN, i.e., THE BATTLE OF BEAR PAWS

p. 161: COULTER'S [sic] RACE FOR LIFE

p. 169: WHEN THE MINER CAME, i.e., PLACER MINERS PROSPECTING NEW STRIKE

p. 179: WHEN NATURE'S STORE SEEMED ENDLESS*

p. 185: THE PRIMAEVAL HOLDS THE RIGHT-OF-WAY, i.e., BUFFALO HOLDING UP MISSOURI RIVER STEAMBOAT

p. 191: LEWIS AND CLARK AT MARIA'S RIVER*

p. 197: A TRAPPER'S FRACAS OUTSIDE THE WALLS OF FORT UNION, i.e., FINK KILLS HIS FRIEND

p. 201: FORT BENTON, i.e., ADVANCE OF BLACKFEET TRADING PARTY

p. 213: FREIGHTING FROM FORT BENTON, i.e., A DIAMOND R MULE TEAM OF THE '70S

p. 219: THE END OF THE PROSPECTOR'S RAINBOW TRAIL, i.e., DEATH LURKS WHERE GOLD LURES*

p. 231: THE IRON HORSE COMES TO THE UPPER MISSOURI, i.e., CHEYENNES WATCHING UNION PACIFIC TRACK LAYERS

p. 237: BRIDGER BRINGING IN SOME OF HIS CELEBRATED VISITORS TO HUNT AROUND FORT UNION*

p. 245: THE FIRST TRIP OF THE SEASON, i.e., CURLEY REACHES THE FAR WEST WITH THE STORY OF THE CUSTER FIGHT

p. 257: A RENEGADE'S END, i.e., KELLY'S DUEL WITH SIOUX INDIANS

Contains, also, 13 untitled line engravings:

t.p.: MEDICINE MAN'S SKULL MASK AND TOMAHAWK*

p. 3: MEDICINE STICK*

p. 38: same as title page

p. 57: BURRO FACING A DEER*

p. 76: same as p. 57

p. 77: FLATBOAT ON RIVER, FORT IN BACKGROUND*

p. 102: SADDLE, CINCH AND STIRRUPS*

p. 116: INDIAN CHIEF #4*

p. 124: BUFFALO SKULL, SPEAR, TOMAHAWK, QUIVER*

p. 125: WATCHERS OF THE PLAINS*

p. 133: SADDLE, SHIELD*

p. 155: same as p. 3

p. 156: same as p. 124

p. 162: PICK, SHOVEL, PAN AND POKE*

p. 175: same as title page

p. 209: GUN, PISTOL IN HOLSTER*

p. 223: PACK MULES LED BY BELL MARE*

p. 251: RIFLE AND POWDER HORN*

41. *Trails Plowed Under*: 1927

Trails Plowed Under By Charles M. Russell with illustrations in color and line by the author. Garden City, New York, Doubleday, Page & Company, 1927.
Pp. xxii + 211. 8vo, size 7 × 10. Cloth. Words "First edition" are on verso of title page. Reprinted here are all the stories in *Rawhide Rawlins Stories* except one, "Johnny Sees the Big Show"; all the stories and the author's preface in *More Rawhides*; "The Ghost Horse," i.e., "The Olden Days," from *Roundup Annual* for 1919; and "Dad Lane's Buffalo Yarn" and "Finger-That-Kills Wins His Squaw," from *Outing*, December, 1907, and April, 1908, respectively. There are six new stories:

p. 25: Injuns

p. 31: Whiskey

p. 57: Curley's Friend

p. 85: A Pair of Outlaws

p. 163: The Open Range

p. 177: The War Scars of Medicine Whip

Contains five double-page color plates, preceding:

front.: JERKED DOWN

p. 55: LAUGH KILLS LONESOME

p. 103: RIDERS OF THE OPEN RANGE, i.e., MEN OF THE OPEN RANGE

p. 157: TAKING TOLL, i.e., TOLL COLLECTORS

p. 177: TRACKS TELL TALES THAT RIVERS MAKE SECRETS

Contains five halftones, facing:

p. 25: WITH A GOOD HOSS UNDER HIM, IT WAS EASY FOR AN INJUN TO GET MEAT*

p. 70: THE INJUN PULLS MURPHY TOWARD HIM, i.e., LIKE A FLASH THE INJUN'S LEFT HAND GOES UNDER HIS GUN-COVER TO THE TRIGGER

p. 88: I'M SCAREDER OF HIM THAN I AM OF THE INJUNS*

p. 121: BLACKFEET*

p. 208: PULLIN' MY GUN, I EMPTY HER IN THE AIR

Contains 57 line engravings:

t.p.: RIM-FIRE OR DOUBLE CINCH RIG

p. 4: A CENTER-FIRE FASHION LEADER

p. 8: HE UNLOADS ME RIGHT IN THE MIDDLE OF THE BOULDER-STREWN FLAT, i.e., I DON'T MISS NONE OF THEM BOULDERS

p. 10: I'M PLENTY SURPRISED TO SEE AN OLD LOG SHACK TO THE SIDE OF THE TRAIL, i.e., HIS WHINNER CAUSES ME TO RAISE MY HEAD

p. 12: THE BEAR'S COMIN' AT US MIGHTY WARLIKE*

p. 14: STEER HEAD*

p. 16: A TAIL-HOLD ON A BUFFALO, i.e., "THERE'S ONLY ONE HOLD", SAYS DUNC, "SHORTER THAN A TAIL HOLD ON A BUFFALO, THAT OF A BEAR"

p. 20: THEY DECIDE THERE'S TWO ONE-LEGGED MEN, i.e., AFTER STUDYIN' THE TRACKS AWHILE THEY DECIDE THE OLD MAN'S RIGHT

p. 22: THE OLD CAYUSE STARTS TRYIN' TO OUT-DODGE THESE WOLVES, i.e., RIGHT THEN'S WHERE THE BALL OPENS

p. 24: AN OLD TIME BRONC

p. 27: BEFORE THIS HE ONLY HAD WOLVES BROKE TO PACK OR DRAG A TRAVOIS*

p. 29: THE BIG CHANGE CAME WHEN OLD CORTEZ BROUGHT HOSSES OVER*

p. 30: COWPUNCHERS WERE CARELESS, HOMELESS, HARD-DRINKING MEN*

p. 36: PETE LANDS RUNNIN'

p. 40: BILL WARD'S SHELBY HOTEL, i.e., SHELBY IN THE EARLY DAYS

p. 43: I'VE SEEN BUFFALO MYSELF*

p. 45: A FULL-BLOODED PIEGAN*

p. 50: I'M HANGIN' ON FOR ALL THERE IS IN ME*

p. 57: PIPE AND MEDICINE*

p. 62: HE SHOOK HANDS AGAIN AND TOLD ME TO GO*

p. 64: AN INDIAN DANCER #3*

p. 68: A SHOW INDIAN*

p. 73: THREE WOLVES WATCHING WAGON TRAIN*

p. 74: HIS HOSS STOPS ON THE END OF THE ROPE, i.e., SUDDENLY SOMETHING HAPPENS

p. 78: A BOUNTY IS PLACED ON A NUMBER OF CITIZENS*

p. 82: STAY IN THAT HOLE YOU DAMN FOOL! i.e., JACK GOES BACK BUT HE DON'T STAY LONG

p. 93: AN INDIAN SIGNAL*

p. 96: THE CHIEF FIRED AT THE PINTO #2*

p. 105: IN FLY TIME THEY STAND HEADS AND TAILS, i.e., IN FLY TIME THEY BUNCH UP

p. 106: PAW'S GOT HOOF MARKS ALL OVER HIM, i.e., MIGHTY HANDY WITH ALL FOUR FEET

p. 109: THE WHOLE FAMILY STARTS OUT MOUNTED, i.e., THE FAMILY STARTS OUT MOUNTED

p. 112: TOMMY SIMPSON'S COW

p. 114: A STICK-UP ON THE ROAD, i.e., WE AIN'T GONE FIVE MILE WHEN THE COACH STOPS

p. 116: HE'S WEARIN' THE GARMENTS OF A BREED*

p. 118: THERE'S STILL A LOT OF INJUN TRADE IN THE COUNTRY, i.e., DUNC SEES A FEW BUFFALO

p. 120: PETE HAD A WINNING WAY WITH CATTLE

p. 123: A BLACKFOOT WOMAN*

p. 127: THE GROS VENTRE BEGINS HACKIN' THE FINGERS OFF*

p. 131: FRIENDSHIP GOES YELPIN' INTO THE WOODS

p. 136: FROM THE SOUTHWEST COMES SPANISH AN' MEXICAN TRADERS*

p. 141: AN INDIAN CAMP #1*

p. 144: I TURNED INJUN AN' I AIN'T CUT MY HAIR SINCE*

p. 145: HE'S GOT HIS PLOW SUNK TO THE BEAM

p. 146: MAYBE THESE HUMP-BACKS KNOWS WHERE THEY'S GOIN'

p. 150: A COW PONY*

p. 158: THE COW RANCHES I KNOWED HAD ONE HOUSE, i.e., IN THE OLD DAYS THE COW RANCH WASN'T MUCH

p. 162: ALL THESE RIDERS GO TO CAMP FOR DINNER, i.e., COMING TO CAMP AT THE MOUTH OF SUN RIVER

p. 169: THE BRONC'S LODGED IN THE TOP OF A (BIG) COTTONWOOD

p. 172: I HIT THE GROUND A LOT HARDER THAN I EXPECTED, i.e., ABOUT THE THIRD JUMP CON LOOSENS

p. 176: HORSE HEAD, LEFT SIDE #2*

p. 182: IT WOULDN'T BE HEALTHY FOR MAN OR BEAST*

p. 189: THE FORCE OF IT LIFTS PAT'S HOSS FROM HIS IRON SHOES, i.e., THE GEYSER BUSTS LOOSE

p. 190: THE MOUNTAINS AND PLAINS SEEMED TO STIMULATE A MAN'S IMAGINATION*

p. 194: ANTELOPE RUNNING*

p. 196: HANK'S SITTIN' ON THE GROUND, i.e., YES, YOU DID!

p. 198: A RACE FOR THE WAGONS*

p. 211: TRAILS PLOWED UNDER*

41a. *Trails Plowed Under* (Reprint edition, 1941)
An edition published in 1941, without date on title

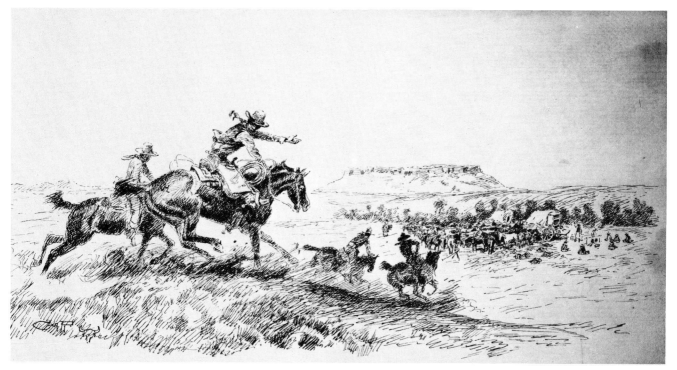

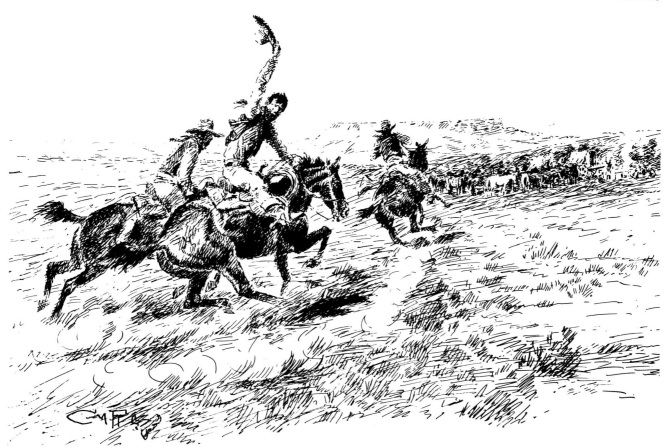

Comparison of similar subjects
A RACE FOR THE WAGONS (above) (note rider's left arm extended). This first appeared at page 198 of *Trails Plowed Under*. COMING TO CAMP AT THE MOUTH OF SUN RIVER (below) (note rider's right arm up-raised). This first appeared in Montana Stockgrowers Association 40th annual convention program for 1925 and then at page 162 of *Trails Plowed Under*, erroneously captioned.

page, contains same material as the foregoing, but has stamping of RIGHT THEN'S WHERE THE BALL OPENS on the front cover.

41b. *Trails Plowed Under* (Reprint edition, 1945). A later edition, 1945. Blue cloth, size 7 × 9. Front cover bears RIGHT THEN'S WHERE THE BALL OPENS stamped in black.

42. *My Life East and West*: 1929

My Life East and West By William S. Hart, with illustrations. Boston and New York, Houghton Mifflin Company, The Riverside Press, Cambridge, 1929.

Pp. viii + 364. 8vo, size $5\frac{7}{8} \times 8\frac{1}{2}$. Bound in tan cloth.

Contains references to CMR on p. 37 (says that "the famous cowboy artist was born in Burlington, New Jersey"); p. 157 (first meeting with Russell at Great Falls in 1902); p. 176 (reference to painting of Hart which is frontispiece to this book); pp. 347–349 (vacation trips with CMR and Nancy Russell).

Contains one color plate, which also appears on the dustwrapper:

front.: WILLIAM S. HART*

43. *Good Medicine*: 1929

Good Medicine The Illustrated Letters of Charles M. Russell With an Introduction by Will Rogers and a Biographical Note by Nancy C. Russell. Doubleday, Doran & Company, Inc., Garden City, New York, 1929.

Pp. xii, 13–162 + one leaf. Size 9 × 12. Bound in three-quarter blue buckram, vellum sides. Backbone gold-stamped, front and back covers blank. Top edge gilt, fore and lower edges trimmed.

Words "First Edition" are on verso of title page.

Colophon:

> This edition of Good Medicine is limited to one hundred thirty-four copies. It was reproduced from lithographic plates on Antique Laid paper made particularly for this printing. The text was hand-set in Old Style Caslon type and the volume designed under the supervision of Walter Darwin Teague. The editorial arrangement was by Harry E. Maule. The edition was produced for Doubleday, Doran & Company, Incorporated, by William C. D. Glaser of New York City, and completed this sixteenth day of December, Nineteen Hundred Twenty-Nine, this copy being Number [here follows number in ink].

Contains 2 color plates: WHERE TRACKS SPELL WAR OR MEAT* reproduced as a supplement, lithographic process print in colors, size $12\frac{1}{8} \times 18\frac{7}{8}$; frontispiece, WHEN I WAS A KID (tipped in); and also contains 145 letters from CMR, which include 105 individual line en-

gravings and 76 color plates, mostly from water colors. N.B. A few sets of sheets of the first edition came on the market about 1956. Some of these were bound by individual purchasers in a binding approximating the genuine original, but without vellum sides.

p. [4] front.: WHEN I WAS A KID (color)

p. [5] t.p.: SKULL #1 (also on many other pages)

p. 25: COYOTE*

p. 27: AN OLD TIME COW DOG*

p. 28: NAVAJO INDIAN, STANDING*

p. 29: THAT TRIP TO WHITE SULPHER OVER THE SOUTH FORK TRAIL*

p. 30: INDIAN HEAD #9*

 WRITING IS NO PASS TIME WITH ME*

 HAND ME THESE TOOLS AN IM DEAF AN DUM*

p. 31: WHOS THE SKY PILOT*

 THE SMOKE OF MY CAMP*

 MY PIPE WILL BE LIT FOR YOU*

p. 32: THE PONEY WARES HIS HAIR LONG*

p. 33: EVERY HOSS WITH HEAD UP AND EARS STRAIGHTENED*

 SIOUX INJUN A HUNDRED YEARS AGO*

p. 34: THEY JUST SAT AT THE MOUTH OF THAIR CAVES AND WACHED THAIR GOLD LOVING BROTHERS

p. 35: WENT HEELED TO THE TEETH

 THIS GENT RIDES A PIERCE ARROW

p. 36: PORTRAIT OF BILLS GRATE GRATE GRATE GRAN DAD*

p. 37: HUMPED BACKED BEEF*

p. 38: HERE'S TO ALL OLD TIMERS, BOB*

 HERE'S TO THE MAN WITH THE GOLD PAN*

 HERE'S TO THE RUSTLER THAT PACKED A NOTCHED GUN*

 HERE'S TO THE SKINNER WITH A JERK LINE*

 HERES TO THE CROOKED GAMBLER*

 HERES TO THE DRIVER THAT SAT ON THE COACH*

 HERE'S TO THE HOLDUP AN' HOSS THIEF*

p. 39: HERE'S TO THE 'WHAKER THAT SWUNG A LONG LASH*

 HERE'S TO HELL WITH THE BOOSTER*

p. 40: IM STILL PACKING COAL*

p. 41: IF HOSSES WERE HEALTH ID COMB THE RANGE*

p. 42: IV SEEN SOM ROPING AN RIDING*

 BULL DOGING THOSE LONG HORNS*

p. 43: A GRAY HOUND WARING HORNES*

 THEY UNLODED THEM TWISTERS*

p. 44: I SEEN THEM RIDE DOWN HILLS*

p. 45: IV KNOWN COW PUNCHERS THAT SAW SUCH THINGS*

43a. *Good Medicine*: 1930

The title page of the first trade edition is the same as the limited DeLuxe first edition, except that it bears the date 1930. The pagination and contents are the same, except that the painting WHERE TRACKS SPELL WAR OR MEAT, which was published as a supplement to the limited DeLuxe first edition, is here used as lining papers and on the dustwrapper. The binding is brown buckram, also coarse-weave gray buckram. Top edge gilt, fore and lower edges trimmed. The words "First Edition after the printing of 134 DeLuxe copies" are on the verso of the title page.

43b. *Good Medicine* (Presentation)

There were 59 copies of the first trade edition (1930, 43a *supra*) bound in full blue buckram, with beveled edges, gilt top, for presentation to people who had contributed letters for reproduction.

43c. *Good Medicine* (Later Editions)

There was an edition by Garden City Publishing Company, size $7\frac{3}{4} \times 10\frac{1}{2}$, with frontispiece as integral part of signature. Dustwrapper is WHERE TRACKS SPELL WAR OR MEAT. There was an edition by Doubleday, size $8\frac{7}{8} \times 12$. Dustwrapper is WHEN I WAS A KID.

43d. *Good Medicine* (Special Edition, 1966)

Special edition of 500 copies issued 1966 by National Cowboy Hall of Fame for presentation to benefactors. These are the pages of the current reprint edition,

edges gilt, special binding, in a slipcase, with two additional signatures of eight pages each, bound in before and after the text, respectively.

44. *Cowboy Songs*: 1934

Cowboy Songs. All Rights Reserved. Copyrighted 1934 By Powder River Jack Lee. For extra copies of this book, please address Powder River Jack H. Lee, Deer Lodge ... Montana. Printed and Engraved by the McKee Printing Company.

Pp. 92. 8vo, size $8\frac{1}{2} \times 11\frac{1}{8}$. Wrappers, stapled. Also an edition 1938, some copies of which were bound in green fabricoid, without wrappers, and therefore lacking MEN OF THE OPEN RANGE.

Contains:

p. 5: THE WEST*
 photo, Charlie Russell at studio at Great Falls, Mont.
p. 17: A BRONC TWISTER (bronze)
p. 86: bust of CMR by Frederick Schweigardt
p. 87: photo of Trail's End, CMR's Pasadena home
p. 88: [THE] SLICK EAR
b. cover: SCATTERING THE RIDERS, i.e., MEN OF THE OPEN RANGE
pp. 80–81: song, "Charlie Russell"
p. 86: "Trail's End," a poem

45. *Horsefeathers* (1940)

Horsefeathers Being a Jumble of Mediocre Verse by an Old Man on the Fringe of Dotage. Pleasingly Illustrated by Charles M. Russell, Now deceased. Johnny Ritch, Helena, Montana.

There is no date on the title page.

Pp. [ii] + 84. 12mo, size $5\frac{1}{2} \times 8\frac{1}{16}$. Pictorial boards, half cloth. Words "Copyright 1940" at bottom of p. [1]. The illustrations are all in black and white. Contains 7 halftones and 6 line engravings:

cover: THREE HORSES' HEADS
p. 5: THE FIRST FURROW
p. 7: SHORTY'S SALOON—BRANDING IRONS*
p. 8: BY THE TRAILS TO THE PAST*
p. 9: NO FINE DRINKS ADORNED THAT PRIMITIVE BAR*
p. 10: GREAT HERDS FROM THE SOUTH SWEPT BY ON THE TRAILS*
p. 11: AND UP FROM THE VAST, SILENT STRETCH OF THE RANGE*
p. 12: THEY DANCED AND THEY DRANK*
p. 13: SOME TRAGEDIES MARK THOSE TRAILS TO THE PAST*
p. 14: BUCKING HORSE
p. 26: part of illustration on p. 10
p. 31: THE PROSPECTORS #2
p. 36: COWBOY ON A SPREE

p. 48: part of illustration on p. 11
p. 72: COWBOY ABOUT TO SADDLE HORSE

45a. *Horsefeathers* (Second Edition, 1941)

Title page virtually identical to the foregoing. Pp. 96. Size $5\frac{1}{2} \times 8\frac{7}{16}$. Binding, similar to the first edition. Words "Copyright 1940 and 1941" are at the bottom of p. [3]. Words "Second printing" appear on p. [6]. This edition contains all the illustrations of the first edition, but the six halftones illustrating the poem "Shorty's Saloon" (pp. 8–13 of first edition) are here in color. There is one additional line engraving:

p. 88: FOUR COWBOYS GALLOPING

N.B. After the first edition was published, but before the second edition was published, the color plates illustrating "Shorty's Saloon" were employed in a publication bearing that title; cf. *Shorty's Saloon*, Sec. XVI, *infra*.

46. *Memories of Old Montana* (1945)

Memories of Old Montana by Con Price, Masachele Opa Barusha. The Highland Press, Highland at Hawthorne, Hollywood 28, California.

There is no date on the title page. Copyright, 1945. Pp. 154. 8vo, size $5\frac{3}{4} \times 8\frac{3}{4}$, cloth. First edition so stated on verso of title page.

Simultaneously with the foregoing, there was published an edition of 125 copies, numbered and signed, called the DeLuxe edition. There were also issued 20 copies, each rubber-stamped "Author's Presentation Copy," identified by letters *A* to *S*, bound in pigskin. There is no change in the content, however.

Contains one halftone facing:

p. 9: THE LAZY K Y*
p. 123: two photos of Russell

47. *Bill Carlisle* (1946)

Bill Carlisle Lone Bandit An Autobiography. Illustrations By Charles M. Russell. Introduction By J. R. Williams. Endpapers By Clarence Ellsworth. Trail's End Publishing Co., Pasadena, Calif.

There is no date on the title page. Copyright, 1946. Pp. 220. 16mo, size $5\frac{3}{8} \times 8$. Cloth. First edition so stated on verso of title page. Simultaneously with the foregoing, there was published an edition of 625 copies, numbered and signed, called the DeLuxe edition. There is no change in the content, however.

Contains two line engravings and one halftone:

p. 50: AN OLD TIME FARO LAYOUT*
p. 58: ROYAL CANADIAN MOUNTED POLICE IN ACTION, i.e., MOUNTED POLICE PATROL CAPTURES AMERICAN WHISKY RUNNERS
fcg. p. 169: I EVEN CONSIDERED SAWING A BAR IN THE LIBRARY WINDOW*

THE WEST
Only previous appearance in *Cowboy Songs*, 1934.
See item 44, this section.

48. Trails I Rode (1947)

Trails I Rode by Con Price. Illustrations by Charles M. Russell. Trail's End Publishing Co., Pasadena, Calif. There is no date on the title page.

Pp. 264. 16mo, size $5\frac{1}{2} \times 9\frac{1}{4}$, cloth. The words "First Edition 1947" are on the verso of the title page. Dedicated to the memory of Charlie Russell. Simultaneously with the foregoing there was published an edition of 350 copies, numbered and signed. There was no change in the content, however.

Contains one color plate and one halftone, facing:

p. 17: WHITE MAN'S SKUNK WAGON NO GOOD HEAP LAME

p. 65: THE CHALLENGE* (bronze)

49. Forty Pen and Ink Drawings (1947)

Forty Pen and Ink Drawings by Charles M. Russell. Trail's End Publishing Co., Pasadena, California. There is no date on the title page. Copyright, 1947. Pp. [86], folio, size $10\frac{1}{2} \times 7\frac{1}{2}$, stapled. Bound in tan cloth. Front cover and backbone in brown, back cover blank. All edges trimmed. The words "First Edition limited to 1000 copies" appear on verso of title page. Contains all the plates from Pen and Ink Drawings Books I and II (cf. Sec. XVI, 77 and 78) plus the following:

RED MOON*

INDIAN CHIEF #4

WHEN GAME WAS PLENTIFUL, i.e., BEFORE THE WHITE MAN CAME #4

PANNING FOR GOLD, i.e., PLACER MINERS PROSPECTING NEW STRIKE

YELLOWSTONE KELLY'S FIGHT WITH THE SIOUX, i.e., KELLY'S DUEL WITH SIOUX INDIANS

THE PONY EXPRESS RIDER, i.e., A PONY EXPRESS RIDER ATTACKED BY INDIANS

Also contains photo of Russell sketching Douglas Fairbanks.

50. Lone War Trail of Apache Kid (1947)

Lone War Trail of Apache Kid by Earle B. Forrest and Edwin B. Hill. Illustration by Charles M. Russell. Trail's End Publishing Co., Pasadena, California. There is no date on the title page.

Pp. 144. 8vo, size 6×9, cloth. The words "First Edition 1947" are on verso of title page.

Simultaneously with the foregoing, there was published an edition of 250 copies, numbered and signed, called the DeLuxe edition. There is no change in the content, however.

Contains one color plate:

fcg. p. 27: MEXICAN RURALES*

51. Firewater and Forked Tongues (1947)

Firewater and Forked Tongues. A Sioux Chief Inter-prets U.S. History by M. I. McCreight. Illustrations by Charles M. Russell. Trail's End Publishing Co., Pasadena, California.

There is no date on the title page.

Pp. xxiv + 180. 32mo, size $5\frac{1}{2} \times 8\frac{1}{4}$, cloth. The words "First Edition 1947" appear on the verso of the title page.

Contains one color plate and one line engraving:

front.: WHEN THE TRAIL WAS LONG BETWEEN CAMPS*

fcg. p. 111: CURLEY, THE CROW SCOUT, BRINGS NEWS OF THE CUSTER FIGHT TO THE STEAMER FAR WEST, i.e., CURLEY REACHES THE FAR WEST WITH THE STORY OF THE CUSTER FIGHT

Endpapers from black and white drawing by CMR:

BLACKFEET TRADING PARTY IN SIGHT OF FORT BENTON

52. Mavericks (1947)

Mavericks The Salty Comments of an Old-Time Cowpuncher by Frank M. King. Illustration by Charles M. Russell. Introduction by Ramon F. Adams. Trail's End Publishing Co., Pasadena, Calif.

There is no date on the title page.

Pp. xii + 276. 16mo, size $5\frac{3}{8} \times 8\frac{1}{4}$. Bound in red cloth. Front cover and backbone gold-stamped. Back cover blank. All edges trimmed. Words "First Edition 1947" on verso of title page.

Contains one color plate:

front.: AN UNSCHEDULED STOP*

Endpapers are reproduction of pen and ink by CMR:

A TEXAS TRAIL HERD

53. Wyoming Frontier State: 1947

Wyoming Frontier State By Velma Linford. Drawings by Ramona Bowman. The Old West Publishing Co., Denver, Colorado, 1947.

Pp. xii + 428. 16mo, size $5\frac{3}{4} \times 8\frac{7}{8}$. Bound in green cloth, stamped in yellow.

Contains one halftone:

p. 55: INDIAN FIGHT #1*

54. Westerners Brand Book: 1947

The Westerners Brand Book Los Angeles Corral . . . 1947

Pp. 176. 8vo, size 8×10, cloth. Edition limited to 600 copies; actually, only 597 were produced.

Contains one line engraving and two halftones:

p. 34: BILLY THE KID AVENGES TUNSTALL'S DEATH, i.e., THE KID SHOOTS DOWN TWO PRISONERS IN COLD BLOOD

p. 82: KIT CARSON, i.e., JIM BRIDGER (bronze)

p. 126: THE BOLTER #2*

55. *The Pronghorn Antelope*: 1948
The Pronghorn Antelope and its management by Arthur S. Einarsen. Published by the Wildlife Management Institute, Washington, D.C., 1948.
Pp. xvi + 238. 16mo, size 6 × 8½. Cloth. There is a deluxe edition limited to 20 copies bound in three-quarter antelope hide with antelope head design stamped in gold on cover. Contents identical.
Contains one color plate:
p. 44: PRONGHORN ANTELOPE*

56. *Rawhide Rawlins Rides Again* (1948)
Rawhide Rawlins Rides Again or Behind the Swinging Doors A Collection of Charlie Russell's Favorite Stories. Illustrations by Charles M. Russell and Others. Published by Trail's End Publishing Co., Inc. Authentic Western Material. 725 Michigan Blvd., Pasadena 10, Calif.
There is no date on the title page.
Pp. 60 + 4. 8vo, size 4¾ × 6¼, uncut pages, flexible leather binding. Back cover gold-stamped using Russell's personal stamping die. Published 1948 in a limited numbered edition of 300 lithographed copies. Includes "The Impotent Pumpkin Vine" (see Sec. XVII).
front endpapers: JUST A LITTLE SUNSHINE*
 JUST A LITTLE RAIN*
p. 12: STRIKING A BARGAIN*
back endpapers: JUST A LITTLE PLEASURE*
 JUST A LITTLE PAIN*
back cover: BEST WHISHES TO THE P–C BUNCH
Contains the following stories:
p. 7: Why and Wherefore (explanatory note, not a story)
p. 13: Down at Maggie Murphy's Home
p. 15: The Keeley Cure
p. 16: The Impotent Pumpkin Vine
p. 21: The Mad Pig
p. 23: Mormon Zack
p. 24: The Tenderfoot Injun Fighter
p. 27: The Duke of Belt
p. 30: Wintering
p. 33: Help! Help!
p. 35: A Hell of an Outfit
p. 36: Piano Jim
p. 39: A Good Dog Gone Wrong
p. 41: The Bear Hunt
p. 43: A Voice from the Depths
p. 45: The Blasphemous Old Prospector
p. 48: Cabin Fever
p. 51: Buck and Be Damned
p. 52: Mose's Daughter
p. 55: Injun Reasoning
p. 57: The Lopsided Englishman
p. 58: One Bluff Too Many
p. 60: A Costly Binge

57. *Biography* (1948)
Charles M. Russell The Cowboy Artist. A Biography by Ramon F. Adams and Homer E. Britzman. Trail's End Publishing Co., Pasadena, Calif.
There is no date on the title page. Copyright 1948.
Pp. xvi + 366. 8vo, size 6 × 9, cloth.
In addition to the Collector's edition and the first edition, the *Biography* was published in an unlimited edition with a bibliographical checklist by Yost.
Contains 12 illustrations and endsheets in color:
endsheets: WHERE GREAT HERDS COME TO DRINK
fcg. p. 1: CHARLES MARION RUSSELL (SELF PORTRAIT), i.e., SELF PORTRAIT #1*
fcg. p. 16: A DREAM OF BURLINGTON*
fcg. p. 65: RIDER OF THE ROUGH STRING
fcg. p. 80: WAITING FOR A CHINOOK, i.e., THE LAST OF 5000
fcg. p. 145: COWBOY SPORT—ROPING A WOLF #2
fcg. p. 160: RETURN OF THE WARRIORS*
fcg. p. 241: WHEN WAGON TRAILS WERE DIM
fcg. p. 256: WHEN THE RED MAN TALKS WAR (ON THE WHITE MAN'S TRAIL)
fcg. p. 273: I DRINK NOT TO KINGS (panel B)*
fcg. p. 288: WHEN MULES WEAR DIAMONDS
fcg. p. 305: HIS HEART SLEEPS #1*
fcg. p. 320: TRAIL'S END
endpapers: WHERE GREAT HERDS COME TO DRINK
Contains 65 black and white illustrations:
p. 1: BEFORE THE WHITE MAN CAME #4
p. 7: MOUNTED POLICE PATROL CAPTURES AMERICAN WHISKY RUNNERS
p. 13: KELLY'S DUEL WITH SIOUX INDIANS
p. 25: A PONY EXPRESS RIDER ATTACKED BY INDIANS
p. 33: CHEYENNES WATCHING UNION PACIFIC TRACK LAYERS
p. 39: BUFFALO HOLDING UP MISSOURI RIVER STEAMBOAT
p. 49: KILLING OF JULES RENI BY SLADE
p. 55: BENT'S FORT ON THE ARKANSAS RIVER
p. [58]: JUDITH BASIN RANCH*
p. 65: BUILDING FORT MANUEL IN 1807
p. [72]: WAITING FOR A CHINOOK
p. 73: END OF OLD BILL WILLIAMS
p. [79]: CHARLIE PAINTING IN HIS CABIN*
p. 81: ONATE'S MARCH INTO THE NEW MEXICAN COUNTRY
p. [86]: WOLF AND STEER*
 WOLF AND BULL*
p. [90]: BEAR AT LAKE*
p. 91: THE FORT AT THREE FORKS
p. [94]: THE LAND HOG*

p. 103: A DIAMOND R MULE TEAM OF THE '70S
p. 107: RUSTLERS CAUGHT AT WORK
p. [112]: CHARLIE AND HANK STOUGH SET OUT FOR GREAT
 FALLS, i.e., TWO RIDERS, ONE LEADING A
 PACK HORSE
p. 117: PLUMMER'S MEN AT WORK
p. 131: MEETING OF SACAJAWEA AND HER RELATIVES OF
 THE SHOSHONE TRIBE
p. [136]: CHARLIE'S IDEA OF HOW CUPID ROPED HIM*
p. [143]: INDIAN SQUAW #1*
 INDIAN BUCK #1*
p. 145: PLUMMER AND TWO FOLLOWERS KILL FORD
p. [148]: THE HUNTER*
 THE WARRIOR*
p. 153: CODY'S FIGHT WITH YELLOWHAND
p. 165: A "SWING" STATION ON THE OVERLAND
p. [174]: THE LAZY K Y
p. 175: WORK ON THE ROUNDUP
p. 183: PLACER MINERS PROSPECTING NEW STRIKE
p: 193: INDIANS MEET FIRST WAGON TRAIN WEST OF
 MISSISSIPPI
p. 201: THE KID SHOOTS DOWN TWO PRISONERS IN COLD
 BLOOD
p. 209: ROCKY MOUNTAIN TRAPPERS DRIVING OFF
 HORSES STOLEN FROM CALIFORNIA MISSION
p. [212]: MOUNTAIN MOTHER (bronze)
 MEAT FOR WILD MEN* (bronze)
p. [216]: CHANGING OUTFITS (model)
 BUCKER AND BUCKAROO, i.e., THE WEAVER
 (bronze)
p. 219: STAGE COACH ATTACKED BY INDIANS
p. 227: CAPTAIN GRAY MAKING GIFTS TO THE INDIANS
 AT THE MOUTH OF THE COLUMBIA RIVER
p. [234]: GREY EAGLE* (model)
 ON NEENAH (model)
 RED BIRD* (model)
p. 235: BRIDGER DISCOVERS THE GREAT SALT LAKE
p. 241: THE DEATH OF LA SALLE
p. 249: RADISSON RETURNS TO QUEBEC WITH 350
 CANOES LOADED WITH FURS
p. [254]: THE WEINARD EXPEDITION* (letter)
p. 255: ADVANCE OF BLACKFEET TRADING PARTY
p. [258]: THE BULL WAS HEAP GOOD* (letter)
p. [262]: I'M STILL AMONG THE PICKNICKERS* (letter)
p. 265: THE HIDE TRADE OF OLD CALIFORNIA
p. [269]: YOU SLEEPING RELICK OF THE PAST*
p. 277: WILD BILL'S FIGHT WITH MCCANDLAS GANG
p. [281]: THE LAND THAT WAS GODS, i.e., WHEN THE
 LAND BELONGED TO GOD
p. [285]: LEWIS AND CLARK AT ROSS' HOLE, i.e., LEWIS
 AND CLARK MEETING INDIANS AT ROSS' HOLE
p. 289: ANNIHILATION OF FETTERMAN'S COMMAND
p. 297: A MANDAN VILLAGE
p. 305: COULTER'S [sic] RACE FOR LIFE

p. 311: CHARGE OF CHEYENNES LED BY ROMAN NOSE
p. 317: PAWNEES SEE "WATER MONSTER"
p. 324: SKULL #3
Also contains innumerable photos of CMR.

58. *Bibliography* (1948)
Charles M. Russell The Cowboy Artist. A Bibliography by Karl Yost with a note by Homer E. Britzman and Frederic G. Renner. Trail's End Publishing Co., Pasadena, Calif.
There is no date on the title page. Copyright, 1948. Pp. 218, 8vo, size 6 × 9, cloth. There was a Collector's edition limited to 600 copies, bound in black cloth. Sold with biography as a set. A few of these, out of series, were bound in full leather. Then the so-called first edition, limited to 500 copies, in maroon cloth, was issued. The Collector's edition has endsheets of WHERE GREAT HERDS COME TO DRINK in color.
Contains:
p. [10]: FRIENDS, I'M IN MISSOURI
p. [114]: CAUGHT IN THE ACT
p. [121]: Ranch Life in the North-West, adaptations
 by J. H. Smith
p. [142]: THE BUCKING BRONCO #1
p. [157]: AN OLD STORY
 LIFE SAVER
p. [164]: A WEAVER
p. [168]: IT USED TO BE THAT HOSSES WAS FAST ENOUGH
 FOR MEN
p. [170]: SMOKING UP (bronze)
p. [178]: IN THE MOUNTAINS
p. [183]: WHEN GUNS WERE THE LOCKS TO THE TREASURE
 BOX
p. [195]: THE NAVAJOS #3

59. *Westerners Brand Book*: 1949
The Westerners Brand Book [illustration] Los Angeles Corral. 1949.
Pp. 264. 8vo, size 8 × 10⅛, cloth. 400 copies. Released October, 1950. The West in Bronze by Homer Britzman, pp. 89–136 is a definitive catalog of all bronzes known at that time.
Contains (all bronzes unless otherwise specified):
p. 89: photo, CMR at log wall
 photo, Russell loved to model for his friends
p. 90: READY FOR THE KILL* (pencil sketch, 1900)
 OFFERING TO THE SUN GODS* (pencil sketch)
p. [91]: photo, Russell with finished model of SPIRIT
 OF WINTER*, 1925
 ELEPHANT* (model)
 CAMEL* (model)
p. 92: A MEXICAN MULE* (model, 1910)
 THANKSGIVING FOR BROTHER FOX?* (model)
 NUDE* (model)

59a. *Westerners Brand Book* (separate). The West in Bronze by Homer Britzman and Lonnie Hull. A Pictorial Study of Bronzes by Charles M. Russell. Copyright 1950 by H. E. Britzman.

Pp. 54, 8vo, size 8 × 10⅛, cloth, half morocco. A few copies in full leather.

Publisher's note: "These pages from the Los Angeles Westerners Brand Book for 1949 were bound separately

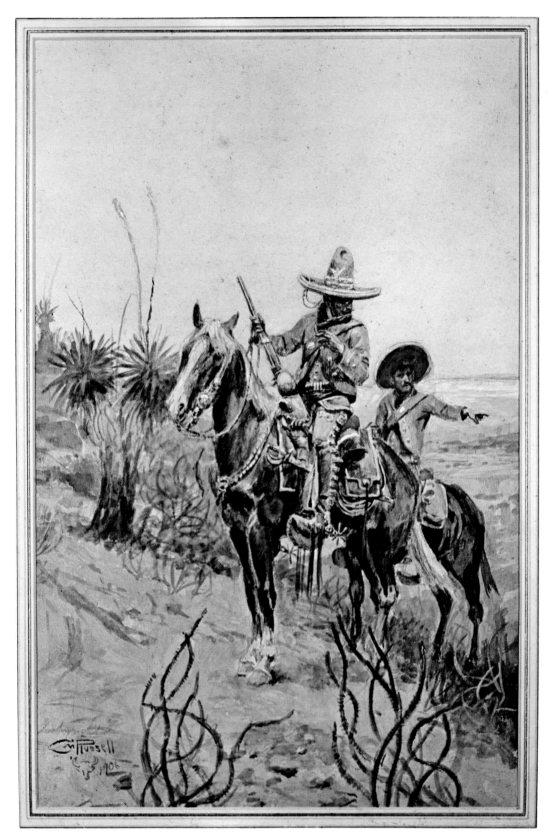

RURALES
This is the first publication of this picture under its correct title.
See item 61, this section.

in 100 sets especially for Russell students and collectors." Page numbers are those of the *Brand Book*. Numbered and signed by Britzman.

60. *The New Colophon*: 1950
The New Colophon A book collectors' miscellany. Published at New York. 1950.
Pp. 375, 8vo, size $7\frac{3}{4} \times 10\frac{1}{4}$. Pictorial cloth. Contains three halftones in article on Doheny library and the Estelle Doheny collection by Robert O. Schad:
p. [238]: MEAT FOR WILD MEN (bronze)
 THE WOLF AND THE BEAVER*
 FRIEZE #2*

61. *Practical Grassland Management* (1950)
Practical Grassland Management by B. W. Allred. Edited by H. M. Phillips. Published by Sheep and Goat Raiser Magazine, San Angelo, Texas.
There is no date on the title page. Copyright 1950.
Pp. 307. 8vo, size $6\frac{1}{4} \times 9\frac{1}{2}$, cloth.
Contains one color plate:
front.: VAQUEROS OF THE SOUTHWEST, i.e., RURALES*

62. *Portrait of the Old West* (1952)
Portrait of the Old West with a Biographical Check List of Western Artists by Harold McCracken. Foreword by R. W. G. Vail, Litt.D., Director, New York Historical Society. McGraw-Hill Book Company, Inc., New York Toronto London.
There is no date on the title page. Copyright 1952.
Pp. 232. 8vo, size $8 \times 10\frac{3}{4}$, cloth.
Contains 11 CMR illustrations:
p. [181]: PAINTING THE BUFFALO ROBE, i.e., THE PICTURE ROBE
p. [182]: IN WITHOUT KNOCKING
p. [183]: WAGON BOSS
p. [184]: INDIAN WARFARE, i.e., FOR SUPREMACY
p. [185]: TRAIL OF THE IRON HORSE #2 (color)
p. [186]: A DESPERATE STAND (color)
p. 187: IF WISHES WERE HOSSES AND YEARS WERE TRAILS*
p. 189: SELF-PORTRAIT #5*
p. 190: COWBOY, i.e., A CONTEST RIDER
p. 191: COW PONY, i.e., AN OLD-TIME BRONC
p. 194: RIM-FIRE OR DOUBLE CINCH RIG

63. *The Old Gravois Coal Diggings* (1954)
The Old Gravois Coal Diggings By Mary Joan Boyer. Imperial, Missouri.
There is no date on the title page. The Introduction is dated 1952, but the book appeared two years later.
Pp. 107. 8vo, size $8\frac{3}{4} \times 6$.
p. 13: Charles M. Russell (photo)
p. 14: THE OLD RUSSELL HOMESTEAD*

p. 16: HERE'S HOPING THE WORST END OF YOUR TRAIL IS BEHIND YOU
p. 19: FRANK E. FULKERSON ROPING HOGS*
p. 20: same as p. 19
p. 21: same as p. 19
p. 22: HERE'S HOPING YOUR TRAIL IS A LONG ONE

64. *Ghost Towns of Wyoming* (1956)
The Ghost Towns of Wyoming by Mary Lou Pence and Lola M. Homsher. Hastings House, Publishers, New York.
There is no date on the title page. Copyright, 1956.
Pp. 242. 8vo, size $7\frac{1}{2} \times 10$, cloth.
Contains reference to CMR on p. 224 and 8 illustrations:
p. [4]: ON THE WARPATH #2*
p. [5]: INDIAN HUNTERS' RETURN
p. [6]: FREE TRAPPERS
p. [7]: MEN OF THE OPEN RANGE
p. [87]: A PAIR OF OUTLAWS, i.e., I'M SCAREDER OF HIM THAN I AM OF THE INJUNS
p. [88]: BRONC TO BREAKFAST
p. 89: TOLL COLLECTORS
p. 90: THE ROUNDUP #2

65. *The Charles M. Russell Book*: 1957
The Charles M. Russell Book. The Life and Work of The Cowboy Artist By Harold McCracken [illustration]. Garden City, N.Y., Doubleday & Company, Inc., 1957.
Pp. 236, size $10\frac{1}{2} \times 13\frac{1}{2}$. Bound in full leather with reproduction of Russell's signature and adaptation of skull on front cover, and also on slipcase.
 The words "This edition of the Charles M. Russell Book is limited to two hundred and fifty copies, numbered and signed, of which this is number ____" appear on the flyleaf preceding the frontispiece.
p. [v]: (THE) FREE TRAPPERS (color) (this appeared in the limited edition only)
frontis.: WATCHING THE SETTLERS (color)
p. [3]: SADDLE, SHIELD
p. [5]: TWO RIDERS, ONE LEADING A PACK HORSE
p. 7: BEST WHISHES TO THE P-C BUNCH
tipped in to p. [9]:
 LEWIS AND CLARK MEETING THE FLATHEAD INDIANS, i.e., LEWIS AND CLARK MEETING INDIANS AT ROSS' HOLE (color)
p. [11]: Charles Marion Russell (H. Pollard photo)
p. 13: THEY'RE ALL PLUMB HOG WILD
p. 14: A BAD DAY AT SQUARE DEAL DAN'S, i.e., COWPUNCHERS WERE CARELESS, HOMELESS, HARD-DRINKING MEN

p. 15: STAMPEDED BY WILD GEESE, i.e., LIKE A FLASH THEY TURNED

p. 16: CHARLIE (i.e., CHARLES M.) RUSSELL AND HIS FRIENDS

p. [17]: SIGNAL FIRE, i.e., SIGNAL SMOKE (color)

p. [18]: RED RIVER BREED, i.e., A FRENCH HALF-BREED

pp. [18–19]: CAUGHT WITH THE GOODS, i.e., WHISKEY SMUGGLERS CAUGHT WITH THE GOODS (color)

p. [20]: SUN WORSHIPERS [sic] (color)

p. 21: THE INDIAN OF THE PLAINS AS HE WAS, i.e., AH-WAH-COUS

p. 22: BUFFALO CROSSING THE MISSOURI, i.e., BUFFALO MIGRATION

p. 23: "YORK" IN THE LODGE OF THE MANDANS, i.e., YORK

p. 24: THE FIRST WAGON TRAIN WEST, i.e., INDIANS MEET FIRST WAGON TRAIN WEST OF MISSISSIPPI

p. 25: JIM BRIDGER DISCOVERING GREAT SALT LAKE, i.e., BRIDGER DISCOVERS THE GREAT SALT LAKE

p. 27: CUSTER'S LAST STAND, i.e., 1876—THE CUSTER FIGHT

p. [28]: AMERICA'S FIRST PRINTER

p. 29: WATCHERS OF THE PLAINS

p. 30: THE WOUNDED BUFFALO*

p. 31: CHEYENNES WATCHING UNION PACIFIC TRACK LAYERS

p. 32: THE OVERLAND STAGE, i.e., STAGE COACH ATTACKED BY INDIANS

p. 33: HOLDING UP THE STAGE, i.e., THE HOLD UP

p. 34: FREIGHTING FROM FORT BENTON, i.e., A DIAMOND R MULE TEAM OF THE '70S

p. 35: DEATH IN THE STREET, i.e., PLUMMER AND TWO FOLLOWERS KILL FORD

p. 36: BUFFALO [#2]

p. [37]: WHEN SIOUX AND BLACKFEET MEET, i.e., WHEN BLACKFEET AND SIOUX MEET (color)

pp. [38–39]: WILD HORSE HUNTERS [#2] (color)

p. [39]: PINTO AND PONY, i.e., HIS FIRST YEAR

p. [40]: SAGEBRUSH SPORT, i.e., DEATH LOOP (color)

p. 41: ON THE MOVE, i.e., DUNC SEES A FEW BUFFALO

p. [42]: THE FREE TRADER*

p. 43: WHEN (i.e., WHERE) GUNS WERE THEIR PASSPORTS*

p. 44: THE CHRISTMAS DINNER

p. 45: LAST OF THE BUFFALO MEAT, i.e., THE LAST OF THE BUFFALO

p. 46: WHEN GUNS WERE SLOW, i.e., FLINTLOCK DAYS—WHEN GUNS WERE SLOW

p. 47: WHEN MEAT WAS PLENTIFUL*

p. 48: THE SCOUT [#7]*

p. 49: FOLLOWING THE FLYING CRANE, i.e., OLD MAN SAW A CRANE FLYING OVER THE LAND

p. 51: JAKE HOOVER'S CABIN, i.e., OLD HOOVER CAMP ON SOUTH FORK OF JUDITH RIVER

p. 52: THE PLACER PROSPECTORS, i.e., PLACER MINERS PROSPECTING NEW STRIKE

p. 53: END OF THE PROSPECTOR'S RAINBOW TRAIL, i.e., DEATH LURKS WHERE GOLD LURES

p. [54]: A DOUBTFUL GUEST*

p. 55: BATTLE OF THE ELKS

p. [57]: STAMPEDED, i.e., BUSHWHACKED (color)

p. [58]: PIEGAN WARRIOR, i.e., BLACKFEET WARRIOR

pp. [58–59]: DEADLINE ON THE RANGE, i.e., TOLL COLLECTORS (color)

p. [60]: [THE] TROUBLE HUNTERS (color)

p. 61: THE HORSE WRANGLER [#2]

p. 63: BUCKING BRONCO, i.e., BUCKING BRONCHO #1

p. 65: DANGEROUS TERRITORY, i.e., PIONEER PROSPECTORS

p. 67: ROPING A WILD ONE, i.e., BRANDING CATTLE—A REFRACTORY COW

p. [68]: THE (i.e., A) BRONC TWISTER (bronze)

p. 69: AN OLD TIME COW DOG

p. 70: THE JUDITH ROUNDUP, i.e., COWBOY CAMP DURING THE ROUNDUP

p. [71]: RAINY MORNING

p. 72: CAUGHT IN THE ACT

p. 73: MEN OF THE OPEN RANGE

p. [75]: THE ROUNDUP [#2]

p. 76: HOSTILES, i.e., WATCHING THE ENEMY

p. [77]: (A) BRONC TO BREAKFAST (color)

pp. [78–79]: CARSON'S MEN (color)

p. [79]: BUFFALO MAN, i.e., THE SIOUX BUFFALO HUNTER

p. [80]: AN UNSCHEDULED STOP, i.e., THE INNOCENT ALLIES (color)

p. 81: RUNNING DOWN A JACK RABBIT, i.e., HE'S JUST TOPPIN' THE HILL OUT OF MILES CITY WHEN HE RUNS DOWN A JACK RABBIT THAT GETS IN HIS WAY

p. 82: THE COWBOY [#2]

 [THE] BULL WHACKER

p. 83: [THE] STAGE DRIVER

 STAGE ROBBER, i.e., THE ROAD AGENT

65a. *Charles M. Russell Book* (First edition)
After the limited edition the first edition was printed. Page size $10\frac{1}{4} \times 13\frac{3}{16}$. Bound in brown cloth, with

adaptation of signature and skull stamped in gold on black relief on front cover; spine stamped in gold, brown, and black. Contents the same as in limited edition, except for omission of plate preceding frontispiece, and the addition of LEWIS AND CLARK MEETING INDIANS AT ROSS' HOLE on front of dustwrapper and WOLF #1* (model), THE COWBOY #2 (part), and THE SIOUX BUFFALO HUNTER (part) on back of dustwrapper.

66. *Westerners Brand Book* (1957)

The Westerners Brand Book [illustration] Los Angeles Corral. Book Number 7.

There is no date on the title page. Copyright 1957.

Pp. 293, 8vo, size 8 × 10⅛, cloth, 475 copies.

The Los Angeles Corral of the Westerners Presents A Charles Russell Sketch Book. Previously unpublished Drawings and Miscellany from the H. E. Britzman collection. Courtesy Mrs. H. E. Britzman.

p. [26]: LEWIS AND CLARK MEETING INDIANS AT ROSS' HOLE
p. [27]: SELF PORTRAIT #7*
 MOUNTAIN MAN*
 COWBOY #4*
 INDIAN, MOUNTED #1*
 HORSE'S HEAD*
p. [28]: COWMAN*
 A ROUGH CHARACTER*
 COWBOY, HEAD*
p. [29]: INDIAN #1*
 INDIAN DANCER #1*
 INDIAN DANCER #2*
 INVOCATION*
p. [30]: INDIAN MAN, SITTING*
 INDIAN HEAD, BONE IN HAIR*
 INDIAN HEAD, WITH TOP-KNOT*
 INDIAN HORSEMAN*
 INDIAN HEAD, ONE GOLD EAR-RING*
 PAPOOSE #2*
 INDIAN MAN, SEATED IN TIPI*
 NAVAJO*
p. [31]: DONKEY*
 DEER, BLACKTAIL*
 DOE, HEAD #2*
 BUFFALO #1*
 STEER #3*
 BLACKTAIL DEER*
 DOE, NECK EXTENDED*
 TURKEY #2*
 MOUNTAIN GOAT ON ROCK*
 SAGE HENS*
p. [32]: COWBOY AND LONGHORN SKULL*
 HORSES*
 BUCKING HORSE AND RIDER*
 THE TROOPER*

 HORSES WITH CROPPED TAILS*
 COWBOY ON A BUCKER*
p. [33]: STEER, BAWLING*
 LADY*
 PACK HORSE #2*
 ARABIAN HORSEMEN*
 COW-BY-THE-TAIL*
p. [35]: AH-WAH-COUS

67. *Charles M. Russell Cowboy Artist* (1957)

C. M. R. Charles M. Russell Cowboy Artist A Biography by Austin Russell. Twayne Publishers, New York.

There is no date on the title page. Copyright 1957.

Pp. 284, 8vo, size 5½ × 8½, cloth.

The following illustrations are tipped in between p. 128 and p. 129:

Nancy Cooper Russell (photo)
Charlie Russell and niece Isabel in Indian costume at Lake McDonald (photo)
Skookum, Charlie Russell, Austin Russell, Minnie Home and Nancy Russell on cabin porch at Lake McDonald (photo)
INDIAN FIGHT ON SUN RIVER*
AH-WAH-COUS
FINE FETHERS*
IF FAIRY WANDS WERE MINE*
PARTHIAN SOLDIER*
PAINTING THE TOWN
THE SHELL GAME

68. *Paper Talk* (1962)

Paper Talk Illustrated Letters of Charles M. Russell. Introduction and Commentary by Frederic G. Renner. Amon Carter Museum of Western Art, Fort Worth, Texas.

There is no date on the title page. Copyright 1962.

Pp. 120, size 9 × 11¾. The first issue of 1,000 copies in wrappers was immediately followed by the regular edition in boards. The first 20 copies of the first issue are marked by the misspelled word "retuning" in text, line 3, page 14.

cover: Hand of CMR (photo)
p. 3: Charles M. Russell, ca. 1924 (photo)
p. 7: Charlie, ca. 1868 (photo)
p. 13: Hand of CMR (photo)
p. 14: WHITE TAILS #3*
p. 15: WHITE TAILS #4
p. 16: OWL*
p. 17: Wedding picture of Charles and Nancy Russell (photo)
p. 18: MONTE AND FRIEND*
p. 19: Charlie and Nancy with Monte (photo)
p. 20: COWBOY SHOOTING RATTLESNAKE*

p. 96: ON THE BEACH*
p. 97: IM STILL AMONG THE PICKNICKERS
p. 98: CALIFORNIA HIDE TRADERS
Will Rogers and CMR (photo)
p. 99: YOU CAN SHOW FOLKS THE TOP OF AMERICA
p. 100: THIS KIND RIDE THE BEACHES OF CALIF.
p. 102: WERE BOATH A LONG WAYS FROM THE SOUTH FORK
Judge Bollinger, CMR, and John Lewis (photo)
p. 103: FOLKS DONT LYE MUCH AT THE SEA SHORE
p. 104: MOVIE COWBOYS*
p. 105: WHEN COWPUNCHERS LEFT HE USED THE BACK DOOR
p. 106: YOUR HORSES UNLODE THE BEST OF THEM*
RAY KNIGHT ROPING A STEER
p. 107: XMAS WHERE WOMEN ARE FEW*
p. 109: Nancy Cooper Russell (photo)
p. 111: BUCKING HORSE AND COWGIRL
BUCKING HORSE AND COWBOY
p. 112: WE MEET AGAIN DOUGLAS FAIRBANKS
p. 113: DOUGLAS FAIRBANKS AS D'ARTAGNAN, i.e., FAIRBANKS AS D'ARTAGNAN (bronze)
p. 114: YOUNG BOY*
p. 115: BEST WISHES FOR YOUR CHRISTMAS
CHARLES M. RUSSELL AND HIS FRIENDS
p. 116: LONGHORN HEAD*
p. 117: IRISH POLICEMAN*
p. 118: YOUR PEOPLE HAVE BEEN IN THE DRY GOODS BUSINESS*
p. 119: MOST OF THIS KIND PLAY GOLF*
A FEW LAZY MEXICANS*
p. 120: HERES HOPING THE WORST END OF YOUR TRAIL IS BEHIND YOU

There was an invitation to the reception for the opening of the exhibition, Tuesday, January 23, 1962, card, size $4\frac{1}{2} \times 6\frac{1}{4}$.

69. *Encyclopedia of Antiques* (1962)
The Complete Encyclopedia of Antiques. Compiled by the Connoisseur. Editor L. G. G. Ramsey. Hawthorne Books, Inc., Publishers, New York.
There is no date on the title page. Copyright 1962.
Pp. 1472, 8vo, size 7×10, blue cloth. Contains one illustration:

p. 662: THE JUDITH ROUND-UP AT SAGE CREEK*

70. *Log of a Cowboy* (1964)
The Log of a Cowboy A Narrative of the Old Trail Days by Andy Adams. Illustrated by E. Boyd Smith. A Bison Book, University of Nebraska Press, Lincoln.
There is no date on the title page. Copyright 1964.
Pp. [x] + 388. 8vo, size $5\frac{1}{4} \times 8$, paperback. Contains one color plate:

cover: THROUGH THE ALKALI*

71. *Cowboys and Cattlemen* (1964)
Cowboys and Cattlemen A Roundup from Montana The Magazine of Western History Selected and Edited by Michael S. Kennedy. Hastings House, Publishers, New York.
There is no date on the title page. Copyright 1964.
Pp. xii + 364, 8vo, size $7\frac{1}{4} \times 9\frac{3}{4}$. Bound in blue cloth.

pp. 173–179: "The Story Behind Charlie Russell's Masterpiece," by Wallis Huidekoper
pp. 181–189: "Charles M. Russell Cowboy-Artist"
dustwrapper: THE HERD QUITTER (color)
endpapers: THE TOLL TAKER, i.e., TOLL COLLECTORS
front.: THE DANGEROUS MOMENT, i.e., A MOMENT OF GREAT PERIL IN A COWBOY'S CAREER
p. [1]: THE WOLFER
p. 23: DIMOND HICH IN RANE
p. 25: VAQUERO, i.e., FROM THE SOUTHWEST COMES SPANISH AN' MEXICAN TRADERS (printed in reverse) (part)
p. [26]: THE SCOUT #4 (vignette)
p. [39]: THE SCOUT #4 (part)
p. [40]: FOUR COWBOYS GALLOPING
p. 52: IN THE OLD DAYS THE COW RANCH WASN'T MUCH
p. 58: ABOUT THE THIRD JUMP CON LOOSENS
p. [63]: COWBOY TWIRLING LARIAT, LONGHORNS RUNNING
p. [68]: A RACE FOR THE WAGONS (part)
p. [73]: NIGHT HERDER, i.e., THE HORSE WRANGLER (bronze)
p. [74]: A DIAMOND R MULE TEAM OF THE '70S
p. [86]: THE ODDS LOOKED ABOUT EVEN (part)
p. 91: THE POST TRADER (part)
p. [101]: THEY'RE ALL PLUMB HOG WILD (part)
p. [102]: RIDING HERD
p. 107: COMING TO CAMP AT THE MOUTH OF SUN RIVER (part)
p. 113: [A] TEXAS TRAIL HERD
p. [114]: THE ODDS LOOKED ABOUT EVEN (part)
p. [145]: CORAZON REARED STRAIGHT UP, HIS FEET PAWING LIKE THE HANDS OF A DROWNING MAN
p. 151: FOUR COWBOYS GALLOPING
p. 157: THE ODDS LOOKED ABOUT EVEN
p. 163: ABOUT THE THIRD JUMP CON LOOSENS (part)
p. 171: THE MOUNTAINS AND PLAINS SEEMED TO STIMULATE A MAN'S IMAGINATION (part)
p. [172]: SPREAD EAGLED (part)
p. 174: C. M. Russell (photo)
p. [175]: WAITING FOR A CHINOOK
p. [177]: C. M. Russell on Red Bird, 1902 (painting by Olaf Seltzer)

Gallery Catalogs

Invitation to Russell's first one-man show, Noonan-Kocian Galleries, St. Louis, 1903. On the left p. [1]; on the right, p. [3].

Catalog of Russell's show, Niederinghaus, 1910. On the left pp. [4] and [1]; on the right, pp. [2] and [3].
See items 2 and 8, this section.

Gallery Catalogs

1. Catalogue of the Art Collection of the St. Louis Exposition and Music Hall Association Third Annual Exhibition. St. Louis, 1886. Pp. 56, size $6\frac{3}{8} \times 8\frac{3}{8}$. Item 461 under "Amateur Department" lists BREAKING CAMP #1 without illustration.

2. You are invited to view a collection of Oil and Water Color Paintings by Chas. M. Russell at The Noonan-Kocian Co's Galleries Six hundred seventeen Locust Street Saint Louis November Twenty-Third Nineteen Hundred Three. This invitation, pp. [4], size 5×4, white stock, heralded Russell's first one-man show. It bears on the front, or p. [1]: COWBOY ON WALKING HORSE*. We have not seen a catalog of the exhibit.

3. Official Catalogue of Exhibitors. Universal Exposition, St. Louis, U.S.A., 1904. Division of Exhibits, Frederick J. V. Skiff, Director, Department B, Art. St. Louis, 1904. Pp. 278, size $6\frac{3}{8} \times 9$, pictorial wrappers. Item 668 of United States section—oil paintings, p. 36, lists PIRATES OF THE PLAINS without illustration.

4. Pennsylvania Academy of Fine Arts. Catalogue of Annual Exhibition, Philadelphia, 1905. Wrappers, size and pagination unknown. Item 917 lists SMOKING UP (bronze) without illustration.

5. Society of Illustrators Exhibition, Philadelphia, 1905. Not seen. A water color, THE FIRST TRAPPERS, was hung.

6. Pennsylvania Academy of Fine Arts. Catalogue of Annual Exhibition, Philadelphia, 1906. Wrappers, pp. 108+24, size $4\frac{5}{8} \times 6\frac{3}{4}$. Items 1013 and 1014 list COUNTING COUP (bronze) and BUFFALO HUNT (bronze) without illustration.

7. Official Catalogue of the Department of Fine Arts, Alaska—Yukon—Pacific Exposition, Seattle, Washington, 1909. A.–Y.–P. Publishing Co. Pp. 124, size $5\frac{1}{4} \times 7\frac{3}{4}$, pictorial wrappers. Items 529, 530 and 531 on p. 108 list 3 bronzes, without illustration: SCALP DANCE, BUFFALO HUNT, and FINISHING COUP, i.e., COUNTING COUP.

8. Paintings by C. M. Russell. Set within pictorical scroll. N.p., n.d. (probably St. Louis, 1910). Pp. [4], size $3\frac{1}{2} \times 6\frac{1}{4}$. Lists 21 pieces. P. [4]: Collection lent through courtesy of George W. Niedringhaus.

9. Eighth Montana State Fair [two rules] 1910. Art Department [rule and vignette] John H. Raftery, Superintendent. September 26 to October 1. Artists Represented: C. M. Russell, J. H. Sharp, Ralph DeCamp, Mary C. Wheeler, E. S. Paxson, Philip R. Goodwin, Mrs. E. Gifford Northern, Mrs. L. Mabel Hight, Lee Hayes. Broadside, size $5 \times 6\frac{1}{2}$. Recto as above. Verso lists title, artist and price of pictures, including 20 by Russell.

10. Paintings by C. M. Russell [vignette]. Words set within double circle. Vignette of Indian below circle (Naegele's). N.p., n.d. (Helena?, 1911?). Pp. [4]. Size $4\frac{1}{2} \times 6$. Lists 7 oils and 6 water colors.

11. Exhibition of Paintings. "The West that has passed". Charles M. Russell. The Folsom Galleries, 396 Fifth Avenue, New York. April Twelfth to May First Inclusive. N.d. (1911). Pp. [8], size 6×9. Light brown paper, stapled. Pp. [3–5] contain descriptive matter by Arthur Hoeber. P. [7] lists 13 oils, 12 water colors, and 6 bronzes.

12. Art Department. 1911. Folio, pp. [4], size $4 \times 5\frac{1}{2}$. No place shown, but undoubtedly a Montana county or regional fair. Lists several CMR paintings.

13. International Art Exhibition. In 1911, at Rome, a bronze by Russell, probably A HAPPY FIND, was exhibited. There was probably a catalog of the exhibition, but we have not seen it.

14. [SKULL #1] Special Exhibition [two rules] Paintings by Charles M. Russell [two rules] at "The Stampede", Calgary, 1912. Pp. [4], size $4\frac{1}{4} \times 7\frac{7}{8}$. Twenty pictures listed on p. [3]. Pp. [2] and [4] blank.

15. Art Exhibition. Paintings, Models and Pen Sketches by Charles M. Russell, Great Falls, Montana. Ridgley Calendar Co., Great Falls, Montana, December the 22d to 31st Inclusive, 1912. Pp. [8], size $3\frac{1}{8} \times 5$. Brown art-paper wrappers, stamped in gold and tied.

16. [SKULL #1] Special Exhibition [rule] Paintings by Charles M. Russell [device] At "The Stampede," Winnipeg, 1913. Text surrounded by border of devices. Pp. [4], size $4 \times 7\frac{15}{16}$, brown paper. Lists 17 oils, 7 water colors, and 9 bronzes.

17. [SKULL #1] Catalogue [rule] Paintings by Charles M. Russell of "The West that has passed" [rule] The Dore Galleries, 35 New Bond Street, W. (London). Pp. [4], size 4×8, brown stiff paper. Text set within ruled border. N.d. (1914, April 2–30). Lists 19 oils and 6 water colors.

17a. Card of Invitation to Private View. The Dore Galleries. Size $6\frac{1}{2} \times 4\frac{1}{2}$. This accompanies foregoing item.

18. [SKULL #1] Paintings. "The West that has passed" by Charles M. Russell. W. Scott Thurber Art Galleries, 408 South Michigan Boulevard. N.p., n.d. (Chicago, 1915). Feb. 3–Feb. 18. Pp. [4], size $3\frac{3}{16} \times 6\frac{1}{2}$.

19. [SKULL #1] Paintings. "The West that has passed" by Charles M. Russell. February Twenty-fifth to March tenth, inclusive. The Folsom Galleries, 396 Fifth Avenue. Text surrounded by rule border. Pp. [4], size $3\frac{3}{4} \times 6\frac{3}{8}$, brown stock. N.p., n.d. (New York, 1915). List of 17 paintings on p. [3]. Pp. [2] and [4] blank.

20. [SKULL #1] Paintings of The West by Charles M. Russell (of Great Falls, Montana) April Twelfth to Twenty-sixth Inclusive. S. & G. Gump Co., 268 Post Street, San Francisco. Pp. [4], size $3\frac{3}{4} \times 5\frac{5}{16}$. N.d. (1915). Lists 6 bronzes and 16 paintings.

21. August Fack Collection described by A. A. Lathrob. Not seen. We surmise about 1915. See *Great Falls Tribune*, Dec. 22, 1930.

22. "The West That has Passed" by Charles M. Russell the Cowboy Artist. Wunderly Galleries, 639 Liberty Avenue, Pittsburgh, Pa. January three to sixteenth, 1916. Lists 24 paintings and 12 bronzes.

23. "The West That Has Passed" [SKULL #1] Paintings and bronzes By Charles M. Russell The Cowboy Artist. Thurber's Galleries, 408 Michigan Boulevard, Chicago. February First to Twentieth, Nineteen Hundred and Sixteen. Front wrapper serves as title page. Text surrounded by double-rule border. Pp. 8, size $3\frac{3}{8} \times 6\frac{1}{8}$, stapled. Lists 24 paintings and 12 bronzes.
p. 3: WHEN SHADOWS HINT DEATH*
p. 4: A DANGEROUS CRIPPLE, i.e., CRIPPLED BUT STILL COMING
 WILD HORSE HUNTERS #2
p. 5: HIS WEALTH*
p. 7: OH, MOTHER! WHAT IS IT?* (bronze)
p. 8: BUCKING BRONCO, i.e., A BRONC TWISTER* (bronze)

24. "The West That Has Passed". Folsom Galleries, 396 Fifth Avenue, New York. March First to Fifteenth, Nineteen Hundred and Sixteen. Same as preceding item.

25. Special Exhibition. Paintings and Bronze [SKULL #1] Calgary, Alberta, August 25 to 30, 1919. Pp. 6, size $6\frac{1}{4} \times 3\frac{1}{2}$. Lists 24 paintings and 8 bronzes.

26. Special Exhibition. Paintings and Bronze [SKULL #1] Saskatoon, Sask. September 10, 11 and 12, 1919. Pp. [4], size $3\frac{3}{4} \times 6\frac{1}{8}$, light brown paper. Text set within rule border. Lists 18 paintings and 8 bronzes.

27. Special Exhibition of Paintings [SKULL #1] Charles M. Russell, Great Falls, Montana, At the Minneapolis Institute of Arts, December, 1919, Minneapolis, Minnesota. Pp. [4], size $3\frac{1}{4} \times 6\frac{1}{4}$, cream paper. Lists 16 paintings.

28. Paintings of the West. Babcock Galleries, 19 East 49th Street, New York. Pp. [16], size $5\frac{3}{8} \times 8\frac{15}{16}$. 1920.
p. [6]: LOOPS AND SWIFT HORSES ARE SURER THAN LEAD

29. [illustration] Paintings of The West by Charles M. Russell. January 17th to 29th. Babcock Galleries. Established by John Snedecor 1852, 19 East 49th Street, New York City. Pp. [4], size $5\frac{3}{8} \times 6\frac{3}{4}$. N.d. (1921). Lists 12 paintings.
p. [1]: LOOPS AND SWIFT HORSES ARE SURER THAN LEAD

30. There was an exhibition Sunday, March 19, 1922, at Kanst Art Galleries, 826 South Hill St., Los Angeles. We have seen card of invitation but no catalog.

31. [SKULL #1] Special Exhibition Paintings and Bronzes by Charles M. Russell, Great Falls, Montana. Santa Barbara Address 509 East Cabrillo Boulevard. N.d. (1923). Pp. [4], size 5 × 8. Lists 12 paintings and 9 bronzes.

32. Special Exhibition of Paintings and Bronzes by Charles M. Russell. March 26th April 9th, 1–9–2–4. The Biltmore Salon, Los Angeles, California. Pp. [6], size 3½ × 7. Lists 14 oils, 12 bronzes. Autobiography, p. [1].

33. Special Exhibition of Paintings and Sculptures By Charles M. Russell. The Corcoran Gallery of Art, Washington, D.C. From Tuesday, February 3, until Friday, February 27, 1925, inclusive [5 lines]. Pp. [4], size 5½ × 8½. Lists 14 paintings and 14 bronzes.

33a. Card, size 5½ × 3¼, announcing exhibition in foregoing item, was distributed by Senator Thomas J. Walsh of Montana.

33b. Card of invitation from the President and Trustees of the Corcoran Gallery of Art announcing a Special Exhibition of Paintings and Sculptures by Charles M. Russell.

34. The First Memorial Exhibition of the works of Charles Marion Russell "Painter of the West" [SKULL #1] Art League of Santa Barbara, 1927, January third to January fifteenth, inclusive. Pp. [8], size 6 × 9. Lists 33 paintings and 21 bronzes.

35. Memorial Exhibition [portrait by Arthur M. Hazard] Charles Marion Russell "Painter of the West" 1865–1926. January 24th to February 12th, Biltmore Salon, Los Angeles Biltmore. Pp. [4], size 5½ × 8⅜, n.d. (1927). Lists 31 paintings and 25 bronzes. P. [2]: SKULL #1 and "A Few Words About Myself."

35a. There was also a card announcing this exhibition.

36. Memorial Exhibition [photo of Hazard portrait] Charles Marion Russell "Painter of the West" 1865–1926. November 8th to 26th, Grand Central Art Galleries, 15 Vanderbilt Avenue, New York City. Pp. [4], size 5½ × 8⅝, n.d. (1927). Lists 45 paintings and 40 bronzes. P. [4]: "A Few Words About Myself."

37. Souvenir Illustrated Catalog. Works of Art by Charles M. Russell Montana's Cowboy Artist, Charles A. Biel, O. C. Seltzer. Compliments of S. A. (Sid) Willis, 220 Central Ave., Great Falls, Montana. The front wrapper serves as the title page. There is no date on the title page. Issued 1928. Pp. [32], folio, size 5 × 7¾. Wrappers, stapled. There are five issues of this catalog. The first includes listing of 59 items. Contains nine halftones:

cover: "I BEAT YOU TO IT"
p. [3]: Charles M. Russell (photo)
p. [5]: THE HOLDUP
p. [6]: A DESPERATE STAND*
p. [7]: INDIAN WOMEN MOVING*
p. [8]: THE BUFFALO HUNT #26*
p. [9]: THE PRICE OF HIS HIDE
p. [10]: BRINGING HOME THE GAME, i.e., BRINGING HOME THE KILL*
p. [11]: MEAT FOR THE TRIBE
p. [12]: EARLY MORNING HORSE THIEVES*

37a. The second issue is the same as the first in format but is one-eighth of an inch shorter. It does not contain the reproduction of EARLY MORNING HORSE THIEVES on page [12]. There are 65 items listed.

37b. The third issue is the same as the previous two in appearance, but it is on cream-colored paper; there are 71 items listed, and there is an advertisement for Bruckert's X–J Guest Ranch on page [31], which is the recto of the back wrapper.

37c. The fourth issue is similar to the third, but there is an addenda slip concerning items No. 10-A and No. 10-B pasted in facing page [12].

37d. The fifth issue is size 5 × 7¹¹⁄₁₆, describes 68 items, and has seven illustrations.

38. Where the Best of Riders Quit. Charles Marion Russell "Painter of the West" 1865–1926. October 24th to November 7th, Grand Central Art Galleries, 15 Vanderbilt Avenue, New York. Pp. [8], size 4¾ × 6¼, self-wrappers, n.d. (1928). Lists 7 paintings and 40 bronzes. Print of WHERE THE BEST OF RIDERS QUIT (bronze) pasted to p. [1].

39. "A Bronc Twister." Charles Marion Russell "Painter of the West" 1865–1926. November thirteenth to twenty-fourth, Robert C. Vose Galleries, 559 Boylston Street, Boston. Pp. [8], size 3½ × 5½, wrappers, n.d. (1928). Lists 6 paintings and 40 bronzes.
wrapper: A BRONC TWISTER (bronze)
p. [2]: CALL OF THE LAW

p. [4]: VACQUEROS [sic] OF OLD CALIFORNIA*
p. [6]: THE HORSE WRANGLER (bronze)
p. [7]: WHERE THE BEST OF RIDERS QUIT (bronze)

40. Grand Central Art Galleries—Year Book 1928. Cloth, size about 7½ × 10.
p. 27: CMR listed under heading "Sculptor Members" as deceased
p. 53: THE BUG HUNTERS* (bronze)
 [THE] RANGE FATHER (bronze)

41. Announcing a permanent exhibition of the work of Charles M. Russell Paintings and Bronzes. A historical delineation of the early days of our great northwest. Studio open by appointment: Phone Terrace 1006. Pp. [8], (1929), 4to, size $4\frac{5}{8} \times 5\frac{1}{2}$. Cream paper, untrimmed, sketch of residence, Trails End, 725 Michigan Boulevard, Pasadena, California, on front. Print of bronze, WHERE THE BEST OF RIDERS QUIT, tipped to p. [4]. Contains broadside insert bearing reproduction in halftone: (THE) CALL OF THE LAW and IN THE ENEMY'S COUNTRY*.

42. The Log Cabin Studio of Charles M. Russell Montana's Cowboy Artist [vignette of studio]. Published and copyrighted by The Russell Memorial Committee, Great Falls, Montana. Pp. [16]. Folio, size $5\frac{1}{16} \times 7\frac{11}{16}$, stapled. There is no date on front wrapper, which serves as title page. The first copies were sold July 4, 1930. Lists 320 items, but no illustrations, except vignette of studio on cover and Ecklund photo of CMR on p. [2]. Pale green stock, with Montana Printing Co. imprint at bottom of p. [16].

42a. Variant, later issue, size $5 \times 7\frac{3}{4}$, on buff stock, without Montana Printing Co. imprint.

43. Twentieth Annual Exhibition of Fine Arts. Fine Arts Galleries, Minnesota State Fair, August 30th to September 6th, 1930. Catalogue Price 10¢. Pp. [10], size $4 \times 9\frac{1}{2}$. Lists two bronzes.
cover: THE WEAVER (bronze)

44. The Log Cabin Studio of Charles M. Russell Montana's Cowboy Artist, 1219 Fourth Avenue North, Great Falls, Montana. Pp. 32, size 6 × 9, gray wrappers, with blue hue, printed in purple ink, stapled. There is no date on the title page. Issued in 1931. Lists 320 items.
wrapper: SKULL #1
p. [2]: Charles M. Russell's Last Portrait (Ecklund photo)
p. [3]: SKULL #1
p. [4]: WAITING FOR A CHINOOK (color)

p. 12: photo of studio and home
p. [13]: photo of CMR at easel
p. 16: photo of "old studio"
p. 19: THE COMING OF THE WHITE MAN*
p. 21: THE SCOUTING PARTY #2*
p. 23: THE BUFFALO HUNT #12*
p. 25: WHERE THE BEST OF RIDERS QUIT (bronze)
 THE BLUFFERS (bronze)
 THE ENEMY'S TRACKS (bronze)

44a. Brown wrappers, also tan "birchbark" wrappers. Has WAITING FOR A CHINOOK in black and white, has all photographs, but does not have other CMR illustrations. The space thus saved permitted use of larger type in listing 320 items.

44b. Variant, later issue, has words "Souvenir Brochure 50¢" at bottom of title page. Gray wrappers, with brown hue.

44c. Title page same as 44b. Tan wrappers. Printed August, 1959. WAITING FOR A CHINOOK in black and white. Photo on p. 16 of "Old Studio" different from photo on p. 16 of 44 and 44a.

44d. Title page same as 44b. Pink wrappers. Printed April, 1963.

45. Sale Number 4047—May 25 and 26, 1933. Interesting Books and Autographs [nine lines] American Art Association. Anderson Galleries, Inc., 30 East 57th Street, New York. Pp. 60, size $6\frac{1}{4} \times 9\frac{1}{4}$, wrappers. P. 48, items 324 and 325, describe 2 illustrated letters: "To Jim Gabril from his friend, C. M. Russell," and "Many snows have fallen since the Blackfeet an' Sioux smoked."

46. Sack collection of bronzes. George D. Sack, an avid collector of Russell, issued a catalog of his own collection of bronzes. This consisted of photos, one to a page, with typewritten explanatory material. The pages are shaped like a steer hide. Size about 7 × 9, ca. 1935.

47. Cole collection of paintings and bronzes. Dr. Philip G. Cole, one of the principal collectors of Russell, issued a catalog of his entire collection. It is said 12 of these catalogs were made up. Size about 18 × 22, pp. about 100, ca. 1936.

48. Collection of Genevieve Garvan Brady (Mrs. William J. Babington Macaulay). Public Sale on the Premises, Inisfada, Manhasset, Long Island, May 10–15 inclusive. Under the Management of the Ameri-

can Art Association, Anderson Galleries, Inc., 1937. Pp. 555, size 7⅞ × 11⅛, boards.

p. 346: HUNTER'S LUCK, i.e., MEAT'S NOT MEAT TILL ITS
 IN THE PAN

p. 347: THE HOLDUP, i.e., THE INNOCENT ALLIES

49. Sale Number 4413. Oil Paintings. Thursday Evening, November 17, Anderson Galleries, Inc., New York, 1938. Pp. 33, size 6⅛ × 9 1/16, wrappers. Lists two CMR paintings and reproduces one.

p. 17: THE TRAIL*

50. American Art Association. Anderson Galleries, Inc. Catalog Sale No. 4456. 30 East 57th Street, New York. N.d. (ca. 1940). Lists one CMR painting.

51. Paintings of our Glamorous West featuring Frederic Remington, Chas. Schreyvogel, Chas. M. Russell. Summer showing: Opening June 17th. Douthitt Galleries, Inc., 9 East 57th Street, New York City. Pp. [4], folio, size 3½ × 7⅜. N.d. (ca. 1941). Lists one CMR painting.

52. Half an Hour in Eldorado. A Trip through the Wells Fargo Bank Historical Collection of the Old West. N.p., n.d. (San Francisco, ca. 1942). Contains, p. 25: WE WENT OVER WITH BAGGAGE, MAIL, TREASURE BOX AND TOOLS.

53. The Bulletin of the Minneapolis Institute of Arts. Vol. XXXII, No. 23, June 5, 1943. Pp. [8] (i.e., [75]–82), size 6¾ × 10.

p. 77: STOLEN WOMEN*

54. A Special Exhibition of paintings from the bequest of C. F. Adams 1862–1943. January 1944. Portland Art Museum, S. W. Park Avenue and Madison Street, Portland, Oregon. Pp. [14], wrappers, size 6 × 9. Lists two water colors by CMR.

55. To Members of the Business Men's Art Institute: Trail's End, July 24, 1945, H. E. Britzman. Pp. [4], size 7 × 8½, mimeographed. Describes contents of Britzman collection.

56. The Rare Collection of Persian Silk Rugs, Remington and Russell Bronzes, Furnishings—Silver—Porcelains by Order of John W. Campbell, Public Auction, September 21st, 22nd and 23rd, 1944, at 1 P.M. Tobias, Fischer & Co., Inc. 71 West 45th Street, New York City. Pp. 68, size 7⅝ × 10⅛, wrappers.

p. 22: "BUSTING THE BRONCO", i.e., WHERE THE BEST OF
 RIDERS QUIT (bronze)

p. 43: "BUSTING THE BRONCO", i.e., A BRONC TWISTER
 (bronze)

57. Catalog of 62 Paintings and Bronzes by Famous American and European artists of the 18th, 19th and 20th Centuries [list of names] J. W. Young, Chicago's Oldest Art Galleries [3 lines]. Pp. [ii + 62]. Size 7 × 10. Wrappers. N.d. (1946).

p. 44: ENEMY TRACKS, i.e., THE ENEMY'S TRACKS
 (bronze)
 PRAYER FOR RETURN OF THE BUFFALO, i.e.,
 SMOKING WITH THE SPIRIT OF THE BUFFALO*
 (bronze)

58. Welcome to Woolaroc. This Booklet is your guide to Woolaroc. We hope you will find it helpful in pointing out some of the interesting facts about the ranch in general and presenting graphically the theme of the museum. We want your visit to be enjoyable. Please feel free to offer suggestions and criticisms, and above all—come back. Pp. 32, size 7 × 9, colored wrappers. N.p., n.d. (Bartlesville, Oklahoma, 1946).

p. 16: THE BUFFALO HUNT #7*

p. [20]: COWBOY ROPING A STEER, i.e., THE BOLTER #3

59. Art Notes. February 1947, J. W. Young, Chicago's Oldest Art Galleries [3 lines]. Pp. [24], size 6 × 9, stapled.

pp. [8–11]: notes on Russell

p. [21]: HE LURED THE IRATE LANDOWNER INTO A
 DEEP HOLE

60. Exhibition and Sale of the works of Frederic Remington and Charles M. Russell and sculptures by Curt Dennis. J. W. Young, Chicago's Oldest Art Galleries, 424 South Michigan Avenue, Chicago 5. Pp. [24], wrappers, size 7 × 10⅛. Front wrapper serves as title page. N.d. (February, 1947).

cover: photo of CMR at work in his Great Falls
 Studio, painting WHEN THE LAND BELONGED
 TO GOD

p. [5]: THE FIRST TRAPPERS, i.e., FREE TRADERS

p. [6]: CROWS ON THE WAY TO THE POW-WOW*

p. [7]: LONGROPE'S LAST GUARD*

p. [8]: INDIAN SCOUTS #1*

p. [18]: INDIAN SPEARING FISH
 INDIAN HARRY [IN BORROWED FINERY]
 "WE MUST RIDE LIKE THE DEVIL"

p. [19]: THERE WAS NO OTHER JAIL BUT A HOLE IN THE
 GROUND [WITH GUARDS OVER IT]
 WHO STOLE THE BACON, i.e., GRIZZLY WITH SACK
 OF FLOUR

p. [20]: IS THIS THE REAL THING? i.e., ARE YOU THE
 REAL THING?

p. [21]: INDIANS ON THE MARCH*
 SKETCHES*

p. [22]: THEY HOISTED THEIR BURROS [A HUNDRED AND
 SIXTEEN FEET]
 WHO PULLED HIS TAIL? i.e., KICKED HALF WAY
 ACROSS THE STREET

61. [photo of CMR at easel] Catalog of the Works of Frederic Remington and Charles M. Russell Loaned to the Houston Club through courtesy of Wyatt C. Hedrick. Pp. [20], size 7 × 10, front wrapper serves as title page. N.d. (1947).
p. [6]: THE FIRST TRAPPERS, i.e., FREE TRADERS
p. [7]: CROWS ON THE WAY TO THE POW-WOW
p. [8]: LONGROPE'S LAST GUARD
p. [9]: INDIAN SCOUTS #1
p. [17]: INDIAN SPEARING FISH
 WHO PULLED HIS TAIL, i.e., KICKED HALFWAY
 ACROSS THE STREET
p. [18]: WHO STOLE THE BACON, i.e., GRIZZLY WITH
 SACK OF FLOUR
p. [19]: IS THIS THE REAL THING? i.e., ARE YOU THE REAL
 THING?
p. [20]: INDIANS ON THE MARCH
 SKETCHES

62. Northern Hotel ... Billings, Montana. Pp. [12], size 4 × 8⅞, stapled, n.d. (ca. 1947). This is a hotel brochure, but pp. [3–6] pertain to "The Northern's Collection of Charles M. Russell's Original Oil Paintings, Sketches, Bronzes." Lists 18 pictures and 7 bronzes. This is the Mackay collection, now in Montana Historical Society.

63. Exhibition of Original Paintings by World-Famous Artists. Lecture by William A. Findlay. January thirty-first, nineteen hundred and forty-eight. The Daniel C. Gainey Room, Free Public Library, Owatonna, Minnesota. Pp. [8], 4to, size 5⅝ × 8¼. Lists 3 oils, 9 water colors, and 4 bronzes.

64. Catalog of 54 Paintings and Bronzes By Famous American and European Artists of the 17th, 18th and 19th Centuries [16 lines in 3 columns]. J. W. Young, Chicago's Oldest Art Galleries. Pp. [64], size 7 × 9⅞, wrappers, n.d. (1948).
p. [43]: PAYING THE FIDDLER*
p. [44]: CHIEF WOLF ROBE, i.e., THE SIOUX* (bronze)
 HEAD OF A TEXAS LONGHORN, i.e., STEER HEAD
 #1* (bronze)
 HEAD OF A COW PONY, i.e., HORSE HEAD*
 (bronze)

65. Thomas Gilcrease Foundation, Tulsa, Oklahoma. Opening Exhibition of Pictures, 1949. Pp. 20, wrappers, size 5 11/16 × 8 3/16. Lists four CMR paintings.

66. Art of Western America. Pomona College Art Gallery, November 1 to 31, 1949. Sponsored by Pomona College Art Department, Dr. Kenneth E. Foster, Chairman. Pp. [16], size 6⅜ × 9⅝, wrappers, limited to 600 copies. Lists 3 bronzes, 1 oil and 4 water colors. Contains 3 illustrations in color, tipped in:
front.: WHEN THE TRAIL WAS LONG BETWEEN CAMPS
center: WHERE GREAT HERDS COME TO DRINK
p. [15]: AN UNSCHEDULED STOP

67. An Exhibition of Paintings and Bronzes By Frederic Remington, Charles M. Russell. May to October, 1950. Thomas Gilcrease Foundation, Tulsa, Oklahoma. Pp. [40], wrappers, size 5⅜ × 8. Front wrapper serves as title page. Lists 46 paintings and 10 bronzes. Article on CMR by J. Frank Dobie, pp. [31–33].
p. [21]: photo of Russell room showing many paintings
 and bronzes on walls and in cases
p. [22]: [THE] SALUTE OF THE ROBE TRADE
p. [23]: JERKED DOWN
p. [24]: LEWIS & CLARK EXPEDITION, i.e., LEWIS AND
 CLARK REACH SHOSHONE CAMP, LED BY
 SACAJAWEA, THE "BIRD WOMAN"
p. [25]: [THE] BUFFALO HUNT #29
p. [26]: WILL ROGERS (bronze)
p. [27]: SMOKING UP (bronze)
p. [28]: NIGHT HERDER, i.e., THE HORSE WRANGLER
 (bronze)

68. Western History Collection, Its Beginning and Growth. Malcolm G. Wyer. Denver Public Library, June, 1950. Pp. [20], size 6 × 9, wrappers. Front wrapper serves as title page.
p. [12]: INDIANS ON HORSEBACK #2*

69. The Charles M. Russell Collection. An Exhibition of Paintings—Sculpture—Memorabilia by the famous cowboy artist, February 11th to 23rd, 1952, at the galleries of M. Knoedler & Co. Inc., 14 East 57th Street, New York City. Pp. [4], size 6 × 8¾. Lists 80 items.
p. [1]: I BEAT YOU TO IT
p. [2]: SKULL #1
p. [3]: THE VIRGINIAN
p. [4]: AH-WAH-COUS

70. Loan Exhibition of Paintings by Artists of the Old West. April 14th to April 25th, 1952. Held at Near East Foundation, 54 East 64th Street, New York. Lists 9 paintings and 1 bronze.

71. Oklahoma Ke Mo Ha. Issued 1952 by Frank Phillips Foundation, Inc. for Woolaroc Museum. Pp. [16], size 9 × 7, wrappers.
p. [4]: STAGE COACH ATTACK* (color)

72. Indians Ke Mo Ha. Issued 1952 by Frank Phillips Foundation, Inc. for Woolaroc Museum. Pp. [16], size 9 × 7, wrappers.
p. [8]: FLYING HOOFS* (color)
p. [10]: THE BUFFALO HUNT, i.e., WHEN BUFFALO WERE PLENTIFUL

73. The Charles M. Russell Room featuring the collection of Malcolm S. Mackay [illustration I'M SCAREDER OF HIM THAN I AM OF THE INJUNS] Historical Society of Montana, Veterans and Pioneers Memorial Building, State Capitol Grounds, Helena, Montana. Single sheet, folded twice to six pages, size 6 × 9½. N.d., issued 1953.

74. Charles M. Russell Exhibition Paintings and Sculpture. January 23–March 16, 1954. An Omaha Centennial Exhibition at the Joslyn Art Museum. Pp. [12], size 6 × 8½, self-wrappers. Lists 24 paintings and drawings and 40 bronzes.
wrapper: photo of CMR at easel painting SALUTE OF THE ROBE TRADE
p. [1]: SKULL #1
p. [3]: THE JERK LINE
p. [4]: CHARLES (i.e., CHARLES M.) RUSSELL AND HIS FRIENDS
p. [7]: [THE] MEDICINE MAN (bronze)

75. Painting and Sculpture by Charlie Russell April 1–18. The Saint Paul Gallery and School of Art, 476 Summit. Pp. [8], size 9½ × 5⅜, wrappers, stapled, n.d. (1954). Lists 29 paintings and drawings and 9 bronzes.
p. [1]: [A] BRONC TWISTER (bronze)

76. Exhibition of Early 19th and 20th Century American Paintings and Water Colors, April 12 to May 15, 1954. Hartert Gallery, 22 East 58th Street, New York. Pp. [8], 4to, size 5 × 7. Lists two CMR paintings.

77. "Remington To Today". Exhibition of Paintings and Sculpture of the Fabulous Old West, April 5th through April 30th, 1955. Grand Central Art Galleries, Inc., 15 Vanderbilt Avenue, New York, N.Y. Pp. [12], size 7¼ × 5¼, wrappers, stapled. The work of several artists, including Russell, was exhibited.

78. C M Russell Gallery, Great Falls, Montana. Pp. [12], size 8½ × 9½, pictorial wrappers, lettered as above. N.d. (1955).
p. [1]: THE COWBOY #2 (part)
 photo of CMR
p. [2]: C. M. Russell Log Cabin Studio (photo)
p. [3]: THE SCOUT #4 (part)
 C. M. Russell Gallery (photo)

p. [4]: THE WOLFER (part)
 C. M. Russell Gallery Entry (photo)
p. [5]: [THE] CREE INDIAN (part)
 C. M. Russell Gallery showing many models and BRONC ON A FROSTY MORN* on wall (photo)
p. [6]: THE STAGE DRIVER (part)
 photo of case in gallery showing many models
p. [7]: CHARLES M. RUSSELL AND HIS FRIENDS
 THE PROSPECTOR (part)
p. [8]: UPPER MISSOURI IN 1840
 THE STORM FROM BULL HEAD LODGE*
 STREET SCENE IN ARABIA*
p. [9]: PAWNEE CHIEF*
 OLD CHRISTMAS IN NEW ENGLAND*
 JOAN OF ARC* (model)
p. [10]: WATCHER OF THE PLAINS (model [sic. i.e., plaster replica])
 CHRISTMAS AT LINE CAMP*
 CHARLES RUSSELL ON RED BIRD
p. [11]: MAY YOUR DAYS BE BETTER*
 BEAUTY PARLOR*
 GALLANT LOVER*
p. [12]: THE JERKLINE
b. wrap.: SKULL #1

79. Auction Catalogue June 21, 22, 23, 24, at 7:30 P.M. Unusual and Important Art Treasures. Chicago Art Galleries, Inc. N.d. (1955). Pp. 56.
p. 38: SMOKING UP (bronze)

79a. Broadside mailing piece, size 17 × 20¼, folded to 8½ × 5⅛, with SMOKING UP on the outside, preceded the foregoing.

80. A Portfolio of Art by the Famous Cowboy Artist In The Charles M. Russell Room, New State Museum, Helena. Historical Society of Montana. $1.00. Copyrighted, 1955, Historical Society Press. Pp. [32], 8vo, size 8⅝ × 8¾, wrappers, stapled.
cover: THE ROUNDUP #2 (color)
p. [1]: Charles M. Russell (portrait) (by Obendorf?)
 SKULL #2*
p. [2]: LEWIS AND CLARK MEETING (THE) FLATHEADS (i.e., INDIANS) AT ROSS' HOLE
 Charles M. Russell Room (photo)
p. [3]: NO CHANCE TO ARBITRATE, i.e., WHEN HORSES TALK WAR THERE'S SMALL CHANCE FOR PEACE
 TOLL COLLECTORS
p. [4]: CHARLEY (i.e. CHARLES M.) RUSSELL AND HIS FRIENDS
 INDIAN HUNTER'S (i.e., HUNTERS') RETURN
p. [5]: THE ROUNDUP #2
 AH-WAH-COUS (part)

p. [6]: THE WOLFER

p. [7]: THE HERD QUITTER

p. [8]: BRONC TO BREAKFAST

p. [9]: YORK
WAITING FOR A CHINOOK
CHARLIE PAINTING IN HIS CABIN

p. [10]: INDIANS AND SCOUTS TALKING
THE FIRST FURROW

p. [11]: I'M SCAREDER OF HIM THAN I AM OF THE INJUNS
BEST WISHES FOR YOUR CHRISTMAS*

p. [12]: COWBOY SPORT—ROPING A WOLF #2
THE SURPRISE ATTACK

p. [13]: ROPING A WOLF #2
WOMEN OF THE PLAINS, i.e., BREAKING CAMP #3

p. [14]: LAST CHANCE OR BUST

p. [15]: AN OLD FASHIONED STAGE COACH

p. [16]: THE KNIGHT OF THE PLAINS AS HE WAS, i.e.,
AH-WAH-COUS
THE SCOUT #4

p. [17]: BUFFALO MAN, i.e., THE WOLFER
STAGE ROBBER, i.e., THE ROAD AGENT

p. [18]: THE TRAPPER

p. [19]: HALFBREED TRADER, i.e., THE POST TRADER
COWBOY'S BEST FRIEND, i.e., COWBOY SEATED,
HORSE NUZZLING HIS LEFT HAND

p. [20]: TIME TO TALK, i.e., THE MOUNTAINS AND PLAINS
SEEMED TO STIMULATE A MAN'S IMAGINATION

p. [21]: WHEN SPUR SPELLS DANGER, i.e., THE ODDS
LOOKED ABOUT EVEN

p. [22]: STAMPEDED BY GEESE, i.e., LIKE A FLASH THEY
TURNED

p. [23]: HOME ON THE RANGE, i.e., COMING TO CAMP AT
THE MOUTH OF SUN RIVER

p. [24]: THE WEAVER (bronze)

p. [26]: BATTLE BETWEEN (THE) CROWS AND BLACKFEET

p. [27]: TRANSPORT TO THE NORTHERN LIGHTS (model)
THE SCOUT #4 (vignette)

p. [28]: LEWIS AND CLARK STATUE—DESIGN BY C. M.
RUSSELL

p. [32]: HERE LIES POOR JACK: HIS RACE IS RUN
CHARLIE PAINTING IN HIS CABIN
CMR photo
Charles M. Russell on Monte (photo)

81. Building The West. Denver Art Museum. Denver Art Museum Fall Quarterly, October, 1955. Pp. 32, folio, size $10\frac{15}{16} \times 8\frac{1}{4}$, pictorial wrappers. Lists 1 painting and 4 bronzes; also 1 painting attributed to Russell, which is illustrated.

82. Kennedy Galleries, Inc. [2 lines] The Western Legend [5 lines] Exhibition April 16 to June 1, 1956 at the Kennedy Galleries, 785 Fifth Avenue, New York 22, N. Y. Pp. 20, size $5\frac{1}{4} \times 8$. Lists one bronze.

83. Important Paintings By Old Masters and XIX Century Works [design, 6 lines, design] Public Auction Sale, Wednesday December 12 at 8 p.m. Parke Bernet Galleries, Inc., New York, 1956. Pp. 48, size $7 \times 10\frac{1}{2}$, wrappers.

p. 34: THE PRINCESS*

p. 35: HUNTING ANTELOPE #1*

84. A Brief History of Wells Fargo told through the mementoes in the Wells Fargo Bank History Room. Published by Wells Fargo Bank, San Francisco, California. N.d. (ca. 1956). Contains:

p. [7]: CORDUROY ROAD, i.e., QUICK AS A THOUGHT HE
WAS PULLING HIS GREAT STALWART FIGURE
FROM OUT THE COACH

84a. A revised edition was issued, September, 1963.

85. Bronzes of C M Russell [SKULL #1] On Exhibit. Trigg-Russell Memorial Gallery, Great Falls, Montana, 1957. Pp. 24, size 6×9, wrappers, stapled. Front wrapper serves as title page. Lists 96 items and reproduces 10 bronzes:

p. 5: BLACKFEET WAR DANCE, i.e., SCALP DANCE

p. 6: THE BLUFFERS

p. 8: THE CRYER

p. 9: INDIAN MAIDEN, i.e., PIEGAN SQUAW

p. 11: MOUNTAIN MOTHER

p. 12: MOUNTAIN SHEEP #1

p. 14: SLEEPING THUNDER

p. 17: CHANGING OUTFITS

p. 18: FOREST MOTHER

p. 19: IN THE WHITE MAN'S WORLD

86. Chicago Art Galleries Auctioneers—Appraisers. 5250 No. Broadway, Chicago 40, Ill. Flyer, printed both sides, folded to size $9\frac{1}{2} \times 4\frac{1}{4}$. Sale March 20, 1957.

THE BUG HUNTERS (silver)

BEAR #1 (silver)

87. Private Collection of The Hammer Bros., the works of C M Russell from the collection of Homer E. Britzman in Trail's End, Pasadena. Last residence of Nancy Russell. Pp. 60, 8vo, size $8\frac{1}{2} \times 8\frac{3}{8}$, pictorial wrappers, stapled. The first issue of this catalog is described. A few copies were bound in cloth, preserving the wrappers. Then the exhibition was taken on tour, and there were six more issues in the order hereinafter listed, with the location, gallery name, sponsors and dates printed on the page opposite the title page, which actually is the verso of the front wrapper. (1) Los Angeles Municipal Art Department, Tower Gallery, Los Angeles City Hall, Aug. 29–Sept. 13, 1957. (2) California Palace of the Legion of Honor, Lincoln

Park, San Francisco, Sept. 19–Sept. 28, 1957. (3) Historical Society of Montana. Charles M. Russell Room of the State Museum, Oct. 1–Oct. 12, 1957. (4) The Trigg–C. M. Russell Foundation Inc. The C. M. Russell Gallery, Great Falls, October 14–26, 1957. (5) Calgary Allied Arts Council. Coste House, Calgary, Canada, November 1–17, 1957. (6) The New York Historical Society, Central Park West, December 17, 1957–February 2, 1958.

Contains 105 illustrations:

cover: SELF-PORTRAIT #4 (color)
p. 10: CHANGING OUTFITS (bronze)
 THE RANGE FATHER (bronze)
p. 11: SELF-PORTRAIT #4 (color)
p. 12: SMOKING UP (bronze)
 ON NEENAH (bronze)
p. 13: RED BIRD (bronze)
 THE BERRY EATER (bronze)
 GREY EAGLE (bronze)
p. 14: THE LAST OF 5000 (color)
 MOUNTAIN MOTHER (bronze)
p. 15: HIS HEART SLEEPS #1 (color)
p. 16: LUNCH HOUR (bronze)
 TREED (bronze)
p. 17: SMOKE OF THE MEDICINE MAN (bronze)
 THE MEDICINE MAN (bronze)
 YOUNG-MAN INDIAN (bronze)
 OLD-MAN INDIAN (bronze)
p. 18: NAVAJO WILD HORSE HUNTERS (color)
 IN THE ENEMY COUNTRY (color)
p. 19: BATTLE OF THE RED MEN, i.e., STORMING A
 WAR HOUSE (color)
 WHEN ARROWS SPELLED DEATH (color)
p. 20: IN THE WHITE MAN'S WORLD (bronze)
 OFFERING TO THE SUN GODS (bronze)
p. 21: NOBLEMAN OF THE PLAINS (bronze)
 THE SIOUX (bronze)
p. 22: RIDER OF THE ROUGH STRING (color)
 LONGHORN (bronze)
p. 23: RETURN OF THE WARRIORS
 THE QUARTERHORSE (bronze)
p. 24: THE CHALLENGE (bronze)
 THE FALLEN MONARCH (bronze)
p. 25: MONARCH OF THE FOREST (bronze)
 FOREST MOTHER (bronze)
p. 26: I DRINK NOT TO KINGS (panels A*, B, and
 C*)
p. 27: TRAIL'S END (color)
p. 28: ALERT (bronze)
 PIG #1* (bronze)
 WILD BOAR (bronze)
p. 29: INDIAN MAIDEN, i.e., PIEGAN SQUAW (bronze)
 NAVAJO SQUAW* (bronze)
pp. 30–31: WHERE GREAT HERDS COME TO DRINK

p. 32: ON THIS DAY, JANUARY 15, 1864, STEVE
 MARSHALL WAS HANGED BY VIGILANTES
 NEAR HILL GATE, i.e., STEVE MARSHLAND
 WAS HANGED BY VIGILANTES*
p. 33: SALUTE TO THE FUR TRADERS, i.e., BUILDING
 FORT MANUEL IN 1807
 BUILDING OLD FORT MANUEL, i.e., ADVANCE
 OF BLACKFEET TRADING PARTY
p. 34: [AN] UNSCHEDULED STOP (color)
 REDWING or Letter to Colonel Dickinson,
 i.e., RED BIRD (color)
p. 35: AT THE END OF THE ROPE (color)
 THE ROBE FLESHER* (color)
p. 36: THE LAST OF THE FETTERMAN COMMAND, i.e.,
 ANNIHILATION OF FETTERMAN'S COMMAND
 THE DEATH OF THE ROMAN NOSE, i.e., CHARGE
 OF CHEYENNES LED BY ROMAN NOSE
p. 37: SCIENCE HAD TO WAIT WHEN NATURE
 CLAIMED THE ROAD, i.e., BUFFALO HOLDING
 UP MISSOURI RIVER STEAMBOAT
 CANADIAN MOUNTED POLICE IN ACTION, i.e.,
 MOUNTED POLICE PATROL CAPTURES AMERI-
 CAN WHISKY RUNNERS
p. 38: [A] NOBLEMAN OF THE PLAINS (color)
 I'M STILL AMONG THE PICKNICKERS
p. 39: MOURNING HER WARRIOR DEAD (color)
 [THE] MEDICINE MAN #1 (color)
p. 40: WHEN NATURE'S STORE SEEMED ENDLESS
 IT WOULDN'T BE HEALTHY FOR MAN OR BEAST
p. 41: INDIAN BATTLE
 AUGUST 12, 1805 . . . ON THIS DAY LEWIS AND
 CLARK CROSSED THE ROCKY MOUNTAINS,
 i.e., LEWIS AND CLARK AT MARIA'S RIVER
p. 42: DUDES (color)
 SKUNK WAGON, i.e., WHITE MAN'S SKUNK
 WAGON NO GOOD HEAP LAME (color)
p. 43: SOLITUDE (color)
 SUN SHINE AND SHADOW(S) (color)
p. 44: ME AN' MORMON MURPHY'S COMIN' UP FROM
 BUFORD FOLLERIN' THE MISSOURI HEADIN'
 TOWARD BENTON, i.e., TWO RIDERS, ONE
 LEADING A PACK HORSE
 BUFFALO HERDER*
p. 45: IN QUIET WEATHER, i.e., ALL CONVERSATION
 WAS CARRIED ON BY THE HANDS
 INDIAN HEAD, i.e., INDIAN CHIEF #4
 RED MOON
p. 46: STAY IN THAT HOLE YOU DAMN FOOL, i.e.,
 JACK GOES BACK BUT HE DON'T STAY LONG
 BRANDING IRONS
 [A] DREAM OF BURLINGTON (color)
p. 47: HAPPY NEW YEAR, i.e., HERS TO A HAPPY NEW
 YEAR 1916 (part) (color)
 THIS KIND RIDE THE BEACHES OF CALIF.

p. 48: SHORTY'S SALOON*
 BUFFALO #2*
p. 49: DEATH LURKS WHERE GOLD LURES
p. 50: THE LAND HE OWNED, FOUGHT FOR, AND
 LOST, i.e., THE RED MAN'S HUNTING
 GROUND (pen and ink drawing)
 THE LAND HE OWNED, FOUGHT FOR, AND
 LOST* (pencil drawing)
 COLT REVOLVER*
p. 51: A SHOOTING SCRAPE*
 RIGHT THERE'S (i.e., THEN'S) WHERE THE
 BALL OPENS
p. 52: WOLF AND WIGWAM, i.e., THE FOX BROUGHT
 A FEATHER TO THE LODGE
 SKELETON OF A STEER #2
 SKELETON OF A STEER #1*
p. 53: WOLF AND STEER
 WOLF AND BULL
p. 54: BUFFALO HUNTER, i.e., THE BUFFALO HUNT
 #28
 INDIAN RIDER*
 MEXICAN RIDER*
p. 55: INDIAN HEAD #3*
 INDIAN HEAD #4*
 INDIAN GIRL #1*
p. 56: INDIAN BUCK #1
 INDIAN SQUAW #1
p. 57: BEAR AT LAKE
 KNIGHT AND JESTER*
p. 58: THURSTON HELD MONA SOMEWHAT TIGHTER
 THAN HE NEED TO HAVE DONE
 JOHNNY LUNCHES WITH THE KING
 ZACK PICKS OUT THE BIGGEST, HARDEST-
 LOOKIN CITIZEN HE CAN SEE
p. 59: STALLION FIGHT*
 SAILING SHIP*
 BULL HEAD LODGE*
p. 60: PRISON SCENE, i.e., I EVEN CONSIDERED
 SAWING A BAR IN THE LIBRARY WINDOW
 NYMPH*
 BURNING OF THE TONQUIN*

87a. Card of invitation to the preview of the first showing at Los Angeles, August 28, 1957, size 5¾ × 5, white stock.

88. The Last Frontier. An Exhibition of the Art of the Old West. October 5 to November 17, 1957. William Rockhill Nelson Gallery of Art and the Mary Atkins Museum of Fine Arts, Kansas City, Missouri. Pp. 28, size 5½ × 8½, wrappers, stapled. Lists 1 painting, 2 illustrated letters, 1 illustrated card, and 7 bronzes.
recto b. wrap.: WE HAVE BOTH SEEN MANEY CHANGES*
 OUR SCHOOL DAYS*

89. Old Masters and XIX Century Paintings. Barbizon and Dutch Landscapes [design 6 lines] Public Auction Sale, Wednesday, October 23 at 8 P.M. Parke-Bernet Galleries, Inc., 1957. Pp. 32, size 6¾ × 10.
p. 14: THE PRINCESS

90. Wm. S. Hart Park. County of Los Angeles. Pp. [6], leaflet, size 5⅞ × 9. (Department of Parks and Recreation, County of Los Angeles). N.d. (1958).
p. [6]: WILLIAM S. HART

91. Official Program. World's Largest Showing of Original C. M. Russell Art. National Collection of Fine Arts, Smithsonian Institution, Constitutional [sic] Avenue at Tenth Street, Washington, D. C. October 12–November 2, 1958. Price $2.00. This catalog was a special issue of Montana the magazine of Western History, Vol. VIII, No. 4, Fall, 1958, q.v., with changes only in printing on cover, inside cover, and title page. Same illustrations except:
Inside cover: LOOKS AT THE STARS substituted for THE
 SCOUT #4 (vignette)

91a. Smithsonian Institution. The National Collection of Fine Arts and the Montana State Society of Washington, D.C. Request the Honor of Your Presence at the Opening of an Exhibition of Sculptures, Oils, Watercolors and Drawings By Charles M. Russell (1864–1926) on Sunday, October 12, 1958 From 2:30 to 4:30 p.m. Open daily through November 2 in the Natural History Building. White card, size 5¼ × 4¼, with seal of Smithsonian Institution.

92. Beaverbrook Art Gallery, Fredericton, New Brunswick, Canada, 1959. Pp. 71 + 68 full-page plates. Size 5⅞ × 9, wrappers. Reference to CMR on pp. 27 and 28.
Plate 22: CANADIAN MOUNTED POLICE BRINGING IN RED
 INDIAN PRISONERS

93. Buffalo Bill Historical Center. Buffalo Bill Memorial Association, Cody, Wyoming. Pp. [12], folio, size 9 × 6, wrappers, n.d. (1959).
p. [11]: Charles M. Russell, the "Cow-boy Artist"
 (photo)
 MAKING THE CHINAMAN DANCE*
 BRONCO BUSTER #3*
 ELK IN LAKE MCDONALD
 COWBOYS FROM THE BAR TRIANGLE*
 BLACKFEET BURNING CROW BUFFALO RANGE
 THE WARRIORS' LONG TRAIL

94. The Land of Buffalo Bill. A Loan Exhibition of Paintings, Watercolors and Sculpture Commemorating the opening of the Gertrude Vanderbilt Whitney

Montana's Cowboy Artist

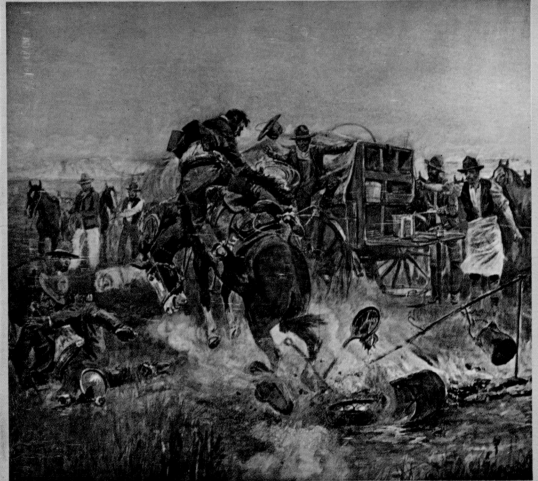

BRONC TO BREAKFAST—One of the greatest of all western watercolors by Charles M. Russell.

$C M Russell$

PRICE: TWO DOLLARS

Cover of catalog of Russell exhibition at the Smithsonian Institution in 1958, showing BRONC TO BREAKFAST.
See item 91, this section.

Gallery of Western Art. May 15th through September 15th. 1959 at the Buffalo Bill Historical Center, Cody, Wyoming. Pp. 16, wrappers, folio, size 7¼ × 9¾. Lists 65 pieces in the William Erhardt Weiss, Jr. collection and 81 bronzes from the R. W. Norton Art Foundation. Also a brief biographical sketch of CMR.

95. American National Exhibition. Moscow (1959) (printed in Russian). Pp. [8], folio, size 8½ × 8. Opened July 25, 1959.
MEAT FOR THE WAGONS (lent by Frederic G. Renner)

96. Grand Central Art Galleries 1959 Yearbook. Erwin S. Barrie, Editor [7 lines] Book copyright 1959 by Grand Central Art Galleries, Inc. Pp. 76, size 9¼ × 12¼, wrappers in spiral binder.
front.: NO CHANCE TO ARBITRATE, i.e., WHEN HORSES TALK WAR, THERE'S SMALL CHANCE FOR PEACE (color)

97. The Kennedy Quarterly [illustration] Kennedy Galleries, Inc. Founded 1874 by H. Wunderlich, 13 East 58th Street, New York 22, N. Y. Vol. I, No. 1, December, 1959.
p. [26]: INDIAN SCOUTS #2*

98. A Catalogue. Art of the Oregon Territory. Paintings from the Collection of Dr. and Mrs. Franz Stenzel. Introduction and catalogue notes By Franz R. Stenzel, Collector. Edited By Wallace S. Baldinger, Director, Museum of Art. Oregon Centennial Festival of Art, Museum of Art, University of Oregon, Eugene, 1959. Pp. [20], size 6 × 9, wrappers. Description of BUFFALO HUNT #49, i.e., #2, on p. [16].

99. The C. Bland Jamison Collection of Western Art. Presented by the Los Angeles Municipal Art Department at the Municipal Art Gallery, Vermont Avenue at Hollywood Boulevard. March 22–April 17, 1960. Pp. 8, size 6 × 9, wrappers.
cover: FOUR COWBOYS GALLOPING
p. [1]: COWBOY TWIRLING LARIAT, LONGHORNS RUNNING (part)
p. [6]: THE CHALLENGE #1*. See addendum 1, p. 307.

99a. The C. Bland Jamison Collection of Western Art. Handbill, tan stock, size 11¾ × 17. Reproduces COWBOY TWIRLING LARIAT, LONGHORNS RUNNING; COWBOY STANDING, RIGHT HAND ON HIP; BULL AND COW; COWBOY ON A SPREE; TWO MEN THROWING PACK HORSE HITCH; COWBOY, SIDE VIEW, CIGARETTE IN LEFT HAND; FOUR COWBOYS GALLOPING; COWBOY ABOUT TO SADDLE HORSE.

100. Exhibition of Paintings, Drawings and Sculpture By Notable Documentary Artists of the Old West and

Plains Indian Art. May 1st to September 15th, 1960 at The Gallery of Western Art, Buffalo Bill Historical Center, Cody, Wyoming. Pp. 66, size 9¼ × 7. Lists 248 pieces.
p. 4: WHERE GREAT HERDS COME TO DRINK WHEN LAW DULLS THE EDGE OF CHANCE
p. 13: SELF PORTRAIT #4

101. Wm. S. Hart Park, County of Los Angeles. Pp. [16], size 5⅞ × 9, self wrappers. Department of Parks and Recreation, County of Los Angeles, n.d. (1960).
p. [8]: photo of William S. Hart and CMR
p. [9]: FORMAL CALL, i.e., "NEXT MORNING SOME UTAH INDIANS CALLED ON US"
THE ATTACK, i.e., THE TRAPPERS PASSED THROUGH THEM WITH THEIR COLT'S REVOLVERS
p. [10]: THE RUNNING FIGHT, i.e., HIS ARROW LODGED IN THE FLESHY PART OF MY HORSE'S SHOULDER
PLAINS INDIANS ON HORSEBACK*
p. [11]: COWBOY LASSOING A STEER*
WILL ROGERS (bronze)
p. [15]: WILLIAM S. HART

102. Catalogue of C M Russell Bronzes In Collection of C. S. McNair, Great Falls, Montana, 1960. Pp. 16, size 6 × 9, stiff printed wrappers. This item contains no illustrations, but 66 Russell bronzes are listed and described. Descriptions are accurate, giving measurements, subject description, date of casting, number of castings, and provenance.

103. Headlines from Findlay Galleries. 320 South Michigan, Findlay Building, Chicago 4, Illinois. Vol. 2, No. 1, October, 1960. Pp. [4], size 8½ × 11.
p. [2]: MOUNTAIN SHEEP #2* (bronze)

104. The Kennedy Quarterly. Painters of the Old West. Kennedy Galleries, Inc. Founded 1874 by H. Wunderlich. 13 East 58th Street, New York 22, N.Y. Vol. I, No. 4, October, 1960. Pp. 48, i.e. [101]–[148], size 6 × 9¼, wrappers.
wrapper: INDIAN WAR PARTY #1*
p. 132: SCARED BY A RABBIT: COWBOY LIFE, 1898, i.e., BRONC ON A FROSTY MORN
p. 134: THREE WHITE TAIL DEER IN DEAD FALL
NO MEAT AS GOOD AS THE WILD FOR ME
AFTER THE HUNT*
p. 135: THE INDIAN FAMILY [2] (bronze)

105. The Quarterly of the Los Angeles County Museum, Vol. XVII, No. I, Winter, 1960–1961. The Charles M. Russell Bronzes by John Dewar, Assistant Curator of History, William S. Hart Museum, 15–17.

p. 15: WILL ROGERS (bronze)
p. 16: Russell painting western scene (photo)
 MOUNTAIN MOTHER (bronze)
 [THE] RANGE FATHER (bronze)
p. 17: INDIAN MAN, i.e., THE INDIAN FAMILY [1] (bronze)
 INDIAN WOMAN, i.e., THE INDIAN FAMILY [2]
 (bronze)
 Charles M. Russell with William S. Hart (photo)

106. Inaugural Exhibition Amon Carter Museum of Western Art. Selected Works, Frederic Remington and Charles Marion Russell. Fort Worth, Texas, 1961, January 21. Pp. [48], 8vo, size 7½ × 10½, wrappers.
p. [31]: UTICA PICTURE, i.e., COWBOY CAMP DURING THE
 ROUNDUP (color)
p. [32]: WILD MEAT FOR WILD MEN*
p. [33]: BRINGING HOME THE GAME, i.e., BRINGING HOME
 THE KILL
p. [34]: MOOSE HUNT, i.e., CAUGHT NAPPING
p. [37]: THE BUFFALO HUNT #39* (color)
p. [38]: THREE WISE MEN #2*
p. [39]: MEAT FOR WILD MEN (bronze)

107. The Discovery of the West. Phoenix Art Museum. March, 1961. Pp. [12], size 9⅞ × 7, wrappers.
wrapper: BUFFALO HUNT #8
p. [5]: APACHE CHIEF*
p. [8]: A DANGEROUS SPORT*
p. [9]: FIGHTING STALLIONS, i.e., THE CHALLENGE #1
p. [10]: A PITCHER*

108. Preserving the Heritage of the Old West. Buffalo Bill Historical Center, Cody, Wyoming, May, 1961. Pp. [28], size 12¾ × 9¾, self-wrappers.
p. [2]: BLACKFEET BURNING CROW BUFFALO RANGE
p. [3]: LEWIS AND CLARK AT THREE FORKS OF THE
 MISSOURI
p. [18]: WHERE THE BEST OF (THE) RIDERS QUIT
 (bronze)
 THE BLUFFERS (bronze)
 WILL ROGERS (bronze)
p. [20]: BUFFALO BILL'S DUEL WITH YELLOW HAND,
 i.e., CODY'S FIGHT WITH YELLOW HAND
b. cover: WHERE GREAT HERDS COME TO DRINK

109. Frederic Remington Centennial Exhibition and Paintings, Drawings and Sculpture by other Notable Documentary Artists of the Old West and Plains Indian Art. May 1st to September 15th, 1961 at The Gallery of Western Art, Buffalo Bill Historical Center, Cody, Wyoming. Pp. 16, size 9 × 7. Lists 266 pieces.
p. 11: SELF PORTRAIT #4
p. 12: THE SMOKE SIGNAL, i.e., SIGNAL SMOKE (reworked
 1915)

110. The Buffalo in Western American Art. An Exhibition from The Collections of The Glenbow Foundation, Calgary. June through September, 1961. Museum of the Plains Indian, Browning, Montana. Pp. 15, size 8 × 10½, mimeographed. Lists 1 painting by CMR and 2 bronzes.

111. Catalogue of fine old masters, engravings and etchings [lines] Sotheby & Co., 34 & 35 New Bond Street, London, W. 1 [lines] on Tuesday, June 13th, 1961. Pp. 46, size 7¼ × 9¾. Lists 2 CMR paintings and reproduces:
fcg. p. 38: TWO COWBOYS CHASING AND PREPARING TO
 LASSOO A STEER*

111a. Another edition of same catalog without illustration.

112. The Bradford Brinton Memorial Ranch, Quarter Circle A Ranch, Big Horn, Wyoming [5 lines] Open Daily—Admission Free. Single sheet, folded twice to size 4 × 8½. Issued in 1961.
cover: COWBOY AND LADY ARTIST, i.e., "SHE TURNED HER
 BACK ON ME AND WENT IMPERTURBABLY ON
 WITH HER SKETCHING" (color)

113. On the Warpath Pipe of Peace. An Exhibition of the Work of Charles M. Russell, 1864–1926. Amon Carter Museum of Western Art. Fort Worth, Texas, Summer 1961. Pp. [16], folio, size 8 × 8. Wrappers of greenish color. The name "Russell" vertically in right margin of title page. Lists 47 items.
wrapper: BRAVE, i.e., ON THE WARPATH #1
p. [4]: COUNCIL OF WAR*
p. [7]: SUNRISE*
p. [8]: SMOKE SIGNAL #2*
p. [11]: [A] DESPERATE STAND
p. [13]: INDIAN SIGNALING #2*
p. [14]: MEDICINE MAN #2

114. The Kennedy Quarterly. Recent acquisitions in important Western paintings [illustration]. Kennedy Galleries, Inc. Vol. II, No. 3, October, 1961. Pp. 40, i.e. [149]–188, size 6¼ × 9¼.
p. 182: TRAIL OF THE WHITE MAN*
p. 183: WAR COUNCIL ON THE PLAINS*
p. 184: SCOUTING AN ENEMY CAMP*
 DRIVING OFF THE STOLEN HERD, i.e., A HORSE
 STEALING RAID

115. October at the Art Museum. Museum of New Mexico, 1961, Santa Fe. Leaflet, quarto, folded to size 6 × 4 for mailing.
p. [5]: SCOUTING THE ENEMY (bronze)

116. The Artist in the American West 1800–1900. October 8 through November 22, 1961. Fine Arts Museum of New Mexico, a unit of the Museum of New Mexico. Pp. [32], size 8 × 8, pictorial wrappers. Lists 15 Russells and reproduces:

p. [26]: WHEN WAGON TRAILS WERE DIM
 BREAKING CAMP #2
 MEN WHO CARRIED THE FLINTLOCK, i.e., MEN THAT PACKED THE FLINT LOCK*
p. [27]: WHEN HORSES TALK WAR THERE'S SMALL CHANCE FOR PEACE
 DAY HERDERS, i.e., THE MOUNTAINS AND PLAINS SEEMED TO STIMULATE A MAN'S IMAGINATION
p. [28]: NIGHT HERDER, i.e., THE HORSE WRANGLER (bronze)
 IN THE WHITE MAN'S WORLD (bronze)

117. First Showing of a Distinguished Art Collection At the home of Mr. and Mrs. Lyle S. Woodcock, 3993 Holly Hills Blvd., St. Louis, Mo. Sunday, November 19, 1961. Benefit for the Methodist Children's Home of Missouri. Single sheet, size 10¾ × 9⅛, folded twice vertically off-center, tan stock, printed both sides. Lists 7 paintings and 6 bronzes.

118. Our Western Heritage. The University of Arizona Art Gallery. February 1–26, 1962. Pp. [8], size 9 × 7, buff stock, wrappers.

p. [5]: TO FORT UNION TO TRADE, i.e., BLACKFEET TRADING PARTY IN SIGHT OF FORT BENTON

119. Our Southwestern Heritage. February 5–March 3. Laguna Gloria Museum, Austin, Texas. Pp. [20], size 8½ × 7. Issued 1962. Lists 1 oil, 3 water colors, 2 Christmas cards, and 2 bronzes by CMR.

120. C M Russell [SKULL #1] Bronzes From the C. S. McNair Collection. All items are for sale. Prices on request. Offered for sale by Kennedy Galleries, Inc. Edward Eberstadt & Sons, New York. Pp. [40], i.e., [189–228], size 6¼ × 9¼, bronze wrappers with illustration of WILL ROGERS on front wrapper. Issued April, 1962 (date, Spring 1962, on front wrapper). "Russell as a Sculptor" by F. G. Renner. Lists 66 bronzes and 1 original clay model with illustrations of the model and 65 of the bronzes. One bronze, THE BEAR AND THE JUG is listed but not depicted.

p. 192: BEAR #2
 BEAR SITTING*
 AN AWKWARD SITUATION
 BEAR #1
p. 194: THE BUCKER AND THE BUCKEROO, i.e., THE WEAVER

p. 196: THE BUFFALO FAMILY
 BUFFALO RUBBING ROCK (pair)
 THE BUFFALO HERD CHIEF, i.e., THE BUFFALO
 LONE BUFFALO
 MINIATURE BUFFALO HEAD*
p. 198: CHANGING OUTFITS
p. 200: THE CHALLENGE
 A DISPUTED TRAIL
 THE BUG HUNTERS
 THE (i.e., AN) ENEMY THAT WARNS
 THE COYOTE
p. 202: GREY EAGLE
 FOREST MOTHER
 (THE) FALLEN MONARCH
 GRIZZLY ON LOG, i.e., GLACIER PARK GRIZZLY
 GRIZZLY SITTING, THE CLOWN, i.e., SITTING BEAR
p. 204: INDIAN MAIDEN, i.e., PIEGAN SQUAW
 HIS WINTER'S STORE
 INDIAN WARRIOR, i.e., LONE WARRIOR
 IN THE WHITE MAN'S WORLD
p. 206: THE CRYER
 BLACKFOOT WAR DANCE, i.e., SCALP DANCE
p. 207: [THE] RANGE FATHER
 THE BLUFFERS
p. 208: YOUNG MAN, INDIAN
 JONES HORSE HEAD
 OLD MAN, INDIAN
 FAIRBANKS AS D'ARTAGNAN
p. 210: [THE] MEDICINE MAN
 MONARCH OF THE FOREST
 THE LAST LAUGH
 (THE) MALEMUTE
p. 212: MOUNTAIN SHEEP #1
 MOUNTAIN LION, i.e., CAT
 MONARCH OF THE PLAINS
 MOUNTAIN MOTHER
p. 214: NAVAJO SQUAW
 OFFERING TO THE SUN GODS
 NAVAJO
 NOBLEMAN OF THE PLAINS
p. 216: READY FOR THE KILL
 O (i.e., OH) MOTHER WHAT IS IT?
 RED BIRD
p. 218: THE SIOUX
 SLEEPING THUNDER
 CHIEF JOSEF [sic]*
 THE SCALP DANCER
 ROYALTY OF THE ROCKIES
p. 220: SMOKE OF THE MEDICINE MAN
 [THE] SNAKE PRIEST
 SMOKING UP
 THE SLED MAN
p. 222: STEER HEAD #2
 JONES STEER HEAD

TO NOSES THAT READ A SMELL THAT SPELLS MAN

[THE] TEXAS STEER

p. 224: WEAPONS OF THE WEAK

WILD BOAR

WHITE MAN'S BURDEN

p. 226: THE SLY INDIAN* (model)

120a. Also, a mailing card, size $5\frac{1}{2} \times 8$, announcing catalogs available on request, with illustration of WILL ROGERS.

121. Exhibition of Paintings, Drawings, and Sculpture by Notable Documentary Artists of the Old West also Plains Indian Art and Other Western Americana. May 1st to September 15th, 1962. The Gallery of Western Art, Buffalo Bill Historical Center, Cody, Wyoming. Pp. 16, size 9×7. Lists 249 pieces.

p. 4: WHERE GREAT HERDS COME TO DRINK

p. 8: IN ENEMY COUNTRY, i.e., IN THE ENEMY COUNTRY

p. 10: BLACKFEET BURNING CROW BUFFALO RANGE

122. [design] Western Art Exhibit Sponsored by Rancheros Visitadores. Rancheros and Guests Preview May 4–5, 1962. Public Showing May 12 to 19 inclusive. Los Adobes de Los Rancheros, 715 Santa Barbara Street, Santa Barbara, California. Hours 10 to 5 and 7 to 9 P.M. Folio, size $9\frac{1}{2} \times 7\frac{1}{2}$. One water color listed on reverse.

123. The Works of Charles Marion Russell, 1864–1926 [skull design]. In the Permanent Collection of The Historical Society of Montana, Helena, Montana. Pp. [24]. Folio, size $11 \times 8\frac{3}{8}$, wrappers, stapled. Front wrapper serves as the title page. Undated. Issued 1962.

cover: THE TRAPPER

inside front cover: photo of CMR

p. [1]: FREE TRAPPERS

TOLL COLLECTORS

MEN OF THE OPEN RANGE

CHARLIE (i.e., CHARLES M.) RUSSELL AND HIS FRIENDS

INDIAN HUNTERS' RETURN

NO CHANCE TO' ARBITRATE, i.e., WHEN HORSES TALK WAR THERE'S SMALL CHANCE FOR PEACE

p. [2]: THE ROUNDUP #2

LAUGH KILLS LONESOME

WATCHING THE SETTLERS

INDIANS DISCOVERING LEWIS AND CLARK

ON THE WARPATH #2

INDIAN CAMP #2

p. [3]: CAUGHT IN THE ACT

KEOMA, i.e., KEEOMA #3

THE HERD QUITTER

MAMIE

BRAVE, i.e., PORTRAIT OF AN INDIAN

BRONC IN COWCAMP, i.e., CHUCK WAGON ON THE RANGE

p. [4]: COON-CAN—A HORSE APIECE

COON-CAN—TWO HORSES

PINTO OUTLAW, i.e., PINTO

ON DAY HERD #2

photo, Russell portrait by Krieghoff

p. [5]: WAITING FOR A CHINOOK

WHEN COWS WERE WILD

BRONC TO BREAKFAST

YORK

INDIANS AND SCOUTS TALKING

INTRUDERS

p. [6]: I'M SCARDER [sic] OF HIM THAN I AM OF THE INJUNS

BEST WISHES FOR YOUR CHRISTMAS

INSIDE THE LODGE

IN THE MOUNTAINS

THE DEERSLAYERS

THE SURPRISE ATTACK

p. [7]: SQUAW TRAVOIS

MY VALENTINE

WILD LIFE EPISODE*

NATURE'S SOLDIERS

HARMONY

KING ARTHUR'S COWHAND

p. [8]: QUICK SHOOTING SAVES OUR LIVES

LEWIS AND CLARK DISCOVERING THE GREAT FALLS OF THE MISSOURI, i.e., CAPTAIN LEWIS AND HIS SCOUTS DISCOVERING THE GREAT FALLS OF THE MISSOURI IN 1805

SELF PORTRAIT, i.e., IL BE THAIR WITH THE REST OF THE REPS

ON THE BEACH

CHIEF JOSEPH #1*

p. [9]: BUFFALO MAN, i.e., THE WOLFER

THE SCOUT #4

STAGE ROBBER, i.e., THE ROAD AGENT

THE TRAPPER

HALFBREED TRADER, i.e., THE POST TRADER

p. [10]: FORT UNION, i.e., FLATBOAT ON RIVER, FORT IN BACKGROUND

HIS HEART SLEEPS #2

GRABBIN FOR GUMBO, i.e., ABOUT THE THIRD JUMP CON LOOSENS

CALF ROPER, i.e., PETE HAD A WINNING WAY WITH CATTLE

THE GEYSER BUSTS LOOSE

NIGHT HERD, i.e., I'M IN THE CENTER OF THE TOWN DUMP

p. [11]: HANDS UP, i.e., WE AIN'T GONE FIVE MILE WHEN THE COACH STOPS

COWCAMP IN WINTER, i.e., IN THE OLD DAYS
 THE COW RANCH WASN'T MUCH
NEWFANGLED COWMAN, i.e., MOST OF THE
 COW RANCHES I'VE SEEN LATELY WAS LIKE
 A BIG FARM
BAD DAY AT SQUARE DEAL DAN'S, i.e., COW-
 PUNCHERS WERE CARELESS, HOMELESS,
 HARD-DRINKING MEN
BUFFALO'S REVENGE, i.e., I'M HANGIN' ON
 FOR ALL THERE IS IN ME
GHOST HORSE, i.e., THE CHIEF FIRED AT THE
 PINTO #2

p. [12]: TIME TO TALK, i.e., THE MOUNTAINS AND
 PLAINS SEEMED TO STIMULATE A MAN'S
 IMAGINATION
COWBOY'S BEST FRIEND, i.e., COWBOY
 SEATED, HORSE NUZZLING HIS LEFT HAND
FOLLOWING THE FLYING CRANE, i.e., OLD
 MAN SAW A CRANE FLYING OVER THE LAND
CANOE INDIAN, i.e., LOOKS AT THE STARS
WHEN SPUR SPELLS DANGER, i.e., THE ODDS
 LOOKED ABOUT EVEN
STAMPEDED BY GEESE, i.e., LIKE A FLASH
 THEY TURNED

p. [13]: HOME ON THE RANGE, i.e., COMING TO CAMP
 AT THE MOUTH OF SUN RIVER
RACE FOR THE GRUB WAGON, i.e., A RACE FOR
 THE WAGONS
CENTERFIRE MAN ON A BRONC, i.e., RAWHIDE
 RAWLINS, MOUNTED
MEXICAN COWBOY, i.e., FROM THE SOUTH-
 WEST COMES SPANISH AN' MEXICAN
 TRADERS
FIRST AMERICAN PRINTER, i.e., FIRST AMERI-
 CAN NEWS WRITER
MOSQUITO SEASON IN CASCADE

p. [14]: SPREAD-EAGLED
LADY BUCKEROO
STEER RIDER #2

p. [15]: A BRONC TWISTER (bronze)
JIM BRIDGER (bronze)
THE WEAVER (bronze)
THE HORSE WRANGLER (bronze)
SMOKING UP (bronze)
THE RANGE FATHER (bronze)

p. [16]: MEDICINE WHIP (bronze)
AN ENEMY THAT WARNS (bronze)
AMERICAN CATTLE (bronze)
LONE WARRIOR (bronze)
OH MOTHER, WHAT IS IT? (bronze)

p. [17]: (THE) MALEMUTE (bronze)
ROYALTY OF THE ROCKIES (bronze)
SITTING BEAR (bronze)
GLACIER PARK GRIZZLY (bronze)

SIGN TALK (bronze)
ARABIAN HORSE* (bronze)

p. [18]: PIEGAN BRAVE* (model)
MONTANA MOTHER* (bronze)
PRAIRIE PALS* (bronze)
THE THOROUGHBRED (bronze)
BLACKFOOT WAR CHIEF (bronze)
SIX REINS FROM KINGDOM COME*
 (bronze)

p. [19]: MEAT FOR WILD MEN (plaster replica)
THE CRYER (plaster replica)
(THE) BEAR AND THE JUG (plaster replica)
BEAR #1 (plaster replica)

p. [20]: BEAR #2 (plaster replica)
THE BUG HUNTERS (plaster replica)
SITTING BEAR* (model)
COYOTE (plaster replica)
PIEGAN MAIDEN, i.e., PIEGAN SQUAW (plaster
 replica)
WILL ROGERS (plaster replica)

p. [21]: NAVAJO (plaster replica)
TRANSPORT TO THE NORTHERN LIGHTS
 (model)
FAIRBANKS AS D'ARTIGAN (i.e., D'ARTAGNAN)
 (plaster replica)
COUNTING COUP (plaster replica)
ENEMY TRACKS, i.e., THE ENEMY'S TRACKS
 (plaster replica)
TEXAS STEERS, i.e., THE TEXAS STEER (plaster
 replica)

p. [22]: MOUNTAIN SHEEP (plaster replica)
ROMAN CHARIOT* (wax model)
PAINTING THE TOWN (plaster replica)
WEAPONS OF THE WEAK (plaster replica)
GRIZZLY BEAR* (model)
MEDICINE MAN (plaster replica)

p. [23]: CAT (plaster replica)
SECRETS OF THE NIGHT (plaster replica)
BUFFALO RUBBING ROCK (plaster replica)
BUFFALO FAMILY (plaster replica)
LONE BUFFALO (plaster replica)
THE BLUFFERS (plaster replica)

p. [24]: LONGHORN, i.e., HEREFORD* (model)
MOUNTAIN SHEEP* (model)
CHIEF JOSEPH (plaster replica)
CARAVAN MAN* (wax model)
WHEN (i.e., WHERE) THE BEST OF RIDERS
 QUIT (plaster replica)

inside b. cover: photo of CMR
back cover: THE WOLFER

124. The Rockwell Gallery of Western Art. Corning,
New York, n.d. (1962). Folder, size $4\frac{1}{4} \times 8\frac{1}{2}$.
ONE DOWN, TWO TO GO

125. The Kennedy Quarterly [illustration] Kennedy Galleries, Inc. Founded 1874 by H. Wunderlich, 13 East 58th Street, New York 22, N.Y. Vol. III, No. 2, October, 1962.

p. 93: WILL ROGERS (bronze)
p. 96: THE BERRY PICKER*
 BUCKING BRONCO #2*
 COWBOY (MEXICAN)*
 INDIAN #2*

126. The Works of Charles M. Russell and Other Western Artists. Hammer Galleries, 51 East 57th Street, New York 22, N.Y. Pp. 56, wrappers, size 8 × 10¼. Front wrapper serves as title page. N.d. (November, 1962). Four-page supplement of Recent Acquisitions inserted.

cover: Charles M. Russell (bronze by unknown sculptor)
p. 3: THE BUCKER AND THE BUCKAROO, i.e., THE WEAVER (bronze)
p. 4: WHERE THE BEST OF RIDERS QUIT (bronze)
p. 5: THE INDIAN FAMILY [1] and [2] (bronze)
p. 6: NOBLEMAN OF THE PLAINS (bronze)
 OFFERING TO THE SUN GODS (bronze)
 SIGN TALK (bronze)
p. 7: PAINTING THE TOWN (bronze)
p. 8: THE SIOUX (bronze)
 SCOUTING THE ENEMY (bronze)
 GREY EAGLE (bronze)
p. 9: THE ROBE FLESHER (plaster replica)
 GOOD MEDICINE (plaster replica)
 SMOKE OF THE MEDICINE MAN (bronze)
p. 10: THE GRUB STAKE (bronze)
 LUNCH HOUR (bronze)
 THE BLUFFERS (bronze)
p. 11: TEXAS STEER (plaster replica)
 HORSE AND STEER HEAD, i.e., JONES HORSE HEAD (bronze) and JONES STEER HEAD (bronze)
p. 12: AN AWKWARD SITUATION (bronze)
 ROYALTY OF THE ROCKIES (bronze)
 WOLF WITH BONE (bronze)
p. 13: WILD BOAR (bronze)
 PIG #4* (model)
 PIG #1 (bronze)
p. 14: THE DUEL*
p. 15: (THE) LINE RIDER
p. 16: NO KETCHUM
p. 17: A SIGNAL OF PEACE
p. 18: THE PEACE TALK
p. 19: INDIAN BUCK #1
 INDIAN SQUAW #1
p. 20: CHIEF JOSEPH, i.e., DEAF BULL #1*
 APACHE CHIEF
 BEAR AT LAKE

p. 21: NYMPH
 BURNING OF THE TONQUIN
p. 22: I DRINK NOT TO KING IN CASTLE STRONG, i.e., I DRINK NOT TO KINGS (Panels A, B, and C)
p. 23: GROUSE SHOOTING IN MONTANA
p. 24: A DREAM OF BURLINGTON
 THE SUN WORSHIPPER #1*
p. 25: HERE'S TO A MERRY CHRISTMAS*
 THE BRONC RIDER
p. 26: SAILING SHIP
 KNIGHT AND JESTER
p. 27: DEAF BULL, i.e., INDIAN HEAD #3
 KEE-OH-MEE, i.e., KEEOMA #2*
p. 28: IN QUIET WEATHER, i.e., ALL CONVERSATION WAS CARRIED ON BY THE HANDS
 THE VIRGINIAN'S FIGHT, i.e., VENGEANCE LIKE A BLAST STRUCK BALAAM
 SO ME RUN UP BEHIN' SHOVE DE GUN IN HIS BACK AN' TELL HIM STOP HIS PONY
p. 33: BUFFALO SKETCH #1*
 BUFFALO SKETCH #2*
 BUFFALO SKETCH #3*
 BUFFALO SKETCH #4*
p. 34: INDIANS CAMOUFLAGED WITH WOLF SKINS*
 A FLEEING INDIAN*
 BUFFALO LYING DOWN*
p. 35: SEATED INDIAN*

127. C M Russell and his Bronze Masterpieces of The Old Frontier. A broad vista of the great Cowboy Artist's genius in sculpting is unveiled for the first time in public display of the long admired private collection of the late W. Alton Jones. Now on exhibition in the C. M. Russell Room—Historical Society of Montana, Helena, December, 1962 to March 1, 1963. Pp. [24], size 7½ × 10½, self-wrappers. Front wrapper serves as title page, and bears a rubber stamp Hammer Galleries 51 East 57th St. New York City. This is a separate used by Hammer Galleries as a catalog from the Winter, 1963 (Vol. XIII, No. 1, pp. [33–56]) issue of Montana, the magazine of Western History, q.v.

128. Exhibition of Paintings, Drawings, and Sculpture by Notable Documentary Artists of the Old West, also Plains Indian Art and Other Western Americana. May 1st to October 1st, 1963, Whitney Gallery of Western Art, Buffalo Bill Historical Center, Cody, Wyoming. Pp. 16, size 7 × 9⅛, wrappers.

p. 8: TRAIL'S END
p. 12: [THE] STRANGLERS

129. An Art Perspective of the Historic Pacific Northwest from the Collection of Dr. and Mrs. Franz R. Stenzel, Portland, Oregon. Exhibited at Montana

Historical Society, August, 1963. Eastern Washington State Historical Society, September, 1963. Pp. (ii)+ 32+(ii), wrappers, size 8½ × 11.

p. 21: (THE) MEN WHO (i.e., THAT) PACKED THE FLINT
LOCK
WALKING TEEPEES*

p. 22: THE ENEMY'S COUNTRY
BUFFALO HUNT #49, i.e., #2*

130. The West Immortalized in Bronze by Charles M. Russell, Montana Historical Society, Helena, Montana. Exhibition, 1963. W. Alton Jones Collection, Hammer Galleries, New York, N.Y. Pp. 36, size 11 × 8⅜, wrappers.

cover: A BRONC TWISTER

p. 5: MEAT FOR WILD MEN
COUNTING COUP

p. 6: THE BUFFALO RUNNER, i.e., BUFFALO HUNT
THE BUCKER AND THE BUCKAROO, i.e., THE WEAVER

p. 7: THE (i.e., A) BRONC TWISTER
THE CRYER

p. 8: SIGN TALK

p. 9: IN THE WHITE MAN'S WORLD
SECRETS OF THE NIGHT

p. 10: [THE] BUFFALO FAMILY

p. 11: BUFFALO RUBBING (ON) ROCK
LONE BUFFALO

p. 12: THE BLUFFERS

p. 13: AMERICAN CATTLE
(A) MONARCH OF THE PLAINS

p. 14: MONARCH OF THE FOREST
AN AWKWARD SITUATION
MONARCH OF THE ROCKIES

p. 15: FOREST MOTHER
MOUNTAIN SHEEP #1
ALERT

p. 16: AN ENEMY THAT WARNS

p. 17: THE LAST LAUGH
READY FOR THE KILL
(THE) COYOTE

p. 18: GLACIER PARK GRIZZLY
BEAR #1

p. 19: BEAR #2
LUNCH HOUR

p. 20: (THE) BEAR AND THE JUG
A DISPUTED TRAIL

p. 21: TREED
(THE) MALEMUTE

p. 22: OFFERING TO THE SUN GODS
BLACKFOOT WAR DANCE, i.e., SCALP DANCE

p. 23: SMOKE OF THE MEDICINE MAN
THE ROBE FLESHER

p. 24: PIEGAN MAIDEN, i.e., PIEGAN SQUAW
SLEEPING THUNDER

p. 25: NOBLEMAN OF THE PLAINS
NAVAJO

p. 26: OLD MAN INDIAN
YOUNG MAN INDIAN
INDIAN HEAD
INDIAN CHIEF JOSEPH, i.e., CHIEF JOSEPH

p. 27: THE SCALP DANCER
SMOKING TO (i.e., WITH) THE SPIRIT OF THE
BUFFALO
THE MEDICINE MAN

p. 28: ENEMY TRACKS, i.e., THE ENEMY'S TRACKS (long
lance)
SPIRIT OF WINTER

p. 29: HIS WINTER'S STORE
THE MEDICINE MAN
ENEMY TRACKS, i.e., THE ENEMY'S TRACKS (short
lance)

p. 30: NIGHT HERDER, i.e., THE HORSE WRANGLER
WILL ROGERS

p. 31: PAINTING THE TOWN
SMOKING UP
WHERE THE BEST OF RIDERS QUIT

p. 32: [THE] TEXAS STEER
STEER HEAD #1
THE CHALLENGE

p. 33: NAVAJO SQUAW
THE WHITE MAN'S BURDEN (two versions)
IT AIN'T (i.e., IT'S) NO LADY'S JOB

p. 34: RUSSELL: SELF-PORTRAITS, i.e., RUSSELL WITH HAT
and RUSSELL WITHOUT HAT
CAT OR MOUNTAIN LION, i.e., CAT
PIG #1
WILD BOAR

p. 35: THE THOROUGHBRED
GREY EAGLE

36: DOUG FAIRBANKS, i.e., FAIRBANKS AS D'ARTAGNAN
RED BIRD
JIM BRIDGER

131. Along the Santa Fe Trail. A Catalogue of the BMA Collection of the Paintings and Artifacts of the Old West and Southwest on display in the BMA Tower (Kansas City, 1963). Pp. 20, size 4⅞ × 7⅞. Lists 54 prints of CMR paintings.

132. The Eye of the Traveler, an historical & artistic perspective of the American & Canadian frontiers in the work of outstanding 19th century artists. The Kennedy Quarterly, Vol. IV, No. 1. Published by Kennedy Galleries, Inc. November, 1963. Pp. 64, size 6 × 9, wrappers, stapled.

cover: MOUNTED INDIAN BRAVE*

p. [60]: (THE) SURROUND

p. [62]: BRONC ON A FROSTY MORN(ING)

p. 63: ROPING A (WHITE) BUFFALO WOLF*
p. 64: INVITATION TO THE OLDTIMERS' BALL*
 BUFFALO HUNT #34*

132a. Announcing an Important Exhibition, November 20–December 30, 1963. Western American Paintings, Watercolors, Bronzes. Illustrated "Kennedy Quarterly" on above, available on request. Kennedy Galleries, Inc. New York. Mailing flyer, size 4⅜ × 9¼.
INDIAN BRAVE (1901), i.e., MOUNTED INDIAN BRAVE

133. A Unique Bronze from Original Model Offered by Trailside Galleries, Idaho Falls, Idaho. American Sculpture Modeler 1864–1926 C M Russell. Pp. [8], quarto, size 8⅜ × 10¾, n.d. (1963).
p. [1]: photo of Russell holding model
p. [4]: COWBOY ON A BUCKING BRONCO* (model)
p. [5]: THE COWBOY ON A BUCKING BRONCO* (bronze)
p. [8]: GLACIER PARK GRIZZLY (bronze)
 SITTING BEAR (bronze)
 (THE) ARABIAN HORSE (bronze)
 HOG ON THE HILL* (bronze)

134. An Art Exhibition for The President and Mrs. John F. Kennedy. The Presidential Suite, Hotel Texas, Fort Worth, 22 November 1963. Folio, pp. [4], size 5½ × 8½, limited to 100 numbered copies. Lists one CMR painting.

135. Baker Collector Gallery, 1963. (Lubbock, Texas). Pp. [32], size 5½ × 8½.
p. [16]: INDIAN (i.e., LONE) WARRIOR (bronze)

136. Tradition and Change a memorial of the old West and a record of the new in paintings and bronzes. The Kennedy Quarterly, Vol. IV, No. 2. Published by Kennedy Galleries, Inc., December, 1963. 13 East 58th Street, New York 22, New York. Pp. [48] i.e., [65]–112, wrappers, size 6 × 9.
p. 100: ENEMY TRACKS, i.e., THE ENEMY'S TRACKS (long lance) (bronze)
 JIM BRIDGER (bronze)
p. 101: THE HORSE WRANGLER (bronze)

137. Formal Acceptance of the Albert K. Mitchell Collection of Western Art by the Board of Trustees of the Lovelace Foundation [7 lines] January 18, 1964. Lovelace Foundation for Medical Education and Research, Alburquerque, New Mexico. Pp. 17, wrappers, size 6 × 7¾. Lists 7 paintings, 3 pen drawings, and 5 bronzes by CMR.

138. Amon Carter Museum of Western Art. Sid W. Richardson Collection. Brochure, folded twice to 11 × 8⅜. Lists 55 paintings.

BUFFALO BILL'S DUEL WITH YELLOWHAND, i.e., FAMOUS DUEL BETWEEN BUFFALO BILL AND YELLOW HAND
WHEN BLACKFEET AND SIOUX MEET

138a. There was a card of invitation to the opening and reception dedicating the new addition to the museum and the opening of the exhibition on January 23, 1964.

139. Woolaroc Museum. Flyer, size 16 × 9, folded twice to size 4 × 9, white stock, printed both sides, n.p., n.d. (Bartlesville, 1964).
COWBOY ROPING A STEER, i.e., THE BOLTER #3

140. Hog On The Hill. Another most unique bronze From the original model Offered by Trailside Galleries, Idaho Falls, Idaho, by C M Russell American Sculpture Modeler 1864–1926. Quarto, pp. [8], size 8½ × 11, peach stock, n.d. (1964).
p. [1]: HOG ON THE HILL (bronze)
p. [4]: HOG ON THE HILL* (model)
p. [5]: BRIDE'S BOUQUET*
 TAKE ONE WITH ME FRED
 photo of CMR and Fred Tharp
p. [8]: GLACIER PARK GRIZZLY (bronze)
 SITTING BEAR (bronze)
 [THE] COWBOY ON A BUCKING BRONCHO (i.e., BRONCO) (bronze)
 (THE) ARABIAN HORSE (bronze)
 HOG ON THE HILL (bronze)

141. Baker Collector Gallery. Spring, 1964. The Baker Company, Lubbock, Texas. Pp. [32], size 5½ × 8½.
p. [16]: INDIAN WARRIOR, i.e., LONE WARRIOR (bronze)

142. Art of the Western Frontier. IBM Gallery, 16 East 57th Street, New York, New York. Exhibit was held March 23 through April 18, 1964. Pp. [12], size 8½ × 6¼.
p. [6]: WATCHER OF THE PLAINS (bronze)

143. American Paintings and Drawings . . . William D. Swaney, New York, And from Other Owners . . . Public Auction Thursday Evening April 23 at 8 o'clock. Parke-Bernet Galleries, Inc., New York, 1964. Pp. [64], size 7 × 10¼, wrappers. Sale Number 2276.
p. 6: MONTY, i.e., THE CHIEF FIRED AT THE PINTO #1
p. 7: SMOKE OF THE MEDICINE MAN (bronze)

144. Trailside Galleries. Dick Flood, Director, Idaho Falls, Idaho. Folio, size 6 × 7¾, greenish stock, (1964). Contains STUDY OF A BUFFALO SKULL* on front. This was also issued as a separate card. Series One, Number Three, of Trailside Galleries Doodles. See Section X.

145. Exhibition. Paintings, Drawings, and Sculpture. Western Americana Art. Edward Borein Restrospective Exhibition. Charles M. Russell, Frederic Remington, Edgar S. Paxson, "Custer's Last Stand" and others. Contemporary Western Art [12 lines] May 1st to October 1st, 1964. Whitney Gallery of Western Art, Buffalo Bill Historical Center, Cody, Wyoming. Pp. 16, size 6¾ × 9½, wrappers.

verso wrap.: SMOKING UP (bronze)
p. 13: ROUNDUP ON THE MUSSELSHELL*
p. 15: COWBOYS OF (i.e. FROM) THE BAR TRIANGLE

146. Exhibit of Boatmen's Art Collection. Special Bicentennial Showing May 4 thru May 29, 1964. Folio, pp. [8], size 5½ × 8½, wrappers.
p. [6]: BLACKFOOT INDIAN #1*

147. Centennial Year—1864-1964. C. M. Russell Gallery, Great Falls, Montana. Pp. [16], size 8½ × 11, wrappers, with back wrapper extended to provide visible index.

cover: RUSSELL ON RED BIRD, i.e., CHARLES RUSSELL
 ON RED BIRD (color)
verso of cover: photo of Trigg–C. M. Russell Gallery
p. [1]: photo of CMR, log cabin studio, and gallery
 STOLEN HORSES #1 (color)
p. [2]: THE COWBOY #2 (part)
 SCOUTING AN ENEMY CAMP
 DRIVING OFF THE STOLEN HERD, i.e., A HORSE
 STEALING RAID
p. [3]: COWBOY #3*
 SHOOTING THE BUFFALO*
 APPROACH OF WHITE MEN*
 CROW INDIANS HUNTING ELK*
 SIGN TALK (bronze)
p. [4]: [A] DESPERATE STAND
 THE BUCKER AND THE BUCKEROO, i.e., THE
 WEAVER (bronze)
 MEDICINE MAN #2
 A PITCHER
p. [5]: TIGHT DALLY AND (A) LOOSE LATIGO
 INDIAN FIGHT, i.e., THE MAKING OF A WARRIOR
 BEFORE THE WHITE MAN CAME #2
 [THE] SLED MAN (bronze)
p. [6]: PABLO BUFFALO HUNT*
 AN EVENING WITH OLD NIS SU KAL (i.e., KAI)
 YO
 ROPING AT RYAN BUTTE*
 THE BONE GAME
p. [7]: THE GREAT GAME FOR THE RULERSHIP OF THE
 WORLD
 FROM THIS DAY FORTH
 AN AWKWARD SITUATION (bronze)
 PRELIMINARY WASH DRAWING*

p. [8]: LONE WOLF* (color)
p. [9]: WHEN (i.e., WHERE) GREAT HERDS COME TO
 DRINK (color)
p. [10]: THE ALARM
 HAVE SOM BOILED BEEF
 ONE DOWN, TWO TO GO
 THE SNAKE PRIEST (bronze)
p. [11]: THE BATTLE BETWEEN THE BLACKFEET AND
 [THE] PIEGANS
 THE MAN WHO PACKED THE FLINT ROCK, i.e.,
 MEN THAT PACKED THE FLINT LOCK
 PABLO-ALLARD BUFFALO DRIVE
 YOUNG-MAN INDIAN (bronze)
 OLD-MAN INDIAN (bronze)
p. [12]: PIEGAN BUFFALO HUNT
 MEAT FOR THE WAGONS
 LEWIS AND CLARK MEETING THE MANDANS
 HEAD OF AN INDIAN CHIEF*
p. [13]: THE SCOUT #4 (part)
 THE SLICK EAR
 NO KETCHUM
 GIT 'EM OUT OF THERE
p. [14]: WALKING TEEPEES
 BUFFALO HUNT #39, i.e., #2
 (A) PARTY OF SITTING BULL'S BRAVES GET (ON)
 OUR TRAIL
 THE PROSPECTOR (part)
 THE ENEMY'S COUNTRY
p. [15]: WHERE THE BEST OF RIDERS QUIT (bronze)
 HORSE AND STEER HEAD, i.e., JONES STEER HEAD
 (bronze) and JONES HORSE HEAD (bronze)
 THE MALAMUTE [sic] (bronze)
p. [16]: MEXICAN BUFFALO HUNTERS* (color)
inside b. cover: THE STAGE DRIVER (part)
 BUFFALOES*
b. cover: THE HOLD UP (color)

148. Charles M. Russell Centennial Exhibition 1864-1964. Hammer Galleries, 51 East 57th Street, New York 22, N.Y. Pp. 48, wrappers, size 8¼ × 10⅝. Front wrapper serves as title page. Summer, 1964.

cover: ON NEENAH (bronze)
p. 3: MEAT FOR WILD MEN (bronze)
p. 4: SIX REINS TO (i.e., FROM) KINGDOM COME
 (bronze)
 IT AIN'T (i.e., IT'S) NO LADY'S JOB (bronze)
p. 5: PAINTING THE TOWN (bronze)
 THE CRYER (bronze)
 COUNTING COUP (bronze)
p. 6: [THE] HORSE WRANGLER (bronze)
 DOUGLAS FAIRBANKS AS D'ARTAGNAN, i.e., FAIR-
 BANKS AS D'ARTAGNAN (bronze)
p. 7: WILL ROGERS (bronze)
 WHERE THE BEST OF RIDERS QUIT (bronze)

p. 43: THEY ACT LIKE THEY WERE RAISED ON GASILENE
MET QUITE A FIEW OF MY BUFFALO ROUND UP
ACQUAINTENCES*
I WAS AT THE WINNIPEG STAMPEDE
p. 44: WISHING YOU AND YOURS A HAPPY NEW YEAR
KANGAROO*
MRS DR ADINES AND I IN THE FOXTROT*
p. 46: BUFFALO SKETCH #1
BUFFALO SKETCH #2
BUFFALO SKETCH #3
BUFFALO SKETCH #4
p. 48: INDIANS CAMOUFLAGED WITH WOLF SKINS
A FLEEING INDIAN
BUFFALO LYING DOWN

149. Buffalo Bill Historical Center, Cody, Wyoming.
Pp. 28, wrappers, size 6 × 9, n.d. (1964).
p. [3]: THE STORY TELLER #1
p. [4]: INDIAN PORTRAIT*
p. [5]: RETURN OF THE WARRIORS
p. [17]: THE LAST OF 5000

150. Forty & Five: An exhibit of paintings of Indians
by Montana artists, past and present. Blackfeet
Agency, Bureau of Indian Affairs, Browning, Montana.
July 1, 1964.
p. [2]: ALL ABOUT OLD MAN'S FIRE THEY SAT

151. Exhibition of Western Paintings. Western En-
counter: The Artists' Record. Two centuries of meet-
ings between Old World and New. The Kennedy
Quarterly, Volume V, No. 1, October, 1964. Published
by Kennedy Galleries, Inc. (New York). Pp. 64,
wrappers, size 6 × 9. There was also a card announcing
the exhibition; see Section VIII-128.
cover: THE SIGNAL, i.e., INDIAN SIGNALING #1 (color)
p. 40: INDIAN WAR PARTY #2*
INDIAN SCOUT*
p. 42: PIEGAN INDIAN HEAD*
THE (i.e., A) BRONC TWISTER (bronze)

152. Yellowstone County Presents. Yellowstone Art
Center, October 18, 1964 through November 20, 1964.
Inaugural Exhibition. Pp. 8, size 7 × 10. Lists one
painting.

153. European and American Paintings From the
Collection of Mr. & Mrs. W. B. Davis. Oklahoma
Art Center, Oklahoma City, November 5-27, 1964.
Philbrook Art Center, Tulsa, Oklahoma, December
1-29, 1964. Pp. [16], wrappers, size 8⅜ × 11. Front
wrapper serves as title page.
p. [15]: BUFFALO HUNT #13*

154. Baker Collector Gallery, Winter, 1964. (Lubbock,
Texas). Pp. [32], size 5½ × 8½.
p. [20]: XT BAR LONGHORN (bronze)

155. The Pennsylvania State University College of
Arts and Architecture presents selected works from
The Rockwell Foundation "Artists of the American
Frontier." Folio, pp. [16], size 8½ × 11, n.p., n.d.
(University Park, Pa., February 21–March 31,
1965).
p. [10]: ONE DOWN (AND) TWO TO GO
p. [12]: LETTER TO FRIEND JESS*. See addendum 2, p. 307.
STOLEN HORSES #1

156. Exhibition. Sports in Art. Grand Central Art
Galleries, The Biltmore, 40 Vanderbilt Avenue, New
York 17, N.Y. March 16–April 3, 1965. Lists one
CMR painting.

157. The Bill Arnold Collection of the works of Charles
M. Russell. Country Store Gallery, 1304 Lavaca,
Austin, Texas. The Pemberton Press, 1965. Pp. [58],
wrappers, size 8¼ × 10⅞.
p. [14]: THROWN*
p. [16]: INDIAN STAFF AND BABY CARRIAGE*
p. [17]: COWBOY ON STEER*
BIRD ON LIMB*
p. [18]: TEXAS STEER (plaster replica)
p. [20]: SKULL OF BUFFALO, i.e., SKULL #3
p. [21]: SADDLE #2*
p. [22]: BRONC BUSTER, i.e., THE COWBOY ON A BUCKING
BRONCO (bronze)
p. [25]: DOE*
p. [29]: MULE DEER*
p. [30]: ALS dated May 10th, 1891
p. [31]: ALS dated Aug. 21, 1917
p. [32]: part of ALS
p. [34]: I BEAT YOU TO IT
p. [36]: part of autograph note
p. [44]: CMR and George Calvert (photo)
p. [45]: CMR (photo)
p. [47]: CMR and William S. Hart (photo)
p. [52]: CMR and friend (photo)
p. [53]: CMR (photo)
p. [54]: CMR (photo)
p. [55]: CMR (photo)
p. [56]: CMR Beating Himself (photo)
The pictures on pp. [14], [16], [17], [21], [25] and
[29] have been examined and authenticated only by
Frederic G. Renner.

158. Farewell to Adventure. Moments of Western
History preserved in Bronze and Paint. The Kennedy
Quarterly, Volume V, No. 3, II, May, 1965. Published

by Kennedy Galleries, Inc. (New York). Wrappers, pp. [64] ([193]–256), size 6 × 9.

cover: [THE] BUFFALO HUNT #7 (color)
p. 212: BLACKFOOT WAR DANCE, i.e., SCALP DANCE (bronze)
p. 214: NATURE'S CATTLE (bronze)
p. 216: THE SNAKE PRIEST (bronze)
p. 218: (THE) MOUNTAIN SHEEP #1 (bronze)
p. 220: THE SCALP DANCER (bronze)
p. 222: THE RANGE FATHER (bronze)
p. 240: THE NAVAJOS #1*
p. 242: SINGLE HANDED
p. 243: LONE HAND*
p. 244: THE GREAT SNAKE, i.e., THIS BIG SNAKE USED TO CRAWL UP A HIGH HILL AND WATCH THE MOON IN THE SKY
THE MAN ROLLING STONES, i.e., HE WENT UP ON THE STEEP HILLSIDE AND COMMENCED TO ROLL BIG ROCKS DOWN UPON HER LODGE
p. 246: INDIAN GIRL #2*
INDIANS ATTACKING A STAGE COACH, i.e., TWO RIFLE SHOTS CRACKED FROM THE THICKET

158a. There was a mailing card announcing the exhibition; see Section VIII-22.

159. Flathead Lake Galleries, P. O. Box 426, Bigfork, Montana 59911. O'Neil and Agnes Jones, Phone: 837-6633. Authentic Western Arts & Crafts, Indian Artifacts, Books, Antiques. (1965). Pp. [4], folio, size 5½ × 8½.

cover: ASSINIBOIN WAR PARTY* (color)

160. Inaugural Exhibition, June 25, 1965. The National Cowboy Hall of Fame and Western Heritage Center, Oklahoma City, Oklahoma, Representing The Seventeen Western States. Pp. 24, wrappers, size 7½ × 10½. Lists 37 items.
p. 8: THE FIRST WAGON TRACKS, i.e., FIRST WAGON TRAIL
p. 14: WORE SKINS AN' SMELT OF WILLOW BARK
BUFFALO GAVE MEAT, CLOTHES, AND A GOOD HOUSE*
GATHERED HAIR TO TRIM YOUR LEGGIONS*
A NEAT BRADE DOWN YOUR BACK*
p. 18: (THE) SURROUND

161. Exhibition. Paintings, Sculpture, Ethnology, Archeology. The Old West—As It Was. [11 lines] May 1st to October 1st, 1965. Whitney Gallery of Western Art, Buffalo Bill Historical Center, Cody, Wyoming. Pp. 16, wrappers, size 6⅞ × 9½. Lists 190 pieces.
p. 13: "ONE MORE WIPED OUT", i.e., BRIDGER'S MEN*
p. 15: "THE CAPTIVE BRIDE", i.e., ABDUCTION OF INDIAN MAIDEN*

162. "Antelope" by C M Russell. American Sculptor-Modeler, 1864–1926. Another most unique bronze from the original model. Offered by Trailside Galleries, Idaho Falls, Idaho & Jackson, Wyoming. Quarto, pp. [8], size 8⅝ × 11, peach stock, n.d. (1965).
p. [1]: ANTELOPE #1* (model)
p. [4]: ANTELOPE #1 (model)
p. [5]: AU WA COS*
p. [8]: GLACIER PARK GRIZZLY (bronze)
SITTING BEAR (bronze)
[THE] COWBOY ON A BUCKING BRONCHO (i.e., BRONCO) (bronze)
ANTELOPE* (bronze)
(THE) ARABIAN HORSE (bronze)
HOG ON THE HILL (bronze)

163. The Art of Living in the Early West. City National Bank. (Studio City, California). Folio, pp. [6], size 5 × 7, n.d. (1965). Lists 1 bronze and 2 paintings.

164. Charles M. Russell. The National Cowboy Hall of Fame and Western Heritage Center, 1700 N. E. 63rd., Oklahoma City, Okla. Pp. 20, wrappers, folio, size 8¼ × 11. (1965).
cover: [THE] RED MAN'S WIRELESS (color)
p. 3: Trail's End, C. M. Russell Studio in Pasadena, California (photo)
Interior of Russell's Studio, Great Falls, Montana (photo)
p. 5: BLACKFOOT WAR DANCE, i.e., SCALP DANCE (bronze)
WATCHER OF THE PLAINS (bronze)
COUNTING COUP (bronze)
p. 6: WHITETAILS #3
p. 7: Nancy and Charley (photo)
p. 8: THE COWBOY, i.e., IN FOR CHRISTMAS (part)
TOMMY SIMPSON'S COW
MILKING TIME
p. 9: INDIAN ATTACK ON STAGECOACH, i.e., STAGECOACH ATTACKED BY INDIANS
HAZING A STEER, i.e., COWBOY MOUNTED, DRIVING A STEER
ATTACKED BY INDIANS, i.e., THE BATTLE OF BEAR PAWS
pp. [10–11]: SMOKE TALK (color)
p. 12: HORSE HEAD, LEFT SIDE #1*
INDIAN ON BARE-BACKED HORSE*
MOUNTED FIGURE WITH RIFLE*
BUCK AND DOE*
SADDLE, HOG-NOSE TAPS*
THREE HORSES*
MOUNTED FIGURE, HORSE SADDLED*
MEXICAN ON A BURRO*
EAGLE*

p. 13: MOUNTED INDIAN WITH PIPE #1*
 MOUNTED INDIAN WITH PIPE #2*
 MOUNTED WHITE MAN WITH RIFLE*
 MOUNTED INDIAN WITH BOW*
 RUSSELL WITH SADDLED HORSE*
 Incomplete figure
 MOUNTED INDIAN, HEAD-ON VIEW*
 SQUAW ON MULE*
 COWBOY ON RUNNING HORSE*
 NIGH WHEELER*
p. 14: INDIAN WITH BEAVERS, i.e., "I AM SORRY
 FOR YOU", SAID THE WHITE BEAVER—
 CHIEF OF ALL THE BEAVERS IN THE WORLD
 BEFORE THE TRIAL*
p. 15: XMAS WHERE WOMEN ARE FEW (color)
p. 16: MEAT FOR WILD MEN (bronze)
 THE BUFFALO RUNNER, i.e., BUFFALO HUNT
 (bronze)
p. 17: [THE] RANGE FATHER (bronze)
 CHANGING OUTFITS (bronze)
 SECRETS OF THE NIGHT (bronze)
 THE BLUFFERS (bronze)
p. 19: INDIAN FAMILY [1] (bronze)
p. 20: Charles M. Russell (photo)
recto b. cover: A Few Words About Myself
 A BRONC TWISTER (bronze)
b. cover: IN [THE] WHITE MAN'S WORLD (bronze)

165. Baker Collector Gallery Presents Western Art A Collection of Outstanding Works by America's Foremost Portrayers of the West Past and Present. December, 1965. Brochure, folded twice to $5\frac{3}{4} \times 8\frac{3}{4}$, pp. [6].
p. [2]: WILL ROGERS (bronze)

166. Chicago Art Galleries takes great pride in presenting the most outstanding sale by auction of the year, Tuesday, October 12th. [12 lines] Chicago Art Galleries, Inc. Pp. [4], folio, size 9×11, n.d. (1965).
p. [4]: THE SIOUX (bronze)

167. Woolaroc Museum by Ke Mo Ha. Ke Mo Ha is the Indian name of Patrick Patterson, Museum Director. Pp. 64, wrappers, also an issue in hard covers, size $8\frac{1}{2} \times 11$ (1965). Front wrapper serves as title page.
p. 27: FLYING HOOFS (color)
p. [42]: COWBOY ROPING A STEER, i.e., THE BOLTER #3
 (color)
p. 43: WILL ROGERS (bronze)
 SMOKING (EM) UP (bronze)
p. 51: THE BUFFALO HUNT, i.e., WHEN BUFFALO WERE
 PLENTIFUL (color)
 RETURN FROM THE HUNT (color)
 (THE) STAGE COACH ATTACK (color)

168. Nancy's Hikin' Stick "Si Pis To" Owl Another most unique bronze From an original C. M. Russell model Offered by Trailside Galleries, Idaho Falls, Idaho & Jackson, Wyoming. (1965). Pp. [8], size $8\frac{1}{2} \times 11$, quarto.
p. [1]: "SI PIS TO" OWL* (bronze)
p. [4]: photo of CMR and Nancy
p. [5]: STUDY OF A BUFFALO SKULL
p. [8]: GLACIER PARK GRIZZLY (bronze)
 [THE] COWBOY ON A BUCKING BRONCHO (i.e.,
 BRONCO) (bronze)
 HOG ON THE HILL (bronze)
 SITTING BEAR (bronze)
 (THE) ARABIAN HORSE (bronze)
 ANTELOPE (bronze)
 "SI PIS TO" OWL (bronze)

169. Yellowstone Art Center Newsletter. Billings, Montana, January 1966. Single sheet, size $8\frac{1}{2} \times 11$.
p. 3: THE SCOUT #4
 THE TRAPPER
 THE POST TRADER
 THE ROAD AGENT
Insert, photo of CMR

170. Stone Galleries, Inc. 105 Amherst, Southeast, Albuquerque, New Mexico. Sunday, the sixth of February (1966). Pp. [4], size $4\frac{1}{2} \times 6$, tan stock.
PIEGAN SQUAW (bronze) on cover.

171. Baker Collector Gallery. N.d., n.p. (1966, Lubbock, Texas). Pp. [32], size $5\frac{1}{2} \times 8\frac{1}{2}$.
p. [1]: WILL ROGERS (bronze)
p. [21]: WILL ROGERS (bronze)
 XT BAR LONGHORN (bronze)
p. [30]: TOLL COLLECTORS

172. A group of Charles M. Russell bronzes and contempory paintings by Byron Wolfe are featured in the special exhibit Art of the American West, May 5–31, 1966, at the St. Louis Public Library, 1301 Olive St., Main Entrance Lobby. Pp. [4], size 9×4, brown stock.
P. [1]: GOING GRIZZLY, i.e., GRIZZLY BEAR (bronze)

173. Special Exhibition of Paintings, Drawings and Sculpture by Charles Marion Russell (from the collection of Mr. and Mrs. F. G. Renner). Potomac Corral of The Westerners, Powell Auditorium, Cosmos Club, Washington, D.C. May 25, 1966. Pp. [4], size 5×8. Lists 44 items. THE TRAIL BOSS (part) on front.

174. 'The Wild Riders and the Vacant Land' A Century of Western Paintings: from Peter Rindisbacher to the Taos School. The Kennedy Quarterly,

Vol. VI, No. 2, June, 1966. Published by Kennedy Galleries, Inc. 20 East 56th Street, New York. Pp. [64], i.e., [64]–128, wrappers, size 6 × 9.

p. 106: ROPING A WHITE WOLF, i.e., ROPING A (WHITE) BUFFALO WOLF

THE SCALP LOCK*

175. Exhibition. Paintings, Sculpture, Ethnology, Archeology. The Old West—as it was. [11 lines] May 1st to October 1st, 1966. Whitney Gallery of Western Art, Cody, Wyoming. Pp. 16, size 7 × 9½, wrappers.

verso front wrap.: "HOW"

p. 9: "INDIAN WOMEN MOVING CAMP"*

176. The Western Frontier sponsored by the Assistance League of Denver and The Denver Art Museum. July 28 through October 9, 1966. Pp. [20], folio, size 6 × 9, wrappers.

p. [39]: PAINTING THE TOWN (bronze)

IN WITHOUT KNOCKING

177. Charles M. Russell. Paintings, Drawings, and Sculpture in the Amon G. Carter Collection. A descriptive catalogue by Frederic G. Renner. Foreword by Ruth Carter Johnson. Published for the Amon Carter Museum of Western Art, Fort Worth, by the University of Texas Press, Austin and London, (1966). Pp. xvi + 148 + 68 unnumbered pages, including therein 35 full-color plates. Size 11 × 11½.

d/w: WHEN HORSEFLESH COMES HIGH (color)

front.: CHARLIE HIMSELF, i.e., CHARLES M. RUSSELL (CARICATURE STATUETTE) (color)

fol. p. 8: BREAKING CAMP [#1] (color)

p. 19: ROPING 'EM*

p. 20: SHOOTING A SPY

A VIEW OF THE BADLANDS, i.e., A VIEW IN THE "BAD LANDS"

fol. p. 20: CROW INDIANS HUNTING ELK (color)

COWBOY CAMP DURING THE ROUNDUP (color)

p. 21: CLOSE QUARTERS

p. 22: THE STAND

CROSSING THE MISSOURI [#1]

p. 23: BRONCHO BUSTING

DRIVING IN

COW PUNCHER

p. 24: WILD MEAT FOR WILD MEN

p. 25: INDIANS HAILING IMMIGRANTS*

THE LAST OF THE BUFFALO

p. 26: BRONCO BUSTER [#1]

fol. p. 26: LOST IN A SNOW STORM—WE ARE FRIENDS (color)

THE SILK ROBE (color)

p. 27: DUEL TO THE DEATH*

p. 28: BRINGING HOME THE MEAT, i.e., BRINGING HOME THE KILL

p. 29: MEAT FOR THE TRIBE

p. 30: SHOOTING THE BUFFALO

p. 31: FOLLOWING THE BUFFALO RUN*

p. 32: BRAVE, i.e., ON THE WARPATH #1

fol. p. 32: COUNCIL OF WAR (color)

FOR SUPREMACY (color)

p. 33: BUFFALO HUNTING*

p. 34: INDIANS ATTACKING*

p. 35: THE POSSE*

p. 36: BRONCO BUSTING*

p. 37: WAR COUNCIL*

p. 38: SMOKE SIGNAL [#2]

fol. p. 38: BESTED (color)

A DOUBTFUL GUEST (color)

p. 39: [THE] BUFFALO HUNT #15*

p. 40: INDIANS SIGHTING BUFFALO*

p. 41: AT THE SPRING*

p. [42]: APPROACH OF THE WHITE MEN*

APPROACH OF (THE) WHITE MEN

p. [43]: SQUAWS WITH TRAVOIS*

INDIAN WOMEN MOVING

p. 44: INDIAN FIGHT [#2]*

fol. p. 44: Nancy posing as Keeoma (photo)

KEEOMA [#1] (color)

BRONC IN COW CAMP, i.e., CHUCK WAGON ON THE RANGE (color)

p. 45: INTERCEPTED WAGON TRAIN

p. 46: INDIANS ON HORSEBACK [#3]*

p. 47: INDIAN MAIDEN*

p. 48: INDIAN SCOUTING PARTY [#2]*

p. 49: SUNRISE

p. 50: THE ATTACK [#2]*

fol. p. 50: A DESPERATE STAND (color)

CAUGHT NAPPING (color)

p. [51]: FOLLOWING THE BUFFALO RUNNERS*

SEEKING THE TRAIL

p. 52: LANDSCAPE [#1]*

p. 53: DEATH BATTLE OF BUFFALO AND GRIZZLY BEAR

p. 54: NATTUCE*

INDIAN CHIEF [#3]

p. 55: NAVAJO INDIAN HORSE THIEVES HOTLY PURSUED BY ROBBED MEXICANS

p. 56: DANGEROUS MOMENT, i.e., A MOMENT OF GREAT PERIL IN A COWBOY'S CAREER

fol. p. 56: THE HOLD UP (color)

THE BUFFALO HUNT #26 (color)

p. 57: ROPING A WOLF [#3]

p. 58: RETURN FROM THE HUNT, i.e., CHRISTMAS AT THE LINE CAMP

p. 59: THE PRIZE SHOT, i.e., CHRISTMAS DINNER FOR THE MEN ON THE TRAIL

177a. Limited edition. Same size and binding as trade edition, with facsimile of Russell's signature stamped in gold on cover, enclosed in slip case bearing WHEN HORSEFLESH COMES HIGH in color. Pp. xvi+148+72 unnumbered pages, including therein 36 full-color plates. The words "This special edition, to which has been added an extra color plate, has been limited to 250 copies, all numbered and signed by the author. This copy is No. ____" appear on the flyleaf preceding the frontispiece. Also accompanied by a folder containing an extra set of 35 of the color plates. See Section V. The extra color plate is:
fcg. p. 4: LASSOING A STEER

177b. There is also a presentation edition limited to 12 copies, identical with the trade edition except that in plate C-11 a photograph of the museum founder's daughter has been superimposed on the face of the Indian girl. This plate carries the added caption "She was only an Indian Princess, but she had her reservations."

178. American XIX–XX Century Paintings Drawings Sculptures Public Auction, Thursday, November 17. Parke-Bernet Galleries, Inc., 980 Madison Avenue, New York, 1966. Items 61–70 are Russell bronzes.
p. 24: (DOUGLAS) FAIRBANKS AS D'ARTAGNAN (bronze)
p. 25: PAINTING THE TOWN (bronze)

Periodicals

SECTION III

Periodicals

Adventure Magazine, 49:6 (November 30, 1924), 181
Letter to the editor from CMR

Agricultural History, 35:3 (July, 1961)
cover: PETE HAD A WINNING WAY WITH CATTLE
p. 154: DAY HERDERS, i.e., THE MOUNTAINS AND PLAINS
 SEEMED TO STIMULATE A MAN'S IMAGINATION
p. 156: COW CAMP IN WINTER, i.e., IN THE OLD DAYS
 THE COW RANCH WASN'T MUCH

Akron Topics, 5:55 (February, 1927), 16, 30
"Scattered Precincts," by Fred Ayer
p. 16: MEXICO*

Alberta Historical Review, 7:3 (Summer, 1959), cover
C. M. Russell at Calgary Stampede, 1919 (with Big
Belly and wife Maggie) (photo)

American Art News, 9:27 (April 15, 1911), 2
"West That Has Passed"
———, 10:22 (March 9, 1912), 2
"Russell and Schille at Folsom's"
———, 13:21 (February 27, 1915), 3
"In the Free Wild West"
THE DANGEROUS CRIPPLE, i.e., CRIPPLED BUT STILL
 COMING

American Art Student, 10 (October, 1926), 14
"Cowboy Artist Dead"

American Artist, 24:3 (March, 1960)
"Our Western Documentarians," by Harold
McCracken, 22–27, 64–67
p. 27: WHERE GREAT HERDS COME TO DRINK
 SELF-PORTRAIT #4
 WHEN LAW DULLS THE EDGE OF CHANCE

———, 25:11 (November, 1961), 14
A RUSSELL BUFFALO (bronze)
———, 29:6 (June, 1965), 75–79
"A Portfolio of Animals in Art," with commentary
by the editors
p. 76: GREY EAGLE (bronze)
———, 30:9 (November, 1966), 26–29, 32–33, 65–66
"The Russell Gallery at Great Falls," by Jane
Meyer
p. 26: Four views of Russell studio (interior and ex-
 exterior) (photos)
p. 27: THE FIRE BOAT
 South end of C. M. Russell Gallery (photo)
p. 28: DANCER, i.e., STREET SCENE IN ARABIA
 WATER HOLE, i.e., DEER AT WATERHOLE
p. 29: Photo of CMR
p. 32: CHRISTMAS AT LINE CAMP
 GREETINGS, i.e., GALLANT LOVER
p. 33: OLD CHRISTMAS IN NEW ENGLAND
 CART DRIVEN BY A COB* (model)

American Book Collector, 6:5 (January, 1956), 24
"Western Book Roundup," by The Old Bookaroos
BUNCH OF RIDERS (part)
This CMR pen drawing has been adopted as the
"mark" of the Old Bookaroos and appears with their
"Western Book Roundup" column in most subsequent
issues of *The American Book Collector*.
———, 8:4 (December, 1957), 26–27
"Western Book Roundup," by The Old Bookaroos,
27–32.
"The West's Best" (review of *The Charles M. Russell
Book*)
p. 26: DOE AND FAWNS, i.e., FAWNS NUZZLING FOR
 DINNER

TIME TO TALK, i.e., THE MOUNTAINS AND PLAINS
 SEEMED TO STIMULATE A MAN'S IMAGINATION
SELF-PORTRAIT #8
PETE HAD A WINNING WAY WITH CATTLE
JIM BRIDGER DISCOVERING GREAT SALT LAKE, i.e.,
 BRIDGER DISCOVERS THE GREAT SALT LAKE
THE COWBOY #2
THEY'RE ALL PLUMB HOG WILD
GRABBIN' FOR GUMBO, i.e., ABOUT THE THIRD
 JUMP CON LOOSENS
p. 27: BUNCH OF RIDERS (part)
———, 12:3 (special number, November, 1961)
"American Bibliophiles V: Frederic G. Renner," by
Jeff C. Dykes, 5–8. "Charles Marion Russell: The
Man and His Work," by F. G. Renner, 10–14. "A
Charles M. Russell Portfolio" (by F. G. Renner),
15–28. "Since Yost—A Preliminary Bibliographic
Check-List, 1948–1961," by the Old Bookaroos,
29–37. "Russell Rarities," by F. G. Renner and Jeff C.
Dykes, 38–40.
cover: (THE) MEDICINE MAN #4
p. 6: THE TRAIL BOSS
p. [16]: PIONEER PROSPECTORS
p. [17]: BUFFALOES PAINTED ON SHOULDER BONE
p. [18]: (THE) BUFFALO HUNT #22
p. [19]: THE WAR PARTY #4*
p. [20]: CROW INDIANS ARRIVING AT FORT BENTON TO
 TRADE, i.e., EARLY LIFE IN MONTANA
p. [21]: CORRAL HUGGER*
p. [22]: A SHADOW RIDER
p. [23]: UTICA
p. [24]: DANCE! YOU SHORT-HORN DANCE!
p. [25]: (THE) BEAUTY PARLOR
p. [26]: BUCKING HORSE AND COWGIRL*
p. [27]: BUCKING HORSE AND COWBOY*
p. [28]: STOLEN HORSES #3
p. 30: PENDLETON COWGIRL
p. 34: C. M. Russell statue by Weaver (photo)
p. 45: BUNCH OF RIDERS (part)

American Cattle Producer, 21:5 (October, 1939), 3–5
"Our Heritage from the Vikings of the Range," by
Dan D. Casement
p. 4: MOST RECKLESS RIDERS THAT EVER STEPPED UP ON
 A HORSE*
———, 25:11 (April, 1944), 9–12
"The Rustler and the Johnson County War," by
John K. Standish
p. 9: RUSTLERS CAUGHT AT WORK
———, 27:1 (July, 1945), 8–9, 20–21
"Cattle in Montana," by Virgil V. Peterson
p. 8: ROPING A WOLF #2
 WOUND UP
p. 9: WAITING FOR A CHINOOK

p. 20: SMOKE OF A 45, i.e., FORTY-FIVE
 JERKED DOWN
p. 21: LAST CHANCE OR BUST
———, 28:12 (May, 1947), 13–16, 22
"Theodore Roosevelt, Cowman and Hunter," by John
K. Standish
p. 13: ROOSEVELT ON ELK HUNT, i.e., JACK GOES BACK
 BUT HE DON'T STAY LONG
———, 29:4 (September, 1947), 9–10
"Opoch [sic] of an Industry," by John K. Standish
p. 9: THE TRAIL BOSS, i.e., A TEXAS TRAIL HERD
———, 33:3 (August, 1951), 9–10
"The Great White Owls," by Toi Kerttulla
p. 9: WAITING FOR A CHINOOK
———, 39:8 (January, 1958), 36
"New York Collector Has Many Russell Works"
WAITING FOR A CHINOOK

American Gun, 1:1 (Winter, 1961), 16
WHEN BLACKFEET AND SIOUX MEET (color)

American Hereford Journal, 50:5 (July 1, 1959), [134]
THE LAST OF 5,000

American Heritage, 6:1 (December, 1954), 32–[42]
"Painters of the Plains," by Eugene Kingman
p. 40: TRAIL OF THE IRON HORSE #2 (color)
———, 6:5 (August, 1955), 109
"Seeing and Hearing History," by William G. Tyrrell
RIM-FIRE OR DOUBLE CINCH RIG
———, 9:5 (August, 1958), 83
BLACKFEET SQUAW AND PAPPOOSE (part)
———, 12:3 (April, 1961), 50–53, 74–77
"The Johnson County War," by Helena Huntington
Smith
pp. 50–51: STEVE MARSHLAND WAS HANGED BY
 VIGILANTES
pp. 52–53: RUSTLERS CAUGHT AT WORK
p. 75: I DON'T MISS NONE OF THEM BOULDERS
p. 76: THE COWBOY #2
p. 77: PETE HAD A WINNING WAY WITH CATTLE
———, 15:1 (December, 1963), [58]–60, 94–101
"I Gave Him Barks and Saltpeter," by Paul Russell
Cutright
p. [58]–59: LEWIS AND CLARK MEETING INDIANS AT
 ROSS' HOLE
b. cover: THE SLY INDIAN (model) (color)
———, 15:2 (February, 1964), [16]–[21]
"How the Indian Got the Horse," by Francis Haines
p. [20]: THE HORSE OF THE HUNTER, i.e., FIGHTING
 MEAT (color)
———, 16:2 (February, 1965), 93
AN (i.e., THE) INDIAN OF THE PLAINS AS HE WAS
HE'S JUST TOPPIN' THE HILL OUT OF MILES CITY WHEN HE
 RUNS DOWN A JACKRABBIT THAT GETS IN HIS WAY

American History Illustrated, 1:5 (August, 1966)
cover: THE STOIC OF THE PLAINS, i.e., MEDICINE MAN #4 (color)
p. 51: SALUTE TO THE FUR TRADERS, i.e., ADVANCE OF BLACKFEET TRADING PARTY
recto b. cover: Charles M. Russell at work in his studio, Great Falls, Montana (photo)

American Home, 64:2 (April, 1961), 13–14
CHANGING OUTFITS (bronze)

American Junior Red Cross Journal, 34:1 (October, 1957), 18–23
"Paris Gibson Junior High School, Great Falls, Montana," by Lois S. Johnson
p. 22: AH-WAH-COUS (part) (printed in reverse)

American Magazine, 68:5 (September, 1909), 485–492
"The Evolution of a Train Robber," by Edgar Beecher Bronson
p. 489: RIDING ONE DAY ACROSS THE PLAIN SOME DISTANCE FROM THE LINE OF FLIGHT NORTH FROM GAGE, WHITEHILL FOUND A FRAGMENT OF A KANSAS NEWSPAPER*
p. 491: CLEVELAND'S HORSE WAS KILLED BEFORE THEY GOT OUT OF TOWN*
———, 88:5 (November, 1919), 66
"A Great Painter of the Vanishing West," by Estelline Bennett
Charlie Russell And His Famous Bull Head Lodge (photo)

American Review of Reviews, 37:1 (January, 1908), 124
(review of *The Lure of the Dim Trails*)
COWBOY, MOUNTED, TWIRLING A ROPE

American Rifleman, 81:5 (May, 1933), 26
"Bausch & Lomb Gives New Rifle Trophy"
SMOKING UP (bronze)

American Scene, 1:1 (Spring, 1958)
cover: THE BEGGERS* [sic]
———, 1:3 (Fall, 1958), [2], [8]
"A Buffalo Hunt with the Grand Duke Alexis of Russia"
p. [2]: RUNNING BUFFALO
———, 2:4 (Winter, 1959–60), 5
DISCOVERY OF GOLD AT LAST CHANCE GULCH, i.e. PAY DIRT
———, 3:2 (Summer, 1960)
"The American Scene Presents the Works of C. M. Russell." "The World of Charlie Russell," by James Taylor Forrest. "The Art of Charles Russell," by J. Frank Dobie.

cover: THE (i.e. A) STRENUOUS LIFE (color)
p. 4: LEWIS AND CLARK EXPEDITION, i.e., LEWIS AND CLARK REACH SHOSHONE CAMP LED BY SACAJAWEA THE "BIRD WOMAN"
p. 5: [THE] SALUTE OF THE ROBE TRADE
p. 6: THE DISCOVERY OF LAST CHANCE GULCH, i.e., PAY DIRT
 RUNNING BUFFALO
p. 7: [THE] BUFFALO HUNT #29
p. 8: WHERE TRACKS SPELL MEAT
p. 9: JERKED DOWN
p. 10: THE CAMP COOK'S TROUBLE
p. 11: INNOCENT ALLIES
p. 12: CARSON'S MEN
 WHEN (i.e., WHERE) GUNS WERE THEIR PASSPORTS
 WAGON BOSS
p. 13: BEEF FOR THE FIGHTERS, i.e., MEAT MAKES FIGHTERS
 A DOUBTFUL HANDSHAKE
 INSIDE THE TEEPEE*
p. 14: ON THE FLATHEAD*
p. 15: WHEN SIOUX AND BLACKFEET MEET, i.e., RUNNING FIGHT
p. 16: THE GETAWAY, i.e., HIS HIND FEET CAUGHT THE TOP WIRE AND SNAPPED IT LIKE THREAD
p. 17: GUN POWDER AND ARROWS
p. 18: PARDNERS, i.e., HOOVERIZIN'
p. 19: THE LAST STAND
 POWDER RIVER LET 'ER BUCK, i.e., THE BUCKING BRONCO #1
p. 20: THE BEGGARS
p. 21: THE NIGHT HERDER, i.e., THE HORSE WRANGLER (bronze)
 SMOKING UP (bronze)
p. 22: BUFFALO RUNNER, i.e., BUFFALO HUNT (bronze)
p. 23: COUNTING COUP (bronze)
p. 24: THE SUNFISHER, i.e., THE WEAVER (bronze)
p. 25: MEDICINE MAN, i.e., MEDICINE WHIP (bronze)
p. 26: FRIEND YOUNG BOY (letter)
b. cover: WHEN GUNS SPEAK DEATH SETTLES DISPUTE(S) (color)
———, 3:4 (Winter, 1960–61), 10–12
"Father De Smet and the Flatheads"
p. 11: FATHER DE SMET'S FIRST MEETING WITH THE FLATHEADS*
———, 4:1 (Spring, 1961), 9
"A Rediscovered Russell," by Bruce Wear
THE LEAD ELK*
———, 4:4 ([Winter, 1961]–1962)
p. [13]: WILL ROGERS ON SOAPSUDS, i.e., WILL ROGERS (bronze)
p. 32: SECRETS OF THE NIGHT (bronze)

p. 28: WILL ROGERS (bronze)
 THE ATTACK, i.e., STAGE COACH ATTACKED
 BY INDIANS
 THE PONY EXPRESS RIDER, i.e., A PONY
 EXPRESS RIDER ATTACKED BY INDIANS
p. [29]: MOUNTAIN MOTHER (bronze)
————, 29:8 (August, 1953), 16–29
"Charles M. Russell, Friend of the Indian," by
Homer E. Britzman
cover: A NOBLEMAN OF THE PLAINS (color)
p. 16: Charles M. Russell (photo)
 THE MEDICINE MAN (bronze)
p. [17]: PIEGAN INDIAN #2* (color)
p. [18]: WHEN MEAT WAS PLENTIFUL, i.e., THE
 BUFFALO HUNT #35 (color)
p. [19]: IN THE ENEMY COUNTRY (color)
p. [20–21]: NAVAJO WILD HORSE HUNTERS (color)
p. [22]: THE MEDICINE MAN #1 (color)
p. [23]: MOURNING HER WARRIOR DEAD (color)
p. [24]: WHEN ARROWS SPELLED DEATH (color)
 SKULL #1
p. 25: Charlie Russell at an Indian Camp in
 Montana (photo)
p. 26: OFFERING TO THE SUN GODS (bronze)
 PIEGAN MAIDEN, i.e., PIEGAN SQUAW (bronze)
p. 27: HIS HEART SLEEPS #1
p. 28: Charlie Russell dressed as an Indian
 (photo)
 IN THE WHITE MAN'S WORLD* (bronze)
p. 29: MEAT FOR WILD MEN (bronze)
 THE ENEMY'S TRACKS (bronze)
————, 33:12 (December, 1957), [11]
 THE WORLD WAS ALL BEFORE THEM, i.e.,
 ROMANCE MAKERS (color)
————, 42:3 (March, 1966), 7
INDIAN GAME HUNT, i.e., BEFORE THE WHITE MAN
 CAME #2

Art Digest, 1:4 (December 15, 1926), 6
"Portrait of Charles M. Russell," by Arthur M. Hazard
————, 2:4 (Mid-November, 1927), 11
"Not Matisse or Picasso, Just C. M. Russell"
WHERE (i.e., WHEN) LAW DULLS THE EDGE OF CHANCE
————, 5:11 (March 1, 1931), 32
"Charles M. Russell's Statue"
————, 15:17 (June 1, 1941), 17
"Pays $40,000 for Cowboy Art"

Art in America, 46:4 (Winter, 1958–1959), 111
BUFFALO HUNT #8*
————, 47:3 (Fall, 1959), 60–63, 103
"Boom Interest in Western Art," by Henry J. Seldis
p. 63: THE SPIRIT OF WINTER (bronze)
p. 103: NAVAJO WILD HORSE HUNTERS

Art News, 25:4 (October 30, 1926), 8
Obituary of Charles M. Russell
————, 53:3 (May, 1954), 63
BUFFALO HUNT #22*

Artist, 27:1 (February, 1900), 241–245
"Ranche [sic] Life in America," by "A Full Hand"
supp.: GOING INTO CAMP*
p. 241: LOST IN A BLIZZARD, i.e., LOST IN A SNOWSTORM
 —"WE ARE FRIENDS"
p. 242: INDIAN HORSE THIEVES, i.e., EARLY MONTANA—
 INDIANS RUNNING OFF HORSES
p. 243: SHOOTING A SPY*
p. 244: A SIGNAL OF PEACE*
 INDIAN HORSE THIEVES*
p. 245: INDIAN BOY*

Arts & Antiques, 1:7 (May–June, 1966), 18
BLACKFOOT WAR CHIEF (bronze)

Atlantic Monthly, 94:565 (November, 1904), ads 20
AS QUICKLY THE HORSE TOOK FRIGHT
BROUGHT HER FACE TO FACE WITH LONG BILL AND SHORTY
 SMITH
DRAGGED THE HEAVY BODY UP TOWARD THE SHELTER OF
 ROCKS
HARRIS AND HIS FRIENDS
"IT IS GOOD, JUST AS I THOUGHT, AND AS COLD AS ICE,"
 HE SAID
NEARLY UNSEATING THE OLD COWPUNCHER IN HER
 DEMONSTRATIONS OF WELCOME
OLD PETER . . . ROLLED OVER IN A CONVULSED HEAP
ON HER FACE WAS THE SNARL OF A DOG
See Plate 20 for illustration.
————, 181:1 (January, 1948), 118
"Peripatetic Reviewer," by Edward Weeks
————, 202:1 (July, 1958), 50
SINGLE HANDED (part)

Bar North, 9:3 (June, 1961), cover
(organ of North Dakota Stockmen's Association)
THE TRAIL BOSS

Baton Magazine (August–September, 1932), 19–20
"Charles M. Russell an Appreciation," by Patricia
Dutcher

Beacon, 15:11 (November, 1950), cover, 1
(house organ of Ohio Oil Co.)
DEAD LINE ON THE RANGE, i.e., TOLL COLLECTORS
————, 17:1 (January, 1952), cover, [1]
(THE) INDIAN HUNTER'S (i.e., HUNTERS') RETURN
 (color)

———, 17:7 (July, 1952)
COVER: LAUGH KILLS LONESOME (color)
 THE ODDS LOOKED ABOUT EVEN
 THE MOUNTAINS AND PLAINS SEEMED TO STIMU-
 LATE A MAN'S IMAGINATION (printed in
 reverse)
p. 1: COWBOY SEATED, HORSE NUZZLING HIS LEFT HAND
———, 21:6 (June, 1956), cover, [1]
MEN OF THE OPEN RANGE (color)
p. [1]: Charles M. Russell (photo)

Bellman, 26:669 (May 10, 1919), 514–521
"Russell the Western Painter," by Estelline Bennett
p. 514: THE RED MAN'S WIRELESS
 The studio in Great Falls (photo)
p. 515: Charles M. Russell (photo)
p. 516: Mr. Russell's cabin at Lake McDonald (photo)
 ROPING BIG GAME, i.e., LOOPS AND SWIFT
 HORSES ARE SURER THAN LEAD
p. 517: THE PRICE OF HIS ROBE (i.e., HIDE)*
p. 519: THE INTERVENTION OF THE LAW, i.e., WHEN LAW
 DULLS THE EDGE OF CHANCE
p. 521: WHEN SHADOWS HINT DEATH

Bit and Spur, 8:7 (June, 1947), 8
"In memory of Charles Russell, Montana's Artist and Author"
The Horse that Carried Charlie Russell's Empty Saddle (photo)
———, 12:6 (May, 1951), 14–15
"Charlie and his 'Hoss Friends,'" by Pat M. Morris
p. 14: Charles M. Russell at work in his studio (photo)
p. 15: Russell Memorial Studio (photo)

Book Club of California Quarterly Newsletter, 12:3 (Summer, 1947), 48–50
"Why I Collect and Enjoy the Work of Charles Russell" by Earl C. Adams

Book-Lover, 5:6 (June, 1904)
Advertisement for *Leslie's Weekly*
NAVAJO INDIAN HORSE THIEVES HOTLY PURSUED BY ROBBED MEXICANS

Bootprints, 1:4 (November, 1921), 6–16
(house organ of H. J. Justin & Sons)
p. 6: "Charley Russell Cowboy and World-Famed Artist"
p. 7: "To Charley Russell," by Ritch of Lewiston, Mont.
pp. 8–9: I RODE HIM
pp. 10–13: "Charley Russell, the Greatest Cowboy Artist on Earth, Tells of His Cowboy Life"

p. 14: "Russell's First Picture, 'The Last of 5000'"
p. 15: THE LAST OF 5,000, i.e., WAITING FOR A CHINOOK
p. 16: "When Starting a Picture Russell Goes Into a 'Great Silence'"

Brand Book, 8:11 (November, 1952), [3–7]
Denver Corral of the Westerners
"An approach to an understanding of the philosophy of Charles M. Russell," by H. E. Britzman

Branding Iron, 2:3 (September, 1948)
Los Angeles Corral of Westerners
"A letter from Will Crawford to Charlie Russell," notes by H. E. Britzman
———, 10 (June, 1950), 5
Los Angeles Corral of Westerners
"Russell's Last Photo," by H. C. Ecklund
———, 66 (September, 1963)
Los Angeles Corral of Westerners
p. 7: Charles M. Russell (photo)
p. 9: two letters to Charles F. Lummis

Business Week, No. 488 (January 7, 1939), 43
"Old West"

California Graphic, 1:20 (May 17, 1924), 7
"Painter Perpetuates Scenes in Making of the West"
THE HORSE WRANGLER* (bronze)
WHERE THE BEST OF RIDERS QUIT* (bronze)

C. M. Russell Gallery Newsletter, 1:0 (December, 1965)
Devoted entirely to CMR and gallery activities

Canadian Cattlemen, 9:2 (September, 1946), 92–93, 101
"Charles M. Russell, The Cowboy Artist, 1864–1926," by J. O. G. Sanderson

p. 92: Charles M. Russell (photo)
 Charlie Russell with a group of Oldtimers at the 1912 Calgary Stampede (photo)
p. 101: Will Rogers with Charlie Russell (photo)
———, 13:1 (January, 1950), 11, 26
"The Old West Lives Through Russell's Brush," by Wm. Bleasdell Cameron, Meadow Lake, Sask.
p. 11: WAITING FOR A CHINOOK
 Russell's home at Cascade (photo)
 CMR, Nancy and horse Monte (photo)
———, 13:2 (February, 1950), 26–27, 34
"Russell's Oils Eye-Opener to the East," by Wm. Bleasdell Cameron

————, 13:3 (March, 1950), 5, 8–9
"Russell's Great Gift of Humor," by Wm. Bleasdell Cameron
p. 8: Charles Marion Russell, the artist, about 1896 (photo)
————, 13:4 (April, 1950), 10, 43, 46–47
"Charlie Russell Comes Home," by Wm. Bleasdell Cameron

Canadian Magazine, 34:1 (November, 1909), 25–34
"The Last Great Round-Up," by Newton Mactavish

Cattleman, 28:8 (January, 1942), 13–15
"The American Buffalo," by A. M. Hartung
p. 12: THE BUFFALO HUNT #35
p. 13: INDIANS HUNTING BUFFALO ON THE GREAT PLAINS WITH BOW AND ARROW, i.e., THE BUFFALO HUNT #28
————, 29:5 (October, 1942), 40
"There was Little Comfort in Early-Day Travel"
BREAKING CAMP #3
————, 30:5 (October, 1943), 34–37
"Charles Russell Famous Cowboy Artist of Montana," by A. M. Hartung
p. 34: BAD HOSS, i.e., THE BUCKING BRONCO #1
 ROPING A BEAR, i.e., ROPING A RUSTLER
 BLACKFEET BURNING (THE) CROW BUFFALO RANGE
 THE TRAIL BOSS
 ROPING A WOLF #2
 WOUND UP
p. 35: Charles M. Russell (photo)
 THE LAST OF 5,000, i.e., WAITING FOR A CHINOOK
————, 33:6 (November, 1946), 12
(THE) BUFFALO HUNT (bronze)
————, 34:8 (January, 1948), cover, 11
THE ROUNDUP #2* (color); same, black and white, p. 11
————, 34:9 (February, 1948), cover, 9
THE KING'S SCOUT (color); same, black and white, p. 9
————, 34:10 (March, 1948), cover, 9
THE TOLL COLLECTOR, i.e., TOLL COLLECTORS (color); same, black and white, p. 9
————, 34:12 (May, 1948), cover, 7
INDIAN CAMP #2* (color); same, black and white, p. 7
————, 35:1 (June, 1948), cover, 7
LAUGH KILLS LONESOME (color); same, black and white, p. 7
————, 35:5 (October, 1948), cover, 9
SCATTERING OF THE RIDERS, i.e., MEN OF THE OPEN RANGE (color); same, black and white, p. 9
————, 35:6 (November, 1948), cover, 7
INDIANS DISCOVERING LEWIS AND CLARK* (color); same, black and white, p. 7

————, 35:7 (December, 1948), cover, 9
INDIAN HUNTERS' RETURN* (color); same, black and white, p. 9
————, 35:9 (February, 1949), cover, 9
INDIANS AND SCOUTS TALKING* (color); same, black and white, p. 9
————, 35:10 (March, 1949), cover, 33–36
"Charles M. Russell," by Helen Raynor Mackay
cover: CHARLES M. RUSSELL AND HIS FRIENDS (color)
p. 33: Charles M. Russell, from a pencil sketch by a friend, Emil Pollak Ottendorff
p. 34: THE MOUNTAINS AND PLAINS SEEMED TO STIMULATE A MAN'S IMAGINATION
 RAWHIDE RAWLINS, MOUNTED
 COMING TO CAMP AT THE MOUTH OF SUN RIVER
p. 35: LIKE A FLASH THEY TURNED
 COWBOY SEATED, HORSE NUZZLING HIS LEFT HAND
 THE ODDS LOOKED ABOUT EVEN
p. 36: THE WOLFER
 THE ROAD AGENT
 THE TRAPPER
 THE SCOUT #4
 FROM THE SOUTHWEST COMES SPANISH AN' MEXICAN TRADERS
————, 35:11 (April, 1949), (cover)
PORTRAIT OF AN INDIAN* (color)
————, 36:4 (September, 1949), cover
WHEN HORSES TALK WAR THERE'S SMALL CHANCE FOR PEACE* (color)
————, 36:9 (February, 1950), cover
THE SURPRISE ATTACK* (color)
————, 39:5 (October, 1952), cover
THE WAR PARTY #3 (color)
————, 39:7 (December, 1952), 89
BRONC TO BREAKFAST
RANGE MOTHER
————, 39:9 (February, 1953), cover
THE SCOUTS #5*
————, 40:5 (October, 1953), 151
THE BUCKER*
————, 40:7 (December, 1953), 85
BRONC TO BREAKFAST
RANGE MOTHER
————, 40:9 (February, 1954), cover
THE OPEN RANGE—OLD-TIME COWMAN, i.e., RAWHIDE RAWLINS, MOUNTED
————, 40:11 (April, 1954), cover
PRAIRIE PIRATES* (color)
————, 41:2 (July, 1954), cover
BUFFALO HUNT #21* (color)
————, 41:6 (November, 1954), cover
COWBOY SEATED, HORSE NUZZLING HIS LEFT HAND

————, 41:9 (February, 1955), cover
THE MOUNTAINS AND PLAINS SEEMED TO STIMULATE A MAN'S IMAGINATION
————, 41:10 (March, 1955), 167
Photo of cattlemen with ROPING A WOLF #6* and NAVAJO TRACKERS* in background
————, 42:1 (June, 1955), 137
THE ROUNDUP #2
————, 42:4 (September, 1955), 137
BRONC TO BREAKFAST
RANGE MOTHER
————, 42:6 (November, 1955), cover
THE BUFFALO HUNT #10* (color)
————, 42:7 (December, 1955), 137
THE ROUNDUP #2
————, 42:11 (April, 1956), cover
WE AIN'T GONE FIVE MILE WHEN THE COACH STOPS
————, 43:9 (February, 1957), cover
FLYING HOOFS (color)
————, 43:11 (April, 1957), cover
WAGON BOSS (color)
————, 44:6 (November, 1957), cover
WHEN GUNS SPEAK DEATH SETTLES DISPUTE* (color)
————, 44:8 (January, 1958), cover
THE (i.e. A) STRENUOUS LIFE (color)
————, 46:9 (February, 1960), cover
THE INNOCENT ALLIES (color)
————, 47:6 (November, 1960), cover
A BAD ONE (color)
————, 48:4 (September, 1961), 130
"Giant Sized Full Colored Lithographs of Charles M. Russell's World Famous Paintings," advertisement of *Horse Lover's Magazine.*
CHARLIE (i.e., CHARLES M.) RUSSELL AND HIS FRIENDS
MEN OF THE OPEN RANGE
THE HERD QUITTER
THE ROUNDUP #2 (part)
p. 131: WHEN COWS WERE WILD
 (THE) TOLL COLLECTORS
 WATCHING THE SETTLERS
 INDIANS DISCOVERING LEWIS AND CLARK
p. 135: WHEN HORSES TALK WAR THERE IS SLIM CHANCE
 FOR PEACE, i.e., WHEN HORSES TALK WAR
 THERE'S SMALL CHANCE FOR PEACE
p. 144: (THE) WILD HORSE HUNTERS #2
————, 48:6 (November, 1961), 129
BRONC TO BREAKFAST
RANGE MOTHER
————, 49:4 (September, 1962), 46, 78–79
"When the Indian Got the Horse," by Raymond Scheussler
cover: PARDNERS, i.e., HOOVERIZIN'

p. 46: THE FORT AT THREE FORKS
 INDIANS MEET FIRST WAGON TRAIN WEST OF
 MISSISSIPPI
p. 167: BRONC TO BREAKFAST
 RANGE MOTHER
————, 49:9 (February, 1963), cover
Charles M. Russell (painting by Olaf Seltzer)

Chronicle of the Horse, 25:10 (Nov. 3, 1961), cover
ROPING THE COYOTE, i.e., ROPING A WOLF #3*

Colliers, 62:13 (December 19, 1908), 18–19, 22
"Wild West Faking," by Emerson Hough (critical of "Brooklyn-style" western literature and art, including that of Remington, as contrasted with that of C. M. Russell—"who can draw a cow-puncher swimming naked in a lake, that any Western man can recognize at a glance").
————, 122:3 (July 17, 1948), 49
Pictorial map with reference to studio of CMR

Congressional Record, 104:28 (February 24, 1958), A1693–5
"Art, The Old West, and Montana's Cowboy Artist, Charles M. Russell," by Hon. LeRoy H. Anderson
————, 107:2 (February 22, 1961), 2530
"The Range Conservation Stamp and Charlie Russell," by Senator Mansfield

Connoisseur, 147:594 (June, 1961), LXXI
THE GRUB STAKE (bronze)
————, 153:616 (June, 1963), CXXVI
THE BUCKER AND THE BUCKEROO, i.e., THE WEAVER (bronze)
————, 153:618 (August, 1963), 39
WHERE THE BEST OF RIDERS QUIT (bronze)

Corral Dust, Potomac Corral of the Westerners. All issues since Vol. 1, No. 1 (March, 1956), have SKULL #4* on the masthead.
————, 1:3 (September, 1956), [17]–21
"Charles Marion Russell—The Man and His Work," by F. G. Renner
————, 5:1 (March, 1960), 4–5
"A New Russell Comes to Light," by William Gardner Bell
THE COWBOY #1*
————, 9:1 (Winter, 1964), 4
WHERE GREAT HERDS COME TO DRINK

Country Life, 50:4 (August, 1926), 35–40
"The Man Behind the Brush," by Frank M. Chapman, Jr.
p. 34: JERKED DOWN (color)

p. 35: Charles M. Russell, portrait by A. M. Hazard (photo)

p. 36: THE WATER HOLE, i.e., TRACKS TELL TALES THAT RIVERS MAKE SECRETS*

p. 37: RETURNING FROM THE WAR PATH, i.e., THE ENEMY'S TRACKS* (bronze)

THE BRONCO BUSTER, i.e., WHERE THE BEST OF RIDERS QUIT (bronze)

A MIGHTY HUNTER, i.e., BUFFALO HUNT (bronze)

p. 38: LAUGH KILLS LONESOME* (color)

p. 39: THE FRIVOLOUS CUBS, i.e., MOUNTAIN MOTHER* (bronze)

TRYING CONCLUSIONS, i.e., THE BLUFFERS* (bronze)

p. 40: RIDERS OF THE OPEN RANGE, i.e., MEN OF THE OPEN RANGE

——, 51:4 (February, 1927), front.

TAKING TOLL, i.e., TOLL COLLECTORS (color)

——, 55:2 (December, 1928), 65–66

"A Savage Santa Claus," by Charles M. Russell

p. 65: IT LOOKS LIKE THE SNOW-MAKER'S BEEN HOLDIN' BACK, i.e., HIS WHINNER CAUSES ME TO RAISE MY HEAD (printed in reverse)

p. 66: I'M PLENTY SURPRISED TO SEE AN OLD LOG SHACK, i.e., IN THE OLD DAYS THE COW RANCH WASN'T MUCH

MR. BEAR STRAIGHTENS UP, i.e., THE BEAR'S COMIN' AT US MIGHTY WARLIKE

Cow Bell, 4:3 (March 1, 1915), 2–3
(Chicago Palette & Chisel Club)

p. 2: BEST WHISHES TO THE P–C BUNCH*

p. 3: Caricature of CMR by Dick Brown

Cow Country, 1:2 (June, 1919), 1, 3, 8, 9, 10, 12, 13, 14, 16

Pen sketch on each page. Not seen.

Dun's Review, 58:2261 (January, 1950), cover
MEAT FOR WILD MEN, i.e., SURROUND

Eagle, 36:8 (August, 1948), 16
Photo CMR and references

El Palacio, 7:7–8 (July, 1920), 236
(Journal of the Museum of New Mexico, the School of American Research, the Archaeological Society of New Mexico, and Santa Fe Society of the Archaeological Institute)
LOOPS AND SWIFT HORSES ARE SURER THAN LEAD

Elks Magazine, 38:11 (April, 1960), 44
THE EXALTED RULER

English Westerners Brand Book, 3:4 (February, 1957)
p. 12: WHERE THE LASSO TRAVELS FREE (printed in reverse)

——, 3:5 (March, 1957)

p. [3]: RUNNING BUFFALO

p. [14]: WHERE THE LASSO TRAVELS FREE

——, 3:9 (July, 1957)

p. 7: WHERE THE LASSO TRAVELS FREE

——, 3:10 (August, 1957)

p. [8]: WHERE THE LASSO TRAVELS FREE

——, 3:12 (October, 1957)

p. [7]: WHERE THE LASSO TRAVELS FREE

Ethyl News (November–December, 1960), cover, 21
(house organ Ethyl Corporation)
THE STAGECOACH ATTACK (color)
THE BUFFALO HUNT, i.e., WHEN BUFFALO WERE PLENTIFUL

Farm Journal, 84:7 (July, 1965), ads
INTRUDERS (color)
[THE] SURPRISE ATTACK (color)
WHEN COWS WERE WILD (color)

Farm Quarterly, 13:3 (Autumn, 1958)
"C. M. Russell," by George Laycock, 52–54, 80–81

p. 52: I'M SCAREDER OF HIM THAN I AM OF THE INJUNS (part)

pp. [53–54]: THE ROUNDUP #2 (color)
WHEN HORSES TALK WAR THERE'S SMALL CHANCE FOR PEACE (part) (color)

p. [55]: C. M. Russell (photo)
WAITING FOR A CHINOOK

Federal Illustrator, 9:4 (winter number, 1926–1927) 2, 20–23

p. 2: JERKED DOWN

pp. 20–23: "The Helpfulness of Charles M. Russell," by Friends Who Knew Him Best. Will James, Joe DeYong and others.

Field and Stream, 3:1 (April, 1898)
front.: THE MAKING OF A WARRIOR*
p. 57: "Russell's frontispiece"

——, 3:2 (May, 1898)

front.: AN OLD TIME BUFFALO HUNT*
p. 95: THE SHAGGY HEAD CRUSHED INTO ME*

——, 3:3 (June, 1898)

front.: THE ATTACK ON THE PACK TRAIN*

——, 3:4 (July, 1898), xix ads

"Striking Pictures of Frontier Life," ad for prints, size 14 × 18

A SKIN HUNTER'S CAMP, i.e., THE OLD TRAPPER'S STORY

BEFORE THE WHITE MAN CAME #2
LEWIS AND CLARKE [sic] MEETING THE MANDANS
BATTLE BETWEEN CROWS AND BLACKFEET, i.e., THE
 MAKING OF A WARRIOR
————, 3:6 (October, 1898), 325
A FRIEND IN NEED IS A FRIEND INDEED*
————, 5:1 (January, 1900), 25
BEFORE THE WHITE MAN CAME #2
————, 5:4 (April, 1900), 213
IN OLDEN DAYS, i.e., THE SHAGGY HEAD CRUSHED INTO
 ME
————, 5:8 (September, 1900), 449, 451
"A Trapper's Yarn," by Jim Burk
A TRAPPER'S YARN*
WITH THE SMOKE STILL CURLIN' FROM HIS OLD FUSEE*
————, 5:12 (January, 1901)
p. 719: CAUGHT NAPPING*
p. 773: BEFORE THE WHITE MAN CAME #2
————, 12:10 (November, 1907), 641–644
"Camp Fires of an Epicure," by Warren H. Miller
AT THE TURN OF THE STREAM, i.e., CAUGHT NAPPING

Films in Review, 13:7 (August–September, 1962),
[401]–406
"The Wm. S. Hart Museum," by George J. Mitchell
p. 405: THE BUFFALO HUNT #14
 WILL ROGERS (bronze)

Fine Arts Journal, 16:2 (February, 1905), [71]–92
"A Group of Clever and Original Painters in Montana"
opp. p. [71]: TRAPPER'S [sic] LAST STAND*
p. 83: SQUAW OFFERING HER PAPOOSE TO THE SUN
 (model)
 BLACKFOOT WAR CHIEF (model)
 HIS WINTER'S STORE* (model)
 THE HUNTER'S RETURN* (model)
p. 84: Log Studio of C. M. Russell (photo)
p. 86: ROPING A GRIZZLY, i.e., ROPING A RUSTLER
p. 87: THE TENDERFOOT #2*
p. 89: COUNTING COUP*
————, 18:6 (June, 1907), 122
Reprint of article in the February, 1905, issue, with
same illustrations.

Ford Times, 57:11 (November, 1964), 22–25
(publication of Ford Motor Company)
"Cattlemen of Old Texas," by J. Frank Dobie
p. 24: THE MIXUP (color)
p. 52: THE BRONC BUSTER, i.e., A BRONC TWISTER (bronze)

Flathead, 1957. Published by the Senior Class of Flat-
head County High School, Kalispell, Montana, 1957.
Vol. LI dedicated to Charles M. Russell, cowboy artist
and Frank B. Linderman, Indian legend story teller as a
tribute to their immortal contribution to Montana's
culture.
cover: BRAVE, i.e., PORTRAIT OF AN INDIAN (color)
p. [3]: INDIANS DISCOVERING LEWIS AND CLARK (color)

Fortune, 38:5 (November, 1948), 161
THE BUFFALO HUNT #26
THE JERK LINE
Ad for Bank Building and Equipment Corporation
showing interior of Great Falls National Bank.

Frank Leslie's Illustrated Newspaper, 68:1757 (May 18,
1889), 265
"Ranch Life in the Northwest—Bronco Ponies and
Their Uses—How They Are Trained and Broken."
Seven pen and ink sketches on one page, signed C. M.
Russell—J. H. Smith. These are adaptations. Editorial
note on the pictures on p. 259.

Frontier, 7:1 (November, 1926), [24]
(published by University of Montana at Missoula)
Note on Charlie Russell.
————, 9:3 (March, 1929), 226–230
"Buffalo in the Judith Basin, 1883," by Pat T. Tucker
p. 226: ROPING THE BUFFALO*

Frontier and Midland, 19:3 (Spring, 1939), 168–171
"Recollections of Charley Russell," by Frank B.
Linderman

Frontier Times, 33:2 (Spring, 1959), 16–18, 43, 59
"The Last Hunt," by Charles Cadieux
pp. 16–17: INDIAN HUNTERS' RETURN
p. [18]: THE BUFFALO HUNT, i.e., WHEN BUFFALO
 WERE PLENTIFUL
p. 59: BUNCH OF RIDERS (part)
 N.B. This sketch has been adopted as the
 "mark" of the "Old Bookaroos" and
 appears at the head of their book review
 column in subsequent issues.
————, 33:3 (Summer, 1959), 15, 34
"Incident on the Musselshell," by Len Turner
FREE TRAPPERS (in reverse) (part)
————, 34:1 (Winter, 1959–60), 59
THE JERKLINE
————, 35:3 (Summer, 1961), 38
Reference to Russell illustrations in *Free Grass to
Fences*, book review.
————, 37:1 (January, 1963), 46
"They Died on the Trail," by Lynn Stanley Garber
THE BROKEN ROPE
————, 37:2 (February–March, 1963), 45, 48
"Hazing the Wild Mustangs," by J. J. Ballard
WILD HORSE HUNTERS #2

———, 37:3 (April–May, 1963), 7
WILD HORSE HUNTERS #2
———, 37:4 (June–July, 1963), [5]
WILD HORSE HUNTERS #2
———, 38:1 (December [1963]–January, 1964), 20–22
"Child of the Open Range," by Mary Stuart Abbott
as told to 'Tana Mac'.
p. 20: CHARLES M. RUSSELL AND HIS FRIENDS
p. 22: THE TRAIL BOSS
———, 38:4 (June–July, 1964), 12–15, 52–56
"Two Giants in Western Art," by North D. Stark
p. 12: CMR and Olaf Seltzer (photo)
p. [14]: Russell in his studio (photo)
p. [15]: CMR painting WHEN THE LAND BELONGED TO
 GOD (photo)

Gilcrease Institute Newsletter, 5:3 (April 10, 1960)
[A] DOUBTFUL HANDSHAKE

Golden West, 1:3 (March, 1965)
COVER: INDIANS DISCOVERING LEWIS AND CLARK (color)
p. 67: INDIANS DISCOVERING LEWIS AND CLARK
 THE SURPRISE ATTACK (printed in reverse)
p. 71: THE SURPRISE ATTACK
p. 73: INDIANS DISCOVERING LEWIS AND CLARK
———, 2:5 (July, 1966), cover
TRAIL OF THE IRON HORSE #1 (color)

Hampton's Magazine, 26:6 (June, 1911), 775–776
"Charles M. Russell—Painter and Sculptor"
C. M. Russell, Cowboy Painter and Sculptor (photo)

Harper's Magazine, 197:1182 (November, 1948), 60
Reference to CMR by Bernard DeVoto

Harpers Weekly, 32:1638 (May 12, 1888), 340
CAUGHT IN THE ACT*

Hobbies, The Magazine for Collectors, 63:3 (May, 1958),
55
"Charles M. Russell, Cowboy Artist"
———, 64:6 (August, 1959), 24–25, 50
"The Old West is Back Home"
p. 25: The "Charles M. Russell Wing" of the Whitney
 Gallery (photo)

Holiday, 8:3 (September, 1950), 34–50, 91
"Montana," by A. B. Guthrie, Jr., mentions CMR
———, 39:5 (May, 1966), 133
JERKED DOWN (color)

Home Magazine, 1:2 (January, 1930), 60–61, 123
"She Had Faith in Her Husband," by Dorothy C.
Reid

p. 60: photos of Charles, Nancy and Jack Russell
p. 61: WHERE (i.e., WHEN) LAW DULLS THE EDGE OF
 CHANCE

Hoofs and Horns, 7:4 (October, 1937)
"Through Other Eyes," by Filomina Shafer
———, 32:6 (December, 1962), 8–9
"The Life of Charles Russell," by Beatrice Levin
THE ROUNDUP #2
THE SCOUT #4

Horse Lover Magazine, 15:3 (December, 1950), 26–27,
44
"Con Price Writes About His 'Buckaroo Days' in
Montana"
p. 26: THERE WAS A TWISTER AT HAVER
 Con Price and Charley Russell (photo)
———, 15:4 (January, 1951), 26, 42–43, 47, 49
"Con Price Writes About His 'Buckaroo Days' in
Montana"
p. 26: SERIOUS PREDICAMENT, i.e., RANGE MOTHER
p. 42: (A) BRONC TO BREAKFAST
 THE NAVAJOS #3
———, 15:5 (February–March, 1951), 46–47, 58
"Con Price Writes About His 'Buckaroo Days' in
Montana"
p. 46: A DANGEROUS CRIPPLE, i.e., CRIPPLED BUT STILL
 COMING
p. 47: Charles M. Russell (photo)
———, 15:6 (April–May, 1951), 32–33
"Con Price Writes About His 'Buckaroo Days' in
Montana"
———, 16:1 (June–July, 1951), 36, 65
"Dally or tie hard?," by Jordon E. Dunaway
p. 36: THE BOLTER #3
p. 44: FIRST WAGON TRAIL
———, 16:2 (August–September, 1951), 20–21, 49
"Throwing the Diamond Hitch"
p. 20: WHEN HORSES TURN BACK THERE'S DANGER AHEAD

Horse Lover's Magazine, 16:3 (October–November,
1951), 22, 23, 46–47
"On the Greatness of Charles M. Russell"
"'Buckaroo Days' in Montana," by Con Price
p. 22: Charles Russell in 1908 (photo)
p. 23: Con Price in 1908 (photo)
p. [67]: THE OUTLAW
———, 16:4 (December, 1951–January, 1952), 20–21,
46–47
"Con Price Writes About His 'Buckaroo Days' in
Montana"
"Don't Mess with a Grizzly," as told by Sam Stacey,
Joe Parrott and Pancho
p. [2]: THE OUTLAW

Horse Review, Christmas Number, (1889–1890)
"A Genius in Chaps"
LOST*
PEACE*
photo of CMR on a paint horse
Not seen.

House Beautiful, 105:8 (August, 1963), 69, 70
A BRONC TWISTER (bronze)

Humble Way, 1:2 (April, 1962)
(house organ of the Humble Oil Co.)
"Monarch of the Old West," 14–19
p. 16: INDIAN HUNTERS' RETURN (color)
pp. 16–17: (THE) BUFFALO HUNT #40 (color)
p. 19: THE WOLFER (part)
PABLO-ALLARD BUFFALO DRIVE* (color)

NO. 2533 MARCH 24, 1904 PRICE 10 CENTS

Leslie's WEEKLY

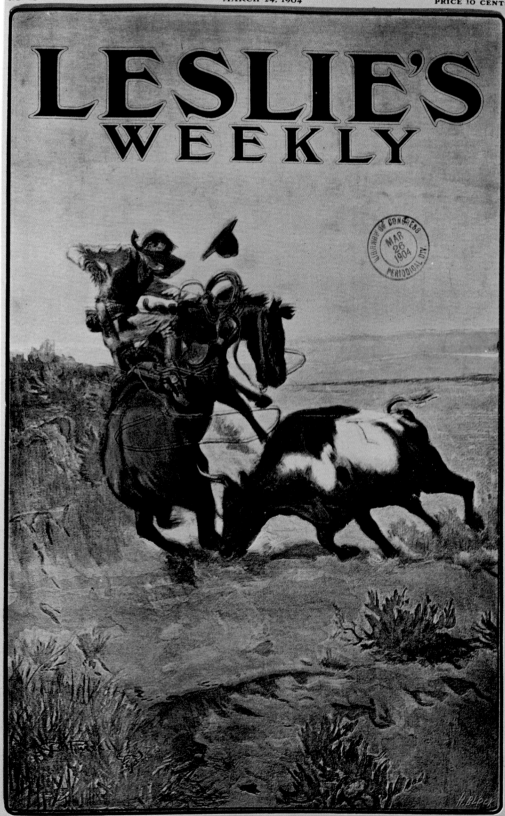

A Moment of Great Peril in a Cowboy's Career.

Drawn for "Leslie's Weekly" by Charles M. Russell, the famous "cowboy artist."

p. [77]: THE (i.e., A) STRENUOUS LIFE (color)

SMOKING UP (bronze)

THE CRYER (bronze)

BEFORE THE WHITE MAN CAME #3* (color)

A BAD ONE (color)

THE SUNFISHER, i.e., COUNTING COUP (bronze) (part)

———, 37:5 (August, 2, 1954)

p. 4: SMOKE TALK

p. 5: SMOKE TALK

———, 39:22 (November 28, 1955)

"The Fabulous Frontier" [74–87]

p. [86]: IN WITHOUT KNOCKING (color)

———, 46:18 (May 4, 1959)

"How the West was won: Part V" [74]–88

pp. [74–75]: TOLL COLLECTORS (color)

p. [82]: WHEN HORSES TALK WAR THERE'S SMALL CHANCE FOR PEACE (color)

IL BE THAIR WITH THE REST OF THE REPS (color)

p. [83]: LAUGH KILLS LONESOME (color)

pp. [84–85]: THE INNOCENT ALLIES (color)

WHEN GUNS SPEAK DEATH SETTLES DISPUTE (color)

Link, 21:6 (November–December, 1956), 3

(house organ of the Carter Oil Co.)

"Charlie Russell—The West's Cowboy Artist"

cover: CHRISTMAS AT LINE CAMP (color)

———, 24:1 (January–February, 1959), cover, 4–6

"C. M. Russell," article (also appeared as a separate)

cover: INDIAN HUNTERS' RETURN

p. 4: BRONC TO BREAKFAST

THE SCOUT #4

p. 5: Charlie and Nancy (wedding photo)

JIM BRIDGER (bronze)

LEWIS AND CLARK MEETING THE FLATHEADS (i.e., INDIANS) AT ROSS' HOLE

p. 6: [THE] RANGE FATHER (bronze)

THE SURPRISE ATTACK

TOLL COLLECTORS

WHEN (i.e., WHERE) THE BEST OF RIDERS QUIT (bronze)

Literary Digest, 42:17 (April 29, 1911), 842–843

Charles M. Russell, The "Cowboy Painter" (photo)

JERKED DOWN

(THE) MEDICINE MAN #2

———, 52:26 (June 24, 1916), cover

SMOKING THEM OUT, i.e., SMOKING CATTLE OUT OF THE BREAKS (color)

———, 54:10 (March 10, 1917), cover

WILD HORSE HUNTERS #2 (color)

———, 95:8 (November 19, 1927), 44, 47–48

"Cowboys, Indians, Buffaloes and Bucking Cayuses"

p. 44: I'M SCAREDER OF HIM THAN I AM OF THE INJUNS TREACHERY ON THE PLAINS, i.e., LIKE A FLASH THE INJUN'S LEFT HAND GOES UNDER HIS GUN COVER TO THE TRIGGER

———, 102:2 (July 13, 1929), 18–20

cover: DISCOVERY OF LAST CHANCE GULCH, i.e., PAY DIRT (color)

p. 19: WHEN THE RED MEN WENT FORTH, i.e., MEDICINE MAN #2

p. 18: "The Spell of the Indian for Artists"

p. 20: "About the Cover Artist." Includes "A Few Words about Myself."

Los Angeles County Employee (September, 1959), 20

"The William S. Hart Ranch," by John Dewar

WILLIAM S. HART

Mademoiselle, 11:2 (June, 1940), 120

Reference to CMR in article "Dudes"

Mainliner, 7:12 (December, 1963), 8–9

(house organ of United Air Lines)

ROUNDUP ON THE MUSSELSHELL (color)

———, 8:12 (December, 1964), [12]–14

WILL ROGERS (bronze)

THE WEAVER (bronze)

WHERE THE BEST OF RIDERS QUIT (bronze)

WATCHER OF THE PLAINS (bronze)

McClure's Magazine, 26:3 (January, 1906), [292]–296

"Arizona Nights," by Stewart Edward White

p. [292]: "A SLATHER OF ROCKS AND STONES COME OUT OF THE MOUTH AND BEGAN TO DUMP DOWN PROMISCUOUS ON THE SCENERY"*

———, 26:4 (February, 1906), 412–419

"Arizona Nights," by Stewart Edward White

p. [417]: "OVER THE NEXT RIDGE, THEREFORE, WE SLIPPED AND SLID, THANKING THE GOD OF LUCK FOR EACH TEN FEET GAINED"*

p. [418]: "HE SNAKED OLD TEXAS PETE RIGHT OUT OF HIS WICKY-UP, GUN AND ALL"*

———, 35:3 (July, 1910), 300–307

"Corazon," by George Patullo

p. 300: CORAZON HELD TO HIS COURSE*

p. [303]: "CORAZON REARED STRAIGHT UP, HIS FEET PAWING LIKE THE HANDS OF A DROWNING MAN"*

p. 305: "THE STEER WAS TOSSED CLEAR OF THE GROUND AND CAME DOWN ON HIS LEFT SIDE"*

Majestic Montana, n.d. (1952)

Charles M. Russell (photo), p. [12]

———, (Fall–Winter, 1959)

"Charles Russell, Articulate Artist of the Old West,"
by Michael Kennedy
Eight pages tipped in between pp. 26–27:
p. [26a]: A SELF PORTRAIT, i.e., CHARLES M. RUSSELL
AND HIS FRIENDS (color)
p. [26b]: INDIAN HUNTERS' RETURN (color)
p. [26c]: FREE TRAPPERS (color)
p. [26d]: LAUGH KILLS LONESOME (color)
p. [26e]: IN (i.e., INSIDE) THE LODGE (color)
p. [26f]: BRONC TO BREAKFAST (color)
p. [26g]: INDIANS DISCOVERING LEWIS AND CLARK (color)
————, (December–January, 1960–1961), cover
FALL ROUNDUP, i.e., THE ROUNDUP #2 (color)

Mentor, 3:9 (June 15, 1915), 5
"Painters of Western Life," by Arthur Hoeber
p. 5: A DANGEROUS CRIPPLE, i.e., CRIPPLED BUT STILL
COMING
Charles M. Russell (photo of CMR on horse)
supp.: WILD HORSE HUNTERS #2* ("intaglio gravure")
————, 15:6 (July, 1927), 1–10
"The American Cowboy," by Douglas Branch
p. 6: WHEN THE BEST OF RIDERS FAIL, i.e., WHERE THE
BEST OF RIDERS QUIT (bronze)
THE HORSE WRANGLER (bronze)
p. 9: TAMING WILD HORSES, i.e., WILD HORSE HUNTERS #2

Missouri Historical Review, 51:4 (July, 1957), 438–439
Notes on Adams' biography and Pence's *Ghost Towns*

Monitor, 56:2 (March, 1962), 22–25
(house organ of Mountain States Telephone Co.)
"Montana's Favorite Son," by Julian H. Hamilton
p. 22: THE BLUFFERS (bronze)
INDIAN STORIES*
BUFFALO HUNT #4*
photo of Gallery
p. 23: photo of CMR
photo of bust statue of CMR
p. 24: photo of Log Cabin Studio interior
THE JERK LINE
p. 25: photo of Log Cabin Studio exterior
N.B. This was issued as a separate, on a single sheet
folded twice, without date, and with photo of CMR
statue by Weaver on cover. See Section X, Trigg–
C. M. Russell Gallery.
————, 58:8 (October, 1964), 21–29
"Montana is Many Things"
pp. 26–27: TOLL COLLECTORS (color)
p. 27: A BRONC TWISTER (bronze)
(Also issued as a separate.)

Montana Alumnus, 5:3 (January, 1927), 5–7, 22
"Charles Russell, LLD, Painter of the Old West, is
Dead"
p. 4: Charles M. Russell (photo of Hazard portrait)

Montana Education, 7:3 (November 19, 1930), 19–21
"Charles Russell," by Dora Leslie

Montana Illustrated, 1:1 (March, 1895), 10
"Chas. Russell and His Work"; portrait
MOVING CAMP #2*
GAMBLING, i.e., COON-CAN—A HORSE APIECE*
LIFE ON THE RANGE, i.e., BRANDING CATTLE—A
REFRACTORY COW
LOST IN THE SNOW, i.e., LOST IN A SNOWSTORM—"WE
ARE FRIENDS"

Montana Magazine (Great Falls), 1:1 (January,
1915)
cover: THE WATER GIRL #2
front.: THE MAD COW
b. cover: INDIAN HEAD #5
————, 1:2 (March, 1915)
p. 6: LAST CHANCE OR BUST
front.: [unknown print]
————, 1:[4] (May, 1915)
p. [3]: THE FIRST FURROW
front.: THE ATTACK #1 (color)
p. [5] ads: INDIAN HEAD #5
————, 2:1 (January, 1916)
front.: BETTER THAN BACON
N.B. It is quite likely that other issues of this magazine
contained CMR illustrations, but we have not been
able to find a complete file.

Montana Magazine of History, 1:2 (April, 1951)
p. [34]: DAME PROGRESS PROUDLY STANDS
p. 64: THE INITIATION OF THE TENDERFOOT
p. 68: INITIATED
————, 1:3 (July, 1951)
p. [14]: THE LAST OF THE BUFFALO
p. [22]: HIS LAST HORSE FELL FROM UNDER HIM
p. [36]: SO ME RUN UP BEHIN', SHOVE DE GUN IN HIS
BACK, AN' TELL HIM STOP HIS PONY
p. [46]: THE CHRISTMAS DINNER
————, 1:4 (October, 1951)
front.: WAITING FOR A CHINOOK (color)
p. [41]: O GHASTLY RELIC OF DEPARTED LIFE
p. [65]: NOW HERDER, BALANCE ALL
————, 2:1 (January, 1952)
p. [32]: "WE FOUND HIS LIFELESS BODY"
p. [54]: HIS FIERCE JAWS SNAP, HIS EYEBALLS GLARE
p. [58]: THEN POOR BILL FELL BACK UNCONSCIOUS
p. [64]: THE TRAIL BOSS
————, 2:2 (April, 1952)
p. 27: "The Conservatism of Charles M. Russell" by
J. Frank Dobie
p. [32]: THE LAST OF HIS RACE
————, 2:3 (July, 1952)

p. [44]: SO ME RUN UP BEHIN', SHOVE DE GUN IN HIS BACK AN' TELL HIM STOP HIS PONY

———, 3:2 (Spring, 1953)

p. 59: A PAIR OF OUTLAWS, i.e., I'M SCAREDER OF HIM THAN I AM OF THE INJUNS

———, 3:4 (Autumn, 1953)

front.: THE LAST OF HIS RACE

b. cover: YORK

———, 4:1 (Winter, 1954)

"I knew Charles M. Russell," by Carter V. Rubottom, 16–25

cover: THE TRAPPER

p. 16: I RODE HIM (part)

p. 17: THE CHRISTMAS DINNER

p. 18: The Cowboy Artist in His Log Studio (photo)
CMR on His Favorite Pinto, Monte (photo)
Russell in Indian costume (photo)

p. 21: Russell and A. J. Trigg (photo)
CMR, Monte and Mamie Russell on a camping trip (photo)

p. 22: 1897 photo of the Artist

p. 24: CHARLIE PAINTING IN HIS CABIN

p. 25: THE KNIGHT OF THE PLAINS AS HE WAS, i.e., AH-WAH-COUS

p. 64: THE TRAPPER

b. cover: YORK

———, 4:2 (Spring, 1954)

cover: THE WOLFER

p. 23: PAINTING THE TOWN

b. cover: THE CHRISTMAS DINNER

———, 4:3 (Summer, 1954)

cover: THE SCOUT #4

p. 3: LEWIS AND CLARK STATUE—DESIGN BY C. M. RUSSELL

p. 10: COWBOY SPORT—ROPING A WOLF #2

p. 14: ROPING A WOLF #2

p. 16: HIS FIERCE JAWS SNAP, HIS EYEBALLS GLARE

p. 30: AN OLD FASHIONED STAGECOACH

p. 39: Charles M. Russell Room (photo)

p. 44: AH-WAH-COUS (part)

p. 56: TRANSPORT TO THE NORTHERN LIGHTS (model)

b. cover: THE CHRISTMAS DINNER

———, 4:4 (Fall, 1954)

cover: THE ROAD AGENT

p. 1: THE POST TRADER (vignette only)

p. 2: CHIEF TAKES TOLL, i.e., TOLL COLLECTORS (part)

p. 5: THE SCOUT #4 (vignette)

p. 8: THE SCOUT #4 (vignette)

p. 25: LAST CHANCE OR BUST

p. 26: THE FIRST FURROW

p. 28: WOMEN OF THE PLAINS, i.e., BREAKING CAMP #3

p. 45: WILD MEN THAT PARKMAN KNEW

p. 46: HOLDING UP THE OVERLAND STAGE

p. 64: TRANSPORT TO THE NORTHERN LIGHTS (model)

p. [65]: FREE TRAPPERS (printed in reverse)

b. cover: CHARLES M. RUSSELL AND HIS FRIENDS (part)
Letter to W. M. Armstrong

———, 5:1 (Winter, 1955)

cover: BEST WISHES FOR YOUR CHRISTMAS (color)

front.: BEST WISHES FOR YOUR CHRISTMAS

p. 67: TOLL COLLECTORS

Montana The Magazine of Western History, [5:2] (Spring, 1955)

cover: THE HERD QUITTER (color)

p. 15: THE ROUNDUP #2 (part)
HERE LIES POOR JACK, HIS RACE IS RUN

p. 31: LEWIS AND CLARK MEETING THE FLATHEAD INDIANS AT ROSS' FORK, i.e., LEWIS AND CLARK MEETING INDIANS AT ROSS' HOLE

p. 32: LEWIS AND CLARK STATUE—DESIGN BY C. M. RUSSELL

p. 39: WILD MEN THAT PARKMAN KNEW

p. 40: THE SCOUT #4 (vignette)

p. 41: BATTLE BETWEEN CROWS AND BLACKFEET

p. 61: AN OLD TIME COW DOG (printed in reverse)

———, 5:3 (Summer, 1955)

cover: LEWIS AND CLARK MEETING THE FLATHEADS (i.e., INDIANS) AT ROSS' HOLE (color)

p. 11: CAPTAIN CLARK, CHABONEAU, SACAGAWEA AND PAPOOSE IN THE CLOUDBURST NEAR THE GREAT FALLS, JUNE 29, 1805

p. 35: SQUAW WITH BULL BOAT (part)

p. 44: CAPTAIN LEWIS AND HIS SCOUTS DISCOVERING THE GREAT FALLS OF THE MISSOURI IN 1805

p. 60: WILD MEN THAT PARKMAN KNEW

p. 61: THE TRAPPER (vignette only)

———, 5:4 (Autumn, 1955)

cover: WHEN COWS WERE WILD (color)

insert: PAY DIRT

p. 34: THE ROAD AGENT (part)

p. 41: PAINTING THE TOWN

p. 48: COMING TO CAMP AT THE MOUTH OF SUN RIVER

p. 51: WILD MEN THAT PARKMAN KNEW

p. 52: BATTLE BETWEEN CROWS AND BLACKFEET

p. 53: HERE LIES POOR JACK, HIS RACE IS RUN

p. 61: AN OLD TIME COW DOG (printed in reverse)

p. 64: LEWIS AND CLARK MEETING INDIANS AT ROSS' HOLE
THE HERD QUITTER

b. cover: THE ROUNDUP #2

———, 6:1 (Winter, 1956)

cover: CHRISTMAS AT LINE CAMP (color)

p. 3: BLACKFEET ATTACK THE FLATHEADS, i.e., BATTLE BETWEEN CROWS AND BLACKFEET

p. 7: THE CHRISTMAS DINNER

p. 12: INDIANS AND SCOUTS TALKING

b. cover: SMOKING UP (bronze)

———, 13:3 (Summer, 1963)

cover: (THE) MEDICINE MAN #4 (color)

and 11 previously published small pictures

———, 13:4 (Autumn, 1963)

cover: THE SLICK EAR (color)

p. 76: Text of appreciation of Edward S. Paxson

p. 84: BENT'S FORT ON ARKANSAS RIVER

and nine previously published small pictures

———, 14:1 (Winter, 1964)

"The Cowboy Artist as Seen in Childhood Memory," by Elizabeth Greenfield, pp. 38–47

cover: CHRISTMAS MEAT (color)

p. 38: SELF-PORTRAIT #5

p. 41: PRAIRIE DOG TOWN*

p. 44: MAGPIE SURVEYING INDIAN TIPI VILLAGE

p. 45: THE MEDICINE ARROW

p. 46: SHIELD, TOMAHAWK, PIPE AND PAINTED ROBE

p. 47: STANDING FEARLESSLY, HIS ARMS THROWN DOWNWARD, EXPOSING HIS BREAST

p. 54: MEETING OF SACAJAWEA AND HER RELATIVES OF THE SHOSHONE TRIBE

p. 61: BRIDGER DISCOVERS THE GREAT SALT LAKE

p. 62: A SWING STATION ON THE OVERLAND

p. 66: A DIAMOND R MULE TEAM OF THE '70S

p. 67: A MANDAN VILLAGE

p. 69: ANNIHILATION OF FETTERMAN'S COMMAND

p. 70: PLUMMER AND TWO FOLLOWERS KILL FORD
FOUR COWBOYS GALLOPING

p. 71: INDIANS MEET FIRST WAGON TRAIN WEST OF MISSISSIPPI

p. 72: ATTEMPTED MASSACRE OF BLACKFEET INDIANS AT FORT MCKENZIE

b. cover: BEST WISHES FOR YOUR CHRISTMAS (color)

———, 14:2 (Spring, 1964)

cover: SURROUND (color)

plus 16 previously published vignettes

———, 14:3 (July, 1964)

cover: DISCOVERY OF GOLD AT LAST CHANCE GULCH,
i.e., PAY DIRT (color)
THE ROAD AGENT (vignette only)

p. 6: PLACER MINERS PROSPECTING NEW STRIKE

p. 20: THE HOLDUP

p. 37: THE HERD QUITTER

p. 75: COMING TO CAMP AT THE MOUTH OF SUN RIVER

p. 76: THE STEER WAS TOSSED CLEAR OF THE GROUND AND CAME DOWN ON HIS LEFT SIDE

p. 78: A DIAMOND R MULE TEAM OF THE '70S

p. 80: FIRST AMERICAN NEWS WRITER (part)

p. 83: TRAILS PLOWED UNDER

p. 86: IDAHO OX TEAMS WERE BRINGING IN SOME 6,000,000 POUNDS OF FREIGHT ANNUALLY

p. 87: ANNIHILATION OF FETTERMAN'S COMMAND

recto b. cover: NATURE'S PEOPLE* (bronze)
BUFFALO BULL* (bronze)
GOING GRIZZLY, i.e., GRIZZLY BEAR* (bronze)

———, 14:4 (Autumn, 1964)

cover: A DESPERATE STAND (color)

p. 70: A DIAMOND R MULE TEAM OF THE '70S

p. 73: LA VERENDRYES DISCOVER THE ROCKY MOUNTAINS

p. 75: PEACE* (bronze)

p. 77: THE SCOUT #4 (vignette)

recto b. cover: NATURE'S PEOPLE (bronze)
BUFFALO BULL (bronze)
GOING GRIZZLY, i.e., GRIZZLY BEAR (bronze)
XT BAR LONGHORN* (bronze)
PIEGAN BRAVE* (bronze)

———, 15:1 (Winter, 1965)

cover: [THE] BUFFALO HUNT #22 (color)

plus five previously published vignettes

———, 15:2 (Spring, 1965)

cover: TRAIL'S END (color)

plus nine previously published vignettes

———, 15:3 (Summer, 1965)

cover: IN THE ENEMY'S COUNTRY (color)

p. [9]: Jack Dempsey and Charlie Russell (photo)

p. 40: BUFFALO HOLDING UP MISSOURI RIVER STEAMBOAT

p. 44: A NECKTIE PARTY, i.e., STEVE MARSHLAND WAS HANGED BY VIGILANTES

p. [55]: FARO LAYOUT

p. 56: BARROOM SHOOTING, i.e., PEACEFUL VALLEY SALOON

p. [57]: HERE LIES POOR JACK, HIS RACE IS RUN

p. 81: PLUMMER AND TWO FOLLOWERS KILL FORD

p. 82: THEY'RE ALL PLUMB HOG WILD (part)

p. 86: BRIDGER DISCOVERS THE GREAT SALT LAKE

p. 90: SELF-PORTRAIT #4

recto b. cover: IN THE ENEMY'S COUNTRY (part)
MEDICINE MAN #4
THE SLICK EAR
BUFFALO HUNT, i.e., SURROUND

———, 15:4 (Autumn, 1965)

cover: NO CHANCE TO ARBITRATE, i.e., WHEN HORSES TALK WAR THERE'S SMALL CHANCE FOR PEACE (color)

p. 70: A MANDAN VILLAGE

p. 72: ME HAPPY (bronze)

p. 73: ATTEMPTED MASSACRE OF BLACKFEET INDIANS AT FORT MACKENZIE

p. 74: ANNIHILATION OF FETTERMAN'S COMMAND

recto b. cover: WHEN COWS WERE WILD

———, 16:1 (Winter, 1966)

cover: NATURE'S SOLDIERS (part) (color)

p. 2: YORK

p. [59]: FROM THE SOUTHWEST COMES SPANISH AN'
 MEXICAN TRADERS
 ONATE'S MARCH INTO THE NEW MEXICAN
 COUNTRY
p. 61: THE FREE TRAPPER
p. 63: BENT'S FORT ON ARKANSAS RIVER
p. 67: A TEXAS TRAIL HERD
p. 73: THE TRAIL BOSS
 TRAIL DRIVERS WATCHING HERD
p. 75: OF COURSE THE RURALES OR THE NATIVES
 WOULD KILL ME IN THE END (part)
p. 76: MOLLY AND HER VIRGINIAN SAT AT A CERTAIN
 SPRING
p. 77: SCOOL MARM
p. 79: SADDLE, SHIELD (in reverse)
 SADDLE, CINCH AND STIRRUPS
 FIRST WAGON TRAIL
p. [81]: THE PROSPECTOR (vignette)
 DIMOND HICH IN RANE
 WHEN MULES WEAR DIAMONDS
p. 83: COWBOY ABOUT TO SADDLE HORSE
 BRIDLE
 FOUR COWBOYS GALLOPING
p. 85: TWO WOLVES TROTTING, SIDE VIEW
p. 91: PIEGAN GIRL (bronze)
 PEACE (bronze)
recto b. cover: THE PEACE TALK
————, 16:2 (Spring, 1966)
p. 48: HIS ARROW LODGED IN THE FLESHY PART OF MY
 HORSE'S SHOULDER
p. 49: THE TRAPPERS PASSED THROUGH THEM WITH THEIR
 COLT'S REVOLVERS
p. 83: WHEN SIOUX AND BLACKFEET MEET, i.e., RUNNING
 FIGHT
p. 86: CURLY, CUSTER'S CROW SCOUT, HAILS THE STEAMER
 FAR WEST TO REPORT NEWS OF THE CUSTER
 BATTLE, i.e., CURLEY REACHES THE FAR WEST
 WITH THE STORY OF THE CUSTER FIGHT
————, 16:3 (Summer, 1966)
cover: LEWIS AND CLARK REACH SHOSHONE CAMP LED
 BY SACAJAWEA [THE "BIRD WOMAN"] (color)
p. 81: THE DUEL
p. 83: A DIAMOND R MULE TEAM OF THE '70S
p. 85: THE RED MAN'S HUNTING GROUND
recto b. cover: YORK
 INDIANS DISCOVERING LEWIS AND CLARK
 LEWIS AND CLARK MEETING INDIANS AT ROSS'
 HOLE
————, 16:4 (Autumn, 1966)
cover: JERK-LINE, i.e., THE JERKLINE (color); same,
 black and white, verso
p. 2: THE VIRGINIAN STOOD LOOKING DOWN AT
 TRAMPAS
p. 6: CHUCKWAGON, COWBOYS EATING ON GROUND

p. 7: FARO LAYOUT
p. 11: SCOOL MARM
pp. 84–85: JIM BRIDGER COMING INTO FT. BENTON, i.e.,
 BRIDGER BRINGING IN SOME OF HIS
 CELEBRATED VISITORS TO HUNT AROUND
 FORT UNION

Montana Outfitter, 5:2 (July 25, 1964), cover
NO CHANCE TO ARBITRATE, i.e., WHEN HORSES TALK WAR
THERE'S SMALL CHANCE FOR PEACE (color)

Montana Post (April, 1963?)
p. 3. A DIAMOND R MULE TEAM OF THE '70S
This is a trial issue, 8 pp. on yellow paper, no volume or
issue number. Official newsletter of the Montana
Historical Society.
————, 1:1 (May, 1963), 3
N.B. Commencing with this issue, the publication
carries THE TRAPPER (part) on its masthead and on the
mailing label in all issues.
WHEN COWS WERE WILD
————, 1:3 (July, 1963), 4
WILD HORSE HUNTERS #2
THE BROKEN ROPE
————, 1:4 (August, 1963), 4
CHARLEY RUSSELL, i.e., CHARLES M. RUSSELL AND HIS
FRIENDS
[THE] LAST OF FIVE THOUSAND (i.e., 5000)
BRONC TO BREAKFAST
LAUGH KILLS LONESOME
LEWIS AND CLARK MEETING THE FLATHEADS, i.e., LEWIS
AND CLARK MEETING INDIANS AT ROSS' HOLE
WATCHING THE SETTLERS
THE VAQUEROS, i.e., VAQUEROS OF OLD CALIFORNIA
WHEN COWS WERE WILD
————, 1:5 (September, 1963), 4
I AIN'T NO SANTA, i.e., BEST WISHES FOR YOUR CHRISTMAS
————, 1:7 (November, 1963), 4
CHARLES M. RUSSELL AND HIS FRIENDS
————, 2:2 (February, 1964), 4
LEWIS AND CLARK MEETING INDIANS AT ROSS' HOLE
PAY DIRT
THE BROKEN ROPE
[THE] SALUTE OF THE ROBE TRADE
————, 2:3 (March, 1964), 4
JERKED DOWN
Centennial Medallion
————, 2:4 (April, 1964), 4
IN THE ENEMY'S COUNTRY
JERKED DOWN
SELF-PORTRAIT #4
CHARLES M. RUSSELL AND HIS FRIENDS
FIRST AMERICAN NEWS WRITER
————, 2:5 (May, 1964), 1, 4

AS QUICKLY THE HORSE TOOK FRIGHT
HARRIS AND HIS FRIENDS
THE SILK ROBE
——, 2:6 (June, 1964), 1
THE HERD QUITTER
——, 2:11 (November, 1964), 2, 3
"From the Kelly Collection"
KOOTENAI CAMP ON SWAN LAKE*
——, 2:12 (December, 1964)
"White House CMR Loaned by Amon Carter"
[THE] SILK ROBE
——, 3:2 (February, 1965), 4
THE SLICK EAR
——, 3:4 (April, 1965), 3
THE HERD QUITTER
WHEN COWS WERE WILD
——, 3:6 (June, 1965), 4
A DIAMOND R MULE TEAM OF THE '70S
——, 3:7 (July, 1965), 4
ME HAPPY (bronze)
——, 3:8 (August, 1965), 4
THE THREE KINGS
MAY YOUR DAYS BE BETTER
BEST WISHES FOR YOUR CHRISTMAS
CHRISTMAS MEAT
DEER AT WATERHOLE
CHRISTMAS AT LINE CAMP
CHRISTMAS RANCH PARTY, i.e., GOING TO A CHRISTMAS
 RANCH PARTY IN THE 1880S

The 1939 *Montanan.* Montana State College, Bozeman,
Montana
Dedication page contains: SO ME RUN UP BEHIN', SHOVE
DE GUN IN HIS BACK; HIS FIERCE JAWS SNAP, HIS EYEBALLS
GLARE; SO WITHOUT ANY ONDUE RECITATION I PULLS MY
GUNS AN' CUTS DOWN ON THEM THERE TIN-HORNS; THE
INDIAN OF THE PLAINS AS HE WAS; and portrait of CMR

Motor News, 47:2 (August, 1964), 20–21, 31
(Automobile Club of Michigan)
"Montana's Charley Russell," by Ralph Friedman
p. 20: THE LAST OF THE BUFFALO (part)
 NO CHANCE TO ARBITRATE, i.e., WHEN HORSES TALK
 WAR THERE'S SMALL CHANCE FOR PEACE
p. 21: Russell in his log cabin studio (photo)
 Russell room in Historical Society of Montana
 Museum (photo)
 COWPUNCHERS WERE CARELESS, HOMELESS,
 HARD-DRINKING MEN (part)
 WHEN COWS WERE WILD
 THE ROUNDUP #2
 LAUGH KILLS LONESOME

Museum News, 26:18 (March 15, 1949), 2
"Russell Memorial"

——, 37:4 (June, 1959), 26
NOBLEMAN OF THE PLAINS (bronze)
——, 38:4 (November, 1959), 10
MONARCH OF THE FOREST (bronze)
——, 44:10 (June, 1966), cover
THE RED MAN'S WIRELESS (color)

Mystic Hour (December, 1949)
(newsletter of B.P.O.E. 214, Great Falls)
p. 2: LETHBRIDGE RIDERS*
 A SOFT DRINK JOINT*
——, January, 1951
p. 1: WOULD YOU KNOW ME BILL?*
p. 6: CAR OF THE SILVER DOLLAR*
 ONLY EXCITEMENT (i.e., ONLEY EXCITMENT) I GET
 IS DODGING CARS*
 WE WERE SHURE GOING SUM*
 THAT LADYS HORSE YOU USED TO OWN*
 I'M GOING TO DRESS WELL IF IT BRAKES ME*
——, (March, 1952)
p. 5: I DON'T THINK THE OLD ATLANTIC HAS CHANGED*
 IT WAS A QUICK TUCH*
p. 8: IN LONDON THE HOLD UP SAYS THANK YOU SIR*
 I HAD A ROUGH TRIP OVER*
——, (September, 1952)
p. 3: HERE I AM BILL*
p. 6: ESQUMO LIVES IN AN EGELOW*
 NATIVE SONS BUILD A BUNGALOW*

National Geographic, 97:6 (June, 1950), 725
THE LAST ROUNDUP, i.e., THE ROUNDUP #2 (color)
——, 120:1 (July, 1961), 50–51
GUNPOWDER AND ARROWS (color)
——, 128:5 (November, 1965), 646–647
LEWIS AND CLARK ON THE LOWER COLUMBIA

National Magazine, 22:3 (June, 1905), front., 317–320
"Chas. M. Russell, The Cowboy Artist," by Wallace
D. Coburn
p. 317: Russell, the "Cowboy Artist" and Coburn, The
 "Cowboy Poet" (photo)
p. 319: FRIENDS I'M IN MISSOURI*

Nature's Realm, 2:4 (April, 1891), 151
"Notes from Montana," by Charles Hallock
N.B. Quotation from this article appears on p. [4] of
advertisement for *Studies of Western Life,* cf. Coll. 1b.

New Trail, 4:2 (April, 1946)
(University of Alberta)
"Charles M. Russell, 1864–1926, The Cowboy Artist,"
by J. O. G. Sanderson
p. 3: THE BUCKING BRONCO #1
also issued as an author's separate

New Weekly, 1 (April 4, 1914), 83
Article "Mr. Charles Russell" (anonymous)
THE JERKLINE

News from Home, 15:2 (Summer, 1954), 28
(house organ of Home Insurance Co.)
Charles Marion Russell (photo)

News-on-the-Move (Second Quarter, 1962)
(house organ of World Wide National Van Lines)
"Our Charlie," by E. Ralph Rundell, 9–12
p. 9: C. M. Russell (photo)
 COWPUNCHERS WERE CARELESS, HOMELESS, HARD-
 DRINKING MEN
p. 10: QUICK SHOOTING SAVES OUR LIVES
 TOLL COLLECTORS
p. 11: [THE] RANGE FATHER (bronze)
 THE SCOUT #4

Northwest Magazine, 6:3 (March, 1888), 1
Crow Indians on the Move (pen etching by Larpenteur
 from a painting by C. M. Russell)
———, 6:7 (July, 1888), 3
First Attempt at Ropeing [sic] (pen etching by Will
 S. Horton after a painting by C. M. Russell,
 "the Cowboy Artist")
———, 7:1 (January, 1889), 6
On a Montana Cattle Range—Ropeing [sic] a Steer
 (after a painting by C. M. Russell, the "Cowboy
 Artist")
———, 19:6 (June, 1901), 28
Newton's Theory of Gravitation (copy of a portion of
CMR oil painting of FIRST ATTEMPT AT ROPING by
another artist)
FIRST ATTEMPT AT ROPING (without credit to CMR)

Observer (London), (September 26, 1965)
p. 18: LAUGH KILLS LONESOME (color)
 A RACE FOR THE WAGONS
pp. [26–27]: TOLL COLLECTORS (color)

Oklahoma Today, 16:2 (Spring, 1966)
p. 2: THE WRANGLER, i.e., THE HORSE WRANGLER
 (bronze)
p. 3: SITTING BULL'S MEN ON THE TRAIL, i.e.,
 PARTY OF SITTING BULL'S BRAVES GET OUR
 TRAIL
p. 4: THE (i.e., A) BRONC TWISTER (bronze)
p. 8: MANY SNOWS HAVE FALLEN* (part)
p. [11]: SMOKE TALK (color)
b. cover: SMOKE TALK (part) (color)

Old West, 1:4 (Summer, 1965), 41, 55
"A Savage Santa Claus," by Charles M. Russell

———, 2:1 (Fall, 1965), 39
BUNCH OF RIDERS

On Tour, 15:10 (December, 1953)
(house organ of Union Oil Company)
cover: WAGON BOSS (color)
p. 4: CHEYENNES WATCHING UNION PACIFIC TRACK
 LAYERS

Orange Disc, 16:4 (January–February, 1964)
(house organ of Gulf Oil Company)
p. 12: THE BUFFALO HUNT #29 (color)
p. 14: WAGON BOSS
p. 15: THE CAMP COOK'S TROUBLE (color)

Outdoor Montana, 2:1 (February–March, 1947), [8]
NATURE'S CATTLE #1
———, 2:2 (April–May, 1947), 2
HIS FIERCE JAWS SNAP, HIS EYEBALLS GLARE
———, 2:4 (August–September, 1947), [3]
THE SCOUTS, i.e., THE INDIAN OF THE PLAINS AS HE WAS
———, 2:5 (October–November, 1947), [6]
WHEN BUFFALO WERE THE MOST PLENTIFUL, i.e., AH-
WAH-COUS
———, 2:6 (December–January, 1947–1948), [3], 25
THE CHRISTMAS DINNER
THE PRICE OF HIS ROBE, i.e., THE PRICE OF HIS HIDE
———, 2:7 (February–March, 1948), [8]
THE HONOR OF HIS RACE, i.e., SO ME RUN UP BEHIN', SHOVE
DE GUN IN HIS BACK AN' TELL HIM STOP HIS PONY
———, 3:2 (April–May, 1948), [3]
LEWIS AND CLARK AT THREE FORKS OF THE MISSOURI
———, 3:3 (June–July, 1948), 3
THE PROSPECTORS #2
———, 3:4 (August–September, 1948), [3]
THE TRAIL BOSS
———, 3:5 (October–November, 1948), 3
HIS LAST HORSE FELL FROM UNDER HIM
———, 3:6 (December–January, 1948–1949), [4]
LEWIS AND CLARK AT GREAT FALLS, i.e., CAPTAIN LEWIS
AND HIS SCOUTS DISCOVERING THE GREAT FALLS OF THE
MISSOURI IN 1805
———, 3:7 (March–April, 1949), [3]
PICTURE WRITING, i.e., THE PICTURE ROBE

Outing, 44:5 (August, 1904), 615–618
"The Tenderfoot," by H. W. Morrow
p. 614: OUT OF THE RUCK AND THE DUST SHOT A LEAN
 YELLOW STREAK*
———, 45:3 (December, 1904), 268–272
"Men and Women of the Outdoor World"
"Russell, the West's Cowboy Artist" (anonymous)
p. 268: THE SCOUT, i.e., THE ALERT
p. 270: THE ATTACK #3

p. 271: CUSTER'S LAST STAND, i.e., CUSTER'S LAST BATTLE
p. 272: C. M. Russell (photo)

Outing Magazine, 50:5 (August, 1907), 550–553
"Mormon Murphy's Misplaced Confidence," by Charles M. Russell
p. 550: "WHAT LOOKS CROOKED TO ME IS THAT HIS QUIRT HANGS ON HIS RIGHT WRIST"*
p. 552: "LIKE A FLASH THE INJUN'S LEFT HAND GOES UNDER HIS GUN-COVER TO THE TRIGGER"*
———, 51:3 (December, 1907), 337–341
"How Lindsay Turned Indian," by Charles M. Russell
p. 338: "JUST AT THE CRACK OF THE GUN THE SUN BREAKS OUT THROUGH A CLOUD HITTIN' THE KID"*
———, 51:5 (February, 1908), 513–514, 529–532
"Dad Lane's Buffalo Yarn," by Charles M. Russell
p. 513: Charles M. Russell—the "Cowboy Artist" (photo)
p. 514: "THE NEXT THING I KNOW I'M AMONGST HIS HORNS"*
———, 52:1 (April, 1908), 32–36
"Finger-That-Kills Wins His Squaw," by Charles M. Russell
p. 32: "THE NEXT THING HE KNOWS THREE INJUNS COMES YELPIN' DOWN ON HIM, QUIRTIN' THEIR PONIES AT EVERY JUMP"*
p. 35: "DROPPIN' THE HAIR HE REACHES FOR THE JEWELED HAND"*
———, 52:2 (May, 1908), 176–181
"Longrope's Last Guard," by Charles M. Russell
p. 176: "PULLIN' MY GUN, I EMPTY HER IN THE AIR"*
———, 53:3 (December, 1908)
fcg. p. 359: THE MAD COW* (color)
———, 53:4 (February, 1909), 558
MOUNTAIN MUTTON*

Outlook, 145:15 (April 13, 1927), 466–468
"Charles Russell Cowboy Artist," by Frank Bird Linderman
p. 466: THE RANGE FATHER* (bronze)
p. 467: WORE SKINS AN' SMELT OF WILLOW BARK*

Outwest, 20:6 (June, 1904), 540–545
"The Grazing Range Problem," by R. H. Forbes
OUT ON THE PRAIRIE'S ROLLING PLAIN

Pacific Monthly, 12:6 (December, 1904), 339–344
"An Artist of the Plains," by Kathryne Wilson
p. 339: A PAPOOSE #1*
INDIAN SIGNALING #1*
p. 340: A HORSE STEALING RAID*
p. 341: THE TRAIL BOSS
p. 342: A WAR PARTY, i.e., SCOUTING PARTY #1
p. 343: Charles M. Russell (pen and ink portrait)
p. 344: AN APACHE INDIAN

Pacific Northwest Playground (1947), [7]
Will Rogers and Charles M. Russell (photo)
———, (1950)
cover: SMOKING UP (bronze)
verso: THE LAST OF THE BUFFALO
BUFFALO (bronze)
HOLDING UP THE OVERLAND STAGE
STEER (plaster replica)
p. 2: SMOKING UP (bronze)

Pic, 111:1 (April, 19, 1938), 45
THE BUFFALO HUNT #14*

Picture and Gift Journal, 63:11 (November, 1926), 671
"Death of Charles Russell, Cowboy artist"
A BAD ONE*

Playgrounds of the Rockies, combined with *Majestic Montana Magazine*, (September, 1961)
p. 36: SO WITHOUT ANY ONDUE RECITATION I PULLS MY GUNS AN' CUTS DOWN ON THEM THERE TIN HORNS
———, 6:4 (September, 1963), 16
"Fort Benton Museum"
WAGON BOSS
(others indistinguishable)
Weaver's statue of CMR (replica)
———, 7:1 (February–March–April, 1964), 6–9
"Olaf Seltzer, Charlie Russell's Friend, Model, Critic, Painted the West"
———, 7:2 (June–July, 1964), 14
IN THE ENEMY COUNTRY
———, 7:5 (April, 1965), 11
Reference to CMR
———, 7:6 (June–July, 1965)
p. [6]: TRAILS PLOWED UNDER
p. 8: COMING TO CAMP AT THE MOUTH OF SUN RIVER (part)
SCOOL MARM
RAWHIDE RAWLINS, MOUNTED
p. 14: RAWHIDE RAWLINS, MOUNTED
SCOOL MARM
FLATBOAT ON RIVER, FORT IN BACKGROUND
ALL CONVERSATION WAS CARRIED ON BY THE HANDS
p. 16: THE ROPE WOULD SAIL OUT AT HIM
p. 19: LIKE A FLASH THEY TURNED (part)
p. 42: COWBOY SEATED, HORSE NUZZLING HIS LEFT HAND

Pony Express, 15:12 (May, 1949), 10
CANDIDATE BRAGS AFTER RIDING GOAT, i.e., I RODE HIM

Popular Magazine, 6:1 (May, 1906), ads
THROWING HERSELF FROM THE SADDLE SHE SLID PRECIPITATELY INTO THE WASHOUT

————, 9:2 (August, 1907), cover
THE SCOUT #5*

Portland Craftsman, 3:6 (June, 1926)
recto front cover: FIRST AMERICAN NEWS WRITER

The 1926 *Prickly Pear*, Vol. IX. Published by the
Junior Class of Intermountain Union College of Helena,
Montana, Helena, 1926.
p. [6]: THE FIRST FURROW (color)

Progressive Arizona, 2:1 (February, 1926), cover
A BAD HOSS (color)

Prudential Mortgage Loan Mirror (June, 1962)
(house organ of Prudential Insurance Company)
p. 22: Chow time at the OH ranch near the DHS
spread in 1883. Charley Russell, frontier
artist is third from the left in the front row
(photo)

Rambler, 1960, Central High School, Billings, Montana
cover: NATURE'S SOLDIERS (part)
pp. 2–3: CHARLES M. RUSSELL AND HIS FRIENDS
p. 4: BLACK EAGLE (part)
 THE MEDICINE MAN (bronze)
 (THE) THREE GENERATIONS
p. 5: FIRST AMERICAN NEWS WRITER (part)
 LEWIS AND CLARK MEETING INDIANS AT ROSS'
 HOLE
 YORK
p. 8: BLACK EAGLE (part)
p. 18: THE MEDICINE MAN (bronze)
pp. 26–27: (THE) THREE GENERATIONS
p. 33: WHEN BUFFALO WERE PLENTIFUL
p. 39: INDIANS DISCOVERING LEWIS AND CLARK
p. 45: INTRUDERS
p. 68: FIRST AMERICAN NEWS WRITER (part)
pp. 80–81: LEWIS AND CLARK MEETING INDIANS AT ROSS'
 HOLE
pp. 92–93: YORK

Real West, 4:20 (November, 1961)
"The Charles M. Russell Story," by Joe Gill, 34–37
p. 3: THE TRAIL BOSS
 YORK
 MEN OF THE OPEN RANGE
p. 34: Charles M. Russell (photo)
 COWPUNCHERS WERE CARELESS, HOMELESS, HARD-
 DRINKING MEN
p. 35: THE TRAPPER
 THE WOLFER
 ON THE WARPATH #2
p. 36: FREE TRAPPERS
p. 37: LAUGH KILLS LONESOME

————, 4:20 (November, 1961)
N.B. There were two different issues bearing the same
date, volume, and issue numbers.
"The Charles M. Russell Story, Second of two parts,"
by Joe Gill, 36–39
p. 36: Charles M. Russell (photo)
 TOLL COLLECTORS
p. 37: YORK
 THE PROSPECTOR
p. 38: THE SCOUT #4
pp. 38–39: LEWIS AND CLARK MEETING INDIANS AT ROSS'
 HOLE
p. 39: AH-WAH-COUS
————, 5:26 (November, 1962)
"Bloody Fourth at Lewistown," by Charles E.
Gould
p. 29: COWPUNCHERS WERE CARELESS, HOMELESS,
 HARD-DRINKING MEN
p. 57: NOW HERDER, BALANCE ALL (printed in reverse)

Recreation, 6:4 (April, 1897), 227–231
"Early Days on the Buffalo Range," by C. M. Russell
p. 227: BUFFALO WATERING*
p. 228: THE INDIANS SLID FROM THEIR PONIES AND
 COMMENCED STRIPPING THEMSELVES*
p. 230: THE BULL CHARGED HIS ENEMY, BELLOWING AS
 HE WENT*
————, 57:1 (July, 1917), 11–13
"Recreation Men IV—C. M. Russell, the Cowboy
Artist," by Edward Cave
p. 11: Today he is still playing with little bits of model-
 ing wax (photo)
 AN OLD-TIME RIM-FIRE MAN #1*
p. 12: THE STIRRUP HITCH*
 Summer house at Lake McDonald (photo)
p. 13: A BLACKFOOT OF THE PAST*
 CENTER-FIRE MAN ON A BRONC*

Rocky Mountain Magazine, 1:4 (December, 1900),
215–221
p. 215: Charles Russell, Artist, Great Falls (photo)
p. 216: THE ALERT*
p. 217: SCOUTING PARTY #1*
p. 218: TRAILING*
p. 219: CAPTAIN LEWIS AND HIS SCOUTS DISCOVERING THE
 GREAT FALLS OF THE MISSOURI IN 1805
p. 220: A PRAIRIE SCHOONER CROSSING THE PLAINS
p. 221: THROWING ON THE HEEL ROPE*
————, 1:5 (January, 1901), 378
JUST AS EVERYTHING'S TURNIN' BLACK I HEAR BEDROCK'S
 WINCHESTER*
————, 4:1 (March, 1902)
front.: THE LAST OF THE BUFFALO
p. 8: note concerning frontispiece

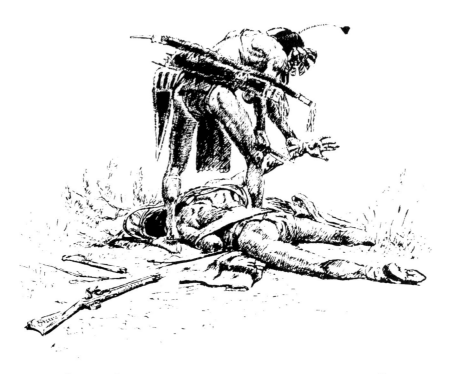

"DROPPIN' THE HAIR HE REACHES FOR THE JEWELED HAND"

"THE GROS VENTRE BEGINS HACKIN' THE FINGERS OFF"

Comparison of treatment of same subject, illustrating the story, *Finger-That-Kills Wins His Squaw.*

DROPPIN' THE HAIR HE REACHES FOR THE JEWELED HAND, (above) *Outing*, April, 1908. THE GROS VENTRE BEGINS HACKIN' THE FINGERS OFF, (below) *Trails Plowed Under*, 1927, p. 127.

Comparison of treatment of same subject, illustrating the story, *The Olden Days*.

THE CHIEF FIRED AT THE PINTO #1 (above). Note horse's head upraised. *Twelfth Annual Roundup*, 1919.

THE CHIEF FIRED AT THE PINTO #2 (below). Note horse's head curled under. *Trails Plowed Under*, 1927.

Roundup, Great Falls High School, No. 2 (1909)
front.: THE BUFFALO HUNT #35
———, No. 3 (1910)
front.: photo of CMR
pp. 7–8: "A Brief Sketch of C. M. R.", by E. F. K.
———, Seventh Annual (June, 1914)
p. 36: Charles M. Russell (photo)
pp. 37–39: "Charles M. Russell"
———, Tenth Annual (June 8, 1917)
pp. 40–42: "The Story of the Cowboy as it was told me
 by an old-time rider of the range"
 BEST WHISHES TO THE P–C BUNCH
"The Story of the Cowboy" later appeared (in *Raw-hide Rawlins Stories* and elsewhere) as "The Story of the Cowpuncher."
———, Eleventh Annual (June 4, 1918)
pp. 48–50: "A Slice of Charley Russell's Early Life"
 BEAR IN GUM BOOTS*
———, Twelfth Annual (June 20, 1919)
pp. 46–52: "The Olden Days"
p. 46: photo of CMR
p. 47: ALL CONVERSATION WAS CARRIED ON BY THE
 HANDS*
p. 48: HIS FIRST YEAR*
p. 49: THE CHIEF FIRED AT THE PINTO #1*
p. 52: TWO RIDERS, ONE LEADING A PACK HORSE*
———, Thirteenth Annual (June 4, 1920)
pp. 48–49: Facsimile reproduction of letter dated
 March 19, 1920, from CMR to Theodore
 Gibson
 THEY JUST SAT AT THE MOUTH OF THAIR
 CAVES AND WACHED THAIR GOLD LOVING
 BROTHERS*
 WENT HEELED TO THE TEETH*
 THIS GENT RIDES A PIERCE ARROW*
The letter appears on pp. 34 and 35 of *Good Medicine* with illustrations reproduced but with text of letter in type.
———, Seventeenth Annual (1927)
"In Memorium [*sic*] Charles M. Russell"
p. 13: portrait of CMR (photo)

Royal Canadian M. P. Quarterly, 13:4 (April, 1948), 292
THE ONLY WAY TO NEGOTIATE WITH THIEVES, i.e.,
 WHEN LAW DULLS THE EDGE OF CHANCE

Ruberoid News, 23:2 (March 19, 1964)
(house organ of the Ruberoid Co.)
cover: JERKED DOWN (stamp)
gatefold: JERKED DOWN (sepia)
p. 2: JERKED DOWN (black and white)
 MEAT'S NOT MEAT 'TILL IT'S (i.e., TILL ITS)
 IN THE PAN
inner gate: THE BUFFALO HUNT #29

S.P.A. Journal, 26:7 (March, 1964)
"Charles M. Russell, American Artist," by Belmont Faries, 485–491
cover: SELF-PORTRAIT #4
p. 485: JERKED DOWN
p. 486: THE TRAIL BOSS
 photo of Range Conservation stamp
 STAGECOACH #1*
p. 487: THE BUFFALO FAMILY (bronze)
p. 488: Russell in his studio (photo)
p. 490: CHARLES M. RUSSELL AND HIS FRIENDS (proposed
 stamp design)
p. 491: TRAIL OF THE IRON HORSE #1 (proposed stamp
 design)
 JERKED DOWN (approved stamp design)
———, 26:11 (July, 1964), 835–839
"Charles M. Russell 5-cent American Painting com-memorative issued March 19, 1964 at Great Falls, Montana" by Belmont Faries
p. 835: JERKED DOWN (postage stamp)
p. 836: CHARLES M. RUSSELL AND HIS FRIENDS (proposed
 stamp design)
 CHARLES M. RUSSELL AND HIS FRIENDS (alternate
 stamp design)
 JERKED DOWN (alternate stamp design)
 TRAIL OF THE IRON HORSE #1 (proposed stamp
 design)
p. 837: JERKED DOWN
 JERKED DOWN (accepted stamp design)
p. 839: JERKED DOWN (stamp design with cut of final
 sheet)

St. Nicholas (December, 1915), ads 13
BADGER, SKUNK, BEAVER, PORCUPINE AND WOODCHUCK

Sales Builder (January 17, 1962)
(house organ of U. O. Colson Company, Paris, Illinois) Punched folder, size 8¼ × 10¾, with insert: "'Lewis and Clark' Acclaimed Russell's Masterpiece." Portrait of CMR. Reproduces LEWIS AND CLARK MEETING INDIANS AT ROSS' HOLE, double truck.

Santa Barbara Community Life, 1:3 (March, 1923), 3–5
"Those Who Knew the Real West"
p. 4: WHEN MULES WEAR DIAMONDS*

Saturday Evening Post, 186:14 (October 4, 1913), 13–16, 30–31, 33–34, 37–39
"Beating Back," by Al Jennings
p. 13: I MADE HIM RIDE BESIDE ME AS WE GALLOPED
 DOWN THE RIGHT-OF-WAY*
p. 14: I FELT A SLAP IN THE FACE*

p. 15: WHENEVER HE LET THE ROPE GO SLACK WE'D TAKE
 A FEW SHOTS IN THE DIRECTION OF HIS HEELS*
p. 16: WE WANTED TO SPY OUT THE COUNTRY IN
 ADVANCE*
————, 186:20, (November 15, 1913), 17–20, 42–43,
45–46
p. 17: WHEN HE HEARD THAT I WAS IN THE VICINITY THE
 CATTLEMAN RAN AWAY*
p. 18: I BROKE THE ICE AND WATERED MY NITRO-
 GLYCERINE*
p. 19: OF COURSE THE RURALES OR THE NATIVES WOULD
 KILL ME IN THE END*
p. 20: WE DROVE FOR TWO DAYS BEFORE WE REACHED
 THE REGION OF FORT COBB*
————, 201:1 (July 7, 1928), 30
WAR PARTY #5* (color) (ad for Reo Motor Car Company)

Saturday Night, 5:19 (June 28, 1924), 7
"Charles Russell: Artist and Range Rider," by V. A. C.
James
Charles Russell Cowboy Artist (photo)
————, 7:12 (January 29, 1927), 7
COUNTING COUP (bronze)

Scholastic News Time, 24:6 (March 6, 1964), cover
JERKED DOWN (postage stamp)
WAGON BOSS

Scholastic Vacation Fun, 1:4 (July 21, 1961), 5
COWBOY LIFE
CMR (photo)

Scribner's Magazine, 37:2 (February, 1905), 30, 158–
162
"Some Incidents of Western Life"
p. 30: photo of Russell and editorial comment
p. [159]: A BAD HOSS* (color)
p. [160]: "BUCCAROOS" FROM THE N–N OUTFIT ON THE
 BIG DRY IN MONTANA* (color)
p. [161]: 1876—THE CUSTER FIGHT* (color)
p. [162]: AN OLD-TIME HUNTING PARTY* (color)
————, 38:1 (July, 1905), ads 86
A BAD HOSS
————, 38:4 (October, 1905), ads 31
A BAD HOSS (in ad for *Western Life* set; cf. Sec. V)
————, 70:2 (August, 1921), 146–150
"Four Paintings by the Montana Artist, Charles M.
Russell"
p. 147: PIEGANS*
p. 148: WHERE (i.e., WHEN) SHADOWS HINT DEATH
p. 149: WHERE TRACKS SPELL MEAT
p. 150: WHEN LAW DULLS THE EDGE OF CHANCE
————, 84:6 (December, 1928), ads 6
A BRONC TWISTER* (model, in ad for Grand Central
Art Galleries)

Shamrock (Spring, 1959), 10–11
(house organ of Shamrock Oil & Gas Corp.)
JOE SLADE—KILLER, i.e., KILLING OF JULES RENI BY
 SLADE

Signature, The Diners Club Magazine, 1:9 (September,
1966), 50–54
"Charles Marion Russell: Cowboy Artist," by Liva
Baker
p. [51]: FREE TRAPPERS (color)
p. [52]: Charles M. Russell (portrait by William G.
 Krieghoff) (color)
 WAITING FOR A CHINOOK (color)

Soil Conservation, 26:6 (January, 1961), 124
THE TRAIL BOSS (part)

South Plains Opportunity, 4 (October, 1934), 3
BRONC TO BREAKFAST

Southwest Review, 30:4 (Summer, 1945), 331
Article by Ramon F. Adams mentions CMR.
————, 31:2 (Spring, 1946), 173
Article by Ramon F. Adams mentions CMR.

Southwestern Art, 1:1 (Spring, 1966), 30–33
"Charles M. Russell's early days," by Finck David
p. 30: WAITING FOR A CHINOOK
p. 32: MULE DEER
————, 1:2 (Summer, 1966)
recto b. cover: CORAZON* (color)

Sports Afield, 20:1 (January, 1898)
"The Medicine Arrow," by Anna P. Nelson (as told to
her by CMR), 20–21
cover: THE MEDICINE ARROW*
p. [6]: THE MEDICINE ARROW
p. [20]: SHIELD, TOMAHAWK, PIPE, AND PAINTED ROBE*
p. 21: STANDING FEARLESSLY, HIS ARMS THROWN
 DOWNWARD, EXPOSING HIS BREAST*

Sports and Hobbies, 3:5 (August, 1929), 3–4
"The Old West in Charles Russell's Statuary," by
Frank Geritz (reprinted from *Touring Topics*)
p. 3: CHARLES M. RUSSELL, i.e., ON NEENAH (model)
 CHANGING OUTFITS (model)
p. 4: (THE) WATCHER OF THE PLAIN[S] (bronze)
 THE LUNCH HOUR (model)
 ON THE TRAIL (model)

Stockman Magazine, 27:5 (May, 1960), 1, 14–15
"Cattle Came Early to Montana and Stayed to Prosper,"
by R. H. Fletcher
cover: A RACE FOR THE WAGONS

p. 1: THE ROUNDUP #2
THE LONGHORN

Sunset, 49:4 (October, 1922), 27–28
"An Artist in Oil and Bronze," by Ona Ellis Smith
Portrait of CMR
THE NAVAJOS #3*
BUFFALO HUNT (bronze)
————, 57:6 (December, 1926), 89
"In Memoriam. Charles M. Russell." Portrait.

Texas Livestock Journal, 3:3 (March 15, 1944), 12–B
RANGE MOTHER

Texas Outlook, 33:1 (January, 1949)
(house organ of Texas State Teachers Association)
cover: INDIAN HUNTERS' RETURN (color)

Think, 25:8 (August, 1959)
(house organ of International Business Machines)
"He Sketched the West in Bronze," by John R. Hamilton
p. 28: A BRONC TWISTER (bronze)
p. 29: CMR statue by Weaver (photo)
THE COYOTE, i.e., WOLF WITH BONE (bronze)
THE MEDICINE MAN (bronze)

This Earth, 16:1 (February–March, 1963), 8–9
(house organ of Permanente Cement Company)
THE SCOUT #4
THE JERK LINE

Time Magazine, 42:14 (October 4, 1943), 98
CITY LIFE IN BUTTE, i.e., SHOOTING UP THE TOWN
————, 60:24 (December 15, 1952), [84]
"Old Montana Master"
————, 62:14 (October 5, 1953), 89
"Charlie's Museum"
photo of CMR at work on THE SALUTE OF THE ROBE
TRADE
————, 63:1 (January 4, 1954), 32
"Art for the Bank"
————, 68:26 (December 24, 1956), [34–35]
LEWIS AND CLARK MEETING INDIANS AT ROSS' HOLE
(color)
————, 70:5 (July 29, 1957), 60
"Charlie goes to Washington"
p. 63: CMR statue by Weaver (photo)
————, 77:11 (March 10, 1961), 78–81
"Museum of Yippee-Yi-Yo"
p. 79: WILD MEAT FOR WILD MEN (color)
THE WEAVER (bronze)
(THE) BUFFALO HUNT (bronze)

Together, 2:7 (July, 1958), [38–39]
'BROTHER VAN' SHOOTING BUFFALO, i.e., RIDING TOWARD
THE FRONT OF THE STAMPEDING BEASTS, BROTHER VAN
SHOT THE HERD LEADER IN THE HEAD (color)

Touring Topics, 21:6 (June, 1929), 44–45, 53–54
"The Old West in Charles Russell's Statuary," by
Frank Geritz
p. 44: IT'S NO LADY'S JOB* (model)
MOUNTAIN MOTHER (bronze)
THE BLUFFERS (bronze)
NATURE'S CATTLE (bronze)
WHERE THE BEST OF RIDERS QUIT (bronze)
THE HORSE WRANGLER (bronze)
THE WEAVER (bronze)
WILL ROGERS* (bronze)
JIM BRIDGER* (bronze)
SMOKING UP* (bronze)
THE ENEMY'S TRACKS (bronze)
THE SPIRIT OF WINTER* (bronze)
MEDICINE WHIP* (bronze)
p. 45: CHARLES M. RUSSELL, i.e., ON NEENAH* (model)
(THE) WATCHER OF THE PLAIN[s]* (bronze)
THE LUNCH HOUR* (model)
ON THE TRAIL* (model) (later, WHITE MAN'S
BURDEN and NAVAJO SQUAW)
CHANGING OUTFITS* (model)

Treasure State, 1:23 (October 10, 1908), 4
"Art in Montana"
————, 1:34 (December 26, 1908), [3]
"The Literature of the West"
————, 1:37 (January 16, 1909), 8
Photo of CMR in Wallace Coburn ad for prints
————, 1:39 (January 30, 1909), 13, [24]
THE PROSPECTORS #2 *
NOW, HERDER, BALANCE ALL
————, 1:40 (February 6, 1909), [19]
COWBOY STANDING RIGHT HAND ON HIP
COWBOY, SIDE VIEW, CIGARETTE IN LEFT HAND
————, 1:46 (March 20, 1909), [19]
same as item immediately preceding
————, 1:47 (March 27, 1909), [19]
same as item immediately preceding
————, 2:7 (June 19, 1909), [24]
OUT ON THE PRAIRIE'S ROLLING PLAIN
————, 2:8 (June 26, 1909), 5, [24]
"Montana Fine Art"
OUT ON THE PRAIRIE'S ROLLING PLAIN
————, 2:20 (September 18, 1909), 9
Mrs. Charles M. Russell (photo)
————, 2:24 (October 16, 1909), [3], [24]
"Our Homeless Indians"
OUT ON THE PRAIRIE'S ROLLING PLAIN

Note: same illustration appears in Treasure State Art Collection ad on back cover of issues of October 9, October 23, October 30, November 6, and November 13, 1909.

——, 3:30 (November 26, 1910), 13
Charles M. Russell, Artist (photo)

——, 5:31 (December 21, 1912)
(Christmas Number. Magazine published in Butte)
cover: THE KID ROAD AGENT* (color)

True, The Man's Magazine, 21:121 (June, 1947), 52–55, 124, 127
"Charles Russell, Cowpoke and Painter," by Oren Arnold
p. 52: COWBOY LIFE (color)
 photo of Russell
p. 53: CAPTURING THE GRIZZLY (color)
 THE BUFFALO HUNT #17 (color)
 IN WITHOUT KNOCKING (color)
p. 54: A SERIOUS PREDICAMENT, i.e., RANGE MOTHER
 SAGEBRUSH SPORT, i.e., DEATH LOOP
 WHEN HORSEFLESH COMES HIGH

——, 39:252 (May, 1958), 68–73
"Oilpaint and Warpaint," by Huntington Smith
p. 68: photo of Russell
p. 69: ON THE WARPATH #2 (color)
p. 70: IL BE THAIR WITH THE REST OF THE REPS* (color)
 REDMAN'S NEWSPAPER, i.e., AMERICA'S FIRST
 PRINTER (color)
 LADY BUCKAROO (color)
p. 71: MEN OF THE OPEN RANGE (color)
 WHEN TWO FRIENDS MEET, i.e., HERE'S HOPING
 YOUR TRAIL IS A LONG ONE (color)
 BEST WISHES, i.e., BEST WISHES FOR YOUR
 CHRISTMAS (color)
p. 72: LAUGH KILLS LONESOME (color)
 LEWIS AND CLARK MEETING INDIANS AT ROSS'
 HOLE
p. 73: INDIAN HUNTERS' RETURN (color)
 NATURE'S SOLDIERS* (color)
 PORTRAIT OF AN INDIAN (color)

True West, 1:1 (Summer, 1953), 9, 48–49
"A Pair of Outlaws," by Charles M. Russell
p. 9: I'M SCAREDER OF HIM THAN I AM OF THE INJUNS

——, 1:2 (Fall, 1953), 16–18, 52–53
"Longrope's Last Guard," by Charles M. Russell
p. 18: "PULLIN' MY GUN, I EMPTY HER IN THE AIR"

——, 3:1 (September–October, 1955), 47
BUNCH OF RIDERS (part)
This sketch has been adopted as the "mark" of the "Old Bookaroos" and appears at the head of their book review column in all subsequent issues.

——, 3:3 (January–February, 1956), 3
"Charley Russell's Last Photo," by Hildore C. Eklund [sic]
Beating Himself at Checkers (photo)

——, 4:1 (September–October, 1956), 1, 11
"Charlie's Big Mosquito," by Walter W. Raleigh
THE ROUNDUP #2 (part)

——, 4:3 (January–February, 1957), [3]
CAPTURING THE GRIZZLY
FIRST WAGON TRAIL
THE MAD COW
BLACKFEET BURNING CROW BUFFALO RANGE
b. cover: THE ROUNDUP #2 (part)

——, 5:1 (September–October, 1957), 44
"Charles M. Russell, Cowboy Artist" (book review)

——, 5:4 (March–April, 1958), 31, 40
"The Charles M. Russell Book" (book review)
THE COWBOY #2

——, 5:6 (July–August, 1958), 6
LEWIS AND CLARK STATUE—DESIGN BY C. M. RUSSELL

——, 6:3 (January–February, 1959), 14–16, 32–34
"Longrope's Last Guard," by Charles M. Russell
p. 16: "PULLIN' MY GUN, I EMPTY HER IN THE AIR"

——, 6:4 (March–April, 1959), 8–12
"Supreme Master of Western Art," by 'Tana Mac
p. 8: Charles M. Russell (photo)
p. 9: THIS IS THE KIND OF RIDER THAT LIVES IN THIS
 COUNTRY
 HE WAS A COWBOY*
p. 10: LEWIS AND CLARK MEETING THE FLATHEADS, i.e.,
 LEWIS AND CLARK MEETING INDIANS AT ROSS'
 HOLE
 WHEN THE LAND BELONGED TO GOD
p. 11: Nancy Russell and Charlie (photo)
 Russells with friends at Glacier Park (photo)
p. 12: Beating Himself at Checkers (photo)
 Charles M. Russell (photo)
 Interior of Studio (photo)

——, 7:2 (November–December, 1959), 61
THE JERKLINE

——, 7:3 (January–February, 1960), 5
THE JERKLINE

——, 7:6 (July–August, 1960), 58
"Cowboy Artist, Charles M. Russell" (book review)

——, 8:1 (September–October, 1960), 20–21, 62
"The Cowboy's Skypilot," by 'Tana Mac
p. 20: BROTHER VAN HUNTING BUFFALO, i.e., RIDING
 TOWARD THE FRONT OF THE STAMPEDING BEASTS,
 BROTHER VAN SHOT THE HERD LEADER IN THE
 HEAD

——, 8:4 (March–April, 1961), 49
THE TRAIL BOSS
INSIDE THE LODGE
MEN OF THE OPEN RANGE

The Treasure State

BUTTE, MONTANA

CHRISTMAS NUMBER

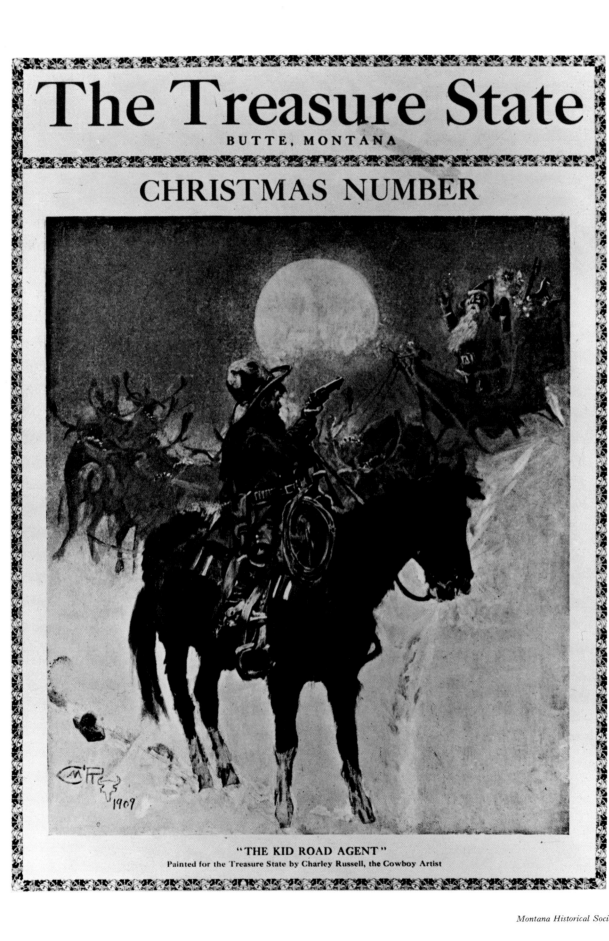

"THE KID ROAD AGENT"
Painted for the Treasure State by Charley Russell, the Cowboy Artist

———, 2:4 (August, 1897), 101
"Chas. M. Russell," by Wm. Bleasdell Cameron
photo of CMR; photo of CMR, his wife and his horse
Monte; photo of CMR home at Cascade
———, 2:5 (September, 1897), [122]
BESTED*
———, 2:6 (October, 1897), 152, 168, 172
THE OLD TRAPPER'S STORY*
reference to CMR
———, 2:7 (December, 1897), [182]
BEFORE THE WHITE MAN CAME #2*
———, 2:8 (January, 1898), [216]
LEWIS AND CLARK MEETING THE MANDANS*
This magazine discontinued publication under this
title; it was later published under title of *Field and
Stream, q.v.*

Western Horseman, 5:3 (May–June, 1940), 22
"Saddle Saga," by Yvonne Bergen
———, 14:10 (October, 1949), 6
"Charlie Russell's Love for Horses," by Ramon F.
Adams
MEAT FOR WILD MEN*
———, 15:2 (February, 1950)
"Joe de Yong, Author—Artist," 19, 41–43, contains
reference to CMR
———, 16:1 (January, 1951), cover, 18–19
"Charles Russell," by John Mariani
GIT 'EM OUT OF THERE* (color)
THE CINCH RING
———, 16:12 (December, 1951)
verso cover: THE CINCH RING
———, 17:11 (November, 1952), 20–21, 54–55
"Charlie Russell's Horses," by Ramon F. Adams and
Homer Britzman
p. 20: ON NEENAH (model)
 CMR funeral procession (photo)
p. 21: Russell on Grey Eagle (photo)
 Charles Russell with Neenah (photo)
 Dexter with Russell's trappings (photo)
 Charlie Russell on Monte (photo)
 Charlie on Red Bird (photo)
———, 23:8 (August, 1958), 24–25, 56–57
"C. M. Russell, The Cowboy's Artist," by Helen M.
Clark
p. 24: Charlie Russell in his log cabin studio (photo)
 Portrait of CMR (photo)
p. 25: The Russell home in Great Falls (photo)
 Statues of CMR by Cole, Weaver, Graber, and
 Lincoln (photos)
 Charles Russell's saddle (photo)
 Russell's tombstone (photo)
 Originals in Russell gallery (photo)

p. 57: Statues of CMR by Gebhart and Scriver
 (photos)
———, 26:2 (February, 1961), 2
THE BROKEN ROPE
(THE) WILD HORSE HUNTERS #2
———, 27:9 (September, 1962), 48–49, 86
"A Trip Back to the Old West," by Duane Valentry
p. 48: COWBOY ROPING A STEER, i.e., THE BOLTER #3
———, 31:6 (June, 1966), cover
LOOPS AND SWIFT HORSES ARE SURER THAN LEAD
———, 31:12 (December, 1966)
"The Winter of '49," by Cecil Dobbin, 6, 130–132
"Montana Historical Society Presents C. M. Russell,"
by Chan Bergen, 38–40, 110–111
p. 6: WAITING FOR A CHINOOK
p. 38: THE RANGE FATHER (bronze)
 Charles M. Russell (photo)
 The formal Charles M. Russell Room (photo)
 JIM BRIDGER (bronze)
p. 39: THE ROAD AGENT
 BRONC TO BREAKFAST
 Charles M. Russell Room (photo)
 LAUGH KILLS LONESOME
p. 40: MEN OF THE OPEN RANGE
 NATURE'S PEOPLE (bronze)
 BLACKFOOT WAR CHIEF (bronze)
 SIX REINS FROM KINGDOM COME (bronze)
 THE ROUNDUP #2
p. 110: THE WEAVER (bronze)
p. 111: [THE] HORSE WRANGLER (bronze)
 AN ENEMY THAT WARNS (bronze)
 THE WOLFER (part)

Western Life, 4:4 (April, 1966), cover, 3, [47]
[THE] HERD QUITTER
HIS HEART SLEEPS #2
Photo and biographical sketch of CMR

Western Livestock Journal, 33:8 (January, 1955), 35
THE TRAIL BOSS (part)
———, (October 29, 1964), 32
"All Around Cowboy to get Russell statue"
THE COWBOY ON A BUCKING BRONCO (bronze)

Western Sportsman, 10:1 (November–December,
1949), 10
NATURE'S CATTLE #1

Westerner (April, 1931), 16–17, 27
"The Cowboy Artist," by M. E. Plassman
Portrait of CMR (photo)

Westerners Brand Book (Chicago), 7:2 (April, 1950), 12
article (short paragraph)

———— (Chicago), 7:7 (September, 1950), 55
"Russell Paintings"
———— (Chicago), 7:11 (January, 1951), 83
"Painters of the Western Scene," by J. H. Euston, contains reference to CMR.
———— (Chicago), 7:12 (February, 1951), 89–91, 96
"Charles M. Russell, Best Artist of the West," by Karl Yost
———— (Chicago), 12:12 (February, 1956)
"Forgeries of the Works of Charles M. Russell," by F. G. Renner
p. 91: COWBOY LIFE
p. 95: RUNNING BUFFALO* (before repainting by CMR)
———— (New York), 1:4 (Autumn, 1954), 1
"Charlie Russell—The Unforgotten Man," by Norman A. Fox
———— (New York), 4:2 (Fall, 1957), 34
Mention of CMR and Wallis Huidekoper

Whoop-Up Trail. Annual Published by the Senior Class of the Conrad (Montana) High School, (1922). P. 5 reproduces a letter from CMR on the Whoop-Up Trail.

Wisconsin Agriculturist, 91:24 (December 19, 1964), 22–[23]
"He Kept Alive the Old West"

p. 22: THE CRYER (bronze)
 [THE] SURPRISE ATTACK
p. [23]: CHRISTMAS MEAT (color)
 Charles Marion Russell (photo)
 THE OLD TIME COW RANCH, i.e., IN THE OLD DAYS THE COW RANCH WASN'T MUCH

Wooden Box and Crate, 21:4 (Oct.–Nov.–Dec., 1959), 5
MEAT FOR THE WAGONS

World's Work, 22:3 (July, 1911), 14626–14635
"The Painter of the West that has passed. The work of Charles M. Russell, hunter, cowboy and artist, the painter of the cattle and Indian days," by Arthur Hoeber
p. 14626: NATURE'S CATTLE* (bronze)
p. 14627: Mr. Charles M. Russell (portrait)
p. 14628: AT ROPE'S END
p. 14629: (THE) WAGON BOSS
 SMOKE OF A FORTY-FIVE
p. 14630: (THE) MEDICINE MAN #2
p. 14631: JERKED DOWN
p. 14632: (THE) SUN WORSHIPPERS*
p. 14633: (THE) BUFFALO HUNT (bronze)
 COUNTING COUPE* [*sic*] (bronze)
p. 14634: MOUNTAIN SHEEP #1 (bronze)

Newspapers

RUSSELL'S FIRST MEXICAN PICTURE DRAWN ESPECIALLY FOR THE RECORD

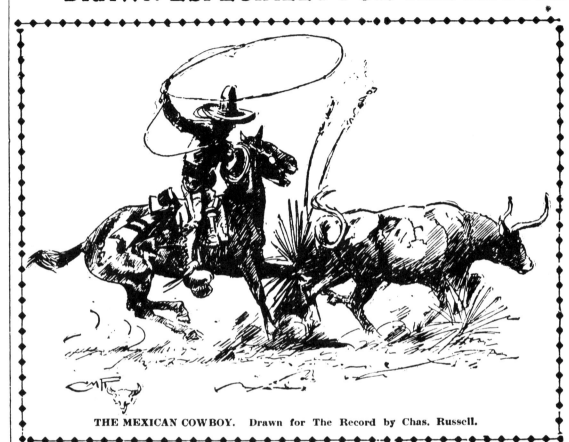

THE MEXICAN COWBOY. Drawn for The Record by Chas. Russell.

"Give yourself a chance," might well be the motto of Chas. Russell, the famous cowboy artist, who gave himself a chance to do the things he wanted to do, and made himself famous.

That there were no art teachers in Montana, where young Russell was "punching cattle" 20 years ago, no one to criticize and tell the pupil how to work, did not stop him from making an artist of himself. He bought a few tubes of paint, some brushes, and gave himself a chance.

He endeavored to paint western life just as he saw it. If he had canvas he used it, if not, a towel, or a piece of smooth wood, served as well. He carried his paints and brushes in his pockets, and after a day in the saddle would paint pictures of "the boys," or a bit of western landscape with a horseman in the foreground.

At first his work was crude in outline, but never in coloring, and gradually improved, until Russell "awoke one morning and found himself famous."

He is now 40, owns a splendid ranch at Great Falls, Mont., has a studio in his log house, and paints pictures to sell when he feels like it. Lovers of western art all over the country write to him for pictures but he pays no heed to letters, persons who want him to paint pictures for them must send a representative to him, or themselves make the request in person. A Mercantile place, Los Angeles, art store has asked Mr. Russell for six paintings, but he merely shrugged his shoulders, and whether he makes them or not, will depend on how he feels when he returns home.

One of the famous pictures of Russell's is "Watching the Trail," showing a group of Indians on horseback, horses and men craning their necks over a knoll of a hill, to better see an approaching line of immigrants. The picture was painted years ago in a western saloon for the amusement of a group of cowboys. As there was not a piece of canvas available, it was painted on a smooth towel. It is one of the best things he has ever done.

Russell is the real Bohemian, loving everything in nature, and all that is natural in life. Any affection of manner, or pretense to society, he scorns. He has a natural tendency to soft shirts and hats, and life in the saddle. He and his wife are at the Hollenbeck hotel after a tour of Mexico.

"I hate this hotel life," says Russell. "By the time the elevator shoots up the shaft a few floors, and I get out and take a few turns down the hall, I never can find where my bunk's kept."

Mr. Russell will make a series of Mexican pictures when the spirit moves him to do so.

The first Mexican picture he has ever made appears with this article and was drawn expressly for The Record. It shows the Mexican cowboy at work.

Newspapers

Albuquerque Tribune, November 24, 1964
PLANNING THE ATTACK

Anaconda Standard, December 15, 1901
ARRIVING AT THE ROAD RANCH FOR CHRISTMAS DANCE*
THE COWBOY #2*
THE STAGE DRIVER*
A FRENCH HALF-BREED*
His Home at Great Falls (photo)
THE PROSPECTOR*
THE BULL-WHACKER*
THE POST TRADER*
photo of CMR
sketch of CMR by Leppert
SINCERLY YOURS C M RUSSELL*
———, October 26, 1926, 1–2
"Charles M. Russell Treasure State's Cowboy Artist
is Fatally Stricken." Photo of CMR. Same spread on
p. 2 is in *Denver Post*, June 20, 1926, *q.v.*
———, December 11, 1952
"Malcolm S. Mackay Collection of Russell Paintings
Safe in Historical Society."

Austin Daily Texan, September 29, 1966
"New Art Book Due Next Month. America's foremost
'cowboy artist' rides again"

Beach Pictorial (Miami), January 27, 1927, 5
"The Story of a Painting"
SMOKE OF A 45 (i.e., FORTY-FIVE)

Big Horn County News, April 13, 1931
"Great Falls Sculptress Will Make Russell Statue For
Hall of Fame," by John K. Standish

Billings Gazette, September 4, 1955, 3
"Second Cousin of Charles Russell Recalls Incidents
of Noted Artist"
———, May 26, 1962, 3
LAST CHANCE OR BUST
———, April 28, 1963, Sec. II, p. 1
"The Old West Comes Alive. CMR in Music. In
Memorial with Another Art Discovery"
WHEN ROPES GO WRONG
BRONC TO BREAKFAST
———, September 20, 1964, 9
"Painting Set a Record"
ROPING A GRIZZLY, i.e., ROPING A RUSTLER

Boston Globe, November 21, 1928
"Painting of Charles Russell on Exhibition"
THE STRANGLERS

Bozeman Daily Chronicle, August 10, 1954
"Bozeman Old-Timer Was Russell Painting Subject"
BRONC TO BREAKFAST
———, August 28, 1954
"Local Man's Charlie Russell Sketches Printed First
Time" [*sic*]
THE COWBOY #2
THE PROSPECTOR
RED RIVER BREED, i.e., A FRENCH HALF-BREED
NORTHERN CREE, i.e., THE CREE INDIAN

Browning Montana Review, May 27, 1921
"Sale of Russell Painting for Ten Thousand Dollars
Sets New Mark for Montana artist; Does Some Fine
Bronze Work"
THE SALUTE OF THE ROBE TRADE
photo of CMR painting Fairbanks as D'Artagnan

Butte Daily Post, September 6, 1956
"Russell Water Color Found in Old Diary Believed to be the Oldest Painted by Famed Cowboy Artist"
————, January 17, 1957
"Russell Statue Hearing Sought"
————, January 21, 1957
"Russell Statue War Continues"
————, January 26, 1957
"Charles Russell Authority to Speak in Falls"

Butte Evening News, Christmas Number, 1905, 9, 49
"Charlie Russell, Montana's Cowboy Artist"
Charlie Russell's Cabin Studio (photo)
The Artist On His Cow Horse Neena (photo)
Chas. M. Russell (photo)
IN FOR CHRISTMAS*

Butte Inter Mountain, January 1, 1903, 9, 15, 16
"Russell, the Cowboy Artist and His Work" (full page, port., six photos of CMR on horseback)
A STAMPEDE #2*
CALLING THE HORSES*
THE BROKEN LARIAT*

Butte Miner, October 11, 1903, 5c
"Charles Russell, Cowboy Artist" (port.)
————, October 20, 1911, 2
"Picture Presented" (to President Taft)
————, July 16, 1916, 5
"A Cowboy's Paintings—Remarkable Pictures of the West That Seem to Promise the World a New Remington"
CHASED BY THE GRIZZLY, i.e., CRIPPLED BUT STILL COMING
WHEN BUFFALO WERE PLENTIFUL
SMUGGLERS CAUGHT ON THE FRONTIER, i.e., WHISKEY SMUGGLERS CAUGHT WITH THE GOODS
————, November 23, 1919, 2a
Russell in characteristic pose (photo)
Charles Russell, Montana Artist (portrait)
FAMOUS DUEL BETWEEN BUFFALO BILL AND YELLOWHAND*
LONG GEORGE BULLDOGGING A STEER*
SHELBY IN THE EARLY DAYS
BEST WHISHES TO THE P–C BUNCH
TRADERS GOING INTO LEWISTOWN OR REED'S FORT, i.e., REED'S FORT
Charles Russell, Montana Artist (photo)
————, October 26, 1926, 1
"Charles M. Russell, Famous Painter of Western Scenes, Succumbs at His Home at Great Falls" (photo)

(Butte) *Reveille*, September 17, 1907, 7
"Artist Russell Regrets Reform"

Bynum Herald, April 10, 1922
Ad for Russell pictures
WAGON BOX FIGHT*
————, May 1, 1922
BUFFALO HOLDING UP MISSOURI RIVER STEAMBOAT
————, June 5, 1922
"The Pinto," by Charles M. Russell
ALL CONVERSATION WAS CARRIED ON BY THE HANDS
THE CHIEF FIRED AT THE PINTO #1
HIS FIRST YEAR
TWO RIDERS, ONE LEADING A PACK HORSE
————, June 26, 1922
GLASS ATTACKED BY GRIZZLY, i.e., ATTACKED BY GRIZZLY BEAR

Calgary Daily Herald, September 4, 1912
"Imposing Array of Pictures of Plains"

Carson, Nevada Appeal, November 17, 1955, 4
"Five Men Named to Cowboy Hall of Fame"

Casper, Wyoming Tribune-Herald, April 1, 1954
"Charles Russell Paintings in Montana Capitol Damaged"

Cheely-Raban Syndicate
William W. Cheely and H. P. Raban formed a partnership and wrote a series of 52 stories, which were syndicated in Sunday editions of newspapers from coast to coast, some 70 of them. These appeared under the general heading of "Back Trailing on the Old Frontiers." A selection of 14 of these stories appeared in the book of the same name. In most cases this was the first appearance of the CMR illustrations, and it will be noted that the titles were subsequently changed in many instances.
Mar. 4, 1922: THE DEATH OF LASALLE*
Mar. 12, 1922: LA VERENDRYES DISCOVER THE ROCKY MOUNTAINS*
Mar. 19, 1922: CAPTAIN GRAY MAKING GIFTS TO THE INDIANS AT THE MOUTH OF THE COLUMBIA RIVER*
Mar. 26, 1922: COULTER'S [sic] RACE FOR LIFE*
Apr. 2, 1922: THE HIDE TRADE OF OLD CALIFORNIA*
Apr. 9, 1922: THE LAST OF THE TONQUIN*
Apr. 16, 1922: FORT MANUEL, i.e., BUILDING FORT MANUEL IN 1807
Apr. 23, 1922: ADVANCE OF BLACKFEET TRADING PARTY*
Apr. 30, 1922: BUFFALO HOLDING UP MISSOURI RIVER STEAMBOAT*
May 7, 1922: ROCKY MOUNTAIN TRAPPERS DRIVING OFF HORSES STOLEN FROM CALIFORNIA MISSION*

May 14, 1922: BRIDGER DISCOVERS THE GREAT SALT LAKE*

May 21, 1922: RADISSON RETURNS TO QUEBEC WITH 350 CANOES LOADED WITH FURS*

May 28, 1922: PAWNEES SEE "WATER MONSTER"*

June 4, 1922: FINK KILLS HIS FRIEND*

June 11, 1922: ONATE'S MARCH INTO THE NEW MEXICAN COUNTRY*

June 18, 1922: CARSON DEFEATS FRENCH BULLY IN HORSEBACK DUEL*

June 25, 1922: ATTACKED BY GRIZZLY BEAR*

July 2, 1922: CORONADO ADVANCING AGAINST A CITY OF CIBOLA*

July 9, 1922: STAGE COACH ATTACKED BY INDIANS*

July 16, 1922: ANNIHILATION OF FETTERMAN'S COMMAND*

July 23, 1922,
No. 1: INDIAN BATTLE*

July 23, 1922,
No. 2: (THE) WAGON BOX FIGHT

July 30, 1922: MEETING OF SACAJAWEA AND HER RELATIVES OF THE SHOSHONE TRIBE*

Aug. 6, 1922: EARLY DAY WHITE BUFFALO HUNTERS*

Aug. 13, 1922: ATTEMPTED MASSACRE OF BLACKFEET INDIANS AT FORT MCKENZIE*

Aug. 20, 1922: A TEXAS TRAIL HERD*

Aug. 27, 1922: BATTLE BETWEEN CROWS AND BLACKFEET*

Sept. 3, 1922: A PONY EXPRESS RIDER ATTACKED BY INDIANS*

Sept. 10, 1922: A "SWING" STATION ON THE OVERLAND*

Sept. 17, 1922: KELLY'S DUEL WITH SIOUX INDIANS*

Sept. 24, 1922: PLUMMER AND TWO FOLLOWERS KILL FORD*

Oct. 1, 1922: WILD BILL'S FIGHT WITH MCCANDLAS GANG*

Oct. 8, 1922: BLACKFEET TRADING PARTY IN SIGHT OF FORT BENTON*

Oct. 15, 1922: THE BATTLE OF BEAR PAWS*

Oct. 22, 1922: CURLEY REACHES THE FAR WEST WITH THE STORY OF THE CUSTER FIGHT*

Oct. 29, 1922: A DIAMOND R MULE TEAM OF THE '70S*

Nov. 5, 1922: MOUNTED POLICE PATROL CAPTURES AMERICAN WHISKY RUNNERS*

Nov. 12, 1922: BENT'S FORT ON ARKANSAS RIVER*

Nov. 19, 1922: PLACER MINERS PROSPECTING NEW STRIKE*

Nov. 26, 1922: RUSTLERS CAUGHT AT WORK*

Dec. 3, 1922: END OF OLD BILL WILLIAMS*

Dec. 10, 1922: THE FORT AT THREE FORKS*

Dec. 17, 1922: CHARGE OF CHEYENNES LED BY ROMAN NOSE*

Dec. 24, 1922: CHEYENNES WATCHING UNION PACIFIC TRACK LAYERS*

Dec. 31, 1922: CODY'S FIGHT WITH YELLOWHAND*

Jan. 7, 1923: KILLING OF JULES RENI BY SLADE*

Jan. 14, 1923: BEFORE THE WHITE MAN CAME #4*

Jan. 21, 1923: A MANDAN VILLAGE*

Jan. 28, 1923: THE KID SHOOTS DOWN TWO PRISONERS IN COLD BLOOD*

Feb. 4, 1923: INDIANS MEET FIRST WAGON TRAIN WEST OF MISSISSIPPI*

Feb. 11, 1923: WORK ON THE ROUNDUP*

Feb. 18, 1923: PLUMMER'S MEN AT WORK*

Chicago American, July 12, 1956
"Cowboy Artist," by Nate Gross in "Town Tattler" column

Chicago Daily News, February 27, 1963, 29
"The Takeover of the West," (review of *Frontier Omnibus*)
CHEYENNES WATCHING UNION PACIFIC TRACK LAYERS
BEST WHISHES TO THE P-C BUNCH

Chicago Examiner, January 31, 1915, 10
"25 Wild West Paintings Are Exhibited Here"
A DANGEROUS CRIPPLE, i.e., CRIPPLED BUT STILL COMING

Chicago Tribune, January 1, 1950, Picture Section
COVER: RETURN OF THE WARRIORS (color)
p. 6: TIGHT DALLY AND LOOSE LATIGO
AT THE END OF THE ROPE
WHEN THE TRAIL WAS LONG BETWEEN CAMPS
WHERE GREAT HERDS COME TO DRINK
p. 7: WHEN WAGON TRAILS WERE DIM
WAITING FOR A CHINOOK: THE LAST OF 5,000, i.e., THE LAST OF 5000
THE CHALLENGE #2
————, January 1, 1950, Grafic Magazine, 4
"Charlie Russell—Genius in Chaps," by Homer E. Britzman
THE RANGE FATHER (bronze)
Charles M. Russell on Nenah [*sic*] (photo)
Russell, William S. Hart and Will James (photo)
————, January 16, 1955
"The Vanished West of Charlie Russell"
"The Cowboy Painter is Famed for His Humor as Well as for His Memorable Pictures"
THE FIRE CANOE* (color)
BLACKFOOT CHIEFTAIN (color)
WAR PARTY #7 (color)
————, December 22, 1957, Magazine of Books, 1
"Cowboy Artist: His Life and Work"
DOE AND FAWNS, i.e., FAWNS NUZZLING FOR DINNER
PETE HAD A WINNING WAY WITH CATTLE
TIME TO TALK, i.e., THE MOUNTAINS AND PLAINS SEEMED TO STIMULATE A MAN'S IMAGINATION
SELF-PORTRAIT #4

JIM BRIDGER DISCOVERING GREAT SALT LAKE, i.e.,
 BRIDGER DISCOVERS THE GREAT SALT LAKE
THE COWBOY #2
THEY'RE ALL PLUMB HOG WILD
GRABBIN' FOR GUMBO, i.e., ABOUT THE THIRD JUMP CON
 LOOSENS
———, March 5, 1961, part 4, p. 6
"Real and colorful history of the Montana range"
THE PROSPECTORS #2
———, February 2, 1964, Section 1, p. 22
"New Stamp Notes Cowboys"
JERKED DOWN
———, April 19, 1964, Section 5, p. 7
"Russell Reproduction Gets No Raves" by Richard
McP. Cabeen

Christian Science Monitor, April 25, 1931
"Montana Cowboy Statue to Be Placed in the Hall
of Fame, Washington." Photo of Mrs. Lincoln and
model.
———, July 19, 1947, 7
"Cowboy Artist," by June Lee Smith
———, June 17, 1959
"Montana Acclaims Artist of Old West"
LEWIS AND CLARK MEETING INDIANS AT ROSS' HOLE
Charles M. Russell (photo)
Four competing statues depicting artist Russell (photo)
———, February 11, 1961, 6
"Flair and Flavor of the Old West, Frontier action
Paintings by Russell"
———, March 9, 1961
WILL ROGERS (bronze)

Cody Enterprise, April 23, 1959
p. [7]: SMOKING UP (bronze)
 A BRONC TWISTER (bronze)
p. [17]: HOW*
 WILL ROGERS (bronze)
p. [18]: THE BLUFFERS (bronze)
p. [21]: THE STORY TELLER #1*

Conrad Independent, March 11, 1920
"Russell's Great Uncle was William Bent"
Russell as He Looks Today; Mrs. C. M. Russell;
Russell in Indian Costume (photos)

Corpus Christi Caller, January 24, 1962
"A 100-million-acre range"
THE TRAIL BOSS

Cut Bank Pioneer Press, December 13, 1912, 2
ROUNDING UP AN UNRULY STEER ON THE BLACKFEET
 INDIAN RESERVATION, i.e., THE BROKEN LARIAT

Daily Missoulian, October 26, 1926

"Montana's Famous Artist Lays Down His Brush"
Portrait

Dallas Morning News, October 30, 1927
"Posthumous Volume is Acclaimed Most Beautiful
Book of the West" by J. Frank Dobie

Davenport (Iowa) *Democrat and Leader*, Tuesday,
January 31, 1950, 9
"Judge Bollinger tells Contemporary Club of Life and
Accomplishments of Charles Russell, Famous Cowboy
Artist and His Personal Friend"
FIRST WAGON TRACKS, i.e., FIRST WAGON TRAIL
THE KILL

Denver Post, June 20, 1926, Magazine Section, 2
"Romantic Secrets of 'Cowboy' Russell, Millionaire
Painter"
BULLARD'S WOLVES, i.e., RIGHT THEN'S WHERE THE BALL
 OPENS
WAITING FOR A CHINOOK
photos of Mrs. Russell and of CMR at his easel;
portrait of Russell by Hazard.
———, February 23, 1947, Rocky Mountain Empire
Magazine, 4
"Cowpoke's Artist," by Ed Orloff; portrait of CMR
ROPING A WOLF #2
WOUND UP
THE TENDERFOOT #1
———, June 24, 1957, 23
"Montanans split on statue of cowboy artist"
Six versions of Charles Russell (models in competition
for Statuary Hall)
Charles M. Russell (photo)
———, March 18, 1962, Sunday Magazine, 12
TELL 'UM YOU HEAP GOOD CHRISTMAS
———, March 22, 1964, Sunday Empire Supplement,
22, 23
"A Stamp for Charlie Russell"
JERKED DOWN (color and reproduction of stamp also)
BRONC TO BREAKFAST
THE HORSE WRANGLER (bronze)
———, Sunday Empire Magazine, 1966. See adden-
dum 3, p. 307.

Denver Republican, August 23, 1903, 15
"Striking Work of Russell, Montana Cowboy Artist"
C. M. Russell, Montana's famous cowboy artist (photo)
THROWING ON THE HEEL ROPE
THE SCOUT, i.e., THE ALERT
THE ATTACK #3*
CUSTER, i.e., CUSTER'S LAST BATTLE

Denver Times, August 13, 1902, 8
"Interview with Charles M. Russell"

Des Moines Sunday Register, December 30, 1951, Magazine, 8
AT THE END OF THE ROPE (color)

Dixon Herald, February 3, 1917
"Russell, The Cowboy Artist, Writes of Prevaricators He Has Met"
CHARLES M. RUSSELL (CARICATURE STATUETTE)*

Fergus County Argus, Lewistown, Montana, Pictorial Edition (1907)
Photo of interior of Bank of Fergus County at Lewistown, Montana, showing the two Russell pictures painted on vault door.

Fergus County Democrat, December 13, 1904, 3
"Russell Tells of Early Days"

Ft. Benton River Press, March 5, 1890
"Col. J. H. Rice has become the . . . owner"

Fort Worth Star-Telegram, January 21, 1962
"Art Museum to have special Russell show"
———, January 23, 1962, 3, 8
"History of Russell's Art Works Told at Preview"; one photo
"Russell Warmth Shows but Cold Delays Art Event"; one photo
———, January 25, 1962
"Russell Art Esteemed, Montana Official Says," three photos
———, October 2, 1966, 2-G, 3-G
"Love of West, Art Shown Early by Russell," by Frederic Renner; photo
———, October 9, 1966, 1-G, 7-G
"Charles Russell—II. Cowboy Finds Art Career," by Frederic G. Renner
p. 1-G: LOST IN STORM, i.e., LOST IN A SNOWSTORM— WE ARE FRIENDS (color)
———, October 16, 1966, 18-A, 19-A
"From Montana Saloons Russell's Art Earned National Stature," by Frederic G. Renner

Free Press (Colorado Springs), October 21, 1965, 13
"Famous Collection to Open Friday with Paintings, Sculpture on West"

Grass Range Review, April 10, 1922
Ad for Russell pictures
DISCOVERY OF THE ROCKY MOUNTAINS BY LA VERENDRYES, i.e., LA VERENDRYES DISCOVER THE ROCKY MOUNTAINS

Great Falls Daily Leader, March 19, 1927
"A Tale of Two Pioneers," by Dan R. Conway; portrait. Second stanza only of "Charley Russell's Sentiments."
JAKE HOOVER'S CABIN, i.e., OLD HOOVER CAMP ON SOUTH FORK OF JUDITH RIVER
———, March 26, 1927
"A Tale of Two Pioneers," by Dan R. Conway, second installment; three photos of Russell.
———, April 2, 1927
"A Tale of Two Pioneers," third installment; photo of CMR on Monte.
———, April 9, 1927
"A Tale of Two Pioneers," fourth installment. Photo of CMR and Teddy Blue; photo of Bancroft bust of CMR.
———, April 16, 1927
"A Tale of Two Pioneers," fifth installment; two photos of CMR.
———, April 23, 1927
"A Tale of Two Pioneers," last installment; photo of CMR at work in studio.
———, April 25, 1927
"Sam Bass," by Dan R. Conway. Photo of CMR and Teddy Blue; sketch from title page of 1899 Ridgley edition of *Rhymes*; sketch from *More Rawhides*.
———, April 14, 1931
"Chamber Group Indorses Falls Model"
———, December 31, 1954
"Two Russell Paintings on Loan Here for First Public Exhibition"
INVOCATION TO THE SUN*
THE ATTACK #3
———, January 30, 1957
"Life of Russell Told in Talk by F. G. Renner to Rotarians"
———, March 16, 1964, 6
THE BULL-WHACKER
———, March 17, 1964, 2
"Interest in Russell Art Will get Impetus This Year, Says Renner"
———, March 19, 1964, 1, 18
"Speakers Laud C. M. Russell at Stamp Issuance Ceremonies"

Great Falls Leader, October 18, 1906, 5
"Brown Prizes His Russell Pictures" (quotes letter of Nov. 14, 1903, referring to Cut Bank Brown)
———, 1907, Reclamation Edition, cover
THE FIRST FURROW* (color)
———, March 16, 1909, 3
"Russell's Pictures are Expensive" (first advertisement for set of 16 "Western Types")
THE WOLFER
———, October 25, 1926
"Charles M. Russell Is Dead," pp. 1 and 3. "Deaths

and Funerals," Russell, p. 3. "Russell Will be Borne to Grave by Beloved Horse," p. 1.
———, October 26, 1926
"Deaths and Funerals," Russell, p. 3. "Riderless Horse to Follow Master to Grave," pp. 1 and 2. "State of Montana Owns One of C. M. Russell's Finest Works," p. 3.
———, October 27, 1926
"Deaths and Funerals," Russell, p. 2. "Falls Bids Farewell to Russell," pp. 1 and 2. " 'He'll Give Me a Foot Up, If I Meet Him Over There,' Says Russell's Old Friend," p. 1. "How!" (editorial), p. 4. "Motion Pictures of Funeral of Charles Russell," p. 5.

Great Falls Tribune, January 14, 1898, 4
"The Cowboy Artist"
———, April 14, 1898, 4
"Russell's Last Painting"
———, September 18, 1898
Mentions masterpieces of Charles Russell in "Cascade Siftings"
———, January 28, 1899, 4
"A Fine painting"
———, May 28, 1899, 6
"Russell's Latest"
———, May 30, 1899, 2
"Russell's Pen Pictures"
———, September 18, 1899
"Cascade Siftings"
———, April 28, 1900, 3
"The Cowboy Artist"
———, July 4, 1900, 24–25
INCIDENTS OF A NORTHERN MONTANA ROUND-UP, i.e., BREAKING CAMP #1
A TYPICAL ROUND-UP CAMP, i.e., COWBOY CAMP DURING THE ROUNDUP
CAPTAIN LEWIS AND HIS SCOUTS DISCOVERING THE GREAT FALLS OF THE MISSOURI IN 1805*
———, August 30, 1900, 10
Charley In His New Home (photo)
———, November 25, 1900, 9
"The Adventures of a Pioneer Plainsman," by Forrest Crissey
LOST IN A SNOWSTORM—WE ARE FRIENDS
COON-CAN—A HORSE APIECE
———, December 23, 1900, 13
"She Leads Ten Thousand to Freedom"
A NEZ PERCE*
———, February 10, 1901, 17
"Men of the Mountains and Plains," by Forrest Crissey
A ROPER*
AN OLD TIME STAGE COACH*
COWBOYS OFF FOR TOWN*

THE ROUNDUP #1*
———, March 16, 1901, 9
ROUND UP IN GREAT FALLS*
———, April 28, 1901, 9
"Lewis and Clark's Arrival at the Falls of the Missouri"
DISCOVERY OF THE GREAT FALLS OF THE MISSOURI BY MESSRS. LEWIS AND CLARK, IN 1805, i.e., DISCOVERY OF THE GREAT FALLS OF THE MISSOURI BY LEWIS AND CLARKE [*sic*], 1805
———, June 30, 1901, 10
"The Days of the Vigilante in the Territory of Montana"
AN OLD TIME STAGE COACH
———, July 28, 1901, 13
"Charles Russell and His Works"
Charles M. Russell (photo)
THE ALERT
———, August 25, 1901, 13
"Some Great Falls Artists and their Clever Work"
———, December 8, 1901, 13
Ad for *Pen Sketches*
THE LAST OF THE BUFFALO
———, December 14, 1902, 12
Ad for *Pen Sketches*
INITIATED
———, December 21, 1902, 11
"Waiting for a Chinook—The Last of Five Thousand"
"The 'Cowboy Artist' Tells How He Came to Draw His First Sketch, One That Has Brought Him Fame"
Charles M. Russell (photo)
———, January 13, 1903, 3
"Charles Russell Tells of His Cowboy Life"
———, October 9, 1903, 8
"Russell's Work at St. Louis Fair"
———, December 24, 1903, 5
"Narrow Escapes in the Life of a Great City. The Cowboy Artist Tells of His Thrilling Experience in Dodging Automobiles and Street Cars in the World's Fair City" (quotes letter of December 17, 1903, to Bill Rance in full; *vide Paper Talk*)
———, January 26, 1904, 4
"Praises Work of Russell's"
——— February 16, 1904, 8
"Prefers Ulm to New York as Place of Residence"
Chas. M. Russell (photo)
———, August 5, 1905, 4
"Gila Monster Is Dead"
———, February 11, 1906, 8
"He Is Going to Old Mexico"
Charles M. Russell (photo)
———, April 8, 1906, 8
"Cowboy Artist in Mexico"
———, December 16, 1906, 21, 25, 30

THE GREAT FALLS LEADER
RECLAMATION EDITION

Great Falls, 1907 Montana

Montana Historical Society

First appearance of THE FIRST FURROW

"He Painted With God-Given Brush asserts E. H. Cooney"

———, November 17, 1926, 6

"Another Safedoor Russell is Owned by Ludwig Garage"

——— January 22, 1927, 12

"Noted Artists Join in Tribute to Memory of Charlie Russell"; "Name is First, Says Will James"

———January 23, 1927, 2

"24 Russell Paintings Composed National Art Exhibit Recently Held in Santa Barbara"; photo, Charlie Beats Himself

———, March 27, 1927, 19

"Movement to Make Great Falls Art Center of Northwest Crystallizes in Exhibit Which Will Be Opened Thursday"; "Will Rogers to Have Part in Ceremony." Photo.

———, March 31, 1927, 9

"Russell Memorial Art Exhibit Opens at 2 o'clock Today"

———, April 1, 1927,

p. 6: "Will Rogers Visits Haunts of Russell After Old Time Reception Here"

p. 7: "Como Gathers Old Photos of Cowboy Artist"

p. 8: "Russell Memorial Exhibit is Blaze of Portrait Color"

p. 11: "Rogers Pledges $500 'Loot' to C. M. Russell Memorial"

———, May 1, 1927, 9

"Old Timers Hold Russell Greatest of All Western Painters, says Linderman"

———, June 23, 1927, 14

"Russell Home in California a Gem of Art"

———, June 30, 1927, 8

"Dan R. Conway Starting Upon Russell Book"

———, September 13, 1927, 14

"Purchase of Russell Cabin for Memorial to be Decided Upon"

———, September 25, 1927, Sec. 2, p. 1

"Four Early Period Russells Received at State Library"

———, October 23, 1927, 2

"W. S. Hart Gives First Cash for Russell Memorial"

———, December 4, 1927, Sec. 2, p. 1

"C. M. Russell Memorial is Now Practically Assured"

———, December 5, 1927, 12

"Railway to Loan Paintings by C. M. Russell to Memorial"

———, October 24, 1928

City Today Observes Anniversary of Russell's Death (photo)

———, January 25, 1929, 1

"Russell Memorial Statue Proposal Being Pushed at Helena"

———, March 19, 1929, 17

"Today is 65th Anniversary of Charley Russell's Birth"

———, March 21, 1929, 4

"Extending the Influence of Charles Russell" (editorial)

———, April 29, 1930, 4

"The Russell Statue" (editorial)

———, June 16, 1930, 12

"Charles M. Russell Cabin Will Soon Open to Public"

———, July 4, 1930, 14

"Russell Log Cabin Studio Will Open This Afternoon"

———, September 16, 1930, 5

"Russell Was Nation's Best Artist of Life in the West"

———, October 19, 1930, Sec. 2, p. 1

"Irvin S. Cobb Pays Tribute to Memory of Charley Russell"

———, December 21, 1930, Sec. 2, p. 1

SACAJAWEA AND LEWIS AND CLARK, i.e., LEWIS AND CLARK REACH SHOSHONE CAMP, LED BY SACAJAWEA, THE "BIRD WOMAN"

———, December 22, 1930, Sec. III, p. 11

"Malta Hotel Man Owner of Art Gallery"; "William Barwarth Has Portion of August Fack Collection from Helena"; "Mr. Barwarth has one of the few remaining copies of a booklet published by August Fack many years ago in which the collection, famous throughout the northwest, was described by A. A. Lathrob (ca. 1915)"

———, May 24, 1931

"Selection of Russell Model is Explained by Member of Commission"

———, April 2, 1933

"Charles Russell got job with roundup when just a kid," by L. L. Jordan. "Sim Hobson Sent the Boy to Ask for Work as a Night Herder; Brewster Said He Turned Out to be a Good Cowboy" (Article based on the recollections of Horace DeWitte Brewster)

WHEN I WAS A KID

CHARLIE IN ACTION, i.e., RUSSELL RIDES REAL OUTLAW

———, August 13, 1933

"Riding the High Country," by Pat Tucker

———, August 1, 1937

"1887—Cascade County Jubilee Edition—1937" (tabloid, 64 pp.). Four illustrations by CMR.

ROPING THE BUFFALO

THE POST TRADER (vignette)

LEWIS AND CLARK REACH SHOSHONE CAMP, LED BY SACAJAWEA, THE "BIRD WOMAN"

WHEN SHADOWS HINT DEATH

———, January 12, 1941, 4

"Russell Statue Should be Placed in National Hall" (editorial)

———, May 21, 1941, 5

"Chas. Russell Art Sells for $40,000"

————, July 20, 1941, 6
"Russell Art Owned in America and England"
————, July 22, 1945
LEWIS AND CLARK STATUE—DESIGN BY C. M. RUSSELL
————, May 3, 1949, 10
"Gov. Bonner Proposes Immediate Plans to Finance Charles Russell Memorial"
————, October 9, 1949, 4
"Bonner Names Russell Week"
————, October 30, 1949, *Montana Parade* (magazine section)
"Governor Proclaims Russell Memorial week Oct. 31—Nov. 7."
"Movement for Statue Recalls Life Story of 'Cowboy Artist.' "
p. 2: THE COWBOY #2
 A FRENCH HALFBREED
 THE SIOUX BUFFALO HUNTER
p. 3: W. S. Hart and C. M. R. (photo)
 THE PRICE OF HIS HIDE
p. 4: Russell Memorial Studio (photo)
 The Buckskin Kid (pen and ink of CMR by Seltzer)
————, January 6, 1951, 1
"Emma Trigg Will Provides Russell Collection Given to Corporation Honoring Artist"
————, June 15, 1952, 1, 3
"$75,000 Goal Set for Campaign to Build Permanent Russell Gallery"
Proposed Gallery (architect's sketch)
Artist's Outing (photo)
Wm. S. Hart and Charles Russell (photo)
Charles M. Russell (photo)
FRIOR TUCK* (model)
VAQUERO* (model)
STOLEN HORSES #4*
THE JERKLINE
Famous Friends—CMR and Will Rogers (photo)
Friend and Patron—Wm. S. Hart and CMR (photo)
————, September 14, 1952, 8, 10
"State Has Only Few Weeks Left to Acquire Mackay Russell Art"
BUCKER AND BUCKEROO, i.e., A BRONC TWISTER (bronze)
SMOKING UP (bronze)
CHARLES M. RUSSELL AND HIS FRIENDS
INDIANS DISCOVERING LEWIS AND CLARK
BRONC TO BREAKFAST
THE HORSE WRANGLER (bronze)
JIM BRIDGER (bronze)
THE BUCKING BRONCO, i.e., THE WEAVER (bronze)
AN ENEMY THAT WARNS (bronze)
————, February 11, 1953
"Legislature has view of home in Russell Capitol painting"

————, September 20, 1953, *Montana Parade* section
p. [1]: CHARLES RUSSELL ON REDBIRD*
p. 2: THE COWBOY #2
 A FRENCH HALF-BREED
 [THE] SIOUX BUFFALO HUNTER
 "Russell Gallery to Show Trigg Art Collection"
p. 3: "C. M. Russell Gallery to Open Saturday"
 photo of Gallery
 photo of CMR and horse
 photo of CMR and Nancy
p. 4: THE FOOL AND THE KNIGHT*
 INDIAN HEAD #8*
 A RUSSELL INDIAN*
p. 5: THOROUGHMAN'S HOME ON THE RANGE*
p. 6: photos of Memorial Studio
 WILL ROGERS (bronze)
p. 7: THE JERKLINE
 UPPER MISSOURI IN 1840*
————, September 26, 1953, 1, 3
" 'Robe spread, pipe lit' Today at Gallery Housing Collection of Russell's Works"; one photo
————, November 1, 1953, 13
"Stories Behind Paintings"
CHUCK WAGON ON THE RANGE*
OUTLAW, i.e., PINTO*
————, January 29, 1954
"Fortune sisters of Helena bequeath art to museum"
————, March 9, 1954, 1
"State Will Honor Foremost Cowboy Artist March 19 in Observing Charlie Russell Day"
————, May 28, 1954, 9
"Russell Art Displayed at White House"
————, August 20, 1954, 10
"Russell Predominance in State Unique in U.S. Biographer [J. Frank Dobie] Asserts"
————, October 13, 1954
"Russell Stamp Promoted by Cowboy Group"
————, December 9, 1954, 10
"Rodeo at 1955 Fair Here Named for C. M. Russell"
————, January 16, 1955, 14
"Early Russell Paintings Given to Gallery"
KIOWAS*
RETURN OF THE INDIANS*
————, January 20, 1955, 5
"Legislation Will Seek Russell Stamp"
————, January 23, 1955, 14-15
"Gallery Acquires More Early Russell Art"
SUNBONNET GAL*
DEER IN FOREST*
BUFFALO CROSSING THE MISSOURI*
PIEGAN*
————, April 3, 1955
"Camera Fans Try Skill on Russell Gallery"; 14 photos

————, January 8, 1956, *Montana Parade* section

"McNair loans Russell models to gallery"

CHANGING OUTFITS* (bronze)

RED BIRD (bronze)

FOREST MOTHER* (bronze)

THE BLUFFERS (bronze)

STEER HEAD #2* (bronze)

NOBLEMAN OF THE PLAINS* (bronze)

THE SIOUX (bronze)

GREY EAGLE* (bronze)

CREE INDIAN, i.e., IN THE WHITE MAN'S WORLD (bronze)

LONE WARRIOR (bronze)

SMOKE OF THE MEDICINE MAN* (bronze)

MOUNTAIN MOTHER (bronze)

A DISPUTED TRAIL (bronze)

OLD MAN INDIAN (bronze)

YOUNG MAN INDIAN (bronze)

THE FALLEN MONARCH* (bronze)

[THE] BUFFALO (bronze)

WILD BOAR* (bronze)

————, March 8, 1956, 1, 11

" 'Russell' Works Priced at $35,000 Called Forgeries by ex-Falls Expert. Forged 'Russell' Works Up for Sale at $35,000"

SMOKING UP

————, July 1, 1956, *Montana Parade* section, 1

"Scrapbook About Russell Goes on Display"

NEW YORK HARBOR

THIS IS WHERE THE DUTCH USTE TO PLAY TEN PINS

The Cow Boy Artist (photo)

HE WHO LOST COMMAND, LEFT HIS BONES ON THE SANDS

A WESTERN GREETING

I WAS ARMED WITH A PUNCH POLE

ARMORED MEN OF RITCHARD THE LION-HARTED'S TIME

————, September 2, 1956

"C. M. Russell Statue Controversy Flares Anew in Montana"; two photos

————, September 16, 1956, 1

"Protege of Charlie Russell Criticizes Model of Hall of Fame Statue"

————, October 14, 1956, 3–6

"Charlie Russell's Boyhood Sketchbook Found"

CROW INDIAN IN WAR DRESS*

PRETZEL PETE HOTEL, LEADVILLE, COLORADO*

A NIGHT WITH THE UTES*

CORRALLING MULES*

————, October 21, 1956

"More About Russell's Boyhood Sketchbook," by Joe de Yong

I FELT A SLAP IN THE FACE (cover)

FLYING LEAD AND SPLINTERS, i.e., I FELT A SLAP IN THE FACE

THE COWBOY #2

A FRENCH HALF-BREED

[THE] SIOUX BUFFALO HUNTER

MEXICAN RANCHEROS*

SCENE IN THE ROCKY MOUNTAINS*

A LEAP FOR LIFE*

INDIANS HUNTING DEER FROM A CANOE*

BUFFALO BILL*

THE INDIAN GUIDE*

CHOCTAW INDIANS MOVING*

INDIANS HUNTING THE DEER BY BREAKING THE STICK*

INDIAN BOYS SHOOTING FOR MONEY*

————, November 18, 1956, 1

THE FIRE BOAT*

————, February 15, 1957

"Early Russell Painting at Gallery"

WANDERERS OF THE PLAINS*

————, February 17, 1957

"Russell Authority Recalls Early Memories of Artist"; one photo

————, May 12, 1957

"Nephew of Russell Writes Biography of Artist"

————, July 15, 1957, 1

"Weaver's Entry Wins Russell Statue Contest"; one photo

————, August 11, 1957, 10

"Another Russell Original"

CHIEF JOSEPH, i.e., INDIAN CHIEF #1*

————, October 6, 1957, *Montana Parade* section, 9, 14

"Charlie Russell's Works Has Two Week Show at Great Falls Art Gallery"

SELF PORTRAIT #4

AT THE END OF THE ROPE

BATTLE OF THE REDMEN, i.e., STORMING A WAR HOUSE

TRAIL'S END

[A] NOBLEMAN OF THE PLAINS

THE LAST OF 5,000

RETURN OF THE WARRIORS

CHANGING OUTFITS (bronze)

RIGHT THERE'S (i.e., THEN'S) WHERE THE BALL OPENS

RIDER OF THE ROUGH STRING

THE RANGE FATHER (bronze)

NAVAHO HORSE HUNTERS, i.e., NAVAJO WILD HORSE HUNTERS

THE DEATH OF ROMAN NOSE, i.e., CHARGE OF CHEYENNES LED BY ROMAN NOSE

WHERE GREAT HERDS COME TO DRINK

————, February 22, 1958, 9

"Gift to Russell Gallery"

WANDERERS OF THE TRACKLESS WAY, i.e., WANDERERS OF THE PLAINS

————, April 21, 1958, 18

"Fame of Charles Russell Pyramiding with Articles"

————, October 13, 1958, 1

"C. M. Russell Paintings Displayed at Smithsonian"

————, July 6, 1963, *Montana Parade* section, 11
"Old-Time Residents Recall Anecdotes About Russell"
————, August 11, 1963, *Montana Parade* section
WHERE TRACKS SPELL MEAT
————, March 15, 1964, *Montana Parade* section
cover: WHERE GREAT HERDS COME TO DRINK
p. 16: PABLO-ALLARD BUFFALO DRIVE
 A PITCHER
 PIEGAN BUFFALO HUNT*
————, March 16, 1964
"Record Russell Art Showing Will be Big Local Attraction"
————, March 19, 1964, 1, 3, 19, 24, 26
"Luncheon Here Today to Mark Russell Commemorative Stamp"; "For 30 Years, Charles M. Russell Made His Home in Great Falls Area"
p. 1: JERKED DOWN (stamp)
 Charles M. Russell (photo)
p. 19: LEWIS AND CLARK MEETING THE FLATHEADS, i.e., LEWIS AND CLARK MEETING INDIANS AT ROSS' HOLE
 INTRUDERS
 SCOUTING THE CAMP
 COWBOYS ROPING A WOLF
p. 26: COWBOY ON A BUCKING BRONCO (model)
————, April 5, 1964, *Montana Parade* section, 1, 14–15
"Tribune-Leader Installs Display of Russell Reproductions"
p. 1: THE HOLD UP (color)
p. 14: FOR SUPREMACY
 INDIANS RUNNING OFF HORSES, i.e., EARLY MONTANA, INDIANS RUNNING OFF HORSES
 THE BUFFALO HUNT #3
 LEWIS AND CLARK MEETING THE MANDAN INDIANS
p. 15: THE HOLD UP
 THE WAY IT USED TO BE
 INDIAN WOMEN MOVING
 THE PRICE OF HIS HIDE
 THE ELK
 A DESPERATE STAND
————, September 24, 1965, 1, 5
"Mystery Painting a Russell"
p. 1: DEER FAMILY*

(Great Falls) *Weekly Tribune*, March 28, 1891, 6
"A New Picture from the Brush of Charles M. Russell"
————, July 23, 1892, 5
"Indians on the Trail, The Latest Picture from the Brush of Charlie Russell"
————, April 28, 1893, 7
"The Cowboy Artist"

Havre Daily News, May 7, 1957
"Creation of Chinook Artist"; Evelyn Cole's Fine

Statue of Charlie Russell to Be Entered into Competition"; six photos of CMR

Helena Daily Independent, June 10, 1887, 4
"By an Untutored Hand—C. M. Russell, The Cowboy Artist Turns Out Some More Attractive Paintings"
————, July 1, 1887, 4
"Life on the Range—Another Picture by the Cowboy, Russell, and the Best that He Has Produced"
————, January 11, 1888
"Russell's Latest. The Cowboy's Masterpiece on Exhibition on Broadway"
————, October 25, 1890
"The Artists' [sic] Whereabouts Discovered"
————, April 10, 1898, 5
"Two New Masterpieces: Reproductions of the Brush of the Famous Cowboy Painter Can Be Seen in Helena"

Helena Independent, May 13, 1901, 5
"Cowboy Artist, St. Louis Lion"

(Helena) *Independent*, October 8, 1909, 5
"Russel [sic] Donates Valuable Canvas"

Helena Independent Record, July 27, 1959
"Russell to the Ruskies"
MEAT FOR THE WAGONS
————, October 3, 1962
"Traffic in Bogus Russell art is on the Increase"; one photo.

Helena Journal, August 27, 1890
"Studies of Western Life, Bits from the Masterwork of the Cowboy Artist"
————, July, 1891 (Souvenir Edition)
Pp. 32, folio, size 15 × 20⅝, pictorial wrappers which serve as title page. The first two pages of text contain photographic reproductions of 6 paintings by CMR. No mention of Russell is made in the text nor are the paintings identified as his work.
COW-BOY CAMP DURING THE ROUND-UP*
EARLY MONTANA, A BUFFALO HUNT, i.e., MEAT FOR THE TRIBE*
FIRST ATTEMPT AT ROPING*
EARLY MONTANA, INDIANS RUNNING OFF HORSES*
EARLY MONTANA—INDIANS STEALING CATTLE—CAUGHT IN THE ACT, i.e., CAUGHT IN THE ACT
BRANDING CATTLE—A REFRACTORY COW*

Helena Record-Herald, June 14, 1929
"Russell Pictures of Western Life Drawn in Kitchen"

Helena Weekly Herald, May 26, 1887, 7
"A Diamond in the Rough"
———, September 4, 1890
"A Handsome souvenir"
———, April 28, 1893, 7
"Our Cowboy Artist. Some Facts About the Natural Born Artist Who Lives Here"
———, January 11, 1894, 2
"Russell's Work—Some New Pictures of Wild Life on Exhibition"

Houston Chronicle, February 12, 1961
"Brush Historians of the Old West"
(THE) BUFFALO HUNT #40 (color)
UTICA PICTURE, i.e., COWBOY CAMP DURING THE ROUNDUP (color)

Houston Post Dispatch, December 12, 1926, magazine section, p. 11
"The End of a Western Trail. Russell, Painter of the West, is Gone with Life That He Painted," by Gutzon Borglum
HERE LIES POOR JACK HIS RACE IS RUN

Independent Star-News (Pasadena), December 15, 1957, 8
"Tribute to Charlie Russell, Cowboy Artist"
CHRISTMAS AT (THE) LINE CAMP

Jackson Hole Guide, July 16, 1964, 5
"Rendezvous Will Have Charlie Russell Theme"
Charlie Russell—self-portrait (i.e., photo)

Kalispell Interlake, March 21, 1954, 6
"Mrs. Coulter Recalls Behavior of Russell"

Kansas City Star, February 20, 1921
WHEN LAW DULLS THE EDGE OF CHANCE and article on purchase of that painting by the Prince of Wales
———, December 12, 1926, rotogravure section
"Russell's West Remains"
THE WAR PARTY #3*
READY FOR THE HUNT*
———, November 20, 1927
"New Humor from the Old West" (review of *Trails Plowed Under*)
HE UNLOADS ME RIGHT IN THE MIDDLE OF THE BOULDER-STREWN FLAT, i.e., I DON'T MISS NONE OF THEM BOULDERS
STAY IN THE HOLE, YOU DAMN FOOL, i.e., JACK GOES BACK BUT HE DON'T STAY LONG
THE MOUNTAINS AND PLAINS SEEMED TO STIMULATE A MAN'S IMAGINATION
TRAILS PLOWED UNDER

Lewistown Argus, February 12, 1891, 3
"Local Happenings"

Lewistown Daily News, July 4, 1957, 5
"Charley Russell's First Meeting with Brother Van"

Lewistown Democrat-News, December 16, 1934, Section 3, p. 4
"Charles M. Russell—An Appreciation of a Great Writer's Tribute to Great Painter" by Irvin S. Cobb. Photo of CMR.

Los Angeles Examiner, February 27, 1923, Section II, p. 1
"Prince of Wales Pays $10,000 For American Artist's Painting"; port.
THE ONLY WAY TO NEGOTIATE WITH THIEVES, i.e., WHEN LAW DULLS THE EDGE OF CHANCE
———, November 28, 1926
"Rogers Bows Head for Three Friends"

Los Angeles Record, April 17, 1906
"Russell's First Mexican Picture Drawn Especially for the Record." See illustration plate 18, facing p. 111.
THE MEXICAN COWBOY*

Los Angeles Times, April 8, 1923, rotogravure section, p. 9
WATCHING THE ENEMY*
WAGONS*
BUFFALO HUNT #40*
———, January 16, 1927, Part II, p. 7
"Artist's Work Breathes Spirit of the Range"; port.
THE FIRST FURROW
THE WILD HORSE HUNT, i.e., WILD HORSE HUNTERS #1
I RODE HIM
THE TRAIL HERD, i.e., THE TRAIL BOSS
———, April 11, 1931, Part III, p. 1
"Widow Scorns Artist Statue"; three photos
———, April 24, 1931
"Our Temple of Fame," by Fred Hogue
———, June 27, 1955
"Audie Will Film Life of American Painter"
———, January 22, 1956
"Cowboys Going to Get Their Own Hall of Fame"
Four photos, including C. M. Russell
———, August 25, 1957, V, 5
"Cowboy Painter Russell to Have Local Exhibit"
RETURN OF THE WARRIORS
———, February 3, 1966, III, 18
"Russell Art in Good Hands"

Los Angeles Times-Mirror, August 5, 1962
"Works of Noted Western Artist Found by Grandson in Shed"; one photo

Mexico City Daily Record, March 24, 1906, 1
"Artists Make Exhibit. Treat Given by Cowboy and Indian Artist"

Minneapolis Journal, February 27, 1927, 5
"Will James, Cowboy, Pays Tribute to Charles M. Russell"
JERKED DOWN

Minneapolis Sunday Journal, July 28, 1912
"Lewis and Clark's Meeting with Western Indians Theme of Painting to Hang in the Montana State House at Helena"
LEWIS AND CLARK MEETING SHOSHONE INDIANS, i.e.,
LEWIS AND CLARK MEETING INDIANS AT ROSS' HOLE*

Minneapolis Sunday Tribune, December 14, 1919, Section II, p. 1
"Minneapolis Views Wild West Through Eyes of Montana Cowboy Artist"
WHERE LOOPS AND SWIFT HORSES ARE SURER THAN LEAD,
i.e., LOOPS AND SWIFT HORSES ARE SURER THAN LEAD
SIGNAL GLASS, i.e., THE RED MAN'S WIRELESS
ROMANCE MAKERS*
WHERE (i.e., WHEN) THE NOSE OF A HORSE BEATS THE
EYES OF A MAN
———, December 8, 1929
"Trails Plowed Under by Charles M. Russell"; portrait
Reprints "A Pair of Outlaws"; "Johnny Reforms Landusky"; "When Mix Went to School."
JERKED DOWN
———, March 12, 1950, Coloroto
RETURN OF THE WARRIORS
TIGHT DALLY AND LOOSE LATIGO
WAITING FOR A CHINOOK, i.e., THE LAST OF 5000
WHEN WAGON TRAILS WERE DIM
THE CHALLENGE #2
photo

Missoulian, July 21, 1912, 5
"Russell Paintings at the Capitol"

Montana American, July 18, 1919, 9, 13, 89
(Fifth Anniversary Edition, Butte, Montana)
"The Genius of Montana—Its Artists," by Clarke Fiske
p. 9: CMR (photo)

Montana Newspaper Association Inserts
Eight of these, entitled "Historical Recollections by Rawhide Rawlins" (actually written as well as illustrated by CMR), are marked by an asterisk.
Oct. 8, 1917: *How Pat Discovered the Geyser**
 THE GEYSER BUSTS LOOSE*
 "RAWHIDE" RAWLINS*
 MOVES HIS HOTEL*

Oct. 22, 1917: *Mormon Zack, Fighter**
 "RAWHIDE" RAWLINS
 HE HANDS BOWLES ONE ON THE CHIN*
 ZACK PICKS OUT THE BIGGEST, HARDEST-
 LOOKIN' CITIZEN HE CAN SEE*
Oct. 29, 1917: *Cinch David's Voices** (not in *Rawhide Rawlins Stories*)
 "RAWHIDE" RAWLINS
 WHEN HE FIRST HEARS THEM VOICES*
Nov. 19, 1917: "Byron Cooney Writes of Russell Picture Which Helped to avert Pugilistic Tragedy"
Nov. 26, 1917: "When Buffalo Roamed Plains and Bulls Fought for Herds; Hunters Killed Millions"
 INDIANS HUNTING BUFFALO IN THE
 ANCIENT DAYS, i.e., THE BUFFALO
 HUNT #35
Dec. 10, 1917: *Where Highwood Hank Quits**
 "RAWHIDE" RAWLINS
 "YES YOU DID"*
Dec. 17, 1917: "Queer Ways of the Cowboy"
 SHELBY IN THE EARLY DAYS* (part)
Dec. 24, 1917: *When Pete Sets a Speed Mark**
 "RAWHIDE" RAWLINS
 PETE LANDS RUNNIN'*
Jan. 28, 1918: *There's More Than One David**
 "RAWHIDE" RAWLINS
 THE SHEPHERD HURLS A BOULDER AT
 "GOLIAR"*
Feb. 25, 1918: *Johnny Sees the Big Show**
 TOOK FOUR STEWARDS TO UNLOAD
 JOHNNY*
 JOHNNY LUNCHES WITH THE KING*
March 4, 1918: "Historic Montana Organization is Marshalling Its Forces"
 THE COWBOY WINS*
 THE COWBOY LOSES*
April 1, 1918: *When Mix Went to School**
 "RAWHIDE" RAWLINS
 WHISKERS DIDN'T HELP HIM*
 WE LOVE OUR LOVIN' TEACHER*
 Russell Sends a Greeting on Birthday
 of Brother Van
 Charles M. Russell and Brother Van
 (photo)
April 15, 1918: "Sam Getts was the Last Stage Driver"
 SAM COULD SWING 'EM AROUND A
 CURVE, i.e., A SHARP TURN
April 22, 1918: "Red Romance of John Slade, Premier Man Killer; Hanged by the Vigilantes"
 ONE OF SLADE'S EARLIEST DUELS, i.e.,
 LAUGHED AT FOR HIS FOOLISHNESS
 AND SHOT DEAD BY SLADE

May 27, 1918,
 No. 1: LEWIS AND CLARK REACH SHOSHONE
 CAMP, LED BY SACAJAWEA, THE "BIRD
 WOMAN"*
 "YES, YOU DID!"

May 27, 1918,
 No. 2: BUFFALO BILL AND GRAND DUKE ALEXIS
 HUNTING BUFFALO WITH THE
 CHEYENNES, i.e., RUNNING BUFFALO*

June 17, 1918: "Narrative of Sacajawea Pathfinder to
 the Coast"
 Lewis and Clark Statue (clay model, by
 Lion)

June 24, 1918: "William Allen White, Noted Writer,
 Drops in on Russell"
 C. M. Russell and William Allen
 White (photo)

July 1, 1918,
 No. 1: "Pictures by Russell Help the Battle
 for Civilization"
 HOOVERIZIN'

July 1, 1918,
 No. 2: "Russell Helps Win the War with
 Posters to Uncle Sam"
 MEAT MAKES FIGHTERS
 I ain't a wearin Khaki; cause I'm too
 old a stag
 But I'm a handin' beef and hide to
 them that holds the flag
 Pie and cake is good when folks just
 feed for fun
 But beef and leather, plenty, puts men
 behind the gun.

July 15, 1918: "Northwest Mounted Police at Last
 Leave for Battlefields of France"
 WHERE (i.e., WHEN) LAW DULLS THE
 EDGE OF CHANCE

July 22, 1918: "Russell's Friends Many; His Horse is
 one of them"
 Charlie Russell and Neenah (photo)

Aug. 5, 1918: "In the Days when the Cowboy was
 the Wildest of all The Western Wild
 Men"
 IN WITHOUT KNOCKING

Aug. 12, 1918,
 No. 1: "Reed's Fort, Last Montana Trading
 Post of Consequence, Scene of Bloody
 Fight between Major Reed and Jim
 Bowles"
 REED'S FORT*

Aug. 12, 1918,
 No. 2: "Havre Has a Buffalo Bull"
 BUFFALO DISCOURAGES LINEBARGER, i.e.,
 PETE LANDS RUNNIN' (part)

April 7, 1919: "How 'Rattlesnake Jake' and Charlie
 Fallon Were Killed in Desperate 4th of
 July Battle With Lewistown Citizens"
 STREET BATTLE IN LEWISTOWN*

April 28, 1919: "Some Notes on the Stockmen's Meet
 As It Looked to a Reformed Cowman"
 "RAWHIDE" RAWLINS
 HE'S JUST TOPPIN' THE HILL OUT OF
 MILES CITY WHEN HE RUNS DOWN A
 JACKRABBIT THAT GETS IN HIS WAY*
 HIS LEGS IS WARPED*

June 16, 1919: RUSSELL RIDES REAL OUTLAW*

June 30, 1919: *The Pinto* by Charles M. Russell
 ALL CONVERSATION WAS CARRIED ON BY
 THE HANDS
 HIS FIRST YEAR
 THE CHIEF FIRED AT THE PINTO #1
 TWO RIDERS, ONE LEADING A PACK HORSE

July 7, 1919: "Calgary Stampede To Be Greatest Ever
 Staged; Prince of Wales Will Open It"
 A MONTANA SHOW RIDER*

Dec. 1, 1919: "Prince of Wales Returns to England
 with a Russell Painting as a Present"
 WHERE (i.e., WHEN) LAW DULLS THE
 EDGE OF CHANCE

Dec. 29, 1919: "Yankee Jim was Champion Fighter of
 River Roughs in the Steamboat Days"
 BEFORE THE IRISHMAN COULD RECOVER
 HIMSELF, i.e., HE HANDS BOWLES ONE
 ON THE CHIN

Jan. 5, 1920: *Hank Winter's Bear Fight**
 JUST AS EVERYTHING'S TURNIN(G) BLACK
 I HEAR BED-ROCK'S WINCHESTER

April 26, 1920: "Big Nose George, Desperado and
 Killer, Whose Gang Terrorized the
 Yellowstone Valley in the Seventies"
 THE HOLD-UP

May 17, 1920: "Greatest Game Slaughter in World's
 History; Real Story of the Annihilation
 of the Buffalo"
 NATURE'S CATTLE #1

June 7, 1920,
 No. 1: "Confederate Gulch Had The Richest
 Placer Mines on Earth; Diamond City,
 Once Rival of Helena, is Now But A
 Memory"
 FIGHT IN CAVE GULCH, NEAR DIAMOND
 CITY*

June 7, 1920,
 No. 2: "In Stage War of '66 Three Outfits
 Ran Coaches at Gallop 125 Miles Be-
 tween Virginia and Helena"
 IT USED TO BE THAT HOSSES WAS FAST
 ENOUGH FOR MEN*

Sept. 20, 1920: "Pike Landusky, Trapper, Woodhawk and Gold Miner"
"DUM-DUM" BILL*
LANDUSKY IN ITS HEYDAY*

Jan. 10, 1921: "At the Grave of 'Long George' Minister Scathingly Attacks Operation of the Law"
THAT REMINDS ME*
LONG GEORGE BULLDOGGING A STEER

Mar. 7, 1921: "Jake Hoover, 'Lucky Boy' Who Discovered More Mines than any Other Man in Montana, Never Had Day's Luck"
OLD HOOVER CAMP ON SOUTH FORK OF JUDITH RIVER

April 18, 1921: "Johnny Ritch, the Poet of the Judith"
RUSSELL'S VALENTINE, i.e., "DUM-DUM" BILL (in reverse)

May 2, 1921: "Stadler & Kaufman, Pioneers of Montana Cattle Industry"
WAITING FOR A CHINOOK

May 23, 1921, No. 1: "Sale of Russell Painting for Ten Thousand Dollars Sets New Mark for Montana Artist; Does Some Fine Bronze Work"
THE SALUTE OF THE ROBE TRADE*
CMR Sketching Fairbanks as D'Artagnan (photo)

May 23, 1921, No. 2: "Famous Artist and Movie Star Photographed Together"
Douglas Fairbanks, Charles M. Russell and Mrs. Russell (photo)

July 11, 1921: The Cowboy As He Was—Reminiscences of a Western Type That Has Passed by Charles M. Russell, i.e., The Story of the Cowpuncher.
Charles M. Russell Famous Montana Artist (photo)
CMR on Monte (photo)
Charles M. Russell at Work in His Studio (photo)

Aug. 1, 1921: "First Business Enterprise in Montana Organized in 1806"
BUILDING FORT MANUEL IN 1807*

Aug. 29, 1921: LEWIS AND CLARK REACH SHOSHONE CAMP LED BY SACAJAWEA THE "BIRD WOMAN"

Sept. 12, 1921: "Advance in Transportation in Montana"
IT USED TO BE THAT HOSSES WAS FAST ENOUGH FOR MEN

THE COMING OF THE PLACER MINER, i.e., TWO RIDERS, ONE LEADING A PACK HORSE

Oct. 31, 1921, No. 1: "New Book by C. M. Russell Filled with Western Humor, Has 35 of His Drawings"
"RAWHIDE RAWLINS'"
ABOUT THE THIRD JUMP CON LOOSENS

Oct. 31, 1921, No. 2: "Charles M. Russell Writes Book of Yarns of Range Days With 35 Pictures"
THE BRONC'S LODGED IN THE TOP OF A COTTONWOOD

Nov. 7, 1921, No. 1: Ad for Rawhide Rawlins Stories
THE FAMILY STARTS OUT MOUNTED

Nov. 7, 1921, No. 2: Ad for Rawhide Rawlins Stories
A CENTER-FIRE FASHION LEADER

Nov. 14, 1921: "Montana Can Show Missouri Some Things"
A MONTANA SHOW RIDER

Nov. 25, 1921: Ad for Rawhide Rawlins Stories
"YES, YOU DID"

Dec. 5, 1921, No. 1: Ad for Rawhide Rawlins Stories
PETE LANDS RUNNIN'

Dec. 5, 1921, No. 2: Ad for Rawhide Rawlins Stories
TOMMY SIMPSON'S COW

Dec. 19, 1921, No. 1: "Old Fort Union, Dominant Trading Post"
FREE TRAPPERS RIDING INTO A FORTIFIED TRADING POST, i.e., REED'S FORT

Dec. 19, 1921, No. 2: Ad for Rawhide Rawlins Stories
MIGHTY HANDY WITH ALL FOUR FEET

Dec. 19, 1921, No. 3: Ad for Rawhide Rawlins Stories
Letter from Irvin S. Cobb

Dec. 19, 1921, No. 4: "A Great Painting by Charles M. Russell"
WHEN SHADOWS HINT DEATH

Jan. 9, 1922: "A Russell Picture with Plenty of Action"
WHEN HORSEFLESH COMES HIGH

Jan. 16, 1922, No. 1: "Joe DeYong A Coming Young Montana Artist Who Knows the West He Paints"

Jan. 16, 1922,
 No. 2: "Painting by C. M. Russell that sold for $10,000"
 THE SALUTE OF THE ROBE TRADE
Jan. 16, 1922,
 No. 1: Ad for *Rawhide Rawlins Stories*
 ZACK PICKS OUT THE BIGGEST HARDEST-LOOKIN' CITIZEN HE CAN SEE
Jan. 16, 1922,
 No. 2: Ad for *Rawhide Rawlins Stories*
 ABOUT THE THIRD JUMP CON LOOSENS
Feb. 13, 1922: "Newspaper Man Who Took His Life in His Hands to call on Sitting Bull for Chicago Paper"
 PARTY OF SITTING BULL'S BRAVES GET OUR TRAIL*
Feb. 26, 1922: Ad for *Rawhide Rawlins Stories*
 ABOUT THE THIRD JUMP CON LOOSENS
Aug. 21, 1922: "How the Cowboy Lived and Had His Being in the Days of the Free Range"
 HOOVERIZIN'
Sept. 25, 1922: "How Charlie Russell Came to Montana 42 Years Ago"
 Charles M. Russell (photo)
Nov. 1, 1926: "A child of the Frontier. He came west and Became the West; 'Cowboy Artist' Saw the Old Frontier with a Wide Eye," by Dan R. Conway
 HIS FIRST YEAR
 THE CHIEF FIRED AT THE PINTO #1
 WHEN LAW DULLS THE EDGE OF CHANCE
 Photo of CMR on Monte
 The Pinto, i.e., *The Olden Days*, by CMR

Montana Standard, April 15, 1952
"Russell painting will be exhibited for first time at Butte Y"
THE SPANISH VAQUERO*
Charles Russell (photo)

Montana Standard-Post, November 29, 1962
"Charlie Russell Screens Found"
———, September 27, 1965, 8
BEST WISHES FOR YOUR CHRISTMAS
PAIR OF OUTLAWS, i.e., I'M SCAREDER OF HIM THAN I AM OF THE INJUNS

Montclair (New Jersey) *Times*, April 6, 1912, 9
"The West Brought to Montclair"; portrait
JERKED DOWN
MEDICINE MAN #2

New York American, July 9, 1916, magazine section, 1
"A Cowboy's Paintings"

CHASED BY THE GRIZZLY, i.e., CRIPPLED BUT STILL COMING WHEN BUFFALO WERE PLENTIFUL*
SMUGGLERS CAUGHT ON THE FRONTIER, i.e., WHISKEY SMUGGLERS CAUGHT WITH THE GOODS

New York Herald Tribune, December 5, 1926, magazine section, 16, 17, 31
"The End of the Trail," by Gutzon Borglum
HERE LIES POOR JACK, HIS RACE IS RUN
THE BUCKING BRONCO #1
———, November 27, 1927, Books, Section VII, p. 7
"Horses, Men and Cattle"
(review of *Trails Plowed Under*, by Ross Santee)
THE BIG CHANCE (i.e., CHANGE) CAME WHEN OLD CORTEZ BROUGHT HOSSES OVER
HIS HOSS STEPS ON THE END OF THE ROPE, i.e., SUDDENLY SOMETHING HAPPENS
———, May 4, 1930, Section XI, 1, 3
"Charlie Was a Cowboy First," by Will James (review of *Good Medicine*)
NAVAJOES HEADED FOR THE BUFFALO RANGE
PAT RILY WAS KILLED WHILE SLEEPING
THIS RIDER DIDENT QUITE WIN
———, June 13, 1954, Book Review, 2
"On books and authors," by John K. Hutchens
(AN) OLD TIME SENTER FIRE MAN
I SAT AT A FARO (i.e., FARYO) LAYOUT IN CHINOOK
I'V SEEN SOM ROPING AN RIDING
———, December 22, 1957, 1
"'Cowboy' Russell and the Old West His Art Recaptured" (review of *The Charles M. Russell Book*)
CHRISTMAS AT (THE) LINE CAMP
———, May 20, 1963, 21
"Charlie Russell's Town"
THE LAST OF 5000

New York Press, January 31, 1904, 4
"Smart Set Lionizing a Cowboy Artist"; portrait
Fireplace in Cowboy Artist's Home (photo)
ROPING A GRIZZLY, i.e., ROPING A RUSTLER*
A BATTLE ON THE PLAINS, i.e., RUNNING FIGHT*
AN INDIAN OUTPOST, i.e., BLACKFOOT WAR CHIEF (model)

New York Times, March 19, 1911, 5
"Cowboy Vividly Paints the Passing Life of the Plains"
Mr. Russell as he looks on the plains (photo)
Charles M. Russell (portrait by Nancy)
JERKED DOWN
THE WAGON BOSS
(THE) MEDICINE MAN #2*
BUFFALO HUNT* (bronze)
———, August 1, 1926, Book Review, 11
"Retracing the Old Frontier," by R. L. Duffus
BUFFALO HOLDING UP MISSOURI RIVER STEAMBOAT

————, October 26, 1926, Section 1, p. 27
"'Cowboy Artist' C. M. Russell, Dies"
————, November 20, 1927, Section X, p. 11
Paragraph on Grand Central Galleries exhibition
————, December 27, 1936, Section X, p. 9
Letter from James B. Rankin
————, February 17, 1952, Section X, p. 9
"Work of Charles Russell, Cowboy Artist, Recalls
Lurid Era of Our History," by Aline B. Louchheim
THE VIRGINIAN
————, December 16, 1956, Book Review, 14
"Western Roundup"
WET HORSES*
————, December 15, 1957, Book Review
"His Pictures Told a Story"
THE STAGECOACH ROBBER, i.e., THE ROAD AGENT
DEATH IN THE STREET, i.e., PLUMMER AND TWO FOLLOWERS
 KILL FORD
RIM-FIRE [OR] DOUBLE CINCH RIG
THEY'RE ALL PLUMB HOG-WILD
THE OPEN RANGE, i.e., COMING TO CAMP AT THE MOUTH OF
 SUN RIVER
————, June 6, 1959
"Books of the Times"
A WESTERN LANDSCAPE, i.e., DUDES
————, July 2, 1965
"Collectors Seek Western Artists. Wild West Art Brings
High Prices"
INDIAN SQUAW #1
INDIAN BUCK #1

Oakland Tribune, February 2, 1964, 30
"Artist Honored by Stamp"
JERKED DOWN

Omaha Daily News, November 19, 1923
"Obscure Cowboy Wins Fame Dabbling with his
Brushes"; portrait

Omaha World Herald, January 19, 1954
"Joslyn to Show Famed Cowboy's Paintings"
CHARLES M. RUSSELL AND HIS FRIENDS
————, February 20, 1959
"Cowboy Artist's Statue Unveiled"

Oregon Journal, November 18, 1966, 17
"Original Charles M. Russell Painting Found in
Thrift Shop"
PORTRAIT OF INDIAN, i.e., INDIAN HEAD #7

Oregonian, April 13, 1958
"Renoir Pales Beside Cowboy Art"
SELF-PORTRAIT #4
[THE] LAST OF 5000

Park County News (Livingston, Montana), March 8,
1956, Section 2, p. 1
"Russell's Art and Character Enriched as Time Goes
On"
I RODE HIM
THE HERD QUITTER
PIG #3* (model)
LEWIS AND CLARK MEETING INDIANS AT ROSS' HOLE

Phillipsburg Mail, November 5, 1926
THE MARE WAS WELL KNOWN*

Pittsburgh Sun Telegraph, July 28, 1929
WHEN SHADOWS HINT DEATH (color)

Redstone Review, May 25, 1921
"Sale of Russell Painting for Ten Thousand Dollars
Sets New Mark for Montana Artist; Does Some Fine
Bronze Work." "Charles M. Russell making sketch of
Douglas Fairbanks"
[THE] SALUTE OF THE ROBE TRADE

River Press, September 6, 1887, 6
"The Artist of the Ranges. Cowboy Artist's Latest
Picture—Scenes Drawn from Life Among the Cattle"

Rocky Mountain Husbandman, August 3, 1911, 1
"To Charles M. Russell" (13-stanza poem to CMR
by anonymous author)
The Cowboy Artist on his favorite mount (photo)
————, August 22, 1918, 8
"Save Food—Help Win the War. Painting and Words
by Charles M. Russell the Montana 'cowboy artist' for
the U.S. Food Administration in Montana."
HOOVERIZERS, i.e., HOOVERIZIN'
————, August 29, 1918, 8
"Painting and Words by Charles M. Russell, the
'cowboy artist' of Montana especially for the Food
Administration in Montana"
HELPING TO WIN, i.e., MEAT MAKES FIGHTERS
————, November 26, 1925, 5
"Diamond City, Center Richest Placer Mines on
Earth"
FIGHT IN CAVE GULCH, NEAR DIAMOND CITY
————, October 28, 1926, 1, 5
"Chas. M. Russell is Dead"
p. 1: "Charley" Russell (photo)
————, February 10, 1927, 4, 5
"Pictures by Russell"
p. 4: THE COWBOY #2
p. 5: THE DEATH OF LA SALLE
————, February 24, 1927, 3
"When Malcolm Clark Shot and Killed Owen
McKenzie at Mouth of Milk River," by Mrs. M. E.
Plassmann
THE FORT AT THREE FORKS

————, March 3, 1927, 7
"To the 'Pays d'en Haut,' " by Dan R. Conway
A MANDAN VILLAGE
————, March 17, 1927, 3
"The Nightherder," by Dan R. Conway
Charles M. Russell (photo)
HACKAMORE
THEY'RE ALL PLUMB HOG-WILD
SKULL #3*
RAWHIDE RAWLINS
————, March 24, 1927, 3
"The Flight of the Nez Perces," by Mrs. M. E. Plassmann
THE BATTLE OF (THE) BEAR PAWS
————, April 14, 1927, 3
"Milestown," by William Lansing
THE STAGE HOLDUP, i.e., THE HOLD UP
————, May 5, 1927, 3
" 'Uncle Billy' Hamilton," by Dan R. Conway
THE DEATH OF CHIEF ROMAN NOSE, i.e., CHARGE OF CHEYENNES LED BY ROMAN NOSE
————, May 26, 1927, 3
"The Dr. Jekyl and Mr. Hyde of the Old West," by Dan R. Conway. In Three Parts, Part One.
LAUGHED AT FOR HIS FOOLISHNESS AND SHOT DEAD BY SLADE
————, June 2, 1927, 3
"The Dr. Jekyl and Mr. Hyde of the Old West," by Dan R. Conway. In Three Parts, Part Two.
KILLING OF JULES RENI BY SLADE
————, June 9, 1927, 3
"The Dr. Jekyl and Mr. Hyde of the Old West," by Dan R. Conway. In Three Parts, Part Three.
PLUMMER'S MEN AT WORK
————, July 7, 1927, 1
LEWIS AND CLARK AND SACAGAWEA, i.e., LEWIS AND CLARK STATUE—DESIGN BY C. M. RUSSELL
————, July 14, 1927, 1
"The Stranglers," by Fred C. Gabriel
LOOKING FOR RUSTLERS
————, September 1, 1927, 1
"Days of the Fur Traders in the Northwest," by Mrs. M. E. Plassmann
FREE TRAPPERS, i.e., REED'S FORT
————, September 22, 1927, 1
"The Language of the Early-Day Cowboy"
ROPING A MAVERICK #2
————, April 12, 1928, 3
"7500 Persons see Art Show"
Charles M. Russell (etching by Branson Stevenson)
————, January 17, 1929, 1
"Negro was Mystery to Northwest Tribesmen," by W. H. Banfill
YORK*

————, June 6, 1929, 1
ROPING A MAVERICK #2
————, October 24, 1929, 1
WHEN LEWIS AND CLARK MET THE SHOSHONE, i.e., LEWIS AND CLARK MEETING INDIANS AT ROSS' HOLE
————, November 27, 1930, 3
"Pictures by Charles M. Russell"
Charles M. Russell (photo)
————, August 27, 1931, 4
"Thousands of Tourists Visit 'Cowboy Artist's' Cabin, Great Falls"
The Relic Room in the Russell Memorial at Great Falls (photo)
————, May 12, 1932, 3
"The History of the Montana Range: Cattle First Came to the Territory in 1832 as Work Animals and Dairy Cows; Kohrs and Beikenberg Were First to Trail into the State"
Charles M. Russell (photo)
————, July 14, 1932, 2
"Pictures by Charles M. Russell Reproduced in Colors"
Charles M. Russell (photo)
————, March 9, 1933, 1
" 'Big Nose' George was Notorious Outlaw"
THE HOLD UP
————, July 6, 1933, 3
LEWIS AND CLARK STATUE—DESIGN BY C. M. RUSSELL
————, January 18, 1934, 1
"Captain James Williams and X. Beidler Were Organizers of Vigilantes"
LAUGHED AT FOR HIS FOOLISHNESS AND SHOT DEAD BY SLADE
————, July 12, 1934, 7
"Big Nose George's Hide Went to the Tanyard; Dr. John Osborne Has Pair of Shoes Made from Skin of Desperado's Breast"
THE HOLD UP
————, November 29, 1934, 1
"Miles Cavanaugh . . . Tells of Vigilantes Work in Montana"
JIM SLADE FIGHTING A DUEL, i.e., LAUGHED AT FOR HIS FOOLISHNESS AND SHOT DEAD BY SLADE
————, August 29, 1935, 1
"When Rogers and Russell Swapped Yarns"
Will Rogers and C. M. Russell (photo)
————, August 20, 1936, 7
"Teddy Blue, Most Typical of Vanishing Cowboys"
Teddy Blue and Charles M. Russell (photo)
————, February 3, 1938, 2
"Scenes from the Old West by Tacetta B. Walker"
Charles M. Russell (portrait by Hazard)
————, July 14, 1938, 1
"Early Day Battle with Outlaws Re-enacted at Lewistown July 4th Stampede"
STREET BATTLE IN LEWISTOWN

———, July 28, 1938, 5
"Charles M. Russell's hand turned as deftly to the pen as to his brushes"
RUSSELL RIDES REAL OUTLAW
———, January 26, 1939, 5
"Three Organizations of Old Time Range Riders Plan to Rope and Brand Fast Vanishing Members of Clan"
MEAT MAKES FIGHTERS
———, February 9, 1939, 1
"Second Annual Cowboys' Reunion Banquet Will Honor Memory of C. M. Russell, Cowboy Artist"
RUSSELL RIDES REAL OUTLAW
———, February 23, 1939, 6
"Bill Hart, Unable to Attend Cowboy Reunion, Writes of Charles M. Russell"
———, March 7, 1940, 3
"Charles M. Russell, Montana's Most Famous Artist, Left Brief Biographical Sketch"
Charles M. Russell (Hazard portrait)
———, March 21, 1940, 1
"Old Time Cowhands Couldn't Carry a Tune in a Bucket"
MEAT MAKES FIGHTERS
———, May 23, 1940, 2
LEWIS AND CLARK REACH SHOSHONE CAMP WEST OF CONTINENTAL DIVIDE, i.e., LEWIS AND CLARK REACH SHOSHONE CAMP LED BY SACAJAWEA, THE "BIRD WOMAN"
———, July 4, 1940, 5
"Pictures by Russell"
RUSSELL RIDES REAL OUTLAW
———, August 8, 1940, 1
"5,000 Buffaloes Killed by Sioux Indians"
EARLY DAY INDIANS HUNTING BUFFALO ON THE PLAINS OF MONTANA, i.e., THE BUFFALO HUNT #35
———, November 21, 1940, 1
LEWIS AND CLARK REACH SHOSHONE CAMP LED BY SACAJAWEA, THE "BIRD WOMAN"
———, December 5, 1940, 1
"Stern Sentences Decreed by Judge Galbraith"
THE HOLD UP
———, January 2, 1941, 1
"Ruxton Fatally Hurt in Blackfeet Camp on Yellowstone in 1845"
REED'S FORT
———, February 13, 1941, 7
"Slug From 'Kid' Curry's Revolver Ended Landusky's Charmed Life"
DUM DUM BILL
———, February 20, 1941, 1
"Huge Grizzly Mauls and Kills Man"
GRIZZLY*
———, May 8, 1941, 1

"20 Million Buffalo Once Provided Good Living for American Indians"
BUFFALO BILL AND GRAND DUKE ALEXIS OF RUSSIA STAGE BUFFALO HUNT, i.e., RUNNING BUFFALO
———, May 29, 1941, 1
"White Hunter's Wasteful Slaughter of Wild Game Aroused Anger of Indians Who Killed for Food and Clothing"
[THE] BUFFALO HUNT #35
———, June 19, 1941, 7
"Free Trappers Invaded California to Bring 200 Horses Back to Montana"
BAND OF FUR TRADERS COMING INTO POST TO CELEBRATE, i.e., REED'S FORT
———, October 9, 1941, 7
"Nineteen White Men Fought from Barricade and Defeated Large Force of Sioux"
(THE) WAGON BOX FIGHT
———, February 8, 1942, 3
" 'Rawhide Rawlins' by Montana's Famous Cowboy Artist"
DUM DUM BILL
———, February 11, 1942, 1
"Why Did 'Rattlesnake Jake' and Pal Stage Shooting Spree in Lewistown 58 Years Ago"
JAKE AND FALLON, AS LONG AS THEY WERE ABLE TO PULL A TRIGGER, RETURNED SHOT FOR SHOT, i.e., STREET BATTLE IN LEWISTOWN
———, March 12, 1942, 3
"Excelbee's Famous Horse Thief Gang Met its Waterloo in Montana Fight"
ROPING A MAVERICK #2
———, March 26, 1942, 8
"Colored Prints: Works of Charles M. Russell; 64 Different Subjects"
Charles M. Russell (photo)
ROPING A MAVERICK #2
———, August 20, 1942, 1
"Mad Wolf, Famed Chief of Blackfeet Tribe Was Brave in Battle and Sagacious in Talk"
CURLEY REACHES THE FAR WEST WITH [THE] STORY OF THE CUSTER FIGHT
———, August 27, 1942, 3
"Woman's Hunch Results in Horse Thieves' Capture but Glory-Hunting Sheriff Claimed Reward Himself"
WHEN HORSEFLESH COMES HIGH

Rocky Mountain News, August 9, 1964, 18H
"Cowboy Artist is Honored"; photo THE JERK LINE

Saco Independent, May 31, 1956
"Exhibit Here June 24 of Charles Russell Paintings"
———, June 21, 1956, 6
"Drive for Russell Statue in Washington, D.C."

St. Louis Post Dispatch, December 6, 1903, Sunday Magazine
"Cowboy Artist Who Has Lived Among the Indians for Twenty-Three Years Will Exhibit Studies at the World's Fair"; portrait
BLACKFOOT WAR CHIEF* (model)
ROPING #2*
ACROSS THE PLAIN IN MIDWINTER, i.e., THE KING'S SCOUT*
———, April 10, 1904, 19–20
"A Cowboy Artist in Gotham," by Seymour Howard Bingham
ROPING A RUNAWAY, i.e., ROPING #2
SQUAW OFFERING HER PAPOOSE TO THE SUN* (this is the model for OFFERING TO THE SUN GODS [bronze])
RETURNING FROM THE HUNT* (model)
A BLACKFOOT ON THE MARCH, i.e., BLACKFOOT WAR CHIEF (model)
Charles M. Russell (photo)
———, February 16, 1910
p. 1: "St. Louis Artist Back from West; Wife is Manager"
p. 2: "St. Louis Painter of Scenes in the West and One of His Works"; portrait
THE ALERT
———, March 13, 1910, Sunday Magazine
"The West That is No More"; portrait
RUSSELL'S CARICATURE OF HIMSELF, i.e., FRIENDS I'M IN MISSOURI
(A) BRONC TO BREAKFAST
A SNIFF OF THE WEST*
(THE) FIRST WAGON TRAIL
———, October 25, 1926
"C. M. Russell, 'Cowboy Artist,' Native St. Louisan, Dies in West"
"Famous Artist and One of His Paintings"
SMOKING THEM OUT, i.e., SMOKING CATTLE OUT OF THE BREAKS
———, November 28, 1926, Sunday Magazine, 1–2
"A Cowboy Who Painted The Passing West"
ON THE WARPATH #1* (color)
BUCKING BRONCHO, i.e., THE BUCKING BRONCO #1 (color)
ACROSS THE PLAINS* (color)
INDIAN WARRIOR*
THE OLD TALE TELLER* (color)
BLACKFEET BURNING (THE) CROW BUFFALO RANGE
SMOKE OF FORTY-FIVES, i.e., SMOKE OF A FORTY-FIVE
THE ATTACK #1
THE TRAIL BOSS
GRIZZLIES AT BAY, i.e., UP AGAINST IT
Charles Marion Russell (photo)
———, November 15, 1961
"Surprising collection of Western art"

PONY EXPRESS RIDER FIGHTING OFF INDIANS, i.e., A PONY EXPRESS RIDER ATTACKED BY INDIANS
WHERE THE BEST OF RIDERS QUIT (bronze)
SMOKING UP (bronze) (two photos)
RUSSELL RIDES REAL OUTLAW

St. Louis Republic, March 6, 1910, Part V, p. 1
"Is he Remington's Successor?"; portrait; portrait of Mrs. Russell
SMOKE OF A FORTY-FIVE
THE FIRST FURROW
THE BUCKING BRONCO #1
THE WINTER PACKET

St. Louis Star, December 27, 1903, magazine section, 1, 5
"Cowboy Artist Now in St. Louis"; portrait
COWBOY ROPING A WOLF*
———, March 12, 1910
"Life of the Plains and Its People Is Vividly Pictured by St. Louisan"; portrait
ELK IN LAKE MCDONALD
ROUND UP, i.e., WOUND UP
A CROW CHIEF
LAST CHANCE OR BUST

San Francisco Chronicle, August 26, 1923
"Comparison of [H. W.] Hansen's work with that of CMR and of Maynard Dixon," by J. N. Pratt. Cf. p. 376 of *Artists and Illustrators of the Old West*, by Robert Taft.

Santa Barbara Daily News, January 1, 1927, 5
SMOKE TALK*
———, January 5, 1927
"First Memorial Exhibit of Russell's Art Displayed Here"
MOUNTAIN SHEEP #1 (bronze)
BEAR AND THE JUG* (bronze)
TO NOSES THAT READ A SMELL THAT SPELLS MAN* (bronze)
WEAPONS OF THE WEAK* (bronze)
MOUNTAIN MOTHER (bronze)
BUCKER AND BUCKEROO, i.e., THE WEAVER* (bronze)

Seattle Post Intelligencer, March 20, 1966, Northwest Today, 1, 14
"Cowboy artists ride into 'Tobey Country'"
p. 1: THE FREE TRAPPER, i.e., FREE TRAPPERS (color)
p. 14: THE DEERSLAYER* (color)
Charles Russell (photo)

Seattle Times, March 1, 1925
WHERE THE BEST OF RIDERS QUIT (bronze); portrait of CMR

South Omaha Sun, August 4, 1960, 60
"Russell's Art Records Last Days of Old West," by Philip Gurney
WOLF AND STEER'S SKULL, i.e., AN ENEMY THAT WARNS (bronze)
BUST OF INDIAN CHIEF, i.e., NAVAJO (bronze)
————, August 11, 1960, 30
"Humanity Greatest Interest of Cowboy Artist," by Philip Gurney (second of two parts)
SQUAW AND PAPOOSE, i.e., OFFERING TO THE SUN GODS (bronze)
[THE] BUFFALO FAMILY (bronze)

Spokesman-Review, August 16, 1959, Inland Empire Magazine
"Charles Russell, Cowboy Supreme . . . West Lives on in His Great Art."
MEN OF THE OPEN RANGE (color)
CAUGHT IN THE ACT
BRONC TO BREAKFAST (color)
COMING TO CAMP AT THE MOUTH OF SUN RIVER
LAUGH KILLS LONESOME (color)
THE ROUNDUP #2 (color)
————, August 27, 1959, 28
"Russell paintings preserve forgotten scenes of early West"
NO CHANCE TO ARBITRATE, i.e., WHEN HORSES TALK WAR THERE'S SMALL CHANCE FOR PEACE (color)
WHEN COWS WERE WILD (color)
TOLL COLLECTORS (color)

Sunday Star (Washington, D.C.), October 16, 1960, p. D-7, Philatelic News.
Range Conservation and Greeley Stamps. THE TRAIL BOSS

Stars and Stripes, September 23, 1963, 12–13
"He Outdrew All the Cowboys," by Patrick Dunn
CMR and Will Rogers (photo)
CMR at easel painting WHOSE MEAT (photo)
CMR and Nancy Cooper (photos)
WHEN HORSEFLESH COMES HIGH
AMBUSHED, i.e., BUSHWHACKED
HEADS OR TAILS, i.e., THE MIXUP (part)

Toronto Globe, September 25, 1909
"C. M. Russell: Cowboy Artist"; portrait, Mr. C. M. Russell Sketching in His Tent

Tulsa World, March 15, 1959
"Philbrook Russell Dated"
THE BUFFALO HUNT #5*

Washington Post, January 20, 1935, Rotogravure section

"The epochal expedition led by Lewis and Clark"
LEWIS AND CLARK MEETING INDIANS AT ROSS' HOLE
————, October 12, 1958
"Russell paintings on display"
SQUAW TRAVOIS
————, April 23, 1961, 8–9
"A young cowboy's dream trip"
(THE) BUFFALO HUNT (bronze)

Washington Post and Times Herald, March 18, 1959
"A statue of Charles M. Russell"; one photo
————, March 20, 1959, C-2
"West rides East to statuary hall"; one photo

Washington Star, September 30, 1958
"Smithsonian to show Russell's cowboy art"
————, October 12, 1958
"Russell's Art show opens here today"
————, October 19, 1958
"Old West panorama by Charles Russell"
INDIAN HEAD #4
————, March 17, 1959
"Cowboys, Indians ride up avenue with statue of painter of old West"; one photo
————, November 26, 1959, E-23
"Old Saloon Preserves Charlie Russell Legend"

Westminster (London) *Gazette*, April 9, 1914
"Horses and cowboys in art"

Whiteside Sentinel (Morrison, Illinois), March 19, 1964, 1
JERKED DOWN

Williston (North Dakota) *Herald*, July 16, 1925, Sec. 2
p. 9: REED'S FORT
p. 12: LEWIS AND CLARK REACH SHOSHONE CAMP LED BY SACAJAWEA, THE "BIRD WOMAN"

World (New York), April 9, 1911, N-8
" 'Cowboy Artist', Self Taught, Will Show in New York"
AT (THE) ROPE'S END*
WAITING FOR A CHINOOK
————, December 19, 1926, Color Gravure Section, 1
RIDERS OF THE OPEN RANGE, i.e., MEN OF THE OPEN RANGE (color)
————, January 9, 1927, Color Gravure Section
(A) BRONK (i.e., BRONC) TO BREAKFAST (color)
The Late Charles M. Russell (portrait by Emil Pollak-Ottendorf)
————, March 20, 1927
TAKING TOLL, i.e., TOLL COLLECTORS (color)
————, July 31, 1927
FREE TRADERS AND TRAPPERS, i.e., FREE TRAPPERS* (color)

———, January 8, 1928, Color Gravure Section
THE STRANGLERS* (color) (first in a series)
———, January 15, 1928, Color Gravure Section
THE BUFFALO HUNT #29* (second in a series)
———, January 22, 1928, Color Gravure Section
JERKED DOWN (color) (third in a series)
———, January 29, 1928, Color Gravure Section
BRUIN, NOT BUNNY, TURNED THE LEADERS* (color) (fourth in a series)
———, February 5, 1928, Color Gravure Section
A BAD ONE (color) (fifth in a series)
———, December 9, 1928
THE ATTACK ON THE WAGON TRAIN #2* (color)
———, April 7, 1929
POWDER RIVER, LET 'ER BUCK, i.e., THE BUCKING BRONCO #1 (color)
DISCOVERY OF LAST CHANCE GULCH, HELENA, MONTANA, i.e., PAY DIRT* (color)
———, April 14, 1929, Color Gravure Section, 1
THE (i.e., A) STRENUOUS LIFE (color)

A DOUBTFUL HANDSHAKE* (color)
WHERE TRACKS SPELL MEAT (color)
———, January 5, 1930, Color Gravure Section, 1
A BAD ONE (color)
———, January 19, 1930, Magazine, Color Gravure, Feature Section
THE STRANGLERS (part) (color)

Yellowstone News, August 7, 1952
"Russell Fund Campaign Near $50,000 Goal"
SMOKING UP (bronze)
THE BUCKER AND THE BUCKEROO, i.e., THE WEAVER (bronze)
THE HORSE WRANGLER (bronze)
JIM BRIDGER (bronze)
CHARLES M. RUSSELL AND HIS FRIENDS
INDIANS DISCOVERING LEWIS AND CLARK
BRONC TO BREAKFAST
THE BUCKING BRONCO, i.e., A BRONC TWISTER (bronze)
THE WARNING, i.e., AN ENEMY THAT WARNS (bronze)

Portfolios and Sets

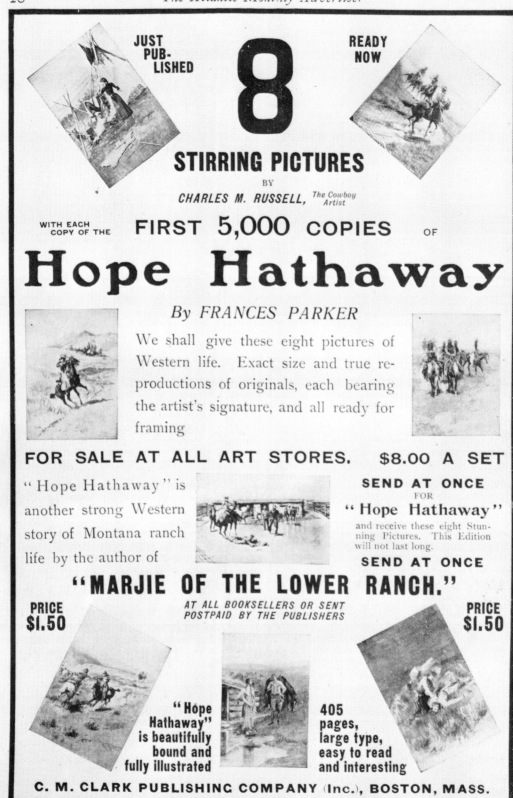

All the illustrations, except two, from *Hope Hathaway* were once available in print form with a copy of the book.
See item 2, this section.

SECTION V

Portfolios and Sets

1. Pen Sketches. First advertised in the *Great Falls Tribune* for December 8, 1901. Size presumed to be 13½ × 10¼. Titles of 12 black and white prints presumed to be same as those in *Pen Sketches*, Section I, item 6.

2. Hope Hathaway. Set of 8 prints, black and white, 9¾ × 14, issued 1904 by C. M. Clark Publishing Co., Boston. See Plate 20 for illustration of advertisement which appeared in the November, 1904, issue of *Atlantic Monthly*.

AS QUICKLY THE HORSE TOOK FRIGHT

HARRIS AND HIS FRIENDS

"IT IS GOOD, JUST AS I THOUGHT, AND AS COLD AS ICE," HE SAID

NEARLY UNSEATING THE OLD COWPUNCHER IN HER DEMONSTRATIONS OF WELCOME

ON HER FACE WAS THE SNARL OF A DOG

OLD PETER ROLLED OVER IN A CONVULSED HEAP

BROUGHT HER FACE TO FACE WITH LONG BILL AND SHORTY SMITH

DRAGGED THE HEAVY BODY UP TOWARD THE SHELTER OF ROCKS

3. Western Life. Set of 4 prints in colors (lithographs), size 12 × 17 on mounts 19 × 24, produced by Grignard Litho. Company and issued by Charles Scribner's Sons, New York, about August, 1905. These are the pictures which appeared in the February, 1905, *Scribner's Magazine*. The set was first advertised (at $3.50 for the set) in the October, 1905, *Scribner's Magazine*, q.v.

A BAD HOSS

THE CUSTER FIGHT, i.e., 1876—THE CUSTER FIGHT

BUCCAROOS, i.e., "BUCCAROOS" FROM THE N-N OUTFIT ON THE BIG DRY IN MONTANA

AN OLD-TIME HUNTING PARTY

4. Pictures in Color by Famous American Artists. Published by Charles Scribner's Sons, New York, n.d. (ca. 1905). Portfolio measures 16½ × 21, with 8 colored prints mounted on boards size 12 × 17. Front cover bears picture of a woman by Harrison Fisher. Contains the picture which appeared at p. [159] of the February, 1905, *Scribner's Magazine*, A BAD HOSS.

4a. Pictures in Color by Famous American Artists. Charles Scribner's Sons, New York, n.d. (ca. 1905). Pictorial cloth-backed folder, size 5¼ × 8.

A BAD HOSS

5. Western Types

A. The first published reference to the Western Types is an advertisement in the March 16, 1909, issue of the *Great Falls Daily Leader* listing the titles below. Although we have not seen it, we assume that a set with these titles was published on or shortly before that date.

THE COWBOY #2

THE PROSPECTOR

THE STAGE DRIVER

THE POST TRADER

THE HALF BREED, i.e., A FRENCH HALF-BREED

THE FREIGHTER, i.e., THE BULL-WHACKER

THE SCOUT #4*

THE TRAPPER*

THE WOOD HAWK*

THE CREE INDIAN*

THE SIOUX BUFFALO HUNTER*

BLACKFEET SQUAW AND PAPPOOSE*
SQUAW WITH BULLBOAT*
THE ROAD AGENT*
THE WOLFER*
BLACKFEET WARRIOR*

B. "Western Types by Charles M. Russell Compliments of the Great Falls Evening Leader." The foregoing text appears in gold stamping on a dark green envelope, with silhouette of THE COWBOY #2 in gold. Size 10¾ × 14⅛, cardboard. Contains:

[THE] SIOUX BUFFALO HUNTER
THE BUFFALO MAN, i.e., THE WOLFER
THE BULL WHACKER
THE COWBOY #2
FLATHEAD SQUAW AND PAPOOSE, i.e., BLACKFEET SQUAW
 AND PAPPOOSE
THE HALFBREED TRADER, i.e., THE POST TRADER
NORTHERN CREE, i.e., THE CREE INDIAN
PIEGAN WARRIOR, i.e., BLACKFEET WARRIOR
THE PROSPECTOR
RED RIVER BREED, i.e., A FRENCH HALF-BREED
THE SCOUT #4
THE STAGE DRIVER
THE STAGE ROBBER, i.e., THE ROAD AGENT
THE TRAPPER
THE WOOD HAWK
YOUNG SIOUX SQUAW, i.e., SQUAW WITH BULLBOAT

C. Same illustrations as the foregoing, but on heavier stock. Each illustration bears: "Copyright 1927 by The Leader Company." Titles are printed in lower corner, with explanatory note clipped to each plate. Size 10⅝ × 14.

D. Same illustrations as the foregoing, except PIEGAN WARRIOR (i.e., BLACKFEET WARRIOR) not included, but no words of copyright or titles. Explanatory note clipped to each plate. In yellow or aqua envelope, size 11 × 16½, with illustration THE COWBOY #2 along left side, bearing the following: "Reproductions of original Russell Sketches [SKULL #1] 15 Famous Sketches [two columns of titles] Copyright The Leader Company, Great Falls, Mont."

E. Advertisement for 5A above. Folio, pp. [4], size 3¾ × 8½.
p. [1]: Russell Sketches Western Types by the Great Cowboy Artist Charles M. Russell. [Line engraving THE COWBOY #2]. A Collection of Reproductions of Original Pen and Ink Sketches, Copyrighted and sold only by The Leader Company, Great Falls, Montana.
p. [2]: Biographical note on CMR and description of prints.

p. [3]: Lists 16 reproductions, same as 5A above.
p. [4]: photo of CMR

F. Reproductions of Original Russell Sketches. 15 Famous Sketches [list of prints in two columns]. Copyright The Leader Company, Great Falls, Mont. This appears on yellow envelope, size 17⅛ × 11½, with illustration THE COWBOY #2 on left side and SKULL #1 in center. Size of plates 10 15/16 × 16½. BLACKFEET WARRIOR omitted. Issued November, 1962.

6. Montana Printing Co., Great Falls, Montana. Portfolio of 24 three-color pictures, size 9 × 12, mounted on cover stock size 14 × 19, in black cover, with INDIAN HEAD #5 and words "Russell Reproductions" on cover. N.d., ca. 1915.

7. Souvenir Russell Sketches. B.P.O.E. No. 214, February 14, 1917. Great Falls, Montana. Contained in envelope size 10¼ × 7, with illustration SHES WIDE OPEN on envelope.
CRAWL HIM, HE'S GENTLE*
THE FIRST GOAT*
THE LIDS OFF*
SAYS HE'S AN ELK*
SHES WIDE OPEN*
WHEN THE GETTING IN WAS EASY*

8. Studies of Western Life
Six Albertypes in an envelope. No letterpress. Unbound. Size 10¼ × 8¼. These appeared in *Studies of Western Life* (Collation 1) and were probably issued about the time the second edition was issued, i.e., 1919.
WAR (INDIAN TELEGRAPHING)
COWBOY SPORT (ROPING A WOLF) #1
"HANDS UP"
CLOSE QUARTERS
THE FORD
CROSSING THE MISSOURI #1

9. Twelve Wonderful Pictures. C. M. Russell. Reproduced in colors from original paintings. Thrilling incidents of the "Wild West." A. C. McClurg & Co., Chicago, Ill. N.d., ca. 1920. Black board folder 15¼ wide by 11½ high with a cream-colored label printed in green in the upper left-hand corner. Contains the following prints:
BRONC FOR (i.e., TO) BREAKFAST
CAPTURING THE GRIZZLY
THE CINCH RING
A DANGEROUS CRIPPLE, i.e., CRIPPLED BUT STILL COMING
A DISPUTED TRAIL
(THE) FIRST WAGON TRAIL
HEADS OR TAILS, i.e., THE MIXUP
IN WITHOUT KNOCKING

A BAD HOSS
Lithograph by Grignard & Co., one of a series of four.
See item 3, this section.

JERKED DOWN
LAST OF THE HERD, i.e., SURROUND
SINGLE HANDED
WHEN HORSEFLESH COMES HIGH

10. Paintings and Pen Sketches. Reproduced exclusively by Naegele Printing Co. (Helena, Montana, n.d., ca. 1922). Bound in heavy boards, fully covered with simulated black leather, gilt-stamped, expanding screw-down loose-leaf album, size $10\frac{1}{2} \times 16\frac{1}{2}$. Apparently this was a prospectus, possibly carried by a salesman. On heavy paper are mounted 31 full-color reproductions of CMR paintings and 21 pen and ink sketches, plus 1 full-color reproduction of a painting by E. S. Paxson. Not seen. Data from catalog 75 of J. E. Reynolds, item R-23, June, 1963.

11. Charles M. Russell's Genuine Portrayals of the Old West. Six artist's proofs. Cheely-Raban Syndicate, Great Falls, Montana. (September, 1922.) Size $17\frac{1}{2} \times 12\frac{1}{2}$.
Portfolio cover: THE OLD WEST*
ADVANCE OF BLACKFEET TRADING PARTY
DISCOVERY OF THE ROCKY MOUNTAINS BY THE DE LA
 VERENDRYES, i.e., LA VERENDRYES DISCOVER THE ROCKY
 MOUNTAINS
PAWNEE INDIANS SEE FIRST MISSOURI RIVER STEAMBOAT,
 i.e., PAWNEES SEE "WATER MONSTER"
RADISSON'S RETURN TO QUEBEC FROM THE HUDSON'S
 BAY COUNTRY, i.e., RADISSON RETURNS TO QUEBEC WITH
 350 CANOES LOADED WITH FURS
STAGE COACH ATTACKED BY INDIANS
WAGON BOX FIGHT

12. Artist's Proofs, C. M. Russell, "The Cowboy Artist." Ridgley Calendar Co., Great Falls, Montana, n.d., ca. 1922. Small folio, gilt-printed wrappers, size unknown. Contains 26 color plates, listed below, and 12 black and white plates. Portrait of CMR on front wrapper.
THE ATTACK #1
BLACKFEET BURNING CROW BUFFALO RANGE
CROW CHIEF
BETTER THAN BACON
THE FIRST FURROW
BOSS OF THE TRAIL HERD
THE BUCKING BRONCO #1
THE HOLD-UP
ELK IN LAKE MCDONALD
THE MAD COW
AN OLD FASHIONED STAGE COACH
INDIAN CHIEF #3
THE PROSPECTORS #1
LAST CHANCE OR BUST

THE TENDERFOOT #1
A RAINY MORNING IN A COW CAMP, i.e., RAINY MORNING
ROPING A WOLF #2
ROPING A GRIZZLY, i.e., ROPING A RUSTLER
SCATTERING THE RIDERS
SMOKE OF A FORTY-FIVE
WILD HORSE HUNTERS #2
A WOUNDED GRIZZLY
WOMEN OF THE PLAINS, i.e., BREAKING CAMP #3
THE WATER GIRL #2
THE WINTER PACKET
WOUND UP

13. Artist's Proofs [rules] [INDIAN HEAD #5] By C. M. Russell [rules]. Black poster paper album, size $11\frac{1}{4} \times 14\frac{1}{8}$, with cover stamped in gold, leather thong tie. N.p., n.d. (probably Ridgley, Great Falls, ca. 1909). Contains 12 color plates (not proofs), size 9×11 average, but not always the same plates.

13a. Artist's Proofs. INDIAN HEAD #5. By C. M. Russell. Yellowstone Park Association, Distributors, Yellowstone Park. Black poster-paper album, size $11\frac{1}{4} \times 14\frac{1}{4}$, with gold lettering, leather thong tie. Plates 9×11 average. Contains 12 plates usually. Not proofs.

14. Reproductions from paintings by C. M. Russell "The Cowboy Artist." INDIAN HEAD #5. Distributed by The Como Co., Great Falls, Montana. Black poster paper, silk cord tie, gold lettering, $13 \times 16\frac{3}{4}$. Contains 32 plates usually. Not proofs.

15. Western Life by C. M. Russell. Text appears in gold on front cover of loose-leaf album of imitation leather, size $13\frac{1}{2} \times 20$, containing 85 different color prints. Issued by Dick Jones.

16. Nine Pictures of Western Life by Charles Marion Russell. Small portfolio of color plates issued by Brown & Bigelow. Not seen.

17. Western Art. Ten prints in portfolio by different artists. Los Angeles, n.d. (ca. 1928). Size of print $4\frac{3}{4} \times 7\frac{1}{2}$; size of mat $11 \times 14\frac{1}{2}$. Descriptive broadside enclosed. Contains:
FIGHTING MEAT* (color)

18. C. M. Russell Western Reproductions. Text in block lettering on cover of heavy tan paper, folio, tied with yellow silk cord, size 20×13 inches. Probably issued by the Dick Jones Picture Company, about 1930, as 16 of the color plates carry the imprint of this firm.
THE BOLTER #3
BRONC TO BREAKFAST

THE CINCH RING

COWBOY LIFE

DANGEROUS CRIPPLE, i.e., CRIPPLED BUT STILL COMING

HEADS OR TAILS, i.e., THE MIXUP

THE HOLDUP

INDIAN HEAD #10 on cover

THE INNOCENT ALLIES

JERKED DOWN

THE JERKLINE

LOOPS AND SWIFT HORSES ARE SURER THAN LEAD

A SERIOUS PREDICAMENT, i.e., RANGE MOTHER

SINGLE HANDED

THE SLICK EAR

SUN WORSHIPPERS

WHEN HORSEFLESH COMES HIGH

WHEN IGNORANCE IS BLISS, i.e., UNEXPECTED GUEST

WHEN (i.e., WHERE) TRACKS SPELL MEAT

WHO KILLED THE BEAR, i.e., THE PRICE OF HIS HIDE

WHOSE MEAT?

19. Frontier Days. Text appears in pictorial script on front of portfolio, size $10\frac{1}{2} \times 15\frac{5}{8}$. Also contains a sketch of Russell's life and the story of each print. Publisher unknown, but may have been Gokey of St. Paul.

(THE) FIRST WAGON TRAIL

CAPTURING THE GRIZZLY

THE CINCH RING

THE LAST OF THE HERD, i.e., SURROUND

WHEN SIOUX AND BLACKFEET MEET, i.e., WHEN BLACKFEET
 AND SIOUX MEET

WHEN HORSEFLESH COMES HIGH

A SERIOUS PREDICAMENT, i.e., RANGE MOTHER

HEADS OR TAILS, i.e., THE MIXUP

JERKED DOWN

20. I BEAT YOU TO IT / Charles M. Russell / Pen and Ink Sketches / SKULL #1. Portfolio in wrappers, punched and tied at top. Size of plates $15\frac{1}{4} \times 12\frac{1}{2}$. Issued by Glacier Printing Co. at Great Falls about 1945. No letterpress. Contains 12 line engravings:

INDIAN OF THE PLAINS AS HE WAS, i.e., AH-WAH-COUS

THE SHELL GAME

THE HOLDUP, i.e., HOLDING UP THE OVERLAND STAGE

NATURE'S CATTLE #1

PICTURE WRITING, i.e., THE PICTURE ROBE

BOSS OF THE TRAIL HERD, i.e., THE TRAIL BOSS

THE SCOUTS, i.e., THE INDIAN OF THE PLAINS AS HE WAS

MOUNTAIN RETREAT, i.e., OLD HOOVER CAMP ON SOUTH
 FORK OF JUDITH RIVER

PAINTING THE TOWN

THE LAST OF THE BUFFALO

THE LAST OF HIS RACE

THE CHRISTMAS DINNER

Subsequently another issue was printed, without the Mint picture, I BEAT YOU TO IT, and with same pictures, but these title changes:

THE INDIAN OF THE PLAIN AS HE WAS, i.e., AH-WAH-COUS

HOLDING UP THE OVERLAND STAGE

THE TRAIL BOSS

OLD HOOVER CAMP ON SOUTH FORK OF JUDITH RIVER (no
 caption)

Variant: Lemon-colored wrappers with profile of CMR; size $14\frac{1}{2} \times 11\frac{1}{2}$; plate of THE KILL* substituted for either THE CHRISTMAS DINNER or THE LAST OF HIS RACE.

N.B. The sequence of the pictures may not be the same in all portfolios, but considering the fact that they could be rearranged simply by untying the shoestring, we do not think any point should be made of the order in which the plates appear. Also, the stock on which the plates are printed is not uniform in all copies.

21. Souvenir Sketch Book of Charles M. Russell Pen & Ink Sketches (with space for writing donor's name). Portfolio in wrappers, punched and tied at left side. Size of plates $7\frac{3}{8} \times 4$. This contains the same plates as the foregoing item. It also was issued by Glacier Printing Co. of Great Falls about 1945.

22. Plates issued with Deluxe edition of biography. Size 6×9 in envelope. Trail's End Publishing Co., 1948.

CHARLES MARION RUSSELL (SELF-PORTRAIT), i.e., SELF-
 PORTRAIT #1

A DREAM OF BURLINGTON

RIDER OF THE ROUGH STRING

WAITING FOR A CHINOOK THE LAST OF 5000, i.e., THE
 LAST OF 5000

COWBOY SPORT—ROPING A WOLF #2

RETURN OF THE WARRIORS

WHEN THE RED MAN TALKS WAR (ON THE WHITE MAN'S
 TRAIL)

WHEN WAGON TRAILS WERE DIM

WHEN MULES WEAR DIAMONDS

I DRINK NOT TO KINGS, panel B

HIS HEART SLEEPS #1

TRAIL'S END

23. Seven Drawings by Charles M. Russell with an additional drawing by Tom Lea all reproduced in the original size and an Essay on these pictures: "The Conservatism of Charles M. Russell" by J. Frank Dobie. Brought together in a portfolio by Carl Hertzog at El Paso, Texas. Portfolio of Tweedweave paper, dusty red, size 22×15, with cover label as above. The prints are on Diploma parchment, loose. The Dobie

essay is a separate folio. Limited to 675 copies, of which 400 were for sale. 1950.

BEFORE THIS HE ONLY HAD WOLVES BROKE TO PACK OR
 DRAG A TRAVOIS
BLACKFEET TRADING PARTY IN SIGHT OF FORT BENTON
CHEYENNES WATCHING UNION PACIFIC TRACK LAYERS
A DIAMOND R MULE TEAM OF THE '70S
PAWNEES SEE WATER MONSTER
A PONY EXPRESS RIDER ATTACKED BY INDIANS
A SWING STATION ON THE OVERLAND

24. The Wonderful West of Charles M. Russell. Portfolio of gray paper, with portrait of CMR on front; lettering in black and red; and two illustrations, THE MOUNTAINS AND PLAINS SEEMED TO STIMULATE A MAN'S IMAGINATION and FLATBOAT ON RIVER, FORT IN BACKGROUND, on the back.
Issued by the Historical Society of Montana, Helena, 1956, in a limited edition of 500 copies. Size 10 × 12⅞, with one deckle edge on each print. Also contains a folio, "The Conservatism of Charles M. Russell," reproduced from the Carl Hertzog portfolio, Seven Drawings, *supra*. The printer was not a Hertzog, however, because the beginning of the essay is p. [4], the remainder is p. [2], and the acknowledgements are on p. [1] and p. [3]. On p. [1] of the folio appears THE SCOUT #4 (reduced) and on p. [3] THE WOLFER and THE TRAPPER. Contains 12 pen and ink drawings. There are no titles printed on the prints, but there is a list of titles assigned by Montana Historical Society on p. [3] of the portfolio; hence the corrections.

BUFFALO MAN, i.e., THE WOLFER
THE SCOUT #4
STAGE ROBBER, i.e., THE ROAD AGENT
THE TRAPPER
HALFBREED TRADER, i.e., THE POST TRADER
FORT UNION, i.e., FLATBOAT ON RIVER, FORT IN BACK-
 GROUND
GRABBIN' FOR GUMBO, i.e., ABOUT THE THIRD JUMP CON
 LOOSENS
HANDS UP, i.e., WE AIN'T GONE FIVE MILE WHEN THE
 COACH STOPS
COW CAMP IN WINTER, i.e., IN THE OLD DAYS THE COW
 RANCH WASN'T MUCH
BAD DAY AT SQUARE DEAL DAN'S, i.e., COWPUNCHERS WERE
 CARELESS, HOMELESS, HARD-DRINKING MEN
GHOST HORSE, i.e., THE CHIEF FIRED AT THE PINTO #2
TIME TO TALK, i.e., THE MOUNTAINS AND PLAINS SEEMED
 TO STIMULATE A MAN'S IMAGINATION

25. A Portfolio of Ten Pen and Ink Drawings by Charles Marion Russell [buffalo skull] Reproduced in Limited Edition From Originals in the Charles M.

Russell Gallery, State Historical Museum, Helena, Montana, 1957. Portfolio of tan paper, with name in red and buffalo skull in green, size 11 × 13⅞. The prints are loose, size 9⅞ × 12⅞. There is a printed sheet the same size entitled "Charles Marion Russell: Some comments." The insides of the portfolio also bear printing. Limited edition of 500 copies.

COMING TO CAMP AT THE MOUTH OF SUN RIVER
LIKE A FLASH THEY TURNED
THE ODDS LOOKED ABOUT EVEN
LADY BUCKEROO
STEER RIDER #2
OLD MAN SAW A CRANE FLYING OVER THE LAND
COWBOY SEATED, HORSE NUZZLING HIS LEFT HAND
I'M HANGIN' ON FOR ALL THERE IS IN ME
MOST OF THE COW RANCHES I'VE SEEN LATELY WAS LIKE A
 BIG FARM
PETE HAD A WINNING WAY WITH CATTLE

26. Charles M. Russell Watercolors of the Old West. Six Superb Reproductions in Full Color. Ready for framing. Overprinted on a color reproduction of IL BE THAIR WITH THE REST OF THE REPS (part of the letter to Geo. W. Farr, see below). Brown paper folder, size 16⅜ × 12⅛, containing six prints loose, size 16 × 12. Issued by Montana Historical Society, 1958.

INTRUDERS*
[THE] SURPRISE ATTACK
WHEN COWS WERE WILD
INDIANS AND SCOUTS TALKING
LETTER TO GEO. W. FARR, i.e., IL BE THAIR WITH THE REST
 OF THE REPS
SQUAW TRAVOIS*

27. Russell Portfolio. Issued by the Historical Society of Montana, 1959. Accompanied by flyer, size 10 × 13, printed both sides, with note by K. Ross Toole. Color.

CHARLEY (i.e., CHARLES M.) RUSSELL AND HIS FRIENDS
THE HERD QUITTER
PONY RAID
TOLL COLLECTORS
WATCHING THE SETTLERS
WHEN COWS WERE WILD

28. The Thomas Gilcrease Institute of American History and Art, P.O. Box 2419, Tulsa, Oklahoma. Portfolio containing 3 CMR prints in color and 1 other, including descriptions of the paintings and biographical material of the artists. Size 17 × 22. N.d. (1961).

[THE] CAMP COOK'S TROUBLE
A DOUBTFUL VISITOR, i.e., A PRAIRIE SCHOONER CROSSING
 THE PLAINS
JERKED DOWN

29. U. O. Colson Company, Paris, Illinois. Portfolio No. 6, 1963, Western Art. A distinguished portfolio by the master artists of the Old West—Charles M. Russell, Frederic Remington. Charles M. Russell "Lewis and Clark Meeting the Flathead Indians," Frederic Remington "Prospecting for Cattle Range." Stiff green manila, printed in black (the foregoing is only a partial rendering). Size 19 × 12¾. Within a stapled pocket are three different sizes of the CMR print LEWIS AND CLARK MEETING INDIANS AT ROSS' HOLE, viz.: 13½ × 20; 18 × 27½; 28 × 41½, folded, and one Remington print. The portfolio was designed for salesmen's use in taking orders for calendars. Issued in January, 1962. See the *Sales Builder* in Sec. III.

30. Paper Talk. 12 Full Color Reproductions of Illustrated Letters of Charles M. Russell. Loose color prints, size 8⅜ × 11¼, in plastic envelope. Each print has letterpress on the reverse: "Reprinted from Paper Talk Illustrated Letters of Charles M. Russell Edited by Frederic G. Renner Copyright 1962 by the Trustees of the Amon Carter Museum of Western Art, Fort Worth, Texas."
Cover: Charles M. Russell (photo).

A BUFFALO
BOOSE FOR BOOSE FIGHTERS
FIGHT IN LUMBER CAMP
HANG AN RATTEL, JIMMY
HAVE SOM BOILED BEEF
IN A MELION PATCH
ME AN JACK
ME AND MY OLD HOSS
SHES AT DINNER
THIS KIND I DONT KNOW
TOOK OF MY HAT TO THE GARD
WE BOTH KNEW THIS KIND

31. A Charles M. Russell Album. Produced by the Historical Society of Montana. Brown wrappers, size 11⅛ × 17¾, n.d. (ca. 1962). Plastic spiral ring binder containing 12 corner-slotted sheets for miscellaneous CMR color prints.
cover: THE STAGE ROBBER, i.e., THE ROAD AGENT

32. Twelve Pen and Ink Drawings from the Gifted Pen of Charles M. Russell. (Montana Historical Society, Helena, n.d., ca. 1962). Gray paper with green ink. Portrait of CMR on front. Prints size 5¼ × 4¼, on white paper, not captioned.
ABOUT THE THIRD JUMP CON LOOSENS
COWBOY SEATED, HORSE NUZZLING HIS LEFT HAND
FROM THE SOUTHWEST COMES SPANISH AN' MEXICAN TRADERS
LADY BUCKEROO

LIKE A FLASH THEY TURNED
THE MOUNTAINS AND PLAINS SEEMED TO STIMULATE A MAN'S IMAGINATION
THE ODDS LOOKED ABOUT EVEN
A RACE FOR THE WAGONS
RAWHIDE RAWLINS, MOUNTED
SPREAD-EAGLED
STEER RIDER #2
WE AIN'T GONE FIVE MILE WHEN THE COACH STOPS

33. Compliments of KOPR Courtesy Car 550 on your dial. Envelope, tan stock, size 14½ × 11½. Contains (THE) TOLL COLLECTORS, size 12½ × 10¼, in sepia. Description of picture on back of envelope. N.d. (1964).

34. Charles M. Russell's Majestic Montana. Centennial Portraits of a Great Frontier Region. Big Sky Art Supply, 1964. Cream wrappers overprinted with green ink. Size 18¹³⁄₁₆ × 13.
cover: IL BE THAIR WITH THE REST OF THE REPS
Contains: INTRUDERS; INSIDE THE LODGE; YORK; BUFFALO HUNT #22; NATURE'S SOLDIERS; WAITING WARRIOR*; SQUAW TRAVOIS

35. Charles M. Russell's Majestic Montana. Centennial Portraits of a Great Frontier Region. Big Sky Art Supply, 1964. Aqua wrappers overprinted with brown ink. Size 25 × 18.
cover: IL BE THAIR WITH THE REST OF THE REPS
Contains: INTRUDERS; INSIDE THE LODGE; BUFFALO HUNT #22; LEWIS AND CLARK MEETING THE FLATHEADS AT ROSS' HOLE, i.e., LEWIS AND CLARK MEETING INDIANS AT ROSS' HOLE; WAITING WARRIOR

36. The Centennial Portfolio of Charles Marion Russell Montana's Pride and the Greatest of All Cowboy Artists [skull design]. Produced for Montana's Territorial Centennial Celebration by The Montana Historical Society. Cream folder, size 12½ × 18. Enclosed black and white prints are 11½ × 17¾. (1964).
Contains:
BLACKFEET RAIDING PARTY, i.e., ADVANCE OF BLACKFEET TRADING PARTY
FIRST WHITE HABITATION IN MONTANA, i.e., BUILDING FORT MANUEL IN 1807
IDAHO (CITY) OX TEAMS WERE BRINGING IN SOME 6,000,000 POUNDS OF FREIGHT ANNUALLY
KIT CARSON OUTDUELS A CANADIAN BULLY, i.e., CARSON DEFEATS FRENCH BULLY IN HORSEBACK DUEL
OLD MAN SAW A CRANE FLYING OVER THE LAND
OVERLAND STAGE ATTACKED BY SAVAGES, i.e., STAGE COACH ATTACKED BY INDIANS

STEER RIDER #2
A TEXAS TRAIL HERD
AN UNSCHEDULED STOP, i.e., PLUMMER'S MEN AT WORK
WAGON BOX FIGHT

FREE TRADERS, i.e., FREE TRAPPERS
INDIAN HUNTERS' RETURN
MEDICINE MAN #4
THE SLICK EAR

37. The Centennial Portfolio of Charles Marion Russell Montana's Pride and the Greatest of All Cowboy Artists [skull design] Produced for Montana's Territorial Centennial Celebration by The Montana Historical Society. Cream folder, size $8\frac{1}{2} \times 10\frac{1}{2}$. Enclosed black and white prints are $7\frac{1}{2} \times 10$. (1964). Contains:

BUFFALO'S REVENGE, i.e., I'M HANGIN' ON FOR ALL THERE IS IN ME
SCOOL MARM
CANOE INDIAN, i.e., LOOKS AT THE STARS
THE CALF ROPER, i.e., PETE HAD A WINNING WAY WITH CATTLE
CENTERFIRE MAN, i.e., RAWHIDE RAWLINS, MOUNTED
FLATBOAT ON RIVER, FORT IN BACKGROUND
THE GEYSER BUSTS LOOSE
HIS HEART SLEEPS #2
SPREAD-EAGLED
STEVE MARSHLAND WAS HANGED [BY VIGILANTES]

38. Charles M. Russell Portraits of the Old West. A quality portfolio of choice art from the Charles M. Russell Room, Historical Society of Montana, reproduced exclusively from the originals by U. O. Colson Co., Paris, Illinois. Six Superb Reproductions in Full Color, Ready for Framing. All the above overprinted on CHARLES M. RUSSELL AND HIS FRIENDS (color). Brown folder, size 14 × 19 (1964). Contains:
INDIANS DISCOVERING LEWIS AND CLARK
WHEN HORSES TALK WAR THERE IS (i.e., THERE'S) SMALL CHANCE FOR PEACE
LEWIS AND CLARK MEETING INDIANS AT ROSS' HOLE
THE HERD QUITTER
MEN OF THE OPEN RANGE
VAQUEROS OF OLD CALIFORNIA

39. Master Portfolio of Western Art Limited Edition of 500 only. Montana Historical Society. Produced and Distributed Exclusively by the Montana Historical Society, Helena, Montana. Size 30 × 24, with WHEN COWS WERE WILD in color on front. Contains 5 plates by CMR, in color, loose in portfolio, and a sixth, entitled "War Party," which is of questionable authenticity. (1965).
SURROUND

40. Important Notice to the purchasers of the special limited edition of Charles M. Russell Paintings, Drawings, and Sculpture in the Amon G. Carter Collection. A Descriptive Catalogue by Frederic G. Renner. This folder contains a set of color prints from the regular edition of the book. No other reproductions of these plates are available. Folder, gray stock, size 11 × $11\frac{1}{4}$, n.p., n.d. (Fort Worth, November, 1966). Contains:
BESTED
BREAKING CAMP #1
THE BROKEN ROPE
BRONC IN COW CAMP, i.e., CHUCK WAGON ON THE RANGE
[THE] BUFFALO HUNT #26
(THE) BUFFALO HUNT #40
CAUGHT NAPPING
CHARLIE HIMSELF, i.e., CHARLES M. RUSSELL (CARICATURE STATUETTE)
COUNCIL OF WAR
COWBOY CAMP DURING THE ROUNDUP
CROW INDIANS HUNTING ELK
A DESPERATE STAND
A DOUBTFUL GUEST
FLINTLOCK DAYS—WHEN GUNS WERE SLOW
FOR SUPREMACY
THE HOLDUP
THE HORSE THIEVES
IN WITHOUT KNOCKING
INDIAN SIGNALLING (i.e., SIGNALING) #2
JUMPED
KEEOMA #1
LEWIS AND CLARK ON THE LOWER COLUMBIA
LOOPS AND SWIFT HORSES ARE SURER THAN LEAD
LOST IN A SNOW STORM—WE ARE FRIENDS
(THE) MEDICINE MAN #2
NOT A CHINAMAN'S CHANCE
THE POKER GAME
POWDER FACE, i.e., POWDERFACE—ARAPAHOE
ROPING A WOLF #1
ROPING FRESH MOUNTS
THE SILK ROBE
SMOKE OF A .45 (i.e. FORTY FIVE)
(A) TIGHT DALLY AND (A) LOOSE LATIGO
WHEN HORSEFLESH COMES HIGH
WHEN MULES WEAR DIAMONDS
THE WOLFER'S CAMP

WESTERN TYPES

	The Anaconda Standard Dec. 15, 1901	Great Falls Daily Leader March 16, 1909	Copyright Titles Issued Feb. 1, 1927 To The Leader Co. Great Falls, Mont.	Price List Copyrighted And Sold Only By The Leader Co. Sec. VI – D-75	Leader Envelopes circa 1927
1.	THE COWBOY	THE COWBOY	THE COWBOY	THE COWBOY	THE COWBOY
2.	THE PROSPECTOR	THE PROSPECTOR	THE PROSPECTOR	THE PROSPECTOR	THE PROSPECTOR
3.	THE STAGE DRIVER	THE STAGE DRIVER	THE STAGE DRIVER	THE STAGE DRIVER	THE STAGE DRIVER
4.	THE POST TRADER	THE POST TRADER	HALF BREED TRADER	THE HALF BREED TRADER	HALF BREED TRADER
5.	A FRENCH HALF-BREED	THE HALF BREED	RED RIVER BREED	RED RIVER BREED	RED RIVER BREED
6.	THE BULL-WHACKER	THE FREIGHTER	THE BULL WHACKER	THE BULL WHACKER	BULL WHACKER
7.		THE SCOUT	THE SCOUT	THE SCOUT	THE SCOUT
8.		THE TRAPPER	THE TRAPPER	THE TRAPPER	THE TRAPPER
9.		THE WOOD HAWK	THE WOOD HAWK	THE WOOD HAWK	THE WOOD HAWK
10.		THE SIOUX BUFFALO HUNTER	BUFFALO HUNTER	SIOUX BUFFALO HUNTER	BUFFALO HUNTER
11.		THE CREE INDIAN	NORTHERN CREE	NORTHERN CREE	NORTHERN CREE
12.		BLACKFEET SQUAW AND PAPPOOSE	FLATHEAD SQUAW AND PAPOOSE	FLATHEAD SQUAW AND PAPOOSE	FLATHEAD SQUAW AND PAPOOSE
13.		SQUAW WITH BULLBOAT	YOUNG SIOUX SQUAW	YOUNG SIOUX SQUAW	YOUNG SIOUX SQUAW
14.		THE WOLFER	BUFFALO MAN	THE BUFFALO MAN	BUFFALO MAN
15.		THE ROAD AGENT	THE STAGE ROBBER	THE STAGE ROBBER	THE STAGE ROBBER
16.		BLACKFEET WARRIOR	PIEGAN WARRIOR	PIEGAN WARRIOR	(missing)

See item 5, this section.

Color Prints

SECTION VI

Color Prints

Russell painted more than 40 paintings called THE BUFFALO HUNT. We have arbitrarily assigned numbers to these in accordance with the year they were executed. The following have been reproduced as color prints:

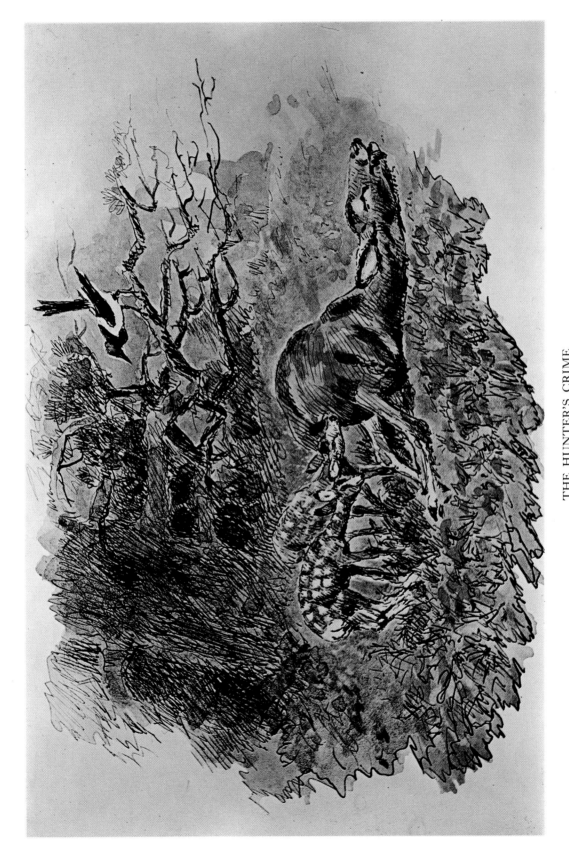

THE HUNTER'S CRIME
Painted by CMR for the Montana Fish and Game Commission.
See item 125, this section.

275. TOLL COLLECTOR, i.e., TOLL COLLECTORS
276. TOLL COLLECTORS*
277. TOLL COLLECTORS (printed in reverse)
 TOLL COLLECTORS (as DEADLINE OF THE RANGE and
 as TOLL COLLECTOR)
278. TOOK OF MY HAT TO THE GARD
 TRAILING (as HEADING THE RIGHT WAY)
279. TRAIL'S END*
280. TRAPPERS' LAST STAND
281. THE TROUBLE HUNTERS*
282. TWO OF A KIND WIN, i.e., MAN'S WEAPONS ARE
 USELESS WHEN NATURE GOES ARMED*
 UNEXPECTED GUEST (as WHEN IGNORANCE IS BLISS)
283. THE UNEXPECTED VISITOR, i.e., A PRAIRIE SCHOONER
 CROSSING THE PLAINS
284. AN UNSCHEDULED STOP
285. AN UNSCHEDULED STOP, i.e., THE INNOCENT ALLIES
 UP AGAINST IT (as AT CLOSE QUARTERS)
286. VAQUEROS OF OLD CALIFORNIA
287. (THE) WAGON BOSS*
288. THE WAGON BOSS* (without bottle in foreground)
289. WAITING FOR A CHINOOK
290. WAITING FOR A CHINOOK THE LAST OF 5000, i.e.,
 THE LAST OF 5000
291. WAITING WARRIOR
292. THE WAR PARTY #3
293. THE WARNING SHADOWS, i.e., WHEN SHADOWS HINT
 DEATH
294. WATCHING FOR THE SMOKE SIGNAL
295. WATCHING THE SETTLERS
296. [THE] WATER GIRL #2*
297. WE BOTH KNEW THIS KIND
298. A WEAVER
299. A WESTERN GREETING
300. WHEN ARROWS SPELLED DEATH*
 WHEN ARROWS SPELLED DEATH (as REDSKIN RAIDERS)
 WHEN BLACKFEET AND SIOUX MEET (as WHEN SIOUX
 AND BLACKFEET MEET)
301. WHEN COWS WERE WILD*
302. WHEN GUNS SPEAK DEATH SETTLES DISPUTE
303. WHEN GUNS WERE THE LOCKS TO THE TREASURE
 BOX*
304. WHEN HORSEFLESH COMES HIGH*
305. WHEN HORSES TALK WAR THERE'S SMALL CHANCE FOR
 PEACE
 WHEN HORSES TALK WAR THERE'S SMALL CHANCE FOR
 PEACE (as NO CHANCE TO ARBITRATE)
306. WHEN HORSES TURN BACK THERE'S DANGER
 AHEAD*
307. WHEN I WAS A KID

308. WHEN IGNORANCE IS BLISS, i.e., UNEXPECTED GUEST*
 WHEN LAW DULLS THE EDGE OF CHANCE (as THE
 ONLY WAY TO NEGOTIATE WITH THIEVES)
309. WHEN MEAT WAS PLENTIFUL, i.e., THE BUFFALO
 HUNT #35
310. WHEN MULES WEAR DIAMONDS
 WHEN SHADOWS HINT DEATH (as THE WARNING
 SHADOWS)
311. WHEN SIOUX AND BLACKFEET MEET, i.e., WHEN
 BLACKFEET AND SIOUX MEET*
 WHEN THE ELK WAS BELIEVED TO BE DEAD (as THE
 WOUNDED ELK)
312. WHEN THE LAND BELONGED TO GOD
 WHEN THE LAND BELONGED TO GOD (as WHEN THE
 LAND WAS GOD'S)
313. WHEN THE LAND WAS GOD'S, i.e., WHEN THE LAND
 BELONGED TO GOD
314. WHEN THE NOSE OF A HORSE BEATS THE EYES OF A
 MAN*
315. WHEN THE RED MAN TALKS WAR*
316. WHEN THE RED MAN TALKS WAR (ON THE WHITE
 MAN'S TRAIL)
317. WHEN THE TRAIL WAS LONG BETWEEN CAMPS
318. WHEN (i.e., WHERE) TRACKS SPELL MEAT*
319. WHEN WAGON TRAILS WERE DIM*
320. WHERE GREAT HERDS COME TO DRINK*
321. WHERE GUNS WERE THEIR PASSPORTS
322. WHERE IGNORANCE IS BLISS*
323. WHERE TRACKS SPELL MEAT
324. WHERE TRACKS SPELL WAR OR MEAT
325. WHISKEY SMUGGLERS CAUGHT WITH THE GOODS*
 WHISKEY SMUGGLERS CAUGHT WITH THE GOODS (as
 CAUGHT WITH THE GOODS)
326. WHITE MAN'S SKUNK WAGON NO GOOD HEAP LAME
327. WHO KILLED THE BEAR? i.e., THE PRICE OF HIS
 HIDE
328. WHOSE MEAT?*
329. WILD HORSE HUNTERS #1* (Indians) (1905)
330. WILD HORSE HUNTERS #2 (Cowboys) (1913)
 WILD MAN'S TRUCE (as THE PIPE OF PEACE)
331. THE WINTER PACKET*
332. THE WOLFER'S CAMP
333. WOMEN OF THE PLAINS, i.e., BREAKING CAMP #3
334. THE WORLD WAS ALL BEFORE THEM, i.e., ROMANCE
 MAKERS
335. WOUND UP*
336. THE WOUNDED ELK, i.e., WHEN THE ELK WAS BE-
 LIEVED TO BE DEAD
337. A WOUNDED GRIZZLY*
338. YORK

Black and White Prints

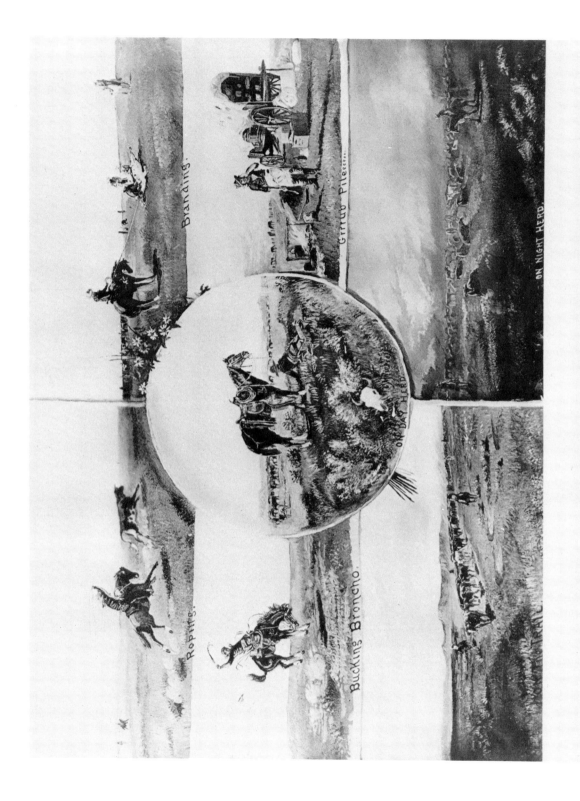

A COPY OF C.M.RUSSELL'S — "THE COWBOY ARTIST" — LAST PAINTING.

This black and white montage is Russell's first published appearance. The words "Chicago Photogravure Co., 1887" are indiscernible here, but do appear in the lower right corner of the original. *See item 46, this section.*

SECTION VII

Black and White Prints

1. ABOUT THE THIRD JUMP CON LOOSENS
 ABOUT THE THIRD JUMP CON LOOSENS (as ALL IN A DAY'S WORK)
2. ADVANCE OF BLACKFEET TRADING PARTY
 ADVANCE OF BLACKFEET TRADING PARTY (as BLACKFEET RAIDING PARTY)
 AH-WAH-COUS (as INDIAN OF THE PLAINS AS HE WAS and as THE INDIAN OF THE PLAIN AS HE WAS)
3. ALL IN A DAY'S WORK, i.e., ABOUT THE THIRD JUMP CON LOOSENS
4. AND I FIND I AM RIDING IN THE MIDST OF RUNNING STEERS
5. AND WITH A SORT O' STATELY BOW HE TURNED HIS BACK ON SIM
6. ANNIHILATION OF FETTERMAN'S COMMAND
7. ARE YOU THE REAL THING?
8. AS QUICKLY THE HORSE TOOK FRIGHT
9. ATTACKED BY GRIZZLY BEAR
10. A BAD ONE
11. BATTLE BETWEEN CROWS AND BLACKFEET, i.e., THE MAKING OF A WARRIOR
12. (THE) BATTLE OF BEAR PAWS
13. BEFORE THE WHITE MAN CAME #2
14. BEFORE THIS HE ONLY HAD WOLVES BROKE TO PACK OR DRAG A TRAVOIS
15. BLACKFEET HORSE THIEVES*
16. BLACKFEET RAIDING PARTY, i.e., ADVANCE OF BLACKFEET TRADING PARTY
17. BLACKFEET SQUAW AND PAPPOOSE
 BLACKFEET SQUAW AND PAPPOOSE (as FLATHEAD SQUAW AND PAPOOSE)
18. BLACKFEET TRADING PARTY IN SIGHT OF FORT BENTON
19. BLACKFEET WARRIOR
 BLACKFEET WARRIOR (as PIEGAN WARRIOR)
20. BLAZING THE TRAIL, i.e., LEWIS AND CLARK AT THREE FORKS OF THE MISSOURI
21. BOSS OF THE TRAIL HERD, i.e., THE TRAIL BOSS
22. BRIDGER DISCOVERS THE GREAT SALT LAKE
23. BROUGHT HER FACE TO FACE WITH LONG BILL AND SHORTY SMITH
24. BRUIN, NOT BUNNY, TURNED THE LEADERS
25. BUFFALO BILL AND THE GRAND DUKE ALEXIS BUFFALO HUNTING, i.e., RUNNING BUFFALO
26. BUFFALO BILL'S DUEL WITH YELLOW HAND, i.e., CODY'S FIGHT WITH YELLOWHAND
27. BUFFALO HOLDING UP MISSOURI RIVER STEAMBOAT
28. BUFFALO HUNTER, i.e., THE SIOUX BUFFALO HUNTER
29. BUFFALO MAN, i.e., THE WOLFER
30. BUFFALO'S REVENGE, i.e., I'M HANGIN' ON FOR ALL THERE IS IN ME
 BUILDING FORT MANUEL IN 1807 (as FORT MANUEL and as FIRST WHITE HABITATION IN MONTANA)
31. THE BULL WHACKER
 THE BULL WHACKER (as THE FREIGHTER)
32. THE CALF ROPER, i.e., PETE HAD A WINNING WAY WITH CATTLE
33. (THE) CALL OF THE LAW
34. CANOE INDIAN, i.e., LOOKS AT THE STARS
35. CAPTAIN GRAY MAKING GIFTS TO THE INDIANS AT THE MOUTH OF THE COLUMBIA RIVER
 CARSON DEFEATS FRENCH BULLY IN HORSEBACK DUEL (as KIT CARSON OUT DUELS A CANADIAN BULLY)
36. CAUGHT IN THE ACT
37. THE CAVE MAN STARTS OUT MOUNTED, i.e., THE FAMILY STARTS OUT MOUNTED
38. CENTERFIRE MAN, i.e., RAWHIDE RAWLINS, MOUNTED
39. CHEYENNES WATCHING UNION PACIFIC TRACK LAYERS
40. THE CHIEF FIRED AT THE PINTO #2

41. THE CHRISTMAS DINNER
42. CLOSE QUARTERS
 CODY'S FIGHT WITH YELLOWHAND (as BUFFALO BILL'S DUEL WITH YELLOW HAND)
43. COMING TO CAMP AT THE MOUTH OF SUN RIVER
44. COON-CAN—A HORSE APIECE
45. COON-CAN—TWO HORSES
46. A COPY OF C. M. RUSSELL'S—"THE COWBOY ARTIST"—LAST PAINTING*

This print was published by Chicago Photogravure Co. about September 1, 1887. The publisher and year date appear on the print. It is noteworthy because it is the first published appearance of Russell paintings. It is a lithograph of a montage, the original of which is on a single piece of canvas. It contains seven separate paintings, entitled:

ROPING*
BRANDING*
BUCKING BRONCHO*
GRRRUB PILE*
ON DAY HERD*
ON NIGHT HERD*
ON THE TRAIL*

Because four of these titles were used subsequently on other paintings, we have assigned the titles ROPING #1, BUCKING BRONCHO #1, ON DAY HERD #1, and ON THE TRAIL #1.

47. THE COWBOY #2
48. COWBOY FUN, i.e., NOW HERDER, BALANCE ALL
49. COWBOY SEATED, HORSE NUZZLING HIS LEFT HAND
50. COWBOY SPORT (ROPING A WOLF) #1
51. COWCAMP IN WINTER, i.e., IN THE OLD DAYS THE COW RANCH WASN'T MUCH
52. COWPUNCHERS WERE CARELESS, HOMELESS, HARD-DRINKING MEN
53. CRAWL HIM, HE'S GENTLE
54. THE CREE INDIAN
 THE CREE INDIAN (as NORTHERN CREE)
55. CROSSING THE MISSOURI #1
56. THE CUSTER FIGHT, i.e., 1876—THE CUSTER FIGHT
57. DAME PROGRESS PROUDLY STANDS
 DAME PROGRESS PROUDLY STANDS (as THE PASSING OF THE OLD WEST)
58. DEER IN THE WINTER*
59. A DIAMOND R MULE TEAM OF THE 70'S
60. DISCOVERY OF THE ROCKY MOUNTAINS BY THE DE LA VERENDRYES, i.e., LA VERENDRYES DISCOVER THE ROCKY MOUNTAINS
61. DRAGGED THE HEAVY BODY UP TOWARD THE SHELTER OF ROCKS
 1876—THE CUSTER FIGHT (as THE CUSTER FIGHT)
 THE FAMILY STARTS OUT MOUNTED (as THE CAVE MAN STARTS OUT MOUNTED)
62. FIRST AMERICAN NEWS WRITER

63. THE FIRST GOAT
64. FIRST WHITE HABITATION IN MONTANA, i.e., BUILDING FORT MANUEL IN 1807
65. FLATHEAD SQUAW AND PAPOOSE, i.e., BLACKFEET SQUAW AND PAPPOOSE
66. THE FORD
67. FORT MANUEL, i.e., BUILDING FORT MANUEL IN 1807
68. FLATBOAT ON RIVER, FORT IN BACKGROUND
69. THE FREIGHTER, i.e., THE BULL WHACKER
70. A FRENCH HALF-BREED
 A FRENCH HALF-BREED (as THE HALF BREED and as RED RIVER BREED)
71. FROM THE SOUTHWEST COMES SPANISH AN' MEXICAN TRADERS
72. THE GEYSER BUSTS LOOSE
73. THE GUN FIGHT, i.e., "SO WITHOUT ANY ONDUE RECITATION, I PULLS MY GUNS AN' CUTS DOWN ON THEM THERE TIN-HORNS"
74. THE HALF BREED, i.e., A FRENCH HALF-BREED
75. THE HALFBREED TRADER, i.e., THE POST TRADER
76. "HANDS UP"
77. HARRIS AND HIS FRIENDS
78. HERE LIES POOR JACK, HIS RACE IS RUN
79. HIS FIERCE JAWS SNAP, HIS EYEBALLS GLARE
 HIS FIERCE JAWS SNAP, HIS EYEBALLS GLARE (as THE WOLF HUNT)
80. HIS HEART SLEEPS #2
81. HIS LAST HORSE FELL FROM UNDER HIM
 HIS LAST HORSE FELL FROM UNDER HIM (as INDIAN TRIBAL WAR)
82. THE HOLD UP, i.e., HOLDING UP THE OVERLAND STAGE
83. HOLDING UP THE OVERLAND STAGE
 HOLDING UP THE OVERLAND STAGE (as THE HOLD UP)
84. THE HONOR OF HIS RACE, i.e., SO ME RUN UP BEHIN', SHOVE DE GUN IN HIS BACK AN TELL HIM STOP HIS PONY
85. IDAHO (CITY) OX TEAMS WERE BRINGING IN SOME 6,000,000 POUNDS OF FREIGHT ANNUALLY
 I'M HANGIN' ON FOR ALL THERE IS IN ME (as BUFFALO'S REVENGE)
86. IN THE ENEMY'S COUNTRY
87. IN THE OLD DAYS THE COW RANCH WASN'T MUCH
 IN THE OLD DAYS THE COW RANCH WASN'T MUCH (as COW CAMP IN WINTER)
88. INDIAN HARRY IN BORROWED FINERY
89. THE INDIAN OF THE PLAIN AS HE WAS, i.e., AH-WAH-COUS
90. INDIAN OF THE PLAINS AS HE WAS, i.e., AH-WAH-COUS
 THE INDIAN OF THE PLAINS AS HE WAS (as THE SCOUTS)
91. INDIAN PICTURE WRITING, i.e., THE PICTURE ROBE
92. INDIAN SPEARING FISH
93. INDIAN TRIBAL WAR, i.e., HIS LAST HORSE FELL FROM UNDER HIM

Postcards

SECTION VIII

Postcards

AH-WAH-COUS (AS THE INDIAN OF THE PLAINS AS HE WAS)

1. ALL WHO KNOW ME—RESPECT ME*
Color; W. T. Ridgley Calendar Co., Great Falls, Mont., 1907

2. AMERICA'S FIRST PRINTER
Color; McKee Printing Co., Butte, Mont.

3. ANTELOPE HUNT
Color; Ridgley

ANTELOPE HUNT (AS ANTELOPE HUNTING)

4. ANTELOPE HUNTING, i.e., ANTELOPE HUNT
Color; Ridgley

5. ARE YOU THE REAL THING?*
Color; Ridgley, 1907

6. ASSINIBOIN WAR PARTY
Color; Flathead Lake Galleries, Bigfork, Montana

AT THE END OF THE ROPE (AS END OF THE ROPE)

7. THE ATTACK #3
Color; Flaherty Enterprises, 1620 4th Ave., North, Great Falls, Montana (1965)

8. A BAD BRONCO, i.e., THE BUCKING BRONCO #1
Color; Ridgley, 1904

9. BATTLE OF THE REDMEN, i.e., STORMING A WAR HOUSE*
Color; Trail's End Publishing Company, Pasadena, Calif., 1952

10. THE BEAR IN THE PARK ARE AWFULLY TAME*
Color; Ridgley, 1907

11. BETTER THAN BACON
Color; Ridgley

12. BLACKFEET BURNING (THE) CROW BUFFALO RANGE
Color; Ridgley

13. BLACKFEET BURNING (THE) CROW BUFFALO RANGE
Color; Ridgley (variant)

14. BLEST IS HE WHO CHEERFULLY GIVES
Black and white; black and tan; black and pink

15. BOLD HUNTERS—HEAVENS! A GRIZZLY BEAR*
Color; Ridgley, 1907

16. BOLD HUNTERS—HEAVENS! A GRIZZLY BEAR
Variant

17. THE BOLTER #2
Color; Trail's End, 1952

18. BOSS OF THE HERD, i.e., BOSS OF THE TRAIL HERD
Color; Ridgley, 1905

BOSS OF THE TRAIL HERD (AS BOSS OF THE HERD)

19. BREAKING CAMP #1
Black and white; Maryhill Museum of Fine Arts, Maryhill, Wash.

BREAKING CAMP #3 (AS WOMEN OF THE PLAINS)

20. BRONC IN COW CAMP, i.e., CHUCK WAGON ON THE
 RANGE
Color; Amon Carter Museum of Western Art, Fort
Worth

 BRONC ON A FROSTY MORN (as COWBOY LIFE)

 THE BUCKING BRONCO #1 (as A BAD BRONCO)

21. BUFFALO HUNT #4
Color; Flaherty, (1965)

22. [THE] BUFFALO HUNT #7
Color; giant; Kennedy Galleries, 1965

23. THE BUFFALO HUNT #28*
Sepia; Ridgley

 THE BUFFALO HUNT #35 (as WHEN MEAT WAS
 PLENTIFUL)

24. BUFFALO HUNT #40
Color; Carter

25. BUFFALO PROTECTING CALF*
Sepia; Ridgley

26. BUFFALO PROTECTING CALF
Sepia; Ridgley (variant)

27. BUSTING A STEER*
Color; Trail's End, 1952

28. CAMP OF THE RED MAN*
Color; Trail's End, 1952

 THE CHALLENGE #2 (as WILD HORSE FIGHT)

 CHARLES M. RUSSELL (CARICATURE STATUETTE) (as
 CHARLIE HIMSELF)

29. CHARLES M. RUSSELL (SELF-PORTRAIT), i.e., SELF
 PORTRAIT #4
Color; Trail's End, 1952

30. CHARLIE HIMSELF, i.e., CHARLES M. RUSSELL (CARICA-
 TURE STATUETTE)
Color; Carter

31. CHARLIE (i.e., CHARLES M.) RUSSELL AND HIS FRIENDS
Color; Montana Historical Society, Helena, Montana,
1964

32. THE CHRISTMAS DINNER
Black and white; Ridgley

33. THE CHRISTMAS DINNER
Printed in black ink on pale green silk and mounted in
double postcard folders of heavy green paper; Ridgley

34. THE CHRISTMAS DINNER
Black and white, varnish-coated card; Glacier
Stationery Co., Great Falls, Mont.

35. THE CHRISTMAS DINNER
Black and white; Glacier (variant)

36. THE CHRISTMAS DINNER
Black and white, not coated; Glacier

 CHUCK WAGON ON THE RANGE (as BRONC IN COW
 CAMP)

37. THE COWBOY #2
On card of Dick Jones Picture Co.; several varieties

38. COWBOY LIFE, i.e., BRONC ON A FROSTY MORN
Painters of the Old West Current Exhibition October
20 through November (1963); size 8 × 5¼; Kennedy
Galleries, Inc.

39. COWBOYS OFF FOR TOWN
Color; Ridgley Calendar Co.

40. COWBOYS OFF FOR TOWN
Color; W. T. Ridgley Press (variant)

41. COWBOYS OFF FOR TOWN
Sepia; B. E. Calkins, Distributor, Butte, Mont.

42. COWBOYS OFF FOR TOWN
Variant

43. A CRITICAL MOMENT
Black and white; size 7 × 5; Hammer Bros., 51 East
57th St., N.Y.

44. CROSSING THE MISSOURI #2
Color; Trail's End, 1952

45. DANCE! YOU SHORTHORN DANCE!*
Color; Ridgley, 1907

46. DUDES*
Color; Trail's End, 1952

47. ELK IN LAKE MCDONALD*
Color; Ridgley

48. END OF THE ROPE, i.e., AT THE END OF THE ROPE
Color; Trail's End, 1952

 EVERY HOSS WITH HEAD UP AND EARS STRAIGHTENED
 (as WATCHING THE HORSE HERD)

 FIRST AMERICAN NEWS WRITER (as THE PICTURE
 WRITER)

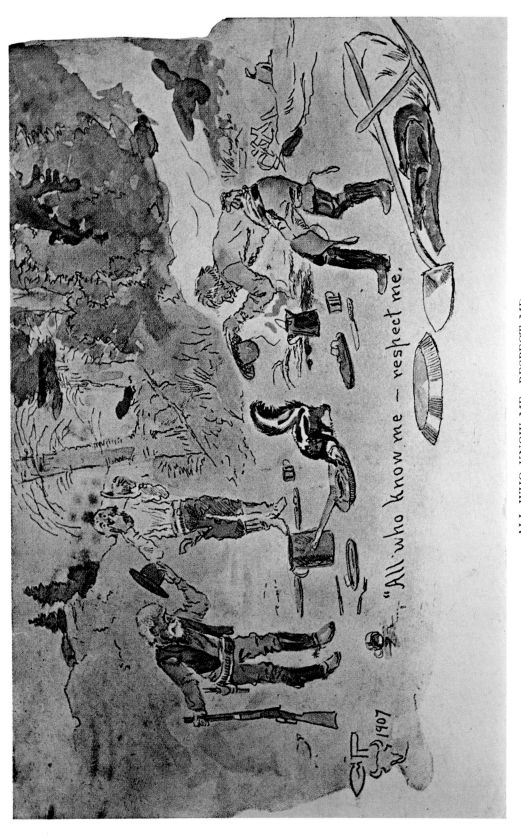

ALL WHO KNOW ME—RESPECT ME
One of a series of postcards published by W. T. Ridgley Co., ca. 1908.
See item I, this section.

49. THE FIRST FURROW
Color; Ridgley

50. GNOME WITH LANTERN*
Sepia; Marble, 1915

51. HAVE ONE ON ME*
Color; Ridgley, 1907

52. THE HERD QUITTER
Color; Historical Society of Montana

53. HERE'S HOW, i.e., HERS TO A HAPPY NEW YEAR 1916*
 (part)
Color; Trail's End, 1952

 HERS TO A HAPPY NEW YEAR 1916 (part) (as HERE'S
 HOW)

54. HIS HEART SLEEPS #1
Color; Trail's End, 1952

55. HOLD HER ZEB, I'M COMING*
C. A. Read Co.

56. HOLDING UP THE OVERLAND STAGE
Black and white; Ridgley

57. HOLDING UP THE OVERLAND STAGE
Ridgley; see item 33

 HOLDING UP THE OVERLAND STAGE (as THE HOLDUP)

58. THE HOLDUP, i.e., HOLDING UP THE OVERLAND STAGE
Black and white; Glacier

59. THE HOLDUP, i.e., HOLDING UP THE OVERLAND STAGE
Black and white; Glacier (variant)

60. HOW
Color; Intermountain Tourist Supply, Salt Lake City,
(1965)

61. I SAVVY THESE FOLKS*
Color; Ridgley, 1907

62. IN THE ENEMY COUNTRY
Color; Trail's End, 1952

63. IN THE MOUNTAINS
Color; Montana Historical Society, 1964

64. INDIAN DOG TEAM*
Sepia; Ridgley

65. INDIAN DOG TEAM
Black and white

 THE INDIAN OF THE PLAINS AS HE WAS (as THE
 SCOUTS)

66. THE INDIAN OF THE PLAINS AS HE WAS, i.e., AH-WAH-
 COUS
Black and white; Glacier

67. INDIAN PORTRAIT
Color; Intermountain; also large, $5\frac{1}{2} \times 8\frac{3}{4}$, (1965)

68. INDIAN SCOUTING PARTY #1
Color; Flaherty, (1965)

 INDIAN SIGNALING #1 (as THE SIGNAL)

69. INDIANS HUNTING BUFFALO
Color; National Cowboy Hall of Fame, Oklahoma City,
(1966)

70. INDIANS ON THE WAR TRAIL*
Sepia; souvenir of Military Circus and Wild West
Show, Southampton, L.I., July 2d–4th, 1910

71. INITIATED
Black and white; Ridgley

72. INITIATED
Ridgley; see item 33

73. THE INITIATION OF THE TENDERFOOT
Black and white; Ridgley

74. THE INITIATION OF THE TENDERFOOT
Ridgley; see item 33

75. INVOCATION TO THE SUN
Montana Territorial Centennial Commission, 1964

76. JERKED DOWN
Color; Thomas Gilcrease Institute, Tulsa, Oklahoma

77. JERKED DOWN
Color; Thomas Gilcrease Institute (variant)

78. THE KILL
Black and white; Glacier

79. LASSOING A WOLF, i.e., ROPING A WOLF #2
Color; Ridgley

 THE LAST OF 5000 (as WAITING FOR A CHINOOK)

80. THE LAST OF HIS RACE
Black and white; Glacier

81. THE LAST OF THE BUFFALO
Black and white; Glacier

82. THE LAST OF THE BUFFALO
Black and white; Ridgley

83. THE LAST OF THE BUFFALO
Ridgley; see item 33

LEWIS AND CLARK STATUE—DESIGN BY C. M. RUSSELL (as SACAJAWEA AND LEWIS AND CLARK)

84. LONE WOLF—PIEGAN*
Color; Ridgley, 1907

85. THE MEDICINE MAN #1
Color; Trail's End, 1952

MEN OF THE OPEN RANGE (as SCATTERING THE RIDERS)

86. MOUNTAIN RETREAT, i.e., OLD HOOVER CAMP ON SOUTH FORK OF JUDITH RIVER
Black and white; Glacier

87. MOURNING HER WARRIOR DEAD
Color; Trail's End, 1952

88. NATURE'S CATTLE #1
Black and white; Glacier

89. NAVAJO WILD HORSE HUNTERS*
Color; Trail's End, 1952

90. A NEZ PERCE
Sepia; Ridgley

91. A NOBLEMAN OF THE PLAINS*
Color; Trail's End, 1952

92. AN OLD FASHIONED STAGECOACH, i.e., AN OLD TIME STAGECOACH
Sepia; Ridgley

OLD HOOVER CAMP ON SOUTH FORK OF JUDITH RIVER (as MOUNTAIN RETREAT)

AN OLD TIME STAGECOACH (as AN OLD FASHIONED STAGE-COACH)

93. ON THE WARPATH #2
Color; Montana Historical Society, 1964

94. ONE DOWN, TWO TO GO
Color; Rockwell Gallery of Western Art, Corning, N.Y., 1962

95. PAINTED PICTURES, i.e., THE PICTURE ROBE
Black and white; Glacier

96. PAINTING THE TOWN
Ridgley; see item 33

97. PAINTING THE TOWN
Black and white; Ridgley

98. PAINTING THE TOWN
Black and white; Glacier

THE PICTURE ROBE (as PAINTED PICTURES and as PICTURE WRITING)

99. THE PICTURE WRITER, i.e., FIRST AMERICAN NEWS WRITER
Color added; Trail's End, 1952

100. PICTURE WRITING, i.e., THE PICTURE ROBE
Black and white; Glacier

101. POWDERFACE—ARAPAHOE*
Color; Ridgley, 1903

102. POWDERFACE—ARAPAHOE
Ridgley (variant)

RAINY MORNING (as RAINY MORNING IN A COW CAMP)

103. RAINY MORNING IN A COW CAMP, i.e., RAINY MORNING
Color; Ridgley

104. RED BIRD*
Color; Trail's End, 1952

105. RED CLOUD*
Color; Ridgley, 1900

106. RED CLOUD
Ridgley (variant)

107. RED MAN'S MEAT, i.e., SIOUX INJUN A HUNDRED YEARS AGO
Color; Trail's End, 1952

108. RETURN OF THE WARRIORS
Color; Trail's End

109. RETURN OF THE WARRIORS
Large, $6 \times 8\frac{7}{8}$; Intermountain Tourist Supply, Inc., Salt Lake City

110. RIDER OF THE ROUGH STRING
Color; Trail's End, 1952

111. A ROPER
Sepia; Ridgley

112. A ROPER
Black and white

113. ROPING A GRIZZLY, i.e., ROPING A RUSTLER
Color; Ridgley

 ROPING A RUSTLER (as ROPING A GRIZZLY)

114. ROPING A WOLF #2
Color; Ridgley

 ROPING A WOLF #2 (as LASSOING A WOLF)

115. THE ROUNDUP #1
Sepia; Ridgley

116. THE ROUNDUP #1
Color; Ridgley

117. ROUNDUP ON THE MUSSELSHELL
Color; large, 6 × 9; Intermountain, (1965)

118. RUSSELL AND HIS INDIAN FRIEND, i.e., TAKE THIS TO
 THE BUTTE OF MANY SMOKES
Color; Trail's End, 1952

119. SACAJAWEA AND LEWIS AND CLARK, i.e., LEWIS AND
 CLARK STATUE—DESIGN BY C. M. RUSSELL
Sepia; Ecklund's Studio, Great Falls, Mont.

120. SCATTERING THE RIDERS
Color; Ridgley

121. SCATTERING THE RIDERS, i.e., MEN OF THE OPEN
 RANGE
Color; giant, $5\frac{3}{4}$ × $8\frac{3}{4}$; Montana Historical Society,
1955

 SCOUTING PARTY #1 (as THE SCOUTS)

122. THE SCOUTS, i.e., THE INDIAN OF THE PLAINS AS HE
 WAS
Black and white; Glacier

123. THE SCOUTS, i.e., SCOUTING PARTY #1
Color; Ridgley

 SELF-PORTRAIT #4 (as CHARLES M. RUSSELL (SELF-
 PORTRAIT))

124. THE SHELL GAME
Black and white; Ridgley

125. THE SHELL GAME
Ridgley; see item 33

126. THE SHELL GAME
Black and white; Glacier

127. THE SHELL GAME
Black and white; Glacier (variant)

128. THE SIGNAL, i.e., INDIAN SIGNALING #1
Color; giant; Kennedy, 1964

 SIOUX INJUN A HUNDRED YEARS AGO (as RED MAN'S
 MEAT)

129. SMOKE SIGNAL #1
Color; Flaherty, (1965)

130. SOLITUDE*
Color; Trail's End, 1952

131. STAGE COACH ATTACK
Color; large, 6 × 9; Leonard Printing Co., Bartles-
ville, Oklahoma

132. STAY WITH HIM!*
Color; Ridgley, 1907

133. STAY WITH HIM!
Color; Ridgley (variant)

134. STOLEN HORSES #1
Color; Rockwell, 1962

 STORMING A WAR HOUSE (as BATTLE OF THE
 REDMEN)

135. THE STORY TELLER #1
Color; Intermountain; also large, 6 × $8\frac{7}{8}$

136. SUN SHINE AND SHADOW*
Color; Ridgley, 1907

137. SUN SHINE AND SHADOW
Color; Trail's End, 1952

 TAKE THIS TO THE BUTTE OF MANY SMOKES (as
 RUSSELL AND HIS INDIAN FRIEND)

138. THIS TYPE OF "COW CATCHER" IS FAST
 DISAPPEARING*
Color; Northwest Postcard & Souvenir Co., Butte,
Mont.

139. "THROWED"*
Color; Trail's End, 1952

140. TOLL COLLECTORS
Color; Montana Historical Society, 1964

141. A TOUCH OF WESTERN HIGHLIFE*
Color; Ridgley, 1907

142. THE TRAIL BOSS
Black and white; Ridgley

143. THE TRAIL BOSS
Black and white; glazed stock; Ridgley

144. THE TRAIL BOSS
Black and white; pink stock; Ridgley

145. THE TRAIL BOSS
Ridgley; see item 33

146. THE TRAIL BOSS
Glacier

147. TRAIL'S END
Color; Intermountain, (1965)

148. TROUBLE AHEAD, i.e., AN UNSCHEDULED STOP
Color; Trail's End, 1952

AN UNSCHEDULED STOP (as TROUBLE AHEAD)

149. UP A TREE
Color; Trail's End, 1952

150. WAITING FOR A CHINOOK
Color; Robbins Hillquist Co., Spokane, Washington

151. WAITING FOR A CHINOOK
Color; Keenan News Agency, Spokane, Wash. (variant)

152. WAITING FOR A CHINOOK, i.e., THE LAST OF 5000
Large, $6 \times 8\frac{7}{8}$; Intermountain

153. WAITING FOR A CHINOOK, i.e., THE LAST OF 5000
Color; Trail's End, 1952

154. WAITING FOR A CHINOOK OR THE LAST OF FIVE
THOUSAND, i.e., WAITING FOR A CHINOOK
Color; J. L. Robbins Co., Spokane, Wash.

155. WATCHING THE HORSE HERD, i.e., EVERY HOSS WITH
HEAD UP AND EARS STRAIGHTENED
Color; Trail's End, 1952

156. WATCHING THE SETTLERS
Color; $7\frac{1}{2} \times 6\frac{1}{8}$; Historical Society of Montana

157. WHEN ARROWS SPELLED DEATH
Color; Trail's End, 1952

158. WHEN COWS WERE WILD
Color; Historical Society of Montana

159. WHEN MEAT WAS PLENTIFUL, i.e., THE BUFFALO
HUNT #35
Color; Trail's End, 1952

160. "WHERE IGNORANCE IS BLISS . . ."
Color; Ridgley, 1907

161. WHERE (i.e., WHEN) LAW DULLS THE END OF CHANCE
Black and white; Grand Central Galleries

162. WHITE MAN'S SKUNK WAGON NO GOOD HEAP LAME*
Color; Ridgley

163. WHITE MAN'S SKUNK WAGON NO GOOD HEAP LAME
Color; Trail's End, 1952

164. WILD HORSE FIGHT, i.e., THE CHALLENGE #2
Color; Trail's End, 1952

165. WILD HORSE HUNTERS #1
Color; Ridgley

166. (THE) WILD HORSE HUNTERS #1
Color; publisher unknown

167. WILL ROGERS
Sepia; $5\frac{3}{8} \times 8\frac{1}{4}$; "C. M. Russell Catalogue of Bronzes
from the C. S. McNair Collection available on request";
Kennedy Galleries, 1962

168. WOMEN OF THE PLAINS, i.e., BREAKING CAMP #3
Color; Ridgley

169. WOUND UP
Color; Ridgley

170. A WOUNDED GRIZZLY
Color; Ridgley

171. YORK
Giant Postcard, $6\frac{3}{4} \times 8$; Montana Historical Society

The following postcards are photographs:

172. Bradford Brinton Memorial Vacationland Studies,
Sheridan, Wyo. Color; photo of interior showing six
bronzes and indiscernible paintings.

173. C. M. Russell, "The Cowboy Artist." Black and
white; head in oval; Ridgley

174. C. M. Russell's Studio and Home

175. Charles Marion Russell. Color; J. L. Robbins
Company

176. Chas. M. Russell and His Studio in Great Falls, Montana. Black and white; Glacier

177. Chas. M. Russell, "The Cowboy Artist." Black and white; Ridgley

178. Chas. M. Russell, "The Cowboy Artist" at His Log Studio, Great Falls, Montana. Color; Post Office News Stand, Great Falls, Montana

179. Chas. M. Russell on His "Cow Pony" at His Log Studio. Color; Chas. E. Morris Co., Great Falls. Also in accordion-pleated mailing piece; Souvenir Folder of Great Falls, Montana

180. "Charles M. Russell Supreme Master of Western Art, Where He Is Beating Himself." Double exposure photograph by H. C. Ecklund

181. C. M. Russell Gallery. Black and white; Cascade Camera Photo, Great Falls, Montana; (ca. 1958)

182. C. M. Russell Gallery, 1201 4th Ave., N., Great Falls, Montana. Black and white; exterior

183. C. M. Russell Original Studio, 1217 4th Ave., N., Great Falls, Montana. Black and white; interior, showing wallcases

184. C. M. Russell Gallery, 1201 4th Ave., N., Great Falls, Montana. Black and white; interior

185. C. M. Russell Gallery, 1201 4th Ave., N., Great Falls, Montana. Black and white; interior, doors on right

186. [Russell Studio.] Black and white; exterior

187. The Formal C. M. Russell Room, Historical Society of Montana; color; 1963

188. Fireplace, Will Rogers State Park, Pacific Palisades, Calif. Black and white; Angeleno Photo Service, L.A., Calif.

189. Fireplace, Will Rogers Ranch Home, Santa Monica, Calif. Black and white

190. Will Rogers Ranch Home, Pacific Palisades, California. Black and white; Angeleno, 1030 S. Alvarado, L.A.

191. Will Rogers Ranch Home, 14253 Sunset Blvd., Pacific Palisades, California

192. Living Room Fireplace. Souvenir Postcard from Will Rogers State Park. Giant, $7\frac{1}{2} \times 8\frac{1}{2}$; B & D Postcard Co., Los Angeles, Calif.

193. Residence of C. M. Russell, "The Cowboy Artist". Great Falls, Montana. Black and white; Ridgley, 1907

194. Russel [sic] Log Cabin Studio, Great Falls, Montana

195. Russell's Tombstone. Black and white

196. Statue by Chas. M. Russell. Will Rogers Ranch House, Santa Monica, California

197. C. M. Russell Gallery. Color; Cascade Camera, 1104 Central Ave., Great Falls, Montana 59401

198. Charles M. Russell Original Studio. Color; Cascade Camera

199. John Lewis, CMR and Nancy, mounted, in front of Glacier National Park Hotel

200. CMR on Redbird, on lawn outside Log Cabin Studio

201. CMR and Nancy, standing under portico of Log Cabin Studio, in snow

202. Chas. M. Russel [sic], "The Cowboy Artist" at His Log Studio, Great Falls, Mont. Color; J. L. Robbins Co., Spokane, Wash.

203. "The Thirty Third Degree." Copyright, 1905, by Dodge Publishing Co. from Rimes to be Read. A printed poem which mentions Russell.

204. "Quartz Train" by Earl Heikka. C. M. Russell Gallery, 1201 4th Ave., N., Great Falls, Mont. CMR models on ledge in background; black and white

205. Cowhand sitting in easy chair in cabin. 25 CMR prints on wall visible in upper left. No publisher, but marked "#70 Tepee" lower left. Copy in Southwest Museum, Highland Park, Los Angeles.

Christmas Cards

SECTION IX

Christmas Cards

1. ABOUT THE THIRD JUMP CON LOOSENS
Greetings of the season and best wishes for the New Year. Folder, size 4 × 5. Issued by Historical Society of Montana (1959). N.B. This card, and items 39, 46, 47, and 54 were issued in a box, with envelopes. The printing on the box cover reads: C. M. Russell Christmas Cards A Choice Collection of Old West Scenes From Originals in the Charles M. Russell Room, State Historical Society, Montana.

2. AMERICA'S FIRST PRINTER
Card of Wm. L. Murphy, Butte; The Murphy Cheely Press, Butte. Four-color plate, 9 × 11$\frac{1}{4}$, mounted inside green folder 10$\frac{3}{8}$ × 13, ca. 1954.

3. BATTLE OF THE SIOUX AND BLACKFEET, i.e., HIS LAST
 HORSE FELL FROM UNDER HIM
Folder, size 9 × 6, of heavy black paper, containing biographical sketch of Charles Marion Russell, "The Cowboy Artist," 1864–1926, and separate plate of picture. Signed "Mr. and Mrs. George H. Tweney, December 25, 1958."

4. BEST WISHES FOR YOUR CHRISTMAS
Best Wishes for a very Happy Holiday Season. Folder, 5$\frac{1}{4}$ × 7$\frac{1}{2}$. Issued by Historical Society of Montana (1955). On p. [4] is the title invented by Mike Kennedy, "I AIN'T NO SANTA," which we disregard.

 BLACKFEET WARRIOR (see item 48)

5. BLEST IS HE WHO CHEERFULLY GIVES*
Size 12 × 9$\frac{1}{8}$. Pen and ink, hand colored. 1922.

6. BLEST IS HE WHO CHEERFULLY GIVES
Size 3$\frac{1}{2}$ × 5$\frac{1}{2}$. Charles M. and Nancy Russell. 1922.

7. BLEST IS HE WHO CHEERFULLY GIVES
Same plate as 1922. Card of H. E. Britzman. 1947.

8. BLEST IS HE WHO CHEERFULLY GIVES
Pink stock, size 5$\frac{1}{2}$ × 3$\frac{1}{2}$, with Charles M. and Nancy Russell, chirographic facsimile, at bottom. Ca. 1947.

9. BLEST IS HE WHO CHEERFULLY GIVES
Gray stock, size 6 × 3$\frac{1}{2}$, with "Trail's End" in italic at bottom. Ca. 1947.

10. THE BOLTER #2
Best Wishes For a Merry Christmas. Size 4$\frac{3}{16}$ × 5$\frac{1}{2}$. Fred Rosenstock's Christmas card for 1950.

11. BRONC TO BREAKFAST and
 INSIDE THE LODGE
Season's Greetings. Michael Kennedy Director for The Historical Society of Montana and a grateful staff. 1958. Folder, 10 × 8$\frac{1}{2}$. Illustration in color.

12. BRONC FOR (i.e., TO) BREAKFAST
Merry Christmas from The Murphys. Folder, white stock, size 8$\frac{1}{2}$ × 11$\frac{9}{16}$. (Ox Yoke Ranch, Emigrant, Montana, 1964.)

 THE CHALLENGE #2 (as WILD HORSE FIGHT)

13. CHRISTMAS AT LINE CAMP
Christmas Greetings and all Good Wishes for the New Year. Folder, size 5$\frac{3}{8}$ × 7$\frac{1}{8}$. Color. (1963). Issued by The Trigg–C. M. Russell Foundation.

 THE CHRISTMAS DINNER (as UNEXPECTED GUESTS
 FOR CHRISTMAS DINNER)

14. CHRISTMAS MEAT

Merry Christmas and Happiness throughout the New Year. Folder, size $5\frac{1}{4} \times 7$. (1963). Color. Issued by The Trigg–C. M. Russell Foundation.

15. CHRISTMAS MEAT

Merry Christmas and Happiness throughout the New Year. Folder, size $5\frac{1}{4} \times 7$. Card of Michael Kennedy of Montana Historical Society. Color. (1963). Reproduces photo of President Kennedy. Card suppressed following assassination.

16. COWBOY'S BEST FRIEND, i.e., COWBOY SEATED, HORSE
 NUZZLING HIS LEFT HAND

Size 4×5. Historical Society of Montana. Ca. 1959.

 COWBOY SEATED, HORSE NUZZLING HIS LEFT HAND
 (as COWBOY'S BEST FRIEND)

17. CROSSING THE MISSOURI #2*

Season's Greetings. Folder, $3\frac{5}{16} \times 7$. Fred Rosenstock's Christmas card for 1951.

18. DEER AT WATERHOLE

The Season's Greetings and all good wishes for the New Year. Folder, size $5\frac{1}{4} \times 7\frac{1}{2}$. Color. (1963). Issued by The Trigg–C. M. Russell Foundation.

19. DISCOVERY OF THE GREAT FALLS OF THE MISSOURI BY
 LEWIS AND CLARK, 1805 (pen)

A Merry Yuletide and a Happy Sesquicentennial 1955. Folder, size $8 \times 4\frac{3}{16}$. Hebe and Alex Warden.

20. DO I WISH YOU HAPPY NEW YEAR*
 WELL ID TELL A MAN I DO
 AND A COACH LOAD OF GOOD LUCK
 FOR NINETEEN TWENTY TWO
 YOUR FRIEND
 C M RUSSELL

Issued in photographic reproduction by David B. Findlay, Christmas 1949.

21. FIRST AMERICAN NEWS WRITER

I am Montana and This Is My Creed
A New Year Greeting by Dan R. Conway. Pen and ink, sepia, $5\frac{1}{2} \times 8\frac{1}{4}$, folded. (N.d., ca. 1928).

22. GOING TO A CHRISTMAS RANCH PARTY IN THE 1880's

Size $7\frac{1}{2} \times 4\frac{7}{8}$. Color. (1963). Issued by The Trigg–C. M. Russell Foundation.

23. GOOD WISHES IS A BROKE MAN'S GIFT—THAT'S TRUE*

Pen and ink, sepia. Size $5\frac{3}{8} \times 3\frac{7}{16}$. 1920. Issued by Mr. and Mrs. C. M. Russell.

24. THE HEIGHT OF FASHION*

Merry Christmas. Folder, size $4 \times 6\frac{1}{8}$. (H. Green, Jr., 1959).

25. THE HERD QUITTER

From the Land of Shining Mountains. Folder, size $6\frac{3}{8} \times 7\frac{5}{8}$. Treasure State Life Insurance Co., Butte, Montana. (1963).

26. HERE'S HOPING THE WORST END OF YOUR TRAIL IS
 BEHIND YOU*

Pen and ink, hand colored by CMR before his death. Size $11\frac{1}{8} \times 8\frac{1}{8}$. Tipped into protective folder of green paper, with "CMR" and buffalo skull embossed in gold on front. 1926.

27. HERE'S HOPING THE WORST END OF YOUR TRAIL IS
 BEHIND YOU

With Best Wishes for a Merry Christmas and a Happy New Year. Size $6\frac{7}{16} \times 4\frac{1}{8}$. 1945. Fred Naegele.

28. HERE'S HOPING THE WORST END OF YOUR TRAIL IS
 BEHIND YOU

Card, white stock, size $13\frac{15}{16} \times 10\frac{5}{16}$, with color added in the printing process. Copyright 1947 Trail's End Publishing Co., Inc. Captioned: "Charles M. Russell's Last Christmas Card From the Original Plates."

29. HERE'S HOPING THE WORST END OF YOUR TRAIL IS
 BEHIND YOU

Card of glazed white stock, size $8\frac{1}{8} \times 11\frac{1}{8}$. Similar to item 27.

30. HERE'S HOPING YOUR TRAIL IS A LONG ONE*

Pen and ink, some hand colored by CMR. Size $12 \times 9\frac{1}{8}$. 1924.

31. HERE'S HOPING YOUR TRAIL IS A LONG ONE

Photograph of this Christmas card reduced to size, about 3×2. Apparently issued by C. N. Kirk of Baltimore. Ca. 1949.

32. HERE'S HOPING YOUR TRAIL IS A LONG ONE

Reproduced from a hitherto unpublished [sic] Charles Russell water color by the U.O. Colson Company, Paris, Illinois, through an exclusive arrangement with the Historical Society of Montana. Color lithograph with tissue guard. Size 8×11. (1955).

33. HERE'S HOPING YOUR TRAIL IS A LONG ONE

Folder, size 11×8, white stock, illustration in color. Merry Christmas in red on front. The Caples. N.d.

 HIS LAST HORSE FELL FROM UNDER HIM (as BATTLE
 OF THE SIOUX AND BLACKFEET)

 I AIN'T NO SANTA (see BEST WISHES FOR YOUR
 CHRISTMAS)

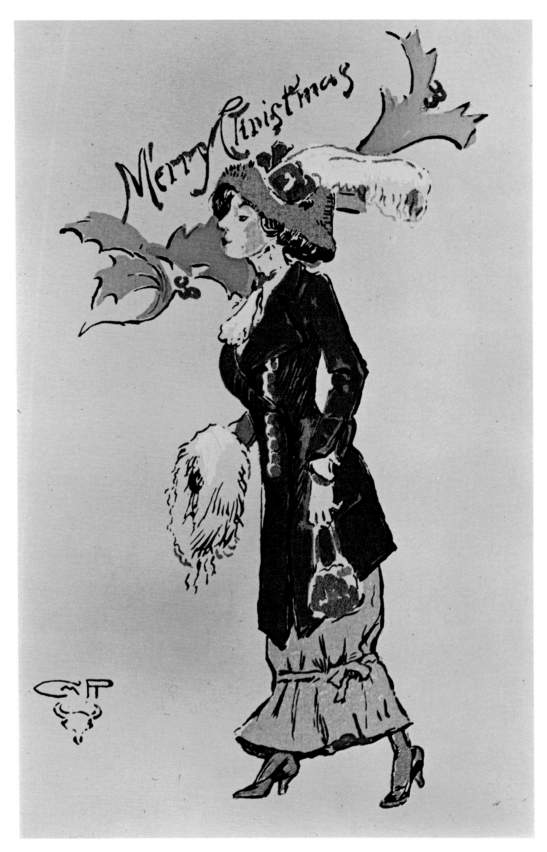

THE HEIGHT OF FASHION
This unusual Christmas card was reproduced by Herbert S. Green, Jr., of Los Angeles, from the original water color owned by him, in an edition of about ninety copies.

See item 24, this section.

34. IF FAIRY WANDS WERE MINE
Whitney Gallery of Western Art. Folder, size $5\frac{1}{4} \times 7\frac{1}{2}$, color. (1964).

35. INDIAN HUNTERS' RETURN
Many, Many Moons Ago, Charley Russell said:
Size $7\frac{1}{2} \times 9\frac{1}{2}$. Earl H. Eby, Elk River Concrete Products Company of Montana. Printed in green ink.

36. INDIAN HUNTERS' RETURN
Many Christmas Moons Ago, Charlie Russell said:
Size $7\frac{1}{2} \times 9\frac{1}{2}$. The Staff, Historical Society of Montana. Printed in green ink.

INSIDE THE LODGE (see item 11)

37. IT USED TO BE THAT HOSSES WAS FAST ENOUGH FOR MEN
Pen and ink, sepia, some hand colored by CMR.
Size $6\frac{1}{8} \times 4$. 1921.

38. THE KING'S SCOUT
With Best Wishes for Christmas and the New Year. Commissioner and Mrs. Geo. B. McClellan. Folder, size $4\frac{1}{2} \times 6$, tied with ribbon of RCMP colors. Color. (1964).
Variant: Same picture, same size, but with imprint of "Hq." Division, Ottawa.

39. LADY BUCKEROO
Greetings of the season and best wishes for the New Year. Folder, size 4×5. Issued by Historical Society of Montana. (1959).

40. MAY YOUR DAYS BE BETTER
Merry Christmas and Happiness throughout the New Year. Folder, size 5×7. Color. (1963). Issued by The Trigg–C. M. Russell Foundation.

THE MEDICINE MAN #1 (see item 59)

41. MEDICINE ROCK*
Greetings and Best Wishes for Christmas and the New Year. Folder, size $4\frac{1}{4} \times 5\frac{1}{2}$. Fred Rosenstock. 1952.

42. MERRY CHRISTMAS*
Whitney Gallery of Western Art. Folder, size $4\frac{1}{2} \times 7\frac{1}{2}$, color (1964). From Original Christmas Card Sent By Russell to a Relative.

MOURNING HER WARRIOR DEAD (see item 59)

NAVAJO WILD HORSE HUNTERS (see item 59)

43. PENDLETON COWBOY
Wishing you a wonderful Holiday Season and every happiness in the New Year. Henry W. Collins. Folder, size $4\frac{1}{2} \times 6\frac{1}{4}$. (1965).

QUICK AS A THOUGHT HE WAS PULLING HIS GREAT STALWART FIGURE FROM OUT THE COACH (as RUN-AWAY STAGE)

THE RED MAN'S WIRELESS (as THE SIGNAL GLASS)

44. RUNAWAY STAGE, i.e., QUICK AS A THOUGHT HE WAS PULLING HIS GREAT STALWART FIGURE FROM OUT THE COACH
Season's Greetings—1939–40. Halftone. Size $5\frac{3}{8} \times 8$, folder. Wells Fargo Bank & Union Trust Co., San Francisco

45. THE SIGNAL GLASS, i.e., THE RED MAN'S WIRELESS
Color plate, $9\frac{3}{4} \times 4\frac{3}{4}$ on mat $12\frac{5}{8} \times 8\frac{3}{8}$. Mat cream color, with poem on left and "Nancy & Jack" on right. 1929.

46. SPREAD-EAGLED
Greetings of the season and best wishes for the New Year. Folder, size 4×5. Issued by Historical Society of Montana. (1959).

47. STEER RIDER #2
Greetings of the season and best wishes for the New Year. Folder, size 4×5. Issued by Historical Society of Montana. (1959).

48. STOLEN HORSES #1 and BLACKFEET WARRIOR
Season's Greetings from the Kennedys Mike Pete Katie Molly Michael Meg. Size $6\frac{1}{2} \times 12\frac{1}{2}$, 3-fold. (1961). This is the MHS flyer for the bronze BLACKFOOT WAR CHIEF made into a Christmas card.

49. TAKE ONE WITH ME, i.e., TAKE ONE WITH ME FRED
Season's Greetings, May the Grass on Your Range Be Green and Deep in 1961. Size $10\frac{1}{2} \times 7\frac{1}{2}$. Color. Historical Society of Montana.

50. TAKE ONE WITH ME, i.e., TAKE ONE WITH ME FRED
Season's Greetings From the Kennedys. Folder, size $6\frac{3}{4} \times 7\frac{1}{2}$. Color.

51. TAKE ONE WITH ME HERS TO A MERRY CHRISTMAS, i.e., TAKE ONE WITH ME FRED
Greetings of the Season and Best Wishes for a Prosperous New Year. Folder, size $6\frac{3}{4} \times 4\frac{3}{4}$. Color. Leanin' Tree, Boulder, Colorado. N.d. (1965).

TAKE ONE WITH ME FRED (as TAKE ONE WITH ME and TAKE ONE WITH ME HERS TO A MERRY CHRISTMAS)

52. THE THREE KINGS
May the Blessings of Christmas be with you this Season and the coming Year. Folder, size 4×9. Color. (1963). Issued by Trigg–C. M. Russell Foundation.

53. UNEXPECTED GUESTS FOR CHRISTMAS DINNER, i.e.,
 THE CHRISTMAS DINNER
Pen and ink, in color. Size 6½ × 4. Four-page card of
Fred Naegele. 1944.

54. WE AIN'T GONE FIVE MILE WHEN THE COACH STOPS
Greetings of the season and best wishes for the New
Year. Folder, size 4 × 5. Issued by Historical Society
of Montana. (1959).

55. A WESTERN GREETING*
Our Greetings Are Big As The Main Range West
Where Nature Catches Her Wealth
May She Open Her Hidings and Give You Her Best
While Santa Gives Socks Full of Health
Charles M. and Nancy Russell. Calendar. Size
7½ × 9⅝. 1925.

56. WHEN HORSES TURN BACK THERE'S DANGER AHEAD
Color plate. Mat cream color, with poem on left and
"Nancy & Jack" on right. Size 9¾ × 4¾ on mat
12⅝ × 8⅜. 1929.

57. WHEN THE LAND BELONGED TO GOD
Another Russell for Your Collection is Bringing our
Christmas Cheer. Size 6⅜ × 7⅝, folded once, color.
Treasure State Life Insurance Co., Butte, Montana.
N.d. (1961).

58. WHEN WAGON TRAILS WERE DIM
Chas. M. Russell When Wagon Trails Were Dim.
Wearin's Holiday Life, Christmas 1946, No. 8,
Hastings, Iowa. Pp. [8]. Folio, size 6¾ × 8¼, self-
wrappers. Color plate, pasted on front cover.

59. WILD HORSE FIGHT, i.e., THE CHALLENGE #2;
 NAVAJO WILD HORSE HUNTERS;
 THE MEDICINE MAN #1;
 MOURNING HER WARRIOR DEAD
Holiday Greetings to All Members of the Denver
Posse of the Westerners. Folder, size 5 × 6¾.

60. Harold D. Bugbee's Christmas card, 1950 (a
brochure), mentions CMR. "John Bouldin's First
Christmas on the Plains."

61. Thomas Teakle of Spokane, Washington, issued a
Christmas card for 1958 which reproduced a water
color by William Standing, an Assiniboin artist, en-
titled "Charley Lit Tobacco for Assiniboins Too,"
showing CMR lighting a cigarette for an Indian.

SECTION X

Ephemera

SECTION X

Ephemera

1. Advertising Club of Great Falls. Montana's Cowboy Artist. Brochure, quarto, size 5 × 7, white stock, with SELF-PORTRAIT #4 in color on front. Issued 1964 at time of issue of JERKED DOWN stamp, which is glued to p. [5].

2. Advertising Club of Great Falls Advents. Honoring Great Falls Own C. M. Russell, Montana's Cowboy Artist at a Dedicatory Luncheon Thursday 11:45 A.M., Rainbow Hotel March 19th (1964). Flyer, size 8½ × 14, folded twice for mailing, cream stock, printed both sides. Contains reproduction of JERKED DOWN stamp.

3. Advertising Club of Great Falls. Honoring Great Falls Own C. M. Russell, Montana's Cowboy Artist at a Dedicatory Luncheon, Thursday, 11:45 A.M. Rainbow Hotel, March 19th. [1964]. Broadside, tan stock, 13¾ × 8½. Reproduces sketch after CHARLES M. RUSSELL AND HIS FRIENDS and on verso JERKED DOWN.

4. American Society of Range Management issued a great many items, all bearing THE TRAIL BOSS (part), which has been adopted as the official emblem of the society.

A. Annual meeting and banquet programs:

Third: Gunter Hotel, San Antonio, Texas, January 10, 11, 12, 1950.

Fourth: Northern Hotel, Billings, Montana, January 23, 24, 25, 1951; banquet January 24.

Fifth: Boise Hotel, Boise, Idaho, January 30, 31, and Feb. 1, 1952; banquet January 31.

Sixth: Hilton Hotel, Albuquerque, N.M., January 20–23, 1953; banquet January 21.

Seventh: Hotel Fontenelle, Omaha, Nebraska, January 26–29, 1954; banquet January 28.

Eighth: Sainte Claire Hotel, San Jose, California, January 25–28, 1955; banquet January 27.

Ninth: Shirley Savoy Hotel, Denver, Colorado, January 24–27, 1956; banquet January 26.

Tenth: Rainbow Hotel, Great Falls, Montana, January 29–31, February 1, 1957; banquet January 31.

Eleventh: Westward Ho Hotel, Phoenix, Arizona, January 28–31, February 1, 1958; banquet January 30.

Twelfth: Hotel Tulsa, Tulsa, Oklahoma, January 27–30, 1959; banquet January 29.

Thirteenth: Multnomah Hotel, Portland, Oregon, February 2–5, 1960; banquet February 4; and card of program sessions.

Fourteenth: Hotel Newhouse, Salt Lake City, Utah, January 31, February 1–3, 1960; banquet February 1. (N.B. This program bears the Range Conservation stamp, which features THE TRAIL BOSS. It was at this banquet that the Postmaster General presented the commemorative stamp.)

Fifteenth: Robert Driscoll Hotel, Corpus Christi, Texas, January 23–26, 1962; banquet January 25.

Sixteenth: Sheraton-Johnson Hotel, Rapid City, South Dakota, February 11–15, 1963; banquet February 14; and ticket.

Seventeenth: Broadview Hotel, Wichita, Kansas, February 11–14, 1964; banquet February 13. Also identification card and registration card and ladies' tour, ladies' luncheon, banquet and social hour tickets.

B. Various regional sections of the American Society of Range Management also held annual meetings and featured THE TRAIL BOSS (part) on their programs. Northwest Section, Yakima, Washington, November 7–8, 1950. Arizona Section, Show Low, Arizona, July 30–31, 1957. Arizona Section, Tenth Annual, Tucson, Arizona, December 17–19, 1959.

C. There were other uses of THE TRAIL BOSS (part) as well. Identification card, size $2\frac{1}{2} \times 3\frac{3}{4}$. Join the A.S.O.R.M., folder, size $8\frac{3}{8} \times 3\frac{5}{8}$. Idaho Section Newsletter, No. 1, June, 1960. The Journal of Range Management, folder, six pages. The Range . . . What's New In Range and Pasture Management, folder, size 8×4. Read the Journal of Range Management, folder, six pages, size $8\frac{3}{8} \times 3\frac{5}{8}$. Cover of *Journal of Range Management*, commencing with issue of January, 1951. Life Membership Certificate. *Selected Bibliography on Southern Range Management*, by R. S. Campbell, *et al.*, 1963. *Out on the Range*, published by the American Society of Range Management and Oregon State College.

5. International Mountain Section American Society of Range Management, Summer Field Trip Schedule. July 15, 16, 17, 1965. Pp. [4], size $8\frac{1}{2} \times 11$.
UTICA

6. Bigfork Summer Playhouse. Sixth Season—1965. Souvenir Program—50¢. Pp. 35, size $8\frac{1}{2} \times 11$, wrappers.
p. 4: ASSINIBOIN WAR PARTY

7. Bigfork Summer Playhouse. Seventh Season—1966. Souvenir Program—50¢. Pp. 35, size $8\frac{1}{2} \times 11$.
p. 6: ASSINIBOIN WAR PARTY

8. $25,000 in cash prizes. Big Victory and Frontier Days Celebration. The Stampede Calgary—Alberta—Canada. August 25–30, 1919. Number of pages unknown, size approximately 8×11.
cover: CALGARY STAMPEDE #1 (color)
p. ?: CALGARY STAMPEDE #2 (color)
We have not seen a complete copy of this item.

9. Cascade County Old Timers Association Promenade Concert and Old Time Dance [Program]

Masonic Temple, Great Falls, Montana, Saturday, April 17, 1926. Card, folded once to size $3 \times 4\frac{1}{2}$.
cover: HE'S JUST TOPPIN' THE HILL OUT OF MILES CITY WHEN HE RUNS DOWN A JACKRABBIT THAT GETS IN HIS WAY

10. Charles M. Russell Gallery, Great Falls, Montana. Montana is the Place. Mailing piece to raise funds for enlargement of the C. M. Russell Gallery. Pp. 8, folio, 6×9, stapled (1965).
cover: SMOKE SIGNAL #1 (color)
p. 1: THE COWBOY #2
 A FRENCH HALF-BREED
 THE PROSPECTOR
p. 4: THE POST TRADER (vignette)
p. 5: BLACKFEET SQUAW AND PAPPOOSE
p. 7: THE SCOUT #4 (vignette)
p. 8: THE SIOUX BUFFALO HUNTER
b. cover: SKULL #1 (in reverse)
insert: SMOKE SIGNAL #1 (postcard)

11. Charles M. Russell. An old-time cowman discusses the life of Charles M. Russell [SKULL #1] By Fred Barton. Front wrapper serves as title page. Printed at Los Angeles, 1961. Pp. 16, 8vo, size 6×9. Wrappers, stapled. The first edition of this pamphlet does not have page numbers and the last page has printing. Later editions have page numbers and last page reproduces three bronzes. Contained within envelope with cut of illustration on cover in upper left corner. Contains nine illustrations:
cover: THEN THE CALDWELLITES CHARTERED THE STAGE AND WENT HOME
p. [1]: photo of CMR
p. 2: A BAD HOSS
 THE BOLTER #1*
p. 4: Statue of CMR by Lion (photo)
p. 7: AH-WAH-COUS
p. 10: COWBOY, MOUNTED #1
 BEAR, FOREFEET ON LOG LOOKING AT RANCH HOUSE
p. 11: SPOKANE FALLS WAS THE CROSSROADS FOR ALL THE INDIAN TRIBES IN THE COUNTRY
p. 13: INDIAN, MOUNTED #2
p. 15: LORDS OF THE YELLOWSTONE

12. Charles M. Russell by Helen Raynor Mackay. Author's separate reprinted from the March, 1949 issue of the *Cattleman, q.v.*
Contains same illustrations.

13. Charles Marion Russell 1864–1926 One of Nature's Noblemen, Beloved Westerner, Greatest Cowboy Artist of the Old West. Saco, Montana, Dedicatory Program, 1956. Pp. [4], folio, size $5\frac{1}{2} \times 8\frac{1}{2}$.
cover: SPREAD-EAGLED*

p. [2]: A RACE FOR THE WAGONS
p. [3]: LIKE A FLASH THEY TURNED
p. [4]: COWBOY SEATED, HORSE NUZZLING HIS LEFT HAND

14. Charles Russell Memorial Committee, Inc., P.O. Box 1956, Butte, Montana. You Can Help Keep the Famous "Mint" Collection of Russell Paintings and Waxes in Montana. Folder, tan stock, size 8½ × 11, n.d. (ca. 1949).
p. [1]: AH-WAH-COUS
p. [2]: PICTURE WRITING, i.e., THE PICTURE ROBE
 THE HOLD UP, i.e., HOLDING UP THE OVERLAND STAGE
p. [3]: STEER (plaster replica)
 THE BUFFALO (bronze)

15. Charles Russell Suite. "All about him are new sounds and sights to match those new songs in his heart's wildest imagination." The Territory of Montana year of our Lord, 1880. Music and text by Francis E. White, Bozeman, Montana, 1963. Pp. [8], wrappers. Front wrapper: (A) BRONC TO BREAKFAST (part)

16. Charley Russell's Sentiments [47 lines plus 11 stanzas of verse] Great Falls, Montana, November 15, 1911. Broadside, size 10½ × 15⅜. Text set within border of red and black rules with device in the corners. Initial letter "C" in red. Contains no illustrations, but the verse was written by Russell in response to a toast delivered by Robert Vaughn.

17. Chuck Wagon Dinner and Old Timers' Reunion. Rainbow Hotel, Great Falls, Montana, July 3, 1928. Invitation, brown stock, size 9⅜ × 12⅝. Contains: LONGHORN STEER SKULL WITH FIVE BRANDING IRONS and COMING TO CAMP AT THE MOUTH OF SUN RIVER (part).

18. Second Conference on the History of Western America. Host Institution, the University of Denver, October 11-12-13, 1962. Albany Hotel, Denver, Colorado
p. [21]: THE SCOUT #4

19. Fifth Annual Conference of the Western History Association. Host Institution, Montana Historical Society, October 14-15-16, 1965. Placer Hotel, Helena.
COVER: THE TRAPPER

20. The Conservatism of Charles M. Russell by J. Frank Dobie. Author's separate reprinted from *The Montana Magazine of History*, Vol. II, No. 2 (April, 1952), 27-[32]. Wrappers, size 9 × 6.
p. [32]: THE LAST OF HIS RACE

21. Ken Crawford, Books, Burbank, California. Catalog Number 35. Pp. [20], size 6 × 9⅛, n.d. (1960). Contains letter from CMR to Jack O'Neill dated Jan. 16, 1918.

22. Denver Public Library, Malcolm G. Wyer, Librarian. Artist: Charles M. Russell, American—1865–1926. Broadside, size 8 × 9.
[THE] SALUTE OF THE ROBE TRADE

23. ——. Artist: Charles M. Russell, American—1865–1926. Broadside, size 8 × 9.
WAGON BOSS

24. Elks Club of Great Falls, B.P.O.E. Lodge 214. Invitation: The Lids On. White Stock, size 5 × 5½, n.d. (1917).
THE LID'S OFF

25. Elks Club of Great Falls. Program Schedule, B.P.O.E., Lodge 214, Great Falls, Montana, 1959. Leaflet, size 8½ × 11½.
COVER: THE EXALTED RULER (color)

26. Elks Club of Great Falls. The Exalted Ruler. B.P.O.E. No. 214, Great Falls. Quarto, folded off center to 4¼ × 5¾, n.d. (ca. 1960).
front: A RODEO RIDER
 Russell painting THE EXALTED RULER (photo)
back: I RODE HIM

27. Forest Service Press Clippings No. 7, February 24, 1961. Many articles about Range Conservation stamp, and reproduction on p. 3, showing THE TRAIL BOSS (part).

28. Fort Worth Art Association. You are invited to the Mint Bar Party May 31, 1952. Pioneer Palace, 7 P.M. Fort Worth Art Association. Folio, pp. [4], size 8½ × 11, yellow stock.
p. [1]: I BEAT YOU TO IT
p. [2]: THE VIRGINIAN
p. [4]: DANCE! YOU SHORT-HORN DANCE!

29. Fort Worth Art Association. Program, Mint Bar Party, May 31, 1952, Pioneer Palace, 7 P.M. Pp. [8], size 8¼ × 10⅞.
p. [1]: I BEAT YOU TO IT
p. [2]: THE VIRGINIAN
p. [7]: DANCE! YOU SHORT-HORN DANCE!

30. Thomas Gilcrease Institute of American History and Art Gilcrease Art Gallery, Tulsa, Oklahoma. Single sheet, folded thrice to 4 × 9, blue and red ink on white, n.d. (ca. 1955).
JERKED DOWN on inner fold

31. ———. Visit the Thomas Gilcrease Institute of American History and Art Museum and Art Gallery, Tulsa, Oklahoma. N.d. (1955). Flyer, folded four times to 4 × 9¼.
MEAT'S NOT MEAT 'TILL IT'S (i.e., TILL ITS) IN THE PAN on inner fold

32. ———. You are cordially invited to join The Thomas Gilcrease Institute of American History and Art, Inc. [22 lines] Broadside, size 8½ × 11, folded twice (1956).
obverse: STEER RIDER #1*

33. ———. Single sheet printed both sides, folded twice to size 3 15/16 × 9 (March, 1964).
JERKED DOWN on inner fold

34. ———. Visit the Thomas Gilcrease Institute of American History and Art. Flyer, folded once to size 4 × 8½ (1964).
WHERE TRACKS SPELL MEAT

35. ———. Pre-Publication Offer. Titans of Western Art. Frederic Remington—Charles M. Russell. Card, size 9⅛ × 3¾ (1964).
STEER RIDER #1

36. ———. Titans of Western Art. Actual Reproduction Inside Cover. Flyer, folded twice to size 8½ × 11 (1964).
cover:　Charles M. Russell (photo)
　　　　THE SALUTE OF THE ROBE TRADE (part) (color)
outer fold: CARSON'S MEN (color)
　　　　OFFERING TO THE SUN GODS (bronze)
　　　　THE MEDICINE MAN (bronze)
　　　　LEWIS AND CLARK REACH SHOSHONE CAMP LED BY SACAJAWEA, THE "BIRD WOMAN" (color)
　　　　SECRETS OF THE NIGHT (bronze)
back cover: THE STORY TELLER #3
inner fold: WATCHING FOR WAGONS*

37. ———. Entire Run of the American Scene. Bound Volumes. Broadside, folded thrice to size 3¾ × 8½ (1965).
A STRENUOUS LIFE

38. ———. Gilcrease is a treasury of material relating to the historic record of America. Salmon stock, size 8½ × 11, folded twice, n.d. (1965).
JERKED DOWN on inner fold

39. Greetings From Great Falls, Montana. There is no date on the front wrapper, which serves as the title page. Pp. [8]. Folio, size 9¼ × 12¼. Wrappers, stapled. Issued by B.P.O.E. No. 214, Great Falls, Montana, 1956. Contains:
front wrap: I RODE HIM (color)
p. [1]:　　photo of CMR in studio painting THE SALUTE OF THE ROBE TRADE
p. [2]:　　IN LONDON THE HOLD UP SAYS THANK YOU SIR
　　　　I HAD A ROUGH TRIP OVER
　　　　CAR OF THE SILVER DOLLAR
　　　　THE LAST OF THE BUFFALO (part)
　　　　ONLEY EXCITMENT I GET IS DODGING CARS
　　　　WE WERE SHURE GOING SUM
　　　　THAT LADYS HORSE YOU USED TO OWN
　　　　IM GOING TO DRESS WELL IF IT BRAKES ME
p. [3]:　　WOULD YOU KNOW ME BILL
　　　　LETHBRIDGE RIDERS
　　　　A SOFT DRINK JOINT
　　　　THEM GAS EATING GUYS GOT THE LEED*
p. [4]:　　THEY HAVE A ROPE ON THE LAST CLIME*
　　　　BOOSE FOR BOOSE FIGHTERS*
　　　　THE GENUINE GRIZZLEY BEAR DANCE*
　　　　THE CHRISTMAS DINNER
p. [5]:　　WELCOMED BY THE HACK DRIVERS*
　　　　I LANDED ALL RIGHT*
　　　　SHES AT DINNER*
p. [6]:　　AS I WAS*
　　　　THE TRAIL BOSS
　　　　THE INDIAN OF THE PLAINS AS HE WAS
　　　　AS I AM NOW*
p. [7]:　　DONT THINK IM CRIPPELD BILL*
　　　　THE SHELL GAME
　　　　I DONT THINK THE OLD ATLANTIC HAS CHANGED
　　　　IT WAS A QUICK TUCH
p. [8]:　　ESQUMO LIVES IN AN EGELOW
　　　　FIGHT IN LUMBER CAMP*
　　　　NATIVE SONS BUILD A BUNGALOW
　　　　THE LAST OF HIS RACE
　　　　HERE I AM BILL
back wrap: GOING HOME

40. Gulf Coast Conservation District Newsletter. Broadside, size 8½ × 13¼. December, 1960. Reproduces THE TRAIL BOSS (part).

41. Helena High School Thespian Troupe No. 745 and the State Department of VFW Presents No More Frontier A Play in Prologue and Three Acts by Talbot Jennings. Helena High School Auditorium February 11 and 12, 1953. Folio, pp. [16], size 12¼ × 8¾.
p. [1] (front wrap): LAST CHANCE OR BUST (color)
p. [4]:　　　　MOCCASINS

p. [7]: INDIAN OF THE PLAINS AS HE WAS, i.e., AH-WAH-COUS
p. [8]: THE TRAIL BOSS
p. [9]: NATURE'S CATTLE #1
p. [10]: PICTURE WRITING, i.e., THE PICTURE ROBE
p. [16]: SKULL #1
 COWBOY ABOUT TO SADDLE HORSE

42. Home Coming Days by Bob Fletcher. Naegele Printing Co., Helena, 1939. Folio, size $12\frac{3}{8} \times 18\frac{3}{4}$. Contains: LAST CHANCE OR BUST (color) and THE PROSPECTORS #2

43. Ninth Annual International Trap Shoot 1959. Montana, Alberta. First Half of Program sponsored by Great Falls Trap & Skeet Club, Wadsworth Park, Great Falls, Montana, June 20 and 21. Contains:
cover: THE INDIAN OF THE PLAINS AS HE WAS
p. [1]: THE LAST OF THE BUFFALO
p. [3]: HOLDING UP THE OVERLAND STAGE
p. [9]: THE CHRISTMAS DINNER
N.B. The printer has added color to make the reproductions of these Russell pen drawings appear to be water colors.

44. Tenth International Trap Shoot, 1960, Montana, Alberta. First Half of Program sponsored by Great Falls Trap & Skeet Club, Wadsworth Park, June 17, 18, 19, 1960, Great Falls, Montana. Contains:
cover: HOLDING UP THE OVERLAND STAGE

45. Jackson Arts and Music Festival presents the annual Rendezvous Ball Celebrating Charlie Russell Centennial. Jackson Lake Lodge Thursday, August 13, 1964. Broadside, 7×12, printed on white, also blue, and orange stock. Photo of CMR captioned "Charlie Russell self-portrait," in center.

46. Jackson Hole Music and Art Festival Rendezvous Ball Thursday August 13, 8:00 P.M. Jackson Lake Lodge. Door Prize. Prize for best mask. Champagne waltz prize. Buffet 11:00 P.M. Tickets $7.50 each. Fine Arts Orchestra Members' Music. Charles Russell Centennial. Window card, white stock, size $12\frac{3}{4} \times 15\frac{1}{4}$, brown ink, n.d. (1964). Photo of bronze of CMR by unknown artist on left side of card. Also, ticket to the ball, size $7\frac{1}{2} \times 2\frac{1}{4}$.

47. First Annual Last Chance Stampede, July 30, 1961, State Fairgrounds, Helena, Montana, First Annual Souvenir Program. Sponsored by the Lewis & Clark County Fair Association. Contains:
cover: THE SURPRISE ATTACK

p. 4: BUCKER AND THE BUCKEROO, i.e., THE WEAVER (bronze)
 HERE'S HOPING YOUR TRAIL IS A LONG ONE
p. 13: THE ODDS LOOKED ABOUT EVEN (part)
 STEER RIDER #2
p. 20: THE POST TRADER
p. 22: THE TRAPPER
p. 23: COWBOY TWIRLING LARIAT, LONGHORNS RUNNING
p. 24: LADY BUCKEROO
p. 26: THE ODDS LOOKED ABOUT EVEN (part)
 PETE HAD A WINNING WAY WITH CATTLE (part)
p. 27: THE WOLFER
back cover: NO CHANCE TO ARBITRATE, i.e., WHEN HORSES TALK WAR, THERE'S SMALL CHANCE FOR PEACE

48. Last Chance Second Annual Stampede, State Fairgrounds, Helena, Montana, July 28–29, 1962. Official Souvenir Program.
cover: STAMPEDING THE STAGE, i.e., THE STAGE COACH ATTACK (color)
verso: A BRONC TWISTER (bronze)
p. [1]: WHERE THE BEST OF RIDERS QUIT (bronze)
p. [5]: BUCKING HORSE
p. [8]: SCOOL MARM
p. [15]: TWO RIDERS ONE LEADING A PACK HORSE
 TRAILS PLOWED UNDER
p. [19]: A RODEO RIDER
 A RODEO RIDER LOSES
p. [24]: GOLD SEEKERS SOUTH OF BENTON ON LAST CHANCE GULCH, i.e., THE PROSPECTORS #2
p. [27]: WASH TROUGH
 THEY'RE ALL PLUMB HOG-WILD
 A RACE FOR THE WAGONS (part)
p. [29]: COWBOY ABOUT TO SADDLE HORSE
 THE GEYSER BUSTS LOOSE (part)

49. Third Annual Last Chance Stampede Official Program 50¢. Fairgrounds, Helena, Montana, July 27 and 28, 1963.
cover: WHEN HORSES TALK WAR THERE'S SMALL CHANCE FOR PEACE (color)
inside: THE ODDS LOOKED ABOUT EVEN
 SCOOL MARM
p. [5]: THE STEER WAS TOSSED CLEAR OF THE GROUND AND CAME DOWN ON HIS LEFT SIDE
 A HERD OF ANTELOPE SCENTING DANGER
p. [6]: HIGHWAYMAN WAITING FOR HIS PREY
 (A) BUCKING HORSE
p. [9]: CORAZON REARED STRAIGHT UP HIS FEET PAWING LIKE THE HANDS OF A DROWNING MAN

p. [11]: WASH TROUGH

p. [14]: IDAHO OX TEAMS WERE BRINGING IN
 6,000,000 POUNDS OF FREIGHT ANNUALLY

p. [17]: PLUMMER AND TWO FOLLOWERS KILL FORD
 BLACKFEET SQUAW AND PAPPOOSE (vignette
 only)
 CAMPER FLIPPING FLAPJACKS

p. [18]: TWO RIDERS, ONE LEADING A PACK HORSE
 BATTLE BETWEEN CROWS AND BLACKFEET
 TRAILS PLOWED UNDER

p. [19]: BULL ELK

pp. [20–21]: COMING TO CAMP AT THE MOUTH OF SUN
 RIVER
 "YES, YOU DID!"

p. [21]: THEY'RE ALL PLUMB HOG WILD
 PETE HAD A WINNING WAY WITH CATTLE

p. [27]: BEFORE THE WHITE MAN CAME #4
 A SWING STATION ON THE OVERLAND

p. [28]: FIRST AMERICAN NEWS WRITER (part)

p. [31]: THE TRAIL BOSS

p. [35]: THE ODDS LOOKED ABOUT EVEN (part)
 THE GEYSER BUSTS LOOSE

p. [36]: DIAMOND HITCH SIDE AND TOP VIEWS

p. [39]: RADISSON RETURNS TO QUEBEC WITH 350
 CANOES LOADED WITH FURS
 [THE] INITIATION OF THE TENDERFOOT
 (part)

p. [40]: IN THE OLD DAYS THE COW RANCH WASN'T
 MUCH
 THE WOLFER

wrap: COMING TO CAMP AT THE MOUTH OF SUN
 RIVER
 THE SURPRISE ATTACK (color)

50. Fourth Annual Last Chance Stampede [illustration] Cut 'er Loose. Helena, Montana. July 31st–August 1st & 2nd (1964). Official Program. 50¢.

p. [7] BEFORE THE WHITE MAN CAME #2

p. [10]: THE WOLFER

p. [16]: THE TRAIL BOSS
 THEY'RE ALL PLUMB HOG WILD (part)

p. [17]: THE ODDS LOOKED ABOUT EVEN (part)

p. [29]: THE PROSPECTOR (vignette)
 TWO RIDERS, ONE LEADING A PACK HORSE

p. [35]: A DIAMOND R MULE TEAM OF THE '70S
 SCOOL MARM
 PLACER MINERS PROSPECTING NEW STRIKE

p. [36]: (THE) BULL ELK
 WASH TROUGH

p. [38]: BLACKFEET SQUAW AND PAPPOOSE (vignette)
 [THE] GEYSER BUSTS LOOSE
 CAMPER FLIPPING FLAPJACKS
 COW CAMP IN WINTER, i.e., IN THE OLD DAYS
 THE COW RANCH WASN'T MUCH

p. [42]: TRAILS PLOWED UNDER
 BUCKING HORSE

51. Fifth Annual Last Chance Stampede [illustration] Cut 'er Loose. Helena, Montana. Official Program. August 6, 7, 8 (1965). 50¢.

p. 6: THE TRAPPER (vignette)
 THE POST TRADER (part)

p. 9: TWO RIDERS, ONE LEADING A PACK HORSE
 THE STAGE DRIVER (vignette)

p. 17: WASH TROUGH
 THE ODDS LOOKED ABOUT EVEN (part)
 COW CAMP IN WINTER, i.e., IN THE OLD DAYS
 THE COW RANCH WASN'T MUCH
 PLACER MINERS PROSPECTING NEW STRIKE

p. 23: BUFFALO HOLDING UP MISSOURI RIVER STEAM-
 BOAT
 THE TRAIL BOSS

p. 25: (THE) BULL ELK

p. 31: TWO MEN LOADING PACK HORSE, SADDLE HORSES
 NEARBY

p. 37: LADY BUCKEROO
 THE PROSPECTOR (vignette)
 CAMPER FLIPPING FLAPJACKS

p. 43: AN UNSCHEDULED STOP, i.e., PLUMMER'S MEN AT
 WORK

p. 48: THE WOLFER

p. 53: TRAILS PLOWED UNDER

p. [56]: A DIAMOND R MULE TEAM OF THE '70S
 THE COWBOY #2 (part)
 THE STAGE DRIVER (part)

52. Sixth Annual Last Chance Stampede [illustration] August 5–6–7. Official Program. 50¢. (Helena, Montana, 1966).

p. [6]: ABOUT THE THIRD JUMP CON LOOSENS

p. [7]: LADY BUCKEROO

53. Letter to Brother Van of March 20, 1918. Broadside, white stock, size 8½ × 11, n.p., n.d. (Great Falls, 1964). Text only.

54. Certificate of Appreciation. The Board of Directors of Lewis and Clark Fair Association, State of Montana, Sponsors of Last Chance Stampede, Hereby Express Sincere Thanks to . . . For your Valuable Aid in making the 1963 Stampede a Success. Broadside, 8 × 10⅜.

LADY BUCKEROO
STEER RIDER #2

55. Lewis and Clark's Trail. Words and music by Robert Vaughn. Published by Robert Vaughn, Great Falls, Montana. Frederick Pollworth & Bro. Music

Lewis and Clark's Trail

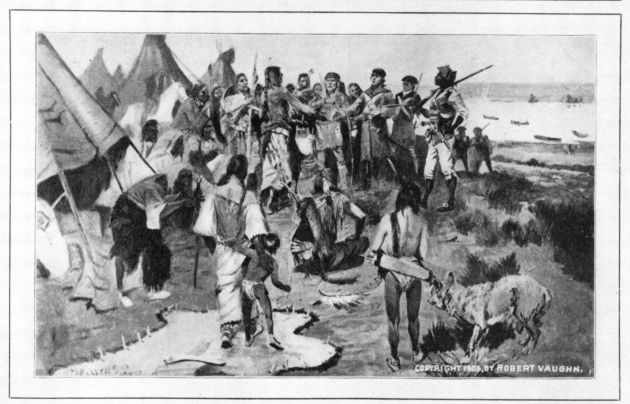

Words and Music by Robert Vaughn

===== Published by =====

 Robert Vaughn

Great Falls, Montana

LEWIS AND CLARK MEETING THE MANDAN INDIANS
See item 55, this section.

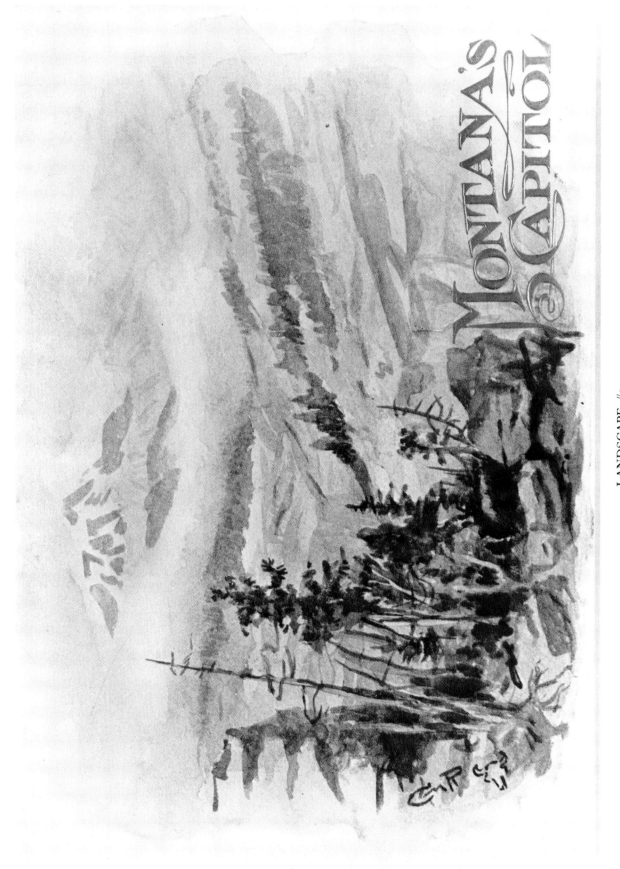

LANDSCAPE #2

Cover of souvenir distributed at dedication of Montana's Capitol.

See item 79, this section.

Printers, Milwaukee. Sheet music, one loose sheet enclosed in pictorial wrapper, size 11 × 13⅞ (1905). Cover, halftone:

LEWIS AND CLARK MEETING THE MANDAN INDIANS

56. Visit the Pacific Northwest Hospitality Room. "Leo the Lion" Graybill for International Director. This is a Lions Club campaign plugger, size 9 × 4, n.d. (1958) with THE INDIAN OF THE PLAINS AS HE WAS made into a color print.

57. Montana Cowboy's Museum. 311 3rd St., N.W. Across from the Fairgrounds. Great Falls, Montana. Mailing leaflet, size 3¾ × 8½. Statue of CMR by Evelyn Cole on p. [2].

58. Forty-Sixth Annual Montana Elks State Convention. July 22, 23, 24, 1948, Great Falls. Compliments of Great Falls 214. The front wrapper serves as the title page. Pp. 16, folio, size 7¾ × 10 9/16, wrappers, stapled. Dedication to CMR, portrait and brief biography on p. 1. Contains one halftone and 12 line engravings, in that order:

wrapper: I RODE HIM
p. 1: THE LAST OF HIS RACE
 photo of CMR at easel painting SALUTE OF
 THE ROBE TRADE
p. 3: NATURE'S CATTLE #1
p. 4: THE RANGE RIDER'S CONQUEST
p. 5: THE LAST OF THE BUFFALO
p. 6: THE SHELL GAME
p. 8: THE TRAIL BOSS
p. 9: PAINTING THE TOWN
p. 10: BLAZING THE TRAIL, i.e., LEWIS AND CLARK
 AT THREE FORKS OF THE MISSOURI
p. 11: THE INDIAN OF THE PLAINS AS HE WAS
p. 14: [THE] CHRISTMAS DINNER
p. 15: HOLDING UP THE OVERLAND STAGE
b. wrapper: GOING HOME!!*

59. Montana Fine Arts Commission. Charles Marion Russell—Artist—Illustrator—Writer. Folio, [8] pages, size 8¼ × 8¾, n.d. (1958).
cover: THE ROUNDUP #2 (color)
p. [4]: Statue of CMR by Weaver (photo)

60. Montana Fine Arts Commission. An Invitation to become the owner of one of a limited number of Charles M. Russell busts. Folio, size 4 × 5, on cream stock with RAWHIDE RAWLINS, MOUNTED on p. [1]. Issued in envelope, in appeal for funds for CMR statue, ca. 1958.

61. Montana Hardware and Implement Association 46th Convention. Placer Hotel, Helena, Montana,

October 24, 25, 26, 1954. Pp. [56], size 6 × 9, wrappers.
cover: THE ROUNDUP #2
p. 29: note on the picture

62. Montana Hardware & Implement Association, 46th Convention, Placer Hotel, Helena, Montana, October 24, 25, 26, 1954. Program, pp. [8], size 9 × 4.
cover: THE ROUNDUP #2

63. Montana State Chapter First Congregational Church. Program, June 1, 2, 3, 1933. Great Falls, Montana.
cover: THE ADVANCE GUARD

64. Montana State Federation of Women's Clubs Banquet Menu, September 9, 1930, Folder on pink stock, size 4⅞ × 7½. Contains:
cover: MONTANA'S FIRST PRINTER, i.e., FIRST AMERICAN
 NEWS WRITER

65. Montana State Press Association. 72 Annual Convention. Program, folio, 4 pp., size 8½ × 5¼, n.d. (ca. 1958).
cover: CHARLES M. RUSSELL AND HIS FRIENDS
p. 2: THE COWBOY #2
 THE PROSPECTOR
 THE WOLFER
p. 3: THE STAGE DRIVER
 THE SCOUT #4
 SKULL #2
p. 4: [THE] JERKLINE

66. Unveiling and Presentation Ceremony, Statue of Charles M. Russell, "Montana's Cowboy Artist" in the Rotunda of the Nation's Capitol, March 19, 1959. Program, folder issued by the Montana State Society, size 9 × 6⅛.
cover: RAWHIDE RAWLINS, MOUNTED
p. [3]: photo of CMR statue by Weaver (part)

67. Montana State University. Cow Camp in the Winter. Flyer, size 7¾ × 10, white stock, obverse printed partly in red. A solicitation by Friends of the Library for historical materials.
reverse: IN THE OLD DAYS THE COW RANCH WASN'T MUCH

68. Montana Stock Growers Association. Thirty-Third Annual Meeting. Great Falls, Montana, April 16 and 17, 1918. Program, pp. [8], quarto uncut, size 11 × 7. Contains 6 line engravings:
p. [1]: THEY'RE ALL PLUMB HOG-WILD*
p. [4]: NATURE'S CATTLE #2*
p. [5]: THE LONG HORN*
 SHEEP*

p. [8]: THE COME LATELY*
 HOG*

69. Montana Stockgrowers Association. Stockmen's Convention. Powder River Special Great Falls to Miles City April 15 and 16, 1919. Northern Montana Passenger List. [Here follows list of names in two columns.] Broadside, size $8\frac{1}{2} \times 14$.
THEY'RE ALL PLUMB HOG-WILD

70. Montana Stockgrowers Association. Fortieth Annual Convention held at Great Falls, Montana, April 7 and 8, 1925. Officers [4 lines]. The foregoing actually appears on the back, p. [8]. There is no text on the front cover, p. [1]. Pp. [8], quarto, size $8 \times 4\frac{7}{8}$, saddle stapled. Four illustrations:
p. [1]: LONGHORN STEER SKULL WITH FIVE BRANDING
 IRONS*
p. [4]: LONGHORN STEER, TH BRAND*
p. [5]: MODERN HEREFORD STEER, TL BRAND*
p. [6]: COMING TO CAMP AT THE MOUTH OF SUN RIVER*

71. Montana Stockgrowers Association. Fortieth Annual Meeting. Great Falls, Montana, April 7–8, 1925. Folio, pp. [8], size $6\frac{1}{2} \times 8\frac{1}{4}$, cover with decorated border and silk tie.
cover: MODERN HEREFORD STEER, TL BRAND (color)

72. Montana Stockgrowers Association. Forty-eighth Annual Convention. May 25, 26, 27, 1932. Grand Theatre, Great Falls. Program, quarto, pp. [8], size $5\frac{7}{16} \times 9$.
cover: HE'S JUST TOPPIN' THE HILL OUT OF MILES CITY
 WHEN HE RUNS DOWN A JACKRABBIT THAT GETS
 IN HIS WAY

73. Montana Stockgrowers Association. Golden Jubilee Convention of the Montana Stockgrowers Association held at Miles City, Montana, May 24, 25, 26, 1934. Pp. 8, wrappers, size $4\frac{1}{4} \times 6\frac{1}{2}$. Contains:
recto front cover: THE INITIATION OF THE TENDERFOOT
p. [2]: THE CHRISTMAS DINNER
p. [4]: HOLDUP OF THE OVERLAND STAGE, i.e.,
 HOLDING UP THE OVERLAND STAGE
p. [6]: THE TRIUMPH OF LAW AND ORDER, i.e.,
 DAME PROGRESS PROUDLY STANDS
recto back cover: INITIATED

74. Montana Stockgrowers Association 54th Annual Convention. Helena, May 18, 19, 20, 1938. Pp. [12], including wrappers, cut in the shape of a Stetson hat. Contains:
p. [2]: THREE HORSES' HEADS
 COWBOY STANDING, RIGHT HAND ON HIP
p. [11]: TWO MEN THROWING PACK HORSE HITCH

75. Montana Stockgrowers Association. Chuck Wagon Feed, Thursday, May 19, 1938, 7 P.M., 54th Annual Convention Montana Stockgrowers Ass'n., Shrine Temple Ballroom, Helena, Montana. Contains:
p. 2: COWBOY ON A SPREE
 FOUR COWBOYS GALLOPING
p. 3: BUCKING HORSE
 COWBOY TWIRLING LARIAT, LONGHORNS RUNNING
p. 4: THE CHRISTMAS DINNER

76. Montana Stockgrowers Association Sixty-Second Annual Convention. Great Falls, Montana, May 16, 17, 18, 1946. Pp. 8, size $9 \times 4\frac{1}{2}$, wrappers, stapled.
cover and p. [1]: [THE] COWBOY LOSES

77. Down the trail for 80 years. An old story brought up to date 1865–1945. The contribution of livestock to Montana's economy. Published and distributed by the Montana Stockgrowers Association, Helena, Montana, 1945. Pp. 14, wrappers, stapled. Size $8\frac{3}{4} \times 11\frac{3}{4}$.
p. 5: WAITING FOR A CHINOOK

78. Montana Territorial Centennial Commission. Charles M. Russell Solid Silver Medallion [9 lines] Old Governor's Mansion, 304 Ewing Street, Helena, Montana. Flyer, yellow stock, size $4 \times 8\frac{1}{2}$. LIKE A FLASH THEY TURNED on one face of the medallion, bust portrait of CMR on the other, both in bas relief.

79. Montana's Capitol Dedicated at Helena, Montana, July 4, 1902. Souvenir published by W. T. Ridgley Printing Co.
Pp. 24, folio, size $9\frac{1}{4} \times 6\frac{5}{16}$. Wrappers, stapled. Front wrapper: Montana's Capitol embossed in gold, in caps. Contains four halftones:
cover: LANDSCAPE #2*
p. [5]: PINE TREE*
p. [9]: MOUNTAIN SHEEP ON LEDGE*
p. [20]: LOG CABIN, SMOKE ISSUING FROM CHIMNEY*

80. The National Association of Soil Conservation Districts Tuesday Letter. Broadside, size $8\frac{1}{2} \times 14$. January 31, 1961. Reproduces THE TRAIL BOSS (part).

81. National Food Administration.
Save Food / Help Win the War.
Broadside, size $3\frac{3}{16} \times 5\frac{1}{2}$. Issued by Food Administration in Montana. N.d., (ca. June, 1918). Illustration, HOOVERIZIN'* and verse by CMR.
I hate to take your grub, old hoss, but then
I'm leavin meat and wheat for fightin' men;
And by your handin' in your oats to me
The both of us is Hooverizin'; see?
We're squarin' up with Uncle Sam, our friend,
Just kinder helpin' hold the easy end.

82. National Food Administration.
Save Food / Help Win the War.
Broadside, size presumably $3\frac{3}{16} \times 5\frac{1}{2}$. Issued by Food Administration in Montana. N.d., (ca. June, 1918). Illustration, MEAT MAKES FIGHTERS*. We have not seen this item, but inasmuch as we do know CMR painted two pictures for the Food Administration, we surmise that this picture was also issued in broadside form.

83. To the Stockholders of Northwest Bancorporation. Quarterly Dividend Election of Director. Montana Meeting, August 25, 1951. Folded twice to size 3×7.
THE BUFFALO HUNT, i.e., RUNNING BUFFALO

84. Order of Eastern Star. Howdy Friend, You are Cordially Invited to Our Western Roundup, Acacia Chapter No. 28, O.E.S., Washington, D.C. Tuesday, February 5, 1963. Folder, size 4×5.
cover: I'M HANGIN' ON FOR ALL THERE IS IN ME

85. Souvenir Program Parker County Frontier Days Celebration Rodeo Livestock Show, Weatherford, Texas, July 27, 28, 29, 30, 1955.
cover: THE WAR PARTY #3 (color)

86. Parker County Frontier Days. Rodeo—Livestock Show, Weatherford, Texas, July 23, 24, 25, 26, 1958. Souvenir Program 50¢.
cover: WHEN GUNS SPEAK, DEATH SETTLES DISPUTE (color)

87. Parker County Frontier Days. Rodeo—Livestock Show. Weatherford, Texas, July 29, 30, 31, Aug. 1, 1959. Souvenir Program 50¢.
cover: [A] STRENUOUS LIFE (color)

88. Parker County Frontier Days. Rodeo—Livestock Show, Weatherford, Texas, July 26, 27, 28, 29, 1961. Souvenir Program 50¢.
cover: THE INNOCENT ALLIES (color)

88.5. Formal Opening of Helena's New Hotel "The Placer" Maurice S. Weiss, Manager. Saturday, April 12, 1913. Pp. [8], folio, size $7 \times 10\frac{5}{8}$, wrappers, punched and tied. Front wrapper contains: THE PROSPECTORS #2

89. A Range Man's Library by J. C. Dykes. Author's separate reprinted from the *Journal of Range Management*, May, 1960. Pp. 8, wrappers. (A) BUNCH OF RIDERS (part) and reference to CMR books.

90. Requiem, Charles Marion Russell.
Folio. Two issues, one $5\frac{1}{2} \times 8\frac{3}{4}$ on wove paper; the other $5\frac{7}{8} \times 8\frac{3}{4}$ on calendered paper. 200 copies litho-graphed for Charles M. Russell meeting of the Denver Westerners, October 22, 1952, by H. E. Britzman.
cover: SELF-PORTRAIT #4

91. Retail Merchants' Association of Montana Souvenir Program. N.d., ca. 1959. Contains:
cover: THE FIRST FURROW

92. The Round-Up. Pendleton, Oregon, Sept. 14–15–16–17, 1927. Leaflet, folded to size $3\frac{3}{8} \times 6\frac{1}{4}$.
p. [2]: PENDLETON BUCKEROO*
p. [3]: NEZ PERCE WARRIOR*
p. [4]: PENDLETON COWGIRL*
p. [5]: PENDLETON COWBOY*

93. Sheriffs' Annual Rodeo Presented by Sheriff's Relief Association of Los Angeles County. Los Angeles Memorial Coliseum, August 23, 1953. Souvenir Program 25¢. The front cover serves as title page. Pp. 12, size 9×12, wrappers, stapled. Contains:
cover: AT THE END OF THE ROPE (printed in reverse and in part only)

94. Society of Montana Pioneers. Programme Twentieth Annual Meeting, Great Falls, Montana, October 1, 2, 3, 1903. Pp. [4], folio, size $5\frac{1}{8} \times 6\frac{3}{4}$. Contains one two-color plate.
p. [1]: AN OLD TIME STAGE COACH

95. Society of Montana Pioneers. Program Thirty Second Annual Meeting. Held at Great Falls, Montana, September 9 to 10, 1915 [4 lines]. Headquarters Rainbow Hotel. Folio, pp. [4], size $5\frac{1}{2} \times 8\frac{1}{2}$. Contains:
p. [1]: AN APACHE INDIAN

96. Society of Montana Pioneers Thirty-Fourth Annual Meeting. Livingston, September 5, 6, 7, 1917. Officers Reports and Address. Pp. [62], folio, size $6 \times 9\frac{3}{16}$. Wrappers, stapled. Words "Copyright 1918" on verso of front wrapper. Contains one halftone:
p. [13]: LEWIS AND CLARK STATUE—DESIGN BY C. M. RUSSELL*

97. Society of Montana Pioneers Thirty Seventh Annual Meeting, Great Falls, Montana, September 9 and 10, 1920. Pp. [4]. Folio, size $6\frac{1}{2} \times 10\frac{1}{2}$, wrappers, silk ribbon tie. Four-line verse under each picture by CMR from "Charley Russell's Sentiments," but the illustrations are different from those which first appeared in *Good Medicine*, p. 38. Contains 3 line engravings.
front wrap: IT USED TO BE THAT HOSSES WAS FAST ENOUGH FOR MEN

p. [1]: OLD HOOVER CAMP ON SOUTH FORK OF JUDITH RIVER*

p. [4]: BUFFALO GROUP ON KNOLL*

98. Society of Montana Pioneers 44th Annual Meeting [illustration] "The Days of Old, The Days of Gold," Missoula, August 4–5–6, 1927. Front wrapper serves as title page. Pp. [4]. Folio, size $6\frac{1}{2} \times 10$, wrappers, stapled. Contains one line engraving:

front wrap: THE PROSPECTOR

99. Society of Montana Pioneers Forty-Sixth Annual Meeting, Great Falls, August 8–9–10, 1929. Greetings [28 lines] Pp. [6]. One sheet, folded twice, to size $4\frac{1}{2} \times 10\frac{3}{4}$. Contains four line engravings:

p. [1]: THE COWBOY #2

p. [3]: THE ROAD AGENT

p. [5]: THE ROAD AGENT (vignette)

p. [6]: THE PROSPECTOR

100. Society of Montana Pioneers. 47th Annual Meeting. Billings, August 7–8–9, 1930. Program. Contains:

p. [1]: THE PROSPECTOR

p. [8]: THE COWBOY #2

101. Society of Montana Pioneers. Golden Anniversary Meeting with Sons and Daughters of Montana Pioneers, Great Falls, August 29, 30, 31, 1934. Pp. [8], size $5\frac{1}{4} \times 8\frac{1}{4}$. Contains:

back cover: STAGECOACH #2*

102. Society of Montana Pioneers. Fifty-Third Annual Meeting Society of Montana Pioneers and Society of Sons and Daughters of Montana Pioneers. Great Falls, Montana, August 19, 20, 21, 1937. Front wrapper serves as the title page. Pp. 16, folio, size $6 \times 8\frac{3}{8}$, stapled. Contains:

p. 7: THE ROAD AGENT (part)

p. 15: C. M. Russell (photo)

p. 16: FIRST ATTEMPT AT ROPING

103. Society of Montana Pioneers. Fifty-Fourth Anniversary of Society of Montana Pioneers Meeting with Sons and Daughters of Montana Pioneers [illustration] Helena, Montana, August 25, 26, 27, 1938 [1 line]. Pp. 4, folio, size 6×9, wrappers, stapled. Contains:

t. p: THE FIRST FURROW

recto back cover: THE PROSPECTORS #2

104. Society of Montana Pioneers 67th Annual Convention. Last Chance Gulch. Helena—August 22–24, 1951. Pp. [4], size $6\frac{1}{4} \times 8\frac{7}{8}$, wrappers.

cover: LAST CHANCE OR BUST (color)

105. Society of Montana Pioneers—Sons and Daughters of Montana Pioneers, 1960 Joint Conventions, Helena, August 26 and 27. Pp. [16], size $8\frac{1}{2} \times 11$, wrappers.

cover: THE SURPRISE ATTACK (color)

verso: THE BULL WHACKER

p. [3]: THE STAGE DRIVER

p. [5]: THE SCOUT #4

p. [12]: WILD MEN THAT PARKMAN KNEW

p. [13]: LAST CHANCE OR BUST

p. [15]: THE MOUNTAINS AND PLAINS SEEMED TO STIMULATE A MAN'S IMAGINATION

p. [16]: INDIANS MEET FIRST WAGON TRAIN WEST OF MISSISSIPPI

 NATURE'S CATTLE #1

recto back: THE PROSPECTOR

b. cover: WHEN HORSES TALK WAR, THERE'S SMALL CHANCE FOR PEACE (color)

106. Society of Montana Pioneers. Hail To The Pioneers, A Tribute to the Bold Men and Women who made Montana "The Treasure State." 78th Convention in conjunction with 68th Convention, Sons and Daughters of Montana Pioneers, Butte, Montana, August 23, 24, and 25, 1962. Pp. 20, size $11 \times 8\frac{1}{2}$, wrappers.

p. 8: THE WOLFER

p. 9: THE STAGE DRIVER

p. [10]: BLACKFEET SQUAW AND PAPPOOSE

p. [11]: THE PROSPECTOR

b. wrap.: THE MOUNTAINS AND PLAINS SEEMED TO STIMULATE A MAN'S IMAGINATION

107. Souvenir Program. July 4, 1919. Issued by Soldiers and Sailors Club of Cascade County. Printed by Montana Printing Co., Ford Bldg., Great Falls, Montana, Pp. 32.

cover: POWDER RIVER*

108. Souvenir of Great Falls, Montana. Published by W. T. Ridgley Printing Co. Pp. [18], folio, size $10 \times 6\frac{3}{4}$. Wrappers, dark greenish-grey in color, bearing words "Carnival Souvenir Great Falls, Montana," on right. The title page is p. [3]. There is no date on the title page. On p. [6], is the date of the carnival, July 8, 1901. Contains one halftone:

wrap.: INDIAN MOUNTED WATCHING FIRE*

109. Supreme Master of Western Art by 'Tana Mac. Reprinted from *True West*, March–April, 1959. (Butte, Montana, n.d. ca. 1966). Pp. [16], folio, size 6×9. The text is the same as that of the magazine article, but illustrations are different.

p. [1]: photo of CMR by H. C. Ecklund

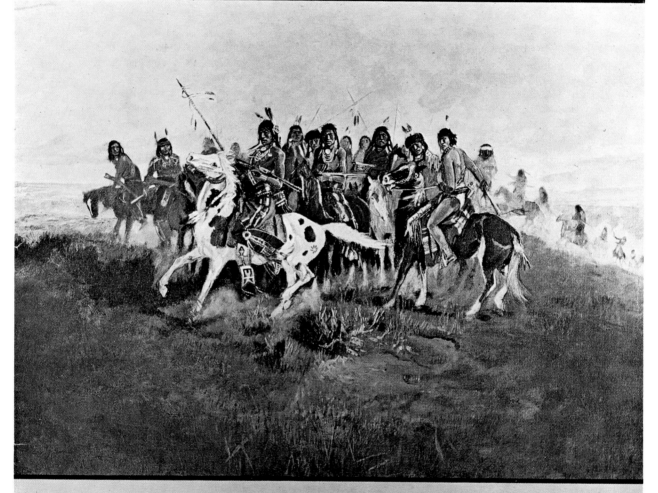

SOUVENIR PROGRAM

PARKER COUNTY
FRONTIER DAYS

CELEBRATION ★ RODEO ★ LIVESTOCK SHOW

WEATHERFORD, TEXAS
JULY 27-28-29-30, 1955

SHERIFF'S POSSE ARENA

35¢

THE WAR PARTY #3
Cover, Souvenir Program, Parker County Frontier Days.
See item 85, this section.

p. [2]: photo of CMR by H. C. Ecklund
p. [5]: CHARLES RUSSELL ON RED BIRD
p. [7]: photo of CMR in Indian dress
p. [10]: THE FIRE BOAT
p. [12]: LEWIS AND CLARK MEETING THE FLATHEAD INDIANS AT ROSS'S HOLE, i.e., LEWIS AND CLARK MEETING INDIANS AT ROSS' HOLE
p. [14]: THE ROUNDUP #2
p. [15]: INSIDE THE LODGE

110. Trailside Galleries, Dick Flood, Director. P.O. Box 1233, Idaho Falls, Idaho, 83402. Good luck. Mailing piece, buff stock, size 4 × 7¼. GOOD LUCK* in color and STUDY OF A BUFFALO SKULL on reverse.

111. The Trappers. Prepared by the State Historical Society of Colorado. Photography by Staley Studio. Copyright 1963 by the State Historical Society of Colorado, Colorado State Museum, Denver. Pp. 16, wrappers, size 5½ × 8½.
front wrap.: THE FREE TRAPPER (part)
p. [4]: BEFORE THE WHITE MAN CAME #4 (part)
p. [11]: FLATBOAT ON RIVER, FORT IN BACKGROUND

112. Tribune Leader, Great Falls, Montana, The Russells On Our Walls [23 lines]. Brochure, folded once to size 8½ × 11 (1962). Tan outer stock. Ecklund photo of CMR on back. White inner stock.
FOR SUPREMACY
THE HOLD UP
THE WAY IT USED TO BE
THE BUFFALO HUNT #3*
THE ELK
INDIANS RUNNING OFF HORSES, i.e., EARLY MONTANA, INDIANS RUNNING OFF HORSES
INDIAN WOMEN MOVING
THE PRICE OF HIS HIDE
LEWIS AND CLARK MEETING THE MANDANS, i.e., LEWIS AND CLARK MEETING THE MANDAN INDIANS
A DESPERATE STAND

113. A Tribute To Russell. Folder, issued by W. T. Ridgley Printing Works, Great Falls, Montana. Pp. 4, size 4¼ × 6, wrappers, silk cord tie, n.d. (ca. 1904). Front wrap.: ROPING A WOLF #2* (color)

114. The Trigg–C. M. Russell Foundation, Inc. Solicitation for funds. Folio, size 5⅝ × 8¹³⁄₁₆, n.d. (1951).

Enclosed in envelope with buffalo skull in upper left corner.
p. [1]: HIS HEART SLEEPS #2*
p. [2]: SKULL #1
p. [4]: SKULL #1

115. Trigg–C. M. Russell Foundation. "My Brother, when you come to my lodge, the robe will be spread and the pipe lit for you." Invitation to the formal opening of the C. M. Russell Gallery, September 26, 1953. Pp. [4], size 4⅜ × 5⅞, white stock. P. [1] has C. M. Russell facsimile signature and skull.

116. Trigg–C. M. Russell Gallery. Montana's Favorite Son. The Trigg–Russell Gallery and Original C. M. Russell Log Cabin Studio, reprinted from the *Monitor*, employee publication of the Mountain States Telephone and Telegraph Company. Sheet folded twice to size 8½ × 11. Contains same material described in the *Monitor* for March, 1962, Sec. III, *q.v.*

117. The West? There Is No More West. Card issued by Roger M. Conger, Waco, Texas, n.d. (ca. 1958), size 8½ × 6⅝.
THE MOUNTAINS AND PLAINS SEEMED TO STIMULATE A MAN'S IMAGINATION

118. Western States Extension Conference, Davenport Hotel, Spokane, Wash. May 24–27, 1937. Contains:
p. 9: THE BIG CHANGE CAME WHEN OLD CORTEZ BROUGHT HOSSES OVER

119. Official Program World Series Rodeo For the Championships of 1928. Presented by Tex Rickard, Madison Square Garden, New York. Copyright 1928 by Broad Street Hospital Rodeo Fund, 522 Fifth Avenue, New York. Pp. 64, 32mo, 8¼ × 11, wrappers, stapled. Contains article "Charlie Russell, Cowboy Genius" and autobiographical sketch of CMR on pp. 15 and 59, and one line engraving:
p. 15: COWBOY ROPING STEER*

120. Official Program World Series Rodeo for Cowboy and Cowgirl Championships of 1929. New York, Madison Square Garden, 1929. Contains:
p. 17: WAITING FOR A CHINOOK
Also contains photo of CMR.

SECTION XI

Advertisements

SECTION XI

Advertisements

1. American Indian Collection. Wallace David Coburn. (Sunland, California, n.d., ca. 1953). Pp. [8], size 5½ × 8¾. Contains, p. [3]: O GHASTLY RELIC OF DEPARTED LIFE. Also contains the "tribute to Coburn" attributed to CMR.

2. The American National Bank of Helena, Montana. Condition at the close of business March 14, 1905. Leaflet, [4] pages, size 4¼ × 5¹³⁄₁₆. Contains, cover: INDIAN HEAD #7.

3. Arizona and the West. A Quarterly Journal of History. One sheet, 8½ × 11, printed both sides, tan stock, folded twice. N.d. (1965). BUNCH OF RIDERS (part).

4. Bar X 6 Ranch, Babb, Montana. Front wrapper serves as title page. Pp. [8] plus wrappers. Quarto, size 6½ × 5⅜, stapled. N.d., but illustration dated 1925. Contains one line engraving, front wrapper: WRANGLING THE DUDES*.

5. Bausch & Lomb Life Long Binoculars, Bausch & Lomb Optical Co., Rochester, n.d. (1933). Pp. 40, size 6⅛ × 9¼, p. 34: SMOKING UP (bronze).

6. The Booster. Edited and Published by Robert J. Horton. Price Ten Cents. Issued as a Souvenir, September the sixth, nineteen hundred and nine. Copyright 1909, by Robert J. Horton. Pp. 64, folio, size 6⅝ × 7⅝. Gray wallet edge wrappers. Contains:
p. [12]: THE COMO COMPANY
p. 59: BEAR HEAD; WOLF HEAD
p. 62: THE BUFFALO HUNT #35

7. Brown & Bigelow. Tales of the Old West featuring action packed western masterpieces by the world famous cowboy artist Charles M. Russell. A series of 12 advertising throw-aways, size 9 × 15, folded off-center to size 4½ × 7¾, printed on inside with western lore, and on the outside with CMR illustrations in color, size 4½ × 3⅜, 1958.
(A) BRONC TO BREAKFAST
(THE) FIRST WAGON TRAIL
HEADS OR TAILS, i.e., THE MIXUP
IN WITHOUT KNOCKING
A LOOSE CINCH (AND A TIGHT LATIGO)
PLANNING THE ATTACK
A SERIOUS PREDICAMENT, i.e., RANGE MOTHER
SINGLE HANDED
A STRENUOUS LIFE
(THE) WAGON BOSS
WHEN HORSEFLESH COMES HIGH
WHEN SIOUX AND BLACKFOOT MEET, i.e., WHEN BLACKFEET
 AND SIOUX MEET

8. Burlington Route. Welcome to Great Falls, Montana, June 2, 1909 [illustration] The Earliest Transportation Line in Montana—1865. The Burlington Route—The Latest. 1909. Pp. [4]. Folio, size 11 × 8½, cardboard folder. P. [1]: LAST CHANCE OR BUST (color).

9. The Stampede. Big Victory & Frontier Celebration, Calgary, Alberta, Canada. August 25 to 30, 1919. Pp. [8], size 3⁵⁄₁₆ × 5⅞. Cover: CINCH 'EM COWBOY*.

10. Calgary Stampede poster. Montana Newspaper Association insert for July 7, 1919 says that the picture therein shown, A MONTANA SHOW RIDER, was done for a poster. We have not seen such a poster, but mention the possibility of such.

11. Cheely-Raban Syndicate. Back-Trailing on the Old Frontiers. A Series of Fifty-two Episodes of Dramatic ... Cheely-Raban Syndicate, Great Falls, Montana. The first Release Date is February 5th, 1922. Broadside, size 12 × 18.

12. The Cheely-Raban Syndicate, Great Falls, Montana. Advertisement for Back Trailing on The Old Frontiers. Charles M. Russell will go down in history as the greatest painter of early Western life. Pp. [4], size 9 × 11¾. N.d., ca. 1922.
p. [1]: full page portrait of Russell
p. [2]: photo, Russell in the woods
p. [3]: photo, Mrs. Russell from a snapshot
p. [4]: photo, Russell as a cowpuncher

13. The Como Company, Great Falls. Calendar issued for 1899 with illustration 5¼ × 7⅞ of three Indians, one of them standing on a horse, painting a cliff. THE COMO COMPANY*.

14. DeLuxe Editions Club. The Folio, Garden City, N.Y., December, 1936. Vol. 1, No. 5. Published exclusively for members. Pp. [8], 4to, size approximately 5 × 7. Ad for *Good Medicine*. P. [2]: WHEN I WAS A KID.

15. R. R. Donnelley & Sons Company. The Broken Rope by Charles M. Russell. Reproduced through the courtesy of the Amon G. Carter Foundation. A demonstration of color printing done at the Lakeside Press. (Chicago, n.d., 1962). Leaflet, pp. [8], size 5½ × 8½ to accompany the picture sent to Donnelley customers. Also contains, p. [7]: WILD HORSE HUNTERS #2.

16. Doubleday & Company, Inc. For Westerners Only. Here are 17 of the finest books ever published about the West that Was—and the West that is. Flyer, size 10 × 21, folded twice to 7¼ × 5, ca. 1957.
Ad for *Charles M. Russell Book*, *Good Medicine*, and *Trails Plowed Under*, printed by Doubleday, overprinted with any number of booksellers' addresses.
WATCHING THE SETTLERS
LEWIS AND CLARK MEETING INDIANS AT ROSS' HOLE
WHEN I WAS A KID
JERKED DOWN

17. ———. Now ... for every admirer and collector ... The Charles M. Russell Book by Harold McCracken. Broadside, 7 × 10, white stock, 1957. Imprinted with numerous booksellers' names. LEWIS AND CLARK MEETING INDIANS AT ROSS' HOLE.

18. ———. Ad for *Charles M. Russell Book* by Harold McCracken. Four items: (a) envelope with one illustra-

tion, AN OLD-TIME COW DOG; (b) broadside, two sizes, 13½ × 10½ and 13⅛ × 14¾, LEWIS AND CLARK MEETING INDIANS AT ROSS' HOLE; A CENTER FIRE FASHION LEADER; AH-WAH-COUS; FAWNS NUZZLING FOR DINNER (part and backwards); A CONTEST RIDER (part); (c) letter with 4 illustrations, BEST WHISHES TO THE P–C BUNCH; DROPPIN' THE HAIR HE REACHES FOR THE JEWELED HAND; LIKE A FLASH THEY TURNED; FAWNS NUZZLING FOR DINNER; and (d) reservation form, size 5 × 6, with 2 illustrations, COWPUNCHERS WERE CARELESS, HOMELESS, HARD-DRINKING MEN; THE SHELL GAME.

19. Western Life for Eastern Boys. Flying "D" Ranch, Gallatin Valley, Montana. Anceney & Child, Proprietors. There is no date on the title page. Printed by Poole Bros., Chicago, January 24, 1912. Pp. 24, folio, size 8 × 5¹³⁄₁₆. Wrappers, punched and tied. Contains one color plate, front wrap.: FLYING "D" RANCH LIFE*.

20. Garden City Publishing Co. Announcing a new DeLuxe Edition of *Good Medicine*. Memories of the Real West. Flyer, size 7⅞ × 7⅞, n.d. IF NOT FOUND IN TEN DAYS RETURN TO GREAT FALLS.

21. Garden City Publishing Co., Garden City. Announcing a New Deluxe Edition of *Good Medicine*. Flyer, size 10½ × 8½, n.d. Two CMR illustrations:
IF NOT FOUND IN TEN DAYS RETURN TO GREAT FALLS
WHERE TRACKS SPELL WAR OR MEAT

22. Gem Publishing Co., Los Angeles. *Rhymes from a Roundup Camp* by Wallace David Coburn Illustrated by Charles M. Russell. Flyer, size 5½ × 7¾, tan stock, for the 1925 edition. Has BUCKING HORSE and RIFLE, POWDER HORN AND SHOT POUCH on obverse.

23. Gem Publishing Co., 336 So. Bdwy., Los Angeles. The True History of the West Lives in This Book. Leaflet, [4] pages, size 8 × 5¼. N.d. (ca. 1925). One CMR illustration, I PULLS MY GUNS AN' CUTS DOWN ON THEM THERE TIN-HORNS, i.e., SO WITHOUT ANY ONDUE RECITATION I PULLS MY GUNS AN' CUTS DOWN ON THEM THERE TIN-HORNS.

24. A Glimpse of Great Falls, Montana [photo of the Great Falls] Souvenir Art Edition Great Falls Tribune Print. Published and copyrighted by La Feits. There is no date on the title page; probably published in 1910, judging from internal evidence. We could not find a copy in the Library of Congress. Pp. [48], size 13½ × 6¾, wrappers. Contains one line engraving, p. [47]: BRINGING HOME THE MEAT*.

FLYING "D" RANCH LIFE
Cover of advertisement for Flying "D" dude ranch.
See item 19, this section.

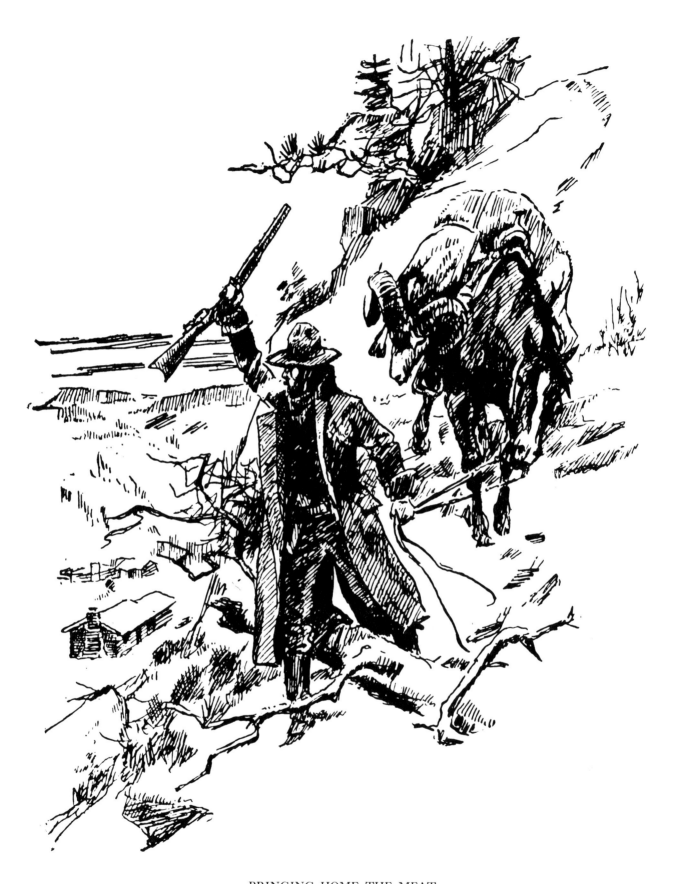

BRINGING HOME THE MEAT
W. T. Ridgley advertisement from p. [47] of *A Glimpse of Great Falls.*
See item 24, this section.
Montana Historical Society

25. C. Gotzian & Co. St. Paul, Minn. Broadside, size 7 × 10⅜. N.d., (ca. 1905). HIAWATHA'S WOOING* (color).

26. Great Falls, Montana. Historic and Scenic By The Tribune [illustration] Discovery of the Great Falls of the Missouri by Lewis and Clarke [sic] 1805. Front cover serves as title page. There is no date on the title page. Half title, p. 3, dated 1899. Pp. 78, 4to, size 12 × 15¾. Stiff pictorial wrappers. Contains:
cover: DISCOVERY OF THE GREAT FALLS OF THE MISSOURI
 BY LEWIS AND CLARKE [sic] 1805*
p. 10: COWBOY CAMP DURING THE ROUNDUP
 BREAKING CAMP #1*

27. Great Falls National Bank Financial Statement at the close of business, September 9, 1903. Leaflet, pp. [4], size 4⅜ × 5¹³⁄₁₆. Contains, cover: AN APACHE INDIAN* (color).

28. The Great Falls National Bank, A Montana Institution since 1891. Statement of condition. Great Falls 1953, 1956, 1957, 1963, and 1964. Leaflet, pp. [4], size 7½ × 7. One Russell illustration, THE JERK LINE in color on front. (The 1957, 1963, and 1964 editions also contain a broadside insert, "Story of the Jerk-Line.") Vignette from THE JERK LINE in reverse on envelope.

29. Great Northern Railway Advertising Department, St. Paul. The Blazed Trail of The Old Frontier. Leaflet, pp. [4], size 6 × 3, n.d. (ca. 1926).
MEDICINE MAN'S SKULL MASK AND TOMAHAWK
THE PRIMEVAL HOLDS THE RIGHT-OF-WAY, i.e., BUFFALO
 HOLDING UP MISSOURI RIVER STEAMBOAT
BUFFALO SKULL, SPEAR, TOMAHAWK, QUIVER

30. Great Northern's Two Great Trains, Mid-Century Empire Builder, The Streamlined Western Star. Broadside, size 16 × 16. Contains: [A] DESPERATE STAND.

31. Hammer Galleries. Russell Exhibition at the Smithsonian Institution, Washington, D.C. October 12 to November 2. Broadside, 5½ × 12, reprinted from Hammer Galleries ad in *Antiques* magazine, October, 1958. SELF-PORTRAIT #4.

32. The Happy Wonder Bakers. Ad, size 8¹¹⁄₁₆ × 4, with THE ONLY WAY TO NEGOTIATE WITH THIEVES, i.e., WHEN LAW DULLS THE EDGE OF CHANCE (color), obverse, and letterpress reverse. N.d.

33. John Hauenstein Company, Brewers and Bottlers since 1864, New Ulm, Minnesota. Broadside, size 19¾ × 28. Hauenstein's Beer, New Ulm, Minn., in circular design, upper left. THE ADVANCE GUARD (color).

34. B. Buster's First Impression of the World's Fair. Pp. [8], size 3¼ × 5¾, n.p., n.d. (ca. 1904). Advertisement for Heptol Splits at the St. Louis World's Fair. P. [1]: BUCKING MUSTANG* (pen and ink).

35. Hertzog, Carl. History of Transportation in the Early West by Charles M. Russell. Flyer, folded twice to size 3⅜ × 6¼. White, also tan, stock, brown ink. N.p., n.d. (El Paso, 1950).
[A] PONY EXPRESS RIDER ATTACKED BY INDIANS
FIRST TRANSPORTATION IN AMERICA, i.e., BEFORE THIS
 HE ONLY HAD WOLVES BROKE TO PACK OR DRAG A
 TRAVOIS
SKULL #1

36. Carl Hertzog, El Paso, Texas. Seven Drawings by Charles M. Russell. Leaflet, pp. [4], 5½ × 7, imprinted with many different booksellers' addresses.
THE PONY EXPRESS, i.e., A PONY EXPRESS RIDER ATTACKED
 BY INDIANS
SKULL #1

37. The Indian Journals, 1859–62, by Lewis Henry Morgan. Prospectus. Folio, pp. [4], size 8½ × 8, white stock with illustration of Indian in color (not by CMR). P. [3]: HIS LAST HORSE FELL FROM UNDER HIM. Oddly enough, the illustration did not appear in the published book.

38. H. J. Justin & Sons. Manufacturers of Celebrated Cowboy Boots [photo] H. J. Justin 1859–1918 [3 lines] Nacona, Texas, U.S.A. (1923). Pp. 48, wrappers. Contains, p. 16: MY HATS OFF TO YOU*. N.B. This sketch illustrated a letter dated December 28, 1921, from CMR to H. J. Justin & Sons. The letter is reproduced in facsimile in Justin Cowboy Boots, 1940–41 (see next item).

39. Dedicated to Charles M. Russell With Introduction by Will Rogers. Justin Cowboy Boots, 1940–41. The front wrapper serves as the title page. Pp. 32, folio, size 7 × 10½, wrappers, stapled. Contains 1 color plate, 9 halftones, 1 line engraving, and 11 photos:
front and back wrap: JERKED DOWN (color)
p. 3: photo of Will Rogers and Charlie Russell
pp. 3–4: A Tribute to Charles M. Russell (Will
 Rogers' Introduction to *Trails Plowed
 Under*)
p. 5: letter from CMR to H. J. Justin and Sons,
 dated Dec. 28, 1921
 MY HAT'S OFF TO YOU
p. 10: photos of CMR, of his saddle, of his home
 and studio, of CMR rolling cigarette, of
 CMR and JackDempsey, of CMR work-
 ing at his easel (THE SALUTE OF THE ROBE
 TRADE and A RODEO RIDER* on wall in
 background), one of CMR's boots

p. 11: photos: of exterior of studio, CMR perched on rail; of interior of studio; of CMR in his studio, standing before easel, painting WHEN THE LAND BELONGED TO GOD*

p. 17: WHEN SIOUX AND BLACKFEET MET, i.e., WHEN BLACKFEET AND SIOUX MEET

p. 18: IN WITHOUT KNOCKING

p. 19: FIRST WAGON TRACKS, i.e., FIRST WAGON TRAIL

p. 20: THE CINCH RING

p. 22: [A] STRENUOUS LIFE

p. 23: SERIOUS PREDICAMENT, i.e., RANGE MOTHER

p. 27: COWBOY LIFE

p. 28: THE BOLTER #3

p. 31: (A) BRONC TO BREAKFAST

40. Lazy D. Ranch, Ada, Oklahoma. We Won't Have A Buffalo Hunt At Lazy D But ... Sales folder. Quarto, pp. [8], uncut, size $7\frac{1}{2} \times 10$, 1947. P. [1]: (THE) BUFFALO HUNT (bronze).

41. The Life Saver Seat Lock Co., Minneapolis and Winnipeg. Broadside, size 17×21. N.d., (ca. 1911).
AN OLD STORY* (color)
LIFE SAVER* (color)

42. Montana—Alberta Playground Published by Montana's Radio Network The Z Bar Net [3 lines] and Montana's Pioneer in Television KXLF—TV-6, Butte. Pp. [32], size 5×8, wrappers, stapled, n.d. (ca. 1954). Contains "Charles Marion Russell (1864–1926)," by K. Ross Toole, pp. [19–21] and "Charles Russell Memorial," p. [22].
p. [19]: KEEOMA #3*
p. [20]: BRONC TO BREAKFAST

43. Montana Centennial. Visit The Old Frontier 1864–1964. Accordion folded twice to $4\frac{1}{2} \times 10$, n.d. (1963).
[THE] FREE TRAPPER (color)
photo of CMR statue by Weaver
WATCHING THE SETTLERS (color)

44. Montana Centennial Commission Celebrating a colorful century. Lyle Downing, Publicity Director, Old Governor's Mansion, Helena, Montana. Flyer, printed both sides, $8\frac{3}{8} \times 13\frac{1}{2}$. Obverse: INVOCATION TO THE SUN.

45. Montana Museums. State and National Parks and Monuments. Folder, pp. [6], yellow stock, $10\frac{3}{4} \times 9$, n.d. (ca. 1965).
A BRONC TWISTER (bronze)

TWO RIDERS, ONE LEADING A PACK HORSE
THE FREE TRAPPER

46. 1943 Annual Report The Montana Power Company, Butte. The front wrapper serves as the title page. Pp. 32, folio, size $11 \times 8\frac{1}{2}$. The President's report on pp. 24–25 is dated March 10, 1944. Contains, entirely across upper three-fourths of front wrapper, in color: BUFFALO HERDS CROSSING THE MISSOURI RIVER, i.e., WHEN THE LAND BELONGED TO GOD.

47. Montana. The Big Sky Country—1864–1964. 1963 Report to Stockholders of the Montana Power Company. Pp. 16, wrappers, size 8×11. MEN OF THE OPEN RANGE (color).

48. Montana Territorial Centennial Headquarters. Just off the press . . . "Montana: The Big Sky Country". Montana Territorial Centennial Official Book and Guide Helena, Montana, n.d. (1964). Flyer, $8\frac{1}{2} \times 11$, tan stock. IN THE ENEMY'S COUNTRY.

49. Montanarama [illustration] Historical Highlights. The front wrapper serves as the title page. There is no date on the title page. Pp. [32], folio, size $5\frac{3}{8} \times 7\frac{5}{8}$, wrappers, stapled. Prepared for and distributed by the "Montana Boosters", Box 1956, Butte, Montana, in April, 1948. Contains 2 color plates and 3 line engravings:
front cover: CHIEF* (color)
p. [1]: OUT ON THE PRAIRIE'S ROLLING PLAIN
p. [3]: COWBOY FUN, i.e., NOW HERDER, BALANCE ALL
p. [14]: HOLDING UP THE OVERLAND STAGE
back cover: AND UP FROM THE VAST SILENT STRETCH OF THE RANGE (color)

50. Thos. D. Murphy Co. The History of a Nation—The Story of a Business—Can be told by pictures [12 lines] The Thos. D. Murphy Co., Red Oak, Iowa, "The Birthplace of Art Calendars". Broadside, $8\frac{3}{4} \times 3\frac{3}{4}$, n.d., (ca. 1947). WHEN WAGON TRAILS WERE DIM.

51. Thos. D. Murphy Co., Red Oak, Iowa. Tight Dally and Loose Latigo. Reproduced from an Original Water Color [sic] Painting by Charles M. Russell. Flyer, size $5 \times 6\frac{1}{2}$. TIGHT DALLY AND (A) LOOSE LATIGO.

52. Northrup, Braslan, Goodwin Co. Northern Grown Tested Seeds 1895 [illustration] A BUCKING BRONCHO. See other side of this page for explanation and offer. Northrup, Braslan, Goodwin Co., 26, 28, 30 & 32 Hennepin Ave., Minneapolis, Minn. Copyrighted 1895

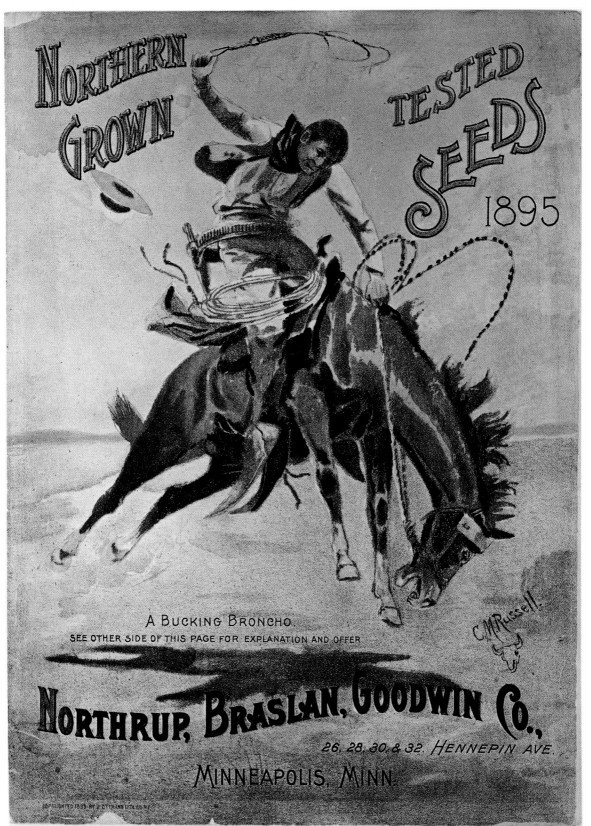

A BUCKING BRONCHO #2
Cover of Northrup seed catalog, 1895.
See item 52, this section.

by J. Ottman Lith. Co., N.Y. Front wrapper serves as title page. Pp. 80, 8vo, size $7\frac{5}{8} \times 10\frac{1}{2}$. Wrappers, stapled. Page 1 bears date January 1st, 1895. Yost has one of two known copies in his collection.

front wrap.: A BUCKING BRONCHO #2* (color)
verso front wrap.: A BUCKING BRONCHO #2 (black and white)

53. The Osborne Company 1888—Fifty Years Ago—1938. The Osborne Company, Indoor Billboards, General Offices and Works, Clifton, New Jersey. Broadside, size $31 \times 42\frac{1}{2}$. Issued in conjunction with letterpress broadside.
THE PRICE OF HIS ROBE, i.e., THE PRICE OF HIS HIDE
THE SLICK EAR
WHEN (i.e., WHERE) TRACKS SPELL MEAT
WAITING FOR A CHINOOK
WHEN SHADOWS HINT DEATH
CHARLIE IN ACTION, i.e., RUSSELL RIDES REAL OUTLAW

54. The Osborne Company. Montage, broadside, size $20\frac{3}{4} \times 27$, on heavy calendar stock with gold background, n.d. (ca. 1938). Contains:
THE PRICE OF HIS HIDE
THE SLICK EAR
WHEN (i.e., WHERE) TRACKS SPELL MEAT
WHEN SHADOWS HINT DEATH
WAITING FOR A CHINOOK
CMR on a horse (touched-up photo)

55. The Osborne Company. Featured in the Sixtieth Anniversary Osborne Line. Winning of the West by Charles M. Russell. An exclusive Osborne Art Blotter series. Published by The Osborne Company, First and finest name in friendly advertising 1888–1948, Clifton, New Jersey. This is a sample of X4 "Winning of the West" Blotter—B177–628. Blotters, size $9\frac{1}{8} \times 3\frac{7}{8}$. (1948). Each blotter bears foregoing text, with following color plates (there were also blotters issued without text):
WHEN HORSES TURN BACK THERE'S DANGER AHEAD
THE PIPE OF PEACE, i.e., WILD MAN'S TRUCE
WHEN THE NOSE OF A HORSE BEATS THE EYES OF A MAN
WHO KILLED THE BEAR, i.e., THE PRICE OF HIS HIDE
MEAT'S NOT MEAT 'TIL IT'S (i.e., TILL ITS) IN THE PAN
(THE) CALL OF THE LAW
THE WARNING SHADOWS, i.e., WHEN SHADOWS HINT DEATH
LOOPS AND SWIFT HORSES ARE SURER THAN LEAD
[THE] RED MAN'S WIRELESS
WHOSE MEAT?
THE SLICK EAR
WHEN (i.e., WHERE) TRACKS SPELL MEAT

56. Pacific Northwest Broadcasters. Future Unlimited. "Booster" pamphlet issued by The Pacific Northwest Broadcasters. Front wrapper serves as title page. N.p., n.d., (Butte, ca. 1945). Pp. [16]. Folio, size $11\frac{3}{4} \times 8\frac{3}{4}$. P. [1]: BLACKFEET BURNING CROW BUFFALO RANGE (color).

57. Pacific Northwest Playground. The Scenic Wonderland of the World Welcomes You. Pp. 48. Butte, 1950.
cover: SMOKING UP (bronze)
inside front cover: THE PICTURE ROBE
HOLDING UP THE OVERLAND STAGE
STEER (plaster replica)
THE BUFFALO (bronze)
p. 2: SMOKING UP (bronze)

58. Park Saddle Horse Company. General Address: Kalispell, Montana. Glacier National Park, Montana. Calendar for the year 1926. Size $8 \times 10\frac{5}{8}$, folded on muslin strip at center. Top half bears: WRANGLING THE DUDES.

59. 1952 calendar with reproductions of selected paintings from the famous Frank Phillips Woolaroc Museum and best wishes from your Phillips 66 Dealer.
WHEN BUFFALO WERE PLENTIFUL
RETURN FROM THE HUNT*
RUNNING BUFFALO

60. Previews Incorporated. No. 90041. Kootenai Lodge, Swan Lake, Big Fork, Montana. P. [3]: KOOTENAI CAMP ON SWAN LAKE.

61. G. P. Putnam's Sons. Fifteen Thousand Miles by Stage [3 lines] By Carrie Adell Strahorn [6 lines] New York. G. P. Putnam's Sons. London. Prospectus. Folio, pp. [4], size $5\frac{1}{2} \times 8\frac{1}{2}$, yellow stock with red and black print. (1911).
p. [1]: THEN THE CALDWELLITES CHARTERED THE STAGE AND WENT HOME
COWBOY, HAND IN WAISTBAND
p. [2]: INDIAN MOUNTED #2
LORDS OF THE YELLOWSTONE (part)
TYPICAL HOME STAGE STATION
p. [3]: BLANKET INDIAN*
TWO MEN MOUNTED, WITH THREE PACK PONIES
p. [4]: THAT DAMN THING AHEAD OF US IS A BEAR

62. Randall Drug Company, Great Falls, Montana. "Rhymes from a Round-up Camp" by W. D. Coburn. Realistic Western Poems by a Western Man. Flyer, folded once to size $3\frac{9}{16} \times 5\frac{3}{4}$, n.d. (ca. 1899). Contains:
O GHASTLY RELIC OF DEPARTED LIFE.

63. W. T. Ridgley Printing Co., Great Falls, Montana. Pen Sketches by Chas. Russell, The Cowboy Artist. Mailing piece, cream stock, size $4\frac{3}{4} \times 8\frac{15}{16}$ (1899).
Charles M. Russell (photo)
THE LAST OF THE BUFFALO

64. Merry Christmas from Robinson's (Department store catalog). N.p., n.d. (Los Angeles, 1964). P. 30:
LEWIS AND CLARK MEETING INDIANS AT ROSS' HOLE.

65. Sage Books Published by Alan Swallow, Publisher, Denver, Spring–Summer, 1964. Catalog, pp. [20], size 4×8. Contains, p. [2]: WAGON BOSS.

66. Southwest National Bank. Full service banking in a traditional atmosphere. (Wichita, Kansas, 1965).
p. [2]: VAQUEROS OF OLD CALIFORNIA
 SMOKING CATTLE OUT OF THE BREAKS
 INDIAN BUFFALO HUNT
 BUFFALO MIGRATION
 TRAILING

67. The Stackpole Company. Harrisburg, Pennsylvania. Announcing . . . Sixguns by Keith. Prospectus, pp. [32], size $5\frac{3}{4} \times 9$, n.d. (1955). SMOKE OF A FORTY FIVE.

68. All Montanans and Tourists are hearing about the Charles M. Russell special painting offer when they !! "Fill-er-up" at your Union 76 Station. Flyer for dealers, size $9\frac{5}{8} \times 6\frac{1}{2}$, n.d. (1964).
COWBOYS ROPING A WOLF
LEWIS AND CLARK MEETING INDIANS AT ROSS' HOLE
SCOUTING THE CAMP
INTRUDERS

69. Free your choice *free* when you fill-er-up Russell prints at your Union 76 Station. Flyer for customers, size $6\frac{1}{4} \times 4$, n.d. (1964). COWBOYS ROPING A WOLF.

70. Your customers and tourists are hearing about the Charles M. Russell Special Painting Offer when they!! "Fill-er-up" at your Union 76 Station. Flyer to dealers, size $9\frac{5}{8} \times 6\frac{3}{4}$, n.d. (1965).
INDIAN SCOUTING PARTY #1
SMOKE SIGNAL #1

THE ATTACK #3
BUFFALO HUNT #4

71. Russell Print Promotion Begins Monday, August 1! Boost your gallonage! Flyer to dealers, size $11 \times 8\frac{1}{2}$. (Union Oil Company, 1966).
BRONC TO BREAKFAST
ON THE WARPATH #2
INDIANS DISCOVERING LEWIS & CLARK
THE HERD QUITTER

72. University of Oklahoma Press Fall Books 1963. Pp. 32, wrappers, size 6×9. Front wrapper: JERKED DOWN.

73. University of Texas Press. Charles M. Russell Paintings, Drawings, and Sculpture in the Amon G. Carter Collection. A descriptive catalogue by Frederic G. Renner. Prospectus. Folio, pp. [4], size $11\frac{1}{4} \times 8\frac{5}{8}$, white stock (1966).
p. [1]: LOST IN A SNOW STORM—WE ARE FRIENDS (color)
p. [3]: A DESPERATE STAND (color)
p. [4]: LOOPS AND SWIFT HORSES ARE SURER THAN LEAD (color)

74. Catalog No. 30 Visalia Stock Saddle Co. Copyright, 1934. San Francisco, Cal., 2117–2123 Market St. Front wrapper serves as title page. Pp. 120, 16mo, size $6\frac{3}{4} \times 8$. Wrappers, stapled. Contains 1 line engraving, 3 halftones, and photo, in that order:
p. 74: MY HAT'S OFF TO YOU
p. 120: THE BOLTER #3
 (A) BRONC TO BREAKFAST
 COWBOY LIFE
 photo of Charles M. Russell

75. Western Air Line, Inc. 1964 Annual Report. P. 2: Photo of Charles M. Russell Memorial Conference Room with THE JERK LINE; LAUGH KILLS LONESOME; INDIAN HUNTERS' RETURN; FREE TRAPPERS; (others indiscernible) in background.

76. Yale University Press. Prospectus of "Yellowstone Kelly." Folder, pp. [4], size 6×9, n.d. (ca. 1926). P. [2]: KELLY'S DUEL WITH TWO SIOUX WARRIORS, i.e., KELLY'S DUEL WITH SIOUX INDIANS.

Montana Historical Society

Montana Historical Society

This section contains material issued by the Montana Historical Society which cannot easily be classified in other sections, although Montana Historical Society items will be found in Section II, Gallery Catalogs; Section IX, Christmas Cards; Section XIV, Stationery and Letterheads; and Section XVI, Appearances.

1. Announcing: For readers of Northwest Americana —One of the Most Important Books to be Published this Year. Flyer, folded, size $3\frac{1}{2} \times 8\frac{1}{2}$. Two CMR illustrations:

THE FREE TRAPPER

IDAHO OX-TEAMS WERE BRINGING IN 6,000,000 POUNDS OF FREIGHT ANNUALLY

2. Another fascinating western bronze fashioned by the magic of C M Russell greatest of the cowboy artists through the auspices of the Montana Historical Society 1963–1964. Brochure, quarto, $8\frac{3}{8} \times 11$, white stock.

p. [1]: XT BAR LONGHORN (bronze)
 TRAIL DRIVERS WATCHING HERD
p. [4]: THE TRAIL BOSS
 A GRAY HOUND WARING HORNES
p. [5]: XT BAR LONGHORN (bronze)
 THE COWBOY LOSES
p. [8]: AT THE END OF THE ROPE
 SPREAD-EAGLED

Contained within protective folder captioned "The West Immortalized in Bronze by Charles M. Russell." Size $8\frac{1}{2} \times 11$, bronze stock, containing:

A BRONC TWISTER (bronze)
MONTANA MOTHER (bronze)
BLACKFEET (i.e., BLACKFOOT) WAR CHIEF (bronze)
PIEGAN BRAVE (bronze)

3. Another fascinating western bronze fashioned by the magic of C. M. Russell greatest of the cowboy artists through the auspices of the Montana Historical Society 1964–1965. Inspired by the great collection in the famed Charles M. Russell Room. Quarto, size $8\frac{1}{2} \times 11$, white stock.

p. [1]: GRIZZLY BEAR (model)
 Charles M. Russell Room (photo)
p. [4]: TWO MEN LOADING PACK HORSE, SADDLE HORSES NEARBY
p. [5]: TWO RIDERS, ONE LEADING A PACK HORSE
p. [8]: GOING GRIZZLY, i.e., GRIZZLY BEAR (bronze)
 OLD-MAN AND HIS NEW WEAPONS (part)

4. Another fascinating western bronze fashioned by the magic of C. M. Russell greatest of the cowboy artists through the auspices of the Montana Historical Society 1964–1965. Inspired by the great collection in the famed Charles M. Russell Room. Quarto, size $8\frac{1}{2} \times 11$, white stock.

p. [1]: NATURE'S PEOPLE (bronze)
 Charles M. Russell Room (photo)
p. [4]: NATURE'S PEOPLE* (model)
 A HERD OF ANTELOPE SCENTING DANGER
p. [5]: NATURE'S PEOPLE (bronze)
p. [8]: NATURE'S PEOPLE (bronze)

5. Another fascinating western bronze fashioned by the magic of C. M. Russell greatest of the cowboy artists through the auspices of the Montana Historical Society 1964–1965. Inspired by the great collection in the famed Charles M. Russell Room. Quarto, size $8\frac{1}{2} \times 11$, white stock.

p. [1]: BUFFALO BULL (bronze)
 Charles M. Russell Room (photo)

p. [4]: EARLY DAY WHITE BUFFALO HUNTERS
p. [5]: BUFFALO BULL (bronze)
 BUFFALO BULL (bronze)
p. [8]: INDIAN BUFFALO HUNT
 BUFFALO AT CASCADE* (pencil)

6. Are you scouting for adventure and romance, hall-mark of the most amazing, robust and thrilling period of American history? Flyer, 9×7, RUNNING BUFFALO (before repainting by CMR) and TOLL COLLECTORS in color on reverse.

7. As Exciting as the Discovery of the Mother Lode ... Mailing folder, folio, size $8 \times 6\frac{7}{8}$, n.d. (ca. 1956).
cover: WATCHING THE SETTLERS (color)
p. [3]: TOLL COLLECTORS
 WHEN COWS WERE WILD

8. Authentic C. M. Russell Bronzes Offered by the Historical Society of Montana. 1962–1963. Broadside, size $8\frac{1}{2} \times 11$. Skull (not by CMR) and facsimile signature.

9. Belatedly, We Strike The Mother Lode ... an invaluable index to western history. Broadside, size $7 \times 7\frac{1}{2}$, blue ink, n.d. (1961). FINDING THE GOLD THAT MADE VIRGINIA CITY FAMOUS.

10. The Best Of the Exciting Old West. Mailing folder, [4] pages, size $7 \times 5\frac{1}{2}$, n.d., with perforated reply card. Three CMR illustrations:
p. [1]: CHARLES M. RUSSELL AND HIS FRIENDS (color)
p. [2]: THE ROUNDUP #2
p. [3]: IN THE ENEMY COUNTRY (part)

11. The Best of The Old West. Folder, with perforated reply card, $6 \times 7\frac{3}{4}$, n.d. Three CMR illustrations:
INDIAN HUNTERS' RETURN (color)
THE ROUNDUP #2
MEN OF THE OPEN RANGE

12. The Best of the Old West ... Flyer, $7\frac{11}{16} \times 5\frac{7}{8}$, white stock. THE ROUNDUP #2 and TOLL COLLECTORS in color on reverse.

13. The Best of the Old West ... Flyer, $6\frac{1}{4} \times 5$, white stock. TOLL COLLECTORS in color on reverse.

14. The Best Recorded Western Music of the Year. Eight thrilling songs of the old west. Broadside, size $8\frac{1}{2} \times 7\frac{3}{4}$, white stock, violet ink, n.d. (ca. 1962). Four CMR illustrations:

CHARLES M. RUSSELL AND HIS FRIENDS
LAUGH KILLS LONESOME
THE LAST OF 5000
BRONC TO BREAKFAST

15. Biennial Report, July 1, 1966, Montana Historical Society. Pp. 54, plastic ring binder. Cover: THE FIREBOAT (part) (color).

16. The Blackfeet were Deathly Serious ... Flyer, $6 \times 3\frac{3}{8}$, white stock, brown ink. N.d., ca. 1962. BATTLE BETWEEN CROWS AND BLACKFEET and WHEN COWS WERE WILD on reverse.

17. Books that create two of western history's complete chapters ... Remarkable new records ... the great Cowboy Artist and his work is immortalized by song and music. Folder, size 4×10, n.d.

18. Centennial Medallion will honor the Cowboy Artist. Broadside, size $7\frac{1}{2} \times 10\frac{1}{2}$, white stock, red and black ink. Depiction of both faces of medal in upper left corner. LIKE A FLASH THEY TURNED.

19. Certificate of Authenticity. Engraved stock, size $11 \times 8\frac{1}{2}$, with flap attached. July 1, 1958.
THE SLED MAN* (bronze)
MALEMUTE* (bronze)

20. Certificate of Authenticity. Engraved stock, size $11 \times 8\frac{1}{2}$, with flap attached. May 17, 1960. THE THOROUGHBRED (bronze)

21. Certificate of Authenticity. Engraved stock, size $11 \times 8\frac{1}{2}$, with flap attached. May 8, 1961. SIGN TALK* (bronze).

22. C. M. Russell. Three-paragraph essay by Michael Stephen Kennedy. Broadside, size 6×8, white stock, n.d. (1959).

23. C. M. Russell Colored Slides from the Collection of Historical Society of Montana. Flyer, size 8×10, n.d. (ca. 1961).

24. C. M. Russell Stationery. Broadside, size $7\frac{1}{2} \times 3\frac{1}{4}$, white stock, with caption printed in red. WHEN COWS WERE WILD.

25. Charles M. Russell (1864–1926). Historical Society of Montana, Helena, Montana. Folio, size $8\frac{1}{2} \times 11\frac{1}{4}$.
p. 1: JERKED DOWN
 THE CAMP COOK'S TROUBLE(S)
 THE DOUBTFUL VISITOR, i.e., A PRAIRIE SCHOONER CROSSING THE PLAINS

THE ROUNDUP #2
LEWIS AND CLARK MEETING THE FLATHEADS, i.e.,
LEWIS AND CLARK MEETING INDIANS AT ROSS'
HOLE
p. 2: [THE] SALUTE OF THE ROBE TRADE
WAGON BOSS
WHERE GUNS WERE THEIR PASSPORTS
THE (i.e., A) STRENUOUS LIFE
A BAD ONE
p. 3: [THE] BELL MARE
DISCOVERY OF LAST CHANCE GULCH, i.e., PAY DIRT
LAUGH KILLS LONESOME
Another issue with addition of TOLL COLLECTORS on
p. 3.

26. Charles M. Russell Christmas and Western Notes.
Broadside, size 7 × 10, n.d., ca. 1954.

27. Charles M. Russell Watercolors of the Old West.
A Magnificent Portfolio of Water Colors of The Old
West. Montana, n.d., ca. 1958. Flyer, size 7½ × 10½.
Reproduction of IL BE THAIR WITH THE REST OF THE
REPS.

28. Charles M. Russell. Portraits of the Old West. Six
Reproductions in Full Color Ready For Framing.
Flyer, size 7¼ × 11. N.d., ca. 1959.
obverse: CHARLES M. RUSSELL AND HIS FRIENDS
IL BE THAIR WITH THE REST OF THE REPS
reverse: LAUGH KILLS LONESOME
C. M. (i.e., CHARLES M.) RUSSELL AND HIS
FRIENDS

29. Charles M. Russell. Portraits of the Old West. Six
Reproductions in Full Color Ready For Framing.
Flyer, size 8½ × 11. N.d.
obverse: CHARLES M. RUSSELL AND HIS FRIENDS
IL BE THAIR WITH THE REST OF THE REPS
reverse: five small pieces.

30. Charles M. Russell Art Reprints Offered Ex-
clusively by The Historical Society of Montana. N.d.,
ca. 1954. Broadside, 7½ × 10½. LEWIS AND CLARK
MEETING THE FLATHEADS AT ROSS' FORK, i.e., LEWIS AND
CLARK MEETING INDIANS AT ROSS' HOLE.
Another version, flyer, size 8½ × 11. LEWIS AND CLARK
MEETING INDIANS AT ROSS' HOLE.
Another version, 8½ × 11, with THE MOUNTAINS AND
PLAINS SEEMED TO STIMULATE A MAN'S IMAGINATION.
Another version, 8½ × 11, without illustration.

31. Charles M. Russell Art Reprints Offered By The
Historical Society of Montana. N.d., ca. 1959. Flyer,
size 8½ × 11, yellow stock. THE ROUNDUP #2.

32. Charles M. Russell Superb Full-Color Art Re-
productions. Flyer, size 8 × 10, n.d. (ca. 1961).
Obverse: RIDERS OF THE OPEN RANGE, i.e., MEN OF THE
OPEN RANGE
Reverse: [THE] TRAIL BOSS

33. The Charles M. Russell Room Featuring the
Collection of Malcolm S. Mackay. Historical Society
of Montana. Veterans and Pioneers Memorial Building.
State Capitol Ground, Helena, Montana. Flyer,
pp. [6], size 6 × 9½, white stock, brown ink, n.d.
(ca. 1960). P. [1]: I'M SCAREDER OF HIM THAN I AM OF
THE INJUNS.

34. Charles Marion Russell, 1864–1926. By K. Ross
Toole, Ph.D., Montana Historian. Broadside, white
stock, red ink, size 8 × 10, 1959.

35. Charles Marion Russell. Reproduces photo of
CMR, biographical sketch and one paragraph referring
to use of JERKED DOWN on postage stamp. Broadside,
white stock, size 5¼ × 6¾ (1964). Some copies of this
item have JERKED DOWN stamp and Range Conservation
stamp pasted to top corners.

36. Charles Marion Russell—Artist—Illustrator—
Writer. Folio, [4] pages, size 8¼ × 8¾, n.d. (ca. 1958).
Contains "A Brief Commentary by Old Friends,"
"Russell, Artist or Illustrator?" by K. Ross Toole,
and "C M R He-Man Artist of a Raw-Boned Era" by
Michael Kennedy. Cover: THE ROUNDUP #2 (color).

37. Charley Russell's Masterpiece can now be yours
to see and enjoy. Broadside, size 9 × 11½, pink stock,
n.d. (ca. 1960). LEWIS AND CLARK MEETING INDIANS AT
ROSS' HOLE and THE COWBOY #2.

38. Charlie Russell's Magnificent Blackfoot War
Chief. Flyer, six pages folded to size 3¾ × 6 with flap on
left, n.d. (1961). White stock, red, green, blue and
yellow ink.
flap: BLACKFEET WARRIOR (part)
pp. [2–3]: BLACKFOOT WAR CHIEF* (bronze)
STEALING HORSES, i.e., STOLEN HORSES #1
pp. [4–5]: STOLEN HORSES #1 (color)

39. Collectors Snapping Up Limited Number of Huge
Master Portfolios of Art. Flyer, size 8½ × 5. N.d.
(1965). WHEN COWS WERE WILD.

40. The Color, Vitality, Excitement, and Adventure of
the Old West is Now Yours to See, Read, and Enjoy.
Folder, with perforated reply card, size 5½ × 7, n.d.
(ca. 1956).

cover: THE HERD QUITTER (color)
p. [2]: LEWIS AND CLARK MEETING INDIANS AT ROSS' HOLE
p. [3]: THE HERD QUITTER

41. Commemorating the Century of Charlie Russell. Broadside, folded to size $3\frac{3}{8} \times 6\frac{1}{4}$, issued by Montana Historical Society for insertion in First Day Cover. (1964). Reproduces:
Will Rogers and Charlie Russell (photo)
Russell with Indians at Calgary (photo)
LEWIS AND CLARK MEETING INDIANS AT ROSS' HOLE
BULL ELK
INDIAN TOMAHAWK PIPE AND MEDICINE
INDIAN MOUNTED CONFRONTING WHITE MAN MOUNTED
A HERD OF ANTELOPE SCENTING DANGER

42. Cowboys and Cattlemen, A Roundup from Montana, The Magazine of Western History, Selected and Edited by Michael S. Kennedy. Single sheet, flyer, printed both sides, size $7\frac{5}{8} \times 10\frac{1}{2}$. THE HERD QUITTER (color).

43. 8 MM Full Color Movies. Seven different subjects from which to choose. Mailing piece, white stock, folded twice to $8\frac{1}{4} \times 5\frac{1}{2}$, n.d. (October, 1964).
LIKE A FLASH THEY TURNED
CHRISTMAS AT LINE CAMP
FREE TRAPPERS
INDIAN HUNTERS' RETURN
JERKED DOWN
WHEN COWS WERE WILD
WAITING WARRIOR
AMERICA'S FIRST PRINTER
INSIDE THE LODGE
IN THE ENEMY'S COUNTRY
Advertises movies, medallions, Christmas cards, lithographs, *Montana Magazine*, coloring set, etc.

44. Exciting New Russell Bronze Now Available to Collectors. Flyer, size $8\frac{1}{2} \times 5$, white stock. August 15, 1965. ME HAPPY (bronze).

45. Exclusive Commemorative Permit to World Premier "Last Chance Gulch" Helena, Montana. Presentation by Governor Tim Babcock, at a special luncheon, 12 o'clock noon, March 30, 1964. Jorgenson's Holiday Inn, Helena. Price $2.00. Auspices of the Montana Historical Society. Broadside, yellow stock, size 9×4. Contains:
STEVE MARSHLAND WAS HANGED BY VIGILANTES
PANNING FOR GOLD, i.e., PLACER MINERS PROSPECTING NEW STRIKE

46. Fascinating Frontier Books distributed exclusively by West-Press, the historical society of Montana. Broadside, size $3\frac{3}{8} \times 8\frac{3}{4}$, n.d. (ca. 1959). A TEXAS TRAIL HERD at top and THE CHIEF FIRED AT THE PINTO #2 at bottom.
Another version, size $3\frac{3}{4} \times 8\frac{3}{4}$. At top, COMING TO CAMP AT THE MOUTH OF SUN RIVER, and at bottom, THE MOUNTAINS AND PLAINS SEEMED TO STIMULATE A MAN'S IMAGINATION.
Another version, size $3\frac{3}{8} \times 8\frac{3}{4}$. At top, A MANDAN VILLAGE, and at bottom, THE CHIEF FIRED AT THE PINTO #2.

47. A Find of Major Importance—An Indian Figure by Charles Marion Russell. Broadside, folded twice to 5×7 (1965). ME HAPPY* (bronze) (color).

48. First Edition, Exclusive Christmas Gifts With a Distinctive Western Flavor! C. M. Russell Stationery and Note Paper. Flyer, size $8\frac{3}{8} \times 10\frac{7}{8}$, white stock (1962).
obverse: THE INTRUDERS
NATURE'S SOLDIERS
WHEN COWS WERE WILD
SQUAW TRAVOIS
SCOUTING THE CAMP*
A PAIR OF OUTLAWS, i.e., I'M SCAREDER OF HIM THAN I AM OF THE INJUNS
IL BE THAIR WITH THE REST OF THE REPS
reverse: BEST WISHES FOR YOUR CHRISTMAS
MAY YOUR DAYS BE BETTER
THE THREE KINGS
CHRISTMAS MEAT
CHRISTMAS AT LINE CAMP
DEER AT WATERHOLE*
CHRISTMAS RANCH PARTY 1880, i.e., GOING TO A CHRISTMAS RANCH PARTY IN THE 1880s

49. The Following Volumes of Montana the magazine of Western History Have Been Beautifully Bound For Your Personal Library. Flyer, accordion folded twice to $4 \times 8\frac{7}{8}$, n.d. (ca. 1963).
cover: CHARLES M. RUSSELL AND HIS FRIENDS (color)
LAUGH KILLS LONESOME (color)
WHEN THE LAND BELONGED TO GOD (color)
p. [2]: INDIANS DISCOVERING LEWIS AND CLARK
p. [3]: THE FREE TRADER
TRAIL OF THE WHITE MAN
XMAS WHERE WOMEN ARE FEW
This also appears in a slightly different form with wording "Is Your Collection of Back Issues Complete?"

50. For . . . The Coin Buff a beautiful Medallion designed to be a show piece in any coin collection.

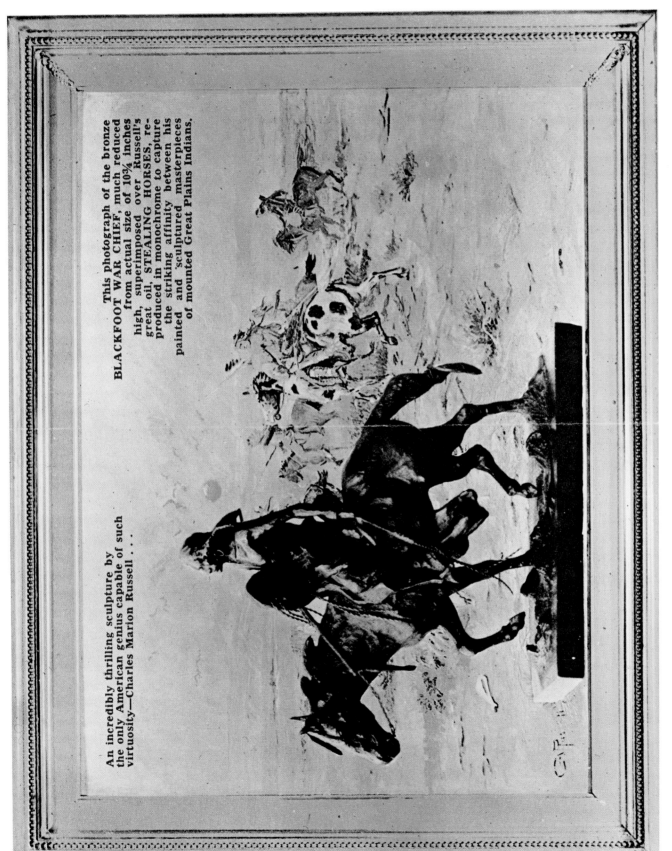

An incredibly thrilling sculpture by the only American genius capable of such virtuosity—Charles Marion Russell . . .

This photograph of the bronze BLACKFOOT WAR CHIEF, much reduced from actual size of 10¾ inches high, superimposed over Russell's great oil, STEALING HORSES, reproduced in monochrome to capture the striking affinity between his painted and sculptured masterpieces of mounted Great Plains Indians.

Advertisement of Montana Historical Society showing BLACKFOOT WAR CHIEF (bronze), overprinted on STOLEN HORSES #1.

See item 38, this section.

Broadside, $5\frac{3}{4} \times 10\frac{3}{8}$, white stock, n.d. (1964). One face of the medallion reproduces YES—THE MICE-PEOPLE ALWAYS MAKE THEIR NESTS IN THE HEADS OF THE DEAD BUFFALO-PEOPLE.

51. For Your Library . . . Bound Volumes of Montana the magazine of Western History. Flyer, size 16×8, accordion folded thrice to size 4×8, white stock, blue, black and red ink (1964).
cover: CHARLES M. RUSSELL AND HIS FRIENDS (color)
 LAUGH KILLS LONESOME (color)
 WHEN THE LAND BELONGED TO GOD (color)
p. [2]: INDIANS DISCOVERING LEWIS AND CLARK
p. [3]: THE FREE TRADER
 TRAIL OF THE WHITE MAN
 XMAS WHERE WOMEN ARE FEW

52. Free Grass to Fences. Flyer, size $7\frac{1}{4} \times 10$, n.d. (1960), white stock, brown ink. One CMR illustration, WHEN COWS WERE WILD.

53. Free Grass to Fences. The Montana Cattle Range Story by Robert H. Fletcher. Flyer, size $7\frac{1}{4} \times 8\frac{3}{4}$, n.d. (1960). THE ROUNDUP #2 (part).

54. Free Grass to Fences. Flyer, size $8\frac{3}{4} \times 10\frac{1}{4}$. Two CMR illustrations:
THE ROUNDUP #2 (part) (color)
IL BE THAIR WITH THE REST OF THE REPS

55. From the First Furrows of Old West Americana. Broadside, size $7\frac{1}{4} \times 10\frac{1}{4}$, n.d., ca. 1957. Reproductions of:
THE FIRST FURROW
WAITING FOR A CHINOOK

56. Frontier Omnibus. Kennedy Announces the Best Western Book of the Year. Folio, $8\frac{3}{4} \times 11\frac{1}{2}$, n.d., ca. 1962.
p. [1]: FREE TRAPPER (color) (also p. [4])
p. [2]: ANNIHILATION OF FETTERMAN'S COMMAND
 THEY'RE ALL PLUMB HOG WILD (part)
 OLD MAN SAW A CRANE FLYING OVER THE LAND
 (part)
p. [3]: HIS LAST HORSE FELL FROM UNDER HIM
 BUFFALO HOLDING UP MISSOURI RIVER STEAMBOAT
 TWO RIDERS, ONE LEADING A PACKHORSE
 FIRST AMERICAN NEWS WRITER (part)

57. Gold! Leaflet, pp. [4], yellow stock, size $5\frac{1}{4} \times 8\frac{1}{2}$. n.d., (ca. 1956). P. [1]: PAY DIRT.

58. A Good Thing About History . . . Its Never Outdated. Flyer, size $7\frac{1}{2} \times 10\frac{1}{2}$. Advertisement for back issues of *Montana, The Magazine of History*, some containing articles about Russell. Historical Society of Montana, Helena, n.d.

59. Goodbye Old Pard! *Montana Magazine* flyer, size $6 \times 3\frac{3}{8}$, white stock, edged in black, n.d. (1963).
obverse: O GHASTLY RELIC OF DEPARTED LIFE
reverse: WHEN COWS WERE WILD

60. Hawks and Doves in the Nez Perce War of 1877. Personal Recollections of Eugene Tallmadge Wilson. Review and Interpretation by Eugene Edward Wilson. Published by The Montana Historical Society in association with The Eugene E. Wilson Collection, U.S. Naval Academy Library (Helena, 1966). Pp. 20, wraps.
p. 8: SCOUTING AN ENEMY CAMP
p. 9: A HORSE-STEALING RAID

61. The Heart of Montana's History and Art. Broadside issued by the Historical Society of Montana. Size $9\frac{1}{4} \times 5\frac{1}{2}$, n.d., ca. 1950. Mentions "Ninety original paintings, bronzes, and other magnificent works of Russell's" on display.

62. Here's Your 1961 Mother Load [*sic*] of Western Book Treasures. Back Order Department, Historical Society of Montana. Broadside, size $7\frac{1}{2} \times 10\frac{1}{2}$. (1962).
THE ROUNDUP #2
SINGLE HANDED

63. The Historical Society of Montana Announces . . . Business reply card mailing piece, size $8\frac{1}{2} \times 3\frac{3}{4}$ (ca. 1962). Three illustrations by Russell:
YORK (color)
THE TRAPPER (part)
XMAS WHERE WOMEN ARE FEW

64. The Historical Society of Montana Takes Great Pride in Announcing . . . Folder, size 10×8, white stock, brown ink, n.d. (ca. 1959). P. [3]: GLACIER PARK GRIZZLY* (bronze).

65. The Historical Society of Montana takes great pride in announcing . . . Folder, folio, size 10×8, tan stock, n.d. (ca. 1959). P. [3]: SITTING BEAR* (bronze).

66. Intruders. Folder, size 6×4, n.d., bearing illustration INTRUDERS in color on front, and title of illustration and three-line description printed on back.

67. An invitation to share excitement, adventure . . . Broadside, size $8\frac{1}{2} \times 3\frac{1}{2}$. RAWHIDE RAWLINS, MOUNTED.

68. It's Time to order for Christmas. The Historical Society of Montana Has: C. M. Russell Prints, Authentic Western Books, Western and Christmas Notes, Russell and Museum Colored Slides. Flyer, black and red ink, size 7 × 10, n.d. (ca. 1962).

69. A Juvenile Book on the Famous Western Artist, C M Russell by Shannon Garst. Flyer, size 8 × 10, n.d. (1960).

70. Last Chance Bronzes. Broadside, size $7\frac{1}{2} \times 3\frac{1}{4}$, pink stock, red and black ink. A BRONC TWISTER (bronze) on right.

71. A Magnificent Portfolio of C. M. Russell's Oils. Flyer, size $8\frac{1}{2} \times 11$, n.d. (ca. 1958). Reproductions of:
CHARLES M. RUSSELL AND HIS FRIENDS
IL BE THAIR WITH THE REST OF THE REPS
Variant of foregoing: Same except $11 \times 7\frac{1}{4}$ and has reproduction of LAUGH KILLS LONESOME in addition. N.d.

72. Membership Card. Historical Society of Montana, size $3\frac{1}{2} \times 2\frac{1}{4}$. WHEN COWS WERE WILD (color), with signature line on reverse. Some with reverse blank.

73. Montana Free Museum Historical Society of Montana State Capitol Grounds, Helena. Flyer, accordion folded twice to 4 × 9, white stock, red bands.
NO CHANCE TO ARBITRATE, i.e., WHEN HORSES TALK WAR THERE'S SMALL CHANCE FOR PEACE
INDIAN HUNTERS' RETURN
THE ROUNDUP #2
photo of CMR galleries

74. Montana Heritage Series. Flyer, size $8\frac{1}{2} \times 10\frac{3}{4}$. Two CMR illustrations:
LAUGH KILLS LONESOME
CHARLES M. RUSSELL AND HIS FRIENDS
Another version with:
BEST WISHES FOR YOUR CHRISTMAS
THE TRAPPER
THE HERD QUITTER
INDIAN HUNTERS' RETURN

75. Montana Historical Society. C. M. Russell Prints. 1964. Leaflet, 16 pp., size $3\frac{1}{2} \times 8\frac{5}{8}$.
p. [2]: A DOUBTFUL VISITOR, i.e., A PRAIRIE SCHOONER
 CROSSING THE PLAINS
 A BAD ONE
p. [3]: [THE] BELL MARE
 [THE] BROKEN ROPE
 BUFFALO HUNT NO. I, i.e., SURROUND

p. [4]: BUFFALO HUNT NO. 2, i.e., BUFFALO HUNT #22
 C. M. (i.e., CHARLES M.) RUSSELL AND [HIS]
 FRIENDS
 CAMP COOK'S TROUBLES, i.e., THE CAMP COOK'S
 TROUBLE
 DISCOVERY OF LAST CHANCE GULCH, i.e., PAY
 DIRT
p. [5]: THE DRIFTERS, i.e., COWBOY ON BAY HORSE
 [THE] EXALTED RULER
 FREE TRAPPERS
 [THE] HERD QUITTER
p. [6]: INDIAN HUNTERS' RETURN
 INDIANS DISCOVERING LEWIS AND CLARK
 INTRUDERS
 INSIDE THE LODGE
p. [7]: JERKED DOWN
 THE JERKLINE
 LEWIS AND CLARK MEETING THE FLATHEADS, i.e.,
 LEWIS AND CLARK MEETING INDIANS AT ROSS'
 HOLE
 LAUGH KILLS LONESOME
p. [8]: MEN OF THE OPEN RANGE
 NO CHANCE TO ARBITRATE, i.e., WHEN HORSES
 TALK WAR THERE'S SMALL CHANCE FOR
 PEACE
 NATURE'S SOLDIERS
 ONE DOWN, TWO TO GO
p. [9]: PONY RAID
 THE ROUNDUP #2
 ROPING A WOLF, i.e., COWBOYS ROPING A WOLF
 STOLEN HORSES #1
p. [10]: [THE] SALUTE TO (i.e., OF) THE ROBE TRADE
 SCOUTING THE CAMP
 SQUAW TRAVOIS
 TOLL COLLECTORS
p. [11]: THE (i.e., A) STRENUOUS LIFE
 VACQUEROS [sic] OF OLD CALIFORNIA
 WATCHING THE SETTLERS
 WHEN THE LAND WAS GOD'S i.e., WHEN THE
 LAND BELONGED TO GOD
p. [12]: WHEN COWS WERE WILD
 WILD HORSE HUNTERS #2
 WHEN (i.e., WHERE) GUNS WERE THEIR PASSPORTS
 WAGON BOSS
p. [13]: WAITING WARRIOR
 YORK
 IL BE THAIR WITH THE BEST OF THE REPS

76. Montana Historical Society Museums Galleries Library. Veterans & Pioneers Memorial Bldg. One sheet folded twice to size 4 × 9, printed both sides, cream stock, with photo of building on front, ca. 1964. Two photos of Russell gallery; photo of CMR statue by Weaver.

77. Montana the Magazine of Western History. Special Introductory Offer. Folder, folio, size $7\frac{1}{2} \times 10\frac{1}{2}$, made of cover for the Winter, 1964, issue.
p. [1]: CHRISTMAS MEAT (color)
p. [3]: THE ROUNDUP #2

78. Montana, The Magazine of Western History. Business reply mailing piece. N.d. Size $7\frac{1}{4} \times 11$. Four Russell illustrations:
CHRISTMAS AT LINE CAMP
THE HERD QUITTER
LEWIS AND CLARK MEETING INDIANS AT ROSS' HOLE
WHEN COWS WERE WILD

79. Montana, The Magazine of Western History. Business reply mailing piece with self-contained order blank. Contains 6 previously published illustrations in miniature, n.d. (ca. 1955).

80. Montana, The Magazine of Western History. Business reply mailing piece. Size $6\frac{1}{4} \times 5\frac{1}{2}$.
PETE HAD A WINNING WAY WITH CATTLE (part)
SPREAD EAGLED (part)

81. We Want You Back On Our Range. Montana, the magazine of Western History. Business reply mailing piece. Size $6\frac{1}{2} \times 8\frac{1}{2}$.
IN THE OLD DAYS THE COW RANCH WASN'T MUCH
PETE HAD A WINNING WAY WITH CATTLE

82. Montana's Greatest Cowboy Artist, Charles Marion Russell. Leaflet, [4] pages, size 5×8, n.d. (ca. 1953). One CMR illustration, THE LAST OF HIS RACE.

83. Montana's Shameful Neglect. Broadside, size 10×8, n.d. Contains photo of CMR statue by Weaver.

84. Most Pioneers Were Only Given One Chance. *Montana Magazine* flyer, $6 \times 3\frac{3}{8}$, white stock, green ink, n.d. (1963).
LAST CHANCE OR BUST
WHEN COWS WERE WILD

85. A Musical Tribute To The Cowboy Artist's Paintings: C. M. Russell Records. Broadside, $6\frac{3}{4} \times 3\frac{1}{2}$, white stock, blue ink.

86. New! In original color! Famous C. M. Russell paintings offer warmth, humor, old west excitement! Flyer, size $11 \times 8\frac{1}{2}$ (1963).
THE THREE KINGS*
MAY YOUR DAYS BE BETTER
BEST WISHES FOR YOUR CHRISTMAS
CHRISTMAS MEAT

DEER AT WATERHOLE
CHRISTMAS AT LINE CAMP
CHRISTMAS RANCH PARTY 1880, i.e., GOING TO A CHRISTMAS RANCH PARTY IN THE 1880S

87. New! In original color! Famous Western C M Russell Christmas Cards. Broadside, size 7×10, n.d. (ca. 1963).
THE THREE KINGS
MAY YOUR DAYS BE BETTER
BEST WISHES FOR YOUR CHRISTMAS
CHRISTMAS MEAT
DEER AT WATERHOLE
CHRISTMAS AT LINE CAMP
CHRISTMAS RANCH PARTY 1880, i.e., GOING TO A CHRISTMAS RANCH PARTY IN THE 1880S

88. Now Available The Life and Work of America's Famous Cowboy Artist. Ad for *The Charles M. Russell Book*, on MHS letterhead with THE MOUNTAINS AND PLAINS SEEMED TO STIMULATE A MAN'S IMAGINATION (part) at top. LEWIS AND CLARK MEETING INDIANS AT ROSS' HOLE in body of ad.

89. Now . . . For Every Admirer and Collector. Broadside, size 7×10, n.d. One Russell illustration, LEWIS AND CLARK MEETING INDIANS AT ROSS' HOLE.

90. Now For The First Time. Quality Western Art from the Historical Society of Montana. Flyer, size $13\frac{1}{2} \times 9$, n.d. (ca. 1960). Reproductions of MEN OF THE OPEN RANGE (color and black and white), and photo of sculptured bust of Russell by Weaver.
Also a broadside with same reproduction, size 14×10.

91. Now! Special Get-Acquainted Offer. Montana the magazine of western history. Flyer, size $8\frac{1}{2} \times 10\frac{5}{8}$, n.d. (ca. 1962). Two illustrations, THE PROSPECTORS #2 and THE PEACE TALK, plus many small pieces.

92. The Old West at Its Best In a Young Journal of Rare Distinction. Broadside, size $5\frac{1}{2} \times 8\frac{1}{2}$, n.d. (ca. 1961). One illustration, BRONC TO BREAKFAST.

93. The Old West At Its Best In a Young Journal of Rare Distinction. Flyer, size $7\frac{1}{2} \times 10\frac{1}{2}$, n.d. (ca. 1961). Two CMR illustrations:
THE TRAPPER
IN THE OLD DAYS THE COW RANCH WASN'T MUCH

94. An Open Invitation To All Lovers Of The Old West. Broadside, size $7\frac{1}{2} \times 10\frac{1}{2}$. Issued 1962. Charles M. Russell statue and WHITE TAILS #4 in photo of *Paper Talk* exhibition.

95. A Perfect Gift for the erudite, Old West-Oriented Man or Woman Who Has Everything. Broadside, size $3\frac{1}{2} \times 5\frac{1}{2}$, n.d. (ca. 1962) to accompany broadside: Bronzes by C. M. Russell, same size.

96. A Plea to Montanans. Folder, size 4×9, n.d. (ca. 1952). Cover: AND UP FROM THE VAST SILENT STRETCH OF THE RANGE.

97. A plea to Montanans. Folder, white stock, green ink, size 4×9, n.d. (ca. 1952). Cover: INDIAN HEAD #5.

98. The Poor Man's Charlie Russell. Broadside, size $7\frac{1}{2} \times 10\frac{1}{2}$, n.d. (1960). Sagebrush Rembrandt (bust of CMR by Weaver).

99. Quality Western Art. Historical Society of Montana, Roberts at Sixth Avenue, Helena, Montana. Flyer, size $8\frac{1}{2} \times 11$, white stock, n.d., ca. 1959. Reproductions of:
WAGON BOSS
[THE] SALUTE OF THE ROBE TRADE
[THE] ROUNDUP [#2]
TOLL COLLECTORS
[THE] BELL MARE
LAUGH KILLS LONESOME
DISCOVERY OF LAST CHANCE GULCH, i.e., PAY DIRT
C. M. (i.e., CHARLES M.) RUSSELL AND HIS FRIENDS
[THE] JERK LINE
WHEN (i.e., WHERE) GUNS WERE THEIR PASSPORTS
LEWIS AND CLARK MEETING THE FLATHEADS, i.e., LEWIS
 AND CLARK MEETING INDIANS AT ROSS' HOLE
WHEN THE LAND WAS GODS, i.e., WHEN THE LAND
 BELONGED TO GOD

100. Quality Western Art from The Historical Society of Montana. Historical Society of Montana, 6th & Roberts, Helena, Montana. N.d., ca. 1960. Broadside, size 10×14. Reproduction of MEN OF THE OPEN RANGE and photo of sculptured bust of Russell by Weaver.

101. The Red Man's West. True Stories of the Frontier Indian from Montana, The Magazine of Western History (1965). Broadside, size $8\frac{1}{2} \times 11$. [THE] PEACE TALK.

102. The Russell Gallery . . . beautiful full color reproductions of famous Charles Marion Russell paintings. Flyer, size $8\frac{1}{2} \times 11$, white stock, n.d. (ca. 1960).
THE ROUNDUP #2
[THE] HERD QUITTER
WATCHING THE SETTLERS
CHIEF TAKES TOLL, i.e., TOLL COLLECTORS (printed in reverse)

103. See It . . . Montana's History and Art Now . . . On display in $800,000 Pioneers & Veterans Memorial Building, Helena, Montana. Folio, 4×6. Photos of Russell Galleries.

104. Sign Talk by C. M. Russell. Broadside, size 8×10, n.d. (1961). SIGN TALK.

105. Special Introductory Offer Six Big Issues for $5.95. Ad for *Montana Magazine*, 1964.
CHIRSTMAS MEAT (color)
THE ROUNDUP #2

106. Special—Authentic C. M. Russell Prints. Flyer, size 6×10, n.d., ca. 1954.

107. Special Membership Pre-publication Offer for "Whoop-Up Country." Broadside, white stock, size $2\frac{3}{8} \times 8$. THE POST TRADER (vignette).

108. Special Offer To Subscribers of Montana the Magazine of Western History. Historical Society of Montana, Helena, Montana, Flyer, folded thrice to size $3\frac{5}{8} \times 8\frac{1}{2}$, n.d., ca. 1962.

109. The Takeover of the West. Photo-offset from *Chicago Daily News* for February 27, 1963, p. 29, review of *Frontier Omnibus*. Broadside, size $9\frac{1}{2} \times 12$. Reproduces:
THE IRON HORSE COMES TO THE UPPER MISSOURI, i.e.,
 CHEYENNES WATCHING UNION PACIFIC TRACK LAYERS
BEST WHISHES TO THE P–C BUNCH

110. The Thoroughbred . . . a magnificent bronze by Charles M. Russell. Broadside, size $8\frac{1}{2} \times 11$, n.d. (ca. 1960). One illustration, THE THOROUGHBRED* (bronze), in two views.

111. To The Montana Traveler. Folder, 4 pages, size $8\frac{1}{2} \times 4$, n.d. Reproduces photo of interior of "The Charles M. Russell Room."

112. Watching the Settlers. Broadside, size $6 \times 7\frac{1}{4}$, white stock, to accompany MHS print of the picture.

113. We Don't Want to Have You Throwed. *Montana Magazine* flyer, size $6 \times 3\frac{3}{8}$, white stock, blue ink, n.d. (1963).
WHEN HORSES TALK WAR THERE'S SMALL CHANCE FOR PEACE
WHEN COWS WERE WILD

114. The West is Dead. Folder, size $5\frac{1}{2} \times 7$. Two Russell illustrations:
THE HERD QUITTER
LEWIS AND CLARK MEETING INDIANS AT ROSS' HOLE

115. "The West is dead! You may lose a sweetheart but you won't forget her." Flyer, size $7\frac{1}{2} \times 10\frac{1}{2}$. INSIDE THE LODGE (color).

116. When Cows Were Wild. Broadside, size $6 \times 8\frac{1}{2}$, white stock, to accompany MHS print of that picture.

117. When Horses Talk War There Is Slim Chance For Peace. Broadside, size $6 \times 8\frac{1}{2}$, white stock, to accompany MHS print of the picture WHEN HORSES TALK WAR THERE'S SMALL CHANCE FOR PEACE.

118. Whoop-Up Country. Broadside, size $8\frac{3}{4} \times 13\frac{1}{2}$, yellow stock. SINGLE HANDED.

119. With Compliments and Best Wishes of The Historical Society of Montana, Roberts at Fifth Avenue, Helena. Flyer, size $7\frac{1}{4} \times 3\frac{3}{4}$, tan stock. SINGLE HANDED and WHEN COWS WERE WILD on obverse; blurb for *Whoop-Up Country* on reverse.

120. The Wonderful Old West of Charley Russell. Flyer, size $3\frac{3}{4} \times 7\frac{1}{4}$. One illustration, WE AINT GONE FIVE MILE WHEN THE COACH STOPS.

121. Would You Like to Own An Original Russell Bronze? Flyer, size $8\frac{1}{2} \times 11$, n.d., ca. 1955. Reproductions of LONE WARRIOR* (model), and LONE WARRIOR* (bronze), with Weaver statue on reverse.

122. Would You Like to Own An Original Russell Bronze? Broadside, $8\frac{1}{2} \times 8\frac{3}{16}$. N.d., ca. 1965.
LONE WARRIOR (model)
LONE WARRIOR (bronze)

123. You Should Order Now ... Two Great New Western Books Exclusively from the Montana Historical Society. Flyer, size $5\frac{3}{4} \times 10\frac{3}{4}$ (1965). THE PEACE TALK.

Price Lists

Price Lists

1. David Ashley, Inc., 230 Fifth Avenue, New York 1, N.Y. Catalogue of Fine Color Reproductions. N.d. (1946). Pp. 32, 8½ × 11, wrappers.
p. 32: [THE] SALUTE OF THE ROBE TRADE
THE WAGON BOSS (without bottle)

2. ———. Artist: Charles M. Russell, American—1865–1926. Broadside, size 8 × 9. [THE] SALUTE OF THE ROBE TRADE.

3. ———. Artist: Charles M. Russell, American—1865–1926. Broadside, size 8 × 9. THE WAGON BOSS (without bottle).

4. Authentic Reproductions, Inc., P.O. Box 204, Loveland, Colorado 80537. Catalogue of Fine Art Reproductions on Canvas. N.d. (1965). Pp. 24, size 8¼ × 10¾, wrappers.
p. 19: [THE] BELL MARE
THE CAMP COOK'S TROUBLE(S)
THE DOUBTFUL VISITOR, i.e., A PRAIRIE SCHOONER
 CROSSING THE PLAINS
THE ROUNDUP #2
LEWIS AND CLARK MEETING THE FLATHEADS, i.e.,
 LEWIS AND CLARK MEETING INDIANS AT ROSS'
 HOLE
[THE] SALUTE OF THE ROBE TRADE
(THE) WAGON BOSS
p. 20: JERKED DOWN
THE (i.e., A) STRENUOUS LIFE

5. Balcony Book Shop, 1607 Carey Avenue, Cheyenne, Wyoming. For Westerners Only. Broadside, folded thrice to 5 × 7¼. N.d. (1958).
WATCHING THE SETTLERS

LEWIS AND CLARK MEETING INDIANS AT ROSS' HOLE
WHEN I WAS A KID
JERKED DOWN

6. Beartooth Curio and Art Store, Red Lodge, Montana. Art reproductions from Original paintings by Charles M. Russell Cowboy Artist. Leaflet, pp. [4], size 3¼ × 6.
THE COWBOY #2
WAITING FOR A CHINOOK

7. Helen L. Card. Salute to the Westerners, New York. The Latendorfer Number One. Pp. 48, wrappers, size 5½ × 8½, n.d. (ca. 1958). P. 46: SMOKING UP (bronze).

8. The Amon Carter Museum of Western Art, 3501 Camp Bowie Boulevard, Fort Worth, Texas. Now available . . . Books, Exhibition Catalogues and authentic full color reproductions. Flyer, size 8½ × 11, folded twice to self-mailer. Obverse has BRAVE, i.e., ON THE WARPATH #1 in two places. Reverse has THE BROKEN ROPE and WILD HORSE HUNTERS #2. Also, a loose broadside insert, size 3½ × 8½, advertising set of reproductions of illustrated letters, with ME AND MY OLD HOSS at top.

9. ———. Now available . . . Books, Exhibition Catalogues and Authentic Full Color Reproductions, ca. 1962. Broadside, size 8½ × 11. Reproductions of:
BRAVE, i.e., ON THE WARPATH #1
THE BROKEN ROPE
WILD HORSE HUNTERS #2

10. ———. Flyer, size 4 × 9, with photo of facade of Museum and HERE'S HOPING THE WORST END OF YOUR TRAIL IS BEHIND YOU on obverse.

11. Carter Museum of Western Art Publications. Leaflet, pp. [12], $3\frac{7}{8} \times 9$, wrappers, n.d. (1964).
p. [7]: THE BROKEN ROPE
 THE WILD HORSE HUNTERS #2
p. [12]: ME AND MY OLD HOSS

12. Peggy Christian, Bookseller. Catalog No. 4. American Artists and Illustrators. 769 North La Cienega Boulevard, Los Angeles (1965). Pp. 20, size $6\frac{3}{4} \times 10$. Lists 14 CMR items.
p. 11: quote from CMR's eulogy on Paxson
p. 14: DOBY CAREY'S GOAT* (bronze)
p. 15: THE MEDICINE MAN #3

13. The Arthur H. Clark Company, 1264 S. Central Avenue, Glendale, Calif. Books By and About Charles M. Russell Offered For Sale. Mimeographed, size $6\frac{1}{4} \times 8\frac{1}{2}$, n.d. (ca. 1958). Lists 91 items.

14. ———. Boots and Saddles—Indians—Featuring two Famous American Artists Frederic Remington Charles Russell (List) S-8504. Describes 26 CMR items.

15. ———. The Wild and Woolly West Cowboys—Indians—Gamblers—Mining—Featuring the Artists: Remington & Russell. (List) S-8510. Describes 35 CMR items.

16. ———. Charles M. Russell—The Cowboy Artist. (List) S-8529. Describes 88 CMR items.

17. ———. Charlie Russell The Cowboy Artist. (List) S-9104. Describes 140 CMR items.

18. ———. Charlie Russell, The Cowboy Artist. Russell content of each item fully recorded in Yost bibliography. (List) S-9201. Describes 83 CMR items.

19. U. Gordon Colson Co., Russell Enterprises, Paris, Illinois (1955). The Russell Gallery . . . beautiful full color reproductions of famous Charles Marion Russell Paintings. Broadside, printed in red and black ink, size $8\frac{1}{2} \times 11$. Reproductions of:
THE ROUNDUP #2
[THE] HERD QUITTER
WATCHING THE SETTLERS*
CHIEF TAKES TOLL, i.e., TOLL COLLECTORS (in reverse)

20. The Como Company, Great Falls, Montana. Charles M. Russell The Artist Who Knew the Old West Because He Lived It. Flyer, n.d. Lists 13 colored prints and 10 pen drawings.

21. ———. Russell Colored Prints Reproduced from Original Paintings of Charles M. Russell. Folder, size $4 \times 8\frac{1}{2}$, n.d. Lists 59 colored prints and pen drawings. Contains THE COWBOY #2.

22. Dawson's Book Shop, Los Angeles. Catalog No. 152. February, 1941. Contains a photo of CMR; a note on CMR by Joe DeYong; and a list of books from Russell's library.

23. Electric City Printing Co., Great Falls, Montana. Illustration, but no type, on first page. Pp. [4], size $5\frac{3}{16} \times 6\frac{5}{8}$. N.d. ca. 1927. P. [1]: AN APACHE INDIAN (color).

24. Flathead Lake Galleries, Box 426, Bigfork, Montana 59911. Pp. [12], pink stock, size $8\frac{1}{2} \times 11$, n.d. (1965). Lists CMR prints, books, portfolios, etc.

25. Gilcrease Art Gallery, Tulsa, Oklahoma. Broadside, folded twice, size 4×9, n.d. JERKED DOWN.

26. Gilcrease Institute of American History and Art, P. O. Box 2419, Tulsa, Oklahoma. Color Reproductions from the Gilcrease Collection. N.d. Broadside, size 14×17. Reproductions of:
A PRAIRIE SCHOONER CROSSING THE PLAINS
THE CAMP COOK'S TROUBLE
JERKED DOWN
PAY DIRT
WAGON BOSS
THE BELL MARE
A STRENUOUS LIFE
WHERE GUNS WERE THEIR PASSPORTS

27. Gilcrease Institute. Return postcard with perforated flap. Buff stock, size $9\frac{1}{8} \times 3\frac{3}{4}$, n.d. (August, 1964). STEER RIDER #1.

28. Gilcrease Gift Shop, Rural Route 6, Tulsa, Oklahoma 74106. Color Reproductions. Broadside, size $8\frac{1}{2} \times 11$, n.d. (1965). Lists 18 CMR color prints.

29. ———. 35 mm. slides. Broadside, size $8\frac{1}{2} \times 5\frac{1}{2}$, n.d. (1965). Lists six CMR color slides.

30. ———. 35 mm. slides. Broadside, size $8\frac{1}{2} \times 11$, n.d. (1965). Lists 10 CMR color slides.

31. ———. Color Reproductions. Broadside, size $8\frac{1}{2} \times 11$, n.d. (1965). List 15 CMR color prints.

32. ———. Color Reproductions. Flyer, size $8\frac{1}{2} \times 11$, n.d. (1966). Lists 20 CMR color prints.

33. Color Reproductions from the Gilcrease Collection. Broadside, size 17 × 14, n.d. (1966). Contains:
A PRAIRIE SCHOONER CROSSING THE PLAINS
THE CAMP COOK'S TROUBLE
JERKED DOWN
PAY DIRT
[THE] SALUTE OF THE ROBE TRADE
WAGON BOSS
A STRENUOUS LIFE
WHERE GUNS WERE THEIR PASSPORTS

34. Glass Art Shop, 423 First Avenue North, Great Falls, Montana. Chas. M. Russell Reproductions. N.d. (ca. 1934). Pp. [4], size 5 × 3½. Cover: THE COMING OF THE WHITE MAN. N.B.: The Glass Art Shop was at the above address from 1929 to 1938.

35. Glass Art Shop, 505 First Avenue North, Great Falls; Montana [32 lines] Chas. M. Russell Reproductions. Foregoing is p. [1] of a sheet size 10½ × 6, folded twice into six pages. N.d. (ca. 1943).
p. [1]: THE COMING OF THE WHITE MAN
p. [5]: SKULL #1
p. [6]: SMOKE OF A FORTY-FIVE

36. The Gokey Co., St. Paul 1, Minn. Catalogue of Sporting Goods. (1945). Lists prints, separately and in portfolio, and has halftone of SMOKE OF A FORTY-FIVE.

37. Hamley & Company, Pendleton, Oregon, U.S.A. Hamley's Cowboy Catalog No. 41. Pp. 160, wrappers, size 5¾ × 8¾, n.d. (ca. 1941).
p. 116: WHEN HORSEFLESH COMES HIGH
IN WITHOUT KNOCKING
SUN WORSHIPPERS
WHISKEY SMUGGLERS CAUGHT WITH THE GOODS
WAGON BOSS

38. ———. Hamley's Cowboy Catalog No. 53. Pp. 144, wrappers, size 6 × 9, 1953.
p. 131: RAWHIDE RAWLINS
RAWHIDE RAWLINS, MOUNTED
p. 136: IN WITHOUT KNOCKING
WAGON BOSS
WHEN BLACKFEET AND SIOUX MEET
SUN WORSHIPPERS
FIRST WAGON TRAIL
BRONC TO BREAKFAST
WHEN HORSEFLESH COMES HIGH

39. Hammer Galleries, 51 East 57th Street, N.Y. Special Offer of Charles M. Russell Bronzes. Flyer, size 7 × 10½, n.d. (ca. 1958). Three CMR bronzes illustrated:

ROYALTY OF THE ROCKIES
JONES STEER HEAD
JONES HORSE HEAD

40. Haynes Picture Shop, Yellowstone Park, Wyoming. Western Life. Charles M. Russell Color Reproductions. Broadside, size 5⅞ × 10, green stock.

41. Dick Jones Picture Co. P.O. Box 1437, Great Falls, Montana, Reproductions from the Original Paintings of C. M. Russell. List of prints, etc. Broadside mailing folder, size 8½ × 11. N.d. (ca. 1930). This is the first plugger issued by Dick Jones. He sold over 100,000 prints the first year he advertised. WHEN SIOUX AND BLACKFEET MET, i.e., WHEN BLACKFEET AND SIOUX MEET reproduced in color, size 4 × 3, top of page.

42. Jones Paint & Picture Shop, Inc. No. 8 Sixth St., No., Great Falls, Montana. Charles M. Russell Reproductions. THE COWBOY #2 (vignette). Pp. [4], size 3¼ × 6. N.d. (ca. 1930).
Variant of foregoing: Same, except imprint is R. O. Jones, 211 Twentieth St., No., Great Falls, Montana.

43. R. O. Jones, P.O. Box 1087, Great Falls, Montana. C. M. Russell Color Reproductions. Successor to the Moscrip Picture Co., The Dick Jones Picture Co. N.d. Broadside, size 6 × 10½.

44. Dick Jones Picture Co., Box 1087, Great Falls, Montana. Russell Pictures, Color Reproductions from the Original Paintings by Charles M. Russell. N.d., folder, size 3⅛ × 6½. Reproduction of THE COWBOY #2 on front.

45. R. O. Jones, 6914 Rugby Ave., Huntington Park, Calif. Specials. Chas. M. Russell . . . Painter of the West. N.d., broadside, size 5¾ × 10⅜.

46. R. O. "Dick" Jones, Huntington Park. Forty Pen and Ink Drawings by Charles M. Russell. Double postcard, size 5½ × 6½, n.d. (ca. 1947).

47. Dick (R. O.) Jones, Huntington Park, California. New Charles M. Russell Prints. Handbill, size 9½ × 12½, n.d. Lists 12 colored prints, 2 books, and other material.

48. Dick Jones Picture Co., Huntington Park. Paintings of Charles M. Russell. Broadside, size 9½ × 12½. N.d. Contains:
WOUND UP
SKULL #1
WOLF HEAD, TONGUE OUT
SHIELD, BOW, WAR HATCHET, PIPE AND SCALP

49. Dick Jones, Huntington Park, California. News for the Russell Collector. Handbill, size $8\frac{1}{2} \times 11$, n.d. Lists 8 CMR prints and 6 books. Contains THE COWBOY #2.

50. Dick Jones Picture Co., 6805 Seville Ave., Huntington Park, Calif. Current List of Pictures by Charles M. Russell Reproduced in Colors. [3 lines and list of 28 prints]. Broadside, size $8\frac{3}{16} \times 14\frac{1}{4}$. N.d. (ca. 1932). Bears reproduction of photo of CMR.

51. Dick Jones Picture Co., 6805 Seville Ave., Huntington Park, Calif. Reproductions from the Original [SKULL #1] Paintings of Chas. M. Russell, Famous Cowboy Artist, Done in Colors [INDIAN HEAD #5]. Suitable for framing [12 lines]. Broadside mailing folder, size 9×12, n.d. (ca. 1939).
top left: SKULL #1
top center: WOUND UP (halftone)
top right: INDIAN HEAD #5
bottom left: WOLF HEAD
reverse, top left: SHIELD, BOW, WAR HATCHET, PIPE AND
 SCALP

52. ———. Attention Russell Collectors. N.d., but text suggests 1942 in that certain items "will not be available for the duration." Broadside, size $8\frac{1}{2} \times 5\frac{1}{2}$.

53. ———. Charles M. Russell Reproductions [12 lines]. Postcard, tan stock, size $3\frac{1}{2} \times 5\frac{1}{2}$.

54. ———. Stories by Charles M. Russell, The Cowboy Artist [11 lines]. Postcard, tan stock, size $3\frac{1}{4} \times 5\frac{1}{2}$. Reproduces THE COWBOY #2.

55. ———. Specials. [13 lines]. Postcard, tan stock, size $3\frac{1}{4} \times 5\frac{1}{2}$. Reproduces THE COWBOY #2.

56. ———. Two New Books Pen and Ink Drawings by Charles M. Russell. N.d. (ca. 1946). Postcard order form, size $6\frac{1}{2} \times 5\frac{1}{2}$. Reproduction of SKULL #1.

57. ———. Russell Pictures, Color Reproductions from the Original Paintings by Charles M. Russell. N.d. Pp. [10], booklet, wrappers. Reproduction of THE COWBOY #2 on cover. Size $3\frac{1}{2} \times 6\frac{1}{4}$.

58. ———. More News for the Russell Collectors. N.d. Broadside, size $8\frac{1}{2} \times 10\frac{3}{4}$. Reproduction of THE COWBOY #2.

59. ———. Current List of Pictures by Charles M. Russell. N.d. Broadside, size $8\frac{1}{4} \times 14\frac{1}{4}$. Reproduction of Russell's last photo by Ecklund.

60. Dick Jones Picture Co., P.O. Box 487, Huntington Park, California. Russell Pictures, Reproductions from the Original Paintings and Pen Sketches by the Famous "Cowboy Artist," Charles M. Russell. N.d. (ca. 1952). Pp. [10], size 4×9, Wrappers, stapled.
cover: photo of Russell with hat
p. [1]: THREE HORSES' HEADS
p. [2]: WOUND UP
p. [4]: INDIAN HEAD#5
p. [6]: COWBOY ABOUT TO SADDLE HORSE
p. [7]: TWO MEN THROWING PACK HORSE HITCH
b. cover: TEN GALLON HAT, CARTRIDGE BELT AND
 REVOLVER IN HOLSTER

61. ———. New Chas. M. Russell Prints. N.d. Broadside, size $8\frac{3}{4} \times 11$. Reproduction of THE COWBOY #2.

62. ———. Chas. M. Russell Prints. N.d. Broadside, size 9×12. Reproduction of THE COWBOY #2.

63. ———. Miscellaneous and Collector's Items. N.d. Broadside, size $8\frac{1}{2} \times 11$.

64. ———. The Works of Charles M. Russell, World Famous Cowboy Artist. N.d. Broadside, size $8\frac{1}{2} \times 11$. Reproduction of THE COWBOY #2.

65. ———. Catalog—Fall and Winter, 1946–1947. Pp. 14, size $3\frac{1}{2} \times 6$.
p. 12: RAWHIDE RAWLINS
b. cover: WHERE THE BEST OF RIDERS QUIT (bronze)

66. ———. Attention—C. M. Russell Collectors. Broadside, pink stock, size $8\frac{1}{2} \times 19\frac{5}{8}$, n.d. (ca. 1946).

67. ———. Attention. C. M. Russell Collectors. Broadside, yellow stock, size $8\frac{1}{2} \times 10\frac{7}{8}$, n.d. (ca. 1953). Reproduction of THE COWBOY #2.

68. ———. The Works of Charles M. Russell Famous Cowboy Artist. Broadside, size $8\frac{1}{2} \times 11$, n.d. (ca. 1958). Reproduces THE COWBOY #2.

69. ———. For Your Western Room—Office. Charles M. Russell Pictures (Reproductions) Dick Jones Picture Company. P.O. Box 487, Huntington Park, Calif. 90258. Folio, pp. [4], size $8\frac{1}{2} \times 11$. (1965).
p. [1]: [THE] BELL MARE
 LEWIS AND CLARK MEETING THE FLATHEAD
 INDIANS, i.e., LEWIS AND CLARK MEETING
 INDIANS AT ROSS' HOLE
 FREE TRAPPERS
 WAGON BOSS

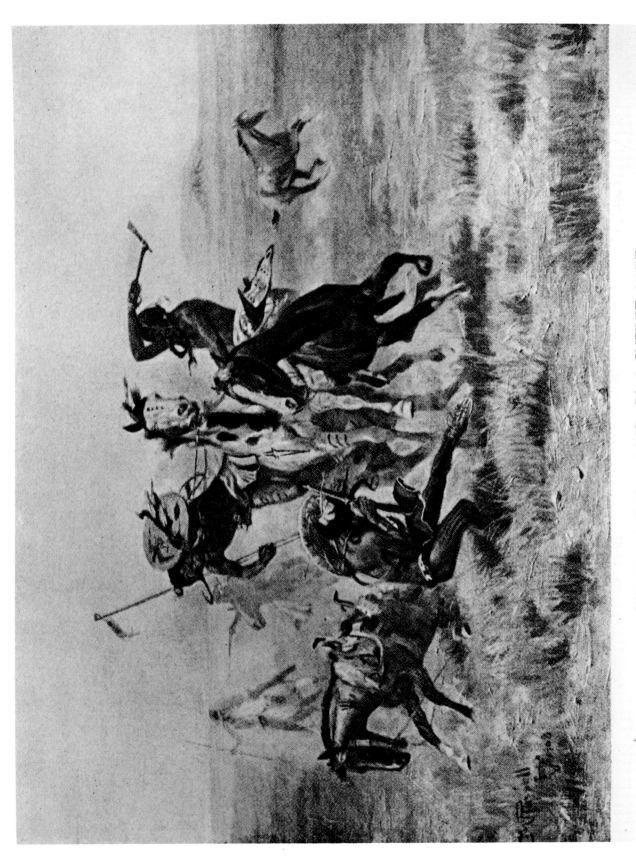

WHEN SIOUX AND BLACKFEET MET

WHEN BLACKFEET AND SIOUX MEET
Dick Jones' first announcement, from which he sold over 100,000 prints.
See item 41, this section.

WHEN (i.e., WHERE) GUNS WERE THEIR PASSPORTS
DISCOVERY OF LAST CHANCE GULCH, i.e., PAY DIRT
[THE] ROUNDUP #2
THE SURPRISE ATTACK
INSIDE THE LODGE
THE BROKEN ROPE
INDIAN HUNTERS' RETURN
THE JERK LINE
p. [4]: THE COWBOY #2

70. E. W. Latendorf. Mannados Bookshop. 19 East 49th Street, New York 17, N.Y. Catalogue No. 1. Size unknown, n.d. (December, 1935). Lists four editions of *The Virginian*.

71. ———. Fact and Fiction of the Old West and the Wild West. Catalogue 15. Size $4\frac{7}{8} \times 7\frac{1}{4}$, n.d. (September, 1943). Lists CMR books and prints.

72. ———. Catalogue 17. More Fact and Fiction of the Old West and the Wild West. Pp. 72, size $5\frac{1}{2} \times 8\frac{1}{4}$, n.d. (May, 1947). Lists 51 CMR items.

73. ———. A Small Group of Choice Russell Items. Catalogue No. 22. Pp. [20], wrappers, size $5\frac{1}{2} \times 8\frac{1}{2}$, n.d. (June, 1950). Lists 51 books and reproduces 13 bronzes.
cover: SMOKING UP
verso: photo of CMR
p. [1]: OFFERING TO THE SUN GODS
p. [2]: MONARCH OF THE PLAINS
MONARCH OF THE ROCKIES
p. [4]: THE CHALLENGE
ALERT
p. [6]: READY FOR THE KILL
A DISPUTED TRAIL
p. [8]: AN AWKWARD SITUATION
MONARCH OF THE FOREST
p. [10]: TREED
HIS WINTER'S STORE
p. [12]: THE CHEYENNE, i.e., THE SIOUX
p. [20]: SMOKING UP

74. E. W. Latendorf. Mannados Bookshop, 43 West 51st Street, New York 19, N.Y. A Dakota Chicken-Wagon. Folio, $5\frac{1}{2} \times 8\frac{1}{2}$, n.d. (1951).
p. [2]: READY FOR THE KILL (bronze)
p. [3]: I DON'T MISS NONE OF THEM BOULDERS

75. ———. Unnumbered leaflet, folio $5\frac{1}{2} \times 8\frac{1}{2}$, n.d. (April, 1953).
cover: ON NEENAH (bronze)
p. [3]: SMOKING UP (bronze)

76. E. W. Latendorf, 714 Madison Ave., New York 21, N.Y. Western Americana Fact and Fiction in Literature and Art. Catalogue No. 24. Pp. 88, wrappers, $5\frac{1}{2} \times 8\frac{1}{2}$, n.d. (May, 1954). Lists 111 CMR items.

77. ———. The West. Catalogue No. 25. Pp. 40, wrappers, size $5\frac{3}{8} \times 8\frac{3}{8}$, n.d. (June, 1955). Lists 31 CMR items. P. 33: HORSE HEAD, LEFT SIDE #2.

78. ———. C M Russell. Catalogue 27. Folio, pp. [48], size $8\frac{1}{2} \times 5\frac{1}{4}$, wrappers, n.d. (May, 1957).
p. [3]: A DANGEROUS SITUATION*
p. [4]: FIGHTING INDIAN*
p. [5]: HAPPY NEW YEAR 1916 #2*
p. [6]: MEAT FOR WILD MEN (bronze)
p. [7]: WHERE THE BEST OF RIDERS QUIT (bronze)
p. [8]: (THE) MOUNTAIN SHEEP #1 (bronze)
p. [9]: NAVAJO (bronze)
p. [10]: THE MEDICINE MAN (bronze)
p. [11]: THE BUG HUNTERS (bronze)
BEAR NO. 1 (bronze)
p. [12]: PAINTING THE TOWN (bronze)
p. [13]: SMOKING UP (bronze)
p. [14]: THE BLUFFERS (bronze)

79. ———. Catalogue No. 27 [sic]. Pp. [40], folio, $5\frac{1}{2} \times 8\frac{1}{2}$. Lists 15 CMR items.

80. The Leader Company, Great Falls, Montana. Russell Sketches, Western Types by the Great Cowboy Artist, Charles M. Russell. Folder, size $3\frac{3}{4} \times 8\frac{1}{2}$. N.d. (ca. 1927). Reproduction of THE COWBOY #2 on front cover and Ecklund photo of CMR on back cover. Lists 16 "Western Types."

81. Leanin' Tree, Box 1500, Boulder, Colorado. New 1965 Collection Western Christmas Cards and Gifts. Pp. [16], size $8\frac{1}{2} \times 5\frac{1}{2}$.
p. [9]: TAKE ONE WITH ME [FRED] (color)
p. [14]: THE COWBOY-ROPER (color)
TAKE ONE WITH ME FRED (color)
THE BUCK I KILLED (color)

82. Longs College Book Co., Columbus, Ohio. Rare Book Department. Catalog 21, Americana. Pp. 24, size $8\frac{1}{2} \times 11$, June 1, 1951. Cover: PAWNEE HORSE THIEVES.

83. ———. Catalog 25, Americana. Pp. 76, size 8×11, 1953. Cover: MEDICINE ROCK.

84. Mint Saloon, Great Falls, Montana. Price list of Charles M. Russell prints. N.d. Unnumbered pages. Illustration of CMR at work painting. Not Seen.

85. The Mint. Allied Printing Co., Great Falls. Pp. 4, n.d. Lists 16 Original Russell Paintings in "The Mint" and 90 colored prints and other items for sale.

86. The Mint Saloon price list. Reproduction of I BEAT YOU TO IT on front, in colors, with 11 lines of type underneath. Pp. 4, size $5\frac{1}{4} \times 3\frac{1}{4}$, n.d., green ink.

87. Another Mint price list with type underneath picture. Same size, same print. N.d.

88. Another, same without text. Blue ink predominantly.

89. Montana Historical Society. Many price lists of prints, books, etc., issued by Montana Historical Society will be found in Section XII.

90. Montana Newspaper Association, Great Falls, Montana. Pictures by Charles M. Russell Reproduced in Colors [3 lines] 50¢ each [2 lines and list of 46 prints]. Broadside, size $10\frac{1}{4} \times 16\frac{1}{4}$. N.d. (ca. 1932).
upper left: RUSSELL RIDES REAL OUTLAW
lower right: AN OLD FASHIONED STAGE COACH

91. Montana Printing Co., Great Falls, Montana, Reproductions from Paintings by Chas. M. Russell, "The Cowboy Artist." Leaflet, size $5\frac{1}{2} \times 3\frac{1}{2}$. Pp. [4], n.d. Reproductions of SMOKE OF A 45 (i.e., FORTY-FIVE) on front cover and CUPID IN THE WEST IS A COWBOY on back cover.

92. The Moscrip Picture Co., 1241 Hassalo Street, Portland, Oregon. Russell Pictures, Color Reproductions from The Original Paintings by Charles M. Russell. Leaflet, pp. [4], size $3 \times 6\frac{1}{4}$, n.d., (ca. 1930). THE COWBOY #2.

93. Naegele Printing Co. Helena, Montana. Reproductions from Paintings by Chas. M. Russell "The Cowboy Artist." Pp. [4], size $3\frac{3}{4} \times 6\frac{1}{8}$. N.d. (ca. 1912).
p. [1]: THE BUCKING BRONCO #1
p. [4]: CUPID IN THE WEST IS A COWBOY

94. ———. Reproductions from paintings by Chas. M. Russell "The Cowboy Artist." Pp. [4], size $3\frac{1}{2} \times 5\frac{5}{8}$. N.d. (ca. 1915).
p. [1]: INDIAN HEAD #5
p. [4]: CUPID IN THE WEST IS A COWBOY

95. ———. Reproductions of Paintings and Pen Sketches by Chas. M. Russell "The Montana Cowboy Artist." Folio, pp. [4], $4 \times 7\frac{1}{4}$, tan art paper, n.d. (ca. 1930). P. [1]: INDIAN HEAD #5.

96. ———. Paintings and Pen Sketches by Chas. M. Russell "The Cowboy Artist." Reproduced exclusively. Pp. [4], size 5×7, n.d. (ca. 1947).
p. [1]: SKULL #1
p. [4]: INDIAN HEAD #5

97. ———. Reproductions of Paintings and Pen Sketches by Chas. M. Russell, The Montana Cowboy Artist. Folio, [4] pages, size $4 \times 7\frac{1}{4}$. Helena, n.d. (ca. 1950).
p. [1]: INDIAN HEAD #5
p. [3]: SKULL #1
p. [4]: TEN GALLON HAT, CARTRIDGE BELT, AND RE-VOLVER IN HOLSTER

98. N. Porter Co. 406 South First Street, Phoenix, Arizona. Famous Russell Prints. Broadside, size 11×34, n.d. (ca. 1938). Reproduction of THE CINCH RING.

99. ———. Porter's Christmas. Pp. 24, wrappers, 1949. Lists six CMR prints.

100. ———. Catalog No. 36. Pp. 120, $6\frac{3}{4} \times 9\frac{3}{4}$ (1952). P. 91: THE CINCH RING and THE LAST OF 5000.

101. ———. Famous Russell Prints, Folder, pp. [6], n.d. Lists nine CMR prints.

102. Porters . . . Greatest Roundup of Western Values. Broadside, folded to $5\frac{1}{2} \times 8\frac{1}{2}$. Lists 49 Famous Russell Prints. N.d. (ca. 1953). Reproduces:
THE CINCH RING
IN WITHOUT KNOCKING
WHEN HORSEFLESH COMES HIGH
CRIPPLED BUT STILL COMING
SHOOTING OUT THE STRAGGLERS, i.e., SMOKING CATTLE
 OUT OF THE BREAKS
THE INNOCENT ALLIES
BRONC TO BREAKFAST
AT CLOSE QUARTERS, i.e., UP AGAINST IT
HEADS OR TAILS, i.e., THE MIXUP

103. Publishers Central Bureau, 33–20 Hunters Point Ave., Long Island City, N.Y. 11101. Winter Clearance, Private Sale of Books, Prints, Records. N.d. (1965). Pp. 8, $9\frac{1}{4} \times 12\frac{1}{2}$, wrappers.
p. 5: INDIANS AND SCOUTS TALKING
 SQUAW TRAVOIS

104. J. E. Reynolds, Bookseller, 16031 Sherman Way, Van Nuys, California. The Old West and C. M. Russell. Catalog 75, June, 1963.
cover: LONGHORN STEER, TH BRAND
b. cover: MOUNTED INDIAN*

105. W. T. Ridgley Calendar Co., Great Falls, Montana. Reproductions from Works of C. M. Russell. The front wrapper serves as the title page. There is no date on the title page. Pp. [12], folio, size $5\frac{1}{2} \times 8$. Wrappers, stapled (ca. 1906). Contains 1 color plate and 11 halftones:

wrapper: ROPING A WOLF #2 (color, pasted)
p. [2]: THE WATER GIRL #2
p. [3]: ROPING A WOLF #2
p. [4]: THE SCOUTS, i.e., SCOUTING PARTY #1
p. [5]: AN OLD TIME STAGE COACH
p. [6]: ROPING A GRIZZLY, i.e., ROPING A RUSTLER
p. [7]: PAINTING THE TOWN
p. [8]: BETTER THAN BACON*
p. [9]: AN APACHE INDIAN
p. [10]: BREAKING CAMP #3*
p. [11]: THE WINTER PACKET
p. [12]: THE BUCKING BRONCO #1

106. W. T. Ridgley Calendar Company, Great Falls, Montana. Russell Post Cards Reproduced from original paintings of C. M. Russell. [vignette]. Pp. [40], size $7\frac{3}{8} \times 5\frac{3}{16}$. Wrappers, stapled. Photo of CMR on title page. N.d. (ca. 1908). Contains 28 color plates and 8 line engravings (items on pages 12, 15, 18, 19, 22, 23, 26, and 29 are line, all others color).

p. [3]: I SAVVY THESE FOLKS
p. [4]: ARE YOU THE REAL THING?
p. [5]: STAY WITH HIM!
p. [6]: COWBOYS OFF FOR TOWN
p. [7]: HAVE ONE ON ME
p. [8]: A TOUCH OF WESTERN HIGHLIFE
p. [9]: THE BEAR IN THE PARK ARE AWFULLY TAME
p. [10]: ALL WHO KNOW ME—RESPECT ME
p. [11]: POWDERFACE—ARAPAHOE
p. [12]: THE CHRISTMAS DINNER
p. [13]: ANTELOPE HUNT
p. [14]: INDIAN DOG TEAM
p. [15]: HOLDING UP THE OVERLAND STAGE
p. [16]: A BAD BRONCO, i.e., THE BUCKING BRONCO #1
p. [17]: A ROPER
p. [18]: THE INITIATION OF THE TENDERFOOT
p. [19]: INITIATED
p. [20]: BOLD HUNTERS—HEAVENS! A GRIZZLY BEAR
p. [21]: WHERE IGNORANCE IS BLISS
p. [22]: THE TRAIL BOSS
p. [23]: THE LAST OF THE BUFFALO
p. [24]: BUFFALO PROTECTING CALF
p. [25]: SUNSHINE AND SHADOW
p. [26]: THE SHELL GAME
p. [27]: AN OLD FASHIONED (i.e., TIME) STAGE COACH
p. [28]: THE BUFFALO HUNT #28 (sepia)
p. [29]: PAINTING THE TOWN

p. [30]: WHITE MAN'S SKUNK WAGON NO GOOD HEAP LAME
p. [31]: ROPING A GRIZZLY, i.e., ROPING A RUSTLER
p. [32]: ROPING A WOLF #2
p. [33]: BOSS OF THE HERD, i.e., BOSS OF THE TRAIL HERD
p. [34]: LONE WOLF—PIEGAN
p. [35]: A NEZ PERCE
p. [36]: DANCE! YOU SHORT HORN DANCE!
p. [37]: RED CLOUD
p. [38]: ROUNDUP #1

107. ———. Colortypes [2 lines] THE BUCKING BRONCO, vignette. "The Bucking Bronco" by C. M. Russell. Reproduction in colors, 8×11 on art mounts 15×19. N.d. (ca. 1909). Pp. [8]. Size $3\frac{1}{2} \times 6\frac{1}{4}$. Green wrappers printed in silver, red, and black.
p. [1]: THE BUCKING BRONCO #1
p. [2]: THE FIRST FURROW
p. [4]: ROPING A GRIZZLY, i.e., ROPING A RUSTLER
p. [6]: THE MAD COW
p. [7]: SMOKE OF A FORTY-FIVE
p. [8]: LAST CHANCE OR BUST*

108. Franklin M. Roshon, 388 First Ave., Phoenixville, Penna. Catalog (No. 6) Western Americana Winter 1948—Spring 1949. Lists 17 books with CMR illustrations published by Trail's End Publishing Co.

109. ———. Sporting Books and Prints. Catalog No. 3. Pp. 28, wrappers, 1951.
p. 26: (THE) WAGON BOSS
p. 27: [THE] SALUTE OF THE ROBE TRADE

110. C. M. Russell Gallery, 1201 Fourth Avenue North, Great Falls, Montana. Charles M. Russell Prints for Your Western Room—Tack Room—Office. Broadside, size $12\frac{3}{4} \times 8\frac{1}{2}$, n.d. (ca. 1957). Reproduction of THE JERK LINE.

111. ———. Variant (ca. 1962).

112. Russell Memorial, 1219 Fourth Ave., North, Great Falls, Montana. The Log Cabin Studio of Charles M. Russell (Montana's Cowboy Artist) [cut of studio] offers the Following Original Paintings, Bronzes, Books, Bookends, Plaques, Paper Weights, and Reproductions [6 lines]. Flyer, 6×14, accordion folded to $3\frac{1}{2} \times 6$, tan stock, n.d. (ca. 1930). Lists 12 oils, 8 water colors, 14 bronzes, 12 prints in color, 20 pen sketches, and 25 early reproductions. In envelope of C. M. Russell Memorial, Great Falls, Montana.

113. Russell Memorial Museum, Great Falls, Montana. Price List of C. M. Russell prints, original oils,

water colors, bronzes and books. Folded strip, size 6 × 14. N.d. Sketch of studio on front cover and reproduction of SKULL #1 from Russell's letterhead on last page.

114. ———. Price List of Charles M. Russell prints. N.d., unnumbered pages. Illustrations include reproduction of CMR at work painting. Not Seen.

115. Snook Art Co., 110 North 29th Street, Billings, Montana. C. M. Russell and Will James Color Reproductions from the Original Paintings. Pp. [16], size 6¼ × 3⅜. N.d. (ca. 1949).
p. [1]: RIM-FIRE, OR DOUBLE CINCH RIG
p. [2]: SKULL #1

116. ———. Western Books and Pictures. Broadside, size 9¼ × 4¾. N.d.

117. ———. C. M. Russell Art Pictures. Broadside, size 9½ × 5. N.d.

118. ———. C. M. Russell Art Pictures. Broadside, size 12¼ × 5. N.d.

119. ———. C. M. Russell Prints. Broadside, size 14 × 9. N.d.

120. Variant of foregoing: same except list concludes with Will James Prints which are in the next to last paragraph in the item above.

121. ———. Price List of Reproductions from Paintings by Charles M. Russell "The Cowboy Artist" [vignette] THE FIRST FURROW. Sold exclusively. Pp. [14]. Size 3¾ × 6⅛. April 1, 1931.
p. [1]: THE FIRST FURROW
p. [4]: CUPID IN THE WEST IS A COWBOY

122. The Stackpole Company. For your unhurried comfort . . . Selected Books from the Stackpole Library. Harrisburg, Pa., n.d. (December, 1955). Pamphlet, size 4 × 9, pp. [32], black cover. Lists Sixguns by Keith with SMOKE OF A FORTY-FIVE on p. [2].

123. ———. New American Books and Prints and Standard Favorites from the Stackpole Library 1956. (Harrisburg, Pa.). Flyer folded to 3¼ × 6. Lists Sixguns by Keith with SMOKE OF A FORTY-FIVE on inner fold.

124. Trail's End Publishing Co., Pasadena. Rawhide Rawlins Stories by C. M. Russell and More Rawhides by C. M. Russell. Descriptive folder and order card. N.d. (ca. 1945).

125. Trail's End Publishing Co., Inc., 725 Michigan Boulevard, Pasadena 10, California. Two Books in Great Demand. Double postcard order form, size 5½ × 6½, n.d. (ca. 1946). Reproductions of RAWHIDE RAWLINS and RAWHIDE RAWLINS, MOUNTED.

126. Trail's End Publishing Co., Pasadena. Pen and Ink Drawings by C. M. Russell. Descriptive folder and order card of the two books. N.d. (ca. 1946).

127. Trail's End Publishing Co., Inc. 725 Michigan Boulevard, Pasadena 10, California. Catalog Fall and Winter [rule] 1946–1947. Authentic Western Material. Pp. 16, size 3¼ × 6. P. 16: WHERE THE BEST OF RIDERS QUIT (bronze)

128. ———. Catalog (No. 3) Western Americana, Spring, 1947. Authentic Western Material. Pp. 16, size 3¾ × 6. P. 16: WHEN (i.e., WHERE) THE BEST OF RIDERS QUIT (bronze)

129. ———. Catalog (No. 4) Western Americana, Fall and Winter, 1947–1948. Authentic Western Material. Pp. 16, size 3¾ × 6.

130. Trail's End Publishing Co. An Event in Book Publishing . . . The exhaustive, comprehensive life and works of Charles M. Russell The Cowboy Artist. Two-volume collector's edition (Twenty-five years of research). Published . . . October 24, 1948. Prospectus, folio, pp. [4], size 6¹¹⁄₁₆ × 8⅞. P. [1]: WAITING FOR A CHINOOK, i.e., THE LAST OF 5000* (color).

131. Trail's End Publishing Co., Inc. 725 Michigan Boulevard, Pasadena 10, California. Charles M. Russell, The Cowboy Artist. Postcard order form, size 3⅜ × 5½. N.d., (ca. 1948).

132. Trail's End Publishing Co., Pasadena. Charles M. Russell, The Cowboy Artist. Order card for the Adams-Britzman biography and 14 other books. N.d. (ca. 1948).

133. Trail's End Publishing Co., Inc. P.O. Box 1887, Colorado Springs, Colo. Catalog (No. 8) Western Americana. Authentic Western Material. N.d. (ca. 1950). Pp. [10], size 6 × 3⅜.

134. Trigg-Russell Gallery. This beautifully detailed model has been cast by Roman Bronze from a clay by C. M. Russell. Flyer, white stock, size 9⅜ × 3½, n.d. (1965). PIEGAN GIRL* (bronze).

135. The Trigg-Russell Memorial Gallery, 1201 Fourth Avenue North, Great Falls, Montana. An Important New Bronze By Charles M. Russell. Flyer, white stock, size $9\frac{3}{8} \times 3\frac{1}{2}$, n.d. (1965). PEACE (bronze).

136. University of Texas Press Fall & Winter 1966. Pp. [52], wrappers, size $3\frac{3}{4} \times 8\frac{7}{8}$. Front wrap.: POWDER-FACE—ARAPAHOE.

137. Whitney Gallery of Western Art, Box 1020, Cody, Wyoming. Fine Western Art Prints. Folder, size $7 \times 8\frac{1}{2}$, n.d. (1965).

138. Yale & Brown, Booksellers, Pasadena, California. Charles M. Russell. Special List No. 9, June, 1963. Mimeographed, $8\frac{1}{2} \times 14$. Lists 113 items.

Stationery

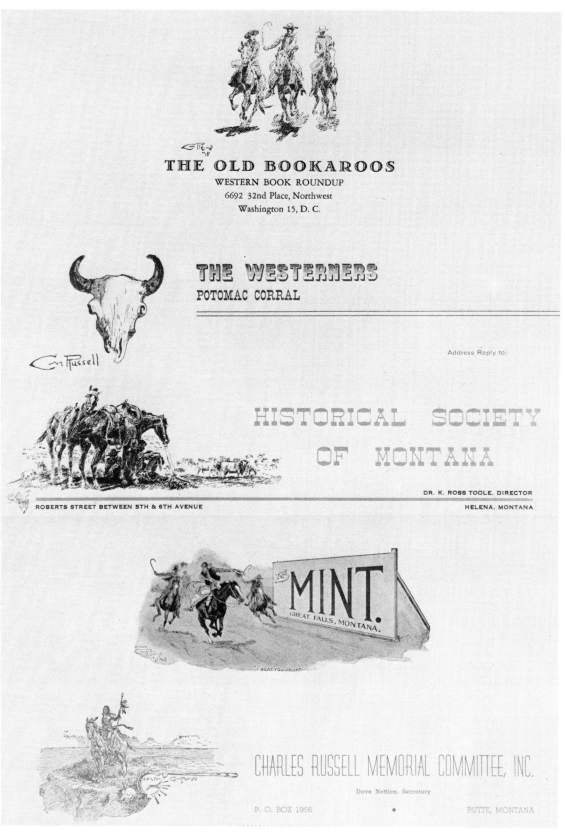

Letterheads. (Top to bottom) The Old Bookaroos—BUNCH OF RIDERS (part); The Westerners Potomac Corral—SKULL #4; Historical Society of Montana—THE MOUNTAINS AND PLAINS SEEMED TO STIMULATE A MAN'S IMAGINATION: The Mint—I BEAT YOU TO IT: Charles Russell Memorial Committee, Inc.—AH-WAH-COUS.

See items 52, 84, 29, 42, and 69, this section.

SECTION XIV

Stationery

BOXED STATIONERY

1. Charles M. Russell Western Stationery. Glacier Stationery Co. INDIAN HEAD #5 on cover. From Montana, "The Land of Shining Mountains." Size 8½ × 11. THE TRAIL BOSS on paper; AH-WAH-COUS on envelopes.

2. Charles M. Russell Western Stationery. Glacier Stationery Company, Great Falls, Mont. Photo of CMR on folder. Size 8½ × 11. HOLDING UP THE OVERLAND STAGE on paper; AH-WAH-COUS on envelopes.

3. C. M. Russell Famous Western Artist [illustration] C. M. Russell "HORSE WRANGLER" (a self portrait). Stationery box, size 6½ × 8¾, containing 18 "HORSE WRANGLER," i.e., IL BE THAIR WITH THE REST OF THE REPS, letterheads, 6 white plain sheets, and 18 envelopes. Historical Society of Montana (1963). Also contains an explanatory note by Michael Stephen Kennedy, white stock, size 6 × 8, printed one side only.

4. C. M. Russell Correspondence Notes. White box, 6½ × 4½, with SCOUTING THE CAMP in color on top. Contains 12 notes (6 scenes) folded once to size 5$\frac{15}{16}$ × 3$\frac{15}{16}$, in color, with envelopes. Broadside explanation by Michael Kennedy inserted. Issued by Historical Society of Montana, n.d. (ca. 1962).
I'M SCAREDER OF HIM THAN I AM OF THE INJUNS
INTRUDERS
NATURE'S SOLDIERS
SCOUTING THE CAMP
SQUAW TRAVOIS
WHEN COWS WERE WILD
Variant: WHEN COWS WERE WILD in color on top. Contents the same.

5. Correspondence Notes from C. M. Russell Original Paintings. Box has transparent plastic top, printed on end: "All Rights Reserved, Historical Society of Montana. Published by Big Sky Art Supply, Polson, Montana." Contains 12 note sheets (6 scenes) folded once to size 5$\frac{7}{8}$ × 3$\frac{7}{8}$, in color, with envelopes. Also contains explanatory note by Kennedy.
AMERICA'S FIRST PRINTER
BUFFALO HUNT #22
INSIDE THE LODGE
LEWIS AND CLARK MEETING THE FLATHEADS (i.e., INDIANS) AT ROSS' HOLE
WAITING WARRIOR
YORK

6. C. M. Russell Western Notes. A choice collection of old west scenes from originals in the Charles M. Russell room, State Historical Society, Helena. White box, size 5½ × 4⅜, with foregoing printed on yellow background. Contains 12 folded note sheets, size 5 × 4, with envelopes.
ABOUT THE THIRD JUMP CON LOOSENS
COWBOY SEATED, HORSE NUZZLING HIS LEFT HAND
FROM THE SOUTHWEST COMES SPANISH AN' MEXICAN TRADERS
LADY BUCKEROO*
LIKE A FLASH THEY TURNED
THE MOUNTAINS AND PLAINS SEEMED TO STIMULATE A MAN'S IMAGINATION
THE ODDS LOOKED ABOUT EVEN
A RACE FOR THE WAGONS
RAWHIDE RAWLINS MOUNTED
SPREAD-EAGLED
STEER RIDER #2*
WE AIN'T GONE FIVE MILE WHEN THE COACH STOPS

7. Olde West Stationery. White stock, size $5\frac{1}{4} \times 6\frac{7}{8}$, ca. 1950. The following line drawings with color superimposed on individual sheets:

HOLDING UP THE OVERLAND STAGE
THE CHRISTMAS DINNER
THE LAST OF THE BUFFALO
THE INDIAN OF THE PLAINS AS HE WAS
THE BIG STACK IS OUR LANDMARK (part)

8. Olde West Stationery. Writing kit containing 10 sheets of paper, $5\frac{1}{4} \times 7\frac{1}{2}$, with colored illustrations, 10 plain sheets, and 10 envelopes. Produced by Electric City Printing Co. of Great Falls, ca. 1950.

THE INDIAN OF THE PLAINS AS HE WAS
THE CHRISTMAS DINNER
HOLDING UP THE OVERLAND STAGE
THE LAST OF THE BUFFALO
THE BIG STACK IS OUR LANDMARK (part)

9. Note Stationery Assorted CMRussell Scenes From Originals in Whitney Gallery of Western Art. White box, size $6\frac{1}{2} \times 4\frac{9}{16}$, with HIS HEART SLEEPS in color, and words "From a CMRussell original painting" on top. Contains 14 note sheets (7 scenes) folded once to size 6×4, in color, with envelopes. Broadside explanation by Harold McCracken inserted. Issued by Whitney Gallery of Western Art, n.d., ca. 1963.

HIS HEART SLEEPS #1
IN (THE) ENEMY COUNTRY
THE LAST OF 5000
READY FOR BATTLE*
SELF-PORTRAIT #4
TRAIL'S END
WHERE GREAT HERDS COME TO DRINK

10. A Russell Collection. Personal Stationery from Paintings by Charles M. Russell. Stationery box, size $7\frac{7}{8} \times 10\frac{7}{8}$, containing 12 sheets of each of THE BUCK I KILLED*; THE COWBOY-ROPER*; and TAKE ONE WITH ME FRED; 36 envelopes; and 14 blank second sheets. Also contains an explanatory note, white stock, $4\frac{1}{2} \times 6$. Leanin' Tree Pub'l. Co., Boulder, Colorado, U.S.A., n.d. (1965).

11. White stock, size $8\frac{3}{4} \times 10\frac{7}{8}$ (loose sheets). PAINTING THE TOWN.

12. Western Sport Notes. Send Your Message on Pages from the West. Tablet, unruled, size $7 \times 10\frac{1}{2}$. Illustration on cover. THE KILL.

LETTERHEADS

13. American Society of Range Management. To Foster Advancement in the Science and Art of Grazing Land Management. White stock, size $8\frac{1}{2} \times 10\frac{7}{8}$. THE TRAIL BOSS (part), lower left corner.

14. Bill Arnold. White stock, size $4\frac{7}{8} \times 7$. HAVE ONE ON ME.

15. Bill Arnold. White stock, size $5\frac{3}{8} \times 7\frac{1}{2}$. THE BIG STACK IS OUR LANDMARK.

16. Fred Barton. White stock, also green, size $8\frac{1}{2} \times 11$. COWBOY MOUNTED #1, upper left, and INDIAN MOUNTED #2, upper right.

17. Bull Head Lodge. White stock, $7\frac{1}{4} \times 10\frac{7}{8}$, "process printed" in brown ink. SKULL #1.

18. Central Cigar Store. White stock, size $7\frac{1}{8} \times 10\frac{1}{2}$, ca. 1901. ROUND UP IN GREAT FALLS.

19. The Charles M. Russell Book. Cream stock, size $8\frac{1}{2} \times 11$.

BEST WHISHES TO THE P–C BUNCH
DROPPIN' THE HAIR HE REACHES FOR THE JEWELED HAND
LIKE A FLASH THEY TURNED
FAWNS NUZZLING FOR DINNER

20. Henry W. Collins. Portland, Oregon. White stock, size $7\frac{1}{4} \times 14\frac{3}{4}$, including foldover flap at top. N.d. (ca. 1931). PENDLETON COWBOY (color).

21. Rev. Jackson E. Gilliam, 600 Third Avenue North, Great Falls, Montana. White stock, size $5\frac{1}{4} \times 8\frac{1}{4}$. THE LAST OF THE BUFFALO (pen sketch with color superimposed).

22. Max Grettenberg, Great Falls, Montana. White stock, size $5\frac{1}{2} \times 7\frac{7}{8}$. Ca. 1952. THE BIG STACK IS OUR LANDMARK (part) (pen sketch with color superimposed).

23. Hagenson's Cigar Store, Butte. Headquarters for all sporting events. 18 East Park Street, Phone 558, Butte, Montana. White wove stock, size $7\frac{1}{8} \times 10\frac{1}{2}$, brown ink. ROUND UP IN GREAT FALLS.

24. Produced by Harry Hillstrand, Electric City Printing Co., Great Falls. These may appear with any name overprinted. White stock, size $5\frac{1}{4} \times 8\frac{1}{4}$. The illustrations were originally pen and ink, but they have been made into color plates.

THE CHRISTMAS DINNER
THE LAST OF THE BUFFALO
HOLDING UP THE OVERLAND STAGE
THE INDIAN OF THE PLAINS AS HE WAS
THE BIG STACK IS OUR LANDMARK (part)

25. Historical Society of Montana, Publisher of Montana, The Magazine of Western History, Read in Every State in the Union. White stock, size $8\frac{1}{2} \times 7$. WILD MEN THAT PARKMAN KNEW.

26. Historical Society of Montana, Helena, Montana. Grey stock, size $5\frac{1}{2} \times 8\frac{1}{2}$. WILD MEN THAT PARKMAN KNEW.

27. Historical Society of Montana. Pink stock, size $8\frac{1}{2} \times 11$. Adaptation of C. M. Russell signature and skull.

28. Historical Society of Montana, Michael Kennedy, Director. [1 line] White stock, size $8\frac{1}{2} \times 11$. THE TRAIL BOSS.

29. Historical Society of Montana. Dr. K. Ross Toole, Director. White stock, two sizes, $8\frac{1}{2} \times 11$ and $8\frac{1}{2} \times 7$, red and black ink. THE MOUNTAINS AND PLAINS SEEMED TO STIMULATE A MAN'S IMAGINATION.

30. C. Bland Jamison, 3057 Queensbury Drive, Los Angeles 64, California. White stock, size $8\frac{1}{2} \times 11$. COWBOY TWIRLING LARIAT LONGHORNS RUNNING COWBOY ABOUT TO SADDLE HORSE (in lower left corner)

31. C. Bland Jamison, 3057 Queensbury Drive, Los Angeles 64, California. White stock, size $8\frac{1}{2} \times 11$. FOUR COWBOYS GALLOPING COWBOY ON A SPREE (in lower left corner)

32. C. Bland Jamison, 3057 Queensbury Drive, Los Angeles 64, California. White stock, size $8\frac{1}{2} \times 11$. BULL AND COW BUCKING HORSE (in lower left corner)

33. Dick Jones Picture Co., P. O. Box 487, Huntington Park, California. White stock, size $5\frac{1}{4} \times 6\frac{3}{4}$. THE BIG STACK IS OUR LANDMARK (part) (pen sketch with color superimposed).

34. Dick Jones Picture Co., P. O. Box 487, Huntington Park, California. White stock, size $5\frac{1}{4} \times 6\frac{3}{4}$. THE INDIAN OF THE PLAINS AS HE WAS (pen sketch with color superimposed).

35. Dick Jones Picture Co., P. O. Box 487, Huntington Park, California. Headquarters for Chas. M. Russell Material. White stock, size $8\frac{1}{2} \times 11$. THE COWBOY #2 (obverse).

36. Dick Jones Picture Co. Wholesale and Retail. C. M. Russell Western Color Reproductions, 6805 Seville Avenue, Huntington Park, California, Kimball 4042. White stock, size $8\frac{1}{2} \times 11$. THE COWBOY #2 in lower left corner.

37. R. O. "Dick" Jones. Established 1930 A. M. Jones, Dick Jones Picture Co. [1 line] C. M. Russell Western Color Reproductions [2 lines] White stock, size $8\frac{1}{2} \times 11$. THE COWBOY #2 in lower left corner.

38. Memo From Michael S. Kennedy. White stock, size 6×8. HORSE WRANGLER, i.e., IL BE THAIR WITH THE REST OF THE REPS (color) .

39. Memo from Michael Kennedy. Tan stock, size $7 \times 9\frac{1}{2}$. Adaptation of C. M. Russell signature and skull.

40. [Jesse Knight], Raymond, Alberta. White stock, size $8\frac{1}{4} \times 10\frac{3}{4}$. RAY KNIGHT ROPING A STEER*.

41. K. S. Kurtenacker. 5007 West Bancroft Street, Toledo, Ohio, 43615. White stock, size $8\frac{1}{2} \times 11$. JIM BRIDGER (bronze).

42. The Mint, Great Falls, Montana. White stock, size $8\frac{1}{2} \times 10\frac{7}{8}$. I BEAT YOU TO IT* (color).

43. The Mint, Great Falls, Montana—Bar—Lunch Counter, Phone 4841. White stock, size $8\frac{1}{2} \times 10\frac{3}{4}$. I BEAT YOU TO IT (color).

44. The Mint. R. M. Burris Pres. & Treas. S. A. Willis Vice-Pres. & Sec'y. White stock, size $8\frac{1}{2} \times 11$. I BEAT YOU TO IT (color).

45. Montana Fine Arts Commission, Capitol Station, Helena, Montana. White stock, size $8\frac{1}{2} \times 11$. SKULL #1.

46. Montana Historical Society. White stock, $7 \times 9\frac{1}{2}$. THE TRAIL BOSS, left top; note on the drawing, right top.

47. Montana Historical Society. Roberts at Sixth Avenue, Helena, Montana. Michael Stephen Kennedy, Director. Cream stock, size $8\frac{1}{2} \times 11$; also blue stock. FLATBOAT ON RIVER, FORT IN BACKGROUND.

48. Montana Historical Society. Pink stock, size $7\frac{1}{4} \times 10$, also $8\frac{1}{2} \times 11$. Adaptation of C. M. Russell signature and skull.

49. [Montana The Magazine of Western History]. Pink stock, size $8\frac{1}{2} \times 11$, with watermark of the Great Seal of the State of Montana. Adaptation of C. M. Russell signature and skull at top center. Used in 1962.

50. Melvin J. Nichols, 65 Edgewood Road, Summit, N. J. Tallyman the Westerners New York Posse. White stock, size $5\frac{1}{4} \times 6\frac{3}{4}$ with fabricated color print of HOLDING UP THE OVERLAND STAGE top center.

51. Van Kirke Nelson, M.D., 216 Buffalo Block, Kalispell, Montana. Collector of Western Americana. White stock, size $8\frac{1}{2} \times 11$. WHERE IGNORANCE IS BLISS, upper left corner.

52. The Old Bookaroos. Western Book Roundup. 6692 32nd Place Northwest, Washington 15, D.C. White stock, size $8\frac{1}{2} \times 11$. BUNCH OF RIDERS (part).

53. Park Saddle Horse Company. General address: Kalispell, Montana. During Park Season: Glacier Park, Montana. Glacier National Park, Kalispell, Montana. Bar X 6. White stock, size $7\frac{3}{16} \times 10\frac{1}{2}$. Envelopes also. WRANGLING THE DUDES.

54. Rancho Linda Vista, Oracle, Arizona. Off-white stock, size $7\frac{1}{2} \times 10\frac{1}{2}$, brown ink. A BAD HOSS in brown and blue, upper left corner.

55. From the desk of Fred C. Renner. White stock, size 7×10. Letterpress in upper right corner, ostensibly explaining THE TRAIL BOSS (part) in upper right.

56. Fred Renner. White stock, size $5\frac{1}{4} \times 8\frac{1}{4}$. THE CHRISTMAS DINNER (pen sketch with color superimposed).

57. Frederic G. Renner, 6692 32nd Place Northwest, Washington, D. C., at top. Member The American Society of Range Management at bottom. White stock, size $8\frac{1}{2} \times 11$, green ink. Illustration at lower left, THE TRAIL BOSS (part).

58. W. T. Ridgley Printing Works, Great Falls, Montana. Printing, Calendar Manufacturing. Reproductions from paintings of C. M. Russell. White stock, size $8\frac{1}{2} \times 11$. Pen sketch in lower left corner. SNOW-SHOES, RIFLE, POWDER HORN HANGING ON DEER HEAD*.

59. Ridgley Calendar Co. Charles Schatzlein, Pres. Chas. M. Russell, Vice-Pres. August Beste, Manager. Ridgley Calendar Co., Printers and Publishers "The C. M. Russell Pictures," Great Falls, Montana. White stock, size $8\frac{1}{2} \times 11$. List of 21 prints down left margin, illustration in color in upper left corner. THE FIRST FURROW.

60. Ben R. Roberts. Reproductions from original paintings of Chas. M. Russell. Characters and incidents of the Old West fast fading away. 107 No. Warren St., Helena, Montana. Upper left: photo of CMR in shape of palette with 2 lines: Chas. M. Russell, The Cowboy Artist. Upper right: Russell's buffalo skull hieroglyph followed by 2 lines: Chas. M. Russell's Trade Mark. White stock, size $8\frac{3}{8} \times 10\frac{7}{8}$, black ink.

61. [Charles M. Russell]. White stock, size $8\frac{1}{2} \times 11$, black ink. AH-WAH-COUS*.

62. SKULL #1. C. M. Russell, Great Falls, Montana, Lettering in caps. Size $6\frac{1}{4} \times 8\frac{1}{2}$.

63. SKULL #1. C. M. Russell Memorial, Great Falls, Montana. Yellow stock, size $8\frac{1}{4} \times 11$, brown ink.

64. C. M. Russell. White stock, size $8\frac{1}{2} \times 11$. "Process printed" in brown ink. SKULL #1.

65. SKULL #1. C. M. Russell. Great Falls, Montana. 190___. Tan stock, size $6\frac{1}{2} \times 9$.

66. C. M. Russell Gallery, 1201 Fourth Avenue North, Great Falls, Montana. White stock, size $7\frac{1}{4} \times 10\frac{1}{2}$. Facsimile of bronze plate on outside wall of the CMR Gallery, printed in brown and yellow ink.

67. C. M. Russell Memorial. Great Falls, Montana. Tan stock, size $7\frac{1}{4} \times 11$. SKULL #1.

68. The Charles Russell Art Fund. Sons and Daughters of Montana Pioneers. White stock, size $8\frac{1}{2} \times 11$. (Ca. 1952). TRANSPORT TO THE NORTHERN LIGHTS * (model).

69. Charles Russell Memorial Committee, Inc. Dave Nettles, Secretary. P. O. Box 1956, Butte, Montana. Cream stock, size $8\frac{1}{2} \times 11$. AH-WAH-COUS.

70. Charles M. Russell Memorial Committee. Montana Cowboys Association, Great Falls, Montana. White stock, size, $8\frac{1}{2} \times 11$, brown ink. SKULL #1.

71. The Stampede. Calgary—Alberta—Canada. August 25–30, 1919. White stock, size $7\frac{3}{4} \times 9\frac{5}{8}$. CALGARY STAMPEDE #1* in color across top. See illustration, Plate 36.

72. From John K. Standish. 2010 N. E. 61st Ave., Portland, Oregon 97213. White stock, size $8\frac{1}{2} \times 11$. FIRST AMERICAN NEWS WRITER.

73. [John K. Standish]. White stock, blue ink, size $8\frac{1}{2} \times 11$. No letterpress. N.d. (ca. 1965). COMING TO CAMP AT THE MOUTH OF SUN RIVER.

$25,000 in CASH PRIZES

Big Victory and Frontier Day Celebration

The STAMPEDE

CALGARY · ALBERTA · CANADA
:: August 25 - 30, 1919 ::

Headquarters: 309a Eighth Avenue West

PATRON:
H. G. THE DUKE DEVONSHIRE
GOVERNOR-GENERAL OF CANADA

_____ 1919

FINANCE COMMITTEE:
GEORGE LANE, CHAIRMAN
P. BURNS
A. E. CROSS
HON. A. J. MCLEAN

MANAGER:
GUY WEADICK

TREASURER:
E. L. RICHARDSON
MANAGER ADMISSION AND
CONCESSIONS

REFERENCE:
DOMINION BANK

PREMIER COWBOYS
INDIANS
RIDERS
ROPERS

BUCKING HORSES
STEERS
BULLS
COWS
BURROS
MULES

ALL PROFITS TO GO TO THE
GREAT WAR VETERANS' ASS'N
Y. M. C. A. AND THE
SALVATION ARMY

CALGARY STAMPEDE #1
Letterhead of Calgary Stampede.
See item 71, this section.

74. Silver Dollar. Philips & Rance, Great Falls, Montana. White stock, size $8\frac{1}{2} \times 11$, color print. THE BIG STACK IS OUR LANDMARK.

75. Earl Talbott, 1521 Seventh Avenue North, Great Falls, Montana. White stock, size $5\frac{3}{8} \times 8\frac{3}{8}$. Part of THE BIG STACK IS OUR LANDMARK in color at top.

76. [Earl Talbott]. No printing. White stock, size $8\frac{1}{2} \times 11$. THE LAST OF HIS RACE.

77. [Earl Talbott]. No printing. White stock, size $5\frac{1}{2} \times 8\frac{1}{2}$, color plate. THE BIG STACK IS OUR LANDMARK.

78. John Tirsell, Great Falls, Montana. White stock, size $7 \times 10\frac{1}{2}$. RED CLOUD in color, lower left corner.

79. John A. Tirsell, Great Falls, Montana. White stock, size $7 \times 10\frac{1}{2}$. AN APACHE INDIAN in color, lower left corner.

80. Trailside Galleries, Jackson, Wyoming in Jackson's Hole Valley. Cream laid stock, size $8\frac{1}{2} \times 7\frac{1}{4}$, ca. 1964. MY SHOT KILLED THE ELK* in upper right.

81. Tribune Printing & Office Supply Company P. O. Box 2468, Great Falls, Montana. Size 5×8, on various colors and kinds of paper.
THE ROAD AGENT (vignette)
THE WOOD HAWK (vignette)
THE POST TRADER (vignette)
THE STAGE DRIVER (vignette)

82. The Trigg–C. M. Russell Foundation, Inc. A non-profit corporation. Great Falls, Montana. White stock, size $7\frac{1}{4} \times 10\frac{1}{2}$. SKULL #1, top center.

83. W. E. Ward. Wholesale and Retail. Cigars, Tobacco, Pipes and Smokers' Articles. P. O. Box 375, Telephone 250, Great Falls, Montana. 190___. White stock. ROUNDUP IN GREAT FALLS.

84. The Westerners. Potomac Corral, Publishers of "Corral Dust." Cream stock, brown ink, size $5\frac{1}{4} \times 8\frac{1}{4}$. SKULL #4.

85. SKULL #4 and facsimile of C. M. Russell signature. The Westerners, Potomac Corral, Publishers of "Corral Dust." Cream stock, brown ink, size $8\frac{1}{2} \times 11$.

86. John A. Willard. AZ Ranch, Augusta, Montana. White stock, size $8\frac{1}{2} \times 11$. THE LAST OF THE BUFFALO.

ENVELOPES

87. First Word of a Major New Book by the Editors of American Heritage. White stock, $10 \times 4\frac{3}{4}$. American Heritage Publishing Co., 551 Fifth Ave., N. Y. 17. MEDICINE MAN #4 (color).

88. American Society of Range Management. White stock, No. 10 size, printed in green. Various branch office imprints. THE TRAIL BOSS (part).

89. American Society of Range Management. Office of the President. White stock, size $9\frac{1}{2} \times 4$. THE TRAIL BOSS (part).

90. Pacific Northwest Section, American Society of Range Management. White stock, size $8\frac{7}{8} \times 3\frac{7}{8}$. THE TRAIL BOSS (part).

91. Fred Barton. Buff stock, size 10×7, imprinted upper left quarter. THEN THE CALDWELLITES CHARTERED THE STAGE AND WENT HOME.

92. [Fred Barton]. Green stock, size $9\frac{1}{2} \times 4\frac{1}{8}$. THEN THE CALDWELLITES CHARTERED THE STAGE AND WENT HOME.

93. [Fred Barton]. Green stock, size $6\frac{1}{2} \times 3\frac{5}{8}$. COWBOY MOUNTED #1.

94. Charles M. Russell [13 lines]. C. Stephen Anderson. White stock, size $3\frac{5}{8} \times 6\frac{1}{2}$. Reproduces photo of C. M. Russell; SPREAD-EAGLED; and IL BE THAIR WITH THE REST OF THE REPS.

95. If you dont brand him in ten days Return to George T. Brown, "The Maverick," Great Falls, Montana. White stock, size $7\frac{1}{2} \times 5$. THIS TYPE OF COWCATCHER IS FAST DISAPPEARING in color. This envelope was used for mailing a colored print of FRIENDS I'M IN MISSOURI, size $4\frac{7}{8} \times 7\frac{3}{8}$. Issued in 1915.

96. Edward Eberstadt & Sons, 888 Madison Avenue, New York, 21, N. Y. A Catalogue of C M Russell Bronzes. SKULL #1 and THE BUCKER AND THE BUCKEROO, i.e., THE WEAVER (bronze). Size 10×7.

97. Official First Day Cover. Montana Territorial Centennial. Old Governor's Mansion, Helena, Montana. White stock, size $3\frac{5}{8} \times 6\frac{1}{2}$. CHARLES M. RUSSELL AND HIS FRIENDS (color).

98. First Day of Issue. Range Conservation To Preserve and Perpetuate the Natural and Man-Made Grazing Lands of the Nation. 1961. White stock, size $3\frac{5}{8} \times 6\frac{1}{2}$. Reproduces THE TRAIL BOSS (part).

99. First Day Cover. The Aristocrats. 100th Anniversary of the Birth of Charles Marion Russell, 1864–1926. "Greatest Artist of the Old West." [5 lines] White stock, size $3\frac{5}{8} \times 6\frac{1}{2}$.

100. First Day Cover. Montana Territory, 1964. Painter of the Old West, Charles Marion Russell. Chickering . . . Jackson. White stock, size $3\frac{5}{8} \times 6\frac{1}{2}$.

101. First Day Cover. 100th Anniversary of Charles Marion Russell 1864–1964. Greatest Artist of the Old West. Cachet Craft. White stock, orange ink, size $3\frac{5}{8} \times 6\frac{1}{2}$.

102. First Day Cover. Honoring Range Conservation. American Society of Range Management. National Convention, Salt Lake City, Utah . . . 1961. Official First Day Cover. White stock, size $3\frac{5}{8} \times 6\frac{1}{2}$. Reproduces photo of C. M. Russell and THE TRAIL BOSS (part).

103. First Day Cover. Commemorating Famous Western Artist C. M. Russell and his painting JERKED DOWN. Texas Refinery Corp., Fort Worth, Texas. White stock, size $4 \times 8\frac{7}{8}$, orange ink.

104. First Day Cover. 100th Anniversary, Charles Marion Russell, Artist. White stock, size $3\frac{5}{8} \times 6\frac{1}{2}$

105. First Day Cover. Honoring C. M. Russell, American Artist of the Old West. First Day of Issue. White stock, green and brown ink, size $3\frac{5}{8} \times 6\frac{1}{2}$. WORK ON THE ROUNDUP.

106. First Day Cover. Commemorating Great Falls Own 1864–1926 C. M. Russell Montana's Cowboy Artist. Tan stock, size $3\frac{5}{8} \times 6\frac{1}{2}$. Reproduction after CHARLES M. RUSSELL AND HIS FRIENDS.

107. First Day Cover. Commemorating Charles M. Russell, 1864–1926. Famous American Frontier Artist. First Day of Issue. Fleetwood. White stock, size $3\frac{5}{8} \times 6\frac{1}{2}$. Reproduces photo of C. M. Russell and FIRST AMERICAN NEWS WRITER.

108. First Day of Issue. Charles Marion Russell, Famous American Artist. Artmaster. White stock, size $3\frac{5}{8} \times 6\frac{1}{2}$. Reproduces photo of C. M. Russell.

109. First Day of Issue. 100th Anniversary of the Birth of Charles M. Russell The Cowboy Artist. Artcraft. White stock, size $3\frac{5}{8} \times 6\frac{1}{2}$. Reproduces LEWIS AND CLARK MEETING INDIANS AT ROSS' HOLE and CMR statue by Weaver.

110. First Day of Issue. 100th Anniversary, Charles M. Russell. Born March 19, 1864. Painter of the Old West. Fluegel Covers. White stock, size $3\frac{5}{8} \times 6\frac{1}{2}$. Reproduces photo of C. M. Russell in color.

111. First Day of Issue. Strengthen America. Scouting can make the difference. Boy Scout first day cover in honor of Charles M. Russell Merit Badge Counselor. White stock, size $3\frac{5}{8} \times 6\frac{1}{2}$. With mailing insert on pink stock, same printing, plus reference to CMR.

112. First Day of Issue. Charles M. Russell 1864–1926. Photo of CMR, and Montana Territorial Centennial seal. White stock, size $4 \times 7\frac{1}{2}$. With insert of mimeographed letter from Senator Lee Metcalf.

113. First Day Cover. No. ___ of 100. An original bronze Cowboy on a Bucking Broncho by Charles Marion Russell. The trophy award for the 1964 world's champion all-around cowboy. Presented by Trailside Galleries, Idaho Falls, Idaho. Cream stock, size $6\frac{1}{2} \times 3\frac{5}{8}$. (March 19, 1964). COWBOY ON A BUCKING BRONCHO, i.e., COWBOY ON A BUCKING BRONCO (bronze).

114. First day cover. White stock, SKULL #1 and initials CMR upper left corner, size $6\frac{1}{2} \times 3\frac{5}{8}$, bearing cachet from Salt Lake City: Blessings of Grass First Day of Issue (pertaining to Range Conservation stamp).

115. C. Bland Jamison, 3057 Queensbury Drive, Los Angeles 64, California. White stock, size $4\frac{3}{16} \times 9\frac{1}{2}$. COWBOY STANDING, RIGHT HAND ON HIP.

116. Postage Guaranteed. Return in 5 days to Dick Jones Picture Co., 6805 Seville Avenue, Huntington Park, California. White stock, size $9\frac{1}{2} \times 4\frac{1}{8}$. THE COWBOY #2.

117. Postage Guaranteed—After 10 days return to Dick Jones Picture Co., P. O. Box 487, Huntington Park, California. White stock, size $9\frac{1}{2} \times 4\frac{1}{8}$. THE COWBOY #2.

118. Postage Guaranteed—After 10 days return to Dick Jones Picture Co., 6805 Seville Avenue, Huntington Park, California. White stock, size $7\frac{1}{2} \times 4$. THE COWBOY #2.

119. The Mint, Great Falls, Montana. White stock, size $9\frac{1}{2} \times 4\frac{1}{8}$. I BEAT YOU TO IT (color).

120. The Mint, Great Falls, Montana. White stock, size $6\frac{3}{4} \times 3\frac{3}{4}$. I BEAT YOU TO IT (color).

121. Historical Society of Montana, Roberts and Sixth Avenue, Helena, Montana. White stock, size $9\frac{1}{2} \times 4\frac{1}{8}$. THE MOUNTAINS AND PLAINS SEEMED TO STIMULATE A MAN'S IMAGINATION.

122. This rare C. M. Russell line drawing is reproduced by the Historical Society of Montana, Helena. White stock, size $7\frac{1}{2} \times 3\frac{7}{8}$. THE TRAIL BOSS.

123. Size $9\frac{1}{2} \times 4$, cream stock. WILD MEN THAT PARKMAN KNEW in upper left corner.

124. Historical Society of Montana. Roberts and Sixth Avenue, Helena, Montana. White stock, size $7\frac{1}{2} \times 4\frac{1}{8}$. THE MOUNTAINS AND PLAINS SEEMED TO STIMULATE A MAN'S IMAGINATION.

125. Montana Fine Arts Commission. Capitol Station, Helena, Montana. White stock, size $9\frac{1}{2} \times 4\frac{1}{8}$. WILD MEN THAT PARKMAN KNEW.

126. Montana Historical Society. White stock, size $9\frac{1}{2} \times 4\frac{1}{8}$, printed in blue and red. Airmail. THE SCOUT #4 at left edge.

127. Montana Historical Society [2 lines]. White stock, $11\frac{5}{8} \times 8\frac{3}{4}$. SCOOL MARM.

128. Montana Historical Society, Roberts and Sixth Avenue, Helena. Publisher of Montana, the Magazine of Western History. White stock, size $9\frac{1}{2} \times 4\frac{1}{8}$. THE SCOUT #4.

129. Montana, The Magazine of Western History. Roberts Street, Helena, Montana. White stock, size 9×6. THE TRAPPER.

130. Montana, The Magazine of Western History, 6th and Roberts, Helena, Montana, 59601. Return postage guaranteed. White stock, size $8\frac{1}{4} \times 11\frac{1}{4}$. THE SCOUT #4.

131. Montana, the magazine of western history, Historical Society of Montana, Helena. The only authentic magazine of the whole true west. Devoted to action, adventure, superb color and exciting, factual incident. White stock, size $6\frac{1}{2} \times 3\frac{5}{8}$, brown ink. THE SCOUT #4.

132. Montana Historical Society. White stock, No. 7 size. THE TRAIL BOSS.

133. Montana Historical Society. White stock, size $9\frac{5}{16} \times 4\frac{1}{4}$. Adaptation of C. M. Russell signature and skull.

134. Charles Marion Russell, Cowboy—Montana Artist, 1864–1926. Van Kirke Nelson, M.D., Buffalo Block, Kalispell, Montana. White stock, size $3\frac{7}{8} \times 7\frac{1}{2}$. WHERE IGNORANCE IS BLISS.

135. Van Kirke Nelson, M.D., Kalispell, Montana. Cowboy Montana Artist, Charles Marion Russell, 1864–1926. White stock, size $3\frac{7}{8} \times 7\frac{1}{2}$. YES, THE MICE-PEOPLE ALWAYS MAKE THEIR NESTS IN THE HEADS OF THE DEAD BUFFALO-PEOPLE.

136. Park Saddle Horse Company. Glacier National Park. U.S. Government Licensed Outfitters. Kalispell, Montana. Ca. 1925. White stock, size $7\frac{1}{2} \times 3\frac{7}{8}$. WRANGLING THE DUDES.

137. Range Conservation stamp, enlarged photo. White stock, size $4\frac{1}{8} \times 9\frac{1}{2}$, printed in green.

138. Range Conservation. United States. Postage 4¢. White stock, size $4 \times 9\frac{1}{2}$. THE TRAIL BOSS (part).

139. S. H. Rosenthal, 5070 Gloria Ave., Encino, Calif. Limited to 42 numbered copies. White stock, size $3\frac{7}{8} \times 7\frac{1}{2}$. TRAIL OF THE IRON HORSE #1*.

140. S. H. Rosenthal. 29 copies printed on photographic paper, cut by hand to form finished envelope, used as "First Day Cover" for philatelic mailing, February 2, 1961, on first day of issue of Range Conservation postage stamp. White stock, size $3\frac{7}{8} \times 7\frac{1}{2}$. BLACKFEET.

141. C. M. Russell, 1201 Fourth Avenue North, Great Falls, Montana. C. M. Russell in script and buffalo skull upper left corner. White stock, size $7\frac{1}{2} \times 3\frac{7}{8}$, brown ink.

142. C. M. Russell Memorial, Great Falls, Montana. Tan stock, size $6\frac{1}{2} \times 3\frac{5}{8}$, brown ink. SKULL #1.

143. John K. Standish. 2010 N. E. 61st Avenue, Portland, Oregon 97213. White stock, size $9\frac{1}{2} \times 4$. THE MEDICINE MAN #3.

144. John K. Standish. 2010 N. E. 61st Avenue, Portland, Oregon 97213. White stock, size $6\frac{1}{2} \times 3\frac{5}{8}$. NORTHERN TRADER*.

145. Earl Talbott. White stock, size $8\frac{7}{8} \times 3\frac{7}{8}$. AH-WAH-COUS.

146. No. ___ of 100 Honoring Charles Marion Russell 1864–1964. Cream stock, size $6\frac{1}{2} \times 3\frac{5}{8}$. (Trailside Galleries, 1964).

147. No. ___ of 100 Honoring Charles Marion Russell 1864–1964. Cream stock, size $6\frac{1}{2} \times 3\frac{5}{8}$. (Trailside Galleries, 1964). GOOD LUCK.

148. The Trigg–C. M. Russell Foundation, Inc. P. O. Box 1926, Great Falls, Montana. White stock, size 9×6. SKULL #1, upper left.

149. Tribune Leader, Great Falls, Montana. White stock, size $8\frac{7}{8} \times 3\frac{7}{8}$ (1964). MOTHERS UNDER THE SKIN*. Inserted, a printed card of description.

150. The Westerners. Potomac Corral, Publishers of "Corral Dust." Cream stock, brown ink, size $6\frac{1}{2} \times 3\frac{5}{8}$. SKULL #4.

BOOKPLATES

151. Albert Forrest Longeway. Two sizes, 5×7 and 4×5. Great Falls, n.d., ca. 1939. THE MEDICINE MAN #3*.

152. Frederic G. Renner. Size $3\frac{3}{8} \times 4\frac{1}{2}$. THE TRAIL BOSS (part).

153. From the Library of C. M. Russell [buffalo skull]. White stock, size $2\frac{5}{8} \times 3$.

154. H. E. Britzman. Two sizes, $3\frac{3}{4} \times 5\frac{1}{2}$ and $2\frac{3}{4} \times 4$. Two line engravings: RIDER OF THE ROUGH STRING (pen and ink adaptation from oil painting) and COWBOY SPORT—ROPING A WOLF (pen and ink adaptation from oil painting).

155. Christoph Keller. Size $5\frac{5}{8} \times 3\frac{1}{8}$. MONTANA MORNING* (pen sketch).

156. Ex Libris William L. Murphy. Size $4\frac{7}{8} \times 6\frac{3}{4}$, white stock. AMERICA'S FIRST PRINTER in color.

157. Ex Libris James Willard Schultz. Size 5×7, white stock. THE MEDICINE MAN #3.

BUSINESS CARDS

158. Ashton Printing & Engraving Co. W. H. (Bill) Chase, General Manager. Color printers for Montana. Ph. 792-0461. 112 Hamilton, Butte, Montana. Size $3\frac{1}{2} \times 2\frac{1}{4}$. WHEN COWS WERE WILD (color).

159. C. M. Russell Gallery. Russell Prints and Books. 1201 Fourth Ave., No., Great Falls, Montana. Mrs. Robb R. Williams, Curator. White stock, size $3\frac{3}{8} \times 1\frac{7}{8}$. SKULL #1.

160. Flathead Lake Galleries. P. O. Box 426, Bigfork, Montana 59911. Card, $3\frac{1}{2} \times 2$. ASSINIBOIN WAR PARTY (color).

161. The Historical Society of Montana, Michael Kennedy Director, Helena, Montana. White stock, size $3\frac{1}{2} \times 2$ with BUCKING HORSE, reduced in size, overprinted in red.

162. Wesley Holm. White stock, size $3\frac{5}{8} \times 2\frac{3}{16}$. SMOKE OF A FORTY-FIVE on reverse.

163. C. Bland Jamison Collector of Western Paintings. Gray stock, size $3\frac{3}{8} \times 2\frac{1}{2}$. COWBOY STANDING, RIGHT HAND ON HIP.

164. Reproductions from original Paintings by Chas. M. Russell, Famous Cowboy Artist. Ben R. Roberts, 107 N. Warren St., Helena, Montana. White stock, size $2\frac{3}{8} \times 4\frac{1}{4}$, also $5\frac{7}{16} \times 3$. THE FIRST FURROW.

BUSINESS FORMS

165. Flathead Lake Galleries on Bigfork Bay, Bigfork, Montana. Box 426. "Speed memo," white stock, size $8\frac{1}{2} \times 7$. THE DANCER*.

166. Bank check on the First National Bank, issued by The Mint, 218–220 Central Avenue, Great Falls, Montana. Size $8\frac{3}{8} \times 3\frac{3}{8}$. I BEAT YOU TO IT.

IDENTIFICATION CARD

167. Issued by the American Society of Range Management. Size $2\frac{1}{2} \times 3\frac{3}{4}$. Bears THE TRAIL BOSS (part), overprinted.

MEMBERSHIP CARD

168. Montana Heritage Foundation. Size $3\frac{1}{2} \times 2$, white stock, ca. 1965. BRIDGER DISCOVERS THE GREAT SALT LAKE.

MAILING LABEL

169. Size $4\frac{1}{2} \times 3$. To [3 lines] from [SKULL #1] C. M. Russell, Great Falls, Montana.

STATEMENT FORMS

170. Dick Jones Picture Co., P. O. Box 487, Huntington Park, Calif. White stock, $6\frac{1}{2} \times 7$. THE COWBOY #2 in upper left corner.

171. Great Falls, Montana . . . 190___. In Account with C. M. Russell. White stock, size $8\frac{1}{2} \times 4\frac{3}{4}$, ruled. SKULL #1 upper left corner.

STATEMENT OF DUES

172. American Society of Range Management. THE TRAIL BOSS (part).

CHRISTOPH KELLER

MONTANA MORNING

THE MEDICINE MAN #3

AMERICA'S FIRST PRINTER

THE TRAIL BOSS (part)

See items 170, 166, 171, and 167, this section.

Related Objects

SECTION XV

Related Objects

ADAPTATIONS

1. The Advertising Club of Great Falls presents a "First Day Cover" program noon luncheon, Thursday March 19, 1964, to celebrate the first day of issue of the C. M. Russell Commemorative Postage Stamp. Ticket, size 3 × 6, tan stock, with COMPANY FOR BREAKFAST (adaptation of THE PROSPECTORS) at top.

2. Early Days. Noted Occurrences on the line of the Colorado Midland Railway. C. H. Schlacks, H. C. Bush, C. H. Speers, Genl. Mgr., Traffic Mgr., Asst. Genl. Passr. Agt. There is no title page. Foregoing description is of front cover. N.d., ca. 1901. Pp. [44]. Folio, size 11 × 9. Bound in pictorial wrappers over boards. This item consists of 11 colored illustrations, one of them a gatefold, printed on recto only. Preceding each plate is letterpress on a tissue guard, printed recto only. Perhaps we should say collation is 22 leaves. The last plate is BRONCHO BREAKING. The text on the tissue guard preceding this plate says (among other things): "In the picture accompanying this, the artist (Russell of Great Falls, Montana, known as the Cowboy Artist), has given a typical scene of daily occurrence on the range." The letterpress also bears a reference to the number of cattle shipped in 1900, which fixes the date of the publication. The Russell plate is undated and unsigned. It is of the 1890 vintage. It has obviously been worked over by an unknown hand from a Russell painting.

3. *The Development of the United States*, by Wilson Porter Shortridge. New York, Macmillan, 1929. P. 521: Cowboys at the Round-up. "This drawing is made from a painting by C. H. Russell." It is an adaptation of JERKED DOWN in pen by an unidentified artist.

4. The Supreme Master of Western Art. Portrait of CMR by Bill Arnold superimposed on a copy by Arnold of WHEN I WAS A KID. Size 10 × 12¾ and 3¹³⁄₁₆ × 5. N.d. (1943).

5. Uke's Sports. Montana Territorial Centennial Commission is pleased to appoint Uke's Sports 114 Central Avenue, Great Falls, Montana, Exclusive distributors for the official Montana Centennial sweat shirt and T-shirts. Flyer, folio, yellow stock, size 8½ × 11, n.d. (1964). Adaptations on:

p. [2]: SAYS HES AN ELK

 THE INDIAN OF THE PLAINS AS HE WAS

 THE BIG STACK IS OUR LAND MARK

 HOLDING UP THE OVERLAND STAGE

6. Northwest Montana Centennial Program Book. O'Neil Printers, Kalispell, Montana, 1964. Both faces of Montana Territorial Centennial medallion shown on front cover.

ASHTRAYS

7. Ceramic oval, about six inches, longer diameter, with adaptation by unknown artist of a Russell skull in black and signature in brown.

8. Set of four, size 2⅛ diameter.
a) THE BUCKING BRONCO #1
b) THE BOLTER #3
c) unknown, not seen
d) unknown, not seen

BANK

9. Coin bank in the form of bust of CMR with hat, executed by C. Dennis, 1962. Available in copper or

bronze finish through Central Bank of Montana, Great Falls, Montana. Height 6⅛.

BEER TRAY

10. Tin, size 12 outside diameter, 9⅜ inside diameter. Lithograph by Chas. W. Shonk Co., Chicago. Copyright 1904 by the Morrison Co. A WEAVER*.

BLOTTERS

11. Issued by the Thos. D. Murphy Co., Red Oak, Iowa. Size 5½ × 10. (A) TIGHT DALLY AND (A) LOOSE LATIGO.

12. Issued by Electric City Printing Co., Great Falls. Size 4 × 9, in two colors, cream and green.
THE CHRISTMAS DINNER
HOLDING UP THE OVERLAND STAGE
THE BIG STACK IS OUR LANDMARK (part)

13. Issued by The Osborne Co., Clifton, New Jersey. Size 9⅛ × 3⅞, white face, blue border.
WHEN HORSES TURN BACK THERE'S DANGER AHEAD
THE PIPE OF PEACE, i.e., WILD MAN'S TRUCE
WHEN THE NOSE OF A HORSE BEATS THE EYES OF A MAN
WHO KILLED THE BEAR, i.e., THE PRICE OF HIS HIDE
MEAT'S NOT MEAT 'TIL IT'S (i.e., TILL ITS) IN THE PAN
(THE) CALL OF THE LAW
THE WARNING SHADOWS, i.e., WHEN SHADOWS HINT DEATH
LOOPS AND SWIFT HORSES ARE SURER THAN LEAD
[THE] RED MAN'S WIRELESS
WHOSE MEAT?
THE SLICK EAR
WHEN (i.e., WHERE) TRACKS SPELL MEAT

BOOKENDS

14. Likeness of CMR fashioned by J. M. Marchand, cast in plaster, in bronze or copper color. Ca. 1929.

15. Bust of CMR by John B. Weaver cast in Vatican Art Stone.

16. Executed by Jesse Lincoln, of CMR, hat on, hand to chin. Adapted from Ecklund's last photo. Cast metal, size 4½ × 6.

BUSTS

17. Simulated bronze plaster replica of bust of CMR from full-length statue by John Weaver in Statuary Hall, Capitol Building, Washington, D.C. Issued by Montana Historical Society. Distributed by Montana Fine Arts Commission, 1958. Height 10¼ on base 4¼ by 4½.

18. Executed by John M. Marchand from model cast by Roman Bronze Works, dated February, 1905. Twelve casts. 1959.

BUTTON

19. Distributed by American Society of Range Management. 2⅛ diameter, bears THE TRAIL BOSS (part).

CALENDARS

20. W. T. Ridgley Printing Company, Brown and Bigelow, The Osborne Company, Lewis F. Dow Co., U. O. Colson Co., and the Thos. D. Murphy Co. (and perhaps others) printed calendars with Russell illustrations for hundreds, perhaps, thousands, of customers. We have made no attempt to list all the individual names of distributors of these calendars.

CAR STICKER

21. Issued by "The Mint." Size 4 × 13. I BEAT YOU TO IT.

CIGAR BOXES

22. Chas. M. Russell cigars. Photo of CMR (bust) inside box lid and on outside end. (#1)

23. Chas. M. Russell cigars. CMR on horse inside box lid. (#2)

COLORING SET

24. Color-your-own C. M. Russell Original Coloring Set with Frames. Yellow envelope, size 11¹⁵⁄₁₆ × 14, with WHEN COWS WERE WILD; WAITING WARRIOR; AMERICA'S FIRST PRINTER; and INSIDE THE LODGE in color on front. Contents: four crude outline drawings, not by CMR, of these same illustrations. Issued by Big Sky Art Supply, 1964.

DECALCOMANIA TRANSFERS

25. The Meyercord Co., Pacific Coast Division, in 1964 issued two sets of 16 transfers, one opaque, the other transparent. Each transfer is 2½ × 3¾, and a sheet of 8 transfers, with margins, is 11¼ × 8. These are the "Western Types," but some titles are wrong.
THE COWBOY #2
THE PROSPECTOR
THE STAGE DRIVER
THE SCOUT #4
THE TRAPPER
[THE] WOOD HAWK
HALF BREED TRADER, i.e., THE POST TRADER
RED RIVER BREED, i.e., A FRENCH HALF-BREED

Cigar Box #2
See item 23, this section.

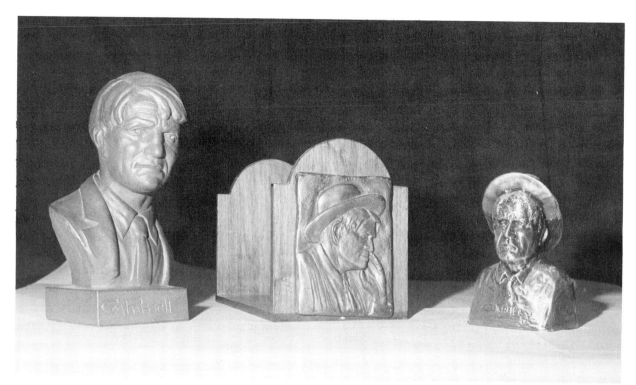

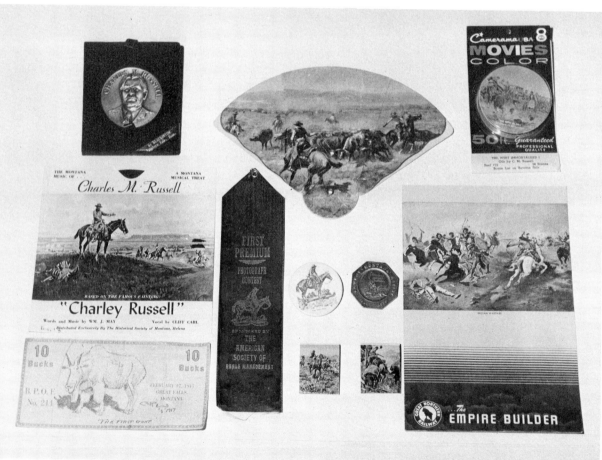

Numerous related objects described in this section.

THE BULL WHACKER

FLATHEAD SQUAW AND PAPOOSE, i.e., BLACKFEET SQUAW
 AND PAPPOOSE

YOUNG SIOUX SQUAW, i.e., SQUAW WITH BULLBOAT

BUFFALO MAN, i.e., THE WOLFER

NORTHERN CREE, i.e., THE CREE INDIAN

THE STAGE ROBBER, i.e., THE ROAD AGENT

BUFFALO HUNTER, i.e., THE SIOUX BUFFALO HUNTER

Adaptation of CMR skull and signature

DUSTWRAPPERS

26. *Soldiers of the Plains*, by Patrick Edward Byrne. Minton Balch & Company, New York, 1926. Reproduces THE INDIAN OF THE PLAINS AS HE WAS in black and white.

27. *The Long Shadow*, by B. M. Bower. Grosset & Dunlap, N.Y., n.d. Reproduces A RIFLE CRACKED AND BOB TOPPLED LIMPLY TO THE GRASS in color.

28. *Bunch Grass and Blue Joint*, by Frank B. Linderman. Charles Scribner's Sons, New York, 1921. Reproduces A BAD HOSS in black and white.

29. *The Pioneer West*, by Joseph Lewis French. Garden City Pub'l. Co., Garden City, New York, 1937. Reproduces TOLL COLLECTORS (part) in color.

30. *Cattle*, by William MacLeod Raine and Will C. Barnes. Doubleday Doran & Co., N.Y., 1930. Reproduces LAUGH KILLS LONESOME in color.

31. *West of Apache Pass*, by Charles Alden Seltzer. Doubleday, Doran & Company, Inc., Garden City, 1934. Reproduces MEN OF THE OPEN RANGE in color.

32. *The Sky Pilot, A Tale of the Foothills*, by Ralph Conner. Special Limited Edition, Grosset & Dunlap, New York., n.d. Reproduces A BAD HOSS in color.

33. *Southwestern Lore*, edited by J. Frank Dobie. Facsimile edition; Southern Methodist University Press, Dallas, 1965. Reproduces CORAZON REARED STRAIGHT UP, HIS FEET PAWING LIKE THE HANDS OF A DROWNING MAN.

FANS

34. Four-ply, paper, expanding, about 10 × 7. You are visiting the C. M. Russell Gallery, 1201 4th Ave., No., Gt. Falls, Montana. THE ROUNDUP #2 in color.

35. Silk cloth, wood handle, size $6\frac{3}{4} \times 7\frac{3}{8}$. THE BUCKING BRONCO #1

FILMS

36. *The works of Chas. M. Russell, Bronzes.* 50 feet, 8 mm., color, produced by Max Howe, Box 185, Rapid City, South Dakota.

37. *The works of Chas. M. Russell, Oils.* 50 feet, 8 mm., color, produced by Max Howe, Box 185, Rapid City, South Dakota.

38. 8 mm. color movies.
The West in Bronze
The West Immortalized I (34 CMR paintings)
The West Immortalized II (28 CMR paintings)

FILMSTRIP

39. *The Last Frontier.* Museum Extension Service, 10 East 43rd Street, New York 17, N.Y. (1953). Frame 20 on this 38-frame filmstrip is WAITING FOR A CHINOOK. Also, reference thereto in teaching manual which accompanies filmstrip.

FIRST DAY COVER INSERTS

40. Range Conservation Commemorative Postage Stamp. Issued February 2, 1961, Salt Lake City, Utah, U.S.A. Card, size $3\frac{1}{2} \times 6\frac{1}{4}$, insert for first-day cover, 1961. Issued by Forest Service, U.S. Department of Agriculture, Soil Conservation Service. Reproduces THE TRAIL BOSS (part).

41. Advertising Club of Great Falls. Commemorating Great Falls Own. Card, tan stock, size $3\frac{1}{2} \times 6\frac{1}{4}$ for First Day Cover insert. Great Falls Advertising Club (1964). Reproduces sketch after CHARLES M. RUSSELL AND HIS FRIENDS.

42. C. M. Russell, Montana's Cowboy Artist [21 lines]. Visit C. M. Russell Gallery and Original Studio— Great Falls, Montana. Card, white stock, size $3\frac{1}{2} \times 6\frac{3}{8}$, to be inserted in envelopes bearing JERKED DOWN stamp, First Day Issue, March 20, 1964.

43. I'm Salutin' One O' My Favorite Western Guys. Sales letter for insertion in First Day Cover issued by Texas Refinery Corp. (1964). White stock, yellow, red, and brown ink, size $8\frac{1}{2} \times 11$. Reproduces Lange photo of CMR.

HIGHBALL GLASSES

44. Etched on side: THE ROAD AGENT

JIGSAW PUZZLE

45. Perfect Picture Puzzles. Jig-saw Picture Puzzle No. 1410. Over 250 inter-locking pieces. Size $13\frac{3}{4} \times 10\frac{1}{4}$. THE ADVANCE GUARD.

KODACHROME SLIDES

46. The Gilcrease Institute of American History and Art, Tulsa, commencing in 1959, issued 35-mm. slides from its collection.

THE BELL MARE
[THE] BUFFALO HUNT #29
[THE] CAMP COOK'S TROUBLE(S)
CARSON'S MEN
GUNPOWDER AND ARROWS*
THE HEAD MAN*
HER HEART IS ON THE GROUND
HOOVERIZIN'
JERKED DOWN
MEAT'S NOT MEAT 'TIL IT'S (i.e., TILL ITS) IN THE PAN
RUNNING FIGHT
[THE] SALUTE OF THE ROBE TRADE
THE (i.e., A) STRENUOUS LIFE
WAGON BOSS
WHERE TRACKS SPELL MEAT
WHERE TRACKS SPELL WAR OR MEAT
WHERE GUNS WERE THEIR PASSPORTS
WHITE MAN'S BUFFALO

47. The Montana Historical Society issued 52 35-mm. slides of CMR paintings and drawings from its collection over a period of years, starting in 1960. Some of these appeared without captions, and later editions appeared with captions and numbers, which do not always jibe.

AMERICA'S FIRST PRINTER
BEST WISHES, i.e., BEST WISHES FOR YOUR CHRISTMAS
BRONC IN COWCAMP, i.e., CHUCK WAGON ON THE RANGE
BRONC TO BREAKFAST
C. M. RUSSELL & FRIENDS, i.e., CHARLES M. RUSSELL AND HIS FRIENDS
CAUGHT IN THE ACT
COON CAN, A HORSE APIECE
COON CAN, TWO HORSES
THE DEERSLAYERS
FREE TRAPPERS
HARMONY*
[THE] HERD QUITTER
HERE'S HOPING THE WORST END OF YOUR TRAIL IS BEHIND YOU
HERE'S HOPING YOUR TRAIL IS A LONG ONE
I'M SCAREDER OF HIM THAN I AM OF THE INJUNS
IN THE MOUNTAINS
INDIAN BRAVE, i.e., PORTRAIT OF AN INDIAN

INDIAN CAMP #2
INDIAN HUNTERS' RETURN
INDIANS AND SCOUTS TALKING
INDIANS DISCOVERING LEWIS AND CLARK
INSIDE THE LODGE
INTRUDERS
KEOMA, i.e., KEEOMA #3
KING ARTHUR'S COWHAND*
LADY BUCKEROO
LAST OF 5000, i.e., WAITING FOR A CHINOOK
LAUGH KILLS LONESOME
LEWIS & CLARK MEETING IN THE FLATHEADS, i.e., LEWIS AND CLARK MEETING INDIANS AT ROSS' HOLE
MAMIE*
MEN OF THE OPEN RANGE
MINER'S CAMP*
MY VALENTINE*
NATURE'S SOLDIERS
NO CHANCE TO ARBITRATE, i.e., WHEN HORSES TALK WAR THERE'S SMALL CHANCE FOR PEACE
ON DAY HERD #2
ON THE BEACH
ON THE WARPATH #2
PINTO OUTLAW, i.e., PINTO
QUICK SHOOTING SAVES OUR LIVES
THE ROUNDUP #2
SELF PORTRAIT, i.e., IL BE THAIR WITH THE REST OF THE REPS
SPREAD EAGLED
SQUAW TRAVOIS
STEER RIDER #2
[THE] SURPRISE ATTACK
TOLL COLLECTORS
WATCHING THE SETTLERS
WHEN COWS WERE WILD
WILD LIFE EPISODE
YORK
Portrait of CMR by Krieghoff

MAPS

48. 1964 Highway Map Montana Territorial Centennial Souvenir Edition. Size $19\frac{1}{4} \times 56$, folded to $6\frac{1}{2} \times 9$. State Highway Commission of Montana, Helena, 1964. Contains: MEETING THE FLATHEADS, i.e., LEWIS AND CLARK MEETING INDIANS AT ROSS' HOLE (part).

49. Montana's Honor Roll. Montana Boosters Tourist information and map. N.p., n.d. (Helena, Montana, ca. 1939). Pp. [8], including wrappers. Size $8\frac{3}{8} \times 10\frac{3}{4}$. front wrap.: [THE] INDIAN OF THE PLAINS AS HE WAS back wrap.: sketch of Russell's life.

50. Montana Vacation Land Montana Streams Are Filled With Fish—Ask Any Montana Booster. White

stock, folded once to size 8½ × 11. N.p., n.d. (Butte? ca. 1940). Cover: THE HUNTER, i.e., MEDICINE WHIP (bronze).

51. A Map of Montana, Whereon is Depicted and Described the Pioneer History of the Land of Shining Mountains. Frontier Montana Pioneer. Broadside, folded to 8 × 11. Montana State Highway Dept., 1937. CHARLES M. RUSSELL AND HIS FRIENDS*.

52. Paintbrush Map of Montana. Size 17 × 22. New Grand Hotel, Billings. 1938. Contains sketch of Russell painting (not by CMR).

53. Montana Aeronautical Map and Airport Directory. Published by the Montana Aeronautics Commission, Helena, Montana (September 15, 1948). Size 40 × 24¾, folded to 8 × 12⅜.
THE MAD COW
BETTER THAN BACON
THE BUCKING BRONCO #1

54. Montana, The Big Sky Country. Broadside, size 19 × 36, folded to 6½ × 9. Montana State Highway Dept., Helena, 1962.
WATCHING THE SETTLERS
Russell statue by Weaver (photo)

MATCH FOLDERS

55. Don't miss the Charley Russell Gallery at the State Historical Museum, Helena, Montana. SKULL #1.

56. Historical Society of Montana. WHEN COWS WERE WILD.

57. Issued by the Mint Saloon, Great Falls. I BEAT YOU TO IT.

58. Jorgenson's Holiday Inn, Helena, Montana. COWBOY LIFE, i.e., THE BOLTER #3 (color).

59. Jorgenson's Holiday Inn, Helena, Montana. THE BOLTER, i.e., COWBOY LIFE (color).

60. Western-Outdoor, Kalispell, Montana. A DISPUTED TRAIL (color).

61. Western-Outdoor, Kalispell, Montana. SMOKING CATTLE OUT OF THE BREAKS (color).

MEDALLIONS

62. Obverse: Charles M. Russell, with portrait of CMR in bas-relief. Reverse: Montana Centennial 1864–1964, with LIKE A FLASH THEY TURNED in bas-relief.

Designed by Philip Kraczkowski, issued by Montana Historical Society. Boxed in maroon leather case with information leaflet. Round, 10 carat gold, size 1⅝, numbered, limited to 24; round, sterling silver, size 2½, numbered, limited to 399; round, sterling silver, size 1⅝, numbered, limited to 1,000; and round, bronze, size 2½, unnumbered, unlimited.

63. Montana Territorial Centennial medallion cast to commemorate inaugural journey from Billings, Montana, on May 5, 1964, to the New York World's Fair. Designed by David Miller and Van Kirke Nelson. Obverse: Montana Territorial Centennial 1864—Flathead—1964, with depiction of Montana Territorial Seal. Reverse: Cowboy-Montana Artist 1864–1926, Charles Marion Russell, with reproduction of YES—THE MICE-PEOPLE ALWAYS MAKE THEIR NESTS IN THE HEAD OF THE DEAD BUFFALO-PEOPLE EVER SINCE THAT NIGHT. Octagonal, 2¾ diameter. Limited, numbered issue of 400 in bronze; seven copies in gold for presentation to the President of the United States and others; limited issue of 300 in silver; and an unlimited issue in bronze.

MENUS

64. Menus of the Empire Builder of the Great Northern Railway. Pp. [4]. Size 6½ × 10. (1948).
[A] DESPERATE STAND (color)
[THE] BUFFALO HUNT #26 (color)
INTERCEPTED WAGON TRAIN* (color)
INDIAN WOMEN MOVING (color)
INDIAN WARFARE, i.e., FOR SUPREMACY (color)

65. Hotel Placer, Helena, Montana. Size 8⅛ × 10⅝. BOSS OF THE TRAIL HERD (color).

66. Hotel Placer, Helena, Montana. Size 8⅛ × 10⅝. THE BUCKING BRONCO #1.

67. Lambkins of Lincoln, Lincoln, Montana. Tan stock, simulated boards, size 6½ × 10. Cover: THE CHRISTMAS DINNER.

68. Lewis and Clark Dining Room, Lincoln, Montana. Size 8 × 10. Cover: THE INDIAN OF THE PLAINS AS HE WAS.

69. Montana Centennial Party, Commodore Hotel Ballroom, New York City, April 23, 1964. Folio, size 6½ × 8½. THE INDIAN OF THE PLAINS AS HE WAS (color fabrication) on front.

70. Montana Hotel. Buffalo Lounge and Dining Room. (Kalispell, Montana, ca. 1962). Size 9¼ × 12¾, wrappers. INDIAN HUNTERS' RETURN (color).

71. Montana Hotel, Kalispell, Montana, Size $9\frac{1}{4} \times 12\frac{3}{4}$. N.d. Cover: INDIAN HUNTERS' RETURN (color).

72. Montana's Territorial Centennial Dinner April 17, 1964. Sheraton Park Hotel, Washington, D.C. Folio, size $8\frac{1}{2} \times 10\frac{7}{8}$. Contains following illustrations:
TWO RIDERS, ONE LEADING A PACK HORSE
THE FREE TRAPPER (part)
RAWHIDE RAWLINS, MOUNTED
TRAILS PLOWED UNDER
COWBOY SEATED, HORSE NUZZLING HIS LEFT HAND
A RACE FOR THE WAGONS (part)
THE STAGE DRIVER (vignette only)
PETE HAD A WINNING WAY WITH CATTLE
RAWHIDE RAWLINS, MOUNTED
THE FOX BROUGHT A FEATHER TO THE LODGE (part)
FLATBOAT ON RIVER, FORT IN BACKGROUND

73. The New Green's Cafe and Lounge. Greatest Guy in the World The man who takes his family out to dine. 41–43 North Main—Butte, Montana. Folder, size $9\frac{3}{8} \times 12\frac{3}{4}$. N.d. (1962).
b. cover: THE CHRISTMAS DINNER
PAINTING THE TOWN

74. The Rancher (Kalispell, Montana). Pp. [8], size 10×13.
p. [1]: NATURE'S SOLDIERS (color)
p. [3]: WE AIN'T GONE FIVE MILE WHEN THE COACH STOPS
p. [6]: STEER RIDER #2

75. Park Hotel, Great Falls. Christmas, 1905. Size $7\frac{1}{8} \times 5\frac{5}{8}$. Folio. SCOUTING PARTY #1 in color, oval, pasted on front.

76. Rainbow Hotel, Great Falls, Montana, Feb. 12, 1946. Printed $8\frac{1}{2} \times 11$ sheet, with menu mimeographed. THE PROSPECTOR.

77. Washington State Soil Conservation Recognition Banquet of 1950. The Empire Builder. Pp. [4]. Size $6\frac{1}{2} \times 10$. Cover: A DESPERATE STAND (color).

78. Washington State Soil Conservation Recognition Banquet of 1950. The Empire Builder. Pp. [4]. Size $6\frac{1}{2} \times 10$. INDIAN WOMEN MOVING (color).

79. Western Star, Great Northern Railway. Pp. [4], size $6\frac{1}{2} \times 10$. (1952). Five different subjects, all in color:
[A] DESPERATE STAND
[THE] BUFFALO HUNT #26
INTERCEPTED WAGON TRAIN
INDIAN WOMEN MOVING
INDIAN WARFARE, i.e., FOR SUPREMACY

MIRROR

80. Size $2\frac{3}{4} \times 2$, with reproduction of the Ecklund photo of CMR on the back.

MOVIE

81. *The Montanan*, narrated by Noah Beery. An 18-minute 16 mm. sound film depicting the experiences and philosophy of the widely-acclaimed western artist: Charles M. Russell.
Reservation card, size $11 \times 8\frac{1}{2}$, folded twice, yellow stock. Photo of CMR on front.
Special Invitation. Quarto, size $4\frac{1}{2} \times 5\frac{1}{2}$. Photo of CMR on p. [1], printing on pp. [4–5].
Ticket. World Premiere: "The Montanan" an 18-minute sound film sponsored by Union Oil Company in tribute to Charles M. Russell before the Advertising Club of Great Falls 11:30 a.m. June 3, 1965. Hotel Rainbow, Great Falls, Montana. Western Buffet Luncheon and Drawings for Russell Memorabilia. Retain this portion. Size 11×4, tan stock. THE SCOUT #4 and THE CREE INDIAN.
Raffle Ticket. World Premiere: "The Montanan" an 18-minute sound film sponsored by Union Oil Company in tribute to Charles M. Russell before the Advertising Club of Great Falls 11:30 A.M. June 3, 1965. Hotel Rainbow—Great Falls, Montana. Size $14\frac{1}{2} \times 4$, green stock. THE WOLFER; THE STAGE DRIVER; and THE PROSPECTOR.

PAPER NAPKINS

82. Don't Miss Northwest's largest North Montana State Fair and C. M. Russell Rodeo. Size 10×10.

83. Size $9\frac{3}{8} \times 9\frac{3}{8}$, issued by B.P.O.E. No. 214, Great Falls, Montana (n.d., ca. 1951). I RODE HIM (blue ink on white tissue) reproduced in one corner of napkin.

PAPERWEIGHT

84. Likeness of CMR (by J. M. Marchand?) cast in copper.

PENNANT

85. Triangular red felt banner, size $11 \times 31\frac{1}{2}$, white band. Large full-color photo of CMR in blue circle at top, with lettering in white: "C. M. Russell Compliments of Sid. Great Falls, Mont. 1915."

PHONY MONEY

86. Size $7\frac{1}{8} \times 3\frac{3}{8}$. B.P.O.E. No. 214. February 17, 1917. Great Falls, Montana.
obverse: SAYS HE'S AN ELK
reverse: THE FIRST GOAT

PILLOW TOPS

87. Size approximately 14×14. Manufactured by W. T. Ridgley, Great Falls, Montana. While only 3 pillow tops, done in black ink on various colors of silk cloth, have been seen, it is understood that others, in addition to the 3 listed below, from *Pen Sketches* (cf. Coll. 6), were printed.

HOLDING UP THE OVERLAND STAGE

PAINTING THE TOWN

THE SHELL GAME

PLACE MATS

88. Two sets of 10 paper doilies in an envelope within an envelope. Outer envelope: "Montana Booster. 20 Chas. Russell Place Mats Published by the *Z* Network [10 illustrations]. A set for you and a set to mail to an out-of-state friend with your invitation to visit Montana Vacationland." Inner envelope is imprinted: "From 'A Montana Booster' [3 rules] To [4 rules]."

THE SILENT WARNING, i.e., O GHASTLY RELIC OF DEPARTED LIFE

THE HONOR OF HIS RACE, i.e., SO ME RUN UP BEHIN' SHOVE DE GUN IN HIS BACK AN' TELL HIM STOP HIS PONY

INDIAN TRIBAL WAR, i.e., HIS LAST HORSE FELL FROM UNDER HIM

LEWIS AND CLARK AT THREE FORKS OF THE MISSOURI RIVER

THE RANGE RIDERS [*sic*] CONQUEST

INDIAN PICTURE WRITING, i.e., THE PICTURE ROBE

THE WOLF HUNT, i.e., HIS FIERCE JAWS SNAP, HIS EYEBALLS GLARE

THE PASSING OF THE OLD WEST, i.e., DAME PROGRESS PROUDLY STANDS

COWBOY FUN, i.e., NOW HERDER, BALANCE ALL

PRAIRIE JUSTICE, i.e., SO WITHOUT ANY ONDUE RECITATION I PULLS MY GUNS AN CUTS DOWN ON THEM THERE TIN-HORNS

89. Paper doilies for restaurants—some bear imprint of the Placer Hotel Coffee Shop, Helena, Mont. Size 10×14. N.d. (ca. February, 1945).

THE LAST OF HIS RACE

[THE] INITIATION OF THE TENDERFOOT

INITIATED

NATURE'S CATTLE #1

THE TRAIL BOSS

THE CHRISTMAS DINNER

THE SCOUTS, i.e., THE INDIAN OF THE PLAINS AS HE WAS

PAINTING THE TOWN

THE LAST OF THE BUFFALO

THE SHELL GAME

THE INDIAN OF THE PLAINS AS HE WAS, i.e., AH-WAH-COUS

HOLDING UP THE OVERLAND STAGE

With the set of 12 went a broadside, signed by Ed Craney, referring to Charlie Russell place mats. A windshield sticker with the set, mentions Russell on the back.

a) Envelope: Montana Booster. Individual Membership Kit. Contents: 36 Chas. M. Russell place mats, 30 copper envelope stickers, 3 copper windshield stickers, 2 mailing envelopes, 1 Montana Booster silver membership sticker. Price 50¢.

b) Envelope: From "A Montana Booster" To: [4 lines] Visit Montana Vacationland.

c) Envelope: "Greeting from Montana" The Treasure State—Land of Shining Mountains [3 stanzas of poetry] Compliments of [6 lines]. SKULL #1 and signature on right, center; war shield (not by CMR) on left, center.

90. Set of four plastic place mats, gold border, size 17×11½, with matching coasters, size 3⅛×3⅛, in color. Enclosed in plastic envelope.

INSIDE THE LODGE

INTRUDERS

NATURE'S SOLDIERS

WHEN COWS WERE WILD

PLAQUE

91. Likeness of CMR fashioned by J. M. Marchand, cast in plaster, in bronze or copper color. Ca. 1929.

PLATE

92. Souvenir of Butte, Montana. Blue and white made by Rowland and Marsellus Co., Staffordshire, England. Designed and Imported by High and Fairchild Co., Butte, Montana. Size 10 inches diameter, 1 inch deep.

BRONCHO BUSTING, i.e., adaptation of THE BUCKING BRONCO #1

PORTRAIT

93. Russell The Cowboy Artist. Black and white. Delineator unknown.

PRIZE RIBBON

94. First Premium. Photograph Contest. Sponsored by the American Society of Range Management. Purple silk, size 2½×10. THE TRAIL BOSS (part).

RECORDINGS

95. Charles Russell Suite. Bozeman Senior High School Band Russell Centennial Chorus. Chorus Director, Eleanor Croone. Composed by Francis E. White, Director of Band (1964). 12-inch phonograph record.

96. 12-inch record, $33\frac{1}{3}$ speed, with 4 Russell songs: "Charley Russell and His Friends," "Bronc to Breakfast," "Last of 5000," and "Laugh Kills Lonesome."

97. Special Record Series distributed by The Historical Society of Montana. Words and music by Wm. J. May. Envelope, size $8\frac{1}{2} \times 8\frac{3}{4}$, with cover from *A Portfolio of Art by the Famous Cowboy Artist*, which reproduces THE ROUNDUP #2 (Sec. II-80) made into a folder for four records. Each record is in a protective folder, size 7×7, bearing, respectively, in color:
BRONC TO BREAKFAST
CHARLES M. RUSSELL AND HIS FRIENDS
LAUGH KILLS LONESOME
THE LAST OF 5000

SPOON

98. Sterling silver souvenir spoon with adaptation of a buffalo hunt engraved in bowl.

STAMPS (POSTAGE)

99. Range Conservation. 4-cent Range Conservation U.S. Postage Stamp. Issue 1961. Full sheet of 50 stamps THE TRAIL BOSS (part) in blue fabricoid binder, stamped in gold. (Presented to members of Range Conservation Stamp Committee by Postmaster General.) Size $9\frac{5}{8} \times 11\frac{1}{4}$.

100. Range Conservation. 4¢ United States Commemorative. February 3, 1961, postage stamp. THE TRAIL BOSS (part).

101. C. M. Russell American Artist. 5¢ United States Commemorative. March 20, 1964, postage stamp. JERKED DOWN.

STAMP BULLETINS

102. 4-Cent Range Conservation Postage Stamp Available at your Local Post Office, February 3, 1961. [12 lines]. U.S. Government Printing Office. 1961. Grey stock, size $8 \times 10\frac{1}{2}$. Reproduces Range Conservation stamp with THE TRAIL BOSS (part).

103. 5-Cent Charles M. Russell Commemorative Postage Stamp Available at Your Local Post Office, March 20, 1964. [17 lines] U.S. Government Printing

Office: 1964. Tan stock, size $8 \times 10\frac{1}{2}$. Reproduces C. M. Russell American Artist stamp with JERKED DOWN.

STAMPS

104. See American First Series No. 3. Glacier National Park [illustration]. See America First. Great Northern Railway. Glacier National Park. Stamps, 10 to a sheet, each stamp size $2\frac{1}{4} \times 1\frac{13}{16}$; whole sheet $4\frac{15}{16} \times 9\frac{1}{2}$. Gummed, perforated edges. Issued sometime between 1914 and 1920.
PLANNING THE ATTACK
HEADS OR TAILS, i.e., THE MIXUP
A STRENUOUS LIFE
A SERIOUS PREDICAMENT, i.e., RANGE MOTHER
IN WITHOUT KNOCKING
(THE) FIRST WAGON TRAIL
SINGLE HANDED
WHEN SIOUX AND BLACKFEET MEET, i.e., WHEN BLACKFEET AND SIOUX MEET
(A) BRONC TO BREAKFAST
WHEN HORSEFLESH COMES HIGH

TRAYS

105. Silver service for the *U.S.S. Montana*, now on display in the Montana Historical Society, includes a sterling silver tray with depiction of THE BUFFALO HUNT, i.e., an adaptation of INDIAN BUFFALO HUNT.

106. Silver service for the *U.S.S. Montana*, now on display in the Montana Historical Society, includes a sterling silver tray with depiction of THE UNWELCOME VISITOR, i.e., an adaptation of A PRAIRIE SCHOONER CROSSING THE PLAINS.

WINDOW POSTERS

107. C. M. Russell Gallery and Studio 1201—4th Ave. N., Great Falls. Winter schedule (September through May) Open Daily 2 P.M. to 4:30 P.M. Summer Schedule (June through August) Week Days: 10 A.M. to 4 P.M. Sundays: 1 P.M. to 4 P.M. Russell prints and books for sale to support gallery. Free admission. Size $10\frac{3}{4} \times 13\frac{7}{8}$. CHARLES RUSSELL ON RED BIRD (color).

108. Variant; same text and size. LONE WOLF (color).

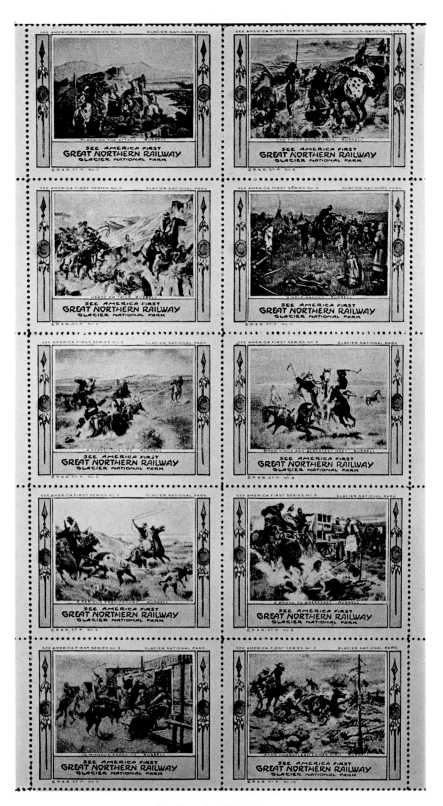

See America First Stamps
Issued by Great Northern Railway. Transparency by Edwin Dodds from the unique copy of this item in the library of the Southwest Museum, Highland Park, Los Angeles, California, founded by Charles F. Lummis, originator of the phrase "See America First."
See item 104, this section.

Appearances

EARLY LIFE IN COLORADO.

Frontispiece of Progressive Men of Western Colorado, showing EARLY LIFE IN MONTANA, erroneously, although deliberately, mis-titled.

See item 12, this section.

SECTION XVI

Appearances

1. *The Great Northern Country: Being the Chronicles of the Happy Travellers Club from Buffalo to the Pacific Coast.* Passenger Department, Great Northern Railway and Northern Steamship Co., n.p., n.d. (St. Paul, 1895). Contains, p. 101: WAITING FOR A CHINOOK, i.e., LOST IN A SNOWSTORM—"WE ARE FRIENDS."

2. *Beauties and Industries of Alberta.* Illustrated in Photo-Gravure. Thomson Bros., Booksellers, Stationers, Printers and Lithographers, Calgary, Alta. New York: The Albertype Company, 1897. Size 7 × 5⅛. Not seen. Contains: DRIVING IN; also inset BRONCHO BUSTING; also inset COW PUNCHER.

3. *Seventh Report of the Bureau of Agriculture, Labor and Industry of the State of Montana for the year ending November 30, 1900.* J. H. Calderhead, Commissioner, Oliver M. Holmes, Chief Clerk. Helena, Montana: Independent Publishing Company, State Printers and Binders, 1900. Contains 2 halftones, in blue ink, on a tipped-in two-page foldover opposite p. 16:
Top picture: COW-BOY CAMP DURING THE ROUNDUP
Bottom picture: BREAKING CAMP #1

4. *A Short History of the Mississippi Valley,* by James K. Hosmer. Cambridge: Houghton, Mifflin and Co., 1901. Contains, fcg. p. 130: LEWIS AND CLARK MEETING THE MANDANS, i.e., LEWIS AND CLARK MEETING THE MANDAN INDIANS.

5. *R. L. Polk & Co.'s Butte City Directory 1902.* [6 lines] R. L. Polk & Co., of Montana Publishers [10 lines] Inter Mountain Printers, Butte. Contains 1 line engraving in sepia, in an advertisement of W. T. Ridgley Printing Co., Great Falls, fcg. p. 804: THREE HORSES HEADS.

6. *Semi-Annual Report of State Game and Fish Warden, State of Montana, 1902.* Contains 4 halftones, facing:
p. 16: A CRITICAL MOMENT, i.e., JUST AS EVERYTHING'S TURNIN' BLACK I HEAR BEDROCK'S WINCHESTER
p. 32: LEWIS AND CLARKE DISCOVERING THE GREAT FALLS OF THE MISSOURI, i.e., CAPTAIN LEWIS AND HIS SCOUTS DISCOVERING THE GREAT FALLS OF THE MISSOURI IN 1805
p. 34: SCOUTING PARTY #1
p. 40: TRAILING, i.e., THE ALERT

7. *Progressive Men of the State of Wyoming.* Illustrated. Chicago, Ill.: A. W. Bowen & Co., Publishers and Engravers, 1903. Contains, p. 546: EARLY LIFE IN WYOMING, i.e., EARLY LIFE IN MONTANA.

8. *Progressive Men of Bannock, Bear Lake, Bingham, Fremont, and Oneida Counties, Idaho.* Chicago: A. W. Bowen & Co., 1904. Contains, front.: "EARLY LIFE IN IDAHO," i.e., EARLY LIFE IN MONTANA.

9. *Progressive Men of Southern Idaho.* Chicago: A. W. Bowen & Co., 1904. Contains, front.: "EARLY LIFE IN IDAHO," i.e., EARLY LIFE IN MONTANA.

10. *Glimpses of the Lewis and Clark Exposition. Portland, Oregon and the Golden West.* Copyright 1905 by William H. Lee. Chicago: Laird & Lee, Publishers. Contains one halftone, p. [134]: TRAILING.

11. *Land of the Flatheads. A Sketch of the Flathead Reservation, Montana,* by W. H. Smead. Copyright

1905. St. Paul, Minn.: Pioneer Press Mfg. Depts. Contains:

p. 2: EARLY DAYS IN MONTANA, AMBUSH OF PACK TRAIN, i.e., THE AMBUSH

p. 8: IN VIGILANTE DAYS, THE SURRENDER, i.e., BESTED

p. 10: THE EASTERN IDEA OF MONTANA, i.e., SHOOTING UP THE TOWN

12. *Progressive Men of Western Colorado.* Chicago: A. W. Bowen & Co., 1905. Contains, front.: EARLY LIFE IN COLORADO, i.e., EARLY LIFE IN MONTANA.

13. *The Souvenir of Western Women,* edited by Mary Osborn Douthit. Portland, Oregon, 1905. This first appeared in pictorial wrappers, stapled, size $7\frac{1}{8} \times 10\frac{5}{8}$, with a frontispiece in color facing the title page. Some of these were bound in full limp leather as presentation copies for the contributors. The second edition appeared in green cloth, blind stamped with the words "The Souvenir of Western Women" on the upper half of the cover, and the color scene of Mt. Hood pasted on the cover. Size $6\frac{3}{4} \times 9\frac{13}{16}$. Frontispiece facing title page. The third edition appeared in blue cloth, with blind stamping and pasted picture as in the second edition, but the size is $7 \times 9\frac{1}{2}$, and the frontispiece illustration appears on the verso of the title page. Contains 1 halftone, p. [26]: INDIANS OF THE PLAINS, i.e., SCOUTING PARTY #1.

14. *The Children's Hour. Adventures and Achievements.* Selected and Arranged by Eva March Tappan. Vol. VIII of ten-volume set. Boston: Houghton Mifflin Company, 1907. Contains 1 halftone, p. 44: THEY TRIED TO MAKE FRIENDS WITH THE INDIANS, i.e., LEWIS AND CLARK MEETING THE MANDAN INDIANS.

15. *R. L. Polk & Co's Great Falls and Cascade County Directory 1908–09.* Fcg. p. 256: THE BUFFALO HUNT #35.

16. *Glimpses of the Alaska-Yukon-Pacific Exposition, Seattle, Washington and The Great Northwest.* Chicago: Laird & Lee, publishers, 1909. P. [111]: TRAILING.

17. *Among the Shoshones,* by Elijah Nicholas Wilson (Uncle Nick). Salt Lake City: Press and Bindery of Skelton Publishing Company. (1910). Fcg. p. 152: THE SCOUT, i.e., POWDERFACE—ARAPAHOE.

18. *The Red-Blooded,* by Edgar Beecher Bronson. Chicago: A. C. McClurg & Co., 1910. Contains one halftone, tipped in, fcg. p. 162: WHITEHILL FOUND A FRAGMENT OF A KANSAS NEWSPAPER, i.e., RIDING ONE DAY ACROSS THE PLAIN SOME DISTANCE FROM THE LINE OF FLIGHT NORTH FROM GAGE, WHITEHILL FOUND A FRAGMENT OF A KANSAS NEWSPAPER.

18a. *The Red-Blooded Heroes of the Frontier,* by Edgar Beecher Bronson, Author of "Cowboy Life on the Western Plains." New York: George H. Doran Company. Apparently the George H. Doran Company bought the plates from A. C. McClurg, because page for page the text and illustrations seem to be identical. The reverse of the title page is exactly the same with the exception that it does not carry the Lakeside Press ad. The paper on which it is printed is thicker and overall the book is about $\frac{3}{4}''$ thicker than the McClurg imprint. (Information from Paul Galleher of Arthur H. Clark Co.) On the front cover the words "Heroes of the Frontier" have been added underneath the title in what was merely blank space in the McClurg edition.

19. *Stories of the Republic. Stories by Theodore Roosevelt* (et al.). New York: G. P. Putnam's Sons, n.d. (ca. 1910). Contains, front.: CAPTAIN CLARK, CHABONEAU, SACAGAWEA AND PAPOOSE IN THE CLOUDBURST NEAR THE GREAT FALLS, ON JUNE 29, 1805.

20. *Flashlights from Mountain and Plain,* by Duke Davis. Bound Brook, N.J.: Published by The Pentecostal Union (Pillar of Fire), 1911. Contains 4 color plates, tipped in and not included in pagination, facing:

p. 33: BOSS OF THE HERD, i.e., BOSS OF THE TRAIL HERD

p. 89: A BAD BRONCO, i.e., THE BUCKING BRONCO #1

p. 153: SCATTERING THE RIDERS

p. 209: (THE) WILD HORSE HUNTERS #1

Contains 7 black and white illustrations (4 halftones and 3 line engravings), included in pagination:

p. [35]: A ROPER

p. [44]: THE INITIATION OF THE TENDER-FOOT (line)

p. [48]: INITIATED (line)

p. [206]: WOUND UP

p. [240]: THE BUFFALO HUNT #35

p. [252]: THE TRAIL BOSS (line)

p. [256]: [THE] ROUND UP #1

21. *Ranching, Sport and Travel,* by Thomas Carson, F.R.G.S. With sixteen illustrations. London and Leipsic: T. Fisher Unwin, 1911. Contains 3 halftones, tipped in, facing:

p. 70: ROPING A GRIZZLY, i.e., ROPING A RUSTLER

p. 76: A SHOOTING SCRAPE, i.e., SMOKE OF A FORTY-FIVE

p. 106: WOUND UP

21a. There is an American edition, New York, Charles Scribner's Sons (1912).

22. *The Untamed. Range Life in the Southwest,* by George Pattullo. New York: Desmond Fitzgerald, Inc., Publishers. Copyright 1911 by Desmond Fitzgerald, Inc. Contains 1 line engraving, tipped in, facing p. 100:

LEAPING, WITH LEGS STIFF, STRAIGHT OFF THE GROUND, i.e., CORAZON REARED STRAIGHT UP HIS FEET PAWING LIKE THE HANDS OF A DROWNING MAN.

23. *Voices from the Range*, by Rhoda Sivell. Illustrated. Printed by The T. Eaton Co. Limited, Toronto and Winnipeg. There is no date on the title page. Entered 1911. Pp. 43, 12mo, size $5\frac{1}{8} \times 7\frac{1}{4}$. Issued in stiff dark green wrappers with illustration of bucking horse (not by CMR), in red and black, pasted on front. Contains one halftone, p. 19: THE RANGE CALL, i.e., RAINY MORNING.

The second edition has the same title page, but contains 88 pages. The CMR illustration is on page 49.

The third edition has the same title page, but contains 101 pages, with the CMR illustration on page 50. It was issued in maroon cloth, gold-stamped, size 5×7, and in pale green wrappers, size $5\frac{3}{16} \times 6\frac{3}{4}$.

The fourth edition was published by William Briggs, Toronto, 1912. It is bound in maroon cloth, with the bucking horse stamped in gold on the front cover, and has 102 pages, with the CMR illustration on page [49].

24. *The Winning of the West*, by Theodore Roosevelt. Putnam, N.Y.: New Library Edition, (ca. 1911). Three-volume set.
Vol. I. front.: CAPTAIN CLARK, CHABONEAU, SACAGAWEA AND PAPOOSE IN THE CLOUDBURST NEAR THE GREAT FALLS ON JUNE 29, 1805
Vol. III. front.: INDIANS HUNTING THE BISON IN THE DAYS OF LEWIS AND CLARK, i.e., MANDAN BUFFALO HUNT
Also Dacota edition, 6 volumes, with frontispieces in Vol. III and Vol. V.

25. *The Young Peoples Bookshelf. Adventures Afloat and Ashore.* G. P. Putnam's Sons (1911).
fcg. p. 358: CAPTAIN CLARK, CHABONEAU, SACAGAWEA AND PAPOOSE IN THE CLOUDBURST NEAR THE GREAT FALLS ON JUNE 29, 1805
fcg. p. 364: INDIANS HUNTING THE BISON IN THE DAYS OF LEWIS AND CLARK, i.e., MANDAN BUFFALO HUNT
N.B. This also appeared in an edition entitled "Reading Circle Classics for Young People," with same illustrations.

26. *Beating Back*, by Al Jennings and Will Irwin. Illustrated by Charles M. Russell. New York and London: D. Appleton and Company, 1914. Contains three halftones, tipped in,
fcg. p. 120: "I MADE HIM RIDE BESIDE ME, AS WE GALLOPED DOWN THE RIGHT OF WAY" (this illustration, in two-color plate, is also on the front of the dustwrapper)

fcg. p. 130: "WE DROVE HIM AHEAD OF US DOWN THE ROAD," i.e., WHENEVER HE LET THE ROPE GO SLACK WE'D TAKE A FEW SHOTS IN THE DIRECTION OF HIS HEELS
fcg. p. 302: "(THERE) I BROKE THE ICE AND WATERED MY NITRO-GLYCERINE"
The narrative, with many more illustrations, first appeared in the *Saturday Evening Post*; see Section III. There were also second and third editions.

27. *Early Days in Old Oregon*, by Katherine Berry Judson, M.A. Chicago: A. C. McClurg & Co., 1916. Contains, fcg. p. 90: A WAR PARTY, i.e., SCOUTING PARTY #1.
Another edition, with same illustration, Metropolitan, Portland, 1935.

28. *R. L. Polk & Co's Great Falls and Cascade County Directory. Classified Business Directory and Buyers Guide.* 1918. Fcg. p. 154: THE COMO COMPANY.

29. *Jul i Vesterheimen 1920.* Minneapolis: Augsburg Publishing House. P. [11]: A LOOSE CINCH (caption in Swedish) (color)

30. *The Book of Cowboys*, by Francis Rolt-Wheeler. Boston: Lothrop, Lee & Shepard Co., (1921). Contains:
fcg. p. 98: THE FATE OF MANY A 'GENTILE' IMMIGRANT, i.e., LAUGHED AT FOR HIS FOOLISHNESS AND SHOT DEAD BY SLADE
fcg. p. 170: MEXICAN VANQUEROS [sic], i.e., HIGHWAYMEN RUN DOWN A PEDESTRIAN ONLY HALF A BLOCK FROM US

31. *Jul i Vesterheimen 1921.* Minneapolis: Augsburg Publishing House. P. [9:] SUN WORSHIPERS [sic] (color).

32. *The Passing of the Frontier, A Chronicle of the Old West*, by Emerson Hough. New Haven: Yale University Press, 1921. Vol. 26 of the Roosevelt edition of the Yale Chronicles of America. Contains one color plate, tipped in, front.: ROPING WILD HORSES, i.e., WILD HORSE HUNTERS #2.

33. *Policing the Plains, being the real-life record of the famous Royal North-West Mounted Police*, by R. G. Macbeth, M.A., author of "The Romance of Western Canada." With illustrations. New York, London, and Toronto: Hodder and Stoughton, Ltd., MCMXXI. Contains 1 halftone, tipped in, front.: MOUNTED POLICE ROUNDING UP HORSE THIEVES, i.e., WHEN LAW DULLS THE EDGE OF CHANCE.
There are later editions published by Hodder and Stoughton and also by George H. Doran bearing no date, and an edition published in Philadelphia in 1931.

34. *The Cowboy*, by Philip Ashton Rollins. New York: Charles Scribner's Sons, 1922. It is the second edition, published August, 1922 (although the words "Published April, 1922" still appear on the verso of the title page), that contains the Russell illustration, a halftone. Front.: SHE WENT WIDE, HIGH AND PRETTY, i.e., A BAD HOSS.

35. *The Frontier Trail or From Cowboy to Colonel*, by Colonel Homer W. Wheeler. Los Angeles: Times-Mirror Press, 1923. Contains 1 halftone, tipped in, facing, p. 95: AN INDIAN VILLAGE CHANGING CAMPING PLACES, i.e., BREAKING CAMP #3.

36. *Jul i Vesterheimen 1923*. Minneapolis: Augsburg Publishing House.
front.: THE SIGNAL FIRE, i.e., SIGNAL SMOKE (color)
p. [9]: [THE] TROUBLE HUNTERS (color)
p. [19]: IN THE WAKE OF THE BUFFALO RUNNERS (color)

37. *Forty Years on the Frontier, the Reminiscences and Journals of Granville Stuart*. Edited by Paul C. Phillips. Cleveland: The Arthur H. Clark Co., 1925. Two-volume set. Contains, Vol. II, fcg. p. 129: FIRST ATTEMPT AT ROPING. Reference to CMR, Vol. II, pp. 172, 188, 236.
This was reprinted in 1957, two volumes in one. Contains, Vol. II:
p. 129: FIRST ATTEMPT AT ROPING
p. 170: RIGHT THEN'S WHEN (i.e., WHERE) THE BALL
OPENS
p. 236: THE LAST OF 5000

38. *The Pageant of America. Adventures in the Wilderness*, by Clark Wissler, Constance Lindsay Skinner, William Wood. New Haven: Yale University Press, 1925. Vol. I of 15-volume set. Contains 1 halftone, p. 41: THE ADVANCE GUARD OF A BLACKFOOT HUNTING PARTY, i.e., PIEGANS.

The Liberty Bell edition is the first, and there are also the Washington edition and the Independence edition.

39. *The Cowboy and His Interpreters*, by Douglas Branch. Illustrations by Will James, Joe De Yong, Charles M. Russell. New York and London: D. Appleton and Company, 1926. Contains two line engravings:
p. 73: NEVADA BUCKAROOS, i.e., WORK ON THE ROUNDUP
p. 119: RUSTLERS CAUGHT [AT WORK]
There is a reprint edition, with introduction by Harry Sinclair Drago, Cooper Square Publishers, Inc., New York, (1961).

40. "*Yellowstone Kelly*," *The Memoirs of Luther S. Kelly*. Edited by M. M. Quaife with a foreword by Lt. Gen. Nelson A. Miles. New Haven: Yale University Press, 1926. Contains, fcg. p. 46: KELLY'S DUEL WITH TWO SIOUX WARRIORS, i.e., KELLY'S DUEL WITH SIOUX INDIANS.

41. *Montana Resources and Opportunities Edition*, Volume 3, Number 2, August, 1928. Helena, Montana. Pp. 109–111: "Art in Montana," by Dan R. Conway, contains references to Russell. Contains 1 halftone, p. [8]: LEWIS AND CLARK EXPEDITION MEETING WITH SHOSHONE INDIANS, AUGUST 22, 1805, AT TWO FORKS NEAR ARMSTEAD, BEAVERHEAD COUNTY, MONTANA, i.e., LEWIS AND CLARK MEETING INDIANS AT ROSS' HOLE.

42. *Heroes and Heroic Deeds of the Pacific Northwest*, by Henry L. Telkington. Caldwell, Idaho: The Caxton Printers, Ltd., 1929. Vol. II, p. 112: THE EARLY STORE, i.e., THE CHRISTMAS DINNER.

43. *Montana State Information and Tourist Guide 1929*. Compiled by Montana Publicity Co., Helena, Montana. Contains, p. 2: LEWIS AND CLARK EXPEDITION MEETING WITH SHOSHONE INDIANS, AUGUST 22, 1805, AT TWO FORKS, NEAR ARMSTEAD, BEAVERHEAD COUNTY, MONTANA, i.e., LEWIS AND CLARK MEETING INDIANS AT ROSS' HOLE.

44. *The Pageant of America. The Lure of the Frontier A Story of Race Conflict*, by Ralph Henry Gabriel. New Haven: Yale University Press, 1929. Volume II of 15-volume set contains three halftones:
p. 169: LEWIS AND CLARK PARTY MEETING THE SHOSHONES, i.e., LEWIS AND CLARK MEETING INDIANS AT ROSS' HOLE
p. 286: WHERE TRACKS SPELL MEAT
p. 287: SMOKING THEM OUT, i.e., SMOKING CATTLE OUT OF THE BREAKS

45. *The Pageant of America. Toilers of Land and Sea*, by Ralph Henry Gabriel. New Haven: Yale University Press, 1926. Volume III of 15-volume set contains 3 halftones:
p. 176: WILD HORSE HUNTERS #2
p. 181: JERKED DOWN
p. 187: WHEN HOSS FLESH (i.e., HORSEFLESH) COMES HIGH

46. *The Romance of the Rails*, by Agnes C. Laut. New York: Robert C. McBride & Co., 1929. Volume One of the two-volume set contains:
p. [7]: CURLEY REACHES THE FAR WEST WITH THE STORY OF THE CUSTER FIGHT

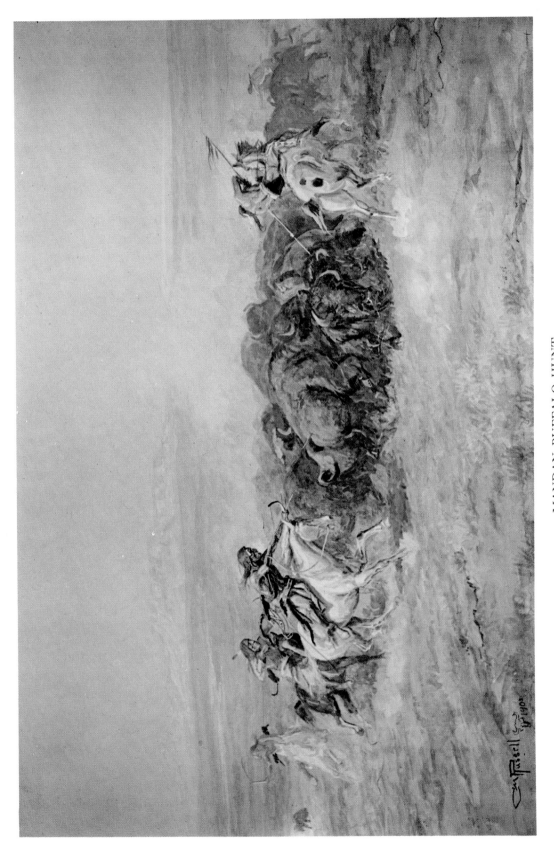

MANDAN BUFFALO HUNT
S. H. Rosenthal Collection
This is the first appearance in color.
See item 25, this section.

p. [157]: PLACER MINERS PROSPECTING NEW STRIKE
p. [175]: STAGE COACH ATTACKED BY INDIANS
p. [227]: CHEYENNES WATCHING UNION PACIFIC TRACK LAYERS

Also a one-volume edition, New York, Tudor Publishing Co., 1936.

47. *Western Montana*, by Chas. W. Towne. Illustrated by Frank Ward. Butte, Montana, 1929. Contains, p. 1: THEN THE CALDWELLITES CHARTERED THE STAGE [AND WENT HOME].

48. *American History*, by Thomas M. Marshall. New York: Macmillan, 1930. Contains, p. 484: COWBOYS.

49. *The Open Range and Bunk House Philosophy*, by Oscar Rush. Printed by Colorado Herald Publishing Co., Denver, 1930. Contains one halftone, tipped in, facing p. 63: CHUCK UNDER DIFFICULTIES, i.e., RAINY MORNING. Another edition by the Caxton Printers, Ltd., Caldwell, Idaho, 1936, contains same halftone facing p. 117. There were ten copies of this issued in a deluxe binding.

50. *Modern Illustrating Division 12*. Compiled and edited by Chas. L. Bartholomew and Joseph Almars. Copyright 1931 by Federal Schools, Incorporated, Minneapolis, Minnesota. There were also editions in 1935 and 1948. Contains:
p. 27: STUDY BY (THE LATE) CHARLES M. RUSSELL
p. 28: PRELIMINARY PENCIL SKETCH
p. 29: THE LAST OF THE BUFFALO
p. [30]: PRELIMINARY PENCIL SKETCH FOR WILD HORSE HUNTERS
Chart, insert: WILD HORSE HUNTERS #2

51. *Western Prose and Poetry*. Selected and edited by Rufus A. Coleman. New York: Harper & Bros., 1932. Contains, pp. 294–298, "The Story of the Cowpuncher." Also contains, fcg. p. 128: THE HOLDUP.

52. *Riding the High Country*, by Patrick T. Tucker. Edited by Grace Stone Coates. Caldwell, Idaho: The Caxton Printers Ltd., 1933. First edition bears words "First printing December 1933" on verso of title page. There is a De Luxe edition limited to 25 signed and numbered copies. A second edition bears the date 1936 on the title page, and the words "Second printing June, 1936" on verso of title page. The text originally appeared in the *Tribune*, Great Falls, Montana, during August, 1933. The CMR letter appeared in the *Frontier* magazine for March, 1929. Contains one color plate, front.: ROPING THE BUFFALO (letter from CMR to Tucker dated October 27, 1921). The same illustration is on the

dustwrapper of the second edition. Fcg. p. 209: photograph of CMR and Mary Tucker.

53. *The Heroic Years*, by Fletcher Pratt. New York: Smith and Haas, 1934. Contains, fcg. p. 49: LEWIS AND CLARK AMONG THE SHOSHONES, i.e., LEWIS AND CLARK MEETING INDIANS AT ROSS' HOLE.

54. *Official Yearbook, Montana State Federation of Labor*. Great Falls, 1934. Contains, p. [26]: OUT ON THE PRAIRIE'S ROLLING PLAIN.

55. *Powder River Jack and Kitty Lee's Cowboy Song Book*. With music. Butte, Montana: McKee Printing Co., 1934. Two volumes in one, 48 pp. each. Contains the same plates, photos, and song and poem that appear in *Cowboy Songs* (see Sec. I).

56. *The Story of America in Pictures*. Arranged by Allan C. Collins. Introduction by Claude G. Bowers. New York: The Literary Guild, (1935). New revised edition Garden City, 1953. Contains, p. 140: LEWIS AND CLARK MEETING WITH THE SHOSHONES, i.e., LEWIS AND CLARK MEETING INDIANS AT ROSS' HOLE.

57. *The Golden Age of American Sculpture: An Anthology*, by Loring Holmes Dodd, Ph.D. Boston: Chapman & Grimes, Mount Vernon Press. Copyright, 1936. Contains brief reference to CMR, p. 104, and 4 halftones of bronzes:
p. [4]: THE BLUFFERS
p. [5]: THE RANGE FATHER
endpaper: SMOKING UP
endpaper: THE SPIRIT OF WINTER

58. *The Stampede and Tales of the Far West*, by "Powder River" Jack H. Lee. Greensburg, Pa.: The Standardized Press, (ca. 1936). Contains, fcg. p. 80: SCATTERING THE RIDERS, i.e., MEN OF THE OPEN RANGE.

59. *Wyoming Cowboy Days: An Account of the Experiences of Charles Arthur Guernsey*. New York: G. P. Putnam's Sons, 1936. Contains 4 halftones, full page each, all tipped in between pp. 264 and 265:
BLEST IS HE WHO CHEERFULLY GIVES
photo of CMR on horse in front of studio at Great Falls, Mont.
HERE'S HOPING THE WORST END OF YOUR TRAIL IS BEHIND YOU
BLACKFEET BURNING THE CROW RANGE, i.e., BLACKFEET BURNING CROW BUFFALO RANGE

60. *The Battle of the Little Big Horn*, by Wallace David Coburn. Overland-Outwest Publication, n.p., n.d. (Helena?, ca. 1936). Contains the foreword, attributed

to Russell, which previously appeared in the 1925 edition of *Rhymes from a Round-Up Camp*.

61. *Great Adventure*, by Frank H. Woodstrike. New York: The World Publishing Co., (1937). Contains, p. 19: WHERE THE LASSO TRAVELS FREE.

62. *New Standard Encyclopedia*. Chicago: Standard Education Society, 1937. Pagination varies. Ten-volume set originally, expanded to 14 volumes.

Because of the many changes made in this set over the years, we are forced to adopt an unusual method of describing the contents. All illustrations are in color.

THE OUTLAW first appeared in the article on Cattle in Vol. II of the 1937 10-volume edition (no pagination). It appeared in Vol. C (i.e., III) of the 14-volume set from 1952 through 1958. It appeared, using new plates, in the article on Cowboy, Vol. C, page C-591, from 1959 to date.

THE ELK first appeared in the article on Elk in Vol. III of the 10-volume set in 1937 through 1958, and in Vol. D–E (i.e., IV) of the 14-volume set in 1952 through 1958. A new offset plate was substituted in 1960 in Vol. D–E, page E-142.

THE ADVANCE GUARD appeared in the article on Indians, American, in Vol. V of the 1937 10-volume edition through 1958; also in Vol. H–I–J (i.e., VI) of the 14-volume edition, 1952 through 1958; it was dropped after the 1958 printing.

THE BUFFALO HUNT #26 appeared in the article on Bison in Vol. II of the 10-volume set in 1954 and in Vol. B. of the 14-volume set through 1956, then was dropped for the following item.

THE BUFFALO HUNT #29 appeared in the article on Bison in Vol. B, page 267 in 1957, and in subsequent editions to date.

WHEN COWS WERE WILD appeared in the article on Russell, Charles M., in Vol. Q–R, page R-410, in 1961, and in subsequent editions to date.

LEWIS AND CLARK MEETING INDIANS AT ROSS' HOLE appeared in the article on Lewis and Clark Expedition in Vol. K–L, page L-176, in 1962, and in subsequent editions to date.

63. *Golden Tales of the Southwest*. Selected with an introduction by May Lamberton Becker. New York: Dodd Mead & Co., 1939. Contains: pp. 12–14: "Speaking of Cowpunchers."

64. *The Long Trail from Texas, the Story of Ad Spaugh, Cattleman*, by Frazier Hunt. New York: Doubleday Doran, 1940. Contains, on title page: COWBOY MOUNTED, DRIVING A STEER.

65. *Mustangs and Cow Horses*. Edited by J. Frank Dobie, Mody C. Boatright and Harry H. Ransom. Austin, Texas: Folklore Society, 1940. Contains:
p. 237: COWBOY SLEEPING ON GROUND, HORSE STANDING
p. 251: CORAZON REARED STRAIGHT UP, HIS FEET PAWING LIKE THE HANDS OF A DROWNING MAN
p. 268: BUCKING HORSE
p. 313: COWBOY SEATED, HORSE NUZZLING HIS LEFT HAND
p. 385: THREE HORSES' HEADS
p. 395: COWBOY ABOUT TO SADDLE HORSE
p. 430: OUT ON THE PRAIRIE'S ROLLING PLAIN

66. *Shorty's Saloon*, by Johnny Ritch. Illustrated by Charles M. Russell. Helena, Montana, n.d. (1940). Contains one pen and six color plates:
p. 3: SHORTY'S SALOON—BRANDING IRONS
p. 4: BY THE TRAILS TO THE PAST
p. 5: NO FINE DRINKS ADORNED THAT PRIMITIVE BAR
p. 6: GREAT HERDS FROM THE SOUTH SWEPT BY ON THE TRAILS
p. 7: AND UP FROM THE VAST SILENT STRETCH OF THE RANGE
p. 8: THEY DANCED AND THEY DRANK
p. 9: SOME TRAGEDIES MARK THOSE TRAILS TO THE PAST

67. *The Longhorns*, by J. Frank Dobie. Illustrated by Tom Lea. Boston: Little Brown, 1941. Contains, pp. 130–138, the story "Longrope's Last Guard," and references, pp. 36, 88, 130, 172, 200, and 226.

68. *The New World, Past and Present*, by Victor L. Webb *et al*. Chicago: Scott Foresman, (1942). Contains, p. 279: LEWIS AND CLARK EXPEDITION MEETING WITH THE SHOSHONE INDIANS, i.e., LEWIS AND CLARK MEETING INDIANS AT ROSS' HOLE.

69. *The Story of American Democracy*, by Mable B. Casner, Washington School, West Haven, Conn., and Ralph H. Gabriel, Professor of History, Yale University. New York: Harcourt, Brace and Company, 1942. Contains, p. 370, A GRAY HOUND WARING HORNES. References pp. 407, 410.

70. *Guide to Life and Literature of the Southwest with a few observations* by J. Frank Dobie. Austin: University of Texas Press, 1943. Contains:
p. 59: THE TRAIL BOSS
p. 69: COWBOY SEATED, HORSE NUZZLING HIS LEFT HAND
p. 71: COWBOY SLEEPING ON GROUND, HORSE STANDING
p. 75: CORAZON REARED STRAIGHT UP, HIS FEET PAWING LIKE THE HANDS OF A DROWNING MAN
Also contains references to CMR on pp. 68 and 104.

70a. *Guide to Life and Literature of the Southwest Revised and Enlarged in both Knowledge and Wisdom* by J. Frank Dobie. Dallas: Southern Methodist University Press, 1952. Contains:

p. 121: COWBOY SLEEPING ON GROUND, HORSE STANDING

p. 135: CORAZON REARED STRAIGHT UP, HIS FEET PAWING LIKE THE HANDS OF A DROWNING MAN

p. 153: BURRO FACING A DEER

p. 163: GRIZZLY WITH SACK OF FLOUR

71. *Buffalo Adventures on the Western Plains.* Edited by Alfred Powers. Portland, Oregon: Binfords & Mort, 1945. This contains one story by Russell, "Yoked to a Plow," on p. 58, which is a shortened version of the story "Broke Buffalo," which previously appeared on p. 15 of *More Rawhides.* The word "damdest" is replaced by the word "fastest," and the word "dam" is omitted. Two complete sentences in the last paragraph are omitted. Neither of the two line drawings which accompanied the story as it appeared in *More Rawhides* is reproduced.

72. *Great Tales of the American West.* Edited and with an introduction by Harry E. Maule. New York: The Modern Library, (1945). Pp. 266–269: "Dog Eater."

73. *The Pocket Book of Western Stories.* Edited and with an introduction by Harry E. Maule. New York: Pocket Books, Inc., 1945. Contains, pp. 257–260: "Dog Eater."

74. *Album of American History.* Vol. III, 1853–1893. Edited by James Truslow Adams. New York: Charles Scribner's Sons (1946). P. 390: WAITING FOR A CHINOOK.

75. *The American West.* Edited and with an introduction by William Targ. Cleveland: The World Publishing Company, (1946). Contains, p. 32 *et seq.*, "Speakin' of Cowpunchers."

76. *Montana Margins: A State Anthology.* Edited by Joseph Kinsey Howard, Formerly Research Associate, The Montana Study. New Haven: Yale University Press; London: Geoffrey Cumberlege, Oxford University Press, 1946. Contains 3 stories by Russell and a letter:

p. 180: "The Story of the Cowpuncher"

p. 378: "Whiskey"

p. 418: "Lepley's Bear"

p. 504: Letter to 'Brother Van'

p. 326: Reference to CMR

77. *Pen and Ink Drawings* by Charles M. Russell. (Book No. 1). Pasadena, Calif.: Trail's End Publishing Co., copyright 1946. SKULL #1 on label pasted to cover. Contains 17 line engravings:

THE COMING OF THE IRON HORSE, i.e., CHEYENNES WATCHING UNION PACIFIC TRACK LAYERS

WHEN THE BUFFALO WAS MONARCH, i.e., BUFFALO HOLDING UP MISSOURI RIVER STEAMBOAT

BUILDING OLD FORT MANUEL, i.e., BUILDING FORT MANUEL IN 1807

A TRAGEDY OF THE ROCKIES, i.e., END OF OLD BILL WILLIAMS

PATRICK FORD DIES FIGHTING, i.e., PLUMMER AND TWO FOLLOWERS KILL FORD

THE LAST OF THE TONQUIN

DON JUAN DE ONATE IN NEW MEXICO, i.e., ONATE'S MARCH INTO THE NEW MEXICAN COUNTRY

THE WAGON BOSS, i.e., A DIAMOND R MULE TEAM OF THE '70S

BILLY THE KID KILLS BILLY MORTON AND FRANK BAKER TO AVENGE THE DEATH OF J. H. TUNSTALL, i.e., THE KID SHOOTS DOWN TWO PRISONERS IN COLD BLOOD

THE CINCH RING, i.e., RUSTLERS CAUGHT AT WORK

AN UNSCHEDULED STOP, i.e., PLUMMER'S MEN AT WORK

JOE SLADE KILLS JULES RENI, i.e., KILLING OF JULES RENI BY SLADE

SACAJAWEA MEETS HER BROTHER, i.e., MEETING OF SACAJAWEA AND HER RELATIVES OF THE SHOSHONE TRIBE

BUFFALO BILL'S DUEL WITH YELLOWHAND, i.e., CODY'S FIGHT WITH YELLOWHAND

THE STAGE COACH CHANGE STATION, i.e., A "SWING" STATION ON THE OVERLAND

TAMING A BAD ONE, i.e., WORK ON THE ROUNDUP

CANADIAN MOUNTED POLICE IN ACTION, i.e., MOUNTED POLICE PATROL CAPTURES AMERICAN WHISKY RUNNERS

78. *Pen and Ink Drawings* by Charles M. Russell. (Book No. 2). Pasadena, Calif.: Trail's End Publishing Co., copyright 1946. SKULL #1 on label pasted to cover. Contains 17 line engravings:

ON THE OLD SANTA FE TRAIL, i.e., INDIANS MEET FIRST WAGON TRAIN WEST OF MISSISSIPPI

THE WHITE MAN'S TEPEE, i.e., THE FORT AT THREE FORKS

A HORSE STEALING EXPEDITION, i.e., ROCKY MOUNTAIN TRAPPERS DRIVING OFF HORSES STOLEN FROM CALIFORNIA MISSION

THE DEATH OF LASALLE

THE WHITE MAN'S FIRE BOAT, i.e., PAWNEES SEE "WATER MONSTER"

THE DISCOVERY OF THE COLUMBIA, i.e., CAPTAIN GRAY MAKING GIFTS TO THE INDIANS AT THE MOUTH OF THE COLUMBIA RIVER

RADISSON—TRAIL BLAZING TRADER, i.e., RADISSON RETURNS TO QUEBEC WITH 350 CANOES LOADED WITH FURS

JIM BRIDGER DISCOVERS SALT LAKE, i.e., BRIDGER DISCOVERS THE GREAT SALT LAKE

SALUTE TO THE FUR TRADERS, i.e., ADVANCE OF BLACKFEET
TRADING PARTY
BENT'S FORT ON (THE) ARKANSAS RIVER
THE HIDE TRADE OF OLD CALIFORNIA
WILD BILL HICKOK'S GREATEST FEAT, i.e., WILD BILL'S
FIGHT WITH MCCANDLAS GANG
THE LAST OF THE FETTERMAN COMMAND, i.e., ANNIHILA-
TION OF FETTERMAN'S COMMAND
BEFORE THE WHITE MAN CAME, i.e., A MANDAN VILLAGE
JOHN COLTER'S ESCAPE, i.e., COULTER'S [sic] RACE FOR
LIFE
THE DEATH OF ROMAN NOSE, i.e., CHARGE OF CHEYENNES
LED BY ROMAN NOSE
THE ATTACK, i.e., STAGE COACH ATTACKED BY INDIANS

79. *Pioneer Western Empire Builders*, by Frank M.
King. Pasadena: Trail's End Publishing Co., (1946).
Contains, p. 94: THE CINCH RING, i.e., RUSTLERS CAUGHT
AT WORK.

80. *Wranglin' the Past: The Reminiscences of Frank M.
King.* Illustrated Including Drawing by Charles M.
Russell. First revised edition after limited edition,
privately published in 1935, by the author for his
friends. Published by Trail's End Publishing Co.,
Pasadena, 1946. Contains 1 line engraving, fcg. p.
[140]: BILLY THE KID KILLS BILLY MORTON AND FRANK
BAKER TO AVENGE THE DEATH OF J. H. TUNSTALL, i.e., THE
KID SHOOTS DOWN TWO PRISONERS IN COLD BLOOD.

81. *Modern Beef Cattle Breeding and Ranching Methods*,
by Wallis Huidekoper. Christmas Greetings and Best
Wishes to the Cattlemen of Wyoming for a Prosperous
and Successful New Year from the Wyoming Stock
Growers Association. (1947). Contains, cover: WAITING
FOR A CHINOOK

82. *My Experience and Investment in the Bad Lands of
Dakota and Some of the Men I Met There*, by A. C.
Huidekoper. Introduction by Usher L. Burdick.
Baltimore: Wirth Brothers, 1947. Contains 1 halftone,
p. 12: COWBOYS ROPING A WOLF, i.e., ROPING A WOLF #2

83. *Plains, Peaks and Pioneers: Eighty Years of Metho-
dism in Montana*, by Edward Laird Mills. Portland,
Oregon: Binfords & Mort, (1947). Reference to CMR
p. 45. Contains facsimile of letter from CMR to
Brother Van (W. W. Van Orsdel), three pages, dated
March 20, 1918, tipped in between pp. 128 and 129:
BUFFALO HERD CROSSING RIVER, BLOCKING STERNWHEELER

84. *Brother Van: A biography of the Rev. William
Wesley Van Orsdel*, by Alson Jesse Smith. Nashville:
Abingdon-Cokesbury Press, (1948). Contains:

p. 96: BROTHER VAN SHOOTING BUFFALO, i.e., RIDING
TOWARD THE FRONT OF THE STAMPEDING
BEASTS BROTHER VAN SHOT THE HERD LEADER
IN THE HEAD
p. 160: THE ATTACK #1

85. *Western Roundup*. Edited by Arnold Hano. New
York: Bantam Books, (1948). Pp. 189–194: "The
Story of the Cowpuncher."

86. *Western Triggers*. Edited by Arnold Hano. New
York: Bantam Books, 1948. Pp. 124–128: "Some
Liars of the Old West."

87. *The Westerners Brand Book*. Los Angeles Corral,
1948. Contains:
pp. 58–59: "Charles M. Russell," by Homer E.
Britzman
p. 27: PANNING FOR GOLD, i.e., PLACER MINERS
PROSPECTING NEW STRIKE
pp. 56–57: WHERE GREAT HERDS COME TO DRINK
p. 58: WHEN THE BUFFALO WAS MONARCH, i.e.,
BUFFALO HOLDING UP MISSOURI RIVER
STEAMBOAT
p. 59: Charles Marion Russell (photo)
p. 101: JIM BRIDGER DISCOVERS SALT LAKE, i.e.,
BRIDGER DISCOVERS THE GREAT SALT LAKE
p. 147: TAMING A BAD ONE, i.e., WORK ON THE
ROUNDUP

88. *Ranching Days in Dakota and Custer's Black Hills:
Expedition of 1874*, by Lewis F. Crawford, deceased.
Introduction by Usher L. Burdick. Baltimore: Wirth
Brothers, 1950. Contains:
fcg. p. 53: A COW FIGHTS FOR HER CALF, i.e., RANGE
MOTHER
fcg. p. 81: ROPING A BEAR, i.e., ROPING A RUSTLER

89. *Songs of the Cattle Trail and Cow Camp*, by John
A. Lomax. Illustrated with 78 drawings and sketches
by famous Western artists. New York: Duell, Sloan,
and Pearce, (1950). Contains:
p. 2: STEER HEAD
p. 45: SHELBY IN THE EARLY DAYS
p. 93: SUDDENLY SOMETHING HAPPENS
p. 96: "YES, YOU DID!"
p. 101: I DONT MISS NONE OF THEM BOULDERS
p. 108: LANDUSKY IN ITS HEYDAY

90. *The Westerners Brand Book, 1950*. Los Angeles
Corral. Contains, p. 195: THE WHITE MAN'S FIRE BOAT,
i.e., PAWNEES SEE "WATER MONSTER."

91. *From the Quarries of Last Chance Gulch*, by William C. Campbell. Helena: Montana Record Publishing Co., (1951). PAY DIRT stamped in gold on cover.

92. *Gallery of Western Paintings*. Edited by Raymond Carlson. New York, London, and Toronto: McGraw Hill Book Company, Inc., (1951). Contains seven color plates:
p. [7]: WHEN WAGON TRAILS WERE DIM
p. [8]: WHEN THE TRAIL WAS LONG BETWEEN CAMPS
p. [9]: TIGHT DALLY AND LOOSE LATIGO
pp. [10–11]: WAITING FOR A CHINOOK, i.e., THE LAST OF 5000
p. [12]: THE CHALLENGE #2
p. [13]: AT THE END OF THE ROPE
p. [14]: RETURN OF THE WARRIORS

93. *The Hard Winter and the Range Cattle Business*, by Ray H. Mattison. Author's separate reprinted from *The Montana Magazine of History*, October, 1951. Contains: WAITING FOR A CHINOOK (color).

94. *Billy the Kid, the Bibliography of a Legend*, by J. C. Dykes. Albuquerque: University of New Mexico Press, 1952. Paper; 30 copies bound in cloth. Contains, front.: BILLY THE KID KILLS BILL MORTON AND FRANK BAKER TO AVENGE THE DEATH OF J. H. TUNSTALL, i.e., THE KID SHOOTS DOWN TWO PRISONERS IN COLD BLOOD.

95. *Original Contributions to Western History*. Edited by Nolie Mumey. Illustrated by Inez Tatum. The Westerners; Denver, Colorado: The Artcraft Press, 1952. "Charles Marion Russell (1864–1926): A Tribute," by Nolie Mumey, pp. 533–534.
p. [535]: NAVAJO WILD HORSE HUNTERS
 WILD HORSE FIGHT, i.e., THE CHALLENGE #2
p. [537]: THE MEDICINE MAN #1
 MOURNING HER WARRIOR DEAD

96. *Trail Driving Days*, by Dee Brown and Martin F. Schmitt. New York: Charles Scribner's Sons, 1952. Contains:
p. 20: INDIANS DEMANDING TOLL, i.e., TOLL COLLECTORS
p. 239: WAITING FOR A CHINOOK

97. *The Westerners Brand Book of Los Angeles Corral*. Book V. Limited Edition. Los Angeles, 1953. P. 102: SACAJAWEA MEETS HER BROTHER, i.e., MEETING OF SACAJAWEA AND HER RELATIVES OF THE SHOSHONE TRIBE.

98. *I Knew Charles M. Russell The Cowboy Artist* by Carter V. Rubottom. Montana Heritage Series, Number 2. (Helena): Montana Historical Society, (1954).
COVER: I RODE HIM
p. 2: I RODE HIM
p. 3: THE CHRISTMAS DINNER
p. 4: photo of CMR at easel, painting THE SALUTE OF THE ROBE TRADE (another Russell in background)
 photo of CMR on Monte
 photo of CMR in Indian costume
p. 6: photo of Ben Roberts' home
p. 7: three photos, of CMR and A. J. Trigg, of CMR and Mamie Russell, and of Mamie Russell and Josephine Trigg
p. 8: photo of CMR in 1897
p. 10: CHARLIE PAINTING IN HIS CABIN
p. 11: THE KNIGHT OF THE PLAIN AS HE WAS, i.e., AH-WAH-COUS
p. 12: photo of Charles M. Russell Room
 TRANSPORT TO THE NORTHERN LIGHTS (model)
p. 13: CHARLES M. RUSSELL AND HIS FRIENDS
p. 14: LEWIS AND CLARK MEETING (THE) INDIANS AT ROSS (i.e., ROSS') HOLE
 LEWIS AND CLARK IN THE MANDAN VILLAGE, i.e., YORK
p. 15: TOLL COLLECTORS
 THE ROUNDUP #2
p. 16: I'M SCAREDER OF HIM THAN I AM OF THE INJUNS
 INDIAN HUNTER'S (i.e., HUNTERS') RETURN

99. *Legends and Tales of the Rockies*, by Amanda S. Ellis. Colorado Springs: The Dentan Printing Co., 1954. Contains, p. 27: INDIAN WARFARE, i.e., FOR SUPREMACY.

100. *Livestock Range, Its Nature and Use.* Part I: Range Plants. By K. G. Parker. Montana Ext. Bul. M-1014. May, 1954. Cover: THE TRAIL BOSS (part).

101. *Livestock Range, Its Nature and Use.* Part II: Forage Values. By K. G. Parker. Montana Ext. Bul. C-1032. May, 1954. Cover: THE TRAIL BOSS (part).

102. *Livestock Range, Its Nature and Use.* Part III: Plant Relationships. [By K. G. Parker]. Montana Ext. Bul. M-1015. May, 1954. Cover: THE TRAIL BOSS (part).

103. *Roundup Years Old Muddy to Black Hills*, by Bert L. Hall. (Kennebec, South Dakota, 1954). Contains, p. 581: WAITING FOR A CHINOOK.
Reprinted, The Reminder, Inc., Pierre, South Dakota, 1956.

104. *Buffalo Bill and the Wild West,* by Henry Blackman Sell and Victor Weybright. New York: Oxford University Press, 1955. Paperback edition published New York, 1959. Contains 1 halftone, p. 47: INDIANS HUNTING BISON WITH BOW AND ARROWS, i.e., SURROUND.

105. *Cattle and Men,* by Charles Wayland Towne and Edward Norris Wentworth. Norman: University of Oklahoma Press, 1955. Contains, tipped in between pp. 162–163: WAITING FOR A CHINOOK.

106. *The Fall Roundup,* by Members of the Western Writers of America. Edited with an introduction by Harry E. Maule. New York: Random House, (1955).
dustwrapper: LAUGH KILLS LONESOME (color)
endpapers:　A CENTER-FIRE FASHION LEADER
　　　　　　AN OLD TIME BRONC
p. i:　　　 STEER HEAD
pp. ii–iii:　THE MOUNTAINS AND PLAINS SEEMED TO STIMULATE A MAN'S IMAGINATION

107. *Great Roundup: The Story of Texas and Southwestern Cowmen,* by Lewis Nordyke. New York: Morrow, 1955. Contains, front.: THE ROUNDUP #2 (color). Same illustration on dustwrapper.

108. *The Heart of Montana's History and Art,* (by) K. Ross Toole, Director. (Montana Heritage Series Number 1). Helena: Montana Historical Society, 1955.
p. 11:　 LEWIS AND CLARK MEETING INDIANS AT ROSS' HOLE
p. 12:　 Charles M. Russell Room (photo)
　　　　 THE ROUNDUP #2
p. 13:　 CHARLES M. RUSSELL AND HIS FRIENDS
　　　　 TOLL COLLECTORS
　　　　 TRANSPORT TO THE NORTHERN LIGHTS (model)
p. 14:　 INDIAN HUNTERS' RETURN
　　　　 YORK
p. 15:　 I'M SCAREDER OF HIM THAN I AM OF THE INJUNS
recto b. cover: AH-WAH-COUS

109. *The Indian and the Horse,* by Frank Gilbert Roe. Norman: University of Oklahoma Press, 1955. Contains four halftones, following:
p. 110: FLYING HOOFS
　　　　 INDIAN HUNTERS' RETURN
p. 206: RETURN FROM THE HUNT
p. 302: (THE) STAGECOACH ATTACK

110. *Old Brewery Theatre. Last Chance Gulch. Helena, Montana Territory.* Another Helena Unlimited Project. Helena Chamber of Commerce, n.d. (ca. 1955). LAUGH KILLS LONESOME (color); two photos of CMR; and photo of Charles M. Russell room.

111. *Out West.* An Anthology of Stories Edited by Jack Schaefer. Boston: Houghton Mifflin, 1955. Contains, p. 270: "Dog Eater."

112. *Pictorial History of America,* by the Editors of *Year.* Foreword by Allan Nevins. The words "Copyright MCMLIV, Revised MCMLV" appear on verso of title page. Contains two halftones:
p. 89:　LEWIS AND CLARK MEETING INDIANS AT ROSS' HOLE
p. 100: WILD MAN'S TRUCE

113. *Report of Montana "White House" Conference on Education.* Helena, Montana, October 7–8, 1955. Sponsored by Honorable J. Hugo Aronson, Governor of Montana, in cooperation with the President's White House Conference Committee. P. i: LEWIS AND CLARK MEETING INDIANS AT ROSS' HOLE.

114. *Sixguns by Keith: The Standard Reference Work,* by Elmer Keith. Harrisburg, Pennsylvania: The Stackpole Company, (1955). Contains, front. (also on dustwrapper): SMOKE OF A FORTY-FIVE (color). Also a limited edition of 100 numbered copies bound in full padded calf, boxed, without dustwrapper.

115. *The American Heritage Reader.* Selections from The Magazine of History by Bruce Catton. New York: Dell Publishing Company, Inc., (1956). Contains, opp. p. 129: TRAIL OF THE IRON HORSE #2 (color).

116. *Montana Directory of Public Affairs 1864–1955.* Compiled by Ralph E. Owings, (Ann Arbor, 1956). Contains, p. [ix], LEWIS AND CLARK MEETING INDIANS AT ROSS' HOLE; and photo of CMR, p. [xi].

117. *Yellowstone Wonderland, the Early History of the Great National Park.* Montana Heritage Series, Eight. Helena: (Montana Historical Society, 1956). Deluxe Edition, $1.00. Recto back cover: THE FIRST FURROW.

118. *The Golden Book of America.* Stories from our Country's past adapted for young readers by Irwin Shapiro from the pages of American Heritage The Magazine of History with a foreword by Bruce Catton. New York: Simon and Schuster, (1957). P. 95: TRAIL OF THE IRON HORSE #2.

119. *Good Old Days in Montana Territory. Reminiscences of the Harrington and Butcher Families.* Edited by George F. Brimlow. Butte, Montana: McKee Printing Company, 1957. Cover: THEN THE CALDWELLITES CHARTERED THE STAGE AND WENT HOME.

120. *See It Now...Historic Montana.* Montana Heritage Series Number Nine. (Helena): Montana Historical Society, n.d. (1957).

p. 4: SINGLE HANDED
p. 33: AH-WAH-COUS (part)
p. 45: [THE] BATTLE OF BEAR PAWS
p. 46: SMOKE OF A FORTY-FIVE
recto b. cover: GOING TO A CHRISTMAS RANCH PARTY IN THE 1880s
INDIAN MAID AT STOCKADE
BRONC TO BREAKFAST

121. *Some of the Old-Time Cow Men of the Great West,* by Usher L. Burdick. Baltimore, Md.: Wirth Brothers, 1957.

front.: ROPING A BEAR ON THE MONTANA RANGE, i.e., ROPING A RUSTLER
p. 37: A WILD COW ON THE "PERK," i.e., RANGE MOTHER
pp. 31–39: Henry A. Miller and Charles M. Russell

122. *This Is the West,* edited by Robert West Howard. Illustrated. New York, Chicago, and San Francisco: Rand McNally & Company, (1957).

pp. [76–77]: JERKED DOWN
p. 88: CHUCKWAGON, COWBOYS EATING ON GROUND
p. 129: HIGHWAYMAN WAITING FOR HIS PREY
p. [157]: A SHARP TURN
p. [162]: A RUNNING OF WILD HORSES, i.e., CORAZON HELD TO HIS COURSE
p. 169: A COWBOY ROPING A STEER, i.e., THE STEER WAS TOSSED CLEAR OF THE GROUND AND CAME DOWN ON HIS LEFT SIDE

A paperback edition was published by The New American Library (1957), which lacks the illustrations of the Rand McNally edition, but does contain references to CMR.

123. *Three Hundred Years of American Painting,* by Alexander Eliot—art editor of *Time* with an introduction by John Walker, director of the National Gallery. New York: Time Incorporated, 1957. Contains, pp. 102–103: LEWIS AND CLARK MEETING INDIANS AT ROSS' HOLE (color).

124. *Tulsa I. T. Indian Territory Oklahoma.* The people of Oklahoma invite you to share with them Oklahoma's semi-centennial celebration, April 22 to November 16, 1957. P. [14]: A DOUBTFUL VISITOR, i.e., A PRAIRIE SCHOONER CROSSING THE PLAINS.

125. *When Wagon Trails Were Dim: Portraits of Pioneer Methodist Ministers Who Rode Them,* by Paul M. Adams. Montana Conference Board of Education of the Methodist Church, (1957). Facing p. 35: RIDING TOWARD THE FRONT OF THE STAMPEDING BEASTS BROTHER VAN SHOT THE HERD LEADER IN THE HEAD.

126. *America on Parade.* Stories from our Country's Past from American Heritage The Magazine of History Adapted for Young Readers by Irwin Shapiro, with a foreword by Bruce Catton. (1958). P. 55: THE TRAIL OF THE IRON HORSE #2.

127. *4-H Leader's Range Management Guide.* Montana Extension Bulletin 1026. Bozeman, November, 1958. Revised and reissued with a slight change in title, February, 1961. Cover: THE HORSE WRANGLER (bronze).

128. *Indians and the Old West.* The Story of the First Americans adapted from the pages of American Heritage, The Magazine of History by Anne Terry White. New York: Simon and Schuster, 1958. Two editions, one $6\frac{5}{8} \times 8$, pp. 56, with illustration, p. 50: THE TRAIL OF THE IRON HORSE #2; the other $7 \times 9\frac{3}{8}$, pp. 54, with illustration on p. 49.

129. *The Missouri: A Great River Basin of the United States; Its Resources and How We Are Using Them.* Public Health Service Publication No. 604. Washington: Government Printing Office, 1958. P. [3]: THE BOLTER #3.

130. *1958 Summer Quarter Bulletin.* Montana State College, Bozeman, Montana.

cover: FREE TRAPPERS (color)
b. cover: INDIAN HUNTERS' RETURN (color)

131. *Rangeland Rembrandt, Charles Marion Russell, Artist, Illustrator,* by F. G. Renner. Montana Heritage Series Number 10. Helena: Montana Historical Society, n.d. (1958).

cover: THE ROUNDUP #2 (color)
p. [1]: Charles M. Russell (photo)
WHEN COWS WERE WILD
p. [2]: GET YOUR ROPES, i.e., CALLING THE HORSES
p. [3]: CAPTAIN LEWIS MEETING THE SHOSHONES
p. [4]: CHIEF BLOOD ARROW, i.e., BLOOD BROTHER
CHIEF BLOOD BROTHER, i.e., BLACK EAGLE
p. [5]: IN WITHOUT KNOCKING
p. [6]: WHEN BUFFALO WERE PLENTIFUL
p. [7]: WHITE TAILS #1
HERE LIES POOR JACK, HIS RACE IS RUN
p. [8]: LAST OF THE HERD, i.e., SURROUND
p. [9]: THE ROUNDUP #2
THE SURPRISE ATTACK
THE ROPE WOULD SAIL OUT AT HIM

p. [10]: THREE GENERATIONS
p. [11]: DEATH SONG OF LONE WOLF
 YORK
 BREAKING CAMP #3
p. [12]: THE INNOCENT ALLIES
p. [13]: THE BATTLE OF BEAR PAWS
 THE MOUNTAINS AND PLAINS SEEMED TO STIMU-
 LATE A MAN'S IMAGINATION (part)
p. [14]: INDIAN HUNTERS' RETURN
p. [15]: WHERE THE BEST OF RIDERS QUIT (bronze)
 OH MOTHER WHAT IS IT? (bronze)
p. [16]: MOUNTAIN SHEEP #1 (bronze)
p. [17]: SPOILS OF WAR
 THE TRAIL BOSS, i.e., TEXAS TRAIL BOSS
p. [18]: RUNNING BUFFALO
 THE BUCKER AND THE BUCKEROO, i.e., THE
 WEAVER (bronze)
 BRONC TO BREAKFAST
p. [19]: WHERE TRACKS SPELL MEAT
 THE WOLFER
 THE BOLTER #3
 MEDICINE MAN #4
p. [20]: ROMANCE MAKERS
 MEAT FOR THE WAGONS
p. [21]: IN THE ENEMY'S COUNTRY
 BEST WISHES FOR YOUR CHRISTMAS
p. [22]: CHARLES M. RUSSELL AND HIS FRIENDS
 THE TRAIL BOSS
p. [24]: RUNNING BUFFALO (before repainting by CMR)

132. *Winter Antiques Show: A Benefit for 1958.* East Side House, Stepney Camp, Winifred Wheeler Day Nursery. P. 53: THE SCOUTING PARTY, i.e., INDIAN HORSE THIEVES.

133. *Acceptance of the Statue of Charles M. Russell Presented by the State of Montana. Proceedings in the Congress and in the Rotunda, United States Capitol.* Pp. 92. 85th Congress, 2d Sess., Sen. Doc. 133. Washington, 1959. Contains:
p. [2]: Charles M. Russell (photo)
pp. 3–4: "Charles M. Russell—1864–1926," by K. Ross Toole
pp. 5–8: "Biography," by Michael Kennedy
pp. 21–25: Welcoming Address of Senator Mike Mansfield
pp. 27–30: "An Appreciation of Charles M. Russell," by K. Ross Toole
pp. 31–37: Remarks made by Representative Sumner Gerard
pp. 39–41: Senator Murray's Acceptance, on Behalf of the Congress, of Charles M. Russell Statue, Thursday, March 19, 1959
pp. 43–66: Tributes

pp. 67–85: "Charles M. Russell, The Man and His Work," by F. G. Renner
p. [86]: Charles M. Russell in His Studio (photo)
pp. 87–92: "A Slice of My Early Life," by Charles M. Russell

134. *The American Heritage Book of the Pioneer Spirit,* by the Editors of American Heritage. New York: The American Heritage Publ. Co. (1959). Contains:
pp. 154–155: LEWIS AND CLARK MEETING THE FLAT-HEADS, i.e., LEWIS AND CLARK MEETING INDIANS AT ROSS' HOLE
p. [338]: "A BULLWHACKER MAKES HIS WHIP SING," i.e., THE BULL WHACKER
p. [339]: "HANDS UP!", i.e., THE ROAD AGENT

135. *A Century on an Iowa Farm,* by Otha D. Wearin. Hastings: Nishna Vale Press, 1959. Contains, p. [87]: THE HORSE WRANGLER #1.

136. *The Cowboy Reader.* Edited by Lon Tinkle and Allen Maxwell. New York: Longmans, Green and Co., 1959. Contains:
pp. 79–83: "The Story of the Cowpuncher"
t.p. A COWBOY AND HIS PONY, i.e., MOUNTED COWBOY
fcg. p. 1: LOTS TO LASSO, i.e., COWBOY TWIRLING LARIAT, LONGHORNS RUNNING
p. 162: THE TRAIL HERD, i.e., TRAIL DRIVERS WATCHING HERD
p. 289: BRONCO, i.e., BUCKING HORSE

137. *Directory and Guide, Malmstrom Air Force Base.* (Great Falls) Montana, 1959. Contains:
cover: A DISPUTED TRAIL
p. 29: Charles M. Russell Art Gallery (photo)

138. *The Fireside Book of Guns,* by Harry Koller. New York: Simon and Schuster, Inc., 1959. Contains, pp. 62–63: LEWIS AND CLARK MEETING INDIANS AT ROSS' HOLE.

139. *The Great American West, A Pictorial History from Coronado to the Last Frontier,* by James D. Horan. New York: Crown Publishers, Inc. (1959). Contains:
p. [190]: WHERE GREAT HERDS COME TO DRINK
p. [191]: AT THE END OF THE ROPE
p. [192]: THE LAST OF 5,000
 AN UNSCHEDULED STOP

140. *The Growth of America,* by Rebekah R. Liebman and Gertrude A. Young. Englewood Cliffs, N.J.: Prentice-Hall, Inc., 1959. Contains, p. 210: QUICK AS A THOUGHT HE WAS PULLING HIS GREAT STALWART FIGURE FROM OUT THE COACH.

141. *Montana an Uncommon Land*, by K. Ross Toole. Norman: University of Oklahoma Press (1959). Contains, p. 243, reference to CMR, and between pp. 134 and 135: THE LAST OF 5000.

142. *Portrait of Progress: Great Falls Diamond Jubilee.* The Electric City 1884–1959 Montana 75 Years. Published by the Diamond Jubilee, Inc., Great Falls, Montana.

p. 11:	DISCOVERY OF THE GREAT FALLS OF THE MISSOURI BY LEWIS AND CLARKE, 1805
p. 13:	BUFFALO ON THE MOVE, i.e., BUFFALO MIGRATION
p. 15:	CARSON'S MEN
p. 19:	THE INDIAN OF THE PLAIN AS HE WAS, i.e., AH-WAH-COUS
pp. 31–33, 35:	"The Russell Story 1865–1926" and Ecklund's Last Portrait
p. 62:	THE JERK LINE
p. 79:	CHRISTMAS AT LINE CAMP
p. 80:	THE COWBOY #2 (part)
p. 84:	THE COWBOY #2 (part)
	[THE] SIOUX BUFFALO HUNTER (part)
	A FRENCH HALF-BREED (part)
p. 91:	WAITING FOR A CHINOOK
p. 115:	Champ Jack Dempsey with Charlie Russell (photo)

143. *The Strange Uncertain Years: An Informal Account of Six Colorado Communities*, by Amanda M. Ellis. Hamden, Connecticut: The Shoe String Press Inc., 1959. Contains, p. [81]: AN INDIAN MASSACRE, i.e., FOR SUPREMACY.

144. *The American Indian*, by Oliver La Farge. Special Edition for Young Readers. New York: Golden Press, (1960). P. 152: LEWIS AND CLARK MEETING THE FLATHEAD INDIANS IN MONTANA; i.e., LEWIS AND CLARK MEETING INDIANS AT ROSS' HOLE.

145. *Bears in the Rockies*, by Olga W. Johnson *et al.* Illustrated by John R. Hennessy. Copyright, 1960. Printed by The Copy Shop, Kalispell, Montana. Contains two halftones:

p. [2]:	GLACIER PARK GRIZZLY (bronze)
p. [80]:	same, photo from rear

146. *Free Grass to Fences: The Montana Cattle Range Story*, by Robert H. Fletcher. Illustrations by Charles M. Russell. Published for The Historical Society of Montana. New York: University Publishers Incorporated, n.d. (1960).

spine:	THE COWBOY #2
d.w.:	THE ROUNDUP #2
endpapers:	TOLL COLLECTORS
fcg. p. i:	THE TRAIL BOSS
p. [ii]:	WHEN COWS WERE WILD
t.p.:	COWBOY TWIRLING LARIAT, LONGHORNS RUNNING
p. [v]:	TRAILS PLOWED UNDER
p. [vii]:	THE MOUNTAINS AND PLAINS SEEMED TO STIMULATE A MAN'S IMAGINATION
p. [ix]:	FOUR COWBOYS GALLOPING
p. [xiii]:	CHUCKWAGON, COWBOYS EATING ON GROUND
p. [xvi]:	THE COWBOY #2
p. [xviii]:	INDIANS MEET FIRST WAGON TRAIN WEST OF MISSISSIPPI
p. 1:	LIKE A FLASH THEY TURNED (part)
p. [3]:	THE POST TRADER (vignette)
p. [13]:	AH-WAH-COUS
p. [19]:	PLACER MINERS PROSPECTING NEW STRIKE
p. 27:	A DIAMOND R MULE TEAM OF THE '70S
p. [28]:	BATTLE BETWEEN CROWS AND BLACKFEET
p. [36-c]:	WHITE MAN'S BUFFALO
p. 42:	NATURE'S CATTLE #1
p. [43]:	THEY'RE ALL PLUMB HOG WILD (part)
p. 51:	TWO RIDERS, ONE LEADING A PACK HORSE
p. [52]:	TRAIL DRIVERS WATCHING HERD
p. 61:	COWBOY TWIRLING LARIAT, LONGHORNS RUNNING
p. [62]:	RAWHIDE RAWLINS, MOUNTED
p. [68-b]:	TEXAS TRAIL BOSS
p. [68-f]:	THE SURPRISE ATTACK
p. [68-g]:	THE FIRST FURROW
p. 73:	A RACE FOR THE WAGONS (part)
p. [74]:	STAGECOACH ATTACKED BY INDIANS
p. 83:	HOLDING UP THE OVERLAND STAGE
p. [84]:	THE WOLFER (vignette)
p. 93:	IN THE OLD DAYS THE COW RANCH WASN'T MUCH
p. [94]:	SPREAD EAGLED
p. [101]:	THE STEER WAS TOSSED CLEAR OF THE GROUND AND CAME DOWN ON HIS LEFT SIDE
p. [108-a]:	I'M SCAREDER OF HIM THAN [I AM] OF [THE] INJUNS
p. [108-g]:	THE HERD QUITTER
p. [108-h]:	NO KETCHUM
p. [108-i]:	GET YOUR ROPES, i.e., CALLING THE HORSES
p. 109:	PETE HAD A WINNING WAY WITH CATTLE
p. [110]:	THREE WOLVES WATCHING WAGON TRAIN
p. 121:	WORK ON THE ROUNDUP
p. [122]:	"YES, YOU DID!" (part)
p. 131:	HIS FIRST YEAR
p. [132]:	COMING TO CAMP AT THE MOUTH OF SUN RIVER (part)
p. 144:	ABOUT THE THIRD JUMP CON LOOSENS (part)

p. [145]: COWBOY ABOUT TO SADDLE HORSE
fcg. p. [149]: WAITING FOR A CHINOOK
p. 154: IL BE THAIR WITH THE REST OF THE REPS
p. [155]: SHORTY'S SALOON—BRANDING IRONS
p. [164]: COWPUNCHERS WERE CARELESS, HOMELESS,
 HARD-DRINKING MEN (part)
p. [165]: BUCKING HORSE
p. 171: THE SCOUT #4 (vignette)
p. [172]: THE LAST OF HIS RACE
p. 183: THE GEYSER BUSTS LOOSE (part)
p. [184]: MOUNTED COWBOY
p. 191: ABOUT THE THIRD JUMP CON LOOSENS
fcg. p. 196: NATURE'S CATTLE #2
 THEY'RE ALL PLUMB HOG WILD
 THE LONGHORN
 THE COME LATELY
p. 199: A SHARP TURN
p. [200]: THE COWBOY LOSES
p. 210: [THE] INITIATION OF THE TENDERFOOT
 (part)
p. [211]: SHELBY IN THE EARLY DAYS
p. 224: HERE LIES POOR JACK, HIS RACE IS RUN
p. [225]: MOST OF THE COW RANCHES I'VE SEEN
 LATELY WAS LIKE A BIG FARM
p. 233: A RACE FOR THE WAGONS
p. [236]: YOU SLEEPING RELICK OF THE PAST

147. *Great Western Indian Fights*, by Members of the Potomac Corral of the Westerners, Washington, D.C. Garden City, New York: Double-D Western Americana, 1960. Contains 1 halftone and 2 line engravings, tipped in following:

p. 120: GUNPOWDER AND ARROWS
 DEATH OF ROMAN NOSE, i.e., CHARGE OF
 CHEYENNES LED BY ROMAN NOSE
 THE BATTLE OF THE LAVA BEDS, i.e., THE BATTLE
 OF BEAR PAWS

148. *Guns of the Lewis and Clark Expedition*, by Ruby El Hult. (Tacoma): Washington State Historical Society, (1960). Contains, front.: "MERIWETHER LEWIS MEETS THE SHOSHONE," i.e., CAPTAIN LEWIS MEETING THE SHOSHONES.

149. *Hoofs to Wings, The Pony Express*. Boulder: Johnson Publishing Co., 1960. Limited 200 numbered and signed copies. Contains, facing p. 66: JOE SLADE SHOOTING A WAGON TRAIN DRIVER, i.e., LAUGHED AT FOR HIS FOOLISHNESS AND SHOT DEAD BY SLADE.

150. *Thomas Jefferson and His World*, by the Editors of American Heritage, The Magazine of History. Narrative by Henry Moscow. New York: American Heritage Publishing Co., 1960. Contains, pp. 138-139: LEWIS AND CLARK MEETING INDIANS AT ROSS' HOLE.

151. *Whoop-Up Country: The Canadian-American West, 1865-1885*, by Paul F. Sharp. With drawings by Charles M. Russell. Helena: Historical Society of Montana, West-Press, n.d. (1960).

d.w.: SINGLE HANDED
 COMING TO CAMP AT THE MOUTH OF SUN
 RIVER
 THE MOUNTAINS AND PLAINS SEEMED TO
 STIMULATE A MAN'S IMAGINATION
cover: ADVANCE OF (THE) BLACKFEET TRADING PARTY
endpapers: FLATBOAT ON RIVER, FORT IN BACKGROUND
p. [i]: THREE WOLVES WATCHING WAGON TRAIN
p. [ii]: OLD MAN SAW A CRANE FLYING OVER THE LAND
p. [iii]: THE POST TRADER (vignette)
p. [iv]: LOOKS AT THE STARS
p. [v]: BUFFALO HOLDING UP MISSOURI RIVER
 STEAMBOAT
p. [vi]: (THE) WAGON BOX FIGHT
p. [vii]: NATURE'S CATTLE #1 (part)
p. ix: AH-WAH-COUS
p. x: A SHARP TURN
p. xi: THE WOLFER (part)
p. xiv: ADVANCE OF (THE) BLACKFEET TRADING
 PARTY
p. xv: THE SCOUT #4
p. xix: THE WOLFER (part)
p. [1]: STAGE COACH ATTACKED BY INDIANS
p. [2]: HIS LAST HORSE FELL FROM UNDER HIM
p. 9: THE PROSPECTORS #2
p. 54: A DIAMOND R MULE TEAM OF THE '70S
p. 106: SO WITHOUT ANY ONDUE RECITATION, I
 PULLS MY GUNS AN CUTS DOWN ON THEM
 THERE TIN-HORNS
p. 132: THE SCOUT #4 (vignette)
p. 156: THE CHIEF FIRED AT THE PINTO #2 (part)
p. 182: IDAHO OX-TEAMS WERE BRINGING IN SOME
 6,000,000 POUNDS OF FREIGHT ANNUALLY
p. 206: A RACE FOR THE WAGONS (part)
p. 246: CAMPER FLIPPING FLAPJACKS
p. 312: THE TRAPPER (part)
p. 316: THE POST TRADER
p. 317: INDIAN TOMAHAWK, PIPE, AND MEDICINE
p. 318: THE WOLFER
p. 319: FIRST AMERICAN NEWS WRITER (part and
 upside down)
p. 337: THE CHIEF FIRED AT THE PINTO #2 (part)
p. [348]: PLACER MINERS PROSPECTING NEW STRIKE

152. *The American Heritage Book of Indians*, by the Editors of American Heritage. Editor in Charge, Alvin M. Josephy, Jr. Narrative by Williams Brandon. (New York): American Heritage Publishing Co., Inc., (1961). Contains, reference to CMR p. 348, and one plate, p. 354: FIGHTING MEAT (color).

153. *Blackfeet Man*, by James Willard Schultz. Montana Heritage Series Number 12. Helena: Montana Historical Society, 1961. Contains INDIANS DISCOVERING LEWIS AND CLARK as cover illustration in color.

154. *Cowboys and Cattle Country*. New York: American Heritage Publishing Co., Inc., 1961. Book Trade Distribution by Meredith Press. Institutional Distribution by Harper & Brothers.

cover:	THE BOLTER #3 (color)
p. 40:	WHEN HORSES TALK WAR THERE'S SMALL CHANCE FOR PEACE (color)
p. 53:	ON DAY HERD #2 (color)
pp. 56–57:	LAUGH KILLS LONESOME (color)
pp. 60–61:	TOLL COLLECTORS (color)
pp. [70–71]:	CAUGHT IN THE ACT (color)
pp. [78]–79:	KILLING OF JULES RENI BY SLADE
p. 79:	STEVE MARSHLAND WAS HANGED BY VIGILANTES
	THE ROAD AGENT (part)
pp. [88]–89:	WHEN GUNS SPEAK, DEATH SETTLES DISPUTE (color)
pp. 104–105:	BREAKING CAMP #1 (color)
p. 108:	A GRAY HOUND WARING HORNES (color)
	BULL DOGING THOSE LONG HORNS (color)
	THEY UNLODED THEM TWISTERS (color)
p. 109:	IV SEEN SOM ROPING AN RIDING (color)
	THIS RIDER DIDENT QUITE WIN (color)
p. [114]:	A RACE FOR THE WAGONS
p. 117:	PEACEFUL VALLEY SALOON (color)
pp. 124–125:	COWBOY CAMP DURING THE ROUNDUP (color)
pp. [128]–129:	THE ROUNDUP #2 (color)
p. 144:	IN WITHOUT KNOCKING (part) (color)
p. 152:	COWBOY ON FOOT, LASSOING HORSE
b. cover:	PETE HAD A WINNING WAY WITH CATTLE

155. *Nursing in Montana*. Helena: Montana Nurses Association, (1961). Contains:

p. 10: WE AIN'T GONE FIVE MILE WHEN THE COACH STOPS (part)

p. 42: OLD MAN SAW A CRANE FLYING OVER THE LAND (part)

p. 44: FIRST AMERICAN NEWS WRITER (part)

p. 48: LEWIS AND CLARK MEETING THE FLATHEADS, i.e., LEWIS AND CLARK MEETING INDIANS AT ROSS' HOLE

p. 52: BUFFALO HOLDING UP MISSOURI RIVER STEAMBOAT

p. 94: AH-WAH-COUS

156. *Pony Tracks*, written and illustrated by Frederic Remington. Norman: University of Oklahoma Press, (1961). P. xx bears COWBOY SLEEPING ON GROUND, HORSE STANDING, and there are many references to CMR in the Introduction by J. Frank Dobie.

157. *Range, Its Nature and Use*: *A Manual for Youth Groups*. Portland: American Society of Range Management, 1961. Cover: THE TRAIL BOSS (part).

158. *Trappers and Mountain Men*. Illustrated with paintings, prints, drawings, maps and photographs of the period. New York: American Heritage, Golden Press, 1961. P. 134: CARSON'S MEN.

159. *The American Cow Pony*, by Deering Davis. Princeton, New Jersey: D. Van Nostrand Company, Inc. (1962). Contains:

p. 26: WE AIN'T GONE FIVE MILE WHEN THE COACH STOPS

p. 28: A RACE FOR THE WAGONS (part)

160. *America's Historylands, Touring Our Landmarks of Liberty*. Washington, D.C.: National Geographic Society, 1962. Contains:

pp. 354–355:	LEWIS AND CLARK MEETING INDIANS AT ROSS' HOLE
p. [480]:	IN WITHOUT KNOCKING
p. [483]:	THE ROAD AGENT
p. [507]:	WHEN GUNS SPEAK, DEATH SETTLES DISPUTE

161. *Charles Marion Russell: Cowboy, Artist, Friend*, by Lola Shelton. New York. Dodd, Mead & Co., 1962. d.w.: Wedding picture of Charles M. Russell and Mamie (Nancy) Mann.

front.:	COWBOY SEATED, HORSE NUZZLING HIS LEFT HAND
p. 1.:	COMING TO CAMP AT THE MOUTH OF SUN RIVER (part)
p. 3:	ALL CONVERSATION WAS CARRIED ON BY THE HANDS
p. 9:	THE ROPE WOULD SAIL OUT AT HIM
p. 13:	INDIANS MEET FIRST WAGON TRAIN WEST OF MISSISSIPPI
p. 22:	COWBOY SEATED, HORSE NUZZLING HIS LEFT HAND
p. 29:	TWO RIDERS, ONE LEADING A PACK HORSE
p. 33:	WE AIN'T GONE FIVE MILE WHEN THE COACH STOPS
p. 40:	HOLDING UP THE OVERLAND STAGE
p. 44:	ADVANCE OF BLACKFEET TRADING PARTY
p. 50:	IN THE OLD DAYS THE COW RANCH WASN'T MUCH
p. 52:	A RACE FOR THE WAGONS
p. 61:	CHUCK WAGON, COWBOYS EATING ON GROUND
p. 65:	RAWHIDE RAWLINS, MOUNTED
p. 69:	LADY BUCKEROO
p. 75:	I'M HANGIN' ON FOR ALL THERE IS IN ME
p. 85:	LIKE A FLASH THEY TURNED
p. 95:	FIRST AMERICAN NEWS WRITER (part)
p. 103:	SQUAW WITH BULL BOAT
p. 112:	STEER RIDER #2
p. 123:	ABOUT THE THIRD JUMP CON LOOSENS
p. 124:	PETE HAD A WINNING WAY WITH CATTLE

p. 129: SCOOL MARM

p. 131: MOSQUITO SEASON IN CASCADE

p. 143: AH WAH COUS

p. 152: HIS FIRST YEAR

p. 161: THE LAST OF THE BUFFALO (part)

p. 166: HERE'S HOPING THE WORST END OF YOUR TRAIL
IS BEHIND YOU

p. 169: THE INITIATION OF THE TENDERFOOT

p. 179: THE LAST OF HIS RACE

p. 181: FROM THE SOUTHWEST COMES SPANISH AN'
MEXICAN TRADERS (printed in reverse)

p. 190: IL BE THAIR WITH THE REST OF THE REPS

p. 193: THE SCOUT #4 (vignette)

p. 203: SPREAD-EAGLED

p. 208: THE MOUNTAINS AND PLAINS SEEMED TO STIMU-
LATE A MAN'S IMAGINATION

p. 218: NATURE'S CATTLE #1

Also five colorplates:

fcg. p. 12: C. (i.e., CHARLES) M. RUSSELL AND HIS FRIENDS

fcg. p. 45: LAUGH KILLS LONESOME

fcg. p. 108: INDIAN HUNTERS' RETURN

fcg. p. 141: FREE TRAPPERS

front d.w.: MEN OF THE OPEN RANGE

Also, on the back dustwrapper, the following bronzes:
THE BLUFFERS, WILL ROGERS, THE WEAVER and CHANGING
OUTFITS

162. *Father DeSmet in Dakota*, by Louis Pfaller, O.S.B.
Richardson, N. Dak.: Assumption Abbey Press, 1962.
Contains, p. 11: LEWIS AND CLARK MEETING INDIANS AT
ROSS' HOLE.

163. *From Buffalo Bones to Sonic Boom. 75th Anniver-
sary Souvenir.* Compiled and edited by Vivian A.
Paladin. Glasgow Jubilee Committee, July, 1962.

p. [i]: THE TRAPPER (part)

p. [ii]: THE WOLFER (part)

p. 6: A DIAMOND R MULE TEAM OF THE '70S

p. 7: SO WITHOUT ANY ONDUE RECITATION, I PULLS
MY GUNS AN CUTS DOWN ON THEM THERE
TIN-HORNS

p. 8: CAMPER FLIPPING FLAPJACKS

p. 101: THE SCOUT #4

164. *Frontier Omnibus.* Edited by John W. Hakola.
Foreword by H. G. Merriam. Missoula: Montana State
University Press, (1962). Contains FREE TRAPPER in
color on front, and LEWIS AND CLARK MEETING INDIANS
AT ROSS' HOLE in color as endsheets, and 60 pen and ink
drawings, or parts of them, scattered through the book.
This also appeared in a limited edition bound in
buckskin.

165. *Kit Carson: A Portrait in Courage*, by M. Morgan
Estergreen. Norman: University of Oklahoma Press,
(1962). Full-color frontispiece, CARSON'S MEN.

166. *Montana, The Big Sky Country.* S. & H. Green
Stamps. N.p. (The Sperry and Hutchinson Company,
1962).

p. [8]: LEWIS AND CLARK MEETING INDIANS AT ROSS' HOLE
THE ROUNDUP #2

167. *Montana 1961 Annual Report.* Bozeman, Mon-
tana: U.S. Department of Agriculture, Agricultural
Stabilization and Conservation Service (1962). Con-
tains, cover: THE TRAIL BOSS.

168. *Open Range Days in Old Montana and Wyoming.*
Montana Heritage Series Number 13. Helena: Histor-
ical Society of Montana, n.d. (ca. 1962). Contains:

cover: GOING TO A CHRISTMAS RANCH PARTY IN THE
1880S

p. [1]: THEY'RE ALL PLUMB HOG WILD (part)
THE GEYSER BUSTS LOOSE (part)
COWBOY ABOUT TO SADDLE HORSE

p. [2]: WASH TROUGH
THE ODDS LOOKED ABOUT EVEN

p. 13: TRAILS PLOWED UNDER

p. 14: THE INITIATION OF THE TENDERFOOT

169. *Proposed Charles M. Russell National Wildlife
Range.* Portland: U.S. Dept. of the Interior, n.d.
(1962).

front cover: WHEN THE LAND BELONGED TO GOD

p. [4]: TWO WOLVES, WALKING, FRONT QUARTER
VIEW

p. [5]: BUFFALO, ONE BULL FOREGROUND, HERD
BACKGROUND

p. [7]: INDIANS MEET LEWIS AND CLARK, i.e.,
INDIANS DISCOVERING LEWIS AND CLARK

p. [8]: TWO WOLVES, TROTTING, SIDE VIEW

p. [15]: photo of CMR

p. [17]: CHIEF TAKES TOLL, i.e., TOLL COLLECTORS

p. [18]: THREE ANTELOPE

p. [28]: BUFFALO ON THE MOVE, i.e., BUFFALO
MIGRATION

p. [36]: [THE] LAST OF THE BUFFALO (part)

p. [40]: OLD MAN FOUND A BIG ROCK AND SAT UPON
IT

p. [42]: BUFFALO HOLDING UP MISSOURI RIVER
STEAMBOAT
OWL ON A DEAD TREE LIMB

back cover: BEFORE THE WHITE MAN CAME #4

170. *A Proposed Lewis and Clark National Wilderness
Waterway, Montana.* Omaha, Nebraska: Midwest

Region Office, National Park Service, February, 1962. Revised, October, 1962. P. 18: WAGON BOSS.

171. *Reminiscences of a Ranchman*, by Edgar Beecher Bronson. Lincoln: University of Nebraska Press, 1962. Contains THE ROUNDUP #2, cover, in sepia.

172. *Reproductions of American Paintings*. Selected from Fine Art Reproductions of Old and Modern Masters. Greenwich, Conn.: New York Graphic Society, Inc., 1962. Contains, p. 129: THE WORLD WAS ALL BEFORE THEM, i.e., ROMANCE MAKERS (color).

173. *South Dakota Range, Its Nature and Use*. S. Dak. Ext. Circ. 605. Brookings, South Dakota, n.d. (1962). Cover: THE TRAIL BOSS (part).

174. *The Southwest in Life and Literature*, by C. L. Sonnichsen. San Antonio: The Devin-Adair Publishing Co., 1962. Title page: RAWHIDE RAWLINS, MOUNTED.

175. *Yellowstone Wonderland: The Early History of the Great National Park*. Montana Heritage Series Eight (Helena): Montana Historical Society (1962). Contains, recto of back wrapper: THE FIRST FURROW.

176. *Young Master Artists: Boyhoods of Famous Artists*, by Irene Wicker. Indianapolis and New York: The Bobbs-Merrill Company, Inc., 1962. Contains: pp. 209–228: "Charles Russell (American) 1864–1926"
p. [210]: SELF PORTRAIT #4
p. [227]: WHERE GREAT HERDS COME TO DRINK

177. *The American Heritage Book of Natural Wonders*, by the editors of American Heritage. New York: Simon and Schuster, Inc., 1963. P. [203]: WAITING FOR A CHINOOK.

178. *Appaloosa the Spotted Horse in Art and History*, by Francis Haines. Published for the Amon Carter Museum of Western Art, Fort Worth, by the University of Texas Press, Austin (1963). Facing p. 4: WATCHING FOR THE SMOKE SIGNAL (color).

179. *The Book of the American West*. Jay Monaghan Editor-In-Chief. New York: Julian Messner Inc., (1963). Contains references pp. 565 and 590, and 3 color plates, 12 halftones, and 1 line drawing:
p. 30: LEWIS AND CLARK MEETING THE FLATHEAD INDIANS, i.e., LEWIS AND CLARK MEETING INDIANS AT ROSS' HOLE
p. [69]: WAR COUNCIL ON THE PLAINS
p. 83: WHITE MAN'S BURDEN (bronze)

p. 137: MOUNTAIN SHEEP #1 (bronze)
p. [261]: THE CRYER (bronze)
p. [276–277]: HOLDING UP THE STAGE, i.e., THE HOLD UP
p. 291: JOE SLADE KILLS JULES RENI, i.e., KILLING OF JULES RENI BY SLADE
p. [323]: THE BUCKER AND THE BUCKEROO, i.e., THE WEAVER (bronze)
p. [377]: SMOKING UP (bronze)
p. 391: WHEN SIOUX AND BLACKFEET MEET, i.e., WHEN BLACKFEET AND SIOUX MEET
p. 417: AT CLOSE QUARTERS, i.e., UP AGAINST IT
p. [501]: THE MEDICINE MAN (bronze)
p. [561]: THE BUG HUNTERS (bronze)
p. 590: COWBOY LIFE, i.e., BRONC ON A FROSTY MORN (color)
p. 591: LAST OF THE HERD, i.e., SURROUND (color)
 THE SIGNAL, i.e., INDIAN SIGNALING #1 (color)
back d.w.: THE WEAVER (bronze)

180. *E. S. Paxson—Montana Artist*, by Franz R. Stenzel, M.D. Montana Heritage Series Number 14. Helena: Montana Historical Society, n.d. (1963). Contains, recto of back cover: PLACER MINERS PROSPECTING NEW STRIKE.

181. *The Hanging of Bad Jack Slade*, by Dabney Otis Collins. Illustrated by Paul Busch. Denver: Golden Bell Press, (1963). Front.: LAUGHED AT FOR HIS FOOLISHNESS AND SHOT DEAD BY SLADE.

182. *The Last Days of the Sioux Nation*, by Robert M. Utley. Yale Western Americana Series 3. (1963). Paragraph by CMR appears as a foreword.

183. *Der Mann der Zuviel Sprach die Schonsten Geschichten aus dem Wilden Westen*. Munich: Nymphenburger Verlags-handlung, (1963). "Der Cowboy" ("The Story of the Cowpuncher"), p. 150; "Freundschaft" ("Dog Eater"), p. 212.

184. *Montana 1963 Annual Report*. Bozeman, Montana: U.S. Department of Agriculture, Agricultural Stabilization and Conservation Service. Contains, cover: THEY'RE ALL PLUMB HOG WILD.

185. *The New American Heritage New Illustrated History of the United States*. Volume 6, The Frontier. New York: Dell Publishing Co., Inc. (1963).
p. 500: FIGHTING MEAT (color)
pp. 512–513: LEWIS AND CLARK MEETING INDIANS AT ROSS' HOLE (color)

186. *The New American Heritage New Illustrated History of the United States.* Volume 9, Winning the West. New York: Dell Publishing Co., Inc. (1963).

p. [723]: ON DAY HERD #2 (color)
p. [728]: STEVE MARSHLAND WAS HANGED BY VIGILANTES
p. [737]: PEACEFUL VALLEY SALOON
p. 741: THE ROUNDUP #2 (part) (color)
pp. [744–745]: COWBOY CAMP DURING THE ROUNDUP (color)
pp. [746–747]: LAUGH KILLS LONESOME (color)
p. 748: THE BOLTER #3 (color)
p. 749: WHEN HORSES TALK WAR THERE'S SMALL CHANCE FOR PEACE (color)
pp. 754–755: TOLL COLLECTORS (color)
p. 756: FARO LAYOUT
p. 757: IN WITHOUT KNOCKING (color)
p. 758: SMOKING THEM OUT (color)
p. 766: WHEN GUNS SPEAK, DEATH SETTLES DISPUTE (color)
p. 777: (THE) MEDICINE MAN #4 (color)
b. cover: COWBOY CAMP DURING THE ROUNDUP (part) (color)

187. *The New American Heritage New Illustrated History of the United States.* Volume 10, Age of Steel. New York: Dell Publishing Co., Inc. (1963). P. [847]: COME OUT OF THERE, i.e., GIT 'EM OUT OF THERE.

188. *Northwest Trail Blazers,* by Helen Addison Howard. Caldwell: The Caxton Printers, 1963. Contains, front.: LEWIS AND CLARK MEETING THE FLATHEADS IN ROSS'S HOLE, i.e., LEWIS AND CLARK MEETING INDIANS AT ROSS' HOLE (color). Also on dustwrapper in color.

189. *Singing Cowboy: A Book of Western Songs.* Collected and edited by Margaret Larkin. New York: Oak Publications (1963). Contains:

p. 71: THE GEYSER BUSTS LOOSE (part)
p. 78: SADDLE, SHIELD
p. 82: THE INITIATION OF THE TENDERFOOT (part)
p. 115: RIM-FIRE, OR DOUBLE CINCH RIG
p. 134: THE TRAIL BOSS
p. 153: COMING TO CAMP AT THE MOUTH OF SUN RIVER
p. 168: HIS FIRST YEAR (part)

190. *The 1963 All Posse Corral Brand Book of the Denver Posse of the Westerners.* 19th Annual Edition. Edited by Robert P. Cormac. Denver, 1964.

p. [277]: SLADE GAINS HIS REVENGE, i.e., LAUGHED AT FOR HIS FOOLISHNESS AND SHOT DEAD BY SLADE
p. [278]: KILLING OF JULES RENI BY SLADE

191. *Adventure Trails in Montana,* by John Willard. Published by John Willard, sponsored by Montana Historical Society, Helena, 1964. Contains:
front wrap.: NATURE'S SOLDIERS (color)
p. [26]: LEWIS AND CLARK AT THE BEAVERHEAD FORKS, i.e., CAPTAIN LEWIS MEETING THE SHOSHONES
p. [162]: WAITING FOR A CHINOOK
p. [186]: LEWIS AND CLARK DISCOVERING BLACK EAGLE FALLS, i.e., CAPTAIN LEWIS AND HIS SCOUTS DISCOVERING THE GREAT FALLS OF THE MISSOURI IN 1805
p. [223]: [A] NOBLEMAN OF THE PLAINS

Also 40 pen and ink drawings, or parts of them, scattered throughout the book and on the back wrapper.

Also issued in boards, with MEN OF THE OPEN RANGE in color as front endpaper. No back endpaper but "Frontier Montana" (map) in envelope attached inside back cover.

192. *Centennial Train Brand Book.* Compiled by Cowbelles in recognition of Montana Centennial, 1864–1964.
cover: BRONC TO BREAKFAST (color)
p. 5: WAITING FOR A CHINOOK

193. *Charles M. Russell Pen Sketches 1964.* Printed at Alhambra, California by the Private Press of C. F. Braun & Co.

p. [9]: THE INDIAN OF THE PLAINS AS HE WAS
p. [13]: NATURE'S CATTLE #1
p. [17]: PAINTING THE TOWN
p. [21]: HOLDING UP THE OVERLAND STAGE
p. [25]: THE TRAIL BOSS
p. [29]: THE CHRISTMAS DINNER
p. [33]: THE SHELL GAME
p. [37]: THE INITIATION OF THE TENDERFOOT
p. [41]: INITIATED
p. [45]: THE LAST OF THE BUFFALO
p. [49]: THE RANGE RIDER'S CONQUEST
p. [53]: THE LAST OF HIS RACE

194. *Horseshoeing Days,* by George Wymer. (Copleras Cove, Texas): Freeman Printing Co., 1964. P. 51: THE TRAIL BOSS.

195. *The Life History of the United States.* Vol. 7: 1877–1890, The Age of Steel and Steam. New York: Time Inc. (1964). Contains:
p. [62]: LAUGH KILLS LONESOME
pp. [62–63]: TOLL COLLECTORS
p. [63]: IN WITHOUT KNOCKING

196. *Montana: The Big Sky Country.* Centennial edition. Helena: Montana Territorial Centennial Commission, 1964.

cover: IN THE ENEMY'S COUNTRY (color)
p. 3: THEY'RE ALL PLUMB HOG WILD (part)
p. 6: FOUR COWBOYS GALLOPING
p. 11: TRAILS PLOWED UNDER
p. 13: TWO WOLVES WALKING, FRONT QUARTER VIEW
p. 15: THE SCOUT #4
p. 29: RAWHIDE RAWLINS, MOUNTED
p. 32: SELF-PORTRAIT #4 (color)
 Charles M. Russell on Monte (photo)
 Russell with Red Bird (photo)
 Will Rogers and Charles M. Russell (photo)
The following tipped in between pp. 32 and 33:
 INDIAN THROWING TOMAHAWK AT KINGFISHER
 THE SLICK EAR (color)
 (THE) MEDICINE MAN #4 (color)
 THE BUFFALO HUNT, i.e., SURROUND (color)
 THE CRYER (bronze)
 (THE) SCALP DANCE (bronze)
 SECRETS OF THE NIGHT (bronze)
 WHERE THE BEST OF RIDERS QUIT (bronze)
p. 43: BRIDLE

197. *Montana Centennial Train and World's Fair Exhibit.* 50¢. (Bozeman, n.d. 1964).
p. 7: LIKE A FLASH THEY TURNED (part)
 RAWHIDE RAWLINS, MOUNTED
p. 8: THE ROAD AGENT (part)
p. 9: SQUAW WITH BULLBOAT (part)
p. 10: THE ROPE WOULD SAIL OUT AT HIM (part)
p. 11: THE FREE TRAPPER (part)
p. 12: FLATBOAT ON RIVER, FORT IN BACKGROUND
p. 13: COWBOY SEATED, HORSE NUZZLING HIS LEFT HAND
p. 14: SQUAW WITH BULLBOAT (part)
p. 15: FLATBOAT ON RIVER, FORT IN BACKGROUND
p. 16: SCOOL MARM
p. 17: THE FOX BROUGHT A FEATHER TO THE LODGE
p. 18: A RACE FOR THE WAGONS
p. 19: BUFFALO #2
p. 20: TRAILS PLOWED UNDER
p. 21: BUFFALO #2
p. 22: PETE HAD A WINNING WAY WITH CATTLE
p. 23: ALL CONVERSATION WAS CARRIED ON BY THE HANDS
p. 24: THE LAST OF THE BUFFALO (part)
p. 25: CHARLES M. RUSSELL AND HIS FRIENDS (color)
 IN THE MOUNTAINS (color)
 THE SCOUT #4
 QUICK SHOOTING SAVES OUR LIVES (color)
p. 26: BUFFALO #2
 SCOOL MARM
 THE STAGE DRIVER (vignette)
 A RACE FOR THE WAGONS (part)
 COWBOY SEATED, HORSE NUZZLING HIS LEFT HAND
p. 27: THE FREE TRAPPER (part)
 TWO RIDERS, ONE LEADING A PACK HORSE

CHUCKWAGON, COWBOYS EATING ON GROUND
RAWHIDE RAWLINS, MOUNTED
WHEN MULES WEAR DIAMONDS
A RACE FOR THE WAGONS (part)

198. *Montana 1964 Annual Report.* Bozeman, Montana: U.S. Department of Agriculture, Agricultural Stabilization and Conservation Service. Contains, cover: COWBOY SEATED, HORSE NUZZLING HIS LEFT HAND.

199. *The Pathfinders: The History of America's First Westerners,* by Gerald Rawling. New York: The Macmillan Company, 1964. Contains fol. p. 42: LEWIS AND CLARK MEETING THE FLATHEADS, i.e., LEWIS AND CLARK MEETING INDIANS AT ROSS' HOLE; YORK.

200. *Treasures of the West. The Montana Territorial Centennial Train World's Fair Exhibit,* by Stella Foote. (Butte, 1964). P. [6]: THE HOLDUP.

201. *Frontiertown Atop the Continental Divide Near Helena, Montana.* (Butte, Montana, n.d. ca. 1964).
p. [2]: THE MEDICINE MAN (bronze)
p. [3]: THE POST TRADER (vignette only)
p. [4]: OFFERING TO THE SUN GODS (bronze)
p. [7]: WHERE THE BEST OF RIDERS QUIT (bronze)
p. [9]: ENEMY TRACKS, i.e., THE ENEMY'S TRACKS (bronze)
p. [10]: DANIELSON'S DOUBLE-END STORE
p. [12]: TWO WOLVES TROTTING, SIDE VIEW
p. [14]: A BRONC TWISTER (bronze)

202. *The American Heritage History of the Great West,* by the Editors of American Heritage. New York: American Heritage Publishing Co., 1965. P. 406: STOIC OF THE PLAINS, i.e., MEDICINE MAN #4 (color).

203. *Artists of the Old West,* by John C. Ewers. Garden City: Doubleday & Co., (1965).
pp. 219–234: "A Montana Cowboy Portrays the Passing of the Old West—Charles M. Russell"
pp. [216–217]: LEWIS AND CLARK MEETING THE FLATHEADS IN ROSS' HOLE, i.e., LEWIS AND CLARK MEETING INDIANS AT ROSS' HOLE (color)
p. [218]: INDIAN MAID AT STOCKADE (color)
p. 221: JAKE HOOVER'S CABIN, i.e., OLD HOOVER CAMP ON SOUTH FORK OF JUDITH RIVER
p. 223: (THE) TOLL COLLECTORS
pp. [224–225]: IN WITHOUT KNOCKING
p. 226: WAITING FOR A CHINOOK
p. 227: BUFFALO HUNT WITH RATTLESNAKE, i.e., THE BUFFALO HUNT #26
p. 229: (A) BRONC TO BREAKFAST

p. 231: YORK

p. [233]: BEST WISHES FOR YOUR CHRISTMAS

204. *The Beauty of America in Great American Art.* Preface by Eric F. Goldman, Introduction by Tracy Atkinson. Published by Country Beautiful Foundation, Inc., Waukesha, Wisconsin (1965).

pp. 84–85: LEWIS AND CLARK MEETING FLATHEAD INDIANS, i.e., LEWIS AND CLARK MEETING INDIANS AT ROSS' HOLE (color)

p. 86: A BUFFALO HUNT, i.e., THE BUFFALO HUNT #7 (color)

205. *Five Artists of The Old West,* by Clide Hollmann. New York: Hastings House, Publishers (1965).

front.: FREE TRAPPERS (color) (also on dustjacket)

pp. [98–99]: [THE] JERKLINE

p. [105]: INDIAN CAMP #3

p. [109]: [THE] FIREBOAT

p. [114]: (THE) THOROUGHMAN'S HOME ON THE RANGE

pp. [120–121]: FOUR GENERATIONS

206. *900 Miles, The Ballads, Blues and Folksongs of Cisco Houston.* New York: Oak Publications (1965).

p. 22: THE ROUNDUP #2

p. 24: THE POST TRADER (part)

p. 25: LAUGH KILLS LONESOME
AN OLD TIME COW DOG

p. 26: THE MOUNTAINS AND PLAINS SEEMED TO STIMULATE A MAN'S IMAGINATION

p. 32: BRIDGER BRINGING IN SOME OF HIS CELEBRATED VISITORS TO HUNT AROUND FORT UNION

p. 33: A STRENUOUS LIFE

p. 34: THE WOOD HAWK (vignette)

p. 39: THE WOOD HAWK (part)

p. 48: THE COWBOY #2 (vignette)

p. 64: THE POST TRADER (vignette)

p. 67: PLUMMER AND TWO FOLLOWERS KILL FORD

p. 78: THE BULL WHACKER (vignette)

p. 79: THE WOLFER (vignette)

p. 87: THE WOLFER (part)

p. 88: THE STAGE DRIVER (vignette)

207. *Osborne Russell's Journal of a Trapper,* by Aubrey L. Haines. Lincoln: University of Nebraska Press, 1965.

cover: CARSON'S MEN (color)

fcg. p. 82: FREE TRAPPERS

fcg. p. 146: ON THE WARPATH #2

208. *The Red Man's West: True Stories of the Frontier Indians from Montana, The Magazine of Western History.* Selected and edited by Michael S. Kennedy. New York: Hastings House, 1965.

d.w.: THE PEACE TALK (color)

p. [40]: LEWIS AND CLARK MEETING THE FLATHEADS, i.e., LEWIS AND CLARK MEETING INDIANS AT ROSS' HOLE (part)

p. [108]: LEWIS AND CLARK IN THE MANDAN VILLAGE, i.e., YORK

p. [123]: INDIAN HUNTER'S (i.e., HUNTERS') RETURN

p. 168: [THE] MEDICINE MAN (bronze)
SECRETS OF THE NIGHT (bronze)
SIGN TALK (bronze)

p. [169]: MEDICINE WHIP (bronze)

p. [192]: INTRUDERS
WATCHING THE SETTLERS

p. [197]: INDIANS AND SCOUTS TALKING
BRAVE, i.e., PORTRAIT OF AN INDIAN

209. *We Came, We Saw and We Loved It . . . From God's Country to the Atlantic.* Words and pictures of the fabulous Montana Territorial Centennial Train. (Helena?) 1965.

p. [xiii]: LIKE A FLASH THEY TURNED (part)
RAWHIDE RAWLINS, MOUNTED

p. 7: SQUAW WITH BULLBOAT (part)

p. 9: THE ROPE WOULD SAIL OUT AT HIM (part)

p. 11: THE FREE TRAPPER (part)

p. 14: FLATBOAT ON RIVER, FORT IN BACKGROUND

p. 17: SQUAW WITH BULLBOAT (part)

p. 23: SCOOL MARM

p. 27: THE FOX BROUGHT A FEATHER TO THE LODGE

p. 29: A RACE FOR THE WAGONS

p. 31: BUFFALO #2

p. 33: TRAILS PLOWED UNDER

p. 36: BUFFALO #2

p. 37: PETE HAD A WINNING WAY WITH CATTLE

p. 40: THE LAST OF THE BUFFALO (part)

210. *The West That Was: From Texas to Montana.* By John Leakey as told to Nellie Snyder Yost. Lincoln: University of Nebraska Press (1965). Cover: THE HERD QUITTER (color).

211. *Brass Checks and Red Lights: Being a Pictorial Pot Pourri of (Historical) Prostitutes, Parlor Houses, Professors, Procuresses and Pimps,* by Fred and Jo Mazzulla. (Denver, 1966). Contains:

p. [27]: JUST A LITTLE SUNSHINE (color)

p. [28]: JUST A LITTLE RAIN (color)

p. [29]: JUST A LITTLE PLEASURE (color)

p. [30]: JUST A LITTLE PAIN (color)

Also an edition in cloth with brass check in envelope, and one in leather with brass check embedded in cover, issued simultaneously.

212. *The Illustrator in America 1900–1960's.* Compiled and edited by Walt Reed. New York: Reinhold Publishing Corporation, 1966. Contains, p. 68: IN THE WAKE OF THE BUFFALO RUNNERS (color) and DROPPIN' THE HAIR, HE REACHES FOR THE JEWELED HAND.

213. *Jesse James Was His Name, or Fact and Fiction Concerning the Careers of the Notorious James Brothers of Missouri,* by William A. Settle, Jr. Columbia: University of Missouri Press, 1966. Contains, p. iv: THE ROAD AGENT.

214. *Montana 1965 Annual Report.* Bozeman, Montana: U.S. Department of Agriculture, Agricultural Stabilization and Conservation Service (1967). Contains, cover: ON THE WARPATH #2.

215. *Pacific Power & Light Company Telephone Directory 1966. Kalispell, Bigfork, Creston, Somers-Lakeside, Swan Lake.* Cover: TIME TO TALK, i.e., THE MOUNTAINS AND PLAINS SEEMED TO STIMULATE A MAN'S IMAGINATION.

216. *Tidbit of Yester Series.* Volume I. Foreword by Robert E. Massman. Lithography by Art Press, New Britain, 1966. Limited to 300 copies. Pp. [20], size $\frac{7}{8} \times 1$. Contains "A Costly Binge."

217. *Der Wilde Westen.* Olten und Freburg im Breisgau: Urs Graf-Verlag, 1966. Contains:
p. [19]: EIN EDELMAN DER PRÄRIE, i.e., A NOBLEMAN OF THE PLAINS
p. [29]: [THE] ROUND UP #2
p. 35: COWBOYS AM LAGERFEUER, i.e., LAUGH KILLS LONESOME
p. 39: WHEN GUNS SPEAK, DEATH SETTLES DISPUTE
p. [45]: INDIANER UND KUNDSCHUFTER IM GESPRÄCH, i.e., INDIANS AND SCOUTS TALKING
p. [47]: GEBET AN DIE SONNE, i.e., SUN WORSHIPPERS

218. *Ho! for the Gold Fields. Northern Overland Wagon Trains of the 1860's.* Edited by Helen McCann White. St. Paul: Minnesota Historical Society, 1966. Contains, between pp. 116 and 117, INTRUDERS.

References

References

Contributions to the Historical Society of Montana. Vol. V. Helena, 1904. Pp. 103, 463.

Charles M. Russell (The Cowboy Artist). Broadside, $7\frac{1}{2} \times 18$. Photo of CMR with hat. "The following poem by Robert Vaughn was read by the author at a banquet given in honor of the Artist, Charles M. Russell, at the Hotel Rainbow, Great Falls, Montana, July 1, 1911."

Senate Joint Resolution No. 3. A joint resolution extending the thanks of the Legislative Assembly of the State of Montana to Charles M. Russell, E. S. Paxson and Ralph DeCamp. March 18, 1913. Two sheets, size $8\frac{1}{2} \times 13$, printed obverse only.

Resources and Men of Montana, by Mary E. O'Neill. Butte: privately printed, 1913. Portrait, p. 397.

Program. Historical Pageant, Monday, July 5, 1915. N.p., but probably Great Falls. Mentions CMR.

A Night For The Actives. Wednesday evening, February 10 at 8 o'clock. N.p., n.d. (Chicago: Palette and Chisel Club, 1916). Pp. 8. Note on Charles M. Russell on p. 5.

Stampede in honor of H.R.H. The Prince of Wales K. G. Souvenir Program September 10–11–12, 1919. This was the official program of the Saskatoon, Saskatchewan, Canada, rodeo. Biographical sketch of Mr. Charles M. Russell on pp. 73, 75, 77 is the same that appeared in the fifth anniversary edition of the *Montana American* (July 18, 1919, see Section III),

"The Genius of Montana—Its Artists," by Clarke Fiske.

On a Passing Frontier. Sketches from the Northwest, by Frank B. Linderman. New York: Charles Scribner's Sons, 1920. Contains "Jake Hoover's Pig," pp. 50–57, and "A Gun Trade," pp. 58–65, two stories told by CMR.

Montana: Its History and Biography, Aboriginal and Territorial. Three Decades of Statehood, by Tom Stout. Chicago: American Historical Society, 1921. Vol. I, p. 320.

American Art Annual. Edited by Francis R. Howard, Washington, D.C.: American Federation of Arts, 1921. Biographical sketch of CMR p. 551.

Indian Why Stories From a Passing Frontier by Mr. Frank Linderman. Mr. Edward Borein, Mr. and Mrs. Charles Russell, Miss Linderman, Mr. Carl Oscar Borg, Mr. and Mrs. Samuel L. Hoffman. Potter Theatre, March 17, 1923, 8:30 o'clock. For the benefit of the School of the Arts. Pp. 4, theatrical program, mentions CMR in several places.

Twenty-eighth Annual Commencement State University of Montana, Missoula. The University Gymnasium, Monday, June fifteenth, nineteen hundred and twenty-five at 10 o'clock. On p. 2 Russell is named as recipient of LLD, Honorary.

American Art Annual. Washington, D.C., 1925. Vol. 22, p. 655, gives Russell's address.

Enchanted Trails of Glacier Park, by Agnes C. Laut. New York: McBride, 1926. Pp. 20, 21.

The Compleat Rancher, by Russell H. Bennett. New York: Rinehart & Co., 1926. Santee drawings on title page, chapter headings, and endsheet. Pp. 148, 198. Reprinted 1946.

Studying Reclamation with Secretary Work and Doctor Mead: Being a Chronicle of a Journey into the Dry and Sizzling West, by Col. John H. Carroll. Washington, D.C., 1926. Pp. 60–61.

In Memoriam. Issued by Members of the Art League of Santa Barbara (California). (1926). Broadside, $11\frac{7}{8} \times 17\frac{3}{4}$. Eulogy of CMR, for presentation purposes.

The Cattle of the World, by Alvin H. Sanders. Washington: National Geographic Society, 1926. Reference to CMR's graphic report portrayed by his famous drawing "The Last of Five Thousand," p. 40.

The Columbia River Historical Expedition of 1926. Mimeographed, 22 pp. P. 7.

The Columbia River Historical Expedition American Good Will Association, Franco-American Branch Edition. 31 pp. P. 8. (1926).

How. Big Chief Multnomah welcomes his white brothers and sisters of the Columbia River Historical Expedition. Broadside, folded twice, size $3\frac{7}{8} \times 9$. July 30, 1926. P. 6.

Police! A History and Pictorial Booster. Great Falls, 1927. Portrait and biographical sketch of CMR, p. 41.

A History of Texas Artists and Sculptures, by Francis Battaile. Abilene, Texas: The Fisk Publishing Co., 1928. Pp. 182–183, 225.

Russell's Masterpiece in the House of Representatives, State Capitol, Helena, Montana. Five pages, size $8\frac{1}{2} \times 13$, mimeographed, bearing descriptions of Russell, Paxson, and DeCamp paintings. N.d. (ca. 1928).

Cowboy, by Ross Santee. New York: Cosmopolitan Book Corp., 1928. P. 35.

The Making of Buffalo Bill, by Richard J. Walsh. Indianapolis: The Bobbs Merrill Co., (1928). P. 132.

71st Congress 1st Session. H. Con. Res. 1. Concurrent Resolution Providing for the acceptance of a statue of Charles Marion Russell, presented by the State of Montana. By Mr. Leavitt. April 15, 1929.

Through Glacier Park, by Mary Roberts Rinehart. Boston: Mifflin, 1930. Photo of CMR fcg. p. 8; reference p. 53.

Lone Cowboy, My Life Story, by Will James. New York: Scribner's, 1930. Pp. 283–286.

Cowboys North and South, by Will James. New York: Scribner's, 1930. P. 69.

Compliments of Montana's Cowboy Museum. Folio, 4 pp., size $3\frac{3}{4} \times 8\frac{1}{2}$, n.d. (1930). Photo of life-size statue of Russell by Evelyn Cole, p. [2].

To Chas M. Russell. Five-stanza poem beginning "The Angels Up in Heaven," by Jim Whilt. Broadside, size 6×9, n.d. (ca. 1930), white stock, with pen sketch (not CMR) at top.

In Search of America, by Lucy Lockwood Hazard. New York: Crowell, (1930). P. 342.

The Range Cattle Industry, by Edward Everett Dale. Norman: University of Oklahoma Press, 1930. P. 205.

America Moves West, by Robert E. Riegel. New York: Holt, (1930). P. 541.

General Index to Illustrations, by Jesse Croft Ellis. Boston: The F. W. Faxon Co., 1931. P. 360.

Montana in the Making, by N. C. Abbott. Billings, Mont.: Gazette Printing Co., 1931. Pp. 331–345, 372.

The History and Ideals of American Art, by Eugen Neuhaus. Stanford: Stanford University Press, 1931. Biographical note on Russell, p. 324.

On the Open Range, by J. Frank Dobie. Dallas: The Southwest Press, 1931. P. 300.

Companions on the Trail. A Literary Chronicle, by Hamlin Garland. New York: Macmillan, 1931. Pp. 217–218.

Finding Literature on the Texas Plains, by John Will Rogers and J. Frank Dobie. Dallas, Texas: The Southwest Press, (1931). P. 52.

The Horse in Art from Primitive Times to the Present, by Lida L. Fleitmann. London: Medici Society (1931). An important history with reference to CMR.

Letters and Journals of Edith Forbes Parker. Edited by her daughter, Edith Forbes Cunningham. Printed at the Riverside Press for private distribution, 1931. Mentions CMR.

America As Americans See It. Edited by Fred J. Ringel. New York: The Literary Guild, 1932. Statement on occasion of Russell's death by his friend Frank B. Linderman, p. 53, and brief essay and appraisal of Russell's work by Will James, pp. 61–64.

A Parade of the States, by Bruce Barton. Garden City: Doubleday Doran & Co., 1932. P. 94.

The Broncho Buster Busted and Other Messages, by Jay C. Kellog, the Cowboy Evangelist. (Tacoma, Wash., The Whole Gospel Crusaders of America, Inc., 1932). Reference to CMR and photo of studio, p. 36.

The Western Pony, by William R. Leigh. Foreword by James L. Clark. New York: Huntington Press, 1933. P. 70.

A Road to Bigger Things. Describing How Success May be Won Through Illustrating and Cartooning. Minneapolis, Minn.: Federal Schools, Inc., 1933. Reference to CMR, p. 7; portrait of CMR, p. 18; statement attributed to CMR, p. 25; reference to preliminary pencil studies by CMR, p. 29; CMR name on letterhead, p. 67.

Montana's Charlie Russell Song, by Powder River Jack Lee. Copyright, 1933. Sheet music. Photo of CMR on cover.

Sweet Land, by Lewis Gannett. Garden City: Doubleday Doran & Co., 1934. P. 234.

Tall Tales from Texas (Cow Camps), by Mody C. Boatright. Dallas: The Southwest Press, n.d. (1934). P. xvi.

Ubet, by John R. Barrows. Caldwell, Idaho: The Caxton Printers, Ltd., 1934. Pp. 54, 145.

Will Rogers, Ambassador of Good Will, Prince of Wit and Wisdom, by J. P. O'Brien. Chicago: Winston, 1935. P. 233.

The West, by I. M. (Tex) Moore. Wichita: Wichita Printing Co., 1935. P. 71.

An Appreciation of Will Rogers, by David Randolph Milsten. San Antonio: The Naylor Co., 1935. P. 238.

Adventures in Americana, by Frederick Woodward Skiff. Portland: Metropolitan Press, (1935). Contains an account, p. 91, of finding a painting by CMR.

Dictionary of American Biography. Edited by Dumas Malone. New York: Scribner's, 1935. Vol. 15, pp. 496–497.

"Vaya Con Dios, Will," by Harry Carr. Introduction by William S. Hart. N.p., n.d. (1935). P. 5.

"Friend Will," by Joe DeYong. Santa Barbara, Calif.: The Schauer Printing Studio, Inc., n.d. (ca. 1935). P. 20.

Folks Say of Will Rogers, by William Howard Payne and Jake C. Lyons. New York: G. P. Putnam Sons, (1936). Pp. 9, 199–202, 216–218.

Party: A Literary Nightmare, by Frederick Lambeck. Garden City, 1936. Pp. 19, 56.

Tales of the Mustang, by J. Frank Dobie. Dallas: Dallas Book Club, 1936. P. 89.

Dust of the Desert, by Jack Weadock. New York and London: D. Appleton Century Co., 1936. Reference to CMR in Introduction.

Peter Lecky by Himself. New York: Charles Scribner's Sons, 1936. Pp. 68–69.

Dude Ranches and Ponies, by Lawrence B. Smith (Lon Smith). New York: Coward McCann, 1936. P. xxiii.

Cowboy Lingo, by Ramon F. Adams. Boston: Houghton Mifflin Co., 1936. Pp. 148, 237, 238. Reprinted 1949.

The Western Range. Edited by Earle H. Clapp. Sen. Doc. 199, 74th Cong. 2d Sess. Washington: Government Printing Office, 1936. Reference to CMR, p. 151.

Out of the West, by Rufus Rockwell Wilson. New York: Wilson-Erickson, Inc., 1936. P. 436.

G. F. H. S. Calendar, 1936. Cover design for this calendar, executed by students of the commercial art class of the Great Falls High School, is in linoleum block by Virginia LaChappelle, entitled Charles M. Russell Memorial.

The Stampede and Tales of the Far West, by "Powder River" Jack H. Lee. Greensburg, Pa.: Standardized Press, n.d. (ca. 1936). A poem entitled "Trail's End" on pp. 101–102 is "Dedicated to our dear friend, Nancy C. Russell, and to the memory of Montana's beloved cowboy Charles Russell, artist, who has passed on to the trails over the great divide."

Powder River Jack and Kitty Lee's Songs of the Range. Chicago: Chart Music Publishing House, 1937. Bust of CMR by Frederick Schweigardt inside front cover.

A Map of Montana. Whereon is depicted and inscribed the Pioneer History of the Land of Shining Mountains. Montana State Highway Department, 1937. Size 23 × 17. Reference to the home of Charles M. Russell, the Cowboy Artist.

Burnt Leather, by Jack Horan. Boston: The Christopher Publishing House (1937). The poems entitled "Pals" on p. 86 and "To My Friend Sid" on pp. 90–91 mention Russell, and the poems entitled "C. M. Russell —Montana's Own" on pp. 87–88 and "In Memory" on p. 89 are about Russell.

Burnt Leather, by Jack Horan. Poetry Sketches from America's Outdoor Studio. Billings: Bit and Spur Publishers (1937). Pp. 86–92.

Frontier Montana Pioneer. A one-page history dedicated to the old timers. Map published by the Montana State Highway Department, 1937. Historic data compiled by Bob Fletcher and Irvin Shope. Broadside, size 25½ × 34. Numerous references to CMR.

Big Loop and Little: The Cowboy's Story, by Alice Rogers Hager. New York: Macmillan, 1937. Photo of Log Cabin Studio, referred to as Charles Russell Cowboy Museum, p. [15].

Chico of the Cross U P Ranch, by Dan Muller. Illustrated by the author. Chicago: Reilly & Lee (1938). P. 155.

Books of the Southwest, by Mary Tucker. Hamburg, Germany: J. J. Augustin, Publisher, n.d. (ca. 1938). P. 69.

1888—Fifty Years Ago—1938. Osborne Calendar Co. Broadside, size 10 × 16¼. Tells briefly the story of Russell's life and mentions reasons for using Russell pictures on an anniversary calendar. Issued in conjunction with the broadside containing five Russell subjects. See Section XI.

My Cousin Will Rogers, by Spi M. Trent. New York: Putnam, 1938. Contains part of Rogers' introduction to *Trails Plowed Under* on pp. 257–258.

American Book Illustrators, by Theodore Bolton. New York: R. R. Bowker, 1938. Contains checklist of Russell material by James B. Rankin, pp. 170–174.

Southwest Heritage, A Literary History, by Mable Major, Rebecca W. Smith, and T. M. Pearce. Albuquerque: University of New Mexico Press, 1938. P. 154.

"Charles Marion Russell. The Man and His Work," by Quintin Morris Martin. M.A. dissertation, University of Texas, 1939. 104 unnumbered pages. Appendix A, List of prints studied. Appendix B, Bibliography.

Soaring Wings, by George Palmer Putnam. New York: Harcourt Brace, 1939. Reference to Russell's paintings, collections of W. S. Hart, p. 236.

Golden Tales of the Southwest. Selected with an introduction by May Lamberton Becker. New York: Dodd Mead, 1939. Brief biography of CMR on p. 265.

Avalanche, by Albert L. Sperry. New York: Christopher Publishing House, 1938. Pp. 30–31, 66–67.

The Cowboy Artist Charles M. Russell, by E. A. Burbank. San Francisco, copyright 1939 by Fred T. Darvill.

Tales From Buffalo Land, The Story of George W. Newton, by Usher L. Burdick. Baltimore: Wirth Bros., 1939. Newton's story of Charles Russell, p. 19.

We Pointed Them North: Recollections of a Cowpuncher, by E. C. Abbott ("Teddy Blue") and Helena Huntington Smith. Illustrated with drawings by Ross Santee, and photographs. New York: Farrar & Rinehart, (1939). Pp. 4, 19, 24, 82, 123, 168, 169, 171, 217, 267.

Montana, A State Guide Book. Compiled by Federal Writers Project. Federal Works Agency Projects Administration. American Guide Series. New York: The Viking Press, 1939. Pp. 108–109, 169, 171, 230, 232, 251, 252, 285, 390

"The Memory of Charley Russell Song," by Jim Whilt and Mimi Grayce. Helena: Montana National Cowboys Association, Inc., 1940. Wrappers, 6 pp., Ecklund portrait of Russell on front cover. Also an edition 1949.

And All Points West, by William S. Hart and Mary E. Hart. Lakotah Press, (1940). Mentions CMR in dedication.

Dude Woman, by Peter B. Kyne. New York: H. C. Kinsey & Co., 1940. Minor reference to CMR prints on p. 154.

Welcome To . . . Montana's State Capitol Building. Helena: Montana Record Pub'l. Co., n.d. (ca. 1940). Leaflet, 4 pp., illustrated. Reference to CMR and painting in capitol building, p. [3].

Short Grass Country, by Stanley Vestal. New York: Duell, Sloan and Pearce, (1941). P. 189.

Encyclopedia of Northwest Biography. Edited by Winfield Scott Downs. New York: The American Historical Co., Inc., 1941. Biographical sketch of CMR, pp. 451-453.

Exit Laughing, by Irvin S. Cobb. Indianapolis: Bobbs Merrill, 1941. Includes Cobb's reminiscences of a summer spent with CMR and Nancy Russell in Glacier National Park; also a chapter entitled "What a Pair to Draw to," pp. 401-415, on Russell and Will Rogers.

Will Rogers, by Betty Rogers. Indianapolis: Bobbs Merrill, 1941. Pp. 270, 295, 296, 297.

Who's Who in Northwest Art, by Marion Brymner Appleton. Seattle: Frank McCaffrey, 1941. Biographical sketch of CMR, p. 60.

Cow Country, by Edward Everett Dale. Norman: University of Oklahoma Press, 1942. Pp. 108, 255.

Northwest Books. Edited by Rufus A. Coleman. Portland: Binford and Morts, 1942. Lists Russell books, pp. 181-183.

The Montana Frontier, by Merrill G. Burlingame. Helena, Montana: State Publishing Co. (1942). P. 332, and list of books illustrated by Russell included in bibliography, pp. 391-397.

Rogue's Gallery. Profiles of My Eminent Contemporaries, by Frank Scully. Hollywood: Murray & Gee, Inc., 1943. References to CMR on p. 169 (complimentary), and on p. 172 (uncomplimentary).

Montana: High Wide and Handsome, by Joseph Kinsey Howard. New Haven: Yale University Press, 1943. Contains references to CMR.

A Book of War Letters. Edited by Harry E. Maule. New York: Random House, 1943. P. 230.

See the Old West at its best in Montana. N.p., n.d. (Butte? ca. 1943). Front wrapper serves as title page. Pp. [12], size $10\frac{13}{16} \times 7\frac{5}{8}$. Photo of interior of Russell museum, p. [9].

American Authors and Books, by W. J. Burke and Will D. Howe. New York: Gramercy Pub'l. Co., 1943. Short biographical sketch of CMR, p. 649.

West Bound, by Floyd I. McMurray. New York: Charles Scribner's Sons, (1943). P. 252.

The Enchanted West, by John McCarty. Dallas: The Dr. Pepper Co., 1944. Pp. 5, 23, 24.

Burbank Among the Indians. By E. A. Burbank as told to Ernest Royce. Caldwell: The Caxton Printers, 1944. Full-page drawing of CMR between pp. 200 and 201.

Western Words, A Dictionary of the Range, Cow Camp and Trail, by Ramon F. Adams. Norman: University of Oklahoma Press, 1944. Pp. 70, 83, 95, 96, 109, 111, 112, 136, 137, 141.

The Missouri, by Stanley Vestal. New York and Toronto: Farrar & Rinehart, 1945. Pp. 116, 319-321.

Mid Country. Edited by Lowry C. Wimberly. Lincoln: University of Nebraska Press, 1945. P. 115.

Will Rogers' Thoughts on the Hereafter Taken from "Trails Plowed Under." Reprinted in Respectful Memory. Central Publishing House, 2969 W. 25th Street, Cleveland 13, Ohio. N.d. (ca. 1945). Pp. [8], size $3\frac{1}{2} \times 6$, wrappers.

Art Notes. J. W. Young Galleries. Chicago, February, 1946. P. [10].

New Grand Hotel, Billings, Mont. Broadside, 17×20, printed both sides, n.d. (ca. 1946). Map of Montana shows caricature of C. M. Russell at easel painting a picture of Great Falls.

Address of Walter Russell. First Baptist Church, Fort Worth, June 18, 1946. P. 5.

Maverick Town, The Story of Old Tascosa, by John L. McCarty. Norman: University of Oklahoma Press, 1946. CMR mentioned p. 157, quoted p. 258.

Land of the Dakotah, by Bruce Nelson. Minneapolis: University of Minnesota Press, (1946). P. 218.

The Pictorial Record of the Old West, by Robert Taft. O. Frenzeny and Tavernier. Reprinted from *Kansas Historical Quarterly*, February, 1946. Pp. 32-33.

1945 Brand Book—The Westerners. Edited by Herbert D. Brayer. Denver, Colorado, 1946. Dr. Davidson, in his "Tall Tales of the Rockies," quotes Russell on liars, p. 14.

A Notebook of the Old West, by W. H. Hutchinson. Designed and printed at Chico, California, by Bob Hurst for the author. N.d. (1947). Reference to CMR and a paraphrase of the story "Safety First" on pp. 120–121.

Golden Multitudes, by Frank Luther Mott. New York: The Macmillan Co., 1947. P. 237.

The Horse of the Americas, by Robert Moorman Denhardt. Norman: University of Oklahoma Press, 1947. Pp. 191, 195.

Piano Jim and the Impotent Pumpkin Vine or "Charley Russell's Best Story—To My Way of Thinking," by Irvin S. Cobb. With a Post Script by Will Rogers and a Preface by John Wilson Townsend. Lexington, Kentucky: Blue Grass Book Shop, 1947 "Piano Jim and the Impotent Pumpkin Vine" is on pages 21–23 of this pamphlet. Although it was written by Cobb, it is Russell's story.

Illustrators of Children's Books, by Bertha E. Mahony, Beula Folmsbee, and Louise Payson Latimer. Boston: The Horn Book Co., 1947. P. 435.

The Westerners Brand Book. Vol. III. Edited by Elmo Scott Watson. Chicago: Chicago Corral of Westerners, 1947. P. 73.

Pacific Northwest. The Scenic Wonderland of the World Welcomes You, 1947. Booster pamphlet, 48 pages. Reference to CMR and Will Rogers, with photo, on p. 7.

Apache Land, by Ross Santee. New York: Scribner's, 1947. P. 70.

Big Country: Texas, by Donald Day. New York: Duell, Sloan & Pearce (1947). P. 287.

Forged In Strong Fires. Edited by M. P. Wentworth. Caldwell: The Caxton Printers Ltd., 1948. Pp. 27–29.

Wyoming Cattle Trails, by John K. Rollinson. Caldwell, Idaho: The Caxton Printers, Ltd., 1948. Pp. 149, 219, 260–261.

America's Heartland—The Southwest, by Green Peyton. Norman: University of Oklahoma Press, 1948. Pp. 244, 252.

The Westerners Brand Book. Vol. IV. Edited by Don Russell. Chicago: Chicago Corral, 1948. Pp. 30, 35, 48, 51.

The Big Divide, by David Lavender. Garden City: Doubleday & Co., 1948. P. 216.

Index to Reproductions of American Paintings, by Kate M. Monro and Isabel Stephenson Monro. New York: H. W. Wilson Co., 1948. Lists 7 paintings by CMR, p. 543.

The William Robertson Coe Collection of Western Americana, by Edward Eberstadt. *Yale University Library Gazette*, Vol. 23, No. 2, October, 1948. P. 95.

Folk Laughter on the American Frontier, by Mody C. Boatright. New York: The Macmillan Co., 1949. CMR quoted, p. 89.

The American Guide. Edited by Henry G. Alsberg. New York: Hastings House, 1949. P. 1051.

It's an Old Wild West Custom, by Duncan Emrich. New York: The Vanguard Press, 1949. Reference to CMR and Con Price, pp. 181 ff. in "The Story of Limburger Cheese."

The Westerners Brand Book. Vol. V. Edited by Don Russell. Chicago: Chicago Corral, 1949. Pp. 3, 24, 44, 65, 79, 473.

Northwest Books—First Supplement. Edited by Rufus A. Coleman. Lincoln: University of Nebraska Press, 1949. Pp. 122–123.

City of Flaming Adventure, by Boyce House. San Antonio, Texas: The Naylor Co., (1949). P. 138.

The Pictorial Record of The Old West, VIII: Graham and Zogbaum, by Robert Taft. Reprinted from the *Kansas Historical Quarterly*, Topeka, August, 1949. P. 209.

Charlie Russell Rides Again. Broadside, size 8½ × 16, cream stock. Bluegrass Bookshop, Lexington, Kentucky, October 24, 1949. Reproducing a letter from Nancy Russell to John Wilson Townsend dated March 5, 1930, on proposed publication of *Good Medicine*.

Gump's Treasure Trade. A Story of San Francisco, by Carol Green Wilson. New York: Thomas Y. Crowell Company (1949). Reference to CMR exhibition in 1915, p. 149.

The Voice of the Coyote, by J. Frank Dobie. Boston: Little, Brown & Co., 1949. Pp. 28, 190.

Will Rogers, A Biography, by Donald Day. Boston: Houghton Mifflin Co., 1949. Pp. 84–85, 395.

The Westerners Brand Book, Vol. VI. Edited by Don Russell. Chicago: Chicago Corral, 1950. Pp. [20], 54, [60], 61, 74, 100.

Old Montana and Her Cowboy Artist. A paper read before the Contemporary Club, Davenport, Iowa, January Thirtieth Nineteen Hundred Fifty by James W. Bollinger. Pp. 24, size 6¼ × 9. Reprinted, World Publishing Co., Shenandoah, Iowa, 1963, with introduction by Otha D. Wearin and illustration by Robert M. Templeton. Wrappers, pp. [30], size 5⅛ × 8½, limited edition 1,000 copies.

Contemporary Club Papers. Volume LIV: 1949–1950. Davenport, Iowa: Contemporary Club, 1950. Contains "Old Montana and Her Cowboy Artist," by James W. Bollinger. This was printed about June, 1950, and follows the separate printing.

Welcome to . . . Montana's State Capitol Building. Folio, size 6 × 9. Helena, n.d., ca. 1950. Mentions CMR, pp. [2] and [3].

Montana, The Treasure State. Folder, issued by Helena Junior Chamber of Commerce. Size 9 × 6, n.d. (ca. 1950). Mentions "Russell's painting of Lewis and Clark meeting the Indians at Ross Hole . . . valued from $5,000 to $25,000."

The Salute of the Robe Trade. Flyer, size 7½ × 6. Contains description of the painting and brief biographical sketch of the artist. Denver Public Library, Malcolm G. Wyer, Librarian, Denver, n.d. (ca. 1950).

The Wagon Boss. Flyer, size 6 × 8. Contains description of the painting and brief biographical sketch of the artist. Denver Public Library, Malcolm G. Wyer, Librarian, Denver, n.d. (ca. 1950).

Chuck Wagon Windies, by Lona Shawver. San Antonio, Texas: The Naylor Co., (1950). P. 108.

Cowboys and Cattle Kings, Life on the Range Today, by C. L. Sonnichsen. Norman: University of Oklahoma Press, 1950. Pp. 280, 288.

Murder in Montana, by Muriel D. Bradley. Garden City: Doubleday, 1950. References on p. 29 to CMR painting in the Montana Club in Helena.

Ed Borein's West, by Edward Borein. Santa Barbara, California: Schauer Printing Studio, (1950). Reference to CMR in Irving Will's "Life of Ed Borein."

Etchings of the West, by Edward Borein. Santa Barbara, California: Press of the Schauer Printing Studio, Inc., 1950. P. [7].

Pacific Northwest Americana, by Charles W. Smith. Portland, Oregon: Binfords and Mort, 1950. P. 298.

Frontier America. Compiled by Glen Dawson. Los Angeles: Dawson's Book Shop, 1950. Items No. 767, 1335, 1343.

The Westerners Brand Book, Vol. VII. Edited by Don Russell. Chicago: Chicago Corral, 1951. Pp. [4], [12], [28], 38–39, 55, 83, 85, 88. "Charles M. Russell, Best Artist of the West," by Karl Yost, pp. 89–91, 96.

Montana State Legislature, Helena. House Bill No. 466. An Act to create the Charles M. Russell Memorial Commission . . . to appropriate $62,500 . . . for the purchase . . . of "The Mint Collection" . . . on condition the further sum of $62,500 is raised by public subscription Introduced by Committee on Appropriations. Folio, n.d. (1951).

The Adventures of a Treasure Hunter, by Charles P. Everitt. Boston: Little, Brown & Co., 1951. Pp. 16–17.

The Cowboy Encyclopedia, by Bruce Grant. Chicago: Rand McNally, (1951). Biographical sketch of CMR, p. 130.

A Treasury of Western Folklore. Edited by B. A. Botkin. Foreword by Bernard De Voto. Southwest Edition. New York: Crown Publishers, 1951. Pp. 97–98, 420, 488.

Back Trailing on Open Range, by Luke D. Sweetman. Caldwell, Idaho: Caxton Printers, 1951. P. 228.

Brand Book, 1950. The Denver Westerners, edited by Harold H. Hunham. Denver, Colorado: University of Denver, (1951), P. 38.

Finding Literature On the Texas Plains, by John William Rogers. Dallas: The Southwest Press, 1951. P. 52.

Pictorial Record of The Old West. XIII: The End of a Century, by Robert Taft. Reprinted from the *Kansas Historical Quarterly,* August, 1951. Pp. 225, 226, 232, 233, 241.

Pinnacle Jake, by A. D. Snyder and Nellie Irene Yost. Caldwell: The Caxton Printers, Ltd., 1951. Pp. 12, 56.

Spurs West. Edited by Joseph T. Shaw. Garden City, New York: Permabooks, (1951). Reference to CMR in introduction.

John W. Thomason, Jr.—Artist—Writer, by Ray Past. *The Library Chronicle of the University of Texas*, Vol. IV, No. 2, Summer, 1951. P. 99.

The Westerners Brand Book, Vol. VIII. Edited by Don Russell. Chicago: Chicago Corral, 1951–1952. Pp. 7, 28, 37, 38, 64, 68, 96.

Montana Elks, B.P.O.E. Golden Jubilee, 1902–1952. Wrappers, 14 pp., illustrated. Great Falls, 1952. Portrait of Russell and photo of artist in front of studio, p. [14].

Majestic Montana, by W. H. Chase. Billings: Reporter Printing and Supply Co., n.d. (1952). Portrait of Russell, p. [10].

The Black Hills, by Roderick Peattie. New York: The Vanguard Press (1952). Pp. 185–186.

A Bill to provide for the issuance of a special postage stamp in honor of the late Charles Russell. By Mr. Mansfield. H. R. 7615, 82nd Cong., 2d Sess., April 28, 1952.

Come An' Get It, by Ramon F. Adams. Norman: University of Oklahoma Press, 1952. Pp. 32, 140.

Ed Borein's West, edited by Edward S. Spaulding. Santa Barbara, California: Press of the Schauer Printing Studio, Inc., 1952. Pp. 2, 4.

Life on the Texas Range, by J. E. Haley. Austin: University of Texas Press, 1952. Pp. 15, 23.

Return of the Warriors Reproduced from An Original Art Painting by Charles Russell. Published by The Thos. D. Murphy Co., Red Oak, Iowa. Broadside, 5 × 7, white stock, n.d., ca. 1952, to accompany print.

The Mustangs, by J. Frank Dobie. Boston: Little, Brown & Co., 1952. P. 56.

A Proclamation establishing the month of May, 1952, as Charles M. Russell Month by John W. Bonner, Governor. March 17, 1952.

Artists and Illustrators of the Old West 1850–1900, by Robert Taft. New York: Charles Scribner's Sons, 1953. Pp. 176, 198, 226, 231, 232, 238, 347, 373, 376, 378.

Bullamanc, 1953. Edited by Perry E. Lunsford. Dallas, Texas: Jack Frost Ranches, 1953. P. 23.

Hell on Horses and Women, by Alice Marriott. Norman: University of Oklahoma Press, (1953). Pp. 138, 232.

The Horse Men of the Americas and the Literature They Inspired, by Edward Laroque Tinker. New York: Hastings House, 1953. Reference to CMR, pp. 112, 147.

Lost Pony Tracks, by Ross Santee. New York: Scribner's 1953. Reference to CMR, p. 135.

The Ranch. Great Northern Railway. Cowboy Painter. 4¼ × 9. 12 pp., wrappers. (1953). Photo of Charles M. Russell, p. 6.

Westward the Briton, by Robert G. Athearn. New York: Scribner's, 1953. Reprinted, University of Nebraska Press, Lincoln, ca. 1962. Contains a quotation from CMR, p. 2.

When the Grass Was Free, by E. F. Hagell. New York: Bouregy & Curl, 1954. Pp. 17, 104.

A Bill to provide for the issuance of a special postage stamp in honor of the late Charles Russell. By Mr. Mansfield and Mr. Murray. S. 862, 84th Cong., 1st Sess., February 1, 1955.

The American Cowboy, by Joe B. Frantz and Julian Ernest Choate. Norman: University of Oklahoma Press, 1955. P. 197.

Frontier Years, by Mark H. Brown and W. R. Felton. 1955. Pp. 56–58, 151–152, and poem from *Good Medicine*, p. 192.

From Wilderness to Statehood, a History of Montana, 1805–1900, by James McClellan Hamilton. Portland: Binfords & Mort (1957). Erroneous account of "Waiting for a Chinook," p. 395.

The Humor of the American Cowboy, by Stan Hoig. Caldwell: The Caxton Printers, Ltd., 1958. Pp. 35, 41, 42.

Charlie's Last Ride. Invitation to members of Montana State Society, Washington, D.C., to escort the Russell statue from the Smithsonian Institution to the Capitol, March 17, 1959. Broadside, size 11 × 8½.

Invitation . . . The Montana State Society invites you to an informal reception following the installation of the

Charles Russell statue, Thursday, March 19, 1959, Five-thirty to Seven-thirty, Old Supreme Court, U.S. Capitol Building. Card, size $4 \times 4\frac{3}{4}$.

Compliments of Montana's Cowboy Museum. Folio, 4 pp., size $3\frac{3}{4} \times 8\frac{1}{2}$, n.d. (ca. 1960). Photo of life-size statue of Russell by Evelyn Cole, p. [2].

John Ware's Cow Country, by Grant MacEwan. Edmonton, Alberta: The Institute of Applied Art, Ltd., 1960. Pp. 50, 177.

Cowboy-Artist, Charles M. Russell, by Shannon Garst. New York: Julian Messner, Inc., 1960.

See It . . . Montana's History and Art Now On Display In $800,000 Pioneers & Veterans Memorial Building. Folder issued by the Historical Society of Montana, Helena, size 6×4, n.d. (1960). Mentions "The Charles M. Russell Room which houses . . . some of the finest works of the justly famous Cowboy Artist."

High Country Empire, by Robert G. Athearn. New York: McGraw-Hill, 1960, Reprinted, University of Nebraska Press, Lincoln, n.d. (1965). Pp. 148, 200–201.

Leaves From the Medicine Tree. A History of the Area Influenced by the Tree and Biographies of Pioneers and Old Timers Who Came Under Its Spell Prior to 1900. Lethbridge: The High River Pioneers' and Old Timers' Association, 1960. P. 45, and account of CMR's winter in Canada, 1888–1889, pp. 106–107.

American Panorama West of the Mississippi. A Holiday Magazine Book. Garden City: Doubleday (1960). P. 127.

"A Montanan's Washington Notebook," by Brit Englund from the Office of Senator Lee Metcalf, September 28, 1961. Reference to commemorative postage stamp honoring CMR.

"A Montanan's Washington Notebook," by Brit Englund from the Office of Senator Lee Metcalf, October 5, 1961. Reference to commemorative postage stamp honoring CMR.

How The West Was Won. Broadside, size $14\frac{1}{2} \times 21$, folded. Reference to "Frederic Remington and Charles Russell as the greatest of all cowboy artists." *Life Magazine*, New York, n.d. (1961).

Compliments of Trailside Galleries. Folder issued by Dick Flood, Idaho Falls, Idaho, n.d. (ca. 1961). Size $7\frac{3}{4} \times 6$. CMR letter to Teddy Blue Abbott, p. 1; painting of CMR with his horse Neenah by O. C. Seltzer, p. 2.

The West of the Texas Kid 1881–1910. Recollections of Thomas Edward Crawford. Edited and with an introduction by Jeff C. Dykes. Norman: University of Oklahoma Press, (1962). "Recollecting with Charlie Russell," pp. 185–187.

Big Game Refuge to Honor Famed Cowboy Artist. United States Department of the Interior Press Release, Feb. 19, 1963. Reference to establishment of the Charles M. Russell National Wildlife Range.

"A Montanan's Washington Notebook," by Brit Englund and Dick Warden, from the Office of Sen. Lee Metcalf, February 2, 1963. Reference to Senator's request for issuance of commemorative postage stamp honoring CMR.

We the People, The Story of the United States Capitol, Its Past and Its Promise. Washington, D.C.: The United States Capitol Historical Society, 1963. P. 98.

"A Montanan's Washington Notebook," by Dick Warden from the Office of Sen. Lee Metcalf, April 6, 1963. Reference to request for commemorative postage stamp honoring CMR.

"A Montanan's Washington Notebook," by Dick Warden from the Office of Sen. Lee Metcalf, April 26, 1963. Reference to the National Wildlife Range named in honor of CMR.

"A Montanan's Washington Notebook," by Dick Warden from the Office of Sen. Lee Metcalf, May 23, 1963. Reference to "Charlie Russell's Town."

Bob Fudge—Texas Trail Driver, Montana-Wyoming Cowboy, 1862–1933. By Jim Russell. Big Mountain Press (1963). Bob wrote about meeting the cowboy artist, Charlie Russell, a kid who he believed might get ahead drawing funny cowboy pictures.

Trailside Galleries. Folder issued by Dick Flood, Director, Idaho Falls, Idaho, n.d. (ca. 1963). Size $7\frac{3}{4} \times 6$. Letter to CMR from Tom Mix, p. 1; painting of CMR on Monte by O. C. Seltzer, p. 2.

Art Guide of Forest Lawn with Drawings, Descriptions and Interpretations of All Works of Art, and Detailed Information on Forest Lawn Memorial-Parks. Los Angeles: Forest Lawn Memorial Park Association, (1963). P. 268.

Reviewing the Years, by John Young-Hunter. New York: Crown Publishers, Inc. (1963). Pp. 74, 79–82.

Great Falls Montana. Montana's largest and Friendliest City. One sheet, 9 × 14½, folded twice, n.d. (1964). Mentions CMR Gallery.

High Spots in Western Illustrating, by Jeff C. Dykes. Kansas City, Missouri: The Kansas City Posse, The Westerners, 1964. Limited to 250 autographed copies. Pp. 6, 7, 8, 9, 17, 18, 19, 20, 26, 27, 28.

One Man's Montana. An Informal Portrait of a State, by John K. Hutchens. New York: Lippincott (1964). Chapter XXIII, pp. 201–211, "Charlie Russell." This article is erroneous and misleading. Dustwrapper carries five of the Western Types series.

A Concise Study Guide to the American Frontier, by Nelson Klose. Lincoln: University of Nebraska Press, 1964. P. 150.

"Chester Place," by Ruth and Chuck Powell. On the occasion of a tour of the Downtown Campus of Mount St. Mary's College located in Chester Place, Los Angeles, Saturday, October 24, 1964. The Historical Society of Southern California and Southern California Chapter of The American Institute of Architects. Pp. 16, size 5½ × 8½, wrappers. P. 13.

The Montana State University School of Fine Arts, Charles Bolen, Dean. Music by Montana's Composers in Two Centennial Concerts. 3:00 P.M. 8:15 P.M. Sunday, May 24, 1964. University Theater Music School Recital Hall. Pp. 12. Text of Charles Russell Suite by Francis E. White.

The Montana State University School of Fine Arts, Charles Bolen, Dean, presents Music by Montana's Composers in Two Centennial Concerts in commemoration of Montana's Territorial Centennial and 75th Year of Statehood. 3:00 P.M. 8:15 P.M. Sunday, May 24, 1964, University Theater Music School Recital Hall. Pp. [8], pink stock.

Centennial 1864–1964 Souvenir Program. Charles Russell Suite Music and Text by Francis E. White, University Theater. Pp. [12], mimeographed.

Art Collecting for Pleasure and Profit, by Ted Farah. With an introduction by Huntington Hartford. New York: Cornerstone Library Publications, 1964. P. 144.

The Mystery of the Shaky Staircase, by Margaret Scherf. New York: Franklin Watts, Inc. (1965). A teen-age story, set in Montana, with numerous references to CMR.

From the Pecos to the Powder, A Cowboy's Autobiography as told to Ramon F. Adams by Bob Kennon. Norman: University of Oklahoma Press, 1965. Pp. vii, viii, 6, 122, 131, 142, 144–152, 161, 163–164, 167–168, 207, 232, 234, 238, 240–241.

Pioneering Tales of Montana, by Warren Woodson. New York: Exposition Press (1965). Pp. 144–145.

Compilation of Works of Art and Other Objects in the United States Capitol. Prepared by the Architect of the Capitol. Washington: Government Printing Office, 1965. Pp. 205, 207, 211, 221.

Mantle Fielding's Dictionary of American Painters, Sculptors, and Engravers. With an Addendum Containing Corrections and Additional Material on the Original Entries. Compiled by James F. Carr. New York: James F. Carr, Publisher, 1965. P. 511, article on CMR by Yost.

Treasury of Frontier Relics, by Les Beitz. New York: Edwin House, 1966. Trade Distribution by Crown Publishers, Inc. Pp. 143, 198, 205–208.

SECTION XVIII

Index to Paintings, Drawings, and Sculpture

Index to Paintings, Drawings, and Sculpture

In conformity with our rules for correctly identifying titles, we have used the following symbols:

© following a title indicates that this was a title copyrighted by someone other than Russell before the first published appearance.

® following a title indicates that this was a title assigned by Russell.

§ following a title indicates that this was a title assigned by Yost or Yost and Renner for bibliographical purposes, in many instances using Russell's words.

No symbol indicates that this was first published title although it may also be the same as a copyright or Russell title.

* following a page number indicates that this is first appearance of the item.

Addenda

1. P. 51, Sec. II, item 99, THE CHALLENGE #1*, Yost questions authenticity.
2. P. 61, Sec. II, item 155, LETTER TO FRIEND JESS*, Yost questions authenticity.
3. P. 114, Sec. IV, add: *Denver Post* Sunday Empire Magazine 1966. THE ATTACK ON THE WAGON TRAIN #2 (color).

N.B. The series of articles by Jack Gunn, including this issue, was reprinted by *The Denver Post* in a tabloid size magazine entitled "The Red Man's Last Struggle." The CMR picture appears in color on p. 30 of the reprint.

4. P. 149, Sec. VI, add: LONE WOLF.

SECTION XIX

General Index

General Index